Digital Photogrammetry:

An Addendum to the Manual of Photogrammetry

AMERICAN SOCIETY FOR PHOTOGRAMMETRY
AND REMOTE SENSING

ISBN 1-57083-037-1

Published by

American Society for Photogrammetry and Remote Sensing
5410 Grosvenor Lane, Suite 210
Bethesda, Maryland 20814-2160

Printed in the United States of America

Please Note: The mention of specific products or services
in this book is not an endorsement by ASPRS.

ii

Foreword

This book, *Digital Photogrammetry: An Addendum to the Manual of Photogrammetry*, is the first update for the *Manual of Photogrammetry* since 1980. The addendum reflects new approaches to solving photogrammetric problems, approaches made possible by the many technological changes of the intervening years.

The American Society for Photogrammetry and Remote Sensing is grateful to all those whose efforts made this book possible.

Tina Cary, 1996

John Jensen, 1995

Maury Nyquist, 1994

Table of Contents

CHAPTER 4
Storage And Compression

CHAPTER 5
Aerial Triangulation Adjustment And Image Registration

CHAPTER 6
DEM Extraction, Editing, Matching And Quality Control Techniques

CHAPTER 7
Digital Orthophotos: Production, Mosaicking, And Hardcopy

CHAPTER 8
Confluence Of Mapping And Resource Management

CHAPTER 9
Feature Extraction And Object Recognition

CHAPTER 10
Softcopy Photogrammetric Workstations
Coordinated by Raad Saleh, Edited by Clifford W. Greve

Author Index

CHAPTER 1

Introduction

CLIFFORD W. GREVE

Since the last edition of the Manual of Photogrammetry was published in 1980, there have been many new techniques and much new equipment introduced to address the traditional problems of photogrammetry, and to extend the application of photogrammetry to new and different areas. While the basic mathematics, optical theory, and many of the basic practices presented in the last edition of the Manual remain valid, the advances in electronics and computer science have permitted new approaches to be used to solve problems more effectively.

This addendum does not address all of the advanced topics of photogrammetry which are missing in the previous edition of the Manual. Among those new and interesting topics which are not addressed are videography, radargrammetry, and lasar imaging direction and ranging (LIDAR). Also, some of the specific metric problems and all of the radiometric problems associated with multi- and hyper-spectral imagery are not addressed. These topics were omitted in the interest of presenting a focussed approach to the advanced techniques used by government and private firms in traditional map making and geographic information extraction processes.

The intent of this addendum is to approach the photogrammetric effort in essentially the same order as the tasks are performed in production. The chapters vary in presentation from an introduction followed by selected papers in traditional compendium style, to integrated presentations combining the ideas of several authors. Most of the papers included are expansions of papers presented at the Mapping and Remote Sensing Tools for the 21st Century meeting held in August, 1994. Some papers have been added, and others expanded, to ensure that this addendum is more complete and comprehensive than the procedings from the conference.

Chapter 2 is a discussion of image scanning, which is the first process required before softcopy methods can be applied to traditional film imagery. Although digital cameras are becoming available, in the forseeable future, there will be no airborne digital equivalent to the standard photogrammetric film mapping camera. This chapter discusses the design of scanner systems, and the practical implications of scanning practice on the quality of the resulting digital representation of the image. A description of many of the currently available scanners is included.

Chapter 3 addresses the acquisition of Global Positioning System (GPS)-derived positions for the perspective centers of aerial photographs. The operating theory of the GPS is discussed, as well as the practical issue of mounting the GPS equipment relative to the aerial camera in the aircraft. Finally, the processing of the observations to remove the various error sources from the data is presented.

Chapter 4 presents various means for dealing with the serious problem of storage and compression of digital imagery data. The volumes of digital imagery data can become very large for many mapping projects, and the efficient storage of these data may require some form of compression. While imagery data contains significant correlation on a pixel to pixel basis, and thus is a good candidate for compression, most compression schemes nevertheless result in some loss of image quality. The various memory technologies are also reviewed with respect to their advantages and disadvantages for the storage of photogrammetric data.

Chapter 5 discusses the statistical adjustment of the photogrammetric data in conjunction with GPS-derived perspective centers, and the special techniques required for the proper mathematical modelling of the solution. In particular, the unique influence of GPS observations upon statistical error propagation are presented.

Chapter 6 is a discussion of the extraction and editing of digital elevation models, in all of their various forms. It includes techniques for matching at join lines, and quality control. The discussion includes incorporation of break lines and triangulated irregular networks, in addition to the classical terrain matrix formulation.

Chapter 7 covers the production, mosaicking, and hardcopy output of orthophoto products. The efficient production of orthophotos is possibly the most obvious initial benefit of the softcopy photogrammetric evolution, in that

productivity benefits over analog methods of orthophoto production are extremely large.

Chapter 8 concerns a topic which was not feasible prior to softcopy photogrammetry, namely the confluence of mapping and resource management activities. Resource managers have used softcopy multispectral imagery for many years in their pursuit of data to feed their information systems. Until softcopy photogrammetry became available, there was no easy way to exploit mapping and multispectral data except by using geographic information derived from mapping data as part of the multispectral exploitation process. Now it is possible to use both sources of image data together at the exploitation stage, thereby increasing the productivity and accuracy of the users.

Chapter 9 discusses another topic, automated feature extraction and object recognition, which was impossible prior to softcopy imagery capability. Although many attempts at solving these problems have been made on a laboratory basis, until the availability of affordable and efficient softcopy photogrammetric devices, the automation of these processes in production was impractical. Even though the current capabilities are limited, these techniques offer much promise for the future, now that softcopy data and the systems to manage and use the data are available.

Chapter 10 discusses softcopy photogrammetric workstations. The softcopy photogrammetric workstation is the platform upon which all of the above functions are combined to produce maps and geographic information.

The totality of the chapters present a tour through the normal photogrammetric mapping sequence. The references provided with the papers will allow further research into specific topics of interest to the reader. Softcopy photogrammetry is a science which will continue to grow in capability with the advent of ever faster workstations, larger storage devices, and better scanners and output devices. It will be aided by an ever growing demand for geographic information in digital form.

CHAPTER 2

Scanning And State-Of-The-Art Scanners

Photogrammetric Scanners

OTTO KÖLBL WITH CONTRIBUTIONS OF M. P. BEST, A. DAM,
J. W. DOUGLASS, W. MAYR, R. H. PHILBRIK, P. SEITZ, H. WEHRLI

Basic Considerations on Photogrammetric Scanners

Role of Photographic Emulsion for Image Acquisition

Softcopy photogrammetry or 'digital photogrammetry', as it is generally called mainly in Europe, has already largely proven its efficiency in practice. The production of orthophotos, aerial triangulation, the derivation of a digital terrain model or photogrammetric plotting are increasingly done on digital photogrammetric workstations; the assistance afforded to the operator by image processing tools and the easy interaction with GIS data bases distinguish digital photogrammetric workstations from the classical analytical plotters.

Although digital photogrammetry is now widely used, in practice the imaging technique has hardly changed and most aerial photographs are still taken with film cameras. Modern aerial cameras make it possible to take photographs within an interval of 2 seconds with a standard format of 23 x 23 cm (9" x 9") and an image resolution of up to 100 lines per millimeter or even more. The information content of an aerial photograph corresponds easily to image matrices of 20.000 x 20.000 pixels (picture elements) with 24 bit requiring a storage space on disc of 1.2 Giga byte, without image compression. Present technology in electronic imagery does not permit one to reach such performances with reasonable means under flight conditions. Consequently film cameras will for several years remain the standard technique for image registration and it will be necessary to convert the analog images by a scanning process into a digital form.

Principle of Image Scanning

An aerial photograph, like any photograph or also a picture on paper, is considered as an analog picture or a continuous document, as opposed to a digital image, which is subdivided into a matrix of image elements, for which the gray values or the color values have been measured (cf. Figure 1.1). It is understood that some simplifications were necessary here, as most of the printed images are screened and decomposed into raster points. Nevertheless, the printed image on paper is considered as an analog document.

During the scanning processes, the gray value or the color value of the original document is measured by a photosensitive element, either by a photo multiplier or by semiconductor image sensors. When treating black and white photographs one generally discreticizes the hue into 256 gray values coded on 8 bits, although the original scanning process might furnish values of 10 to 12 bits. By the use of an appropriate 'look up table', the values of 10 to 12 bits are then reduced to 8 bits or even less.

A color film is generally digitized in 3 bands, (red, green, blue) using color filters. Most of the films are composed of 3 layers dyed according to the principal colors of subtractive color mixture (yellow, magenta, cyan). The information content of the sandwich film is measured by rather narrow filters in the colors red, green and blue for color separation, again using 8 bits for each band.

Configuration of Scanners

Various tools have been developed for image scanning, originating from the photogrammetric industry and from

3

the printing industry. In the printing industry, it was particularly desktop publishing which provoked great demand for scanners of various qualities and performances.

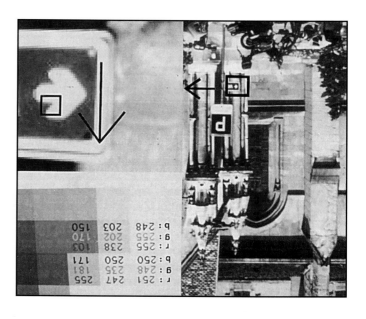

FIGURE 1.1

Illustration of the decomposition of an image into a matrix of gray values or using three different values to represent the three bands red, green and blue. The left section shows the image as a whole, the right lower part a detailed magnification of a small section which allows already to recognize individual pixels and the upper part shows, heavily enlarged, the individual pixels with the corresponding numerical values.

Without any doubt, the best known scanner in the past was the Optronics, which was developed some 20 years ago. It was a drum-scanner; light density was measured with a photomultiplier. Meanwhile flat-bed scanners have been developed beside the drum-scanners and the photomultiplier has been replaced by CCD-photodetectors as line or matrix sensors.

The configuration of a scanner is heavily influenced by the type of photodetectors used. The most current photodetectors are photomultipliers and photodiodes (CCD - Charge Couple Devices) which can be arranged in a line or as a matrix. The photomultipliers can only be used as single elements; however, they have a very short response time and very high sensitivity.

Consequently, most of the scanners based on the principle of photomultipliers are drum scanners. In this case, the original document is mounted on a rotating drum. The photodetector is mounted outside the drum and scans the image line by line. Where transparencies are used, the document is illuminated from inside the drum and, to avoid overheating, strongly directed light is very often used, even laser illumination. This type of scanner offers an extremely high level of performance with regard to the resolution and the dynamic range of density. However, the fact that the

film has to be mounted on a drum represents a certain disadvantage for the geometric precision (cf. Figure 1.2). Consequently, all photogrammetric scanners are flat-bed scanners.

The mounting of the film between two glass plates offers much better protection, but is only possible for flat-bed scanners. In this case, the film is placed on a mobile stage driven by motors, meaning that the scanning device can also move together with the illumination.

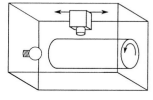

FIGURE 1.2

Diagram of a flat-bed scanner (left) and a drum scanner (right).

The Illumination System of Scanners

In image reproduction, the illumination system plays a very important role. It is useful to distinguish between diffused light and directed light (Figure 1.3). The directed illumination generally uses a condenser in order to enlarge the more or less punctual light source and projects it into the opening of the projection lens. A special advantage of this type of illumination is the very economic use of the light energy and consequently only a rather faint heat diffusion is produced by the lamp. To reduce this heat diffusion yet further, fiber optics are often used for the transfer of the light from a remote lamp. A directed light source generates a light bundle with a very small opening and in this way provides a great depth of field. Consequently, an optical system with directed light is less sensitive to defocalization. On the other hand, the light is nearly coherent and can cause diffraction effects.

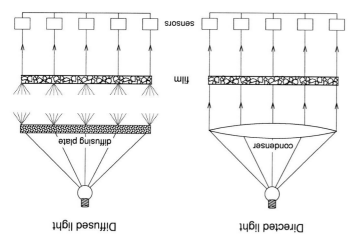

Directed light Diffused light

condenser diffusing plate

film

sensors

FIGURE 1.3

Illustration of an illumination system with directed light by a condenser (left) and diffused light by a diffusing plate (right).

Diffused light is obtained by a frosted or opalescent glass. One can put this frosted glass directly on the film or even use fluorescent tubes which also generate rather diffuse light. An even more sophisticated technique is the use of an integrating sphere or a light channel.

It is interesting in this context to refer to the construction of photographic enlargers. Today, practically all photographic enlargers use diffused light, whereas older instruments or photogrammetric rectifiers were equipped with condensers, or later mainly with Fresnel lenses. Nowadays, the Durst light channel is used for practically all photographic enlargers. For example, the Zeiss rectifier is equipped with the Durst illumination system, whereas the older model SEG4 was equipped with a Fresnel lens. The same principle is found back in photogrammetric plotters. In general, plotters with good image quality use diffused light. It is interesting to note that the DSR15 was equipped with fiber optics and used directed light, whereas its successor the SD2000 works with diffuse illumination. The old Wild instruments, including the analytical plotter, were practically all equipped with diffused light.

Introduction to the Following Sections

According to the intention of this manual, the chapter on scanners has been revised by several authors and there was an attempt to combine these different views on scanning technology in a comprehensive presentation. The next two sections give an introduction to the functioning and performance of image sensors. Currently, the performance of image sensors still limits the quality of the digital image and a basic knowledge of image sensors might contribute to a better understanding of the problems. In the 4th section, an attempt is made to present the most important scanners on the market in a short overview. The various vendors were invited to submit a description of their instruments according to unified criteria. The last section gives an analysis of the tone reproduction of the various scanners according to a technique devised by the author.

Fundamentals of Image Sensors[1]

Introduction

This document is an introduction to electronic image formation with semiconductor image sensors. The events are described, beginning with the incidence of the particles to be detected — the photons — and ending with the generation of an analog (video) signal containing the image. In a summary, typical characteristics of three types of modern image sensors are described and the future of intelligent image sensors (seeing chips) is sketched.

Photons

The information to be detected with image sensors is the spatial and 2-dimensional distribution of light, i.e. an electromagnetic field. The intrinsic duality of this field is expressed in alternative descriptions. Light can be considered to be an electromagnetic wave, with a wavelength λ, a frequency ν, and a propagation speed c, obeying the following relationship

$$c = \lambda \nu, \quad c_{vacuum} = 3 \times 10^8 \ m/s$$

On the other hand, light's behavior can be considered as that of particles (quanta, named **photons**) with a certain energy E :

$$E = h\nu = \frac{hc}{\lambda}, \quad h = 6.626 \times 10^{-34} \ Js$$

In optics and physics, energy is also measured in eV (electron Volt) units, according to the following relationships

$$1 \ eV = 1.602 \times 10^{-19} \ J$$

$$E \ [eV] = 1240 / \lambda \ [nm]$$

Example: a green photon (λ=555 nm) has an energy of 2.23 eV = 3.58x10^{-19} J.

The spectral region corresponding to a wavelength between 380 nm (violet) and 780 nm (red) is the visible region. The shorter wavelength photons (higher energy) are the ultra-violet rays (UV), the longer wavelengths (lower energy) correspond to infrared radiations (IR). As an example, the spectral radiance of the sun is shown in Figure 2.1.

The appropriate description of the propagation of light is that of a wave — deduced from Maxwell's laws — where diffraction effects can be observed. A common simplification is to consider the movement of the particles along straight lines, called light rays. This simplification leads to geometrical optics. It has been observed that for the correct description of the interaction between light and matter, light behaves like particles. So, in the context of this paper, light is a distribution of photons traveling with the speed c in vacuum.

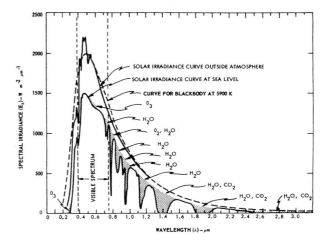

FIGURE 2.1
Spectral radiance of the sun at a mean earth-sun separation [8].

The Semiconductor

The basis of image sensors are semiconductors, solid-state materials with specific electrical properties, that are the consequence of the atomic construction and quantum physics. Solid state matter can form three-dimensional crystal lattices (periodic arrangements) called single crystals. In such a crystal, each electron can only have an energy in one of several energy bands. Between those allowed bands there are forbidden energy gaps, as illustrated in Figure 2.2.

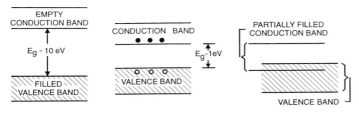

FIGURE 2.2
Schematic energy band representation of (a) an insulator (b) a semiconductor (c) conductors.

The electrons occupy the allowed energy states from lower energies upwards. The highest (partially) filled band is called the *conduction band*, while the next lower band is called the *valence band*. The energy difference E_g between these two bands is called the *bandgap*. If the electron distribution is such that the conduction band is partially filled at a temperature of T=0K (and consequently there are still electrons that are mobile), the material is a **conductor**. On the other hand, when the conduction band is empty at T=0K, the material is a **semiconductor** or an **insulator**. The difference between these two is qualitative and is only approximately defined:

semiconductor: Eg < 6 eV
insulator: Eg > 6 eV

Some of the most important properties of the semiconductors for photoelectronics are shown in table 2.1.

In a semiconductor, it is necessary to activate (to free) the electrons from the valence band to the conduction band. Only free electrons of the conduction band participate in current conduction. Thermal generation of such mobile electrons follows an exponential law. In a pure semiconductor, the intrinsic carrier density n_i is given by:

$$ n_i = n_0 T^{3/2} \exp(-\frac{E_g}{2kT}), \quad k = 1.3804 \times 10^{-23} \; Ws/K $$

Example: For silicon, $n_i = 1.45 \times 10^{10}$ cm^{-3} at a temperature T=300 K.

Fortunately, the free electron density is not limited to n_i; it is possible to dope the semiconductors with appropriate impurities. Two types of doping agents are employed:

the donors (donating impurities), which can thermally be easily excited to produce free electrons. The semiconductor then becomes **n-type**. Such free electrons can move away, for example under the influence of an electric field, leaving the donor -fixed in the lattice of the material- with a spatially fixed positive charge.

Propriety	Si	Ge	GaAs	a-SiC	C$_{diam}$	SiO$_2$
Band gap E$_g$ [eV]	1.11	0.67	1.40	3.00	5.47	8
l_{max} = h c / E$_g$ [nm]	1088	1850	867	413	227	155
Density [g/cm^3]	2.33	5.32	5.32	3.2	3.51	2.27
Lattice constant [Å]	5.43	5.66	5.65	3.1,15.8	3.57	...
Mobility μ_e [cm^2/V/sec]	1350	3900	8600	100	1800	...
Dielectric constant e	11.7	16.3	12	6.7	5.7	3.9
Index of refraction n	3.45	4.0	3.4	2.63	2.4	1.46
Direct/indirect bandgap	i	i	d	i	i	...
Melting point [°C]	1415	937	1238	2830	980 gr.	1700
Therm. conduc. [W/cm/K]	1.5	0.6	0.8	4.9	20	0.014

TABLE 2.1
Most important properties of the semiconductors for photoelectronics.

The acceptors (accepting impurities) can capture electrons, thus producing a positively charged quasi-particle called a **hole**. Such holes are also mobile, and they can contribute in a **p-type** semiconductor to the current conduction. In an analog fashion as in the n-type for electrons, a free hole leaves a spatially fixed acceptor with a negative charge.

By varying the type and density of the dopant, large variations in the density of charge carriers (electrons or holes) and conductivity in a semiconductor can be achieved. In silicon, for example, conductivity can be changed by a factor of 10^8 or more. It is important to note that a semiconductor is not charged by the doping impurities: n- or p-type implies only presence of mobile, **free** charge carriers (electrons or holes); electrical neutrality is maintained.

The most important semiconductor for industry (computers, micro-mechanics, integrated sensors, etc.), and also for image sensors that are sensitive in the visible spectrum, is **silicon**. One of the main reasons for that leading position of silicon is the possibility of producing an excellent insulator layer, SiO$_2$, on the silicon's surface by oxidation.

Generation of Photocharges in the Semiconductor

Thermal generation of free charge carriers always occurs in pairs: if an electron is excited from the valence band to the conduction band, a hole is created simultaneously. Consequently, this pair of charge carriers can recombine again. The thermal generation and recombination of charge pairs is a temperature-dependent dynamic equilibrium.

Heat is not the only source of energy for the generation

of free charge carriers. The energy for freeing charge pairs can also be supplied by incident light. If a photon possesses an energy exceeding the bandgap E_g (in silicon, $E_g = 1.11$ eV), the photon is absorbed by the semiconductor, creating a pair of free charge carriers. Therefore, the existence of a photon can be determined (in a destructive manner) by electrically detecting the generated charge pair. The lower a photon's energy, the more transparent the semi-conductor, as depicted in Figure 2.3.

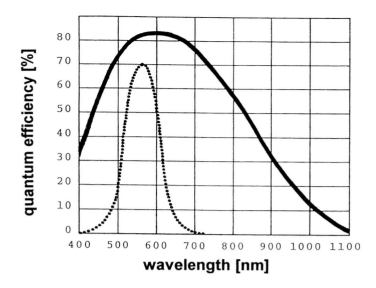

FIGURE 2.4
Absolute spectral quantum efficiency of a FT CCD image sensor, compared with the relative spectral sensitivity of the human eye.

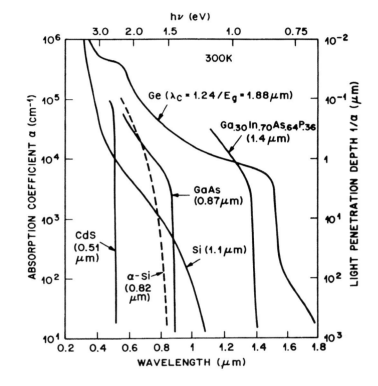

FIGURE 2.3
Optical absorption coefficient for various semiconductors [4].

Red light penetrates very deeply into the semiconductor, causing a reduction of sensitivity in image sensors for infrared light, and blurring such images substantially. For this reason, cameras are usually equipped with an optical filter blocking infrared light. Blue light, on the other hand, is already absorbed in the inactive surface layers at the surface of the sensor. Sensitivity is therefore also reduced in the blue, as can be seen in Figure 2.4, leading to this typical spectral sensitivity behavior of CCD image sensors.

Conversion efficiency h is measured as the rate of generated photocharges divided by the number of incident photons on the image sensor. The diagram shows that in practice quantum efficiencies near 100% in the visible spectrum can be achieved with CCD sensors.

Instead of the conversion efficiency h, the electric responsivity R is sometimes used. It is defined by

$$R = \frac{e\lambda\eta}{hc} = \frac{I_{photo}}{P_{light}} \quad [A/W]$$

with the electronic unit charge value $e = 1.602 \times 10^{-19}$ As and the wavelength l of the incident light. In the same way, R can be obtained as the current I_{photo} produced by incident light, divided by the power P_{light} of the light.

The linearity of the generation of the photocharges is excellent: the observed number of photocharges is strictly linear, related to the number of incident photons, for illumination levels varying by a factor of at least 10^6.

The Electron and the Hole: the Moving Particles in the Semiconductor

The illumination of a semiconductor with a sufficiently short wavelength causes the generation of pairs of mobile charges, electrons and holes. Both behave like charged free particles, the electron wearing a negative charge and the hole a positive one. If one leaves the two particles of a pair near each other after their generation, they recombine promptly, under emission of the stored energy mostly as heat (and a tiny fraction in the form of light in silicon). Because they can move, photocharges can be separated and subsequently stored.

There are two physical effects that can make the photocharges move: **electrodynamic forces** acting on the charges, and **diffusion** — a consequence of thermodynamics — that tends to spread the particles of the same type in order to distribute them equally.

Charges move under influence of an electric field E at a speed v proportional to the field, $v=\mu E$, up to a maximum speed v_{max}. In silicon this speed is $v_{max}=1\times10^5$ m/s.

Diffusion proceeds on average at the mean thermal speed of particles, $v_{therm}\cong10^6$ m/s at T=300 K, making the diffusion process very fast. Diffusion tries to equalize the concentrations of particles. Since the particles are charged, an electric field can be created that counteracts diffusion, thus reducing the effect of diffusion. The movements and distributions of the charged particles in a semiconductor are therefore a consequence of the combined effects of electric fields as well as diffusion, leading to a dynamic equilibrium of the two.

Collection and Storage of Photocharges

As seen earlier, the pairs of photocharges should be separated immediately after their creation, in order to avoid their recombination. This separation is easily done with an electric field, realized by pn-junctions (diodes) or with integrated MIS capacitors (**M**etal - **I**nsulator - **S**emiconductor). The pn-junctions are used in photodiodes image sensors, while MIS structures are the basis of CCD image sensors. Both devices not only separate the photocharges, they are also capable of collecting and storing photocharges. For this reason these two structures have to be discussed in more detail.

A **pn-junction** consists of two silicon parts, one being p-type and the other n-type, as illustrated in Figure 2.5. The mobile holes from the p-type side diffuse into the n layer, leaving the fixed acceptors with a negative charge. The free electrons from the n-type semiconductor diffuse to the p-type side, leaving the fixed donors with a positive charge. Finally, the strength of the electric field created by the fixed charges dynamically compensates the effect of diffusion, and the whole system finds itself in a dynamic equilibrium.

It is important to note that there is always an electric field built into a pn-junction. This field is used to separate pairs of photocharges, generated by incident photons. Each diode of the pn junction-type can therefore be used as a **photodiode**. Since a diode also has a certain capacitance, photocharges can be stored in it. As a consequence, a photodiode can separate the photocharges, and store them for a subsequent detection. The typical capacity per surface area of a photodiode is about 10^{-15} F/µm², which is sufficient to store a few 10'000 electrons/µm².

MIS capacitors (or MOS, Metal-Oxide-Semiconductor) consist of a semiconductor of a certain-type, let us say p, covered by an insulator (generally an oxide) and by a metal, as illustrated in Figure 2.6. The semiconductor is grounded. A positive voltage is applied to the electrode (i.e. the metal), pushing the holes into the bulk of the semiconductor, and producing a region where no mobile charge carriers are found, called depletion region. The resulting negative charge of the fixed acceptors thus creates the desired electric field.

Similar to the situation in photodiodes, this electric field in MIS structures can be used for the separation of pairs of photocharges: electrons are attracted by the positively biased electrodes, and they propagate to the surface where they accumulate at the interface between semiconductor and insulator. The holes are pushed back to the interior of the semiconductor, and they do not play a role any more. The simplified description of the resulting potential distribution at the surface of the semiconductor is a potential well for negative charges (a "charge bucket").

Unfortunately, charge pairs can also be created by heat, without illumination of the image sensor, as discussed in Section 2.4. The dark current density i_d depends exponentially on temperature:

$$i_d = i_0 \exp(-\frac{E_g}{2kT})$$

FIGURE 2.5
A pn-junction (diode) with its built-in electric field.

FIGURE 2.6
Illustration of a MIS (MOS) structure, a capacitor consisting of a metal layer on a semiconductor, separated by an insulator (oxide) [5].

The factor i_0 is highly depedent on the purity of semi-conductors. For silicon near surfaces, a value of $i_0=4.5$ A/cm^2 is typical. This value corresponds to a current density of $i_d = 1$ nA/cm^2 at room temperature, T=300 K. Far from the silicon's surface the current density can be as low as $i_0=0.045$ A/cm^2, as observed in today's best CCD image sensors.

An immediate conclusion from this equation is the possibility of reducing the dark current by cooling the sensors. A simple rule can be calculated : each reduction in temperature of 8-9 K reduces the dark current by a factor two. Indeed, image sensors for astronomical applications are cooled, down to a temperature of as low as 153 K (-120 °C). The number of thermally generated photocharges can be reduced to the very low level of a fraction of an electron per hour and per pixel at such low temperatures.

The capacity per surface area of a modern MIS structure is about 10^{-15} F/μm^2, which is sufficient to store a few 10'000 electrons/μm^2.

Transport of Photocharges

The charge stored in a photodiode can simply be transported by a connection of the photodiode to a conductor, by means of an electric switch, a MOS-FET transistor (see Section 2.9). The transport of photocharges occurs in the metal, using the principles of electric conductivity in metals.

For MIS or MOS structures, the mechanism of transport of the photocharges is completely different. For this purpose MOS structures are placed one beside the other, leading to an arrangement called **charge coupled device** (CCD), developed in 1970, see Figure 2.7.

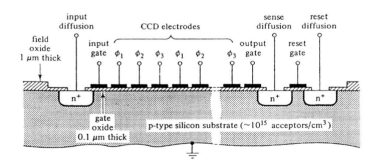

FIGURE 2.7
Schematic diagram of an image sensor of type S-CCD
(surface channel charge coupled device) [6].

The electrodes are connected into three or four groups, called phases. By changing the voltage of the CCD phases, photocharge packets can be moved laterally, as illustrated in Figure 2.8 for a three phase CCD.

For a description of the CCD's principle let us begin with a distribution of potentials as illustrated in Figure 2.8 (a): photoelectrons are gathered in a charge packet under

the positively charged electrodes. If a positive potential is also connected to the right neighbor, see illustration (b), the potential wells in the CCD are broadened and the photo-electrons are distributed more or less equally in the new, wider well. The new distribution of the electrons is the consequence of the interplay between the electric field (the repellent strength between electrons), the potential distribution imposed by the electrodes and diffusion.

The first electrode now returns to a low potential and reduces the width of the potential well within the semiconductor. Due to the electric field, the photoelectrons are collected in this small well. In the final situation (c) the photocharges have been transferred to the right by one electrode width.

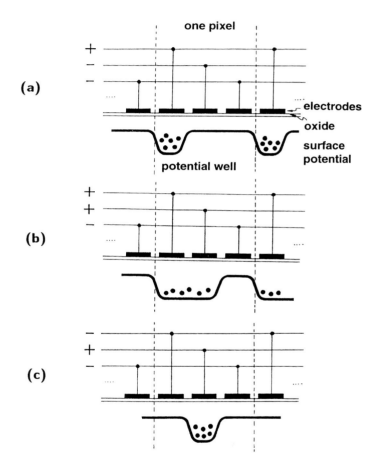

FIGURE 2.8
Principle of charge transport in CCD devices.

The charge transfer performance can be described with the concept of CTE (Charge Transfer Efficiency). In silicon SCCD devices (surface channel CCDs), the measured CTE is more than 99.99%, and in silicon BCCD devices (buried channel CCDs) CTEs as high as 99.99995% have been experimentally observed, although values of 99.995% are more typical. The difference between these two types of CCDs is that in SCCDs the photocharge movements take place at

the surface of the semiconductor (at the interface between semiconductor and insulator), while in BCCDs, charges are transported in the bulk of the silicon. Because of the presence of charge traps at the semiconductor-insulator interface, the transfer charge losses are lower in BCCDs, whose architecture is shown in Figure 2.9; consequently, this device has become the standard in modern image sensors.

The capacity per surface area of a BCCD structure is reduced by a factor of about 10 compared to a SCCD structure. It is about 10^{-16} F/μm^2, enough for the storage of a few 1'000 electrons/μm^2.

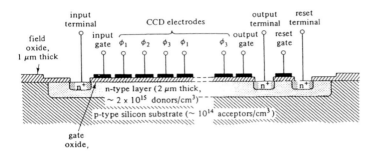

FIGURE 2.9
Diagram of a B-CCD image sensor (buried channel charge coupled device) [6].

The charge transfer rate is limited by charge losses. The highest measured clock frequency for silicon BCCD is 325 MHz, and for GaAs BCCD, 18 Ghz has been employed. Typical values for standard video cameras are about 15 MHz (CCIR) and 2 x 36 MHz (with two serial amplifiers) for CCD HDTV sensors.

Electronic Detection of Photocharges

The individual units that separate and store photocharges (the photodiodes or a group of electrodes of the same number as there are phases) are called **pixels** (picture elements). A one- or two-dimensional array of pixels forms the image sensor. The individual pixels store a certain number of photocharges, corresponding linearly to the local incident light intensity (i.e. the number of photons per surface area and exposure time). The number of photocharges is limited by the surface of the pixels and by the architecture of the image sensor. The maximum, called full well charge in CCDs, can vary between 10'000 and 500'000, with 50'000 being a typical value for CCD video image sensors.

The small photocharge signals are amplified and converted in voltage signals directly on the sensor chip for minimum noise pickup.

The method for scanning pixels and reading/converting the photocharge signals is very different for photodiode and CCD image sensors, as illustrated in Figure 2.10.

Each photodiode has its own switch (a MOS-FET tran-

sistor) through which the pixels are connected -one after the other- to the amplifier. This implies the existence of common lines (usually fabricated out of metal) in which charge carriers are transported. The advantage of this structure is the possibility of addressing each pixel selectively and in an arbitrary sequence (random access), at the price of a high capacitance of these lines.

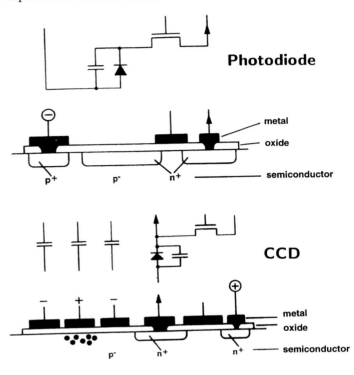

FIGURE 2.10
Illustration of the scanning and readout methods for photodiodes image sensors (a) and in CCD image sensors (b).

The pixels are reset by reverse-biasing the photo–diodes to charge them to a fixed reverse voltage. Under the influence of the light (and the dark current) a pixel discharges itself. At the next reset, the pixel is recharged, and the only thing to be measured is the necessary charge to reset the pixel, so that the photocharge of the pixel is now known.

The CCD transfers the photocharges under the pixels to the amplifier. The disadvantage of this device is that access to the information in the image pixels is sequential. On the other hand, the advantage is that the line to the amplifier can be very short, with a low capacitance. To understand why this fact is so important, consider the realization of the most commonly used amplifier, a MOS-FET transistor as a source-follower, Figure 2.11.

A charge Q is placed on the gate of the transistor. Because ambient temperature causes electrons to move in a statistical way in transistors, the charge Q cannot be detected precisely. Consecutive measurements produce different values, due to statistical fluctuations. This noise corre-

sponds to a statistical uncertainty σQ in the determination of Q, approximately given by

$$\sigma Q = C_{gs} \sqrt{4kTB / g}$$

with the input capacity of the transistor Cgs, the temperature T, the maximum output frequency B, and the transconductance $g = \partial I_{DS} / \partial V_G$ of the transistor.

Typical values for those parameters are: Cgs=100 fF, T=300 K, B=20 MHz (video), g=1000 μmho (=0.001 A/V), thus resulting in a minimum theoretical noise of σQ=12 electrons per pixel. Typical amplification (voltage/charge conversion) is 1 μV/electron.

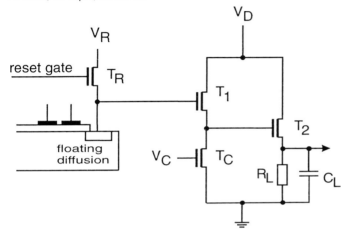

FIGURE 2.11
Typical amplifier circuitry for CCDs. The photocharge is amplified by the transistor T_1, which is mainly responsible for the noise. T_2 accomplishes the secondary amplification, T_R is used for resetting the photodiode, while T_C is T_1's active load.

There are five possibilities to reduce the noise of the photocharge determination:

1. Reducing the temperature, as realized in astronomy applications. The problem is that sensors should be protected from ambient air to avoid condensation on the surface.

2. The maximum frequency is reduced. Since the noise generation mechanism is different under 50 kHz, the lowest used frequencies in practice are 50-100 kHz. This means that the reading of photocharges is slower, the reading of an entire image taking from several seconds to several minutes.

3. Another solution is to read the same photocharge non-destructively several times, and to determine the average measured value. Such a realization (the "skipper" CCD, Janesick and al., 1991) reached a noise of 0.5 electrons per pixel.

4. The "amplification factor" g of the transistor is increased. Since this implies larger transistors, the capacity is in-

creased, actually leading to much higher noise values.

5. The biggest effect is due to the input capacitor of the transistor, which is difficult to reduce. The invention and realization of the buried gate with a capacity of below 1 fF has produced transistors with a noise of only 0.5 electrons at T=300 K and B=7.2 MHz, sufficient for video applications.

One should be aware that the formula predicts only a theoretical limit to thermal noise in the amplifying transistor. In image sensors, there are other mechanisms responsible for additional noise, most importantly Poisson noise in the detection of the number of photons: the statistical variation σN of the number of photons under constant illumination, producing an average value of N photons per measurement, is given by

$$\sigma N = \sqrt{N}$$

The effect of all these noise sources is to reduce the precision at which the photocharge Q can be determined. To quantify the noise σQ, relatively to a signal Q, a signal to noise ratio S/N is employed, defined by

$$S / N \ [dB] = 20 \log_{10}(Q / \sigma Q)$$

Obviously, the S/N ratio depends on the momentary value of Q. For this reason the dynamic range D/R is defined, by making use of the full well charge Q_{max}:

$$D / R \ [dB] = 20 \log_{10}(Q_{max} / \sigma Q)$$

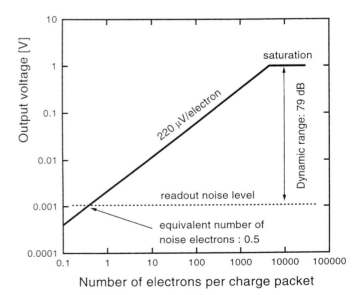

FIGURE 2.12
llustration of the dynamic range D/R, in a CCD with a new type of amplifier, called "double gate MOS-FET" [10].

Example: Q_{max}=4500 electrons, σQ=0.5 electrons. Dynamic range D/R=79 dB, see Figure 2.12.

Pixel Types and Architecture of Image Sensors

The two most important types of pixels are photodiodes and MOS capacitors in CCD image sensors. There are other types of pixels, such as phototransistors, CID pixels (Charge Injection Device), etc., but they are of secondary importance in practice, so they will not be described any further.

The illustration on the next page shows three CCD architectures and the most common type of photodiode image sensor. These four solutions, depicted in Figure 2.13, for realizing an image sensor are often found in modern video cameras or as one- or two-dimensional photosensitive elements.

(a) The **frame transfer** CCD (FT-CCD) is a simple two-dimensional array of pixels. It consists of a number of registers, often three. The A-register is light-sensitive. The contents of this register is quickly transferred into the B-register, which is covered by an opaque metal layer. The charge packets constituting the image are protected from light in the B-register. Line after line, the image is transferred to the C-register, a single CCD line, feeding charge packets to the amplifier. The disadvantage of FT-CCD is that while the image is transferred from the A-register to the B-register, incident light still generates photocharges, thus compromising the quality of the final image.

In special applications, in which the refresh rate is not too fast, for example in astronomy, FT-CCD are used without B-register, but with a mechanical shutter.

(b) The necessity of a shutter led to the invention of a CCD with an electronic shutter, the **interline transfer** CCD (IT-CCD). Today, IT-CCDs are the most common image sensors, found for example in all video cameras. The pixel consists of individual photodiodes, horizontally connected with a transfer gate to a linear vertical CCD. An opaque metal layer covers the vertical CCD column, making it insensitive to light. The vertical transfer to the C-register and the horizontal transfer to the amplifier occurs shielded from light, and so the image is not corrupted during photocharges transfers. The desired electronic shutter is realized using a variable time interval for the time the switch connects pixels with the CCD columns. Integration times between 0.05 ms and 40 ms (=1/25 sec) are typically available.

(c) For professional applications, shielded CCD columns in IT-CCDs are not sufficient to protect the image during the vertical transfer of photocharges. This problem led to the invention of **field interline transfer** CCDs (FIT-CCD). They are a combination of an IT-CCD with the B-register storage principle of an FT-CCD. FIT-CCD image sensors are found in professional cameras of television studios.

(d) Photodiode image sensors consist of pixels, each of which is equipped with a transistor. The transistor works as a switch, controlled by a digital addressing circuit. One after the other, the pixels are connected through their switching transistor to a common line, leading to the amplifier. The capacity of this line is quite high, on the order of a few pF, so that the noise of photodiode sensors is higher than the one of CCD's. This is one of the reasons why these sensors are only used in special applications, for example when random access is necessary. An alternative solution, called **APS** (Active Pixel Sensors), is to supply each pixel with its own amplifier and reset transistors, leading to a new type of photodiode image sensor with significantly reduced noise. This development, however, is still in its early stages.

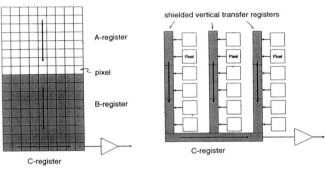

FT-CCD IT-CCD

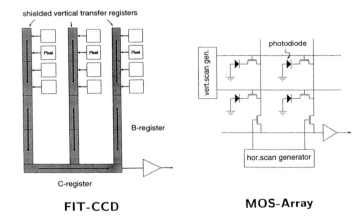

FIT-CCD MOS-Array

FIGURE 2.13
The four most commonly used types of image sensors: (a) Frame transfer CCD, (b) Interline transfer CCD, (c) Field interline transfer CCD, (d) Photodiode image sensor.

Only FT-CCD offers pixels covering the whole surface, because of the absence of dark structures. The photosensitive fraction, called fill factor, is 100% in FT-CCDs, but only 20-30% in IT-CCDs and 50-80% in photodiodes sensors. FT-CCDs need electrodes, realized in polysilicon, and these elec-

trodes reduce sensitivity in the blue region of the spectrum. Sensitivity can nevertheless be increased by reducing the sensor's thickness and illuminating the back-side of the device ("back-side illumination").

"Typical" Modern Image Sensors

A large number of sensors with various properties are commercially available. Fortunately, there are some standards, which enables one to categorize image sensors. In the following table, three "typical" modern image sensors are described. The first one is a video image sensor conforming to the CCIR standard. The second one implements the new HDTV standard. The third one is the largest image sensor manufactured to date, used in photogrammetric applications and in electronic professional photography.

Property of image sensor	CCIR	HDTV	Megapixel
Sensor type	IT-CCD	IT-CCD	FT-CCD
Sensor size [mm x mm]	3.7 x 4.9 (1/3")	7.4 x 12.2	61.4 x 61.4
Number of pixels	576v x 768h	1152v x 2048h	5120 x 5120
Pixel size [μm x μm]	6.4 x 6.4	6.4 x 6.4	12.0 x 12.0
Full well charge [electrons]	30'000	30'000	130'000
Capacity per pixel [fF]	3	3	15
Fill factor	30 %	30 %	100 %
D/R @ T=300K	60 dB	60 dB	51 dB
Maximum scanning frequency	14.1 MHz	2 x 36 MHz	4 x 12 MHz
Frame rate [images per second]	25	25	1.8
Price of an excellent sensor	$ 50	$ 5000	$ 100'000

TABLE 2.2
Properties of three "typical" modern image sensors.

The Future: From Electronic Photography to Seeing Chips...

The future of image sensor technology is to realize smaller devices (at a lower price), featuring a higher D/R and a larger pixel number meeting electronic photography needs. Here are some predictions of what will be available in the year 2000:

· Multi-Megapixel CCDs: 8kx8k pixels with multi-tap scan (several parallel amplifiers)

· Large surface CCDs: 80 x 80 mm² (6" wafer)

· Micro-pixels: period of 3-4 μm (not smaller for optical reasons)

· Active pixel sensors (APS): additional functionality in "smart" pixels

· High D/R: 80 dB or more

· Cheap video CCDs: 1/6" IT-CCD (1.9v x 2.5h mm²) for complete cameras costing less than $ 100

· Small HDTV CCDs: IT/FT-CCD (4v x 7h mm²)

· Micro-cameras (≤ 1 x 1 mm² for 256² pixels) used in pens,

spectacles, watches, pocket calculators, and so on.

· Electronic photography (solve problem of image storage !)

· X-ray cameras: especially for dental applications (30 x 40 mm²)

· Electronic imaging with an extended scope : IR, UV, X-rays, particle rays, with signal processing directly on the chip

· Seeing chips: photo-ASICs and micro-optics. Integrated image processing. Automatic recognition included in the image sensor (writing, human faces, traffic signs, etc.)

· Smart and standalone systems: micro-robots possessing a certain visual sense.

Conclusions and Summary

Semiconductors, in particular silicon, are very effective in generating, storing and transporting photocharges (total efficiency in the visible spectrum more than 50%). Progress in semiconductor technology for digital applications (microprocessors, RAM memories, microcontrollers, ...) is the basis of rapid advances in the image sensor field. Today, it is possible to produce CCDs containing 26 millions pixels on a 62 x 62 mm² surface.

The advances in photocharge detection with new device types leads to the possibility of detecting charge packets with a noise figure of under one electron, even at a temperature of T=300K and at video frequency (3.6 MHz). Such sensors now have a dynamic range D/R of 90 dB (60 dB being a typical value for today's video CCDs). By cooling them (-100 °C) and employing low-frequency readout (100 kHz), sensors can reach a D/R of 120 dB, particularly for astronomy applications.

The future devices will be smaller (1/6" for video applications) and will offer high on-chip functionality ("seeing chips"). In the year 2000, large-area image sensors with 8192 x 8192 pixels or more will be available.

The progress in image sensor technology will be at the heart of the revolution in electronic photography (probably replacing classical films in a few years), cheap video cameras, micro-cameras (for medical applications), clever sensors, and metrology applications in other regions of the electromagnetic spectrum (IR, UV, X-rays).

References

Bleicher, M., 1986. *Halbleiter-Optoelektronik*, Dr. Alfred Hüthig Verlag, Heidelberg.

Beynon, J. D. E. and Lamb, D. R., 1980. *Charge-coupled Devices and Their Applications*, McGraw-Hill, London.

Dereniak, E. L. and Crowe, D. G., 1984. *Optical Radiation Detectors*, John Wiley & Sons, New York.

Grove, A. S., 1967. *Physics and Technology of Semiconductor Devices*, John Wiley & Sons, New York.

Knop, K. and Seitz, P. 1990-1994. *Elektronische Bildsensoren*, Class notes, ETH Zürich.

Matsunaga, Y., Yamashita, H. and Ohsawa, S., 1991. *A Highly Sensitive Charge Detector for CCD Area Image Sensor*, IEEE Journal of Solid-State Circuits, Vol. 26, No. 4, pp. 652-656.

Paul, R., 1985. *Optoelektronische Halbleiter-Bauelemente*, B.G. Teubner, Stuttgart.

RCA Electro-Optics Handbook, 1974. RCA Commercial Engineering, Harrison NJ.

Séquin, C. H. and Tompsett, M.F., 1975. *Charge Transfer Devices*, Academic Press, New York.

Sze, S. M., 1985. *Semiconductor Devices*, John Wiley & Sons, New York.

[1]Author: Dr. Peter Seitz, Paul Scherrer Institut, Badener Strasse 569, 8048 Zürich, Switzerland, translated by David Meylan, Swiss Institute of Technology, CH-1015 Lausanne

The Efficiency of Linear Solid State Imagers for Film Scanning Applications[1]

Introduction

The efficiency of modern linear solid state imagers for film scanning applications is reviewed by examining several critical performance parameters including photodiode quantum efficiency, charge transfer efficiency, dynamic range, and spatial resolving power (MTF). The physical origins of performance limiting phenomena are discussed and design alternatives are presented to maximize imager efficiency in scanning systems.

Background

Solid state imagers are presently used in a wide range of scanning applications. Consumer products like hand-held scanners, desktop scanners, and fax machines contain low cost, 200 to 600 DPI resolution linear sensors. Photographic film scanning applications such as real time motion picture film-to-tape converters (Lees, et al 1990), and high resolution large format film scanners (Kennel 1994, Milch 1990, Davis 1989) use ultra high resolution (> 600 DPI) linear imagers. Linear imagers tend to dominate over area arrays in film scanning applications due primarily to the capability of higher spatial resolution and charge capacity, and because today's films offer such high dynamic range and resolutions. Most modern linear image sensors can be described as an array of photosensitive elements with an associated transfer gate and shift register structure. A charge coupled device (CCD) concept is commonly used as the analog shift registers due to its high charge transfer efficiency, high charge capacity, and high speed operation. Color scanning applications which once required use of a filter wheel for spectral separation now can utilize a tri-linear color imager such as the KLI-8003 (Anagnostopoulos 1993) where each channel, as illustrated in figure 3.1, is covered with a color filter to restrict photon absorption within a limited band of wavelengths (e.g. red, green, or blue) as shown in figure 3.1b.

Performance of the drive mechanism, optical components, and signal processing electronics have continued to improve as users demand higher spatial resolution and dynamic range from film scanners. In keeping pace, linear imager technology has significantly evolved over the last decade, resulting in multi-spectral image sensors with ultra high spatial resolution (8K elements per array), dynamic range approaching 14 linear bits, electronic exposure control, and blooming protection. Therefore, a good understanding of the capabilities and performance limitations of modern linear imagers is necessary when designing or analyzing film scanners.

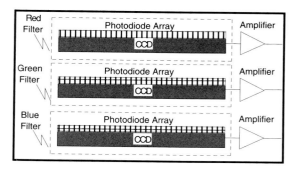

(a) Block Diagram

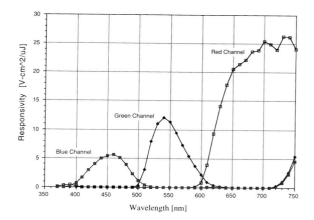

(b) Spectral Response

FIGURE 3.1
KLI-6003 Tri-Linear CCD Imager.

Quantum Efficiency

Absorption of photons within silicon is described by the photoelectric effect (Dereniak 1984). Collection of charge liberated by absorbed photons is commonly handled using either a MOS photocapacitor or a light sensitive PN diode structure (i.e. photodiode). Photocapacitor structures offer deeper space-charge regions for improved spectral response at longer wavelengths, but have reduced short wavelength response (< 600 nm) due to absorption of photons in the gate electrodes. Photodiodes, on the other hand, can be manufactured with fairly constant response from 400 to 750 nm, and hence are typically the preferred detector choice. To function as an efficient photon detection site a photodiode must not only capture a high percentage of photo-generated charge, but also store the charge without loss, and completely transfer the charge to an adjacent shift register.

The ratio of the number of photogenerated electrons captured by a photodiode to the number of photons incident upon the photodiode during a period of time is termed the quantum efficiency, and can be approximated as (Jespers 1976)

$$QE = \left(1 - \frac{e^{-\alpha(\lambda) \cdot L_d}}{(1 + \alpha(\lambda) \cdot L_n)}\right) \cdot \sqrt{\frac{\varepsilon_{si}}{\varepsilon_o}} \cdot \left(\frac{|E_{si}^+|^2}{|E_{in}^+|^2}\right)$$

where ϵ is the permittivity, $a(\lambda)$ is the absorption coefficient, L_n is the depth from the silicon surface to the end of the photodiode space-charge region, L_d is the minority carrier diffusion length, and E_{si} and E_{in} are the complex electric field strengths in the silicon and incident media, respectively. The first term in equation (3.1) describes the absorption of photons within the silicon substrate, which can be further broken down into two major components: one due to electron drift, and one due to electron diffusion. Figure 3.2 depicts photon absorption events corresponding to each component within a typical photodiode. Event (1) is the absorption of a photon within the space-charge region of the photodiode (i.e. $0 \leq$ Event $\leq L_n$). Charge liberated within the space-charge region will be driven by the built in electric field to the deepest potential of the photodiode. Charge liberated below the space-charge region (e.g. event 2) will experience no such electric field, and will randomly diffuse until it (a) recombines in the substrate, (b) is collected by the photodiode electric field, or (c) is collected in an adjacent structure such as a neighboring photodiode or nearby CCD.

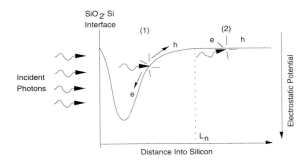

FIGURE 3.2
Absorption of Photons within Silicon Photodiode.

The drift and diffusion components of quantum efficiency are shown in figure 3.3 for a large area photodiode (Philbrick 1990), where it is seen the diffusion component increases with wavelength. Diffusing charge can cause a number of undesirable image artifacts, as will be discussed below. A critical design challenge, then, is to minimize the degrading effects of diffusing charge on imager performance, while maintaining sufficiently high quantum efficiency. The periodic pattern observed in figure 3.3 is due to interference in films on the photodiode surface. The amplitude of the pattern can be controlled by making the film thickness greater than the temporal coherence length of the illumination source, or by adding topology irregularities. (Note: smaller pitch photodiode arrays show reduced peaking due

to inherent surface irregularities.) Variation in film thickness across a photodiode array can cause the peaks to shift, resulting in variations in quantum efficiency across the array. Therefore, tight control of the film thickness covering the detector is required.

Color separation can be accomplished by use of either absorption or dichroic type filters. A comparison of the performance of each filter type is shown in figure 3.4. A typical color scanning application requires three bandpass filters (blue, green, red) to extract a full color description of the image. Absorption type filters are less efficient and can fade with time, temperature and illumination. Interference filters are extremely efficient, do not fade, and can yield extremely sharp filter characteristics. However, they are more difficult and expensive to produce, and therefore their application has been limited to high-end, more costly scanners.

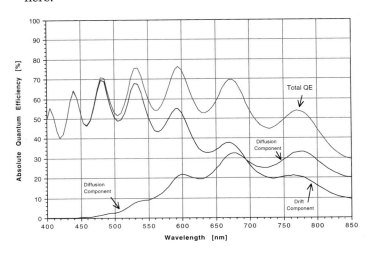

FIGURE 3.3
Electron Drift and Diffusion Components of Quantum Efficiency for a Large Area Photodiode with L_n = 2.2 mm.

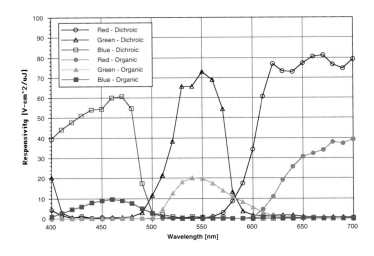

FIGURE 3.4
Comparison of Absorption and Dichroic Type Color Filters.

Photodiode LAG

Lag is defined as the percentage of charge remaining in the photodiode after the photodiode-to-CCD transfer period is complete. Certain types of photodiodes have much higher values of lag than others. For example, a standard PN photodiode has relatively high lag while a "pinned" photodiode has virtually zero lag. The origins of lag can be understood by picturing the space-charge region of a reversed biased PN diode acting as a photon collection site. As photo-generated charge is collected, the space-charge region collapses. At the end of the collection period, an adjacent transfer gate potential is increased by applying an external bias and the stored charge is allowed to flow into the adjacent CCD. As the charge flows out of the photodiode the space-charge region begins to extend back to the starting boundaries. At the tail end of this process the photodiode potential approaches the value of the adjacent transfer gate potential, and the flow of charge slows due to sub-threshold effects (Troutman 1973). The net effect is that not all charge is transferred out of the photodiode. Increasing the transfer time will reduce but not eliminate the lag - at the expense of slower scan speeds. The remaining charge in the photodiode appears in subsequent readout lines. Lag is most noticeable when scanning an image with a sharp bright-to-dark transition, where the first lines following the bright edge will not be totally dark.

"Pinned" photodiodes (Burkey et al 1984) have greatly improved lag performance due to the control of the space-charge region. These type of photodiodes are created by using a P+NP type structure. If the P+ implant is made sufficiently high, the N type region will be totally depleted and will have an associated electrostatic potential independent of the adjacent transfer gate potential. A substantial potential difference can be maintained between the photodiode and the transfer gate during the entire transfer period, regardless of the amount of remaining charge in the photodiode. Pinned type photodiodes allow linear imagers to operate at high readout speeds without suffering from lag.

Crosstalk

The mean absorption depth of photons in silicon is a function of the optical wavelength, with shorter wavelengths being absorbed closer to the surface and longer wavelengths being absorbed deeper into the substrate. Figure 3.5 shows the percentage of absorbed photons within a photodiode with a 2.2 mm deep space-charge region (Philbrick 1990). It is seen that 80% of all 550 nm photons and only 45% of all 650 nm photons are absorbed within the photodiode space-charge region. The remainder of uncollected charge carriers wander in the substrate until collected by another structure.

Crosstalk is a term used to describe the diffusion of photogenerated charge from a site of origination to nearby photodiode or CCD structures where they are collected. Figure 3.6 shows two types of image degradation which can occur due to crosstalk. The first is photodiode-to-photodiode, and the second is photodiode-to-CCD (smear). Photodiode

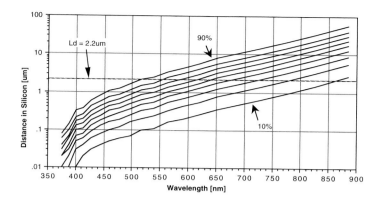

FIGURE 3.5
Percent of Absorbed Photons versus Absorption Depth and Wavelength.

crosstalk reduces the cross track spatial response of a given device, whereas smear reduces the along track and cross track MTF and limits the achievable dynamic range.

Photodiode-to-Photodiode

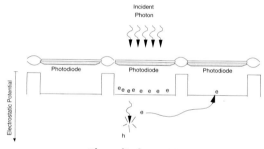

Photodiode-to-CCD

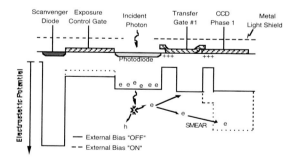

FIGURE 3.6
Diffusion Crosstalk in Linear Imager.

Maximizing the depth of the space-charge region of the photodetectors will minimize the degrading effects of diffusing charge. However, manufacturing technology and electrostatics limits the achievable depths of the space-charge

region; thus, alternative methods for reducing the effects of diffusing charge are required. Filtering the incident light to remove wavelengths outside the visual spectrum (> 700 nm) is critical and will significantly reduce the diffusion component of absorbed photons. Increasing the separation between adjacent collecting structures will also greatly reduce crosstalk, at the expense of increased silicon area. Photodiode separation is dictated by the desired spatial sampling frequency, and thus remains fixed. However, extending the photodiode in the along track dimension and adding a second transfer gate between the photodiode array and the CCD can greatly reduce the crosstalk into the CCD by increasing the path length and capture cross-section area as seen by the diffusing charge.

Charge Transfer Efficiency

The total charge remaining in a CCD stage after being clocked through an entire CCD shift register is termed the total transfer efficiency (TTE) and is given by

$$\text{TTE} = (\text{CTE}_{\text{Transfer}})^{\text{\#_CCD_Transfers}} \quad ,$$

where $\text{CTE}_{\text{Transfer}}$ is the efficiency of a single transfer. Note that a true two phase CCD has two transfers per CCD stage. Clearly the degrading effects of inadequate CTE have the greatest impact on the image at the far end of the CCD. The physical mechanisms causing charge transfer inefficiency (CTI=1-CTE) have been studied (Brodersen 1975) and have led to common use of buried channel CCD structures. These structures confine charge to a channel located below the silicon dioxide - silicon interface, as illustrated in figure 3.7, and routinely yield values of $\text{CTE}_{\text{Transfer}}$ greater than 0.99999. Achieving high CTE is especially crucial for long linear imagers (> 2K element) due to the high number of transfers involved. An example of the impact on MTF of varying levels of CTE for an 8000 element linear with a single two phase CCD shift register is shown in figure 3.8. Note if the CTE drops to 0.999995 the MTF can be degraded to ~85% of its original value. Depending of cell size, the CTE of a given device can be strongly dependent upon clocking levels and clocking frequency. Increasing clock amplitudes is often a simple method of improving CTE margin, although this results in increased power dissipation and device heating. With good process control techniques, imagers are presently capable of achieving greater than 0.999999 efficiency per transfer with near TTL compatible clock levels and operating speeds up to 10 MHz.

Dynamic Range

The imager output voltage per incident optical energy density is called the imager responsivity, and it can be expressed in terms of the photodiode quantum efficiency (QE), charge-to-voltage conversion factor (dV/dN_e), the energy per photon, and the photodiode active area (A) as

$$R(\lambda) = QE \cdot \frac{dV}{dN_e} \cdot A \cdot \frac{\lambda}{hc} \quad \left| \frac{V}{\mu J/cm^2} \right| \quad .$$

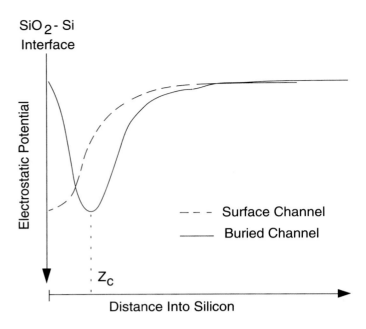

FIGURE 3.7
Surface and Buried Channel CCD Potential Profiles.

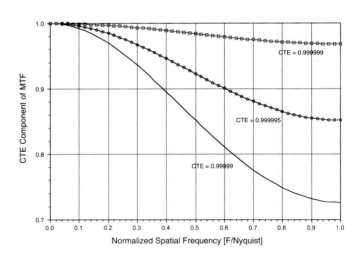

FIGURE 3.8
CTE Effects on MTF for 8000 Element Device.

A curve of responsivity versus wavelength is required to calculate the imager output response to a given optical input. If the spectral irradiance is known at the imager plane, the imager output voltage can found from

$$V_{out} = T_{int} \cdot \int_{\lambda_{min}}^{\lambda_{max}} R(\lambda) \cdot I(\lambda) \, d\lambda \quad [\text{volts}]$$

where T_{int} is the integration time and $I(\lambda)$ is the irradiance in units of $W/(m^2\text{-nm})$. The dynamic Range (DR) is typically defined as the ratio of the maximum output signal, or saturation level, to the rms. dark noise level of the imager, or

$$DR = 20 \cdot LOG\left(\frac{V_{sat}}{V_{Dark,rms}}\right) = 20 \cdot LOG\left(\frac{N_{sat}}{N_{Dark,rms}}\right) \quad [dB].$$

To achieve the highest dynamic range it is necessary to maximize the charge capacity (N_{sat}) and minimize the dark noise level. The charge capacity can be increased by expanding the size of the photodiode and CCD storage areas. However, this requires additional silicon area which can increase the imager cost and in the case of tri-linear arrays, increase the line delays between color channels. In addition, expanding the CCD area will increase dark current, and increase CCD load capacitance, which limits the maximum clocking speed and increases power dissipation. The final choice of areas is ultimately determined by the scanning application requirements. For high resolution film scanning applications where film density spans 0.2 to 3.8 D, a charge capacity of 0.4 to 1.0 million electrons is usually the desired goal.

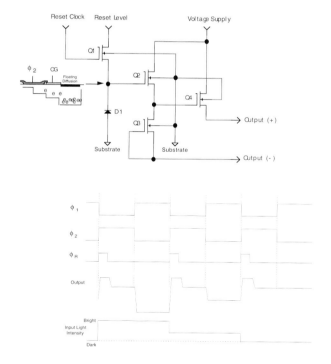

FIGURE 3.9
Typical Linear Imager Output Amplifier and Waveforms.

The charge packets transferred through the CCD are ultimately moved to an output structure where they are dumped onto a resettable floating diffusion capacitor, which produces a change in voltage equal to the change in charge divided by the capacitance value ($DV = q \cdot DN / C$). To maximize the output sensitivity, the floating diffusion node capacitance is made as small as possible. A typical value

for the node capacitance is 10 to 50 femto-Farads. The resultant voltage change is fed to the imager output through a two stage source follower amplifier as depicted in figure 3.9. Maximizing the charge-to-voltage conversion factor acts to minimize all noise sources from the buffer amplifier through the signal processing. But if high charge capacities are utilized to improve dynamic range, the output sensitivity must be properly tailored to limit the signal swing to levels acceptable for the sensing amplifier (typically 2.0 to 5.0 volts).

Temporal noise sources in linear imagers include the dark current, photon shot noise, reset transistor noise, clock noise, and the output amplifier noise. Dark current is dependent on the fabrication process and imager operating temperature (it doubles for every 8 to 10°C increase in temperature) and can be reduced by cooling the imager. Photon shot noise cannot be eliminated; however, by acquiring and averaging several lines it, and all temporal noise sources, can be reduced. Amplifier noise consisting of 1/f and thermal terms, is attributed to the variation is FET channel conductance and is typically on the order of 20 electrons (rms.). The reset transistor noise, and much of the amplifier 1/f noise, can be removed using correlated double sampling signal processing (White 1974). The net result of all noise sources is a noise floor of 25 to 50 electrons (rms.) for an imager operating at 25°C. (Cooled imagers can approach electron limited noise performance.) Inserting the minimum case charge capacity and maximum noise level values into equation 5 yields a minimum dynamic range of 78 dB, requiring 14 bit analog-to-digital converter accuracy. However, noise sources associated with the scanner system such as signal processing electronics and drive motors may also reduce the overall scanner dynamic range, if not carefully considered.

Electronic Exposure

To achieve the maximum dynamic range in color systems it is desirable to achieve near full scale operation of all three channels of a tri-linear CCD imager. One approach is to ensure that the light source is well characterized and balanced against the imager responsivity curves. A properly balanced system will allow all photodiode arrays (i.e. red, green, blue) to achieve the maximum storage charge without causing blooming in any other array. But this task requires external filters to be installed in the optical path, and can be expensive as well as produce less than optimal performance due to variations in film types and when switching between positive and negative films. A linear imager with variable exposure control for each photodiode array solves this problem. An architecture which achieves this is depicted below in figure 3.10, where the effective exposure time is adjusted by the duty cycle of the exposure control gate. Exposure control is accomplished by draining carriers during the leading portion of the line time, through the exposure gate to a charge drain. The adjustment of the exposure is linearly coupled to the duty cycle, allowing for compensation of a wide variety of exposure conditions, film types, and source color temperatures.

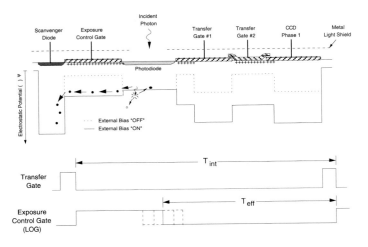

FIGURE 3.10
Cross Sectional View of Electronic Shutter Structure.

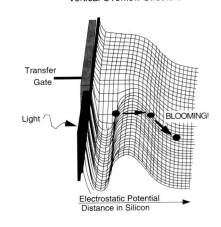

FIGURE 3.11
Two Common Types of Antiblooming Structures.

Blooming Control

The process which occurs when the charge capacity of the photodiode or shift register is exceeded is called blooming. The space-charge region collapses as photogenerated charge is integrated, ultimately disappearing when charge capacity is reached. If photon absorption is allowed to continue, the additional photogenerated charge will randomly diffuse into neighboring photodiodes and CCD structures; thus, corrupting the line image near the blooming site. Blooming can occur when scratches in film are encountered in scanning systems. Reducing the light source intensity so the image of the scratch or hole would just fill the photodiode would reduce the effective dynamic range for the rest of the image, and thus is not a preferred solution.

Linear imagers with antiblooming capability have a special structure adjacent to each photodiode which funnels the excess charge safely into the substrate, eliminating image corruption. Figure 3.11 depicts two common types of antiblooming structures found in linear solid state imagers; namely, the lateral overflow drain (LOD) and the vertical overflow drain (VOD). Vertical antiblooming structures typically consist of a PNP transistor arrangement, operating in a punch-through mode, and hence reside below the charge collection site and allow excess charge to overflow directly into the substrate. Lateral antiblooming structures reside adjacent to the charge collection site and allow excess charge to overflow across a lateral MOSFET. While VOD structures allow a more compact cell structure, they are also more difficult to manufacture and control and reduce the photodiode efficiency at longer wavelengths by reducing the diffusion component of quantum efficiency (i.e. the signal charge swept away by the overflow drain). In linear arrays space is available at less of a premium, so LOD structures are typically utilized. Antiblooming is usually specified in increments of the photodiode or shift register charge capacity, and levels of 100X or greater are not uncommon (Stevens 1992).

Spatial Resolution

The overall spatial resolving power of an imaging device is cited in terms of its modulation transfer function (MTF). Three major components limit the device MTF: aperture MTF, diffusion MTF, and charge transfer MTF. Aperture MTF is determined by the sensor cell pitch and patterning of the aperture itself, giving rise to the familiar $sinc(p \cdot f \cdot Dx/(f_n \cdot p))$ function, where Dx is the aperture, p is the pitch, and f_n is the nyquist frequency. The CTE MTF discussed earlier can be controlled to have a negligible impact on the net MTF for most present day manufacturers. The diffusion MTF component is the most difficult to predict and is coupled to the aperture architecture and substrate material (Stevens 1992).

The architecture depicted in figure 3.12 provides a solution to this problem by breaking the single photodiode array into two staggered offset arrays (Kodak 1994). This design permits individual photodiodes to be twice the sampling aperture size, which significantly reduces the diffusion crosstalk between photosites, while still providing complete image coverage. For additional MTF improvement, between each row of photodiodes, and optionally between adjacent photodiodes, are placed light scavenging diodes to reduce the inter-array and photodiode-to-photodiode diffusion crosstalk. This architecture adds an along track MTF component due to sub-array crosstalk; however, this term is negligible with the inter-array scavenging diode present.

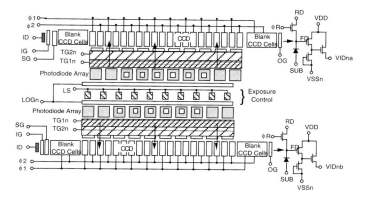

FIGURE 3.12
Linear Imager With Staggered Offset Photodiode Architecture.

A comparison of conventional and staggered offset linear imager MTF is shown in figure 3.13, where the performance improvement of the staggered design is clearly observed from 1/2 nyquist to nyquist. In fact, at nyquist near aperture limited performance is achieved. This architecture will most likely dominate the next generation of high performance linear imagers, allowing for high density imagers with correspondingly high MTF capability.

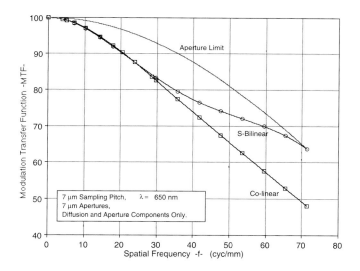

FIGURE 3.13
Modeled Crosstrack MTF Comparing Staggered/Offset and Collinear Architecture's.

Conclusions

Performance limiting phenomena in linear solid state image devices have been reviewed and techniques for maximizing the efficiency of these devices presented. Linear imagers making use of these techniques offer higher performance options for film scanning applications, including improved spectral sensitivity and reduced artifacts while providing high spatial resolution. Many of the architecture's discussed herein are readily available from several device

manufacturers; however, it is ultimately up to the system designer to choose the device attributes which critically affect the system performance Film scanners using such devices will be able to acquire increased amounts of information from film samples, and give more accurate renderings of the original image scenes.

References

Anagnostopoulos, C. N., 1993. *A Single Register 8K CCD Tri-linear Color Sensor with Unrestricted Exposure Settings*, IEEE International Solid-State Circuits Conference, Paper TP 12.2.

Brodersen, R., et al, 1975. Experimental Characterization of Transfer Efficiency in Charge-Coupled Devices, *IEEE Trans. on Elect. Devices*, Vol. ED-22, No 2.

Burkey, B., et al, 1984. The Pinned Photodiode for an Interline-Transfer CCD Image Sensor, *1984 IEDM Technical Digest*, pp. 28.

Davis, M., 1989. *High Resolution CCD Film Scanner for Special Effects Applications*, 131st SMPTE Conference, October.

Dereniak, E. and Crowe, D., 1984. *Optical Radiation Detectors*, Wiley & Sons, New York, ISBN 0-471-89797-3.

Jespers, P., et al, 1976. *Solid State Imaging*, Noordhoff International, Leyden - The Netherlands, ISBN 90-286-0046-9, pp. 33 and 65.

Kennel, G., 1994. Digital Film Scanner and Recording: The Technology and Practice, *SMPTE Journal*, March 1994, pp. 174-181.

Kodak Corp., 1994. *CCD Image Sensor Having a Reduced Photodiode-to-Photodiode Crosstalk*, USA Patent Application 08/169,946, Rochester NY.

Lees, R., et al, High Performance CCD Telecine for HDTV, *SMPTE Journal*, Vol. 99 No. 10, pp. 837-843.

Milch, J. R., 1990. Line Illumination System and Detector for Film Digitization, *SPIE* Vol. 1242, *Charge Coupled Devices and Solid State Optical Sensor's*, pp. 66-77.

Philbrick, R., 1990. Modeling of Light Absorption in Solid State Imagers, *MSEE Thesis* from Rochester Institute of Technology.

Stevens, E., et al, 1992. The Effects of Smear on Antiblooming Protection and Dynamic Range of Interline CCD Imager Sensors, *IEEE Trans. on Electron Dev.*, Vol. 39, No 11.

Stevens, E., 1992. A Unified Model of Carrier Diffusion and Sampling Aperture Effects on MTF in Solid State Image Sensors, *IEEE Trans. on Electron Dev.*, Vol. 39, No. 11.

Troutman, R., et al, 1973. Subthreshold Characteristics of Insulated Gate Field-Effect Transistors, *IEEE Trans. on Circuit Theory*, Vol. CT-20, No 6.

White, M., 1974. Characterization of Surface Channel CCD Image Arrays at Low Light Levels, *IEEE Journal of Solid State Circuits*, Feb. No. 1.

[1]Author: Philbrick, R., Erhardt, H., Eastman Kodak Company, Microelectronics Technology Division, 66 Eastman Ave, Rochester, NY 14650

Commercial Photogrammetric Scanners

General Remarks

It is not very easy to give a comprehensive description of instruments in constant development. Nevertheless, it is important for the photogrammetrist to get an overview of a selection of instruments on the market. We have therefore invited the vendors to supply a brief description of their instruments, with the technical data. Many instruments are very new, and consequently are not taken in consideration for the tests described in section 5. In the next paragraphs, a brief description of the following scanners, appropriate for use in photogrammetry, are given:

- DSW200 by Helava
- PhotoScan PS1 by Intergraph
- VX3000 by Vexcel Imaging
- RasterMaster RM-1 by Wehrli
- OrthoVision 950 by XL Vision
- Phodis SC by Zeiss

The author is grateful to these valuable contributions and invites the readers to follow the rapid developments in that field.

DSW200 Film Scanner by Helava[1]

Helava Associates Inc. (HAI) developed the DSW200 film scanner in 1994. It creates accurate digital images from 9 x 9 inch aerial film transparencies. The design criteria were those important to photogrammetry. Digital copies should preserve the inherent accuracy, resolution and radiometry of film for mapping purposes. Speed of operation should be fast enough to allow one scanner to support many softcopy workstations. The unit is assembled and tested at Helava's San Diego, USA headquarters. Key components in the scanner, (computer, lens and camera), are interchangeable in both a hardware and a software sense. Interchangeability ensures an upgrade path for rapidly advancing imaging technology. This successful design is an evolution of the previous generation HAI scanner, the DSW100, introduced in 1988. Equally important were the collaborative efforts of Dr. U.V. Helava, Kodak and Leica. Although retired, Dr. Helava contributed to the project until several months before his death in 1994.

The DSW200 scanner configuration consists of:

1) Movable xy axis cross-carriage stage with flat film platen and associated control electronics

2) Fixed large area array CCD camera and imaging optics

3) Xenon light source and three color filter wheel

4) Workstation host computer, storage peripherals and control software

FIGURE 4.1
Helava DSW200.

Instrument Design

The basis for the scanner's accuracy is in the stage mechanics and calibration software. The positive or negative film transparency lies horizontally on the xy cross-carriage's central 270mm x 270mm glass platen. The film is held flat by a top glass pressure plate. The carriage, supported on a rigid metal base plate, moves the film relative to this base. Servo controlled motors drive each axis independently. Linear encoders monitor position in 1 micron increments. The motion control electronics, designed by Helava, combine stage motion with encoder feedback for precise positioning. This closed loop servo system has an accuracy after calibration of typically better than 1.5 microns RMS per axis.

Scanner resolution comes from minimal optics and good camera MTF. The image optical path is straight and fixed to the base plate. Most of the path is enclosed in a hollow .3 meter long aluminum cylinder that extends through the base plate. The cylinder stands vertically underneath the film platen and is just cleared by the moving film carriage. A continuous range of optical magnifications can be operator set by adjusting the location of the camera and lens in the cylinder. Magnification limitations are based on the exit aperture size of the light, length of the cylinder, lens focal length and camera sensor pixel size. With the standard 120mm lens and 9.0 micron square sensor pixel, the optical pixel size is adjustable between about 4 microns and 16 microns. This is possible while still maintaining a uniform low distortion field and Nyquist resolution.

Good radiometry is achieved with proper lights and sensitive cameras. The film is illuminated from above by a highly uniform and diffuse light disk fixed over the optical cylinder opening. This disk emanates from a large integrating sphere, the characteristic ball on top of the stage. A Xenon short arc lamp provides a high intensity full spectrum light source. Its output is condensed through a selectable glass filter into a 5mm light channel opening. The Xenon source was specifically chosen for color applications. Four

different glass filters are selectable under computer control (clear, red, green and blue). The filtered light travels through the channel to the integrating sphere entrance. The sphere entrance contains operator changeable apertures designed to adjust the amount of light needed for the film type. These sphere apertures allow modulation of light intensity by a factor of close to 100. This available light range, combined with the camera dynamic range of 1000 to 1, allows film densities of almost 5.0 optical density to be discernible. Equivalently, this reserve energy can be employed for very high magnifications of any type of aerial film in the typical 0.2 to 3.3 optical density range.

Software Design

Any technological product's quality, speed, functionally and ease of use are normally always being challenged. The computer and software are key in permitting users the full potential of the hardware capabilities. The scanner software, written in the object-oriented C++ language, is currently based on SUN workstations and designed to use the X11/Motif windowing user interface. The software remotely controls the stage, color wheel and camera operation. Geometric stage and sensor calibration, radiometric sensor calibration, interior orientation, full photo scanning and image viewing are available. Image correlation algorithms automate the stage calibration and interior fiducial measurements. An interactive tonal editor creates custom lookup tables to support visual and informational needs. Pixel transformations can be performed on the input camera pixels before display or writing to disk. Accurate 24-bit transformations of these displayed images can be output to the monitor in near real-time. Fast scan times shifted the goal of software to minimize setup time, while maximizing quality of scan results.

The scanner should be fast enough to stay ahead of the softcopy mapping stations it provides imagery to. Film is scanned on the DSW200 in a "step and stare" operation. The basis of this method is the large area array sensor from Kodak. The DSW200 currently contains a 2029 by 2044 pixel array camera with 10-bits of digital data per pixel. The stage is moved a distance equal to the size of the array ("the step"). After each step, the stage is held motionless while the array is exposed to capture the film image patch ("the stare"). Exposure time may be varied to allow tuning to the specific film's radiometry. Based on automated stage and sensor calibrations, any rectangular film region can be scanned by exactly dividing it up into a precisely fitting mosaic of patches, cropping where necessary. During the time interval the stage is driving, the host computer radiometrically corrects and merges the patches together into a single output disk file. At the pixel size of 12.5 microns, each patch covers 25 by 25 mm and there are 81 patches for a typical 225 by 225 mm scan. This complete process can execute in about 3 minutes. Only one pass of the film is required for color scanning. The filter wheel rotates one complete revolution at each step to capture the 24-bit or 30-bit color patch information. In this way, no color registration errors occur.

The previously described design allows addition of capabilities as technology and film evolves. For example, resolution can be more than doubled to a 2 micron pixel size limit by using a 90 mm lens. Speed can be quadrupled by replacing the 2000x2000 pixel camera with a 4000x4000 pixel camera and upgrading the host computer. Higher radiometric resolutions of 12-bits to 16-bits per grayscale pixel, (36-bit to 48-bit color), are also possible with a camera change. Camera changes only require a new camera mount and software controller. The software can take advantage of multiple processors or faster disk systems to increase performance. Finally, automatic roll-film scanning is being considered with stage modifications. This modular, "step and stare", design philosophy is therefore able to keep pace with the future of softcopy photogrammetry.

Intergraph Photoscan PS1[2]

This scanner was developed jointly by the firms Intergraph, Huntsville, and Zeiss, Oberkochen. Zeiss concentrated on the opto-mechanical part, while Intergraph developed the electronic controller and the data processing units. This scanner is composed of a digitizing unit driven by an Intergraph workstation.

The Scanning Unit of the PS1

The digitizing unit is a relatively compact cabinet containing in its upper part the opto-mechanical components, with a stage moving in one direction, while the CCD camera and the illumination system moves in the other direction. The lower part contains the electronic controller and the light source.

The mechanical system is based on the principle of the Zeiss Planicomp analytical plotter and it allows scanning of photographs of sizes up to 26x26 cm. The film placed on the plate carrier is illuminated from the top by a light source magnified by a condenser. Light is transmitted from the light source to the upper part using fiber optics. For digitizing color images, the light source is equipped with a filter wheel. Just below the film carrier is a high quality imaging lens specially designed by Zeiss.

FIGURE 4.2
The Intergraph-Zeiss Photoscan PS1.

The Photosensors of the PS1

A linear photosensor of 2048 pixels is used for digitizing. While processing, the film is moved continuously at the appropriate speed. At the end of each swath, the sensor is moved laterally in order to process the next swath. The image is digitized block after block, each sizing 7.5x7.5 μm (standard configuration). The processing time for each block is about 1 ms. The signal can be integrated over several pixels by electronic processes, in order to modify the pixel size to 15x15 μm, 30x30 μm or more. The analog to digital converter produces gray tones coded on 11 bits; this information is then reduced to 8 bits, using a look-up table. This technique allows to gain on the density dynamic range.

The photosensor used is a linear Fairchild 145 CCD, the sensitive elements of which are placed every 13μm. So a digitized swath has a width of 15.36 mm width. The sensors can be oriented within a range of ± 5°, in order to be perfectly perpendicular to the scanning direction. The scanning direction can be selected along the coordinate axis of the aerial photograph defined by the fiducial marks of the film.

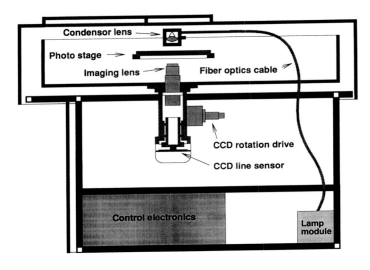

FIGURE 4.3
Block diagram of the PhotoScan.

Performances of the PS1

The maximum stage speed is 16 mm/s, which implies 15 seconds for a 240 mm swath. As 16 swaths are necessary for a 240 mm photo, a minimum time of 6 minutes is required to digitize an image. This time is achieved only for low resolutions and is considerably raised if higher resolutions are desired. For example, a 23x23 cm image at a resolution of 22 μm needs 12 min. to be digitized (depending on the performance of the host computer processor).

The host computer is an Intergraph Interpro 345 workstation, based on a 32-bit Clipper CPU, a RISC processor with a performance of 5 MIPS (status of 1989). The station is completed with a GX graphic processor and a mass storage on discs. A special JPEG processor can also be used in parallel in order to compress the images, so that space is spared on disc. Both the scanner functions and the image visualization are performed on the same high resolution screen (1600x1200 pixels). The computer described above is used as a stand-alone station; however, the processor of a photogrammetric ImageStation may be used to control the scanning process, but when the scanner is working, no other task can be performed on the workstation. Therefore a stand-alone version is advisable.

It seems that the digitized image is corrected neither radiometrically nor geometrically after scanning. This implies that sometimes small radiometric differences are visible between adjacent bands. In any case, the PhotoScan is used in various applications and it seems to be the scanner most used in 1994 for photogrammetric tasks.

Vexcel VX3000[3]

The VX3000 is a film scanner which converts film images into digital form for use by GIS, Image Processing and Mapping computer programs. The VX3000 scanner brings high end scanning to users who require a cost effective way to digitize with high geometric and radiometric accuracy and high spatial resolution.

The VX3000 provides exceptional flexibility in the area of film type, film size, resolution and setup. This scanner digitizes at resolutions ranging from 160 micrometers/pixel to 8.5 micrometers/pixel in increments of 0.1 micrometers. This allows scanning at any resolution with no post processing or resampling required. The system will also scan positive or negative films in either color or monochrome.

The system can accommodate images up to a size of 25 cm X 50 cm in the backplane. The optional film roll attachment permits roll film scanning. The system may be configured with an automated roll film device which enables unattended scanning.

Technology

This accuracy and flexibility is made possible by technology which simplifies the hardware at the expense of sophisticated software technology. Vexcel Imaging Corporation holds eight patents which makes the VX3000 possible. The geometric accuracy of the system is derived from technology called the invisible reseau system. The VX3000 implements this technology with a vertical carriage which contains a pair of glass plates for mounting the film. The front plate contains precisely etched grid lines throughout the active area. These gridlines can be selectively illuminated or hidden and provide a reference frame for precise camera alignment.

During the scanning process an image frame is acquired with the digitizer along with an image of the illuminated reseau at the same location. The image of the reseau is used to precisely calculate the location of the camera at the time the image was taken. This information is used to correct

the image geometry for perspective and scale distortions which may have been added by the camera and lens. (See Figure 4.4)

The combination of the precisely etched grid and image processing software provide exceptional geometric accuracy. The scanner produces a digital file which is consistent with the analog input to an accuracy of 3 micrometers RMS over the 23 cm X 23 cm area of a standard aerial photograph.

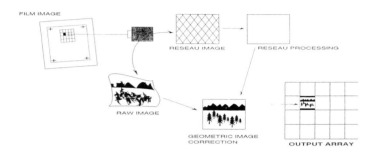

FIGURE 4.4
Reseau scanning technology.

Components: Scanner

The VX3000 film scanning unit consists of a vertical film carriage which is mounted in front of a computer-controlled illumination system. A robotic arm controls the position of the digitizing sensor which can be located at any position in front of the illuminated film. The digitizing sensor is an area array camera which contains 512 X 480 elements (optionally 1K X 1K elements).

The sensor is mounted with the lens on a positioning system which controls the distance between the film image and the lens, as well as the distance from the lens to the CCD array. This two axis zoom system allows the resolution of the scan to be chosen by selection of the proper optical magnification (not downsampling). The resolution chosen is accurate because of the scale correction done along with the positioning correction. The use of a single lens element provides superior quality in a variable resolution system.

The lighting is provided by an area illumination system based upon a cold cathode technology. This illumination system is controlled by a diode feedback system which regulates the light and ensures stability over the product lifetime.

Color scanning is accomplished by means of three color filters which are placed in the optical path. At each location, data is gathered with each of three color filters, and co-registered through the use of the reseau image.

The vertical carriage provides easy loading of the film. Film alignment is controlled by a simple film guide which makes the mounting process fast and accurate. This verti-

cal system also allows visual observation of the film as it is mounted in the carriage. The vertical carriage also allows the system to accommodate roll film.

Controller

The VX3000 is delivered complete with a computer which controls the motion and lighting system of the VX3000 scanning unit. This computer also houses the digitizing and image processing hardware which gather the data form the scanning sensor. Under program control, the scanner can be made to change the resolution of the imaging sensor, change the location of the sensor, adjust the lighting control and digitize data. (See Figure 4.5)

FIGURE 4.5
VX3000 system diagram.

The controller is also responsible for gathering, storing and transferring the digitized data to other computers. As the control computer is also a UNIX workstation, it has all of the connectivity features that are embedded in the UNIX operating system. Connectivity with destination computers is accomplished by standard access methods such as TCP/IP and the Network File System (NFS).

Software Modules

The vxscan program is responsible for controlling all phases of the scanning process. These include servo control of the scanning mechanism, control of the image processing subsystem and digitizer, presentation of the user interface to the operator, and storage and transfer of the image data to the appropriate network location for processing.

The vxformat program, which works in conjunction with the vxscan programs, is designed to manipulate the output data files and convert them to the proper output format at the proper destination on the network. The vxformat program is automatically initiated by the vxscan program and

can execute on any of the networked computers which are properly configured. The vxformat program can also be executed on the scanner controller as a post process.

The VX3000 is designed to be self calibrating during operation. However, manual recalibration is sometimes necessary and when required is performed by the vxcal program. This program is designed to make measurements of the scanner hardware components and create software calibration files which are used by the vxscan program.

Features

The VX3000 offers a collection of features which make it the perfect tool for film digitization for GIS and photogrammetry. These features provide unmatched flexibility for scanning and measuring data from film.

Film Size

The VX3000's unique design accommodates multiple sizes of film. The vertical mount and flat carrier design allows images from less than 35 millimeters2 to images greater than 25 millimeters by 50 millimeters. Even larger images can be mounted to scan a subset of an image frame in excess of 25 X 50 millimeters2.

Region-of-Interest Capability

A unique feature of the VX3000 is its ability to scan regions of interest (ROI). ROIs are spatial areas of the film that the user desires to digitize. Every region can have a unique set of scanning attributes include positive/negative, color/monochrome, resolution setting, normal/mirror and a variety of processing options.

Interactive Setup

The operator can, in real time, see an actual preview of the resultant scan during the setup process. The user can adjust the resolution so that the proper amount of detail is seen, and control the lookup tables, color settings, film type and image processing modes. The interactive capabilities save the customers significant time in setting up scans, but more importantly save rescan time by preventing inappropriate settings from being used.

Roll Film Scanning

Most aerial photography is digitized in cut sheet form, with 23 cm X 23 cm images mounted in the scanner singly or in pairs. The VX3000 also has the capability of supporting roll film either in a manual or automated form. The manual system accommodates rolls 1000 feet in length and widths from 35 mm to 25 cm. The manual film system makes the handling of roll film images simple. Proven roll mounting hardware makes the loading and unloading of film very easy.

The automated film drive can be setup for unattended scanning of images. With the automated frame finding system, regions of interest can be scanned to within ten microns of the desired locations. The system can be configured to use optimal radiometric setup or constant radiometric setup.

Integrated Digital Aerotriangulation System (IDAS)

The Integrated Digital Aerotriangulation System is a data collection and measurement package which operates in conjunction with the VX3000. Its purpose is to increase efficiency in the aerotriangulation process through the application of digital imaging technology. IDAS turns the VX3000 film scanning system into a monocomparator for photogrammetric operations. IDAS enables the aerotriangulation procedures in a fraction of the time of normal triangulation projects, while still maintaining accuracy

IDAS operates on low resolution image scans of photogrammetric blocks, and high resolution patches of data localized around the measurement area. Since these high resolution patches have small data size, they are easy to manipulate. However, as their position is accurately known, digital measurement from these patches yield very high accuracy.

FIGURE 4.6
Wehrli RM-1 RASTERMASTER.

Wehrli RM-1 RASTERMASTER[4]

The RM-1 RASTERMASTER is a high precision photoscanner especially designed for the photogrammetric market. (Figure 4.6) It is a flatbed scanner accepting black/white and color transparencies up to 250x250 mm. It is PC based and supported by optional, third party aerotriangulation and orthorectification software.

The RM-1 competes in the price range of high resolution desktop scanners yet provides the geometric and radiometric accuracy required for large scale mapping.

The RM-1 was introduced as a prototype at the 1992 ISP Congress and the first production instrument was delivered in March 1993.

General Description

The RM-1 consists of a photo carrier on a two-axis cross slide. The image is illuminated from above by a fluorescent lamp, collected by the objective lens, reflected from a 45-degree mirror and focused in the plane of the sensor mounted below the stage. Motion is controlled by a DC servo system through a friction drive with position feedback supplied from 0.5 micron linear encoders. The individual digitized lines are stored in memory and after a pass of the scanner along the length of the photograph is completed, this swath of information is written to disk while repositioning the scanner for the next swath. Figure 4.7 provides a system overview.

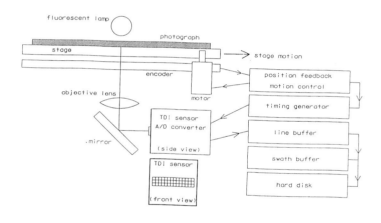

FIGURE 4.7
System overview.

The sensor used is a unique, state-of-the-art time-delay and integration (TDI) sensor consisting of 2048 x 96 elements which are square, with a size of 13x13 microns. It is aligned with the long dimension horizontal. With the current instrument configuration, 1024 pixels in each line are used. A window of 1024 pixels out of 2048 available is selected in order to allow some adjustment of the effective sensor position to compensate for illumination characteristics, and to cut in half the memory requirements for a full swath of image data. This window position is software selectable. The pixel size at the plane of the photograph is 12 microns, thus the magnification of the optical system is very nearly 1:1. The advantage of working at 1:1 magnification is that it is easy to design a lens that is distortion free in this configuration, with equal object and image distances. Coarser resolution is effected by aggregating the pixel data acquired at this base resolution of 12 microns.

To the video capture module, the TDI sensor appears to be a linear sensor, whereas in fact each single line of the digitized image has been accumulated in each of the 96 lines of the sensor. In other applications, this feature is exploited for high speed or low light operations. In this case, the effect of such an architecture is that each digitized line is effectively averaged over 96 integration periods thus reducing noise in the data. Assuming no other time constraints, this would allow the scanner to move with a higher velocity than with a strictly linear sensor. With a TDI sensor, the relative motion between the stage and the sensor must be tightly synchronized with the charge transfer between sensor lines in the direction of the scanning motion. This is accomplished by the timing control module, which senses the quadrature square waves from the encoder. Then, via a programmable counter, this module supplies regular trigger pulses to the sensor to advance the lines, and to output the final integrated line of video data for the single line of image. As was mentioned, the design specification called for a 12 micron pixel size in the image. The counter is then set up to trigger the sensor at exactly 12 micron intervals, regardless of velocity.

Technical Data

ILLUMINATION	Fluorescent
SENSOR	Linear sensor with 2048 pixels of 12 microns (TDI)
GEOMETRY RESOLUTION	0.5 micron linear encoders
SCAN RESOLUTION	12 microns; multiples of 12 by aggregation i.e. 24, 48, etc.
PRECISION	Less than 5 microns
RADIOMETRIC RESOLUTION	8 bit B/W; 24 bit color (option 12 bit b/w; 36 bit color)
ACCURACY	LUT, calibration of light source and sensor elements
DENSITY RANGE	0.2 - 1.8
SCANNING SPEED	9"x9" photograph at 12 micron pixel size = 14 min.
IMAGE FORMAT	Raw Binary, Tiled Raw Binary, Windows BMP TIFF, GIF and other formats by conversion
COMPUTER	Pentium 90, 32 Mb RAM, 2 Gb SCSI-2 FAST harddisks, 3_FDD, CD-ROM, 15" SVGA color monitor, ATI Ultra graphics adapter, 1 parallel port, 2 serial ports
OPERATING SYSTEM	MS-DOS 6.2x
CONTROL & SYSTEM	LUT managing radiometric corrections On-line pixel aggregation in multiples of 12 microns
APPLICATIONS	Stage calibration; Scanning of user defined rectangle; Histogram, Conversion utilities. Third party aerotriangulation and orthophotorectification software.

OrthoVision™ 950 Image Scanner by XL Vision[5]

The OrthoVision™ 950 is a high-speed film scanning system designed to serve the conversion needs of the photogrammetric, GIS and intelligence markets. The product is designed to scan both positive and negative transparencies in either color or black and white. The OrthoVision™ 950 provides high quality imagery with excellent geometric accuracy. Figure 4.8 below shows the OrthoVision™ 950 with the automated roll film transport attached. A few important system specifications and characteristics are listed below.

FIGURE 4.8
OrthoVision™ 950.

- 24,000 pixel linear array.
- 10μ,12.5μ or 15μ native optical resolution.
- Operator selectable resolution by factors of 2,3,4,5,6,8.
- 21 second fast scan at 120μ.
- 4.3 min. scan of full B&W 9.5 in. image.
- Film density range of .1 - 2.4OD.
- Near diffraction limited optics.
- Excellent system MTF.
- 10 bit dynamic range mapped to 8 bits.
- 24 bit color in single pass geometric accuracy of 3μ at the 1 sigma level.
- ERDAS IMG tile and LAN formats

System Configuration

The OrthoVision™ 950 consists of a one-dimensional precision translation stage, image capture system, custom high-speed electronics, and a host computer with applications software interface. These subsystems are discussed in detail in the following sections.

Precision Stage

XL Vision uses a high-precision uni-directional stage to translate the film between the fixed illumination source and optical subsystem. The stage carries a platen which holds the film between two precision glass plates to insure good focus throughout the scan. Cut film can be accommodated in any size up to 10" square.

An optional automated roll film transport is available that mounts on the stage. This unit will handle roll films up to 9.5" in width. Cut film can also be scanned when the roll film option is attached.

Image Capture System

The OrthoVision™ 950 image capture assembly uses three tri-linear CCD arrays, a lens assembly, and an illumination source.

The CCD arrays used in the OrthoVision™ 950 consist of three 8000 pixel linear arrays. These arrays are optically and electronically butted to provide a continuous scan line of 24,000 pixels. The arrays each have three rows of pixels. For the color configuration, each row is masked with a red, green, or blue filter. This allows for a one pass scan which produces a full 24 bit color image and eliminates all color registration problems. The selected arrays support a dynamic range of 10 bits/pixel with relatively low noise and excellent MTF.

A single high-quality apochromatic lens is used to focus the image onto the three CCD arrays. This lens is operated at approximately 1:1 magnification and provides near diffraction limited performance.

An apertured fluorescent bulb is used to illuminate the image. The light source is customized to match the phosphors with the color sensitivities of the respective masked arrays. Therefore the light intensity at a pixel is such that maximum dynamic range is achieved with equal integration times.

Host Computer

The host computer consists of a dual pentium processor with 64MB RAM and local hard disk storage. The applications software runs under the Windows NT operating system and supports a range of functions including radiometric and geometric calibration, scanner control, automated roll film control, and system diagnostics. The system provides a <u>G</u>raphical <u>U</u>ser <u>I</u>nterface (GUI) which makes the control and operation of the scanner very straightforward and intuitive.

The host computer can be networked with other users through the Fast Ethernet interface. Scanned images can then easily be transferred via this interface. The scanned images are available in various formats. They include TIFF, ERDAS IMG TILE and ERDAS LAN file formats.

Geometric Accuracy

In order to achieve high geometric accuracy with the OrthoVision™ 950 (3μ at 1 sigma), a combination of hardware precision, accuracy and analytical geometric correction have been applied. The basic approach was to design a system with high repeatability and low random error. Through a rigorous calibration procedure, an error model is determined which accurately predicts the absolute error at any position in the scanned image. This error model is determined by mathematically modeling all of the systematic errors of the system. These modeled errors include the effects of lens distortion, stage motion non-linearities, magnification errors, and detector mounting errors.

To perform the calibration of the system and establish the parameters of the error model, a precision calibrated target is utilized. This target is a special glass plate containing an array of 49 x 49 points. The locations of these points are known to an absolute accuracy of less than 1 micron and have been verified through NIST standards. The calibration target is scanned by the system and the collected data is used in a rigorous least squares adjustment to determine the error model coefficients. This calibration is done at the factory prior to shipment of the unit and need not be redone unless servicing requires a recalibration.

Once calibrated, the scanned data can be corrected using the error model in two ways. Either the image can be remapped or measured points of interest can be corrected. These techniques are very different and the one chosen depends on the specific circumstances.

Radiometric Calibration

The OrthoVision™ 950 custom electronics provide for sophisticated radiometric correction in real time. Through a special calibration procedure, the scale and offset for each pixel is determined. These values are stored in the electronics subsystem and used to correct the pixel output values. As a result, radiometrically accurate images are produced. The user can adjust the integration time to expand the dynamic range of the image to cover a selected radiometric range.

Selected Features

A fast scan feature (20 to 60 seconds) is provided which allows the user to quickly overview the image and select a region of interest for high resolution scanning. The operator may also select scanning resolutions which are up to 8 times of the systems native pixel size.

Zeiss PHODIS SC[6] : Photogrammetric Scanning System with SCAI Precision Scanner

PHODIS SC is a photogrammetric system for scanning of the original photos without any need to cut the aerial film and without an intermediate photographic process to generate original digital images. PHODIS SC features a modular structure comprising SCAI as the basic scanner unit, the optional Autowinder attachment for roll film, and the SC-software implemented on a Silicon Graphics workstation to which SCAI is attached.

FIGURE 4.9
Zeiss PHODIS SC.

Instrument Design

Main performance features of the scanner system SCAI are the high geometric positioning accuracy with a standard deviation better than 2 microns, the high radiometric resolution of up to 1024 gray levels, a superior resolution with pixel sizes as small as 7 microns, monochrome or color scanning in a single cycle, and a high data transfer rate of up to 4 million pixels/s.

SCAI's design is determined by the capability of processing roll film. The Autowinder is permanently connected with the iron-cast enclosure of the scanner. The copy to be scanned - either a sheet of film or roll film - is placed on the photo stage. The illumination arm, the optics module, and the CCD camera module form the secondary carriage which scans the photo stage in a highly precise and comb like movement. The CCD module consists of a 1D-CCD-array with 3 parallel, red-green-blue, CCD-lines.

The secondary carriage continuously moves the CCD camera in the scanning direction while the primary carriage advances it in steps defined by the swath width. The swath width is 39.424 mm. This permits a copy with a width of 240 mm to be scanned in 7 swaths.

The image section is imaged on the CCD camera by a mirror lens system which is free from distortion and chromatic aberrations. A lamp module and moveable fibre glass optics with diffuse cross-section converter illuminate the image section corresponding to the swath width. The light source is a highly stabilized 250 W halogen lamp.

The drive and control system of the moving carriages comprise precision guideways precision spindles, linear encoders, and DC motors. They ensure the exceptional geometric accuracy of 2 microns.

The Autowinder is attached to the iron-cast enclosure and permits fast throughput of the film and accurate positioning to the selected photos. The glass cover is lifted and lowered automatically.

The film is moved in the Autowinder by two motorized reels. For scanning, the film is placed on the photo stage.

Both, the glass cover plate and the film are lifted for film transport during which the film is guided by two deflection rollers. The film can be rewound in both directions at a maximum speed of 1 m/s, i.e. rewinding 150 m of roll film takes approximately 2.5 min. An electronic frame counter enables automatic positioning to preselected photos.

For visual observation the film can be illuminated from below, and the speed of motion can be varied at the panel. Also, partially rewound film can be loaded and removed directly.

Software Design

The SC-software package of PHODIS SC permits perfect functionality. The user interface is based on OSF Motif with menu control for the complete operation cycle and context sensitive on-line help functions for each step of operation. The system functions allow scanning in batch mode, specification of the data format, display of the scanner activities, and generation of an automatic operation cycle. The latter one is dependent on the availability of the Autowinder and is covered in the AW-software package.

The scanning functions include identification of the source film format and position, processing of roll film using the Autowinder, a resolution selection of 7, 14, 28, 56, 112 or 224 microns and other parameters. Further steps to a complete automatic scanning procedure are scanning in the unattended batch mode, automatic film advance, identification of the frame edge for counting the photos when rewinding, automatic movement of the film to a specified position, fine positioning of the photo and presetting of photo sequences for automatic digitization.

The photogrammetric functions include input of aerial camera data, scanning and measurement of the fiducials, photo orientation, automatic interior orientation, and image pyramid derivation.

A comprehensive package of image processing functions is available such as positive/negative representation, mirror inversion and rotation of the image, histogram manipulation, normalization and color correction as well as elimination of color distortions by modifying the histograms of the individual color channels.

Integration in Image Processing System

PHODIS SC is one of several application components in the PHODIS photogrammetric image processing system. PHODIS uses the computer platform Silicon Graphics. Various applications can either be installed on the PHODIS SC host computer, or other workstations are connected via network. PHODIS covers all tasks of digital photogrammetry comprising automatic aerial triangulation, digital 3D workstation, automatic generation of digital terrain models, generation, and production of orthophoto products as well as digital monoplotting.

References

[1] Author: Alex DAM, Helava Assoc. Inc., 10965 Via Frontera, San Diego CA 92127 (USA)

[2] Described by the principal author on the basis of personal experiences and an article by: Hans W. Faust, 1989, *Digitization of Photogrammetric Images*, Procceding of the 42nd Photogrammetric Week at Stuttgart University, Heft 13, Page 69, Stuttgart

[3] Author: Martin P. Best, Vexcel Imaging Corporation, 3131 Indian Road, Boulder, Colorado 80301 (USA)

[4] Author: Hans Wehrli, Wehrli & Assoc. Inc., Upland Drive, Valhalla NY 1995 (USA)

[5] Author: James W. Douglass, XL Vision, 10305 102nd Terrace, Sebastian FL 32958 (USA)

[6] Author: Werner Mayr, CARL ZEISS, Abt. Geodäsie und Photogrammetrie, Postfach 1380, D-73447 Oberkochen (Germany)

Performances of Photogrammetric Scanners

Requirements in Photogrammetric Scanners

The original image quality defines decisively the quality of the subsequent processed images. The image quality is determined by the taking camera and also, in digital photogrammetry, by the scanning process. The efficiency of the whole process is affected, when reductions in the quality of the scanning process are admitted. Taking as basis the experiences in classical photogrammetry, one can define the following requirements in photogrammetric scanners:

Geometry: With current aerial photographs, a level of precision of the order of ±2 µm can be reached in aerotriangulation. This precision is also usually obtained with analytical plotters. Consequently, it is important to require the same precision for photographic scanners.

Image resolution: This parameter is decisively determined by the quality of the film used for the usual aerial photographs and by the aerial camera. As will be shown later on, it seems appropriate to require a pixel size about 10x10 µm for black-and-white, whereas a pixel size of 15 µm might be sufficient for color. Higher resolution is necessary for special reconnaissance films.

Image noise: The noise of photographic film is mainly defined by its granularity. If considering the values given by the producers, the sensor noise should not exceed ±0.03 - 0.05 D for a pixel size of 10 x 10 µm and an image noise of only ±0.02 - 0.03 D should even be reached with the Kodak Panatomic-X film. This presumes that the pixel size can be chosen small enough, allowing full benefit to be derived of the film resolution.

Dynamic range: It should correspond to the contrast of aerial photographs which might range from 0.1 to 2.0 D for black-and-white pictures and from 0.1 to 3.5 D for color photographs.

Color reproduction: With the increasing use of color photographs, it is important to be able to also scan color photographs.

Data compression : The great mass of data produced when digitizing images can be effectively reduced by data compression techniques.

Performance Analysis of Photogrammetric Scanners

Characteristics like the noise of a scanner, the dynamic range or the modulation transfer function (MTF) are rarely published by the manufacturers. The user or buyer is immediately confronted with the problem of how to determine these characteristics with rather simple tests. In principle, specific tests would be necessary for the various parameters, although no general agreement was yet reached how to perform these tests. However, the photogrammetrist is mainly interested in the overall performance and the performance of individual components are of minor importance. In this case, the illumination and the diffraction on the film might play a similar important role as the quality of the optics and the photosensor.

Three years ago, the Institute of Photogrammetry of the Technical University of Lausanne was occupied with the acquisition of a scanner and the problem of scanner evaluation. The simplest approach seemed to be to ask the various manufacturer to scan an aerial photograph, and to analyze the quality of the digital image. Table 5.1 gives an overview of the different scanners, which have been evaluated in this way. The procedure applied at that time is described here in more detail, in order to give potential users the opportunity to perform similar tests. The figures obtained may not remain representative for the tested scanners, as vendors continuously try to improve their products; nevertheless, they serve as a reference, in order to illustrate the testing procedure and can serve as rough reference of the products.

Sensor	Type of construction	Trademark	Illumination System	Minimum Pixel size	Maximum Bit/pixel	Variability of Pixel size
Photo-multiplier	Drum-Scanner	Screen DT-S1030AI	directed	13 µm	10 b/w	Software
	Drum-Scanner	Crosfield	directed	14 µm	10 b/w	Software
	Flatbed-Scanner	Perkin Elmer 20 x 20 G	directed	22 µm		Exchangeable optic
Line-CCD	Flatbed-Scanner	Du Pont High_Light 1850/1875	diffused	10 µm	12	Software
		PhotoScan PS1 (Zeiss)	directed	7.5 µm	11/color	Software
		Wehrli RM1	directed	12 µm		Zoom-lens
		Agfa ACS100	diffused	10 µm	12	Zoom-lens
		Agfa Horizon	directed	21 µm		Software
Matrix-CCD	Flatbed-Scanner	Vexcel VX 3000	diffused	10 µm		Zoom-lens
		DSW100 (Helava)	diffused	13 µm	12	2 cameras
		Philips CCD in the DSR15	directed or diffused	8*12 µm	8	Software

TABLE 5.1
Overview of the different scanners used for the practical tests.

When comparing corresponding image sections, scanned on different scanners, one gets an interesting impression of the resulting image quality, and one realizes quickly considerable differences in image reproduction. Figure 5.1 shows the reproduction of the same image section, scanned on twelve different scanners. One remarks that, for example, the image from the PhotoScan (pixel size of 7.5 µm) shows more granularity than the image of the DuPont 1850 scan-

ner; furthermore, certain scanners seem to lose sensitivity in dark areas. However, this first glance is somewhat misleading, as the granularity of the PhotoScan is due to a better resolution and the smoothness of the image of the DuPont scanner is caused by a poorer resolution of the optics. It appeared therefore of great importance to develop procedures to determine the image resolution or the modulation transfer function (MTF), the granularity and the dynamic range of a scanner from scanned images.

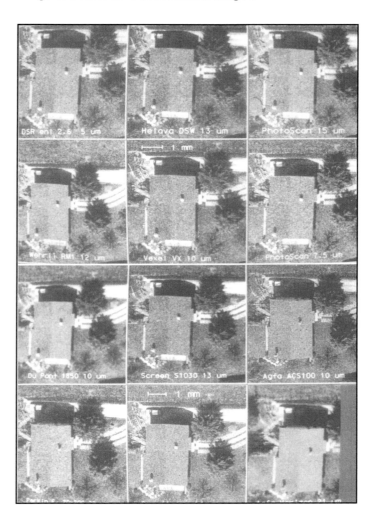

FIGURE 5.1
Comparison of an image section scanned on different instruments, displayed on a CRT screen.

Determination of the Modulation Transfer Function of Digital Images

When discussing image quality one is very often tempted to use the image resolution in lines per millimeter. Although the resolution represents a very interesting measure of image quality, the MTF gives a much more complete information. The resolution in lines per millimeter represents only the limiting frequencies (cut-off frequency), for which a regu-

lar line pattern can still be distinguished. Information on the contrast reduction is however much more important for much longer frequencies. Effectively, the limiting frequency can be artificially increased by various techniques of image processing like edge enhancement.

The MTF indicates the contrast reduction of a sine wave pattern for various frequencies. It can be easily derived from a digital image. A rather simple approach is the determination of the autocorrelation function of the gray values of neighboring pixels. In this way, one obtains a measure of the image spread function, that means the image resulting from an idealized point. The Fourier transform of the spread function is the MTF. The spread function can be approximated by a Gauss function with more or less steep slopes. The spread of this Gauss curve, that means the distance between the inflexion points, can serve as measure of the resolution. In fact, this value also roughly gives the resolution in lines per millimeter, with a precision of about 10%. Table 5.2 gives an overview of the investigation in question, with the resulting correlation values and the derived spread

function in comparison with the effectively used pixel size. In this study, the autocorrelation function strictly speaking is used, not the spread function of our idealized image point, which can be derived from it. It is noticeable, that many scanners show a resolution of about 2 pixels, whereas others, like the Agfa Horizon, give a much lower resolution.

The autocorrelation function was determined for image matrices of 20x20 pixels. The correlation values for neighboring pixels were then approximated by a Gauss function; the parameters obtained for the spread are given in table 5.2, column 7. The inverse of this value, multiplied by 1000 and by $\sqrt{2}$ (factor between auto-correlation function and spread function), is a rough measure of the resolution in lines per millimeter. The same table gives the correlation between neighboring pixels (columns 8, 9). Rather large values of 50% or even more are obtained to the first neighbor, but then the correlation coefficient decreases rapidly. Very similar results for the spread functions have been obtained when analysing the images of edges.

Scanner	Measured image noise in [D]				Pixel size	Spread	Corr. 1.Pix	Corr. 2.Pix	Image noise reduced to a spread of 10µm in [D]				Light type
	0.4 D	0.5 D	0.6 D	0.7 D	in [µm]	in [µm]	in [%]	in [%]	0.4 D	0.5 D	0.6 D	0.7 D	
1	2	3	4	5	6	7	8	9	10	11	12	13	14
Du Pont High_Light 1850 2540dpi	0.011	0.014	0.017	0.021	10	40*46	72.3	53.3	0.044	0.060	0.073	0.090	diffused
1875 2540dpi off	0.008	0.009	0.009	0.008	10	62*56	88.1	68.4	0.047	0.053	0.053	0.047	
1875 1132dpi soft	0.013	0.018	0.023	0.028	22	40*44	48.6	16.8	0.055	0.076	0.097	0.118	
1875 1132dpi off	0.009	0.011	0.013	0.014	22	60*64	64.0	35.8	0.056	0.068	0.081	0.087	
Helava DSW100	0.024	0.023	0.024	0.028	13	25*34	58.3	25.0	0.072	0.069	0.072	0.084	
Vexcel VX3000 10µm	0.036	0.038	0.044	0.051	10	18*18	40.9	16.0	0.065	0.068	0.079	0.092	
24µm	0.021	0.019	0.019	0.020	24	58*52	54.0	27.7	0.116	0.105	0.105	0.110	
Philips - CCD in the DSR15- **diffused**													
- dark (GV 90 ~ 0.4D)	0.017	0.018	0.017	0.019		36*40	62.6	49.4	0.065	0.068	0.065	0.072	
- medium (GV 130 ~ 0.4D)	0.013	0.012	0.013	0.013	8*12	38*48	69.6	54.6	0.056	0.052	0.056	0.056	
- bright (GV 230 ~ 0.4D)	0.017	0.015	0.013	0.017		43*66	79.7	64.4	0.095	0.083	0.072	0.095	
Philips - CCD in the DSR15- **directed**													
- dark (GV 80 ~ 0.4D)	0.024	0.022	0.018	0.018		36*36	68.5	48.6	0.086	0.079	0.065	0.065	
- medium (GV125 ~ 0.4D)	0.025	0.022	0.025	0.020	8*12	40*50	78.7	57.6	0.113	0.099	0.113	0.090	
- bright (GV 240 ~ 0.4D)	0.026	0.022	0.017	0.016		42*52	82.7	59.0	0.122	0.103	0.080	0.075	
Agfa ACS100 - 2400dpi (EPFL)	0.025	0.026	0.027	0.029	10	35*38	74.2	37.9	0.093	0.096	0.100	0.107	
- 1800dpi (firm)	0.044	0.045	0.044	0.049	14	34*34	59.8	13.6	0.150	0.153	0.150	0.167	
- 900dpi (firm)	0.088	0.089	0.134	0.121	28	30*30	12.4	6.4	0.264	0.267	0.402	0.363	
- 300dpi (firm)	0.190	0.142	0.103	0.061	85	250*145	62.3	14.4	3.8	2.8	2.1	1.2	
Agfa Horizon - 1200dpi	0.010	0.011	0.011	0.011	21	114*120	87.5	65.5	0.117	0.129	0.129	0.129	directed
Screen DT-S1030AI 2000dpi	0.038	0.037	0.026	0.026	13	26*36	58.4	15.9	0.123	0.115	0.079	0.079	
Crosfield - 900dpi	0.062	0.058	0.054	0.050	28	34*52	27.3	9.5	0.267	0.249	0.232	0.215	
1800dpi	0.060	0.059	0.059	0.058	14	19*33	37.4	14.7	0.156	0.153	0.253	0.151	
Perkin Elmer 20 x 20 G	0.042	0.047	0.053	0.064	22	22*22	8.6	1.9	0.092	0.103	0.117	0.141	
Wehrli RM1	0.027	0.024	0.026	0.026	12	29*32	61.8	20.3	0.084	0.074	0.081	0.081	
Zeiss PhotoScan PS1 7.5µm	0.058	0.060	0.071	0.080	8	12*14	46.6	9.1	0.075	0.078	0.092	0.104	
15µm	0.024	0.026	0.029	0.029	15	27*36	50.9	19.4	0.074	0.081	0.090	0.090	

*Overview of the image noise and of the size of the spread function determined for the different scanner. Columns(C) 2-5 give the root mean square deviation of gray values computed for an image matrix of 20 x 20 pixels of homogeneous areas expressed in density; C 8 and 9 give the correlation coefficients to the neiboring pixels and the second neigbor and C 10-13 represent the standardized image noise for a point spread funtion of 10µm (f.e. C10=C2*C7/10)*

TABLE 5.2

When analyzing the image resolution one is astonished to see that the Agfa-Horizon scanner seems to have an image resolution of only 0.1 mm or about 10 lines per millimeter. Other scanners have a resolution much closer to the pixel size but the size of the spread is in general 2-3 pixels. It was only for the Perkin Elmer scanner that practically no correlation was obtained between neighboring pixels. This is not astonishing, if one considers that this scanner operates with a photomultiplier at low measuring rate and uses a microscope optics, that scanns sequentially pixel by pixel.

It is most probable that not all factors influencing the resolution were properly located. For example, the DSR15 shows a strong increase of the spread with increasing light intensity, which might be due to the special behaviour of the photosensor (cf. table 5.2, column 7). Nevertheless, an interesting value is determined by the autocorrelation function characterizing the resolution of digital images much better than the pixel size only.

Analysis of the Image Noise

The RME (Root Mean Square Error) of the pixel values of an homogeneous area was interpreted as the image noise. This value was computed from image matrices of 20 x 20 pixels. For each image, some 20 different matrices have been used with different densities. In the first line, a scanner gives gray values without clear relation to the density of the photograph. For a proper comparison of the measurements, it was therefore necessary to establish a clear reference, for which the density was chosen. The Figure 5.2 shows the relation between the gray values measured on the PS1 and the corresponding density of the test patches as measured on a Macbeth densitometre (diaphragm 0.1 mm).

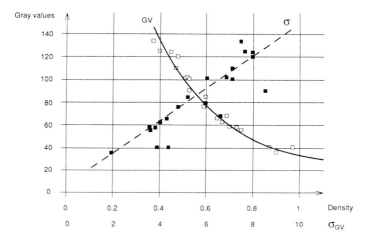

FIGURE 5.2
Relation between gray values obtained by scanning and the density of the corresponding batches for the PS1 (GV). The same diagram gives the image noise in gray values and the density values (σ).

Table 5.2 also gives an overview of the computed image noise reduced to density values. The image noise is given for densities between 0.4 and 0.7 D (columns 2-5), values that occurred frequently in the used photograph. The same table also gives the pixel size used for scanning (column 6) and the size of the point spread function (column 7). The point spread function was then used to standardize the image noise for a uniform point spread function of 10 μm (columns 10-13). This corresponds to a scan with a pixel size of 10 μm, provided that the correlation to the neighboring pixel is not higher than ~ 10% (exact value 6.7%!).

After the conversion of the image noise to a standardized spread function of 10 μm, one gets a rather uniform result with an image noise of about ± 0.1 D. Somewhat higher values are obtained with scanners from the printing industry like Screen, Crosfield or Agfa Horizon. The lowest image noise was also obtained with a scanner of the printing industry, the DuPont High Light 1850. The experimental results confirm that scanners with diffused light give about 20% less image noise than scanners with directed light. This is also shown very clearly by the comparative test on the DSR15. The same equipment was used in this case, only the illumination system was changed. For the test with the directed light, the original light source was used, whereas a diffuser plate and a stronger light source were used in the other case.

However, these tests do not reveal the source of the image noise. According to prior computations, one should expect an image noise of ± 0.03 - 0.05 D for the film used. Only the DuPont High Light is close to the expected values, whereas all other scanners seem to generate additional noise within the electronic system. Specific tests on the DSR15 using films with different graininess (Kodak Double-X, and Kodak Plus-X) did not give the expected results. The image noise did not increase with the graininess of the film; it seems that the effect of the graininess is much smaller and does not significantly influence the image noise, apart from the above-mentioned effect of the illumination.

Dynamic Range of Scanners

The resulting measurements from the photographic material used give little information on the dynamic range of the scanners tested. The photographs used have a low contrast and most of the picture information is limited to a density between 0.4 and 1.0 D. This rather poor image contrast appeared ideal in the beginning, as the dynamic range of a CCD-camera used earlier by the Institute of photogrammetry had a very limited density range and a brightness saturation of one pixel resulted in a blurring of the whole scan line. Meanwhile, the scanners have been mainly equipped with array sensors with an internal measuring range of 10 -12 bits (or even more) and anti-blurring systems. The usual 8 bits values are obtained after conversion, allowing much greater internal sensitivity. Consequently, the results presented can only give an indication of the tendency, but no concrete values on the dynamic range.

Scanner	Max. sensit. in [D/10GV] in 0.4 D	Sensitivity in Density			Corresponding grey value				Look-up-table (LUT)/ Change of Light Intensity (ChLI)
		Sensit. reduced to 1/2	Sensit. reduced to 1/4	Estim. Minim.	Max. sensit. in GV in 0.4 D	Sensit. reduced to 1/2	Sensit. reduced to 1/4	Estim. Minim.	
1	2	3	4	5	6	7	8	9	10
Du Pont High_Light 1850 2540dpi	0.025	const	const	>>	210	-	-	<<	Lut/ChLI
1875 2540dpi off	0.025	const	const	>>	220	-	-	<<	
1875 1132dpi soft	0.025	const	const	>>	220	-	-	<<	
1875 1132dpi off	0.025	const	const	>>	230	-	-	<<	
Helava DSW100	0.035	0.7	0.9	1.0	120	60	40	~30	Lut
Vexcel VX3000 10μm	0.045	0.8	1.0	1.2	130	40	30	~20	
24μm	0.035	0.7	0.9	1.2	110	40	20	~10	
Philips - CCD in the DSR15- diffused									Lut/ChLI
- dark (GV 90 ~ 0.4D)	0.078	0.9	1.0	1.3	90	40	30	~20	
- medium (GV 130 ~ 0.4D)	0.050	0.8	0.9	1.1	130	60	50	~40	
- bright (GV 230 ~ 0.4D)	0.025	0.7	0.9	1.2	240	120	100	~80	
Philips - CCD in the DSR15- directed									Lut/ChLI
- dark (GV 80 ~ 0.4D)	0.050	0.7	0.8	1.2	80	30	20	~10	
- medium (GV125 ~ 0.4D)	0.035	0.8	0.9	1.0	130	50	30	~20	
- bright (GV 240 ~ 0.4D)	0.025	0.8	0.9	1.2	240	70	50	~40	
Agfa ACS100 - 2400dpi (EPFL)	0.038	const	const	>>	190	-	-	<<	Lut
- 1800dpi (firm)	0.035	0.7	0.9	1.2	140	70	50	~40	
- 900dpi (firm)	0.045	0.8	1.0	1.2	130	60	50	~40	
- 300dpi (firm)	0.040	0.7	1.0	1.1	140	60	50	~40	
Agfa Horizon - 1200dpi	0.030	0.8	-	>>	120	20	-	<<	Lut
Screen DT-S1030AI 2000dpi	0.020	0.7	0.9	>>	180	40	10	<<	Lut
Crosfield - 900dpi	0.050	const	const	>>	190	-	-	<<	Lut
1800dpi	0.045	const	const	>>	200	-	-	<<	
Perkin Elmer	0.045	0.9	1.1	1.3	190	100	90	~70	
Wehrli	0.045	0.7	0.9	1.2	80	40	20	~10	Lut
Zeiss PhotoScan PS1 7.5μm	0.015	0.6	0.7	1.1	220	100	70	~20	Lut
15μm	0.028	0.6	0.8	1.1	130	80	50	~20	

TABLE 5.3
Analysis of the sensitivity of the scanners.

Table 5.3 gives an overview of the reduction of sensitivity with increasing density. One may note that many scanners have a constant relation between gray values and the density of the photographs and clearly have a rather high dynamic range far beyond a density of 1 D such as Crosfield or Screen. These scanners use photomultipliers which generally show very high levels of sensitivity. On the other hand, a much smaller dynamic range must be expected from scanners with CCD-matrix sensors. This is extremely well demonstrated on the DSR15; however, the dynamic range of this instrument is also considerably reduced by parasite light, which is difficult to control, due to the open construction of the plotter. The values in Table 5.3 show that parasite light is much more important when working with diffused light than with the original illumination source of the instrument (directed light). The measurements on this instrument also show that an increase of the light intensity does not allow a better observation of the dark areas of the photographs. This might appear to be a paradox and could be explained by the diffusion of light from the surrounding brighter parts of the image.

This diffusion probably also does much to explain why many of the other scanners lose their sensitivity in darker areas, which finally indicates the determined values (cf. columns 5 and 9 of table 5.3). This means that the measured density of small dark areas is reduced by the scanning process and the detail recognition in dark areas might also be reduced in comparison to the original photographs. In this sense it is understandable that the Zeiss PhotoScan also shows in this example a density limit of 1.1 D, although photographs with a much higher density can be scanned on the instrument. Nevertheless, the dynamic range of this instrument also showed clear limitations when we tried to scan a Panatomic-X negative image of a snowy scene with extended areas of a density up to 3.0 D.

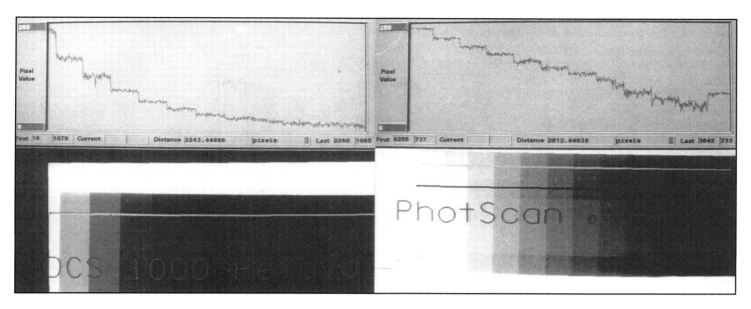

FIGURE 5.3
Profile of a Kodak step wedge scanned on the Helava DSW100 and the Intergraph Photoscan. The density difference between two steps is 0.12 D. It can be noticed that the dynamic range for the Photoscan is higher than the DSW100.

It is understood that the data analysis of an aerial photograph gives only limited information on the dynamic range. Much more efficient is the use of a gray wedge with more or less controlled density values (f. e. Kodak photographic step tablet no. 2). Figure 5.3 and table 5.4 show the analysis of the data of such a gray wedge. The image noise is calculated for the different steps; it is expressed in density, though it was not possible to normalize these values with respect to the size of the spread function; consequently, the values are, strictly speaking, not comparable between the different scanners. Nevertheless, the table gives an interesting information on the dynamic range of the scanners. If one considers an image noise of ± 0.03 D as tolerable than the dynamic range for the DSW100 is smaller than 1 D, a similar value would result from PhotoScan PS1, provided that the sensor array is oriented in such a way that it coincides completely with the gray wedge. A blurring effect is observed, when a part of the sensor array scans also areas outside of the gray wedge (cf. column 5 of table 5.4). This effect, reduces considerably the dynamic range of the system. However, image noise increases less rapidly on the Photoscan than on the DSW100, outside of 1 D.

Visual Analysis of Image Disturbances

A numerical analysis of the scanned images might appear very objective due to the clearly defined computation process. Such a process also clearly provides comparable results, as long as all images are obtained under the same conditions. However, the scanning process is very often combined with procedures for image correction and image improvement. For example, the images from the Crosfield scanner had undergone a rather strong edge enhancement (cf. Figure 5.4); the image scanned on the Screen scanner shows a different image resolution in the scanning direction and perpendicular to it (cf. Figure 5.5 and Table 5.2, column 7) and the Vexcel scanner gave a repeating pattern in low-contrast areas (cf. Figure 5.6). On a great number of scanners, it was also possible to observe remaining errors between scanning strips. Many scanners apply some tone correction on the edges. This type of tone adoption is of course very important for matrix scanners, but is also often applied for array scanners.

This brief review of image disturbances shows that a visual image inspection is very important beside the various numerical analyses and might reveal very fundamental problems in a scanner. It is not our intention here to provide a complete overview of the image disturbances detected and the few aspects mentioned only serve as examples.

Density	Variance of density			
	DSW100 Helava	PhotoScan PS1 Intergraph-Zeiss		
		0.2 - 2 D ⇑	0.05 - 3 D ⇑	0.05-3 D Edge +
0.05	0.016	0.006	0.012	0.011
0.23	0.014	0.022	0.021	0.020
0.38	0.015	0.025	0.028	0.024
0.54	0.019	0.028	0.026	0.030
0.70	0.023	0.031	0.031	0.033
0.86	0.031	0.034	0.034	0.040
1.01	0.047	0.039	0.039	0.057
1.17	0.069	0.044	0.044	0.067
1.33	0.100	0.050	0.049	0.107
1.49	0.166	0.061	0.069	0.190
1.65	0.312	0.118	0.093	0.362
1.82	0.892	0.000	0.135	0.526
1.99	0.405		0.168	0.566

TABLE 5.4
Image noise in density values as a function of the density determined for a grey wedge on the scanner DSW100 of Helava/Leica and the Photoscan of Intergraph. For the Photoscan, the wedge was digitized in different ways (scan perpendicular to (+) and in the strip direction(↑)).

Conclusions

The main objective of this chapter was to present a number of testing procedures concerning tone reproduction, which can be easily applied by a photogrammetrist engaged in the use of digital images. The most important arguments concerned the image noise, the image resolution, the sensitivity (or dynamic range) of the scanner and the visual appearance of the images. A good scanner should show an image noise lower than ± 0.03 - 0.05 D for a pixel size of 10μm, although only one scanner came rather close to these values. Depending on the purpose of the image, one can also fairly state that a good scanner should allow a resolution up to 10μm (pixel size and size of the point spread function). Deficiencies seem to occur as for the dynamic range and it is likely that the sensitivity of a scanner is consider-

ably reduced in dark areas, affecting the detail recognition in these zones. It seems that all scanners reach their limits in dark areas and reasonable tolerances should be applied corresponding to the effective requirements of production.

We had the feeling that such a study did not make sense without showing the practical application to various products of the arguments put forward. It is however clear that the results of these tests allow only a very limited comparison of the products. As already mentioned, the results are heavily influenced by the current calibration of the instrument, the skill of the operator and other exterior factors, which have practically nothing to do with the effective quality of an instrument. Many of the tests are already over two years old and many elements might have changed meanwhile. For example, earlier tests on the Vexcel scanner gave a rather low image resolution; when discussing the results with the manufacturer, it became evident that these results are no longer representative of the instruments and a new scan gave the results shown in the tables and corresponding to the performance of a good scanner of that type. Although many restrictions have to be made concerning this study, one nevertheless gets the impression that the development of scanners is still in progress and that no final stage has yet been reached.

The authors are grateful to all firms having contributed to this study by scanning photographs on their products. All the scanners included in this test certainly have a number of special advantages not brought out within this study, which concentrated only on rather limited aspects. Consequently, we would like to encourage all firms to continue in their line of research.

FIGURE 5.4
Section of the image scanned on the Crosfield scanner, showing the effect of edge enhancement.

FIGURE 5.5
Section of the image scanned on the Screen scanner, showing the different levels of image resolution, in the scanning direction (vertically) and perpendicular to it.

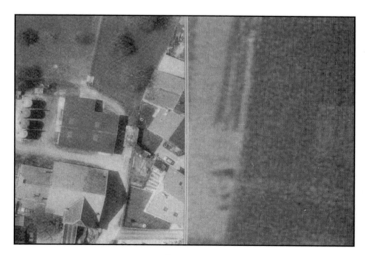

FIGURE 5.6
Section of the image scanned on the Vexcel scanner showing a repeating pattern due to image processing, most probably to some effects of the special frame grabber used.

References

Agfa-Gevaert Ldt, INFO. *Technical Information on Aviphot Pan 200PE and on Aviphot Pan 150PE.*

Eastman Kodak Company, 1982. *Kodak Data for Aerial Photography*, M-29.

Jaakkola, M., et al., 1985. *Optimal Emulsions for Large-Scale Mapping (Test of 'Steinwedel).* Official Publication N° 15 of OEEPE, 102 p.

Kölbl, O. and Hawawini, J., 1986. *Determination of the Modulation Transfer Function for Aerial Cameras under Flight Conditions.* Proceedings Int. Symposium ISPRS Commisssion I 'Progress in Imaging Sensors', Stuttgart, pp. 565-572.

Murphy, H., et al., 1989. *Image Intensifier Modules for use with commercially available Solid state cameras, Solid State Camera Products 1989.* Publication of EG&G Reticon 173-203.

Vieth, C., 1974. *Messverfahren der Photographie.* R. Oldenbourg Verlag, München-Wien; Focal Press, London-New York, pp. 108-128.

CHAPTER 3

Airborne Global Positioning System

Airborne GPS

JAMES R. LUCAS AND LEWIS A. LAPINE

Introduction

For years photogrammetrists have dreamed of being able to do aerotriangulation and mapping without having to worry about ground control. With airborne GPS that dream has almost come true. In theory, we can eliminate ground control with airborne GPS, but as a practical matter it is always advisable to have some ground control to serve as check points in order to detect systematic errors. Therefore, it is prudent to say that airborne GPS can greatly reduce, but not completely eliminate the need for ground control.

History

The Global Positioning System (GPS) was designed by the Department of Defense to be a world-wide, real time navigation system with an accuracy of about 100 meters. Civilian scientists and engineers soon found ways to postprocess the GPS data to achieve relative positional accuracies on the order of a centimeter or less, and a whole new era in precise land surveying began.

Airborne GPS can trace its heritage to the development of kinematic GPS for land surveying (Remondi 1984). Kinematic GPS is one of several differential techniques in which a fixed or reference receiver occupies a known position and a mobile receiver is moved from point to point acquiring data with which to compute positions relative to the reference receiver position. The kinematic procedure differs from conventional differential GPS in that the mobile receiver does not need to occupy any new position for more than a few seconds. If the mobile receiver starts from a known position, so that the cycle ambiguity can be resolved with a

few observation epochs, then the mobile receiver can continue to accumulate correct cycle counts as it is moved to a new position, provided that it maintains continuous lock with a sufficient number of satellites. Hence, when the mobile receiver comes to rest, there is immediately sufficient information to compute an accurate position for the new point. In fact, there is also sufficient information to compute the position of the mobile receiver at any instant while it is in motion, which is the basis of airborne GPS.

The significance of "cycle ambiguity resolution" is explained in detail in the paper in this chapter by Gerald Mader. A simple explanation is that the receiver observes the phase of the GPS carrier wave with an accuracy of about 0.01 cycles, but has no way of knowing how many full cycles have been completed as this wave traveled from the satellite to the receiver. Determination of the integer number of full cycles from each of the satellites being observed is known as cycle ambiguity resolution.

The first successful experiment to demonstrate the feasibility of airborne GPS for altimetry, which verified only the elevation component of positions, was conducted in 1985 by a joint effort of NOAA's National Ocean Service (NOS) and NASA's Wallops Flight Facility (Mader 1986). The first successful photogrammetric application of kinematic GPS was an experiment conducted in 1986 as a joint effort of NOS and the Texas Department of Transportation (Lucas and Mader 1989). This experiment showed that airborne GPS can attain precision of better than 10 cm in each coordinate of the camera positions derived from the GPS observations. This experiment also showed that airborne GPS results can be contaminated by systematic errors that are considerably larger than their random counterparts. This prompted the development of a method for calibrating air-

borne GPS systems (Lapine 1991) so that accuracies, rather than precisions, of decimeter level became achievable.

In the meantime, the European photogrammetric community adopted a slightly different approach to airborne GPS that was developed at the University of Stuttgart. Rather than requiring the aircraft receiver to maintain lock with the satellites, this technique employs a minimal amount of ground control in order to solve for and remove the effects of any loss of integer count that may occur. This method is described in a paper by Friedrich Ackermann that appears in another chapter of this publication .

There have since been many improvements in all phases of airborne GPS. The hardware has improved, particularly the increased number of satellites as the GPS constellation was completed, and receivers have become more reliable. New software and techniques have been developed which have also improved the reliability of this technology. Most importantly, many of these later developments have been made by the private sector practitioners who have applied this technology to compete successfully in the business world.

Basic Theory

Airborne GPS for photogrammetry or remote sensing poses a more complicated problem than land surveying by kinematic GPS. Kinematic GPS provides a very precise position of the aircraft antenna at some fixed interval of time, usually one second. For photogrammetry or remote sensing we need to know the positions of the camera or sensor, rather than the GPS antenna, and we need these positions at the time of exposure.

If calibration of the airborne GPS system included measuring the components of the offset vector between the camera and antenna, then the camera's position in space can be determined from the antenna position and the orientation of the aircraft. If the camera is locked in position so that its orientation remains fixed with respect to the airplane, then the attitude of the camera, as determined from the photogrammetric adjustment, can be used to determine the aircraft attitude and, therefore, the camera position. There is one restriction, however, the photos cannot all be in a single strip unless some ground control is included, because the entire strip would be free to rotate about a line that best fits the antenna positions.

If the exact time of each exposure is recorded, it is possible to interpolate between the positions at fixed intervals provided by the kinematic GPS data. It has been demonstrated that a high degree of precision can be achieved while interpolating the motion of the aircraft over intervals of one-second. The paper in this chapter by Lewis Lapine describes the method generally used and provides some insight into the expected errors.

One other important aspect of airborne GPS used for photogrammetry is the fact that positioning based on GPS is purely geometric. In conventional photogrammetry we use ground control points whose positions are based on orthometric heights and our photogrammetric adjustment is expected to produce orthometric heights, which are relative to the geoid. This is a desirable circumstance for nearly all projects. When using airborne GPS for control, however, computed elevations will be relative to the ellipsoid and may disagree with existing ground control point elevation by tens of meters. Conversion of these elevations to orthometric heights requires a knowledge of the geoid model in the project area.

Chapter Overview

The papers in this chapter provide a diverse view of the current state of airborne GPS, including detailed methodology, assorted applications, and practical experience. Gerald Mader discusses the basics of kinematic GPS as well as advanced topics such as ambiguity resolution on the fly. Lewis Lapine provides an in-depth look at the problem of interpolation for position at the time of exposure and discusses the precision that can be expected. The paper by Peter Connors and Leslie Perry presents an airborne GPS flight management system which combines the GPS information with a moving map display for real-time navigation with sufficient accuracy to ensure that photo coverage is always adequate. Larry Hothem, Kari Craun, and Maria Marsella discuss the use of airborne GPS, and some of the problems encountered, in two dissimilar and extensive projects undertaken by the U.S. Geological Survey. Robert Kletzli then adds the private industry perspective to airborne GPS.

References

Lapine, L. A., 1991. *Analytical calibration of the airborne photogrammetric system using a priori knowledge of the exposure station obtained from kinematic Global positioning system techniques*, Report No. 411, Department of Geodetic Science and Surveying, The Ohio State University, Columbus, OH.

Lucas, J. R. and Mader, G. L., 1989. "Recent advances in kinematic GPS photogrammetry." *ASCE Journal of Surveying Engineering*, Vol. 115, No. 1, pp. 78 - 92.

Mader, G. L., 1986. "Dynamic positioning using GPS carrier phase measurements." *Manuscr. Geod.*, Vol 11, p. 272.

Remondi, B. W., 1984. "Performing centimeter-level surveys in seconds with GPS carrier phase: Initial results." *NOAA Technical Memorandum NOS NGS 43*, National Geodetic Information Center, NOAA, Silver Spring, MD.

Kinematic Positioning with the Global Positioning System

GERALD L. MADER

Abstract

The Global Positioning System (GPS) has been fully operational since January 1994 and is providing, through a variety of processing techniques, navigation and positioning precisions from 100 m to 1 cm. These include pseudo-range point positioning, differential pseudo-range positioning, and carrier phase positioning. The methods by which these techniques are used will be examined and demonstrated on a sample data set. Other factors influencing GPS positioning will also be discussed.

Introduction

The Global Positioning System (GPS) is a series of 24 satellites launched by the U.S. Department of Defense (DoD) and is primarily designed to provide precise navigation to U.S. and allied military forces. These satellites orbit the earth in nearly circular orbits every 12 hours. They are distributed among 6 orbital planes inclined at $55°$ so that at least 4 satellites are visible to observers anywhere on earth anytime during the day. The satellites broadcast coded signals on two frequencies, 1575.42 MHz (L1) and 1227.6 MHz (L2).

The constellation of operational GPS satellites was completed during 1993 but earlier satellites were available for testing during the 1980's. During that test phase civilian geodesists developed techniques to use GPS to obtain relative positions over baseline lengths up to thousands of kilometers with precisions of a few centimeters. The techniques to position moving platforms with precisions of centimeters were also demonstrated. These precise kinematic GPS positions were used with airborne photogrammetry to successfully demonstrate the advantages available with precise aircraft positioning. Kinematic GPS has also been used to enhance a variety of other remote sensing applications.

Observables

The original and primary method of GPS navigation and positioning is by means of time-coded transmissions from the satellites along with satellite broadcast messages containing the means to estimate satellite positions and clock offsets. By timing the arrival of these coded transmissions at the receiver, the range from the satellite to the receiver can be derived. By simultaneously measuring the range to at least 4 satellites, the user's 3-dimensional position as well as his clock offset can be estimated.

These coded transmissions are modulations of the L1 and L2 carrier frequencies and have the appearance of random noise. However, since the sequence of digital modulation is unique and repetitive for each satellite the codes are usually described as pseudo-random noise. The modulation conveying the satellite broadcast messages is also superimposed on the L1 carrier signal. The GPS coded signals are:

C/A code: The C/A or civil access code is the means by which the DoD intended the civilian community to access the GPS. The C/A code is present on the L1 frequency only precluding the possibility of ionospheric corrections. The modulation rate is 1 MHz with a repeat cycle of 1 ms.

P-code: The p-code or precise code is the method by which military and other authorized users have access to the full capability of GPS. The p-code for each satellite is broadcast on the L1 and L2 frequencies which allows the possibility of ionospheric corrections. The modulation rate is 10 Mhz. Each satellite's p-code is a repeating 1 week segment selected from a random noise sequence that is 37 weeks long.

In addition to these coded transmissions GPS receivers may also track the carrier phase from the satellites. This means that the pure sinusoidal signal on which all the codes and messages are superimposed is reconstructed in the receiver as a sinusoid. The difference between this carrier signal and the L1 signal generated in the receiver is recorded as the carrier phase. The value of this carrier phase and the rate at which it changes (Doppler rate) can be very precisely measured and are essential observables for GPS positioning at the centimeter level.

The complete set of possible GPS observables is:

C1 The C/A code

P1 The L1 p-code

P2 The L2 p-code

ϕ_1 The L1 carrier phase

ϕ_2 The L2 carrier phase

D1 The L1 Doppler rate

D2 The L2 Doppler rate

Military type receivers use the P1 and P2 observables. Basic civilian navigation receivers use the C1 observable and may also often track the L1 carrier phase. Precise geodetic receivers can track all 7 observables and are capable of static and kinematic positioning at the centimeter level. The methods by which these observables are used to obtain various levels of positioning precision are described below.

GPS Signal Degradation

Because of the military value of precise navigation, DoD employs a method of signal distortion that limits the precision with which the C/A code may be used to navigate and position. This technique is called selective availability, S/A, and consists of a variable dithering of the satellite local oscillator. These excursions currently appear to be on the order of a few microseconds with timescales of about a minute. The DoD presumably can control the amplitude and frequency of these distortions. The algorithms describing this dithering are contained in military type receivers which are consequently immune to this distortion. The effect on C/A code users is to limit the probable spherical error to about 100m for a single unassisted user. The effects of S/A can be circumvented by differential positioning which will be described below.

Another possible threat perceived by the DoD is the transmission of false GPS signals by an adversary. This "spoofing" would yield inaccurate positions for authorized system users, rendering the system useless. To prevent this, DoD employs an "anti-spoofing", A/S, technique. A/S consists of apparently random p-code phase reversals with a time scale on the order of milliseconds. The resultant coded signal is known as the y-code. While the p-codes are freely known, the y-codes are known only to suitably equipped receivers which are now able to recognise the "true" GPS signals. A/S has inhibited the ability of civilian receivers to track the p-codes. However, several techniques have been developed by receiver manufacturers to recover the p-code observables. The principle effect of the DoD's A/S and the civilian communities counter measures appears to be varying levels of signal/noise ratio degradation on the p-codes.

Pseudo-Range Point Positions

The pseudorandom noise codes transmitted by the GPS satellites and replicated within the GPS receiver are cross-correlated to estimate the time of flight from the satellites to the receiver. From this time increment the range from the satellite position, at the time the signal was transmitted, to the receiver position, at the time the signal was received, may be computed. This observed range, commonly known as the pseudo-range may be written as:

$$R_i^j(t_R) = c(t_T - t_R) + \frac{c\alpha}{f^2} + T$$

where:

t_R	is the receive time
t_T	is the transmit time
α	contains constants relating to the electron density of the ionosphere
f	is the GPS frequency
c	is the speed of light
$\frac{c\alpha}{f^2}$	is the excess path length due to the ionosphere
T	is the excess path length due to the troposphere

Since the range is estimated using real clocks in the satellite transmitter and the user's receiver and since real clocks do not always read the correct time, these effects must be accounted for. The time system in which GPS measurements are made is called GPS time. GPS time flows at the same rate as Universal Time Coordinated (UTC) but does not update for leap seconds as UTC does. As of this writing, GPS time and UTC differ by 11 seconds. These clock offsets are introduced into the range equation using the following definitions:

$$t^j - t_G = \tau^j$$

$$t_i - t_G = \tau_i$$

where:

τ	is the offset from GPS time
superscripts	denote satellite quantities
subscripts	denote receiver quantities
t_G	is GPS time

Noting that the transmit time is measured with the satellite clock and the receive time is measured with the receiver clock, the range equation may be rewritten as:

$$R_i^j(t_R) = c(t^j - t_i) + c\tau^j - c\tau_i + \frac{c\alpha}{f^2} + T$$

The satellite clock offset from GPS time is monitored by the U.S. Air Force and is broadcast by the satellites. The broadcast correction gives an accurate estimate of the average satellite clock offset and drift rate from GPS time. However, as part of selective availability, S/A, the U.S. DoD dithers this clock term so that at any given time the satellite clock will be in error from the broadcast corrections by amounts varying, thus far, from about 0 to ± 1 microsecond on a time scale of minutes. The complete corrections are encrypted and are only available to authorised users with appropriate receiving equipment.

In order to make practical use of the range equation, the receiver position must be introduced. This is done by noting that:

$$c(t^J - t_i) = D(t_T, t_R) =$$

$$\sqrt{(x^J(t_T) - x_i(t_R))^2 + (y^J(t_T) - y_i(t_R))^2 + (z^J(t_T) - z_i(t_R))^2}$$

where:

$x^J(t_T), y^J(t_T), z^J(t_T)$ is the satellite position at the transmit time

$x_i(t_R), y_i(t_R), z_i(t_R)$ is the receiver position at the receive time

The satellite positions are available in real-time from the satellite broadcast message. For practical reasons, these GPS orbits are extrapolated from computations using data from DoD tracking stations. These broadcast orbits have precisions at about the 10 m level. More precise orbits are continuously produced using GPS phase data for one to several days at a time by NOAA and other analysis centers of the International GPS Service for Geodynamics (IGS). These post-processed orbits show precisions on the order of 10 cm and are available within 1 week after any given day.

The range equation is linearized by estimating the distance $D(t_T + t_R)$ using either the broadcast or post-processed orbit and an a priori estimate of the receiver position and forming the range residual ΔR. Finite values for this range residual are assumed due to errors in the estimated receiver position where:

$$\Delta D(t_T, t_R) = \frac{1}{D(t_T, t_R)}(x^J(t_T) - x_i(t_R))\Delta x +$$
$$(y^J(t_T) - y_i(t_R))\Delta y +$$
$$(z^J(t_T) - z_i(t_R))\Delta z)$$

The range equation may now be rewritten as:

$$\Delta R_i^J - c\tau^J - T = \frac{x^J - x_i}{D_i^J}\Delta x_i + \frac{y^J - y_i}{D_i^J}\Delta y_i + \frac{z^J - z_i}{D_i^J}\Delta z_i - c\tau_i$$

where since the satellite clock term is known from the broadcast message (within the limits allowed by S/A) and the tropospheric correction may be modeled, these terms are shown as a priori corrections to the observed range residual. For simplicity the ionospheric term has been momentarily omitted.

This equation contains 4 unknowns: 3 coordinates plus the receiver clock term which is common to all satellites observed by this receiver. By simultaneously observing 4 or more satellites, these quantities may be iteratively estimated using least squares to obtain what is called the pseudo-range point position. Such positions may be independently computed at each time, or epoch, the receiver collects data, as would be the case for a receiver on a moving platform. Alternatively, the observations may be accumulated over longer time spans to give an integrated estimate of static receiver positions.

An example of a pseudo-range point position solution using the C/A code on the L1 frequency is shown in Figure 1. This receiver remained at rest during the time span of the solution so that its estimated pseudo-range position could be compared to its true position. The north, east and up offsets for each solution with respect to the true position are shown if Figure 1. The data were recorded at a 1 second rate but the solutions shown in the Figure were obtained every 10 seconds to make it easier to read the individual components. The meandering of the estimated coordinates is due to A/S and amounts to several 10's of meters.

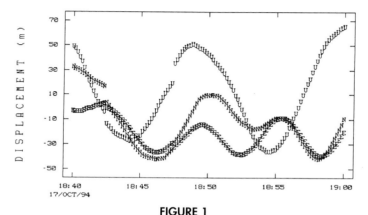

FIGURE 1
The pseudo-range point position solution for the test data set shows the severe systematic effect of S/A on the north (N), east (E), and up (U) station coordinates with respect to the true position. The occasional discontinuities in coordinates coincides with satellites rising or setting causing changes in the overall satellite geometry.

Differential Pseudo-Range Positions

The effects of S/A that were discussed above could be expressed in the range equations in the following way:

$$\Delta R_i^J - c\tau^J - T = \Delta D_i^J - c\tau_i + \delta\tau^J$$

where $\delta\tau^j$ is the S/A clock dithering that was neglected before. Since this term is unique to each satellite and varies rapidly with time, it can not be estimated as an independent variable. Instead the effects of S/A are eliminated by differencing the common satellite observations from two receivers. One of these receivers occupies the points or the moving platform whose positions are to be estimated. The other receiver occupies a known position and remains stationary. The receivers are usually designated the rover and the reference respectively.

The S/A dithering is a satellite clock perturbation that is identical to all receivers simultaneously tracking a given satellite. By differencing the rover and reference observations, this effect disappears.

$$\Delta R_i^J - \Delta R_{i_o}^J - (T_i - T_{i_o}) = \Delta D_i^J - c(\tau_i - \tau_{i_o})$$

The satellite clock offset and drift terms have also disappeared with this differencing. The observations now need only be corrected for the difference in tropospheric path delay, a quantity that is much less sensitive to tropospheric models and surface meteorological data than the total path delay. The receiver clock term has also now become the difference between the rover and reference receiver clock offsets, i.e. the relative clock. Since the reference position is assumed to be correct, its coordinates do not appear in the linearization of the distance D_i^j.

This differential pseudo-range positioning technique minimizes other common mode errors. These include the already mentioned troposphere, the ionosphere, and satellite orbit errors provided the separation between the rover and reference does not get too great. For differential positioning to work, a minimum of 4 satellites must be simultaneously and mutually visible to both receivers. This is generally not a problem even for separations of several hundred kilometers. At separations greater than this, there may no longer be sufficient satellite overlap between the two receivers. These longer separations would require careful planning to ensure adequate mutual satellite visibility during the time of operations.

To illustrate the value of differential pseudo-range positioning, the C/A code data used previously to illustrate point positioning has been combined with similar data from a reference receiver located approximately 33 km away. Figure 2 shows the results for this differential solution for each second of the same 20 minute segment shown in Figure 1. Once again the north, east, and up displacement from the true position is shown for each independent differential pseudo-range solution. The large systematic effects of S/A, seen previously, are gone and the three dimensional precision of these solutions for this particular case is better than 0.5m.

The only quantities required from the reference receiver to achieve this improvement are the range residuals, $\Delta R^j_{i_o}$. Since navigation is intrinsically a real-time activity and since the far superior precision afforded by differential positioning may often be required by civilian users of GPS, several efforts are under way or already in place to broadcast these differential correctors from networks of dedicated reference receivers. The U.S. Coast Guard has begun deploying such a broadcasting network consisting of about 50 stations along the coasts of the U.S. which should provide 1-2m precisions out to 200 mi from a reference station. The Federal Aviation Administration is also planning a network of about 40 stations distributed across the U.S. whose differential correctors will be broadcast by satellite. In addition, private companies are providing a variety of differential services also. Standard formats for the transmission of these correctors has been defined and GPS receivers capable of receiving these transmissions and displaying differential solutions are already commercially available.

Ionosphere Correction

The pseudo-range point and differential position solutions described above may use either the C/A, P1 or P2

pseudorange as the observable. In either case, the propagation delay through the ionosphere has thus far been ignored. Pseudo-range solutions that are independent of ionospheric delays require dual frequency observations, P1 (or C/A) and P2, to utilize the dispersive nature of the ionosphere to remove this effect. The ionospheric term described earlier may now be reintroduced into the pseudo-range equation.

$$\Delta R'_{1_i} = \Delta D_i^j - c\tau_i + \frac{c\alpha}{f_1^2}$$

$$\Delta R'_{2_i} = \Delta D_i^j - c\tau_i + \frac{c\alpha}{f_2^2}$$

where the subscript 1 or 2 is now used to distinguish the P1 and P2 observations and the prime notation indicates that the satellite offset and drift and tropospheric correction have already been incorporated into the pseudo-range residual. These two equations may be combined to yield a linear combination that is independent of the ionosphere.

$$\frac{f_1^2 \Delta R'_{1_i} - f_2^2 \Delta R'_{2_i}}{f_1^2 - f_2^2} = \Delta D_i^j - c\tau_i$$

This combination of the two P-code observables may be treated as a single observable and used in either the point or differential mode to solve for the receiver position and clock.

Phase Smoothed Pseudo-Range Solutions

The precision with which a GPS receiver measures the pseudo-range observables varies among receivers. Generally the precision with which the C/A code is measured is on the order of meters while the P-codes are measured with precisions of decimeters. The precision with which these observables are measured is clearly a significant factor contributing to the precision of the position solutions.

The carrier phase may be used to improve the precision of these pseudo-range measurements because the carrier phase itself is measured with precisions on the order of millimeters. However, the carrier phase is not a direct measure of the range from a receiver to a satellite. The carrier phase observable is actually the difference in phase between signal generated by the local oscillator within the receiver and the signal received from the satellite upon which the codes and broadcast messages are superimposed. The receiver measures an initial phase difference and changes in this phase difference after the initial measurement. The phase changes include the integer cycle count as well as the fractional phase. What the receiver can not do is estimate the number of integer cycles (or wavelengths) between the receiver and the satellite. However, the receiver can very accurately measure the change in phase, or equivalently, the change in range. Occasionally, the tracking of a satellite by the receiver will experience problems resulting in an interuption of the continuity of these phase measurements.

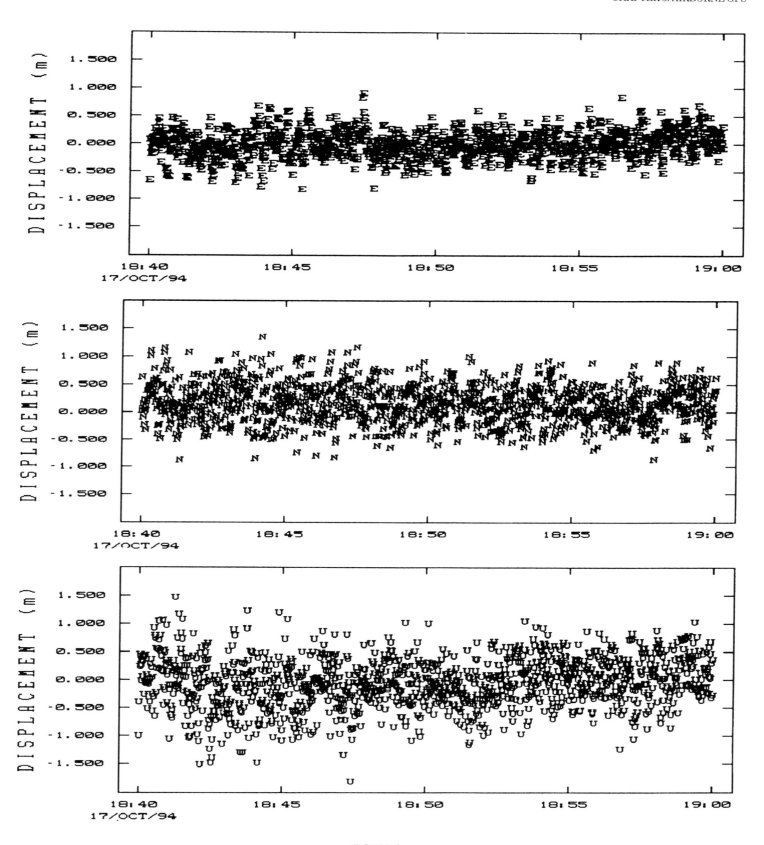

FIGURE 2

The differential pseudo-range solution for the same station shown in Figure 1, but with the addition of a base station located approximately 33 km away. The systematic effects of S/A have canceled out leaving east, north, and up displacements with respect to the true position that are well under 1 m.

These breaks are referred to as losses of lock or cycle slips and will require a re-estimation of the initial integer cycle count.

The relation between the range and the phase may be expressed as:

$$\rho(t)_i^j = \lambda(\phi(t)_i^j + N_i^j)$$

The phase bias, N_i^j, is the number of integer cycles needed to make the measured phase equal to the range to the satellite. The wavelength, λ, converts the phase and bias values in cycles to meters. Since the receiver measures phase changes with time, this bias is constant - at least until a cycle slip is encountered, whereupon a new phase bias must be designated.

From the above equation, the range may be expressed in terms of the phase difference from some initial epoch.

$$\rho(t)_i^j = \lambda\left(\phi(t)_i^j - \phi(t_o)_i^j\right) + \rho(t_o)_i^j$$

If the range at some time is known, the phase differences may be used to give the range at subsequent times. How might this initial range be determined? The pseudo-range measured at that epoch could be used, but all subsequent ranges would be biased by the measurement error of that single measurement. A much better technique would be to use all the pseudo-range measurements after the initial epoch to obtain an average value for that initial range estimate.

Such an average may be found by using the change in phase as a precise estimate of the change in pseudo-range. By subtracting this change from each measurement, an estimate of the pseudo-range at the initial epoch is effectively created. This values may be combined to find the average initial range.

$$\overline{\rho(t_o)_i^j} = \frac{\sum_n R_i^j(t_n) - \lambda(\phi(t_n)_i^j - \phi(t_o)_i^j)}{N}$$

The observed pseudo-range, $R(t)_i^j$, may now be replaced by the phase-smoothed pseudo-range, $\rho(t)_i^j$ where:

$$\rho(t)_i^j = \lambda\left(\phi(t)_i^j - \phi(t_o)_i^j\right) + \overline{\rho(t_o)_i^j}$$

The iterative expression for the average initial range is:

$$\overline{\rho(t_n)_i^j} = \frac{(n-1)\overline{\rho(t_{n-1})_i^j} + R(t_n)_i^j + \lambda(\phi(t)_i^j - \phi(t_o)_i^j)}{n}$$

The computation of the average initial range must be restarted each time a cycle slip is encountered.

These equations offer a method to improve the precision of the pseudo-range observable and consequently improve the precision of the receiver positions. Practically however, there are systematic errors present that will not aver-age away. The most frequently encountered is multipath. Multipath causes errors in the pseudo-range and phase measurements due to reflections from the surfaces in the vicinity of the receiving antenna. These distortions are largest for the pseudo-range, amounting typically to several meters, and vary on a time scale of minutes. The phase smoothing described above does not explicitly include the dispersive effects of the ionosphere. The ionosphere increases the propagation path of the pseudo-range measurements because this is a group delay measurement while it decreases the propagation path of the phase delay measurements. Since the ionosphere affects the pseudo-range and phase observables with opposite signs, differencing the pseudo-range and phase, as has been done here, doubles the effect of the ionosphere. This increase in ionospheric noise may be mitigated by differential processing of phase-smoothed pseudo-ranges. Alternatively, the ionosphere-free phase, which will be described later, may be used to smooth the ionosphere-free range.

GPS Carrier Phase

The carrier phase is the observable providing the most precise GPS positions. As mentioned above, GPS receivers cannot measure the carrier phase directly but measure instead the difference in phase between the incoming satellite signal and a reference signal of very nearly the same frequency generated within the receiver. From this difference and the phase changes of the local oscillator required to track the satellite signal, the carrier phase is measured. The carrier phase may be written as:

where:

$$\phi_i^j(t_i) = \phi^j(t_T) - \phi_i(t_i)$$

$\phi_i^j(t_i)$ is the carrier phase at receiver i from satellite j at receiver time t_i.

$\phi^j(t_T)$ is the phase transmitted by satellite j at transmit time t_T.

$\phi_i(t_i)$ is the receiver oscillator phase at receiver time t_i.

The satellite phase may be expressed in terms of the receiver time using $t_T = t_R - \Delta t$ where Δt is the time of flight of the signal. Expanding about Δt in a Taylor series and keeping the first term, the carrier phase may be rewritten as:

$$\phi_i^j(t_i) = \phi^j(t_i) - \Delta t \frac{\delta\phi^j}{\delta t} - \phi_i(t_i)$$

The time of flight, Δt, is equal to the range from the satellite at transmit time to the receiver at receive time and the rate of change of satellite phase is the frequency.

$$\Delta t = \frac{R_i^j(t_T, t_i)}{c}$$

$$\frac{\delta \phi^j}{\delta t} = f^j$$

The carrier phase may now be written as:

$$\phi_i^j(t_i) = \phi^j(t_i) - \frac{f^j}{c} R_i^j(t_T, t_i) - \phi_i(t_i) + N_i^j$$

where the integer phase bias, N_i^j, is introduced to ensure numerical equality since the observed phase is measured with respect to an arbitrary initial number of integer cycles.

The carrier phase must now be expressed in GPS time to yield an expression that is independent of individual receiver clock drift. This is done by replacing t_i by $t_G - \tau_i$, the GPS time and the receiver offset from GPS time. Provided that the offset from GPS time is small, the carrier phase may now be written as:

$$\phi_i^j(t_i) = \phi^j(t_G) - f^j \tau_i - \frac{f^j}{c} R_i^j(t_T, t_G) + \frac{f^j}{c} \dot{R}_i^j \tau_i - \phi_i(t_G) + f_i \tau_i + N_i^j$$

where \dot{R}_i^j is the range rate or Doppler rate for satellite j seen from station i. This term may be used to correct the observed carrier phase recorded at indicated receiver time t_R to what it would be at the GPS time by using:

$$\phi_i^j(t_G) = \phi_i^j(t_R) - \frac{f^j}{c} \dot{R}_i^j \tau_i$$

The range rate is readily calculated from the satellite position, velocity and the station position. The clock offset is adequately determined from the pseudo-range residuals. Having applied this a priori correction to the observed phase, the phase is now described by:

$$\phi_i^j(t) = \phi^j(t) - f^j \tau_i - \frac{f^j}{c} R_i^j(t) - \phi_i(t) + f_i \tau_i + N_i^j$$

where the subscript denoting GPS time has been dropped since all quantities are expressed at the same GPS time.

Phase Differencing

The above expression for GPS carrier phase contains several nuisance terms which are unrelated to station position. These terms are eliminated by differencing the phase data between stations and between satellites, the so-called double difference.

The first step in this differencing is to use a reference receiver, just as was described for the differential pseudo-range positioning, to remove terms that are entirely satellite dependent, i.e. terms that only contain the superscript j.

$$\phi_i^j - \phi_{i_o}^j = f^j(\tau_i - \tau_{i_o}) - \frac{f^j}{c}(R_i^j - R_{i_o}^j) - \phi_i + \phi_{i_o} + f_i \tau_i - f_{i_o} \tau_{i_o} + N_i^j - N_{i_o}^j$$

where the explicit time notation has been omitted for convenience and the subscript i_o denotes quantities at the reference station.

The next step is to difference this single difference between the satellites. This is most easily done by designating a reference satellite, j_o, and subtracting its single difference, between the two stations, from each of the remaining observed satellites. This will remove terms in which only the subscript i appears.

$$\left(\phi_i^j - \phi_{i_o}^j\right) - \left(\phi_i^{j_o} - \phi_{i_o}^{j_o}\right) = \frac{f}{c}\left((R_i^j - R_{i_o}^j) - (R_i^{j_o} - R_{i_o}^{j_o})\right) + N_i^j - N_{i_o}^j - N_i^{j_o} + N_{i_o}^{j_o}$$

The negligible difference in satellite frequencies over the receiver clock offset time has been used to omit the $f^j \tau_i$ terms. The frequency that now appears is the L1 or L2 rest frequency since similar expressions may be written for the L1 and L2 phase. This double-differenced phase observable is independent of satellite and station clock errors and depends only on the satellite to receiver ranges and phase biases.

Carrier Phase Solutions

The explicit dependence on mobile station position is introduced by linearizing the double difference phase equation just as was done for the pseudo-range solutions. The residual observed phase, $\Delta \phi$, is the difference between the observed and calculated phase using an a priori estimate of the mobile station position. Since the satellite and reference station positions are assumed known, the range to the reference receiver drops out of the residual equation.

$$\delta^2 \Delta \phi_i^j = \frac{f}{c}\left(\Delta R_i^j - \Delta R_i^{j_o}\right) + n_i^j$$

where the δ^2 operator denotes the double difference and the lower case n_i^j denotes the double-differenced integer biases. The linearized expression for double-differenced carrier phase residuals may now be written as:

$$\delta^2 \Delta \phi_i^j - n_i^j = \frac{f}{c}\left(\left(\frac{x^j - x_i}{R_i^j} - \frac{x^{j_o} - x_i}{R_i^{j_o}}\right)\Delta x_i + \left(\frac{y^j - y_i}{R_i^j} - \frac{y^{j_o} - y_i}{R_i^{j_o}}\right)\Delta y_i + \left(\frac{z^j - z_i}{R_i^j} - \frac{z^{j_o} - z_i}{R_i^{j_o}}\right)\Delta z_i\right)$$

The integer bias term now appears as a correction to the differenced phases. These biases must be known for kinematic solutions where an independent position estimate is computed at every measurement epoch. The initial determination of these biases and those for later rising satellites and their redetermination after cycle slips is the most fundamental activity of kinematic GPS using carrier phase data. This topic will be addressed in a later section.

Unlike the pseudo-range expressions, the receiver clock offset does not explicitly appear in the double-difference phase equation but a minimum of 4 satellites is still required to obtain at least 3 double differences required to estimate the mobile station position.

Ionosphere Correction

The carrier phases measured for the L1 and L2 frequencies may be used to eliminate the effects of the ionosphere. The ionospheric term may be explicitly added now to the

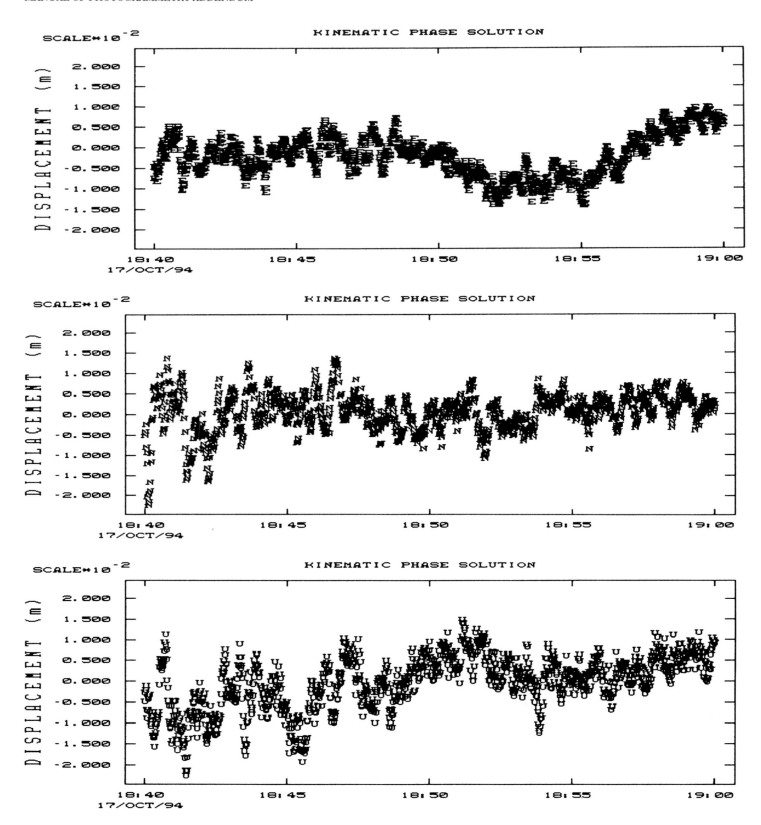

FIGURE 3
The double-differenced, ionosphere-free, phase solution for the test data shown previously. The north, east and up displacements from the correct position are shown for each second during this segment and are generally less than 1 cm.

double difference phase equations for L1 and L2.

$$\delta^2 \Delta \phi_{i\,1}' - n_{i\,1}' = \frac{f_1}{c} \Delta R_i^{j, j_o} - \frac{\delta^2 \alpha}{f_1}$$

$$\delta^2 \Delta \phi_{i\,2}' - n_{i\,2}' = \frac{f_2}{c} \Delta R_i^{j, j_o} - \frac{\delta^2 \alpha}{f_2}$$

The ionosphere term is double differenced like the phase observables. These two equations may be used to solve for the double differenced constant.

$$\delta^2 \alpha = \frac{f_1^2 f_2^2}{f_1^2 - f_2^2} \left(\frac{\delta^2 \Delta \phi_{i\,1}' - n_{i\,1}'}{f_1} - \frac{\delta^2 \Delta \phi_{i\,2}' - n_{i\,2}'}{f_2} \right)$$

When the integer biases for L1 and L2 are known, the carrier phase data may be used to determine the ionosphere correction very precisely. In this case an ionosphere free expression for the L1 phase can be written as:

$$\delta^2 \Delta \phi_{i\,1}' - n_{i\,1}' + \frac{f_1 f_2^2}{f_1^2 - f_2^2} \left(\frac{\delta 2 \Delta \phi_{i\,1}' - n_{i\,1}'}{f_1} - \frac{\delta 2 \Delta \phi_{i\,2}' - n_{i\,2}'}{f_2} \right) = \frac{f_1}{c} \Delta R_i^{j, j_o}$$

This expression has been used to produce kinematic phase solutions for the same test data set that was shown for the differential pseudo-range solutions. The results are shown in Figure 3. The north, east and up deviations from the correct position are generally less than 1 cm. The small systematic variations that are seen are probably due to multipath and imperfect tropospheric corrections.

Bias Determination

Knowledge of the double-difference integer biases is what allows the tremendous precision of kinematic carrier phase solutions to be realized. There are several different situations where satellite biases must be determined. These situations are distinguished by the number of biases that may already be known and the kinematic status of the mobile platform. These situations are summarized in Table 1.

The first case would occur when the reference receiver and the mobile receiver, for example, an airplane, are both at the same airport and are tracking for some time prior to any movement. In the second case, the airplane might fly near a reference receiver located in a project area and require initialization with respect to that receiver. The third case might occur after a prior successful initialization on all satellites, but a loss of lock has occurred on all but 1 or 2 satellites perhaps from a steep banking turn where the wing has blocked most of the visible satellites. In these first three cases the position of the mobile receiver cannot be estimated from a bias-fixed carrier phase solution since a sufficient number of biases are not yet known. This is not the situation for the remaining 2 cases where only 1 or 2 satellites

are being initialized and there is a sufficient number of other satellites with continuous phase to provide a precise solution.

case #	Description	# of known biases	comment
1	full bias initialization	0	rapid-static, on-the-fly (otf)
2	full bias initialization	0	kinematic otf
3	partial initialization	<3	kinematic
4	initialize rising satellite	>2	kinematic
5	reinitialize after cycle slip	>2	kinematic

TABLE 1
Cases of Bias Initialization

In each of these cases, the biases are found by an integer search technique. Although this discussion will follow the procedures used in the KARS program written by the author and used by NOAA, practically all integer search techniques share the same basic features.

In this search algorithm, it is recognized that the double-difference biases cannot explicitly be solved. Instead, an initial bias value is estimated for L1 and L2 for each satellite using the best available receiver position. These initial values are given by:

$$n_i' = \delta^2 \Delta \phi_i'$$

A search range is then defined for each L1 and L2 bias for each satellite. This search range corresponds to the uncertainty in the initial position estimate and must be broad enough to be sure to include the correct bias values. The search ranges may be found from:

$$\Delta n_i' = \frac{f}{c} \left(\left(\frac{x^j - x_i}{R_i^j} - \frac{x^{j_o} - x_i}{R_i^{j_o}} \right) \Delta x_i + \left(\frac{y^j - y_i}{R_i^j} - \frac{y^{j_o} - y_i}{R_i^{j_o}} \right) \Delta y_i + \left(\frac{z^j - z_i}{R_i^j} - \frac{z^{j_o} - z_i}{R_i^{j_o}} \right) \Delta z_i \right)$$

In principle, the correct suite of integer biases could be found by forming all possible permutations of the satellite biases and testing each candidate suite in a least squares solution of the double-difference phase equation. The correct suite should have the lowest residuals, while the incorrect suites of integers will have larger residuals. In practice, this cannot be done because of the enormous number of possible permutations, especially when the initial position uncertainty is large, and the computer time that would be required. Furthermore, many incorrect integer suites will give low residual values, even lower than the correct suite, for data at a particular time just by chance. However, these same integer suites will yield poor residuals using data at different times. The increase in residuals with time as sub-

sequent data is processed using a particular integer suite is a sure indication of a bias error.

The number of possible integer permutations is minimized by examining each satellite separately and eliminating particular integers from further consideration. This may only be done using both the L1 and L2 data. Single frequency L1 data, does not offer the possibility of eliminating possible L1 integers within the L1 search range. Unless the initial position estimate is very good (within about 1 wavelength) and the number of satellites in view is large (generally at least 6), single frequency solutions may suffer from numerous ambiguous solutions. Dual frequency receivers would also be preferred because of the extended range that is possible when the ionosphere is eliminated.

In KARS the number of possible integers is minimized for each satellite by computing the ionosphere correction for each L1 and L2 integer pair within the search range. These corrections at L1 are given by:

$$I'_i = \frac{f_1 f_2^2}{f_1^2 - f_2^2}\left(\frac{\delta^2 \Delta \phi'_{i1} - n'_{i1}}{f_1} - \frac{\delta^2 \Delta \phi'_{i2} - n'_{i2}}{f_2}\right)$$

The approximate value of these corrections at the zenith are found by simply multiplying by the sine of the elevation. This enables a more uniform comparison between all the satellites. An example of these corrections is shown

for a single satellite in Table 2 as a function of the change in the L1 and L2 integers from their initial estimated values. Most of these corrections are unrealistically large. A reasonable estimate of an upper limit for the zenith double-difference ionosphere correction for the 33 km baseline of the test data set is about 0.3 cycles. The integer pairs that yield ionosphere corrections with absolute values less than this cutoff are shaded in Table 2. These pairs are saved for further filtering and forming the integer permutations. The remainer are eliminated from further consideration.

In KARS, the integer pairs that pass through this ionosphere filter may next be filtered by their wide-lane value. The wide-lane is the designation for the difference between the L1 and L2 phases. The wide-lane integer is the difference between the L1 and L2 integer biases. It is sometimes possible to independently estimate the wide-lane integer from the L1 and L2 phases and the P1 and P2 pseudo-ranges from the expression:

$$N'_{i1} - N'_{i2} = N_{wl} = \phi'_{i1} - \phi'_{i2} - \frac{f_1 - f_2}{f_1 + f_2}\left(\frac{f_1}{c} P'_{i1} + \frac{f_2}{c} P'_{i2}\right)$$

This wide-lane expression is independent of the ionosphere, clock errors, and receiver position. It is sensitive to multipath and phase/pseudo-range calibration errors which may prevent unambiguous recognition of the wide-lane integer. When it is known, the wide-lane selects a particular

N1\N2	-4	-3	-2	-1	0	1	2	3	4
-5	-0.07	0.45	0.98	1.50	2.03	2.55	3.08	3.60	4.13
-4	-0.48	0.04	0.57	1.09	1.62	2.14	2.67	3.19	3.72
-3	-0.89	-0.37	0.16	0.68	1.21	1.73	2.26	2.79	3.31
-2	-1.30	-0.78	-0.25	0.27	0.80	1.32	1.85	2.38	2.90
-1	-1.71	-1.19	-0.66	-0.14	0.39	0.91	1.44	1.97	2.49
0	-2.12	-1.60	-1.07	-0.55	-0.02	0.51	1.03	1.56	2.08
1	-2.53	-2.01	-1.48	-0.96	-0.43	0.10	0.62	1.15	1.67
2	-2.94	-2.42	-1.89	-1.37	-0.84	-0.31	0.21	0.74	1.26
3	-3.35	-2.83	-2.30	-1.77	-1.25	-0.72	-0.20	0.33	0.85
4	-3.76	-3.24	-2.71	-2.18	-1.66	-1.13	-0.61	-0.08	0.44
5	-4.17	-3.64	-3.12	-2.59	-2.07	-1.54	-1.02	-0.49	0.03

TABLE 2
Estimated L1 Zenith Double-Difference Ionosphere Corrections Over Search Range

diagonal in the N1,N2 matrix as shown by the lightly shaded values in Table 2. Those integer pairs not lying along this diagonal are eliminated from further consideration.

The integer pairs for each satellite that survive these filters are saved and used to create permutations of all possible remaining integers. A least squares solution and the post-fit residuals are found for each integer suite being tested. The integers are now evaluated as complete sets. When the correct integers for some satellites are used with the incorrect integers for other satellites, the residuals should still be large. When the integer combination that contains all the correct integers is tested, the residuals should be minimal. A successful search must meet two conditions. First, the minimum residual value found must be acceptable, indicating a viable solution. Second, the contrast between this minimum value and the next nearest value must be large enough (i.e. the next best solution is bad enough) so that a single solution may be unambiguously identified.

The KARS program can successfully conduct this integer search often using just one or several data epochs. For longer distances where the ionosphere is likely to be a problem, the ionosphere corrections for each integer pair are applied to the phase residuals during the least squares solutions allowing KARS to determine integer bias values out to distances of several hundred kilometers. The typical search time is less than 1 second.

The initial position estimate needed to initiate the search algorithms for cases 1, 2, and 3 in Table 1, comes from a differential pseudo-range solution. A search volume centered on this position is proportional to the component errors of that solution. Since no external information or static initialization is required, these solutions are self-starting and this type of technique is described as on-the-fly. Case 1, is distinguished from the other cases primarily by the ability to use alternate techniques to find the initial position when the receiver is static.

Cases 4 and 5 have precise carrier phase solutions available. This allows a much smaller search volume and consequent integer search ranges to be defined. The integer search for these cases is conducted only over those satellites whose biases are not known. All the satellites are used in the least squares solutions with the known biases used for those satellites with continuous phase tracking. The primary distinction between these two cases is the recent ionosphere correction information available for satellites that underwent cycle slips. This usually allows the ionosphere correction filter to be centered, and a width used, that is more realistic. No such history is available for newly rising satellites although the current satellite constellation may be used to more loosely set these filter values.

Integer search techniques are being used operationally to routinely process kinematic GPS phase data for a wide vareity of applications. Kinematic positions with precisions on the order of centimeters are regularly supporting photogrammetry as well as a number of other remote sensing activities.

Summary

GPS offers the user a wide range of navigation and positioning precisions. Point positioning using the civil service provides approximately 100m precisions. These precisions are dramatically improved using differential techniques which provide relative positions with precisions on the order of 1m. Several broadcast services are becoming available which will allow real-time differential pseudo-range positioning with these enhanced precisions using commercially available equipment. GPS carrier phase measurements are providing kinematic positions with precisions of centimeters using search algorithms to obtain the required bias estimates.

Airborne Kinematic GPS Positioning for Photogrammetry: The Determination of the Camera Exposure Station

LEWIS A. LAPINE, PH.D.

Abstract

Kinematic GPS positioning of airborne platforms coupled with aerial photogrammetry has become an operational reality within NOAA. Real time GPS positioning is utilized for navigation, while post processed carrier phase differencing is employed for exposure station locations. Since it is not presently practical for the exposure station event to control the GPS collection, the antenna phase center position at the time of exposure must be computed by interpolating the aircraft trajectory after the appropriate timing biases have been added to the observed exposure time. This paper will discuss present and future methods for determining the position of the exposure station event.

Introduction

Kinematic GPS positioning of airborne platforms coupled with aerial photogrammetry has become an operational reality within NOAA (Lapine 1990). Real time GPS positioning is utilized for navigation, while post processed carrier phase differencing is employed for exposure station locations. Nearly every NOAA aerial mapping project employs some combination of airborne GPS and ground control for the aerotriangulation process. In every case, the requirement for ground control has been reduced. Operational efficiency has increased as the need for expensive and labor intensive ground control has diminished. This technology is rapidly maturing such that it will become the most commercially viable approach for aerial mapping. Commercialization will be heavily dependent on instrumentation, capitalization costs and processing efforts, all of which are now in the favor of the technology. Instrumentation is available as a result of other GPS and photogrammetric applications. Capitalization costs have decreased as a result of the increased market share of GPS in the surveying and mapping fields. Post processing software has been improved by the manufacturers, academia and federal sector (Mader 1992) to the point where user friendly software is efficient and readily available. Since it is not presently possible to sample the GPS signal at the instant of exposure, some form of interpolation of the GPS positional information is required. The ultimate goal is to select a sampling rate and interpolation model which yield exposure station accuracy commensurate with the final mapping product while at the same time minimizing post processing effort.

Relationship of the GPS Antenna Phase Center to Exposure Station

The GPS receiver collects the carrier phase and pseudorange information pertaining to the trajectory of the aircraft throughout the photo mission. The raw data is post processed into trajectory information consisting of GPS time-tagged geocentric positions for the GPS antenna phase center. This position is correlated to the camera exposure station through time and orientation of the spatial offsets between two origins, earth center and photo center. Exposures rarely coincide with the times at which the antenna positions are recorded. Therefore, the antenna position at the time of exposure must be computed by interpolation. The camera exposure station position can then be determined using an orthogonal three-dimensional transformation incorporating the spatial offsets between the entrance node of the lens system and GPS antenna phase center and a priori estimates for the elements of exterior orientation. These a priori estimates may be refined during aerotriangulation and more accurate exposure stations computed after each iteration of the aerotriangulation solution (Lucas 1989). The error of the individual component observations can be propagated during this process to yield a variance-covariance matrix for the camera exposure station.

Interpolation Accuracy as a Function of GPS Sampling Rate

Since it is not presently practical to control the GPS collection by the exposure event, the antenna phase center position at the time of exposure must be computed by interpolating the aircraft trajectory after the appropriate timing biases have been removed from the observed exposure time. The exposure station position accuracy is a function of the kinematic positioning accuracy (1 or 2 cm relative accuracy for most geodetic quality GPS receivers), sampling rate and interpolation model. GPS receiver manufactures have increased sampling rates in part to enhance the accuracy of interpolation. The inclination would be to sample the GPS receiver at as high a frequency as possible to minimize the time difference between GPS epochs and exposure times. This practice also increases the processing burden. A more practical solution would be to select a sampling rate and interpolation model which yield exposure station accuracy commensurate with the final mapping product while at the same time minimizing post processing effort. Operational experience gained by NOAA has demonstrated that a 1 hertz

GPS sample is adequate for photo scales as large as 1:10,000 when using the interpolation model discussed in this paper. Higher sampling rates or different interpolation models may be necessary for low altitude (larger scale) photography to accommodate aircraft trajectories influenced by short period turbulence. To this end, the following analysis of the interpolation process is presented.

The GPS signals are generally sampled on a nearly uniform time interval affected only by a very small (one usec/sec) (King and Durboraw 1988) drift in the receiver clock. The signals, subsequent to being post-processed generally have receiver clock drift removed and are time shifted so that all antenna positions are equally spaced in time. The interpolation becomes simplified since the data points are evenly spaced in time. As mentioned above, the length of the uniform interval (time between successive epochs of data) is governed by the GPS receiver hardware and may be the limiting factor for the accurate interpolation of the exposure station position from the aircraft trajectory. The interpolation precision is well correlated to the limit of positional resolution which can be expected from kinematic GPS (Lapine, 1991). Longer time intervals degrade the interpolation. The following example used GPS data collected at a 1-second rate and then thinned to 2-second and 5-second rates by removing the appropriate sample points. The thinned data sets were interpolated for the missing midpoint samples. The GPS data used for this test came from two data sets collected aboard the NOAA Citation II jet and one data set from the Texas Highway Department King Air Turbo-prop. Comparison of the interpolated positions with the observed positions indicate a standard deviation about the mean difference as great as 41 cm. The number of samples whose position difference was greater than 20 centimeters was recorded for each data set and reported in Table 1.

The Citation and King Air results are still commensurate with kinematic positioning expectations when thinned to 2 seconds. The sample standard deviations for the data thinned to 5 seconds for the King Air suggest a serious degradation in position. It is interesting to note that the magnitude of the standard deviations associated with the NOAA Citation are different from the Texas King Air. The population variances were tested and failed the equality test based on the F statistic (Hamilton 1964). The differences between the 2- and 5-second populations are most likely caused by the inability to model the aircraft trajectories over a time span greater than 2 seconds. The difference between the NOAA and Texas populations may result from the same inability to model the trajectories or may be caused by a larger signal-to-noise ratio in the receivers used for the tests (different manufactures). The trend indicates that sampling intervals greater than 1 second should be avoided if the full accuracy of kinematic GPS positioning is required. However, the good comparison between the data thinned to 2 seconds and observed positions does validate the ability of the interpolation process when sampling at 1 hertz.

An interesting alternative to the above timing situation would be to activate the camera shutter with the 1-second timing pulse generated by the GPS receiver. In this procedure one may be able to entirely eliminate the time difference between GPS fix information and exposure. Interpolation of the GPS navigation file would be eliminated except possibly for a constant time offset between the timing signal and the camera response to the signal. A short test conducted aboard the NOAA aircraft indicated that the time delay would be on the order of 0.1 second for the particular Wild RC-10 camera used in the test. The camera service manual states that the maximum time delay between rotating shutter blade opening and capping shutter delay is on the order of 0.070 second. The time delay depends on the shutter speed, position of the rotating shutter blades at the time the pulse was initiated, and the vacuum status. One major problem with this procedure would be the inability to accurately control overlap.

Aircraft Type	Sample Size	Sample Rate	% of sample >20 cm	Mean/Std Dev of Sample (m) X,Y, and Z
King Air	2086	2 Sec	15	0.000/0.055 -0.001/0.122 0.001/0.114
King Air	1039	5 sec	58	-0.002/0.270 0.004/0.412 -0.007/0.409
Citation	1715	2 sec	4	0.000/0.031 0.000/0.063 -0.001/0.055
Citation	1503	2 sec	5	0.000/0.032 0.001/0.084 0.000/0.063
Citation	873	5 sec	33	0.000/0.292 -0.002/0.261 0.002/0.281
Citation	748	5 sec	34	0.001/0.286 0.000/0.274 -0.002/0.261

TABLE 1
Evaluation of 2- and 5-Second Sample Rates for GPS Phase Information During a Photo Mission.

Interpolation Algorithm

The objective of the interpolation is to compute, using a limited portion of the navigation file, a position for the antenna phase center at the time of exposure which is within a half epoch of the central time of the limited data set i.e., less than 0.5 second for a 1-Hertz sample.

The interpolation algorithm uses a second-order poly-

nomial whose three coefficients are solved for by least squares method. The polynomial represents a curve which fits the aircraft trajectory over a 5-epoch period. A different curve is fit to each coordinate axis. The coefficients of this polynomial can be used to compute the aircraft position offset, velocity and acceleration in each coordinate direction.

The following models are used for interpolating the antenna phase center coordinates:

$$X_1 = a_x + b_x t_1 + c_x t_1^2$$
$$X_2 = a_x + b_x t_2 + c_x t_2^2$$
. . . .
. . . .
$$X_i = a_x + b_x t_i + c_x t_i^2$$

where $t_i = time_i - time_3$; when $i = 1,2,...5$;
$time_3$ is the central time and

$t_1 ... t_5$ are the five consecutive time tags of GPS antenna phase center positional data

Similar equations could be written for the other two models:

$$Y = a_y + b_y t + c_y t^2$$
$$Z = a_z + b_z t + c_z t^2$$

The unknown parameters for each model can be related to distance, velocity and acceleration by differentiating the above equations as follows:

distance from origin = a,
velocity = $dX/dt = b + 2ct$, and
acceleration = $dX^2/d^2t = 2c$ at t_3 .

The observation equations are:

$$v_x = \quad a_x + b_x t + c_x t^2 - X = 0$$
$$v_y = \quad a_y + b_y t + c_y t^2 - Y = 0$$
$$v_z = \quad a_z + b_z t + c_z t^2 - Z = 0$$

The coefficient matrix elements for all three models are the partial derivatives of the model with respect to the unknowns. The coefficient matrix is the same for all three models, as follows:

$$A = \begin{array}{ccc} 1 & (t^1-t^3) & (t^1-t^3)^2 \\ 1 & (t^2-t^3) & (t^2-t^3)^2 \\ 1 & (t^3-t^3) & (t^3-t^3)^2 \\ 1. & (t^4-t^3) & (t^4-t^3)^2 \\ 1 & (t^5-t^3) & (t^5-t^3)^2 \end{array}$$

From this point forward in the discussion, time differences will be denoted as simply "t" to simplify the expressions.

The observation vectors composed of the observed coordinate values for each GPS epoch are:

for X;	for Y;	for Z;
$- x_1$	$- y_1$	$- z_1$
$- x_2$	$- y_2$	$- z_2$
$- x_3$	$- y_3$	$- z_3$
$- x_4$	$- y_4$	$- z_4$
$- x_5$	$- y_5$	$- z_5$

A least squares solution minimizing the function

$$PHI = V' P V$$

is used to solve for the unknown parameters (Uotila 1986). The P matrix is the scaled inverse of the variance-covariance matrix (Sigma Lb) for the observed quantities. The scaling is represented by Sigma ϕ^2, the variance of unit weight, which in this case has the value of 1. The solution for the unknown parameters begins with the normal equations noted as follows:

$$V_x = AK_x + X$$
$$V_y = AK_y + Y$$
$$V_z = AK_z + Z$$

where;

$$K_x = -(A'PA)^{-1}(A'PX)$$
$$K_y = -(A'PA)^{-1}(A'PY)$$
$$K_z = -(A'PA)^{-1}(A'PZ)$$

and the ' symbol represents the transpose matrix. For the moment consider the weight matrix P to be the Identity matrix I,

$$A'IA = \begin{array}{ccc} 5 & 5t & 5t^2 \\ & 5t & 5t^2 & 5t^3 \\ & & 5t^2 & 5t^3 & 5t^4 \end{array}$$

$$A'IX = \begin{array}{ccccc} x_1 & + x_2 & + x_3 & + x_4 & + x_5 \\ x_1 t & + x_2 t & + x_3 t & + x_4 t & + x_5 t \\ x_1 t^2 & + x_2 t^2 & + x_3 t^2 & + x_4 t^2 & + x_5 t^2 \end{array}$$

similar equations can be written for A'PY and A'PZ.

Variance-Covariance Weight Matrix for GPS Observations

The variance-covariance matrix, P, is used to weight the contribution of each observation considering the span of time between the central observation point and the camera exposure station. The assumption is made that the five observations are independent and, therefore, the co- variances between observations are zero. Several different choices for the variances were considered. The first choice was equal weights. This choice was not considered appropriate considering possible non-uniformity of the trajectory. A second choice was to compute the variances by giving more weight to the center value of the interpolation, a central weight scheme. The justification for this decision is based on the increasing difficulty to accurately model a trajectory as the distance between the central data point and its neighbors increases. This fact was confirmed in Table 1. The weight for the central value is, therefore, greatest with decreasing weights for the other data points as the time span from the data point to the central value increases. Several central weight systems were tried including the use of the Geometric Dilution of Precision (Spilker 1980), an estimate of GPS relative accuracy, obtained from the satellite geometry at the time of exposure. The final scheme weights the data points as a binomial expansion technique. The central variance was chosen to be 1.0 cm². The following formula for the variances of the weight matrix (Sigma$_{Lb}$) follows:

$$\begin{matrix} 2^2*0.01\ m^2 & 0 & 0 & 0 & 0 \\ 0 & 2^1*0.01\ m^2 & 0 & 0 & 0 \\ 0 & 0 & 2^0*0.01\ m^2 & 0 & 0 \\ 0 & 0 & 0 & 2^1*0.01\ m^2 & 0 \\ 0 & 0 & 0 & 0 & 2^2*0.01\ m^2 \end{matrix}$$

or

$$\begin{matrix} 4\ cm^2 & 0 & 0 & 0 & 0 \\ 0 & 2\ cm^2 & 0 & 0 & 0 \\ 0 & 0 & 1\ cm^2 & 0 & 0 \\ 0 & 0 & 0 & 2\ cm^2 & 0 \\ 0 & 0 & 0 & 0 & 4\ cm^2 \end{matrix}$$

The time separation from the central observation is inversely proportional to the weight. No correlation was considered between observations. The P (weight) matrix is a diagonal matrix with the following elements when a 1 Hertz sample rate is used:

$$P_{11} = 1.0 / Sigma^2_1 = 1/(2^2 * 0.01\ m^2)$$
$$P_{22} = 1.0 / Sigma^2_2 = 1/(2^1 * 0.01\ m^2)$$
$$P_{33} = 1.0 / Sigma^2_3 = 1/(2^0 * 0.01\ m^2)$$
$$P_{44} = 1.0 / Sigma^2_4 = 1/(2^1 * 0.01\ m^2)$$
$$P_{55} = 1.0 / Sigma^2_5 = 1/(2^2 * 0.01\ m^2)$$

The a priori variance of unit weight is 1.0. The validity of this weight system can be proven using a Chi Square test of the a posteriori variance of unit weight against the a priori variance of unit weight. The test indicated equal variances in 43 of 45 selected interpolation tests. The validity must be tempered by the knowledge that the degrees of freedom for the test is only 2 (number of observations - number of unknowns, 5 - 3 = 2).

The interpolated values for the antenna phase center at the time of the exposure are expressed as follows:

$$X_{exp} = K_x(1) + K_x(2)*(time_{exp} - time_3) + K_x(3)*(time_{exp} - time_3)^2$$

$$Y_{exp} = K_y(1) + K_y(2)*(time_{exp} - time_3) + K_y(3)*(time_{exp} - time_3)^2$$

$$Z_{exp} = K_z(1) + K_z(2)*(time_{exp} - time_3) + K_z(3)*(time_{exp} - time_3)^2$$

As a final note, the model used in this paper only approximates the actual trajectory of the aircraft. The mathematical modeling process acts as a filter, smoothing the aircraft trajectory using a second order polynomial. It would be interesting to examine the extent of smoothing which actually takes place. The model is validated by the results illustrated in Table 1. This same model was independently developed by James Lucas (Lucas 1989) and is currently used within the National Geodetic Survey.

Antenna Phase Center Transformation to Exposure Station

The interpolated geocentric position of the antenna phase center at the exposure time can now be transformed through the previously determined system of spatial offsets to the position of the exposure station.

Errors introduced by the observed quantities and interpolation model can be propagated through the above system of interpolation equations if the variances for the unknown parameters and time can be estimated. The variance- covariance for the parameters is obtained from the inverse of the normal equation matrix scaled by the a posteriori variance of unit weight. The estimate for timing error is obtained empirically as follows:

1. Knowledge of the precision for the GPS time tags which are receiver dependent.

2. Knowledge of the uncertainty in timing delay between the camera and GPS which is GPS receiver and camera system dependent.

3. Knowledge about the uncertainty of shutter timing offset measurement at the midpoint of shutter opening which is camera dependent (Taylor 1964).

The first two error sources are insignificant considering the velocity of the aircraft and the stability of the receiver and timing clocks. The largest contributing factor is, therefore, the shutter timing offset. This error is currently estimated to be 0.0005 sec (Lucas 1989). This estimate will decrease in magnitude as camera manufacturers refine internal timing techniques associated with forward motion compensation requirements (Coker 1989). The error estimate for the GPS position is given as 2 cm in planimetry and 4 cm in elevation (Mader 1992) . These values have been accepted as true. Assuming that there is no correlation between the position, timing and unknown parameters, a combined variance-covariance matrix can be derived. The derivation can be found in the author's dissertation (Lapine 1991) and will not be developed at this time.

Several assumptions are made about the camera and aircraft attitudes and the resultant contribution to the error in the exposure station position:

a. The exposure station will be defined as the entrance node to the lens system of the camera.

b. Vertical photography is assumed a priori and refined during the aerotriangulation. The initial swing angle is estimated by the azimuth between two consecutive antenna positions and can be refined as improved knowledge is obtained from aerotriangulation.

c. The pitch and drift angles are measured between the aircraft and the camera. The pitch and drift angles were zero when the spatial offsets were measured.

d. The variance-covariance matrix for the exposure station can be propagated through the various models using a priori estimates of the precision for the observations.

The antenna and camera coordinate systems are right-handed as are the three rotations about the camera axes. Three rotations and three translations are used in the transformation:

a. The antenna coordinates at the time of exposure are converted from NAD83 rectilinear to ellipsoidal latitude, longitude and elevation. The latitude (lat) and longitude (lon) are then used to rotate the NAD83 coordinates into an East, North, local vertical system.

b. The covariance matrix from the interpolation model error propagation is similarly transformed to obtain a covariance matrix in the local vertical system.

c. The spatial offset components between the camera and antenna are then rotated into the local coordinate system using the standard gimbal form. The rotation elements of Kappa and drift are combined into a single rotation. Rotational elements of Phi and pitch are also combined. No determination of roll was made during the flight, so Omega is treated independently.

It may be argued that the camera rotates about a set of mechanical gimbals whose rotational center may or may not be coincident with the exposure station. If there is any eccentricity between the gimbal rotational center and the exposure station, then the angles of exterior orientation can not be algebraically summed with the observed angles of pitch and swing. The eccentricity discussion will begin with the particular situation encountered in NOAA's application where pitch and swing angles are small (less than 2°).

By design of the RC-10 camera mount, the optical axis, about which swing is measured also coincides with the vertical axis of the mount, therefore swing and kappa angles can be combined without an eccentricity correction. Such is not the case for the pitch angle. The exposure station has a vertical separation of approximately 27 mm from the gimbal origin (the gimbal center is probably at the camera's center of gravity). The aircraft pitch relative to the camera mount was measured during actual flight conditions and is referenced to the gimbals. A maximum and generally constant pitch angle of 1.50 was measured and occurred at the lower limit of the Citation's operating speed. The consequences of not taking the eccentricity into account are as follows:

*Maximum pitch error = 0.027m * sin(1.50) = 0.0007 m*

A displacement error of the exposure station of less than 1 mm in the direction of flight is introduced if the eccentricity correction is neglected. In the most general case, a camera mount consists of a double concentric two orthogonal axis gimbal. The mechanical design of the gimbals and the magnitude of the rotation angles may dictate a more thorough investigation of the effect of the eccentricity.

The gimbal form rotation matrix (Merchant 1988) is formed by the product of the three independent rotations of pitch roll and swing. The order of multiplication is important only in the general case mentioned above. The order of rotation for the specific case is not critical, considering, the design of the camera mount, magnitude of the angles (generally less than 2°), and the fact that the rotations are being treated in a purely analytical application.

The combined rotation matrix would transform survey coordinates to photo coordinates. Since the spatial offsets are measured in the photo system, the transpose of the combined matrix is required. The product of the transposed matrix times the spatial offset vector yields values for the spatial offsets in the survey system. The spatial offsets may now be algebraically added to the interpolated position of the antenna position at the time of exposure. The result is a set of NAD83 coordinates for the exposure station and the associated estimates for the position precision.

References

American Society of Photogrammetry, 1980, *Manual of Photogrammetry, Fourth Edition*, Banta Publishing Company, New York, New York.

Coker, Clayton, and Clynch, J. R., and Brock, C., 1989. *"Calibration of the Exposure Status Signal from the Wild RC20 Aerial Camera,"* Technical Report, Applied Research Laboratories, The University of Texas, Austin, Texas.

Hamilton, W.C., 1964. *Statistics in Physical Science,* The Ronald Press Company, New York, New York.

King, Michael and Durboraw, I. N. III, 1988. *"A Detailed Description of Signal Processing in Motorola's Eagle GPS Receiver,"* Unpublished Proprietary Report, Motorola Inc., Tempe, Arizona.

Lapine, L. A., 1990. "Practical Photogrammetric Control By Kinematic GPS," *GPS World, Vol. 1, No. 3,* pp. 44-49.

Lapine, L. A., 1991. *Analytical Calibration of the Airborne Photogrammetric System Using A Priori Knowledge of the Exposure Station Obtained from Kinematic Global Positioning System Techniques,* University Microfilms International, Dissertation Information Services, Ann Arbor, Michigan.

Lucas, J. R., 1989. *"GPS-Assisted Phototriangu-lation Package (GAPP) User's Guide, Version 1.02,"* NOAA Technical Memorandum NOS CGS 2, Geodetic Information Center, NOAA, Rockville, Maryland.

Mader, G. L., 1992. *"OMNI 3.22 Users Guide,"* National Geodetic Survey Manual.

Merchant, D. C., 1988. *Analytical Photogrammetry Theory and Practice, Fourth Edition, Parts I and II,* Department of Geodetic Science, The Ohio State University, Columbus, Ohio.

Spilker, J. J., Jr., 1980. *"GPS Signal Structure and Performance Characteristics,"* Global Positioning System, Volume 1, Papers published in *"Navigation,"* The Institute of Navigation, Washington, D.C.

Taylor, E. A., 1964. *"Calibration of the Coast and Geodetic Survey Satellite-Tracking System,"* Invited Papers, The International Society for Photogrammetry, *Technical Commission V,* Lisbon, Portugal, pp. 13-36.

Tudhope, R. L., 1988. *"Dynamic Aerial Camera Calibration Combining Highly Convergent and Vertical Photography,"* M.S. Thesis, Department of Geodetic Science and Surveying, The Ohio State University, Columbus, Ohio.

Uotila, U. A., 1986. Adjustment Computation Notes, Department of Geodetic Science, The Ohio State University, Columbus, Ohio.

An Integrated GPS - Flight Management System

PETER M. CONNORS AND LESLIE PERRY

Abstract

The high operating costs associated with utilizing aircraft for remote sensing applications are well known. Keeping flight hours to a minimum while maximizing data collection is the ultimate financial goal. Many of the contributing factors that determine hourly flight time expenses must be absorbed, however, others can be significantly reduced. Highly efficient aircraft navigation utilizing the Global Positioning System (GPS) in conjunction with commercially available digital map databases, and integrated remote sensing equipment, can dramatically increase aircraft efficiency. This paper will detail a low budget, state-of-the-art flight management system currently used by the National Oceanic and Atmospheric Administration's (NOAA) Photogrammetry Branch in support of their Coastal Mapping Program. The system described not only enhances daily aircrew flight operations, but has dramatically changed routine mission planning and photographic inventory methods.

Introduction

Finally, as the long awaited completion of the Global Positioning System implementation schedule approaches, most of the initial uncertainties of depending on the system as a full time practical tool have been dispelled. Thanks to the efforts of several fastidious believers, the ability to use the system to change the way daily remote sensing flight operations are conducted, is now a reality. Combining Standard Position Service (SPS) GPS point information into a central computer system along with remote sensing hardware, can dramatically enhance both the data collection process and efficiency of airborne field operations.

Having flown and coordinated numerous Coastal Mapping projects for NOAA's Photogrammetry Branch, it was evident to us, that the effort involved in collecting aerial photography had significant inefficiencies. Of particular concern to the mission commander is the controllable yet irritating uncertainty associated with flight line navigation. Because the costs associated with operating a photogrammetric aircraft are substantial, to re-fly a previously flown photographic strip for whatever reason amounts to triple jeopardy; air time, film costs, and travel expenses. For this reason, it is paramount that the aircraft's location be constantly monitored using reliable instruments that are sensing a repeatable form of positioning.

NOAA s answer to these problems have been addressed through experimentation and the customization of relatively inexpensive off-the-shelf hardware and software products. The fruits of this effort is an integrated GPS Flight Management System that is currently being used on a Citation jet which supports NOAA s high-level mapping requirements. Although the individual components that presently comprise this system will be thoroughly described, this in no way implies that these are the only commercial products available, or capable, of achieving similar results. The system detailed is best described as an evolution which reflects the constant changes in computer technology.

The Photogrammetry Branch seriously embarked on improving its method of flight line navigation in 1990. The GPS Flight Management System is based on a portable onboard personal computer (PC) operating under the disk operating system (MS-DOS) in the Microsoft WindowsTM environment. The computer presently integrates two primary components, a GPS receiver and an onboard aerial mapping camera, into a powerful spatial database management and display system; DeLorme s XMap Professional digital map system. The CD-ROM based XMap system is fully capable of translating GPS positional information into a real-time moving map display. Additional remote sensing devices could likewise be integrated, as well as, the aircraft auto-pilot. Before detailing the flight management system itself, in order to fully appreciate the importance and impetus for designing this system, a brief description of the problems it addresses is appropriate.

History

NOAA's Coastal Mapping Program involves the cyclic collection of controlled geodetic coastal aerial photography. Primarily, this photography is used to define the legal shoreline represented on the NOAA Nautical Chart Series. This controlled small scale (1:50,000) strip photography is collected and used to aero-triangulate important objects throughout the numerous photographs within the planned mission area. Black & white infrared photography is also collected over the same geographic area during specific stages of tide. This photography is used to supply the accurate depiction of the mean lower low and mean high water lines on these nautical charts. To collect this small scale photography efficiently, a Cessna Citation II Fan-jet is used as the camera platform. This aircraft has proven to be ideally suited for this mission and was selected for the following reasons:

- **High altitude capability;** service ceiling 43,000 feet.

- **Moderate cabin size;** allowing dual camera operation.

- **Fan-jet power;** fuel efficient at both low and high altitudes.

- **"Straight" wing;** provides excellent handling characteristics and field length requirements.

- **Endurance;** 5 hours at cruise performance.

- **Reliability;** excellent safety and mechanical record.
- **Weight;** heavy enough to provide good stability.

The Citation is crewed with two pilots, one aerial photographer, and is equipped with two large format (23x23 cm) - 152mm focal length - metric mapping cameras. In addition to eliminating mission down-time due to a camera failure, dual cameras increase productivity by providing the ability to capture two different film emulsions (i.e. color and infrared) simultaneously. This particular configuration has worked well, providing quick response throughout the United States and its territories.

Most of these coastal mapping missions are flown at 1:50,000 scale (25,000 feet above ground level using 152mm focal length camera cones) employing conventional photogrammetric techniques, in ideal atmospheric conditions. Flight line coverage to aero-triangulate this strip photography, requires 60% end-lap between successive exposures and minimally 15% side-lap between adjacent strips. Standard operating procedures dictate that flight line photographs be completely free of clouds (and cloud shadows) with horizontal visibility requirements of 12 miles minimum. The weather conditions necessary under these specifications occur rather infrequently. Additionally, the integral requirements that this ideal weather has to occur during daylight hours, at specific sun angles, and during certain stages of tide, makes data collection all the more difficult. Weeks can pass waiting for all of these parameters to come together at many coastal locations throughout the U.S.

Prior to the flight management system, our photogrammetric flight line navigation was accomplished using a camera navigation site (a "bomb" site with limited forward looking capability) in conjunction with cluttered, cryptic-looking paper flight maps. The flight maps were simply cut-up 1:500,000 scale VFR (visual flight rules) aeronautical sectional charts, with numbered, straight, inked lines, drawn to indicate where photographic coverage was desired. The flight lines were drawn so that adjacent strips would have a minimum of 30% side-lap, hopefully, to accommodate flight line mis-navigation. With unstable winds aloft even a 100% safety factor is not sufficient to prevent rejected strips of photography.

Photographic flight line navigation using a photo-nav site is inherently inaccurate for three key reasons, 1) the longitudinal lubber line of the navigation site shifts instantaneously in relationship to ground reference with any change in aircraft yaw, 2) this shift is directly proportional to scale, or aircraft altitude, i.e. the higher the altitude, the greater the horizontal shift, 3) navigating with a photo-nav site involves lowering one's head to one's knees and looking down while simultaneously being jolted by air currents; this is not the recommended treatment for vertigo. The point here is that someone is less likely to sense subtle aircraft attitude changes (bank, pitch or yaw) with one's head lowered, concentrating on distant ground objects observed through a set of magnified lenses.

Flight line mis-navigation generates three major photogrammetric problems:

- **Ground control not captured;** targets being outside the limits of the photographs.
- **Inadequate coverage;** "holidays" between adjacent strips of photography.
- **Unrectifiable models;** gross changes in aircraft attitude between consecutive or adjacent photos.

These problems occur to varying degrees and are rarely apparent to the aircraft navigator. As a result, the extent of these problems are not immediately known or field correctable in a timely manner. Usually the imagery has to be developed, plotted, and inspected for the existence of ground control, before the photographic strip is declared a success. This process will take several working days; some of which will invariably be weather perfect for corrective, replacement photography. The desire to overcome this "time delay" and substantial costs associated with flying corrective photography is tremendous incentive to improve flight line navigation.

The NAVSTAR Global Positioning System has proven to be the practical solution to the accurate positioning dilemma. Because GPS is space-based, many of the reception and terrain problems associated with other navigation systems are eliminated. Although the GPS has not been declared operational, 3-dimensional positioning throughout the conterminous U.S. is now continuous. The accuracy of locations derived from the GPS Standard Positioning Service is variable, however, up to now, the accuracies achieved have been consistently better than that of other navigation systems. Department of Defense policy for SPS civilian use (Federal Radionavigation Plan) is to maintain this current accuracy stan- dard in peacetime. Cockpit GPS receivers are readily available for a reasonable price. Clever features and improvements are constantly being added. Using the GPS Standard Positioning Service provides more than adequate positioning accuracies for most high level photogrammetric applications. To improve positional accuracies, many receivers have the ability to accept differential correctors as well. This feature can be used where very accurate positioning is required, or where tolerance levels are lower, as in perhaps low level photogrammetric missions. The ability to store numerous waypoints and output GPS computed navigation information has given these receivers added impact. Cross-track error messages continuously indicate (every second) how the aircraft is progressing in relation to pre-defined flight line vectors.

System Details

The NOAA Photogrammetry Branch's GPS Flight Management System consists of a luggable 486-33 MHz PC, a modified Wild Heerbrugg RC-20 metric mapping camera, a Trimble 4000 SSE GPS receiver, connecting hardware, and associated peripherals. As previously mentioned, the digital geographic display software is DeLorme Mapping

Company's CD-ROM based XMap Professional. The self-contained computer includes a 10 inch VGA color monitor, a 3.5 inch floppy disk drive, a 200 megabyte hard drive, a CD-ROM reader, mouse, keyboard, and an internal modem.

Spatial Database Software

DeLorme s XMap Professional software package provides a rapid and seamless display of digital map data. Its resolution ranges from world view, to street level detail. Integrated with GPS messages, it can also function as a highly customizable moving map display. Additionally, because it works in the Microsoft Windows environment, it provides the ability to link user composed relational databases with user defined graphical objects, while concurrently running other software programs. Its other features are too numerous to describe in detail, however, for this application its key attributes are:

· Street level detail throughout the U.S.

· Ability to overlay geometric and text objects interactively

· Precise measurement with latitude - longitude conversion

· Ability to quickly change map scales and detail.

· Simultaneously link and display maps of different resolution

· Ability to create and save overlays to the geographic database.

· Ability to import and display relational database files.

· High quality printout of any generated map.

· Provides a friendly interactive presentation

GPS Receiver Functions

The Trimble SSE receiver is a primary component of this system as it serves two functions. To allow for GPS controlled photogrammetry (Lapine 1990), it operates in a continuous kinematic mode with a second, airport based, twin reference receiver. Both receivers observe and store satellite carrier phase measurements. This allows the aircraft s GPS antenna position to be determined accurately (to a few centimeters) using post-processing software. Additionally, the aircraft s receiver drives the "moving map" system by transmitting two SPS messages to the DeLorme software. Figure 1 below, shows the relationship between components and system interfaces.

These two Trimble messages, the Position Calculation and the Navigtion Calculation, are received at the computer s Com #1 serial port every second. The software uses the data from these messages to depict an aircraft icon (representing the jet s position) as an overlay to DeLorme s digital map. This icon moves and rotates as the jet changes position and ground track azimuth. XMap software senses icon movement as it approaches the edge of the VGA display,

and automatically relocates the icon to the center of the monitor as additional digital geographic data is filled in. This updates the aircraft's pseudo-range position (SPS) on the geographic computer display, and simultaneously allows the operator to monitor displayed flight parameters contained within the messages such as: ground track, horizontal and vertical velocity, time, waypoint settings, PDOP, latitude, longitude, ellipsoidal flying height, etc.

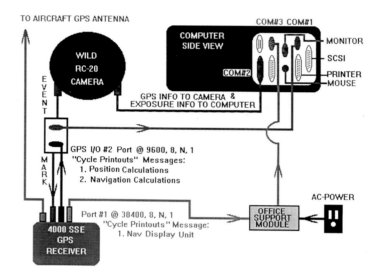

FIGURE 1

Mapping Camera Functions

Similarly, the Wild Heerbrugg RC-20 mapping camera is integrated into this system in two different ways. In order to photogrammetrically achieve the accuracies possible with differential GPS carrier phase measurements, and the fact that a photographic exposure is unlikely to occur at the exact instant phase measurements are recorded (typically every GPS second), additional timing information is necessary. This information is obtained by sending an electronic pulse from the camera to the GPS receiver at the instant of shutter opening, and internally recording (to the micro-second) the GPS reception time of this pulse at the receiver. Both the Trimble SSE receiver and the Wild RC-20 camera are configured to accomplish this event mark type of communication.

By splitting this pulse from the camera, and mixing it with the receiver's SPS messages (as shown in Figure 1), it is possible to geographically show the limits of these exposures. Each camera exposure is annotated on the moving map by shutter pulsing the XMap software. This annotation creates a square overlay on the moving map display that delineates the approximate geographic area covered by each exposure event. The dimensions of the squares are variable, depending on photographic scale, so these limits are manually entered by the operator. Depending on the circumstances, additional parameters (like, kappa, phi,

```
┌─────────────────────────────────────────────────────────────────────────────┐
│ Filename: ACN22.EDI        (sample "A" camera, Color Negative, Roll           │
│ 22)                                                                           │
├─────────────────────────────────────────────────────────────────────────────┤
│ PC:3484                                                                       │
│ FS125  1/ 550  f/5.6     FF1.0  EC 0   SP- v/h.01540  60% dt533.0  ds004  27.3V -61mb ER00 CAM5136 │
│ JD:207 26-JUL-93 GMT-20:11:36 LAT-48:58.3732N LON-122:43.5472W HT:+7506 PDOP:02.3 HV:218.20 GT:268.5 │
│ PC:3485                                                                       │
│ FS125  1/ 400  f/5.6     FF1.0  EC 0   SP- v/h.01548  60% dt038.7  ds005  27.1V -61mb ER00 CAM5136 │
│ JD:207 26-JUL-93 GMT-20:12:15 LAT-48:58.3656N LON-122:47.1142W HT:+7506 PDOP:02.3 HV:217.18 GT:269.5 │
│ PC:3486                                                                       │
│ FS125  1/ 300  f/5.6     FF1.0  EC 0   SP- v/h.01544  60% dt038.8  ds007  27.2V -61mb ER00 CAM5136 │
│ JD:207 26-JUL-93 GMT-20:12:54 LAT-48:58.3746N LON-122:50.6712W HT:+7512 PDOP:02.3 HV:216.53 GT:270.2 │
│ PC:3487                                                                       │
│ FS125  1/ 260  f/5.6     FF1.0  EC 0   SP- v/h.01548  60% dt038.3  ds008  27.3V -61mb ER00 CAM5136 │
│ JD:207 26-JUL-93 GMT-20:13:32 LAT-48:58.3769N LON-122:54.1351W HT:+7516 PDOP:02.3 HV:216.05 GT:270.5 │
│ . . . . . . . . . . . . .                                                     │
│ . . . . . . . . . . . . .etc                                                  │
└─────────────────────────────────────────────────────────────────────────────┘
```

FIGURE 2

omega) could likewise be fed to the computer.

The squares depicted by the spatial database are approximations due to the following assumptions: 1) the exposure event is assumed to be parallel with the underlying terrain, 2) the square is centered on the following (next) GPS pseudo-range position of the aircraft, and 3) the camera drift is assumed to be set properly with the aircraft s ground track. For NOAA's purposes (typically small scale photography) these limitations do not significantly degrade the outstanding benefits derived from this feature. As the squares are systematically accumulated, the navigator can visually see the area of photogrammetric coverage. Each strip of squares is saved as a photo overlay file and can be viewed, combined, or computer manipulated at any time. Also, specific GPS message output can be imprinted and linked to these squares. By synchronizing the camera clock with GPS time, and attaching GPS time messages to the square overlays, each photograph can be cross-referenced to an overlay square on the digital map base. Another very informative feature involves linking the aircraft icon's color with certain ranges of PDOP. This visually alerts the navigator to weakening satellite geometry. Numerous customizations are possible and easily accomplished with XMap software, however, the major importance of this function is the real-time ability to visually see and ascertain areas of concern as related to photographic endlap and sidelap.

The second camera function incorporated into this system deals with an- notating the photographic emulsion, and is possible on this RC-20 camera as a result of a Wild hardware modification option. This modification provides two, 100 character storage buffers, along with two LED arrays. The arrays are internally located outside the registration frame on both edges of the camera mount. After an expo-sure, these arrays flash alpha-numeric characters from the buffers, exposing the emulsion as the film is accurately metered (transported) through the cassette. NOAA uses this capability to encode each photograph with internal camera parameters (using one buffer), and GPS SPS parameters (using the other buffer) as depicted in Figure 2.

Figure 1, shows that a third GPS message, the Nav Display Unit message, is passed to the computer's Com #3 serial port. This message contains many of the same parameters as the Navigation Calculation message, but is needed because of an additional software program. A smart program called GPSLOGR (GPS Logger) was written, that will concurrently run with the XMap software, as a DOS application in Windows. GPSLOGR accepts this third message, reformats it, and combines it with other titling information, to produce a new 100 character message. The new character string is then sent to the GPS buffer of the camera via the computer s Com #2 serial port. This process is performed every second! When an exposure occurs, the camera s buffers (internal and GPS) are frozen as the film is transported and annotated. This annotated information (exposure message) is then transmitted from the camera back to the computer, along the same serial line. At the computer, the exposure message is logged to produce an ASCII database (Electronic Data Interface- EDI) file for each roll of film. An excerpt from one such database below (Figure 3), shows that each exposure produces a separate three line entry according to the following format:

1. Exposure number

2. 100 character field with internal camera parameters

3. 100 character field with GPS parameters

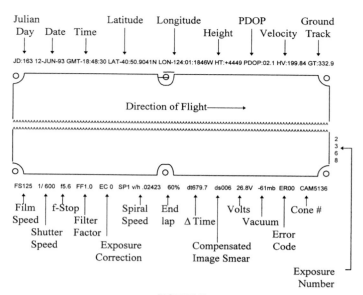

FIGURE 3

Due to the fact that each NOAA collected photograph is a legal record, GPSLOGR was purposely designed to do more than just pass information. In an automated world, many things can go awry. For instance, in the case of a computer lock-up or malfunction, one does not want the same buffered GPS information passed to many consecutive exposures. Likewise, one does not want to expose erroneous GPS positioning information to a photograph, as in the case of receiving less than four satellites — the minimum required for 3 dimensional positioning. These and other safeguards were incorporated into GPSLOGR so that SPS accurate information could be written to each photograph.

Once this database is amassed (roll of film is exposed), a two step process is performed that allows one to link this database to XMap. First, another program called PINDEX (photo index — also written in-house) is used to strip away the headers and reformat the three lines of information for each exposure into one line, using commas as field limiters. In the above example, ACN22.CSV (comma separated value) would be created after executing PINDEX on the ACN22.EDI file. Next this newly created *.CSV file is directly importable into most database application software. Presently, XMap supports two sophisticated database software applications: Microsoft Excel and Software Publishing Corporation's Superbase. After importing, a macro can be written that will reinstall the headers and format the data into a linkable database. Once linked, this and similar databases can be geographically queried by state or coordinate ranges, as well as, by year, scale, etc. This tremendously expedites photo inventory and retrievals.

Mission Planning and Flight Line Navigation

Flight planning a photo mission primarily involves determining the layout of the flight lines to be flown, in order to obtain photographs covering the area desired. This includes line length, azimuth and relative orientation. All of which may be dictated by various factors such as terrain, airspace limitations, sidelap, scale, and ground control. In all cases, the flight lines will be space vectors comprised of two endpoints, each having a geographic coordinate. Once these endpoints are derived, they are individually identified as numbered waypoints (navigation terminology) and may be used by GPS receivers that have navigation software packages. These packages simply compute the distance and azimuth between these waypoints and calculate pertinent relative information relating one s current position to this vector. Typically this information includes present distance and bearing, to the end of the vector (waypoint denoted second), along with cross-track error distance. Cross-track error is the shortest distance from one s current position to the original vector extended (from each endpoint, along the vector azimuth, to infinity), and is usually indicated as left or right some number of distance units (i.e. feet, meters, miles, etc.). Most GPS receivers will store these vector waypoints internally to be called when desired. These waypoints can then be called up on the receiver as specific photographic flight lines are flown.

In the Flight Management System, the receiver's navigation message passes to the computer waypoint range, bearing, and cross-track information. Once on line, this information allows the navigator to very accurately track the desired flight line. With a little concentration, crosstrack errors of 50 meters (relative to GPS positional accuracy) or less can easily be obtained. Although it is possible to accomplish this solely by reading the GPS receiver s navigation display, the moving map is particularly useful in getting the aircraft initially set up to track the desired flight line. By being able to simultaneously see the aircraft's position in relation to the flight line's location (as an overlay to the spatial database), the navigator can quickly evaluate course changes necessary to efficiently maneuver the aircraft. Using only the GPS receiver's navigational information during this phase of flight is considerably more difficult.

Navigation by waypoints works very well if the waypoint information is correctly stored in the GPS receiver. However, it is easily possible to unknowingly fly a flight line vector very precisely, yet very inaccurately. This can occur if a GPS waypoint coordinate is inadvertently mis-entered. Because GPS receivers can typically store 100 or more waypoints, each having 16+ digits (latitude and longitude) associated with it, extreme diligence must be employed to prevent this from happening. To assist in the entering of waypoints, another program was written for the Flight Management System called WAYPOINT. WAYPOINT reads a digital database (*.WPT) file that contains all of the planned flight line numbers along with their associated waypoint numbers and geographic coordinates. This information can be viewed and either totally, or selectively, uploaded directly into the Trimble SSE GPS receiver. Although this eliminates the possibility of mis-entering waypoint information into the receiver, the database used by WAYPOINT must be thoroughly verified

Conclusions

Three flight navigation problems (ground control, "holidays", and exposure rotational angles) are virtually eliminated when using this system. Ground control positions (derived from hand-held GPS receivers) can be overlaid on XMap as soon as control panels are placed. By displaying these locations on the moving map, the aircraft navigator knows instantly whether or not panels are being covered by the photography collected. Similarly, "holidays" between adjacent strips of photography can be visualized by simultaneously displaying two or more photo overlay files. Field photographic rectification cannot be completely guaranteed, however, using GPS, photogrammetric model rotational problems (without the aid of a stabilized camera mount) due to aircraft navigation are greatly reduced. This is assured because GPS provides accurate numerical navigation information every second. As a result, aircraft course corrections using GPS are more frequent, but of a much smaller magnitude. To minimize the photogrammetric effects of pitch, roll, and yaw, the navigator inputs all auto-pilot course corrections in a timely manner according to the camera's intervolometer.

Perhaps the greatest benefit from using this system is eliminating the photograph collection-evaluation "time delay" problems. Aircraft field personnel now have the information necessary to make accurate photographic collection decisions in real time. It is estimated that by using this system, the Branch's mission related overhead has been reduced by 20% or more. In the field, in addition to daily progress reports, the mission can transmit (via modem) both the photographic flight line overlay files, as soon as photography is secured, and the associated film data-base, once the roll is completely exposed. The Branch receives the exposure locations, time, and geographic limits of each photo often before the roll of film is in the can!

As photogrammetric mission costs continue to climb, a system similar to the one described will be common throughout the remote sensing community. The potential for customizing software and hardware for particular photogrammetric configurations is limited only by one's imagination.

The GPS flight management system described has been operational for the past two years. In this time it has proved invaluable not only in flight operations, but also to mission planning, and the Branch s Support Section, which is responsible for photo inventory and customer service.

This system has continuously been improved upon as advances in technology have emerged. Initially, many potential problems were anticipated concerning the ability of the hardware components to stand-up and operate normally in an aircraft environment. Computers are notoriously finicky instruments and CD-ROM readers are known to be sensitive. So far, none of these problems have materialized. As new ideas were implemented, and the system became more sophisticated, conflicts were encountered, particularly involving asynchronous communications and CPU interrupts. As can be seen from the overall configuration in Figure 1, there are many bytes flowing in and out of the computer every second! These problems were solved through diligent efforts, experimentation, and employing additional software & hardware. Specifically, by using 16550 type Universal Asynchronous Receiver Transmitters (UARTs) in the serial cards and installing a high performance communications driver called TurboComTM, most of these problems disappeared.

Operational Experience with Airborne GPS-Controlled Photography at the U.S. Geological Society

LARRY HOTHEM, KARI CRAUN, AND MARIA MARSELLA

Abstract

In 1993, the U.S. Geological Survey conducted two airborne Global Positioning System (GPS)-controlled photography projects. The area for the first project was over the central one-third of Utah where 1:40,000-scale images were acquired for the National Aerial Photography Program (NAPP). The NAPP images are used in the planimetric revision of the USGS 1:24,000-scale map series and in the production of 1:12,000-scale digital orthophotos.

The second airborne GPS project was conducted in cooperation with the National Science Foundation and the New Zealand Department of Lands and Information. Photographs and airborne GPS-derived camera station coordinates were acquired in areas located near McMurdo Station, Antarctica. The primary objectives for the project were to produce 1:50,000-scale mapping and digital orthophotos. Some of the project involved acquiring images for 1:5,000- and 1:10,000-scale maps.

Both projects used late-model cameras and dual-frequency P-code GPS receivers. The GPS data were collected simultaneously with two receivers installed on the aircraft and two to four receivers operating at base reference stations. The airborne GPS projects demonstrated the practical application of GPS-derived coordinates for camera exposure stations and their use as control in aerial triangulation block adjustments.

Introduction

The goal of the National Aerial Photography Program (NAPP) is to update a data base of images on a 5-year cyclic basis for the conterminous United States. The images are used for various purposes, including revision of 1:24,000 scale maps and the production of 1:12,000 scale orthophotos. To use the NAPP images properly for producing accurate maps or orthophotos requires geodetic control. Traditionally, geodetic control needs depend on the availability of ground points identifiable on the images. Establishing ground control points makes up a substantial portion of the production cost for maps or orthophotos.

Accurate maps and orthophotos are essential for Antarctic research and for supporting operational and logistical activities. Map scales range from 1:3,000 to 1:1,000,000. The U.S. Geological Survey (USGS) Antarctica mapping program is conducted in cooperation with the National Science Foundation (NSF) and the New Zealand Department of Lands and Information (DOSLI). The primary focus of the mapping program is the production of 1:50,000 scale maps. The remoteness and the harsh environmental conditions of Antarctica make it costly to conduct aerial photography missions and to establish adequate geodetic control at ground points. Substantial savings in production costs are possible when ground control is replaced or significantly reduced by using airborne GPS-derived positions.

In May 1991 and May 1992, the USGS conducted tests in the use of airborne GPS for photogrammetry (Craun and others, 1994). Photographs for the two projects were acquired over a 9-quad area near Phoenix, Arizona, using specifications for NAPP. The results were encouraging. Positions of test points derived from aerotriangulation adjustments in which only the GPS-derived positions of the camera exposure stations were held fixed were within 1.5 m (Root-Mean-Square) of the positions determined by GPS terrestrial survey methods. The aircraft positions were obtained using double-difference carrier phase kinematic GPS data-processing software.

In this paper, key factors in developing the specifications and guidelines for the USGS airborne GPS operations are presented. This is followed by a description of the Utah and Antarctica aerial photography projects, including information on the location, equipment, position accuracies required, field procedures, data processing, and initial results. In the Utah project, a special research activity involving a small portion of the total project is under way. The study will test the results of combining the GPS-determined aircraft positions in the aerotriangulation adjustments.

Specifications and Guidelines

The experience gained in the 1991 and 1992 tests was consistent with findings reported by other investigators. An excellent review of the potential benefits and critical issues is found in Ackermann (1992). In late 1992, planning began for a pilot project in the 1993 NAPP program. Additionally, in planning for the resumption of aerial photography in Antarctica, USGS scientists decided to include airborne GPS technology.

Aerial photographs for the NAPP program are acquired by private aerial photography companies under contract to the USGS. The specifications for the contract arrangements were revised to include airborne GPS requirements.

The GPS requirements added to the specifications included camera capability and exposure pulse criteria, aircraft attitude and camera orientation measurements, the number of GPS antennas, and guidance on where the antennas should be placed on the aircraft. The specifications provided guidance on minimum components and capabilities of the GPS systems operated in the aircraft. The accuracy standards for the camera station positions were defined. Other factors included in the amended specifications

were observing criteria, guidance on using the land-based reference stations, and procedures for handling the data files. Finally, general instructions were provided on acceptable methods for processing the airborne data, analyzing the results, and adjusting the camera station positions.

A critical requirement in the specifications was the added responsibility for the contractor not only to operate GPS positioning systems in the aircraft but also to deliver adjusted positions for each camera exposure station along with the raw GPS data collected. The contractor must provide estimates for the coordinate accuracies and furnish information on how these estimates were obtained. Formal errors produced in the GPS solutions are not acceptable as the sole basis for the accuracy estimates. Accuracy estimates are based on findings from analysis of repeatability, comparisons, and residuals of weighted adjustments.

After NAPP photographs are acquired, several months may pass before there is an opportunity to incorporate the photo measurements in aerotriangulation adjustments. This delay requires that accuracy estimates for airborne GPS-derived positions be determined by analyzing redundant data. Therefore, the GPS field observing procedures must produce consistently high quality data with adequate redundancy on the aircraft and at the land-based reference stations.

The accuracies for the camera station positions must be within the tolerances acceptable for products that meet national positional accuracy requirements for spatial data. For example, allowable RMS errors in the horizontal components of USGS products range from 0.75 m for maps at 1:3,000 scale to 12.5 m for maps at 1:50,000 scale.

Project Description and Experiences

Both the Utah and the Antarctica airborne GPS projects were carried out in 1993. There were many similarities between the two operations: multiple receivers and antennas installed in the aircraft, multiple land-based reference stations, dual-frequency P-code GPS receiver technology, and processing software that incorporated the most current algorithms and models.

Significant differences between the two projects included the number of satellites in view, the satellite geometric distribution, and the environmental conditions. In Antarctica, the harsh environment is characterized by extreme temperatures and frequent ionospheric disturbances. But these unfavorable conditions were offset by the benefits of having eight or more satellites in view and consistently good satellite geometry. The situation was different during the Utah project. Often during each mission, less than six satellites were in view above a mask angle of $15°$. Occasionally, less than five satellites were in view. When the number of satellites and the geometric distributions do not meet minimum requirements serious problems may occur during data processing. These problems may cause positioning accuracies that are unacceptable or, at best, marginally acceptable.

Utah

The project in Utah was one of the first attempts to apply airborne GPS-controlled photography over a large area. It was also the first airborne GPS operation involving a project of this size undertaken by a private aerial photography company. The contractor for the project was chosen by a qualification-based selection process. In July 1993, the contract was awarded, and the first mission was flown in August 1993.

Project Location

The project was located in the central third of Utah and covered an area of approximately 64,507 sq. km (fig. 1). The circles in Figure 1 represent a radius of about 300 km referenced to the base stations shown by the triangle. Table 1 lists key information for the project.

Reference Stations

Three reference stations were established with GPS receivers collecting data continuously during each flight mission. One station was located at Provo, Utah, airport. All flight missions were deployed from this airport. The other two reference stations were established in Salt Lake City, Utah, and in Cedar City, Utah (fig. 1). At the instance of each camera exposure, the distance between the aircraft and any of the three reference stations ranged from 10 to 400 km.

FIGURE 1
Utah 1993 airborne GPS project and reference stations.

Methodology

Table 2 provides a list of missions, dates, and the observed reference and aircraft stations. All GPS receivers were P-code dual frequency. Figure 2 shows where the GPS antennas were placed on the aircraft. Data were collected at the 0.5-second rate. One objective of the Utah project was to evaluate the capability of double-difference carrier phase data processing software to resolve integers on-the-fly. Is it possible to achieve positioning accuracies within a decimeter level, and what are the practical limits in distances between the aircraft and the base stations? Can acceptable positioning accuracies be achieved by dual-frequency range differential processing methods? Are submeter accuracies possible when the aircraft is several hundred kilometers from the base stations?

Contract awarded:	Early July 1993	
Data acquisition completed*:	Mid-September 1993	
Project location:	Center one-third of Utah	
Use of photographs:	Photogrammetric mapping, orthorectified imagery, and resource inventory	
Approximate area:	64,507 sq. km (24,906 sq. mi)	
Film type:	Panchromatic	
Aerial Camera - lens focal length:	153 mm/6 inch	
Lens type:	U. Aviogon, Pleogon A, Lamegon PI, or equal	
Flight height - above mean ground:	6,069 m (20,000 ft)	
- above sea level:	7,437 m (24,400 ft) to 9,266 m (30,400 ft)	
Number of flight lines:	24	
Direction of flights:	North/South	
Datum breaks:	84	
Total flight line segments:	108	
Spacing of photos - Minimum:	.50	
Along flight lines - Optimum:	.57	
Base-height ratio - Maximum:	.65	
Minimum sun angle:	45 degrees	
Linear distance of flight lines:	7,783 miles/12,525 km	
Approx. photographic period:	7/12 to 9/30/93	
Terrain conditions:	No snow, no flooding	
Aerial films:	Kodak Plus-X Aerographic 2402 or Kodak Panatomic-X Aerographic II 2412 or Agfa Aviphot PAN 150 PE 1	

*Most of the photography was acquired by mid-September 1993; however, a few reflights occurred after this date.

TABLE 1
Utah airborne GPS-controlled photography project for NAPP.

Flight Mission Experiences

Flight mission experiences. As indicated in Table 2, GPS data were not collected at one of two antenna/receiver aircraft stations during 4 of the 15 missions. Data were missing because of power failures, insufficient storage capacity in the data logging devices, or unexplained "lock-up" of the data logging software. Late in the project, it was found that the quality of GPS data collected at reference station CARL was unsatisfactory. Interference from a microwave radio transmission had degraded the L2 signal. The station was abandoned, and a new reference station was established at an alternate location in Salt Lake City. Unfortunately, this move did not occur until near the end of the project.

Mission	Day	GPS Week	Date	Span(1) (UTC)	Stations Observed				
1	226	709	Aug. 14	1615-2051	PROV	DAVE	CARL	XAFT	XFWD
2	227	710	15	1545-2200	PROV	DAVE	CARL	XAFT	XFWD
3	228	"	16	1633-1913	PROV	DAVE	CARL	XAFT	XFWD
4	229	"	17	1516-1953	PROV	DAVE	CARL	XAFT	XFWD
5	234	711	22	1650-1834	PROV	DAVE	CARL	XAFT	XFWD
6	235	"	23	1557-2052	PROV	DAVE	CARL	XAFT	XFWD
7	236	"	24	1548-2006	PROV	DAVE	CARL	XAFT	XFWD
8	240	"	28	1636-2138	PROV	DAVE	CARL	XAFT	XFWD
9	245	712	Sept. 2	1632-1959	PROV	DAVE	CARL	XAFT	XFWD
10	246	"	3	1611-1958	PROV	DAVE	CARL	XAFT	XFWD
11	250	713	7	1634-1959	PROV	DAVE	CARL	XAFT	XFWD
12	251	"	8	1619-2139	PROV	DAVE	CARL	(2)	XFWD
13	252	"	9	1621-2148	PROV	DAVE	(2)	(2)	XFWD
14	253	"	10	1547-1651	PROV	DAVE	(3)	(2)	XFWD
15	264	715	21	1806-1945	PROV	DAVE	XBLM	(2)	XFWD
16	265	"	22	1651-2125	PROV	DAVE	XBLM	XAFT	XFWD
Reflights in 1994									
17	227	762	Aug. 15	1500-1828	PROV	DAVE	RIVE	XAFT	XFWD
18	229	"	17	1500-1935	PROV	DAVE	RIVE	XAFT	XFWD
19	247	765	Sept. 4	1625-2040	PROV	DAVE	(4)	XAFT	XFWD
20	248	"	5	1515-1725	PROV	DAVE	(4)	XAFT	XFWD

(1) This is the period between the first and last camera exposure for the mission; (2) No data were collected due to failure of data logger; (3) Due to receiver power failure, data were not collected until after 1711 UTC; (4) Station was not occupied during missions 19 and 20. Station locations in Utah: PROV (XGND) - Provo; DAVE - Cedar City; CARL and XBLM - Salt Lake City; XAFT - aircraft antenna on the tail; XFWD - aircraft GPS antenna on the fuselage above camera; RIVE - Salt Lake City.

TABLE 2
Summary of missions - Utah 1993 Airborne GPS Project.

Anti-spoofing (AS) was not activated during any missions. Because AS was off, all receivers observed the P-code and produced both L1 and L2 P-code ranges and full-wave carrier phase measurements. Selective availability (SA) was not a concern because the aircraft positions were computed by differential positioning methods.

GPS Data Management and Analysis

The amount of raw data collected in each mission averaged about 150 Mb. For the 15 missions, the total amount of raw data collected was about 2 Gb. All data were translated into the receiver independent exchange (RINEX) format, version 2. The volume of compressed RINEX formatted data was approximately equal to the raw data. The total volume of data, including solution outputs, was about 4.5 Gb.

The large data files were transmitted on high-density tapes. This was a very time-consuming process that was fraught with problems such as incompatibilities between tape drives and tape backup software. In future projects, data will be transmitted and archived using CD-ROM storage media. Data will be recorded on CD-ROM's using standard recording software.

Initial aircraft positions were computed relative to the reference station PROV. The processing method combined all observables (that is, L1 and L2 carrier phase and P-code pseudorange measurements) in the vector baseline solutions. The solutions were based on an algorithm that resolved the ambiguity function and fixed integers while the aircraft was moving. This is called on-the-fly (OTF) ambiguity resolution, and it is able to achieve accuracies that range from 5 to 50 cm, depending on whether the integers are fixed or floating. Successful application of OTF depends on the quality and quantity of GPS data. For example, the data should be free of cycle slips, and the impact of multipath should be low. Other factors influencing OTF results include the number of satellites in the solution (there should be a minimum of five satellites above $20°$) and the distance between the aircraft and the reference stations. It is difficult to fix the integers when the distance between the aircraft and reference station exceeds 50 km.

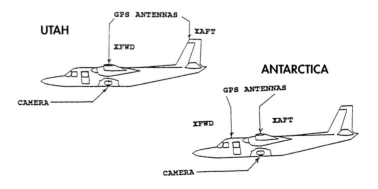

FIGURE 2
Relationship of multiple aircraft GPS antennas and camera for the Utah 1993 and Antarctica 1993 projects.

The antenna positions for corresponding camera exposure times were based on interpolated estimates from the positions along the aircraft trajectory. The interpolated positions were then used to compute chord distances and height differences between the two antennas on the aircraft. The chord distances were analyzed by comparison with the known chord distance between the two antennas. Along a flight line, the consistency of the height differences was evaluated.

The chord distances and height differences for missions 12, 13, 14, and 15 could not be evaluated because data for the aircraft antenna station XAFT were not available. The results for the other 11 missions suggest the horizontal positions and heights of the antennas at the camera exposure times are consistent at the 1-m and 1.5-m level, respectively. Evaluating the chord distances and height differences between the aircraft antennas for each instant of camera exposure is a standard in the specifications for future projects. Comparison of differences in positions computed at each aircraft antenna relative to a minimum of two reference stations is also a standard requirement in future specifications.

The OTF solutions for airborne positions referenced to stations CARL, DAVE, and XBLM are delayed until software that allows for processing of mixed receiver data is available. Investigations are also under way to process the L1 and L2 P-code range data. In the range differential solutions, the carrier phase data are used in a Kalman filter-smoothing algorithm. Baseline lengths between the aircraft and reference stations may be considerably longer than the allowable distances for effective solutions by OTF integer fixing. It may be possible to achieve positions with acceptable accuracies for baselines with lengths up to 1,000 km. The expected accuracies for results by the dual-frequency range differential method range from 0.5 to 2 meters.

Research Project and Test Area

A research project is now evaluating a small portion of the Utah project. Wasatch County is the general location for the project. The area is designated for production of digital orthophotos in cooperation with the state of Utah. The objective of the research is to test aerotriangulation results using airborne GPS-derived camera station positions with and without ground control. The test area contains a various terrain conditions, including both flat and steep terrain. Test points were established in April 1994 and positioned by the use of GPS surveying methods.

Camera station position data are available for both aircraft antennae. These data were derived with OTF ambiguity function software. Other camera station position data that will be tested in the aerotriangulation block adjustments include results from processing mixed receiver data and from range differential methods. At least two kinds of independently developed aerotriangulation software will be used in the studies.

Some of the benefits expected from the research finding includes improving specifications for airborne GPS operations, selecting aerotriangulation software appropriate for production use, and developing appropriate analysis procedures for estimating GPS derived camera station position accuracies. Reliable estimates for positioning accuracies require the collection of redundant data from two or more GPS systems operating in the aircraft and the occupation of two or more reference stations. A report on the results from multiple stations operated on the aircraft and at ground reference stations, shows that improved accuracies are possible (Cannon and others, 1991).

Reflights

Though all specified flight lines were flown, a small percentage will be reflown in August 1994. The reflights were necessary to replace images that did not meet criteria for quality. Other reflights are for images that had no GPS-computed positions. During the reflights a minimum of three reference stations will be occupied during each mission.

Antarctica

The airborne GPS project in Antarctica was unique for several reasons. It was the first application of fixed-wing airborne GPS positioning for aerial photography in Antarctica. Antarctica is remote and the environment is very harsh. The target areas were scattered over a wide area and involved flight lines at various heights above the ground.

The project was organized by the USGS in cooperation with the NSF and the DOSLI. The DOSLI handled the arrangements for the services of a private aerial photography company in New Zealand (NZAS, 1994). The primary objective was to obtain aerial photographs in support of a 1:50,000 mapping and orthophoto program. Additional photographs for various other purposes were acquired for the Italian Antarctic Program and the New Zealand Antarctic Program. Initial positions have been computed for all images, and these data were used to compile a reference index of positions and identification codes for each image.

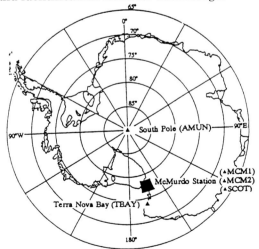

FIGURE 3
Antarctica Airborne GPS Project - McMurdo Station And Location Of Reference Stations.

The wheeled turboengine aircraft, a Rockwell Commander 690B, was flown nonstop from an airport in southern New Zealand 3,500 km to McMurdo Station. The journey took 8 hours. The aircraft was based at the sea ice runway located in McMurdo Sound. The ice runway is operated from early October to the end of the first week in December. The aircraft arrived at McMurdo on October 29, and most of the mission objectives were completed before its return to New Zealand on November 29. The GPS was used to navigate the aircraft to and from McMurdo Base and during each aerial photography mission.

Project Location

Most of the 12 photography missions were located within 200 km of McMurdo Station. Two missions were over areas located near Terra Nova Bay, the station for the Italian Antarctic Program (fig. 3). General information for the project is listed in Table 3.

Reference Stations

Up to five reference stations were occupied during each mission. Three stations at McMurdo Station were within 9 km of where the aircraft was parked before and after each mission. Additional stations were at Terra Nova Bay (the Italian scientific station) and at the South Pole (fig. 3). During each camera exposure, the distance between the aircraft and the nearest and most remote reference stations ranged from 10 to 400 km, and from 1,000 to 1,300 km, respectively.

```
When:                    November 1993
Project location:        Vicinity of McMurdo Station
Use of photographs:      Photogrammetric mapping, orthophotomapping,
                         scientific research, penguin rookery studies,
                         resource inventory, environmental monitoring
Approximate area:        21,000 sq. km.
Number of missions:      12
Number of mission days:  9
Total flying hours:      44
Days lost to weather:    21
Flight height:           460 to 7,620 meters
Number of photos:        2,345
Photo scale:             1:3,000 to 1:50,000
```

TABLE 3
Antarctica 1993 airborne GPS photography project.

Mission	Day	GPS Week	Date	Span(1) (UTC)	Stations Observed						
1	311	722	Nov. 7	2007-0023	MCM1	MCM2	SCOT	AMUN	TBAY	(2)	(2)
2	317	"	13	2001-2254	(3)	MCM2	SCOT	AMUN	TBAY	XAFT	XFWD
3	318	723	14	0149-0447	(3)	MCM2	(3)	AMUN	TBAY	XAFT	XFWD
4	318	"	14	2046-0015	MCM1	MCM2	SCOT	AMUN	TBAY	XAFT	XFWD
5	319	"	15	2248-0132	MCM1	MCM2	SCOT	AMUN	TBAY	XAFT	XFWD
6	322	"	18	0013-0022	(4)	MCM2	(2)	AMUN	(5)	XAFT	XFWD
7	323	"	19	2018-2021	(4)	MCM2	SCOT	AMUN	TBAY	XAFT	XFWD
8	325	724	21	0020-0345	(4)	MCM2	(2)	AMUN	(5)	XAFT	XFWD
9	325	"	21	1947-2246	MCM1	MCM2	(4)	AMUN	TBAY	XAFT	XFWD
10	326	725	22	0057-0428	MCM1	MCM2	(4)	AMUN	TBAY	XAFT	XFWD
11	326	"	22	2001-2325	MCM1	MCM2	(4)	AMUN	TBAY	XAFT	XFWD
12	327	"	23	0128-0317	MCM1	MCM2	(4)	AMUN	TBAY	XAFT	XFWD

(1) This is the period between the first and last camera exposure for the mission; (2) No data were collected due to failure of power supply for the receiver and data logger, (3) receiver malfunctioned, (4) station not observed, (5) no data were collected at the 1-sec rate. Legend: MCM1, MCM2, and SCOT - reference stations at McMurdo Station; AMUN - reference station at the South Pole; TBAY - reference station at Terra Nova Bay; XAFT - aircraft GPS antenna on fuselage above camera; XFWD - aircraft GPS antenna on fuselage forward of the camera.

TABLE 4
Summary of missions - 1993 Antarctica airborne GPS project.

Methodology

Table 4 is a list of missions, dates, and the reference and aircraft stations observed. All GPS receivers used in the project were P-code dual frequency. The data collection rate in the aircraft and at reference stations was 1 second. Because the number of satellites in view above 10° was always at least eight, the mask angle was set to 10° rather than the 5° setting used during the Utah 1993 project.

Figure 2 illustrates where the GPS antennas were placed on the aircraft. During missions one through five, the receivers on the aircraft were an Ashtech P12 and an Allen Osborne Turbo Rogue model 8000. A second Turbo Rogue was used at reference station MCM2. The receiver deployed on the reference station TBAY was a Trimble model SSE. Ashtech P12 models were deployed at all other stations. Because the Turbo Rogue receivers were available only for a limited period, these receivers were swapped with Ashtech P12 receivers during missions 6 through 12.

Flight Mission Experiences

As noted in Table 4, airborne GPS data are not available for the first mission. Data were lost when the aircraft power to the data logging devices was interrupted. A battery backup system was in use during a brief stop at the Terra Nova Bay ice runway. Before the plane's departure, the batteries discharged, causing an abnormal termination of the data logging software. To reduce the chance of airborne GPS data losses in future missions, a more robust power system was installed in the aircraft. No significant losses of airborne data occurred during the remaining missions.

At some reference stations, problems with data collection were experienced during a few missions. Except at station MCM2, power was supplied directly from batteries. Unreliable battery power was the cause for failure to collect data during two missions at station SCOT. Attempts to collect data during two missions at MCM1 and one mission at SCOT failed because of receiver malfunction, possibly related to the unreliable battery power supply.

The possibility of problems with RFI was a major concern. During a few instances on the aircraft, RFI was the suspected cause for interruption of the signal tracking. Of more critical concern was the intense amount of RFI from various communication systems in the region of McMurdo Station. During portions of each mission, the quality of the data was affected. In the future it may be necessary to locate the reference station farther away from potential sources of RFI originating from McMurdo Station.

AS was not activated during any of the missions; thus, all receivers observed the P- code and produced both L1 and L2 P-code ranges and full-wave L2 carrier phase measurements. Because the aircraft positions were computed by differential positioning methods, SA had no impact on the results.

GPS Data Management and Analysis

The amount of raw data collected at each station during each mission was about 10 Mb, or about 50 Mb per mission. Raw data accumulated for the project came to about 600 Mb, and this amount was doubled when combined with

files produced from translation to the standard RINEX format. At McMurdo Station, the raw and RINEX data files were backed up on high-density tapes. At the USGS National Center, all files, including initial solutions and camera exposure time files, were archived on two CD-ROM's. The CD-ROM's were recorded in the ISO 9660 international format. Copies of the CD-ROM disks were provided to DOSLI, our cooperating agency in New Zealand.

Initial positions were computed for each camera exposure station. Positions were determined relative to one or more of the reference stations at McMurdo and for one mission relative to station TBAY and AMUN. Most of the positions were determined by using the differential range method smoothed with the aid of the carrier phase data. Four independently developed software programs are being used for further data processing and analysis. The software combines all observables (that is, L1 and L2 carrier phase and P-code pseudorange measurements) in the vector baseline solutions.

The 1-sigma horizontal and vertical accuracy objectives are about 2-3 m for the 1:50,000-scale and about 25 cm for the 1:5,000-scale maps and orthophotos. Initial processing produced positional accuracies at a 1-2 m level. Most of the more stringent accuracy requirements are for flight lines located within 50 km of the McMurdo base stations.

To obtain accuracies at the decimeter level requires continuous carrier phase kinematic data-processing methods. One method is the standard approach of attempting to fix the integers while the aircraft is stationary before and after each mission. The other method, developed within the past 2 years, involves determining the integers and fixing them while the aircraft is in motion.

The steps employed in analyzing the results and estimating accuracies are similar to those used in the Utah project. This includes comparisons of positions and position differences between the two aircraft antennas. The aircraft antenna position differences are compared to the true chord distance. The consistency of the height difference between the two antennas is evaluated. An initial report on analysis of the Antarctic airborne data should be available later in 1994.

Operational Aspects

Successful airborne GPS operations in the NAPP projects depend on many factors, such as field operation procedures, data quality, methods for data processing and for obtaining the required positional accuracies, and the handling of critical geodetic considerations. Also, the success of a project depends on the technical capability and performance of those responsible for providing the service. Thus, the process for selecting a contractor is important.

Factors Affecting Data Quality

Factors that are significant sources of error are the effects of multipath, signal shadowing, ionospheric effects, tropospheric effects, and extraneous radio frequency interference (RFI) or signal jamming.

Multipath

The effect of multipath (reflected signals) and impact

on data quality is prominent at times in both projects. Typically, the impact is qualitatively most significant for the pseudorange data. At the aircraft antenna, multipath signals are reduced by the airframe vibration, pitch/roll/yaw dynamics, and overall motion of the aircraft. Error impact at ground reference stations may be more consequential because of the static relationship of the antenna to static sources. This requires careful study when planning for the location of a station. Sources of reflected signals should be avoided.

Signal Shadowing

Terrain and aircraft bank angle will affect the availability of signals. The antenna placement on the aircraft is an important design and engineering consideration. Maintaining continuous lock on the GPS signals depends on the antenna design and receiver signal acquisition capability. Two receiver/antenna systems on the aircraft help to ensure that gaps in the aircraft positioning are avoided or are very small. This appears to have been true of the two-antenna systems employed for the two projects. At the ground station, avoid deploying antennas at sites with obstructions above 10°.

Ionospheric Effects

Ionospheric refraction is a significant error source. This error source can be controlled with data from dual-frequency receivers. In dual-frequency solutions, corrections for refraction errors are accurately estimated. Another concern with ionospheric effects is when major sunspot or solar flare activity occurs. During these intense ionospheric disturbances, the reception of signals from one or more satellites may be interrupted.

Tropospheric Effects

Tropospheric refraction effects are another significant source of error. The experience has shown that the use of standard weather models removes errors in the differential processing. These models are based on assumptions of homogeneous meteorological conditions. Therefore, if there are major differences in the meteorological conditions between the aircraft and a ground reference station, data from this station may produce results with large residual errors. The possibility of a major meteorological disturbance at a reference station is another reason to plan for acquiring data from a minimum of three land-based reference stations.

Radio Frequency Interference

RFI can affect the operation of GPS receivers. The signals from the GPS satellites are very weak. In the presence of RFI, the GPS signals may not be tracked (that is, they may be jammed) or the quality of observations may be unacceptable. During the Utah project, one of the reference stations experienced interference from microwave signals. This caused severe problems in collecting data on the L2 frequency. The site was eventually abandoned for an alternate location. To help avoid this type of problem before a

project begins, a set of test data should be collected and evaluated for each of the proposed reference stations.

Also, RFI can cause problems with GPS observations on an aircraft. The source may be external, such as high-powered radar or other transmissions from ground stations. Internal sources for RFI may be the aircraft's radio communication system. Placing the antenna preamplifier very close to the antenna and using specially shielded cable will help to avoid problems with internal RFI sources. The receiver electronics design and capability may also be factors in reducing problems with RFI.

Geodetic Considerations

The successful application of airborne GPS for photogrammetry requires a clear understanding of GPS technology and the methodologies for processing, analyzing, and adjusting the positions for the camera exposure stations. It is most important to understand the underlying geodetic considerations.

In a recent paper that provided an overview of the primary geodetic considerations in GPS-assisted photogrammetry, several issues were discussed (Chaplin and others, 1994). Among the issues were coordinate systems and datums, the antenna-camera offset vectors, the effect of the aircraft dynamics during each camera exposure, understanding height systems, the accuracy of geoidal models, and orthometric height estimation techniques. The authors concluded that airborne GPS control for aerotriangulation block adjustments is viable if a rigorous geodetic approach is adopted.

Contracting Selection Process

The contractor for the Utah project was chosen by a qualification-based selection process that was important in helping to ensure the project's success. Successful application of the fast-paced developments in airborne GPS technology requires innovation and flexibility. Successful results depend on the contractor's being technically capable of performing at high standards. Airborne GPS operations and proper application of strategies for the data processing and the analysis of results are new services for most aerial photography companies. Thus, a qualification-based process appears to offer the best approach for procuring aerial photography services that include collecting airborne GPS data and delivering accurate positions for each camera exposure station.

Summary and Future

Airborne GPS offers a flexible and cost-effective alternative to land-based methods for obtaining the geodetic control needed in aerotriangulation block adjustments. This has been demonstrated in small projects involving a few hundred kilometers of flight lines. However, there are no reports of experiences gained with large projects. In 1993, the USGS performed two airborne GPS projects that covered a wide area of space and involved several thousand kilometers of flight lines. The projects were located in Utah and in Antarctica. Operational problems occurred during both

projects, most minor and similar in nature, but some of the problems were unique and location dependent. Today, most of the factors that caused the problems in 1993 can be controlled, minimized, or avoided.

The constellation of GPS satellites is now complete, with 24 or more satellites. The number of satellites in view is important in determining whether the required accuracies for airborne GPS-derived positions can be achieved. Most of the receivers used in 1993 have been upgraded with improved or enhanced capabilities. Compared to 1993, today better quality data can be produced. Significant enhancements are occurring in the data processing software. Methodologies and strategies for analyzing the results continue to improve. In particular, to achieve reliable estimates for position accuracies involves a series of well-defined computational steps and precautions.

The USGS plans to continue exploring the cost-benefits of using airborne GPS for photogrammetry. Several research topics warrant further investigation, such as accuracies required from GPS methods for the camera station coordinates. The research project involving a test block from the 1993 Utah project should help to answer questions of concern in production operations.

Though the full 24 GPS satellite constellation is now available, airborne GPS technology is still evolving. Reliable operations are still a concern, particularly for wide-area projects such as the NAPP and the Antarctica projects. Significant improvements in receiver design and enhancements in the processing software are expected to continue for the near future. A few more years will pass before the technology matures. By the beginning of the 21st century, extensive use of GPS positioning technology for photogrammetry and integration with other airborne sensors is expected. In these intervening years, careful planning and maintaining an awareness of potential sources of problems are critical for successful operations. Experiences gained will result in expanded applications and refinement of procedures for airborne GPS operations.

References

Ackermann, F., 1992. Prospects of Kinematic GPS Aerial Triangulation, *ITC Journal*, 1992-4, pp. 326-338.

Cannon, M. E., Schwarz, K. P., Wei, M. and Delikaraoglou, D., 1992. A Consistency Test of Airborne GPS Using Multiple Monitor Stations, *Bulletin Geodesique*, Vol. 66-1, pp. 2-11.

Chaplin, B. A., DesRoche, D. E., Greening, W. J. T. and Robinson, G.L., 1994. Geodetic Considerations in GPS-Assisted Photogrammetry, *Fourth International GPS/GIS Conference*, Washington, D.C., 11 p.

Craun, K., Hothem, L. and Cyran, E. 1994. Mapping Applications of the Global Positioning System on Airborne Platforms, *ASPRS/ACSM Annual Convention and Exposition*, Reno, Nevada, 12 p.

New Zealand Antarctic Society (NZAS), 1994. GPS Used by New Zealanders for Mapping in the Ross Dependency, *Antarctic Bulletin*, Vol. 13, No. 5, pp. 186-189.

GPS Aided Photogrammetry

ROBERT KLETZLI

Abstract

Photo Science, Inc. has been active the acquisition of control data through airborne GPS for several years. This paper documents the status of development of this technology in the production environment. Separate discussions cover hardware, software and procedures currently in use and further discussion addresses the levels of performance achieved under various configurations of ground station deployment.

Aircraft Configuration

To this point, both conventional photography and several forms of sensor data were collected using a twin engine Piper Aztec aircraft equipped with a Wild/Leica RC-20 camera system. This camera system has several advantages for Photo Science's methods of data capture. Photo Science uses color photography extensively and frequently queues projects requiring multiple emulsion types. The compact magazine configuration enables the air crew to carry several film types and to switch between types in the air. This type of camera system required no modification for airborne GPS collection due to the fact that the camera design outputs an electrical pulse at the mid-point of the exposure sequence (midpulse). Prior to the Spring of 1994, Photo Science obtained a Navajo Chieftain. Numerous upgrades were performed to this aircraft to support an array of acquisition needs. These include twin camera capability. Both openings and the on-board electronics are equipped to operate twin RC 20 systems for the simultaneous acquisition of black and white and color or conventional photography and other sensor data. The larger cabin size provided space to add a surveyor and all equipment necessary to operate a ground station to support airborne GPS. The surveyor travels with the flight crew and is responsible for the location and establishment of the ground station at or near the project site for use during photographic acquisition.

A L1/L2 GPS antenna was required on the aircraft and needed to be positioned directly above the nadir point of the camera. To accomplish this the aircraft was levelled in flight during a period of calm weather and the camera mount was levelled. The plane landed leaving the camera in this levelled position. Once in the hangar, three large jacks were placed under the wings and tail to recreate the aircraft's normal flight attitude using the camera level as a reference. A calibration quality 1/4" glass flash plate was obtained and used to determine the nadir point of the camera. This point, which was determined from the current USGS cali-bration report was marked on the glass plate. The film magazines and transport module of the camera were removed and the flash plate was carefully aligned to the fiducial marks. A plumb bob was used to transfer the point of symmetry (nadir point) to the top of the aircraft's fuselage. A small hole was drilled through the fuselage of the aircraft by the mechanic and used for reference for the installation of the antenna. A mark was placed on the outside of the antenna to mark the phase center determined by the manufacturer. When the antenna installation was completed and approved, a theodolite was set up in various locations around the aircraft and the phase center of the antenna was sighted). This sight was projected back onto the glass plate of the rear camera. These multiple setups allowed a highly accurate triangulation of the final planimetric position of the antenna with respect to the camera's film plane. The vertical offset was determined using a steel engineers tape and adding the offsets for the glass plate, aircraft skin and internal antenna offset.

GPS Hardware

GPS data are collected using three Ashtech P12 (now Z12 to nullify the effects of anti- spoofing) carrier phase, dual frequency, full wavelength L1 and L2 (P-code) receivers. Post processing is accomplished using Ashtech differential processing software. Photo Science has also incorporated and is in beta test for Ashtech PNAV software.

Post Processing

PNAV (Precise Differential GPS Navigation and Surveying) uses a recursive KALMAN filter parameter estimation technique that has the ability to resolve ambiguities while the roving receiver is in motion. Unlike standard kinematic processing PNAV does not require static initialization or an antenna swap to solve the ambiguities and therefore does not require the aircraft to be returned to an initialization point if lock on the satellites is lost. A linear combination of full wave length L1 and L2 is used to create an effective 86cm wide-lane (WL) which is used to rapidly fix ambiguities (usually after just a few epochs) and set the initial state for the KALMAN filter. The speed and reliability of this method are affected by the following factors:

Pseudo-range bias and noise
Carrier phase bias and noise
Multipath
Baseline separation
Satellite geometry

In general using Z12's if :

> PDOP is < 4
> you are observing > 5 satellites
> baseline is < 15km
> you have a minimum number of cycle slips
> caused by obstructions

PNAV will resolve the integer ambiguities in less than 5 minutes. If the baseline is longer than 15km and the other criteria is met the following formula provides good results.

(baseline in km + recording interval in seconds) / 2 = minutes of observation time.

Another feature of PNAV that is extremely advantageous is the backward and forward processing algorithm. This feature expands the range of the solution by processing data in both directions. Airports are usually not available at the center of an airborne project as would be optimum. It is common for the closest airport to a project site to be 20km to 100km. Without the forward and backward processing the aircraft would be required to remain on the apron for 50 minutes (using the formula above) prior to the flight to resolve the initial baseline. Using the bi-directional algorithm the aircraft is only required to remain stationary for 10 minutes before and 10 minutes after the photo mission. The software resolves the ambiguities continuously throughout the flight. If the airport is over 100km from the project site, the receiver is activated in flight 15 minutes before photographic acquisition and remains on for 15 minutes post-mission. Provided we have met all conditions stated above, the software always resolves the mission.

During data capture, one second epochs are acquired for most photo missions. The Z12 receivers have been upgraded to their current maximum capability of 6mb of internal memory which provides for approximately four and one half hours of observation time. An independent on-board computer ruggedized for aviation operations is used for flight management and can provide additional storage if a particular project requires a longer observation window.

Immediately after the flight mission, the project surveyor returns to the airport and the mission data are transferred to QIC 80 tape cartridge for backup and post-processed to review data quality. The Ashtech software provides the tools to perform linear interpolation of the precise photo center time tags onto the one second epoch data set and provides an RMS position error for that epoch. After verification of the results the aircraft, flight crew and surveyor take off and fly home or to the next project.

Aerotriangulation

A number of photogrammetric analytical block adjustments have been adapted to accept the airborne GPS data. Photo Science has selected ISBBA (Interactive Simultaneous Bundle Block Adjustment) produced by Dr. Riyadh Munjy. ISBBA is based on the rigorous and advanced mathemati-

cal approach of simultaneous bundle adjustment method for the solution of the block aerial triangulation problem. The redundancy of the image coordinate data is effectively utilized in a generalized least squares adjustment model. Full self calibration capability as well as error checking and blunder detection are incorporated. The option to include additional block parameters in the bundle adjustment is extremely useful when GPS drift has occurred on a project. The ISBBA software converts all airborne data from geodetic coordinates to earth centered earth fixed (ECEF) tangent to the center of the project area. These coordinates essentially become a local system throughout the adjustment process and are converted back to geodetic coordinates after the adjustment. The antenna eccentric is an input parameter and also modeled by the software.

Project Name	Satellites Visible	Exposures	Distance to Base Station	Photo Scale	RMSE (m)
COE 29 Palms	7	42	0	1:2500	0.21
DOE Paducah	8	630	0	1:7200	0.09
DOE Portsmouth	7	625	0	1:7200	0.12
COE Ft. Benning	6	23	0	1:10,000	0.14
Carnegie Mellon	6	47	0	1:10,000	0.19
Amherst	5	75	30	1:10,000	0.24
COE 29 Palms	7	90	0	1:10,000	0.21
NPS Assateague Isl.	6	80	120	1:12,000	0.32
Sebring	7	102	30	1:12,000	0.21
COE Yakima	9	90	0	1:12,000	0.20
DOE Paducah	8	580	0	1:14,400	0.18
DOE Oak Ridge	7	385	0	1:14,400	0.16
DOE Portsmouth	7	675	0	1:14,400	0.16
COE Ft. Meade	7	75	55	1:15,000	0.16
COE Ft. Irwin	7	26	0	1:20,000	0.17
Maryland DNR	9	780	50	1:40,000	0.78
SCS Chestnut Creek	8	92	130	1:40,000	0.53

TABLE 1

This table represents a sampling of projects undertaken by Photo Science using airborne GPS for mapping control. In most cases, the projects listed involve the production of planimetric, topographic and digital orthophoto map products which meet or exceed National Map Accuracy Standards. For each project, the table indicates the number of satellites visible at the time of the mission (column 2), the total number of exposures (column 3), the distance in kilometers to the base station (column 4), the photo scale (column 5), and the Root Mean Square Error (RMSE) derived from the aerotriangulation adjustment (column 6).

Overview of Accuracies Obtained Using Airborne GPS

Flight planning incorporates perpendicular flight strips at the extreme ends of the photographic block to aid the software in resolving the solution with no ground control. Typically, five control points (acquired conventionally) are located near the four corners of the block and at the center to verify the airborne solution and bundle results. The solution of airborne GPS heights is performed using the ellipsoidal height of the base (ground) station so that all airborne heights are in the ellipsoidal system. Elevations relative to the geoid are normally desired so that the geoidal heights must be applied to the airborne heights. The most accurate method of determining a local geoid height is to

perform a ground survey where vertical control points are occupied. The locally derived geoid heights can then be applied to the appropriate photo heights to obtain the proper elevation.

Performance and Conclusion

As shown on the enclosed chart, more than 6000 frames of airborne data have been captured. As much of it has been flown this spring, we have final adjustment results for about one half of the projects. Please note the sixth column headed by the title RMSE - these results are the residuals of ground control points withheld from the aerial triangulation software. The better results seem to be the projects flown after December 28, 1993 when we upgraded our P12 receivers to the new Z12 components. The observed data appears to be much cleaner and processing typically yields more accurate results in fewer epochs. Generally it can be stated that based on current experience it is possible to obtain airborne photo centers accurate to 1 part in 10,000 of the flight height. Further experience with multiple ground stations has shown that it is possible to resolve each epoch to the 3-7cm range if two receivers are set up within the project area while recording one second epochs.

CHAPTER 4

Storage And Compression

Introduction

CHARLES K. TOTH

Storing and retrieving large volumes of high resolution digital imagery in softcopy photogrammetric systems require huge amounts of data space and advanced data transfer techniques. The diference in hardware between general-purpose and photogrammetric workstations is actually characterized by two features: 3-D displaying capabilities and large capacity short- and long-term storage subsystems. Compression is an integral part of any large volume information processing and archiving system. Images usually exhibit quite high degrees of redundancy; thus, they compress well. This chapter introduces the basics of compression techniques and provides an overview of currently available data storage technologies.

The first part of this chapter addresses the theoretical foundations of digital image compression. The discussion explains the concepts of various techniques and focuses on the specific needs of daily photogrammetric production along with practical comparisons. The second part deals with wavelets, a rapidly progressing technique primarily affecting image compression and feature extraction algorithms. Finally, the third section of this chapter lists and evaluates current and future storage technologies.

Image Compression in Photogrammetric Practice: An Overview

CHARLES K. TOTH

Abstract

Storage and data compression techniques are vital components of any digital photogrammetric system. In fact, without advancements in storage and data compression technologies, there would be no practical use of digital photogrammetry besides academic research. During the past few years, several lossy and lossless compression techniques have been developed and have gained acceptance. Although storage technology is developing rapidly (and the available storage capacity is endlessly growing), there are two important reasons to use adequate compression techniques. First, data access and transfer rates are proportional to the actual data size. Second, data processing time depends greatly on the data size. Compression is based on the inherent redundancy of the images, and thus, carefully implemented algorithms can execute faster on compressed datasets. This will be an issue in the future when autonomous procedures are expected to replace most tedious manual measurements. When using lossy compression techniques, it is important to know their impact on geometry and accuracy. This paper gives a dedicated summary of compression by addressing those aspects that are important to the photogrammetric practice.

Introduction

In recent years, there has been an increasing demand for handling images in digital form. Direct acquisition of digital images is becoming more common as sensors and associated electronics improve; the use of satellite imaging is a good example. Computer tomography and magnetic resonance imaging in medicine generate images directly in digital form. The recent introduction of high resolution image scanners signaled the arrival of the new era of softcopy photogrammetry. Photographs can now be easily converted into digital form.

The majority of modern business and consumer usage of photographs and other types of images takes place through more traditional analog means. The key obstacle for many applications is the vast amount of data required to represent a digital image directly. A digitized version of a single, color picture at TV resolution contains on the order of one million bytes; 35 mm resolution film requires ten times that amount; a LANDSAT multispectral scene or a standard 9" by 9" aerial photograph may reach the billion byte range. Modern image compression technology, a branch of digital image processing, offers a possible solution. State-of-the-art techniques can compress typical images from 1/3 to 1/50 their uncompressed size without visibly affecting image quality.

There are two main applications of image compression: transmission and storage. In photogrammetric practice, storage is currently the major concern. Photographs are scanned in large numbers, and vast amounts of data must be reliably stored. The newly emerging fully digital mobile mapping systems are also based on local data archival.

This paper starts with a brief introduction to the basic concept of image compression, followed by a summary of the compression techniques. The emphasizing is on continuous-tone images. The third part deals with the radiometric and geometric degradations inherent in all lossy compression schemes. Finally, after the conclusion, an extended bibliography is provided for interested readers. Papers [1] and [2], and books [10] and [13] provide excellent overviews.

Image Compression

Compression techniques focus on reducing the number of bits required to represent an image by removing or reducing redundancies in images. The compression ratio (CR) is defined to be:

$$CR = \frac{\text{Number of bits for original image}}{\text{Number of bits for compresses image}}.$$

It is important to note that the CR parameter is defined for a digital image, and thus, it doesn't say anything about how well the digital image represents the real object scene. An overall parameter would depend on the sampling rate, the quantatization levels, film grain noise, etc..

Types of Redundancies

Data and digital images in their canonical representation contain a significant amount of redundancy. In general, three types of redundancy in digital images can be identified:

- Spatial redundancy, which is due to the correlation between neighboring pixel values (e.g., still continuous-tone images);

- Spectral redundancy, which is due to the correlation between different color planes or spectral bands (e.g., satellite imagery in remote sensing);

- Temporal redundancy, which is due to the correlation between different frames in a sequence of images (e.g., video frames).

Without redundancy there is no compression. The ob-

jective of image compression is to eliminate or significantly reduce redundancy — in theory, to make images free of redundancy.

Source Models and Entropy

Any information-generating process can be viewed as a source that emits a sequence of symbols chosen from a finite alphabet. The simplest form of an information source is the discrete memoryless source, in which successive symbols produced by the source are statistically independent. It is reasonable to assume that the occurrence of a less probable symbol should provide more information than the occurrence of a more probable event. Furthermore, the information of independent symbols taken as a single event should equal the sum of such events. Based on the above intuitive properties, we define the information of some symbol $ s_i $ in terms of its probability $p(s_i)$:

$$I(s_i) = log \frac{1}{p(s_i)} \cdot$$

The average amount of information per source symbol ($H(S)$) is also known as **entropy**:

$$H(S) = \sum_{i=1}^{N} p(s_i)I(s_i) = -\sum_{i=1}^{N} p(s_i)log_2 p(s_i) \ [bits/symbol].$$

If the symbol distributions were uniform, the entrophy would have a maximum at

$$H(S)_{max} = log_2 N.$$

The redundancy is defined as

$$R = H(S)_{max} - H(S).$$

The objective of coding is to achieve a code in which the average length of the code approaches the entropy. Code efficiency is defined as the ratio of the two:

$$\eta \ (code \ efficiency) = \frac{H(S)}{\overline{L}},$$

where the average length of the code is denoted by \overline{L}.

Operation Modes

A wide range of compression techniques have been developed over the years, several new methods are currently being developed, and novel approaches continue to emerge. Although classifying compression techniques is becoming more and more difficult, they can be always categorized into two fundamental groups: **lossless** and **lossy**. Similarly, there are only a few typical modes of operation of continuous-tone image compression systems (which have been exemplified

in the JPEG still image compression standard):

- **Sequential encoding**, each image component is encoded in a single left-to-right, top-to-bottom scan;

- In **hierarchical encoding**, the image is encoded at multiple resolutions, so that lower resolution versions may be accessed without first having to decompress the image at its full resolution;

- In **progressive encoding**, the image is encoded in multiple scans for applications in which transmission time is long, and the viewer prefers to watch the image build up in multiple coarse-to-clear passes.

- **Lossless encoding** means that the image is encoded to guarantee exact recovery of every source image sample value.

These modes are generally available on high-end softcopy scanning systems.

Coding

The following section summarizes the most important coding schemes used in image compression for continuous-tone images.

Huffman Coding, Arithmetic Coding

Huffman coding [6] can encode source symbols with an average bit rate arbitrarily close to the source entropy. Huffman coding is based on the probablities of symbols, assigning shorter codes to high frequency symbols and longer ones to low frequency ones.

To achieve a reasonable coding efficiency with Huffman coding, the sequence generated by the source is generally divided into blocks, and each block is assigned a variable-length codeword. There is a one-to-one correspondence between the codeword blocks and the source sequence blocks. In comparison, arithmetic encoding [16] is a nonblock code, where a codeword is assigned to the entire input sequence s_m of length m symbols. For any sequence, the subinterval generated by arithmetic coding has a width equal to the probablity of the sequence.

Lossless Predictive Coding

For typical images, the values of adjacent pixels are highly correlated; that is, a great deal of information about a pixel value can be obtained by inspecting its neighboring pixel values.

Each pixel is represented by k bits ($K = 2^k$), and a given pixel x_m depends on the values of the m previous pixels. For each state, the lookup-table provides the estimated value of x_m that maximizes the conditional probablity of x_m based on the m previous pixel values.

To eliminate the need for a potentially large lookup-table, the prediction can be formed as a linear combination of the m previous pixel values. Linear prediction is suboptimal, compared to nonlinear prediction, which maximizes

conditional probability, but it results in significant reduction in complexity and storage.

Complex lossless predictive coding schemes are typically used to transfer images down from space.

Lossy Compression

In lossy compression schemes, degradations are allowed in the reconstructed image in exchange for a reduced bit rate as compared to lossless schemes. It includes three components: **image decomposition** or **transformation, quantization** and symbol **encoding**. The goals of transformation are (1) to reduce the dynamic range of the signal and (2) to eliminate redundant information, i.e., to provide a representation that can be coded more efficiently.

The primary difference between lossy and lossless schemes is the inclusion of quantization in lossy techniques. The type and degree of quantization has a significant impact on the bit rate and quality of a lossy scheme.

Any components of a lossy scheme may be implemented in an **adaptive** or **nonadaptive** mode. A compression scheme is adaptive if the structure of a component or its parameters changes locally within an image, taking advantage of variations in local statistics. Adaptivity offers the potential for improved performance in exchange for an increase in complexity.

Transform Coding

A general transform coding scheme involves subdividing an $N \times N$ image into smaller $n \times n$ blocks and performing a unitary transform on each subimage. A unitary transform is a reversible linear transform whose kernel describes a set of complete, orthonormal discrete basis functions. The goal of the transform is to decorrelate the original signal and subsequently to redistribute the signal energy among only a small set of transform coefficients. In this way, many coefficients can be discarded after quantization and prior to encoding.

Though it would be desirable to use image-dependent basis functions, finding the basis functions would be a computation intensive task. As a result, image-independent basis-functions are generally used. Furthermore, the ideal transform packs the most amount of energy in the fewest number of coefficients and also optimizes the number of operations required.

The most commonly used image transforms satisfying the above conditions are:

- the **Karhunen-Loéve** transform (KLT), which is the optimal transform in the energy-packing sense, i.e., the KLT coefficients will contain a larger fraction of the total energy as compared to any other transform;

- **Discrete Fourier Transform** (DFT), which is a very commonly used transform for spectral analysis and filtering and has a fast implementation (FFT);

- **Discrete Cosine Transform** (DCT), which also has a fast implementation as DFT, but it also has a higher

compression ratio since it avoids the generation of spurious spectral components;

- **Walsh-Hadamard** transform, which is far from optimal in an energy-packing sense, but its simple implementation made it popular, especially for hardware implementations.

- Wavelet transforms (DPWT) represent an emerging compression technique, featured by joint space and transform domain localization properties, see [3].

JPEG: Still Image Compression Standard

For digital image applications involving storage and transmission to become widespread in today's marketplace, a standard image compression method is needed to enable interoperability of equipment from different manufacturers. One example is the CCITT recommendation for Group 3 fax machines [14]. The Joint Photographic Experts Group (JPEG) has been working toward establishing the first international digital image compression standard for continuous-tone (multilevel) still images, both grayscale and color, see [5], [8], [12], and [15].

Baseline System

JPEG's proposed image-compression standard is based on Discrete Cosine Transform (DCT). DCT-based compression is essentially the compression of a stream of 8×8 blocks of grayscale image samples. Color image compression can then be approximately regarded as compression of multiple grayscale images, which are either compressed entirely, one at a time, or are compressed by alternately interleaving 8×8 sample blocks from each in turn.

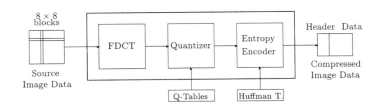

FIGURE 1
JPEG Still Image Compression.

At the input to the encoder, source image samples are grouped into 8×8 blocks and input to the Forward DCT (FDCT). Each 8×8 block of source image sample is effectively a 64-point discrete signal, which is a function of the two spatial dimensions x and . The FDCT takes such a signal as its input and decomposes it into 64 orthonormal basis signals. The output of FDCT is the set of 64 basis-signal

amplitudes or "DCT coefficients" whose values are uniquely determined by the particular 64-point input signal.

DCT coefficients are quantized, which may introduce some loss to the accuracy. The purpose of quantization is to achieve further compression by representing DCT coefficients with no greater precision than is necessary to achieve the desired image quality.

The final DCT-based encoder processing step is entropy coding. This step achieves additional compression losslessly by encoding the quantized DCT coefficients more compactly based on their statistical characteristics. Two methods, the Huffman coding and arithmetic coding, are used in the JPEG proposal. Huffman coding requires that one or more sets of Huffman code tables be specified by the application. The same tables used to compress an image are needed to decompress it. Huffman tables may be predefined or computed specifically for a given image in an initial statistics-gathering pass prior to compression.

Extended System

The extended JPEG system has several additional functionalities. It offers a lossless DPCM scheme with Huffman or arithmetic encoding. It also offers increased, 12 bits/pixel source image precision, which is available with sequential or hierarchial buildup with arithmetic coding.

MPEG: A Video Compression Standard for Multimedia Applications

Video compression may seem to be a task remote from routine photogrammetric practice, but video recorders are already showing up on mobile mapping systems as supplemental data logging devices.

The MPEG video compression algorithm (see [4] and [7]) relies on two basic techniques: block-based motion compensation for the reduction of temporal redundancy and transform domain-based compression for the reduction of spatial redundancy. Information relative to motion is based on 16×16 blocks and is transmitted together with spatial information. Motion information is compressed using variable-length codes to achieve maximum efficiency.

Temporal Redundancy Reduction

Because of the importance of random access for stored video and the significant bit-rate reduction afforded by motion-compensated interpolation, three types of pictures are considered in MPEG:

- Intrapictures provide access points for random access, but only with moderate compression;

- Predicted pictures are coded with reference to a past picture;

- Bidirectional pictures provide the highest amount of compression but require both a past and a future reference for prediction.

Motion Compensation

Motion compensation techniques assume that the current picture can be modeled "locally" as a translation of the picture at some previous time. Motion information is part of the information necessary to recover the picture and has to be coded appropriately.

Hierarchal Predicitve Coding

Hierarchical Predictive Coding (HPC) as described in [11] was based on a compression scheme for digital video sequences.

The algorithm starts by smoothing the gray values of the original image to a predefined, lower resolution. For instance, a square image of 1024×1024 pixels is decomposed into lower scale levels: 1024×1024, 512×512, 256×256, etc.. Then, difference images are computed between all levels. The original image can be reconstructed from its representation at the coarsest level (e.g., 64×64 pixels), and all the difference images. The pixel values of the difference images are usually small; therefore, they can be coded and stored by a lower number of bits. In order to achieve higher compression ratios, the number of bits of the difference images are reduced by quantization, which leads to image degradation and lossy compression.

Scale space algorithms play an important role in softcopy photogrammetry. Working with image pyramids, the processing starts at coarse level. Then, the higher resolution images are considered by improving the approximations. HPC coding not only supports these techniques but also has a built-in smoothing function that is also beneficial in scale space methods.

A similar scheme to HPC is used in Kodak's PhotoCD technology.

Practical Considerations

Despite the availability of a plethora of compression techniques, choice is currently quite limited for softcopy systems. This is mainly due to extremely large image sizes. The practical implementations for image sizes in the $10K$ by 10K range and beyond are very difficult and consequently rare. However, to achieve acceptable response times, compression, but more importantly decompression, should execute at a pace comparable to the speed at which data are moved to and from the storage device. This currently leaves us with only one technique, the JPEG scheme, which has hardware implementations to support fast, on-the-fly conversions. Lossless JPEG offers low compression rates for quality 9" by 9" images. Thus, lossy JPEG is the only alternative, and the quantatization factor is the only parameter needing attention, if compression is used at all.

Geometric and Radiometric Degradations

In a lossy compression scheme, the reconstructed image differs from the original image. Degradations are introduced in image quality in exchange for larger compression

rates. The difference between the original and reconstructed images is modeled by radiometric and geometric distortions. The geometric distortions are most important for softcopy photogrammetry because they change locations of image points and, consequently, influence the accuracy of objects reconstructed by photogrammetric procedures.

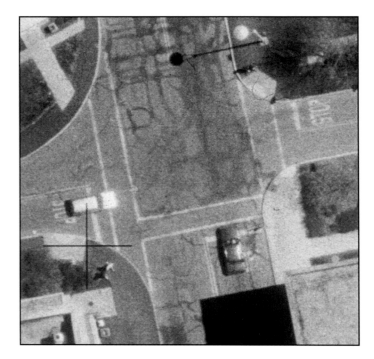

FIGURE 2C

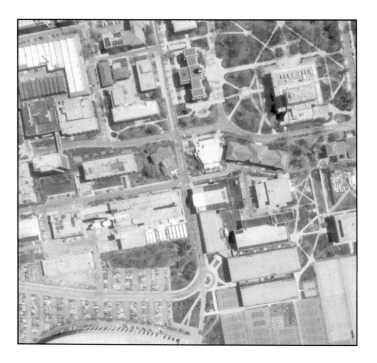

FIGURE 2A

Figure 2 shows a sequence of aerial images of the main campus of The Ohio State University. The standard 9" by 9" frame image was digitized at 30 micron resolution. Figure 2b and 2c show the central part of the image, a smaller patch of an intersection, at different zoom factors. Figure 3a-d shows four decompressed images that were compressed at different quantization (Q) parameters. The blocking effect of the JPEG scheme using coarse quantatization is very visible in Figure 3c and 3d.

FIGURE 3A

FIGURE 3B

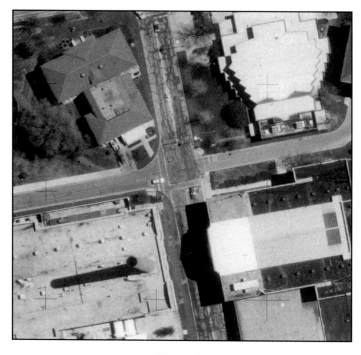

FIGURE 2B

FIGURE 3C

FIGURE 3D

The effect of geometric distortions is usually assessed by manual point mensuration or by autonomous point matching. In one investigation, [11], 2500 points were defined in the original image. In the reconstructed images their positions were found using the least-squares matching method. The authors concluded that geometric distortions for compression ratios below 5 can be neglected. The study included JPEG and HPC schemes with different quantatization parameters. Table 1 contains a summary of the main results of the comparative investigation.

	Aerial Image	Road Image	Target Image
Image entropy [bits/pixel]:	5.79	3.36	2.75
Image redundancy: [bits/pixel]:	2.21	4.64	5.25
Compression ratio:			
JPEG Q=100	1.3	2.4	2.9
JPEG Q=75	5.9		
JPEG Q=40	12.5	40.0	62.5
HPC scheme=8531	3.6	3.6	3.6
HPC scheme=8331	4.5	4.5	4.5
Radiometric distortion [gray bits]:			
JPEG Q=75	2.6	1.3	0.5
JPEG Q=40	4.0	1.4	0.5
JPEG Q=5	8.3	2.1	1.7
HPC scheme=8531	1.6	1.6	1.5
HPC scheme=8331	1.6	1.6	1.6
Geometric distortion [RMS pixels]:			
(Maximum dist. [pixels]:)			
JPEG Q=75	0.06 (0.3)		
JPEG Q=40	0.15 (2.5)		
JPEG Q=4	1.12 (17)		
HPC scheme=8531	0.05 (0.7)		
HPC scheme=8331	0.09 (2)		

TABLE 1

Radiometric distortion is determined by comparing the reconstructed image to the original one on a pixel by pixel basis. Again referring to [11], it was found that the average difference in pixel intensities is in the 1% range for compression ratios below 5. These results show that radiometric distortions depend to a limited degree on the level of quantization and therefore, increase with the compression ratio. This is very visible for JPEG, where block patterns show up in the reconstructed image if quantization level was set to a low value. The blocking effect of the JPEG scheme using coarse quantatization is very visible in Figure 3c and 3d.

A study of the accuracy of softcopy systems is found in [9]. Although image compression itself is not directly addressed in the paper, the results of comparing the accuracy of softcopy systems to analytical instruments are important since all the digital images used in the study were JPEG compressed at an approximate 1/3 rate.

Compression Rate

The achievable compression rate is influenced by several factors. Most of them, e.g., sampling rate, are system parameters specific to an application field and thus should be considered accordingly. The three primary factors affecting the compression ratio are:

- As the sampling rate is increased, pixel-to-pixel correlations increase, which allow for a higher compression ratio. However, it will result in a larger dataset due to the increased image size. The actual application should determine which is the required minimum sampling rate.

- Increasing the number of quantization levels reduces the pixel-to-pixel correlations to some extent, thus, reducing the achievable compressions. This is important if the radiometric quality of the image is the primary concern. For applications concerned only with point measurements, this is just the opposite; quantatization levels can go down.

- The presence of any noise will decrease the pixel-to-pixel correlations and reduce the achievable compression. Smoothing type filtering is inherent in the digitization process, and with or without additional noise filtering at the scanning phase, it can improve the compression rate.

Conclusion

Image compression is an integral part of softcopy systems. Handling very large digital images is already a daily practice. Currently, most of the commercial softcopy systems use the industry standard JPEG still, continuous-tone lossy image compression scheme. To achieve high performance, the compression is typically implemented in hardware.

The degradations introduced by the lossy compression scheme are under control. In general, radiometric and geometric distortions can be safely ignored at modest compression rates (CR $<$ 5). At this rate, the localization error is well in the subpixel range. Radiometric quality of the images tends to decrease before the geometry is severely affected.

In an era of very rapid technological developments, we are witnessing rapid advances in photogrammetry, resulting in the recent introduction of softcopy systems and their prompt acceptance. Currently, nonadaptive compression methods dominate the softcopy market because they are simpler, easier to implement, and thus, execute faster. However, adaptive schemes offer better compression rates with increased complexity. This is not feasible today, but the available processing power can change this situation quickly.

References

[1] Benjauthrit, B., and Yovanof, G., 1994. *An Overview of Data and Digital Image Compression Techniques*, 1994 Spring Conference on Solid-State Memory Technologies.

[2] Brenner, A., 1994. There Would Be No Imaging Without Compression, *Imaging Magazine,* January.

[3] Chan, Y. T., 1995. *Wavelet Basics,* Kluwer Academic Press.

[4] Committee Draft of Standard ISO 11172, 1990. *Coding of Moving Pictures and Associated Audio,* ISO/MPEG 90/176.

[5] Draft ISO 10198, 1991. *JPEG Digital Compression and Coding of Continuous-Tone Still Images.*

[6] Huffman, D.A., 1952. A Method for the construction of minimum-redundancy Codes, *Proceedings of the I.R.E.,* 1098-1101.

[7] LeGall, D., 1991. *MPEG: A Video Compression Standard for Multimedia Applications,* Communications of the ACM, Vol. 34, No 4, April.

[8] Loger, A., Omachi, T., and Wallace, G. K., 1991. JPEG Still Picture Compression Algorithm, *Optical Engineering,* Vol. 30, No. 7, July.

[9] Madani, M., 1993. *A Preliminary Study on Accuracy of a Digital Photogrammetric Workstation, Operationaliza-tion of Remote Sensing,* ITC Enschede.

[10] Nelson, M., 1992. *The Data Compression Book,* M&T Books, San Mateo, CA.

[11] Novak, K., and Shahin, F., 1994. A Comparison of Two Image Compression Techniques for Softcopy Photogrammetry, *PE&RS,* Vol. LXII, No. 6, pp. 695-701.

[12] Pennebaker, W. B., and Mitchell, J., 1993. *JPEG: Still Image Compression,* Van Nostrand Reinhold, NY.

[13] Rabbani, M., and Jones, P. W., 1991. Digital Image Compression Techniques, Tutorial Texts in *Optical Engineering.*

[14] Urban, S.S., 1992. Review of Standards for Electronic Imaging for Facsimile Systems, *Journal of Electronic Imaging,* Vol. 1(1), 5-21, January.

[15] Wallace, G. K., 1991. *The JPEG Still Picture Compression Standard,* Communications of the ACM, Vol. 34, No 4, April.

[16] Witten, I., and Neal, R., and Cleary, J., 1987. Arithmetic Coding for Data Compression, *Comm. ACM Computing Practices,* 512-540.

[17] Ziv, J., and Lempel, A., 1977. A Universal Algorithm for Sequential Data Compression, *IEEE Trans. on Information Theory,* Vol. IT-23, No. 3, May.

Wavelets and Their Applications in Photogrammetry and Remote Sensing Imagery

PALLAVI SHAH

The What and Why of Wavelets

"Wavelets" are a very popular topic of conversation in many scientific and engineering communities. Some think of wavelets as a new mathematical subject, some view them as a technique for time-frequency analysis, and some think of them as a new basis for representing functions. What is so peculiar about wavelets that makes them special in Photogrammetry and remote sensing imagery?

All this time, the guard was looking at her, first through a telescope, then through a microscope and then through an opera glass.

Lewis Carroll, Through the Looking Glass

The analysis of images often involves a compromise between how well transitions or discontinuities can be located and how finely the objects can be identified. The goal is "to see forest and trees." This involves looking at an image at different "scales" or "resolutions." The essence of wavelet transform is multiresolution or multiscale representation. By varying the window used, one can trade the resolution. As a result, wavelet transforms are better able to "zoom in" on very short-lived high frequency phenomena, such as transients or edges. Wavelets can be thought of as a band pass filter. Fine analysis is done with the contracted (high frequency) version of the wavelet, while fine frequency analysis uses dilated (low frequency) versions. Thus, the relative bandwidth of the bandpass filters remains constant. Wavelet transforms resemble the human visual model because of the varying window-size property of the wavelets.

Image Compression and Image Transforms

The biggest problem in handling photogrammetry and remote sensing imagery is that the images are far too large (of the order of gigabytes) to be handled as one unit. The images take too much storage space; also, it takes too long to transmit and load up an image file. The obvious solution to this problem is image compression. Wavelet transforms play a very important role in this aspect of photogrammetry and remote sensing imagery.

The goal of any image compression algorithm is to represent the information in the image with a considerably smaller number of bits and at the same time be able to reconstruct an image that is close to the original image. Traditionally, there are two basic techniques of image compression: spatial coding techniques and transform coding techniques. The transform method uses an invertible linear transformation to transform the given correlated image array to an array of uncorrelated variables that can be represented by a much lower number of bits compared to the original array. Image transforms thus serve as "deterministic" models for discrete images. In spatial coding schemes, an array of uncorrelated random variables is generated from the given image using an invertible transformation. The structure of the transformation is defined by appropriate models. By fitting these models to the given image, one generates the so-called residual, which is less correlated than the original image pixels and hence can be represented by fewer bits. Given the quantized residuals and the parameters of the model, an image close to the original can be generated.

Wavelet Transforms

The Fourier Transform is the simplest and most commonly used transform for obtaining the representation of frequency content in a signal or image. However, the information concerning the time-localization, such as high frequency bursts in a signal, can not be determined that easily from the Fourier transform. The basis functions for the Fourier Transform are the familiar sines and cosines.

FIGURE 1
(a) Coarse scale, low frequency basis functions: Long spatial extent, narrow bandwidth, useful for isolating trends or signals more localized in frequency. (b) Fine scale, high frequency basis functions: short spatial extent, wide bandwidth, useful for isolating anomalies such as edges.

On the other hand, the wavelet transform divides functions, data or operators into different frequency components and then analyzes each component with a resolution matched to its frequency or scale. The wavelet transform of a signal changing with time depends on two variables: scale (frequency) and time. In the wavelet domain, the basis functions are somewhat more complicated and have more fanciful names such as, "mother functions" or "wavelets." What makes wavelet basis functions more interesting is that, unlike sines and cosines, individual wavelet functions are quite localized in space. Also, like sines and cosines, individual wavelets are quite localized in frequency. Thus, wavelets provide a tool for time-frequency localization.

Wavelets use short windows at high frequencies and long windows at low frequencies. In general, different sets of wavelets make different trade-offs between how compactly they are localized in space and how smooth they are.

Image Compression Algorithm Using Embedded Zerotrees of Wavelets

In addition to compression, photogrammetry and remote sensing applications have a critical need to transmit, store, access, and browse through gigabytes of image information quickly and efficiently. A good compression algorithm associated with progressive transmission capability is needed to handle the photogrammetry imagery effectively and efficiently.

Traditional compression systems are designed for a particular purpose and are optimized for a particular class of images and for certain compression ratios. Additionally, using compression approaches for progressive transmission, the partial information corresponding to lower bit rates (or higher compression ratios) is never the best representation for that bit rate; thus, valuable time and bandwidth is wasted when it cannot be determined in advance where the stopping point is. The Embedded Zerotrees of Wavelets (EZW) approach solves these problems via its embedding and adaptivity feature. EZW ensures that the bits in the compressed bitstream are generated in order of importance, yielding a fully embedded code. All lower rate codes are embedded at the beginning of the bit stream. In other words, the information is ordered in numerical importance in the sense that the most significant bits of the largest wavelet coefficients are represented before bits of lesser significance. In order to understand this concept, let us consider the numerical representation of real numbers. All real numbers can be represented by a string of binary or decimal digits. Each new digit added to the right adds precision to the number. For example, consider the decimal representation of the real number

$$\pi= 003.14159265358979323....$$

Within the framework of decimal representation and with the "budget" of two decimal places at the right of the decimal point, the best representation of π is 3.14. With the budget of six decimal places, the best representation is 3.141592. Similarly, the embedded bitstream produced by

EZW compression represents a sequence of binary decisions, where each bit sequentially refines the image. Although the representation of images is much more complex than the representation of real numbers, the key to both is ordering the information in importance from coarse to fine information. Figure 2 shows how the embedded feature of compressed bitstream allows coarse to fine representation of the image at various points in the bitstream. The information is sequentially encoded so that at any truncation by either the encoder or decoder, the best EZW representation at the corresponding lower bit rate can be obtained. Higher compression ratios are obtained by the encoder simply by chopping off bits from the end of the bit stream. At the decoder end, progressive transmission is achievable, and the decoder can stop as soon as the quality is sufficient for the specific application.

This magnitude-based prioritization also makes intuitive sense. Most compression algorithms, even other wavelet compression approaches, implicitly define lower frequency coefficients as more important than higher frequency coefficients. In contrast, EZW treats larger coefficients as more important than smaller coefficients, regardless of the frequency range of the coefficient. Under most circumstances, large coefficients are also low-frequency. However, for high-contrast details, some high-frequency coefficients are also large; EZW would treat this detail information as extremely important and its representation would occur early in the bit stream. Thus, using EZW for progressive transmission allows some details to be represented much more quickly than in techniques that prioritize information by frequency.

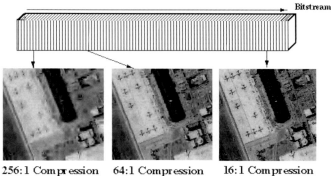

256:1 Compression
8192 bits decoded

64:1 Compression
32,768 bits decoded

16:1 Compression
131,072 bits decoded

FIGURE 2
EZW's embedded feature allows any target compression ratio to be met exactly.

The adaptivity feature circumvents the need for training the algorithm to a class of images. EZW is fully adaptive and it appears to work well with any image type. The main advantage of EZW is that it does not require prestored tables or codebooks and does not require any prior knowledge of the image source. The EZW algorithm is based on four key concepts:

1. A discrete wavelet transform or hierarchical subband decomposition which provides a complete multiresolution representation of the image.

2. Zerotree coding that provides a compact multiresolution representation of significant maps, which are binary maps indicating the positions of the significant coefficients. Zerotrees allow the successful prediction of insignificant coefficients and prediction of the absence of significant information across the scales by exploiting the self-similarity inherent in images.

3. Entropy-coded successive approximation quantization (Amplitude-precision analysis), which provides compact multiresolution representation of the significance maps and facilitates the embedding algorithm.

4. Universal lossless data compression achieved via adaptive arithmetic coding.

Figure 3 shows block diagrams of the generic transform coders and EZW coder. The penalty for using EZW is that, although it is several orders of magnitude faster than fractal compression, it requires approximately 2-3 times as much computation as DCT-based techniques such as JPEG. However, the compression performance obtained with EZW is far superior to that of JPEG at extremely high compression ratios and thus, will be more useful in a browsing scenario.

Embedded Zerotree Wavelet Coder

FIGURE 3
Block diagrams of the Generic Transform coder and the Embedded Zerotree Wavelet Coder.

A detailed description of how the algorithm works is beyond the scope of this book, and interested readers may refer to Reference [1] for additional information.

FAST (Fast Access Softcopy Tool)

The biggest problem in photogrammetry and remote sensing imagery is that the images are far too large (of the order of gigabytes) to be handled as one unit. Presently, sophisticated and expensive computers are used to handle these databases. COTS (Commercial On The Shelf) workstations can not handle such large files because they;

· take too long to load up a file;

· have limited display capability;

· have limited disk space.

Image analysts would be very pleased to get hierarchical and fast access to these images on the COTS. What are the key ingredients for handling such image databases? As discussed earlier, compression is needed to store the images in compressed form to save disk space. In addition, it would be very useful, to get multiresolution representation of the images. This feature will be useful, not only for accessing large images, but also for viewing the same image at variable display resolutions. In short, compression and multiresolution representation will take care of the storage and display problem. Transmission, however, may still be a problem. Image analysts often must browse through large databases to select the image of his/her interest. Downloading the entire full resolution image one after the other until he/she finds the one of interest is not a practical solution. Transmission bandwidth is one of the biggest problems we face in the imaging world. What we really need is a way to progressively transmit the image from very low resolution to high resolution. This will allow the fastest and most efficient access to the huge databases. Finally, the icing on the cake would be to have interactive use control allowing fast and efficient transmission and viewing of very large images without having to transmit and load the whole image in memory at once. This will also provide the ability to view images at multiple resolutions, allowing users to precisely navigate in real time through the image at various positions and resolutions. How do we get all this out of a single data representation? The solution is to store the image as a hierarchical tree of embedded compressed bitstreams and provide an interactive user interface for accessing the image databases. Consider an image of the size 32K X 32K with a GSD of 2 meters. Suppose the workstation's basic display size is 1K X 1K. To see the entire image on the screen, there must be a way to view a 1K X 1K image corresponding a GSD of 64 meters. Fastest access is achieved by storing an embedded compressed bitstream for the 1K X 1K, 64 meter image and then decoding and displaying it progressively.

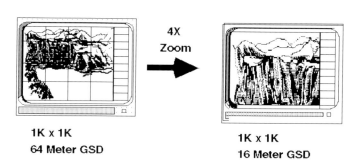

FIGURE 4
Interactive control of resolution: The image analyst can select a region and zoom (for example by 4X) to view more details at higher resolution.

FAST is a multiresolution fast access softcopy tool designed for viewing very large images on a workstation with limited communications, storage, and display capabilities. As shown in Figure 5, each image is stored in a multiresolution pyramid of compressed image tiles and can be decoded in real time using a specialized progressive transmission decoder of the Embedded Zerotree Wavelet (EZW) image compression algorithm, developed by the David Sarnoff Research Center. The compressed images can be viewed with the graphical user interface (GUI) in the X-windowing environment.

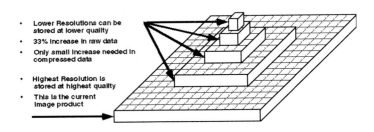

- Lower Resolutions can be stored at lower quality
- 33% Increase in raw data
- Only small increase needed in compressed data
- Highest Resolution is stored at highest quality
- This is the current image product

FIGURE 5
Image storage as hierarchical tree of compressed bitstreams: Each block represents 1K X 1K displayable image, and has its own compressed EZW bitstream.

In short, the following are user benefits addressed by FAST.

- Ability to precisely navigate through the image at various positions and resolutions in real time.

- Ability to view the full size, low quality image even when a portion of the bitstream is transmitted and decoded, allowing progressive buildup to the full quality as the transmission continues.

- Complete decoding of one view is not necessary to zoom or unzoom to another

- Interactive image loading allows the user to select the amount of data based on his/her needs.

- Ability to zoom in and decode a selected region of interest, thus avoiding the slow loading of the entire full resolution image into memory at once.

Smart Compression

Smart compression is the compression program's capability to steer the compression process to encode critical regions of interest with higher quality while maintaining sufficient quality in surrounding regions to preserve the context. Huge photogrammetry and remote sensing imagery often contains small but critical regions. If human or computer-generated knowledge is used to identify and favor critical regions of interest prior to compression, the massive storage and transmission requirements for handling such huge imagery can be greatly reduced. In addition, the critical information from the compressed bitstream can be decoded first during access or browsing. If less data can be used to perform analysis, the burden on communication networks when databases must be accessed remotely can be relieved.

Smart compression builds on the other core programs that use EZW technology for compression. The key concept here is that if you can perform database access by recognizing a feature of interest, you can also perform priority control for the purpose of improving data compression performance. Using Smart Compression, an order of magnitude improvement in compression efficiency is achievable. By favoring selected critical regions, as identified by automatic or user-interactive techniques, the algorithm can allocate more of its limited resources, i.e., bits, to accurately represent the most critical information.

References

Chui, C., 1992. *An Introduction to Wavelets, Wavelet Analysis and its Applications*, Vol. 1.

Daubechies, I., 1992. *Ten Lectures on Wavelets*, SIAM, Philadelphia, PA.

Shapiro, J. M., 1993. Embedded Image Coding Using Zerotrees of Wavelet Coefficients, *IEEE Trans. Signal Processing*, December.

Data Storage Systems

TED SCHWARZ, LAWRENCE J. PTASIENSKI, JOHN MERTZ,
LEON D. WALD, SUZANNE J. THOMPSON, GARY R. ASHTON,
JOHN W.C. VAN BOGART, AND JOSE KOPPUZHA

Foreword

Storage technology is undergoing changes at a very rapid pace. In order for the National Media Laboratory to stay alert to these changes, to predict the future adequately, and to provide timely information to customer inquiries, a program was started to examine, follow, and chart the progress of all data storage technologies. By continually investigating the data storage field, even without a pressing need for specific information, the National Media Laboratory is better prepared to respond to customer needs and to help influence the future of storage technology in a positive way.

The goal of this work was to study all forms of commercially available information storage devices: integrated circuit, optical, and magnetic.

Mature and new storage systems were investigated and assessed, with particular attention paid to industry trends. The information used in this assessment was gathered from vendors, users, technical documents, trade journals, and attendance at trade shows or technical conferences. Each section was authored by a different technical expert.

Linear Tape Systems

Introduction

Linear tape systems have been the backbone of computer data storage systems since the beginning of the computer age. Tape has continued to provide the lowest cost means of storing digital information. Variations are found across a wide range of computer data applications and requirements from large mainframe systems requiring high data rates (up to 9 Mbytes/sec) and high cost (>$1,000,000 library systems) to economical (< $100 individual end user system cost) PC backup systems. Linear tape systems may be divided into two categories: "fixed head," in which the data is recorded and/or played back on a single or, at most, a bidirectional pass down the length of the tape; and "serpentine," in which the head is moved and the tape direction reversed at the end of each full-length traverse at beginning or end of the tape to singly, sequentially record and/or play many tracks.

Reel-to-reel systems were the mainstay of early (circa 1953) computer systems for not only archival data storage, but, initially, for mass memory and software and data distribution. Individual drives were roughly refrigerator-sized. A large 10.5-inch diameter reel of data could contain up to 200 Mbytes of data. Most data archived today is still in this format. The last of these systems, developed and introduced

in the early 1970s for the large system commercial market was the IBM 3420. These were replaced in the mid-1980s by the IBM 3480, and, more recently, the IBM 3490 tape cartridge drives. The large reel was replaced by an approximately 4-inch by 4-inch 3480 cartridge containing 200 Mbytes. An individual drive was reduced in size to something only slightly larger than a bread box. These systems employed mechanically fixed heads and 0.5 inch (12.7 mm) wide tape.

Approximately twenty-five years ago, the forerunner of the Quarter-Inch Cartridge, QIC, was introduced. QIC systems employ a head that is stepped to the next track at each end of the tape, resulting in a serpentine track pattern, to achieve higher track density. Also utilizing this technique are the Data Cassette and the Digital Linear Tape. The former is derived from the ubiquitous audio cassette and the latter utilizes a cartridge that is nearly identical in configuration to the 3480/3490 cartridges. These systems are the basis of compact, relatively low cost, rugged, reliable tape systems. The intrinsic drive size of the larger form factor drives, DLT and the 5.25-inch QIC, are the approximate size of a hard cover novel, and the smaller form factor 3.5-inch QIC and the Data Cassette are only slightly larger than a paperback novel.

In the past several years, however, consumer-based helical scan technology has made significant inroads upon the data storage market. These are derived from the consumer VHS video recorder, the 8mm camcorder, and the 4mm digital audio recorder, DAT. Systems employing helical scan technology have been able to penetrate the data storage backup market by offering low-cost, high-capacity solutions. The larger capacity is achieved by a track density that is more than 10 times the best stepper head system track density. This is accomplished by employing azimuth recording to reduce adjacent track interference and a track center-finding servo. This may change, however, as thin film magneto-resistive (MR) heads and track-following servos are introduced into linear tape data cartridge systems that allow much higher track densities. One advantage of linear tape systems over helical scan systems are the life cycle costs. Linear tape systems have been less expensive to operate due to the lower head to tape speeds and reliability, due to the less torturous tape path.

The infusion of new technology into linear tape systems provides new life and a continued migration path to higher areal density and capacity. Track-following servos and MR read head technology are easily applicable to all forms of linear tape technology. The 3480 was the first to introduce MR head technology to any magnetic data storage system, nearly a decade ago. QIC systems are the first of the linear

tape systems to realize the full benefit of MR head technology. With an increase in areal density approaching 100X, tape technology should remain competitive with all other forms of mass storage technology for at least the next decade.

Helical Scan Recording

Introduction

Helical scan recording can be described as follows: a magnetic head or heads rotate within a cylindrically shaped column. The rotating heads interact with a magnetic tape partially wrapped around the cylindrically shaped column. The path that the tape follows around the cylindrically shaped column creates a helix. The track or scan which is recorded onto the tape is at an angle to the bottom edge of the tape. Thus, the name helical scan recording is derived.

The main advantages of helical scan recording are high data rates with high capacities per cassette.

Technology

There are two classes of helical scan recorders, video and digital data. The classes are derived from their intended application, with video historically being utilized in the broadcast industry and the home entertainment industry. Digital data, historically, has been involved with the computer industry. Today, the two industries are merging, and digital data recorders are finding applications in the broadcast industry. They will then move into the home entertainment industry, while continuing to be utilized in the computer industry.

The helical scan recorders have, historically (and the trend continues today), dominated the high data rate range for storage devices. A 1.2 Gbit/sec (150 MB/sec) recorder has been successfully demonstrated. There are commercially available systems that record data at 400 Mbits/sec. The chart below shows a sample of the helical scan recorders vs. other storage devices and their respective data rates. However, the industry trend today is to increase system throughput by utilizing a data compression technique, rather than

only pursuing increased data rates. Those applications that require higher data rates without compression will see a slowing in the system data rate growth.

Operation and Maintenance Costs

For high data rate helical scan recorders, the operating costs can be quite high, just for the normal maintenance required. The lower data rate machines have a maintenance philosophy of replacement, not repair. The life of the heads for helical scan systems is typically much shorter vs. linear tape systems, which translates into increased operational costs. An advantage is that helical scan systems offer much higher data rates than linear tape systems.

Media used in helical scan systems must be properly handled and maintained to insure reliable performance. Helical scan tape systems incorporate a tape path that is more complicated and potentially more damaging then a linear tape system. Also, the tracks per inch are typically higher then linear tape systems, which means the systems require tighter tracking control and adjustment of the tape path for recording and playback. This is especially true for the high data rate machines. Interoperability between different manufacturers systems utilizing the same format is dependent on the maintenance of the machine and the media. Also, the higher head to tape speeds in helical scan recorders forces the replacement of heads, or machines (some recorders do not allow simple head replacements, instead, machines are replaced) at a higher rate then linear tape systems. Time and material to maintain the higher data rate helical scan systems adds recurring cost, which can be substantial over time.

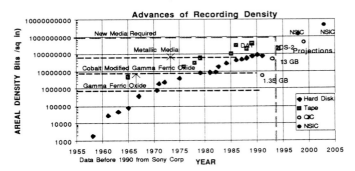

Trends

As can be seen from the chart above, researchers and developers are looking at higher areal densities for magnetic tape. The advantage of high capacity in a small area (areal density) is a major strength of tape systems in the future, and is driven by the advances in materials that translate into higher areal densities. As stated earlier, the continuance of ever-increasing data rates for helical scan systems is in doubt, with the advent of data compression techniques. Some of the lower data rate computer backup recorders (i.e., 8 mm) already offer compression, while the high performance systems do not. Which compression technique the manufacturers will use in future products is still very unclear.

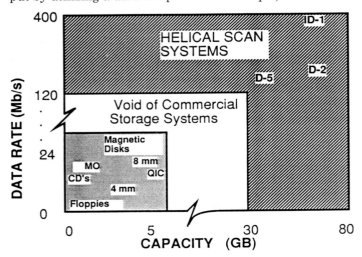

Another trend that becomes clear when looking at the marketplace, is that all of the high performance systems use 19 mm tape. There is also a price-performance relationship, with the higher data rate systems also having the highest system purchase costs and highest operating and maintenance costs.

Rigid Disk Systems

Introduction

The increasing popularity of notebook and sub-notebook computers and the hefty space requirements of today's operating systems and applications are fueling a demand for smaller, faster, higher-capacity magnetic disk drives. Drive-manufacturing technology, responding to demand and market competition, continues to provide the improvements necessary for industry survival. For example, areal density (the combination of linear and track density), which used to grow at a 25 percent annual rate, has been growing 60 percent annually since 1990. Industry observers predict that it will continue to do so for the foreseeable future.

Development of new technologies like magneto-resistive heads, digital read channel, and glass/ceramic media promise to increase capacity and data transfer rates while reducing access time, power consumption, and cost. This report discusses these new technologies as they relate to magnetic disk drives (MDDs).

Drive Technology Review

Magneto-Resistive Heads

Arguably, the greatest improvement to the MDD has been the development of magneto-resistive (MR) read heads. IBM introduced MR head technology in 1991, and continues to dominate research in this area.

Magneto-resistance is the property of certain materials to change their electrical resistance in the presence of a magnetic field. An MR head consists of a thin stripe of magneto-resistive material which is supplied with a constant sense current. Within the MDD, information is stored as tiny magnetized spots on the surface of a rotating platter. These spots generate extremely small magnetic fields which are detected by the head. As an MR head passes over a magnetic spot, the magnetic field causes the head's resistance to increase. The increased resistance produces a voltage increase and an output signal corresponding to a single bit of data. (Note that MR heads are only used to read data. An inductive head is still used to write to the disk).

MR read heads possess a number of advantages over common inductive read heads:

- Output signal strength is typically two to four times greater. This allows magnetic spots on the disk to be smaller and more densely packed.

- Smaller, more densely packed spots result in a substantial increase in areal density. Current inductive read heads can handle densities of 300 to 350 million bits

per square inch (bpi). Industry experts expect inductive technology to top out at 400 million bpi. MR head technologies capable of 2 billion bpi have already been developed. MR head technology is expected to reach 7 or 8 billion bpi by the end of the decade. Some observers expect MR technology to reach 10 billion bpi in the same time frame due to "giant magneto-resistance" (GMR). GMR technology produces an output signal more than five times that of conventional magneto-resistive technology. If this goal is realized, the common, 3.5", single-platter MDD will be able to store the equivalent of 10,000 300-page books.

- Volume production relies on a simpler manufacturing process.

There are, of course, drawbacks in moving to MR head technology:

- While the MR head itself is actually simpler to make than an inductive head, alignment of the read and write components is critical. This alignment is made more difficult due to tighter dimensional tolerances.

- Materials used in MR head manufacture corrode more easily.

Clearly, MR head technology will continue to offer the best hope for a new generation of ultrafast, miniature disk drives. However, important manufacturing issues need to be resolved before the technology can find widespread acceptance.

Digital Read Channel

The ability to pack more data into a given area means little if there is no reliable method to retrieve that data. Older analog technologies have a difficult time dealing with the head positioning and noise problems created by ever-increasing areal densities. A new technology, called digital read channel (DRC), promises to at least double the capacity of inductive read head drives by employing sophisticated drive electronics and digital signal processing (DSP) algorithms to help solve positioning and noise problems. Coupled with MR technology, DRC should help speed implementation of massive storage densities.

The heads of a magnetic disk drive "float" less than a hair's thickness over the surface of a rotating disk. The disk itself rotates at 3,600 revolutions per minute (although some manufacturers are using faster spindle speeds to achieve higher data transfer rates and shorter access times). The read head must be able to distinguish a particular magnetic spot on the disk from its adjacent neighbors. Therefore, it must be accurately positioned over the correct track.

A more complex problem exists when magnetic fields begin to overlap (as they do when bits and tracks are moved closer together). Magnetic field overlap results in noise that conventional analog read methods have a difficult time filtering out. This problem affects both inductive and MR read heads.

Companies such as IBM, Adaptec, and Cirrus Logic are developing low-cost drive controllers which incorporate digital positioning circuitry as well as DSP. The positioning circuitry allows drive manufacturers to place more tracks on the disk, while the DSP removes noise from the disk signals fast enough to keep up with the computer's data rates.

These new controllers use a DSP technique called partial-response, maximum-likelihood (PRML) that was originally used to filter interference from deep space probe communications. The raw drive signal is first converted to digital, then smoothed and equalized. The digital signal is then presented to the PRML algorithm which determines which signal peaks represent actual data and which are noise. Now that digital disk technology is feasible, users can expect even more sophisticated filtering algorithms.

Glass/Ceramic Media

Until recently, the vast majority of MDD platters were made from aluminum. However, the surge in demand for smaller form factor drives created a need to accommodate more platters in the same height enclosure. Due to "potato chip effect" (edge curl), typical aluminum disks cannot be made less than about 25-mils thick. Glass and ceramic substrate disks, which do not exhibit edge curl, can be made to thicknesses approaching 15 mils. These substrates are more durable than aluminum and their slightly higher cost can be easily justified due to their additional capacity. In addition, their lighter weight results in lower power consumption, a necessity for notebook computer applications. Areal Technology, Inc., a leader in 2.5-inch drives, uses only glass platters in its drives. Look for glass and ceramic substrates to appear in an increasing number of new MDD products.

Conclusions

Choosing a magnetic disk drive has never been easy. Today's buyers must face constantly changing product lines brought on by rapid technological advances. And while the dizzying pace of MDD technology makes products "obsolete" sooner, it also provides buyers with a myriad of choices. The expression "don't buy what you won't use" is especially applicable when choosing a hard drive. But, don't "under buy" either. "It's safe to assume that you will always wish you had more storage space."

Optical Tape and Cards

Introduction

Optical tape and cards comprise a very small but growing segment of the data storage marketplace. Only a few companies have ventured into manufacturing either hardware or media for these formats. As a result, promises of low cost and ready availability of a range of options have not yet been realized. For the most part, even field testing has been on a small scale.

Optical Cards

Several formats and implementations have been proposed for optical cards. Most of these are based upon the LaserCard developed by Drexler Technology Corporation (DTC), which holds many patents dating back to 1982, and which has licensed many other companies to develop alternate approaches and market the technology.

An optical storage card is a credit card-sized data storage medium containing a reflective area that stores information using optical recording technology. As implemented by Drexler, the recording layer is a photographic emulsion that may be patterned by traditional photolithography to prerecord or preformat the media during the manufacturing process. The layer then is converted by proprietary processes to a stable reflective surface that is insensitive to magnetic or electrical fields or light, except for a fairly intense laser beam. The writing beam produces permanent changes in reflectivity, corresponding to the information to be stored. Readout is by a lower power laser beam. Thus, the currently available cards are either ROM (preprogrammed, read-only) or (more commonly) WORM (written once by the user, and read-only after that). Recorders have normally been implemented for direct readout after write (DRAW).

A totally different approach is being developed by a small company, Urshan Research Corp., Los Angeles, begun in 1992. A data capacity of 1GB on a credit card-size unit has been claimed, with a $20 projected retail price. The company is developing both the card and the drive, but no technical details have been given. Several major corporations, including Apple and Tektronix, are confirmed as sponsoring Urshan to some degree.

Such a card/drive system could revolutionize information storage across a broad range of applications, from diskettes and CDs to videotapes and laser disks. However, to our knowledge, no announcements have been forthcoming in the two years since the initial release. Severe or fatal problems, financial or technical, may have been encountered.

Various card specifications have been published to guarantee interchangeability. The earliest standard was adopted in March 1989 by the Drexler European Licensees Association (DELA), now named the European Optical Memory Card (OMC) Forum. This standard has been endorsed by the Japanese Business Machine Makers Association (JBMA) and forms the basis for the U. S. standard in preparation by the American National Standards Institute (ANSI) Committee X3B10.4 and a draft ISO (International Standards Organization) standard. This format provides for 4 MB of graphics and sound or 3 MB of text. A newer format, from Drexler, allows 6.6 MB per card. Canon USA, Inc. has also announced a 6 MB card.

Advantages and Disadvantages

The advantages, long cited by Drexler, for the optical memory cards (LaserCards) include high capacity in a convenient and familiar format, easy incorporation of high-level security measures such as fingerprints, photographs, or

voiceprints, cost savings due to elimination of manual procedures and paperwork, faster access to individual medical and other records, tolerance to a great range of environmental conditions that would destroy diskettes, magnetic credit cards and IC cards, and insensitivity to magnetic and electrostatic fields.

Drawbacks cited are a prohibitive expense in converting established industries (such as bank card terminals), vulnerability of data to card loss and damage, poor performance of drives, and lack of hardware availability. Privacy could be a problem, depending upon the environment in which the cards were used. For example, if wide-ranging information about a person, such as financial, medical, and educational history were stored on a card, then carefully thought out legal, mechanical, and electronic safeguards would have to be built into systems to prevent disclosure of more than necessary information to anyone with access. Even then, the possibility of access, for example, by law enforcement, to essentially one's entire life, including errors in the database, is no trivial privacy issue.

Media Durability

No reliability measurements or estimates for Laser-Cards have been published, to our knowledge. However, some high temperature exposure tests have been performed. Drexler reported a test of several media in a piece of sales literature. Five types of media, including floppy disks, solid state memory, a conventional credit card, and the optical card were exposed to a 100° C (212° F) environment. The LaserCard was still fully functional after 1000 hours, whereas the others had been destroyed in less than five minutes. In contrast, the Naval Air Warfare Center (NAWC) tested several types of optical disks with the LaserCard and the Datastor Data Card for 150 hours at 80° C (176° F) and 90% relative humidity. Most of the disks survived. The cards did not. Several possible explanations could be offered for the apparent discrepancy between the results:

1. The Drexler test might be more recent (no date was given), and the design of the cards may have been improved.

2. The Drexler test may have been run at a much lower humidity (no value was stated).

3. The sample size in the Drexler test may not have been large enough to include cards with edge seal or other defects that led to the failures in the NAWC test.

Trends

Applications have been proposed for optical cards and a considerable number of trials are in progress. Many will watch the results of these trials carefully while contemplating whether to incorporate the cards into their infrastructures. It would seem that the cards have advantages over competing approaches in a number of cases, and the trials should demonstrate this. Public acceptance and willingness of industry to make the investment for conversion will be critical. Reliable, economical equipment and cards must be available from multiple suppliers.

While some writers speak glowingly of optical cards replacing videocassettes, floppies, and CD-ROMs, it appears more likely that the cards will find niche (though potentially very large) markets in areas where other technologies are not firmly entrenched and where the optical cards have clear advantages over competing technologies (such as health record cards). In this case, the changes will not appear to be profound to the consumer, so acceptance should be rather rapid. On the other hand, the quite substantial infrastructure changes required of the service providers should be justifiable on the basis of cost savings. Optical cards proposed to store records that could just as well be kept on optical disks or other popular media will face an enormous competitive challenge stacked against them by the sheer power of numbers-standards, drive manufacturers, drive-installed base, and media sources. It is highly unlikely that optical memory cards will ever overcome this barrier.

Optical Disk Drives

Introduction

The following table is a summation of a database available from the National Media Lab. There are different types of "Optical Disks", and these are denoted under the Drive Type heading.

Not all of the numbers (provided by the manufacturers) are equally believable; there are several reasons for this. Drives are sold on the basis of speed and vendors often "improve upon" these specifications by measuring "short stroke" seek times, reporting burst rather than sustainable data rates, and in general by giving best-case rather than average or worst-case figures. Often the measurement techniques or meaning of the numbers is not shown. In some cases, it is unclear even whether data flow was measured in bits or bytes. Since it is so common to report the burst data rate from the buffer over the high speed interface as the maximum rate for the drive, these figures have been included in the table. The minimums are sustained rates from the media.

Drive Type	Mfgrs. in Survey	Maximum Capacity (GBytes)	Minimum Avg. Access Time (mS)	Maximum Transfer Rate (Mbytes/S)	Pricing Minimum	Pricing Maximum
CD-R	3	0.680		1.00	$3,899	$5,000
CD-ROM	62	3.200	150	4.20	$199	$4,195
Optical Disks - WORM	40	20.400	35	4.00	$795	$85,000
Optical Disks - Erasable	100	5.200	14	10.00	$640	$75,000
Optical Disks - Multifunction	33	4.000	27	10.00	$800	$16,700
Floptical Drives	17	0.021	65	1.60	$295	$1,000
Summary	255	20.400	14	10.00	$199	$85,000

SUMMARY-OPTICAL DRIVE MANUFACTURERS DATABASE.

Drive prices range widely, depending upon the application. Most of the extremely high-priced drives are intended

for use with mini- or main-frame computers rather than desktops. These drives are presumably designed to satisfy the high duty cycle, continuous operation, and reliability requirements of such an application.

Optical Tape

Technology

Optical tape holds forth the promise of very large capacity in a single media unit (cassette or reel), fairly great information volume density, and very low cost per MB. The generally long access times have been improved and are really not a problem in some sequential types of applications, such as entertainment presentation (audio and video) and data archiving.

Development has been reported for a number of approaches. The two that appear to be the most viable commercially are by LaserTape Systems (Campbell, CA) and Creo Products Inc. (Burnaby, BC, Canada).

The LaserTape system uses 0.5-inch tape in 3480-compatible cartridges. The media, which they call Digital Optical Tape (DOTTM), uses the same polyester substrate as is used for 3480 magnetic tape. Layers added to the substrate are: a metallic reflector, a dye polymer, and an overcoat. The drive is essentially a standard IBM 3480 drive with an optical read/write head replacing the magnetic head.

To write to the DOTTM, a laser beam heats the dye polymer layer, producing a pit. Because this layer is a very poor heat conductor, the heat does not spread, and very small, well defined pits can be produced (with sharp transitions). This permits high sensitivity and fast writing and reading rates. Readout is accomplished by using a low-power laser beam to sense the reflectivity differences between pit and land areas. The media is designed to give a distance between the top surface and the reflective layer equal to an integral number of half-wavelengths, so that the beam is reinforced in the absence of a pit. This condition is disturbed at a pit, significantly reducing the reflected energy.

An acousto-optic technique, incorporating a Bragg cell, is used to direct the writing or reading beam, eliminating all moving parts from the head assembly. The Bragg cell consists of a crystal with an acoustic transducer bonded to one end. An RF signal applied to the transducer sends ultrasonic waves of corresponding wavelength across the crystal. The wavefront of a coherent light beam passing through the crystal interacts with the wavefront of the ultrasound signal, causing the beam to be diffracted by an amount proportional to the applied frequency. In the simplest application, the drive records one track at a time in alternate directions of the tape, stepping the beam across the tape width. A much faster data rate is achieved with an alternate design that uses a read/write head capable of writing a transverse column array of 48 or 64 bits simultaneously.

The system is designed to be write-once, although erasable magneto-optic and dye polymer tapes have been demonstrated, since the 3480 system operates this way.

Another optical tape system is under development by Creo. The tape is 35 mm wide on a 12-inch reel. The recorder is an open-reel configuration. The media structure is similar to the DOT tape. A parallel head, capable of writing or reading 32 bits (tracks) in parallel is mechanically stepped across the tape width, using an air-bearing slide and a voice coil actuator. The writing method is similar to that described above for the LaserTape system.

Optical Tape Manufacturers

Several manufacturers have shown interest in optical tape. However, only a few appear to be committed to quantity production. The DOT cartridges for the LaserTape system are apparently not in production anywhere yet, although tape has been fabricated by the Dow Chemical Company and ICI Imagedata (Wilmington, DE), a subsidiary of the British firm, Imperial Chemical Industries Ltd. The latter is also a qualified supplier of certified tapes for Creo. Southwall Technologies (Palo Alto, CA), in cooperation with Dow Chemical, and the Eastman Kodak Company (Rochester, NY) have also developed media for this system.

Optical Tape Drive Manufacturers

The LaserTape recorder is made only by LaserTape Systems. Similarly, the Creo recorder is manufactured only by Creo Products Inc.

Applications

No sales or applications of the LaserTape system are known at present, although many archival and backup applications could be envisioned. Environments where 3480/3490 cartridges are presently in use should be particularly attractive. The capacity per (outwardly identical) media unit would be increased by a factor of 250 to 500 at a fairly modest cost per recorder (about $25,000) and virtually no other changes to the computer system hardware or software.

The first production unit of the Creo 1003 Optical Tape Drive was delivered to the Canada Centre for Remote Sensing at Gatineau in 1990. The system stores image data beamed from earth observation satellites. Drives are also archiving operational data at the Canadian Department of National Defense and the Australian Centre for Remote Sensing at Bruce, ACT. Additional systems are being commissioned at the European Space Agency at Frascatti and the South African Satellite Applications Centre at Pretoria.

Media Durability

Tapes are somewhat more susceptible to damage from handling (both by humans and by the recorders), and from the environment than disks, which are more readily enclosed in protective layers and caddies. Thus, tape archivability may not be as good (susceptibility to surface and edge damage and dust could be much higher). As indicated above, the base films used for optical tape have been quite thick, 23 to 75 mm (1 to 3 mils), films that have been used for decades in the production of audio, video, and computer tapes. However, magnetic tapes designed for helical scan

recorders have trended toward ever thinner substrates, with 13 mm being fairly common and thinner tapes not far behind. This should give a durability advantage to the optical tapes. Optical recorders have also been designed to greatly reduce mechanical contact with the tape as compared to magnetic drives. The potential for damage is still somewhat higher than for optical disks, where intentional contact is never made.

Accelerated aging tests were run on the ICI 1012 optical tape designed for the Creo recorder. The optical and several magnetic recording tapes were subjected to 60° C, 80% R.H. environments for periods of three, six, and nine weeks. Measurements were made of extractables (a measure of chemical degradation), magnetic remanence (for the magnetic tapes, to measure particle corrosion), error rates, and carrier to noise ratio. No changes outside the range of experimental error were observed for the optical tapes. Some of the magnetic tapes degraded significantly and some became inoperable.

The ICI 1012 tapes were also aged by Battelle in their class II environment, which simulates a worst case office environment (similar to Los Angeles smog). The tapes exhibited no degradation after thirty days, and Battelle estimated a lifetime exceeding fifteen years. A D-2 metal particle tape tested concurrently showed signs of degradation in its saturation moment, leading to the conclusion that the ICI media had equal and possibly better life expectancy than MP tapes.

Advantages and Disadvantages

Compared to magnetic tape, optical tape offers orders of magnitude greater capacity per media unit. In fact, capacity comparisons with virtually all other storage media are impressive. One DOT cassette is equivalent to 250 to 500 3480 cartridges. One reel of tape for the Creo system holds the data of 5000 conventional computer tapes, 100 12-inch instrumentation tapes, or 2000 5.25-inch optical disks. Optical proponents also feel that their media will last much longer in archives. Tests appear to confirm advantages of optical over magnetic tape with regard to aging and sensitivity to environmental deterioration. Use of the popular 3480/3490 format for the LaserTape system will certainly be advantageous for both users and manufacturers trying to establish a marketplace. Since the manufacturing cost for optical tape should approximate that for magnetic, whereas the optical storage density is far greater, the media cost per capacity unit will be far lower. In fact, optical tape media cost appears to be lower than that for any storage competitor at this time.

The primary advantage of optical tape over optical disks is sustainable data transfer rate. Current projections are that tape data rates will be about an order of magnitude faster than that for disks. Of course, random access to a given file is far slower for tape.

Since optical tapes are fabricated on much thicker substrates than magnetic tape for helical scan systems, the volume information storage density suffers somewhat, but the durability should be considerably better.

Mass Storage Technologies

Introduction

Three technologies address the ever-growing requirements for storage by incorporating multiple units into a larger system. Optical jukeboxes manipulate many optical disks to provide hundreds of gigabytes of optical storage. Tape libraries, or autochangers, use multiple drives and robotic arms to manipulate as many as 18,000 tape cartridges. RAID is a system incorporating two or more magnetic hard disks into a system that provides data protection, as well as the potential for increased capacity and speed.

Databases have been created for each of these technology areas. Included in each database are the true Mass Storage systems, defined by the Goddard Conference as greater than 0.1 terabyte. The following sections will discuss each mass storage type more fully.

Optical Jukebox

An optical jukebox is a storage system that has one or more drives, slots to hold (store) the disks, and robotics that move the disks to or from slot or drive. Information is written to or read from marks on the surface of a disk, or platter, using a laser-based optical stylus. Each of the optical drive technologies discussed in Section 7 Optical Disk Drives: WORM (write-once-read-many), CD-ROM, rewritable, and multifunction can be found incorporated into optical jukeboxes. A listing of optical jukebox vendors and information about the products they offer appears at the end of this section in 9.3 Optical Jukebox Vendors Database.

Write-Once-Read-Many

The original jukeboxes used WORM technology on 12- or 14-inch platters. Today's 12-inch disks can hold as much as 10.2 gigabytes on a single platter. One reference lists a Filenet jukebox containing 340 platters with a capacity of over 2 terabytes, run on up to six drives. This same reference, however, discusses the fact that having too few drives results in a sluggish system. It recommends a ratio of disks to drives of 50:1.

The Navy Research Lab's Ruth H. Hooker Research Library is utilizing SONY WDA-610 optical jukeboxes to convert research papers into stored digital images. The collection of 600,000 titles, dating back to the 1940s, is expected to fit into two jukeboxes. Additional jukeboxes can be daisy-chained together to provide up to 1.3 terabytes of storage through one SCSI interface. After scanning and verification that a good image has been obtained, the digital image is stored to 12-inch WORM disks, and the paper documents and duplicates are disposed of. Each WORM disk can hold up to 130,000 pages (6.5 GB) of information.

CD-ROM

CD-ROM, the first commercial optical-storage technology, is a data version of the audio compact disc. Close to 1 MB of data can be stored on the disk. CD-ROM drives have slow average seek times of 300 to 500 msec, with transfer rates of 300 to 600 KB/sec. CD-ROM jukeboxes are generally small six-disk minichangers with a capacity of less than 6 GB. Pioneer recently introduced an eighteen-disk jukebox with about 11 GB capacity. However, the single reader allows access to only one disk at a time and limits the utility of the jukebox to small networks or a single user.

The low cost (under $200) of CD-ROM drives, low media cost, media removability, and read-only format make CD-ROM a publishing and distribution medium. Some manufacturers are gearing up to participate in the mass storage market. Kubik Enterprises Inc. sells a 240 disk CD-ROM jukebox containing up to four drives. JVC Information Products Co. of America has announced the DOS-compatible Pro-CD Library, which consists of a 100-disc jukebox, double-speed CD-ROM drive and storage-management software, at a price of $8995. In addition, Pioneer has just announced the marketing of a 500-disk CD-ROM changer that should be available this fall with a version with the ability to write to blank disks.

Rewritable

Rewritable disks employ one of two non-interchangeable technologies to store information. Data is stored to phase-change media by a high-power laser which changes the media's crystallinity. The read laser detects the difference in reflectivity between the crystalline spots and the amorphous surroundings. Data is erased by returning the crystalline spots to the amorphous phase.

The second type of rewritable technology is magneto-optical (M-O). The write laser heats spots on the disk to the temperature at which an electromagnet can change the magnetic polarity of the spot. Light from the read laser is rotated right or left depending upon the polarity of the spots. This rotation is detected by the M-O drive. Once an M-O disk has been recorded, two passes are required to rewrite the disk: one pass to realign all the domains north-pole-down and one pass to write the new data.

Multifunction

Jukeboxes that contain multifunction drives can handle both WORM and rewritable media. These systems provide flexibility for the user who needs some unalterable storage and also requires rewritability. Some multifunction drives combine WORM and phase-change technology while others combine WORM and M-O capability. Therefore, a user moving into a jukebox from a single drive should be careful to purchase a multifunction drive compatible with previously recorded media.

Tape Library

Tape libraries are automated tape handling systems with the potential to provide "near-line" access to many terabytes of storage. Autochangers are available in a variety of tape formats including: DAT, 8 mm, QIC, 3480/3490, DLT, VHS, and DD-2. A listing of tape library vendors and information about the products they offer appears at the end of this section in 9.4 Tape Library Vendors Database.

The nation's new weather surveillance radar (Nexrad) is utilizing 8 mm jukeboxes from Exabyte to store the data gathered. The Doppler sensing system of Nexrad (Next Generation Weather Radar) can produce more than 4 GB of data per day at each radar installation. Nine sites are operational and up to 140 are planned by 1996.

Each remote site has a series 8200 or 8500 tape drive with a cartridge handling jukebox to archive all the data generated from the radar on 8 mm tape cartridges. Originally, a 12-inch optical platter system was planned for the system but, each optical disk would only hold 1 GB of data (or about six hours for a typical radar site). Each 8 mm cartridge holds 5 GB and the jukebox will store about 300 hours of data. Approximately every two weeks maintenance workers visit each site to replace the tapes with ten blank cartridges. The filled tapes are delivered to the National Climatic Data Center in Asheville, N.C. for analysis and archiving.

RAID

RAID (Redundant Array of Inexpensive Disks) is a storage technology that groups multiple hard drives into what appears to be one logical volume. The term RAID was introduced in a late-1987 paper by Patterson, Gibson, and Katz of the University of California-Berkley titled "A Case for Redundant Arrays of Inexpensive Disks (RAID)." The paper compared RAID to SLED (Single Large Expensive Disk) and described five-disk array architectures, or levels. RAID technology is currently the hottest mass storage topic in the literature.

Disk arrays generally improve system performance by supporting multiple simultaneous read and/or write operations as well as by increasing capacity and providing fault tolerance. The use of multiple drives in an array actually increases the chances that a drive failure will occur. However, the data redundancy of RAID allows the array to tolerate a drive failure. A basic description of each of the levels of RAID follows.

RAID 0

This form of RAID is not RAID as described in the Berkley paper because there is no data redundancy. Most disk arrays use striping, or distribution of data across multiple drives. RAID 0 implements striping without redundancy and is, therefore, less reliable than a single drive. The only advantage is increased speed.

RAID 1

RAID 1 implements "mirroring," or shadowing, of disks. Each drive in the system has a copy, or "mirror," of itself. If a drive fails, the duplicate drive keeps working with no lost data or downtime.

Since there are two sources of data, the average access time for a read request will be faster than that for a single drive. For a write request, which is almost always preceded by a read, the decrease in read seek time of RAID 1 is offset by the increase in write seek time (since the data has to be written to two disks). A read and two writes takes the same time as a read/write for a single drive. RAID 1, with an optimized controller, has slightly lower overall access times than a single drive.

The main advantage of RAID 1 over other RAID architectures is simplicity. It only requires a dual channel controller or a minimal device driver using one or two controllers to implement. No change to the operating system is needed. RAID 1 is relatively expensive to implement because only half the available disk space is used for data storage. In addition, the necessity of duplicate drives requires more power and more space for the same storage capacity.

RAID 0/1 (sometimes also called 10) is a hybrid of RAID 0 and RAID 1. The data is striped across the drives in the array as in RAID 0. In addition, each striped drive group is "mirrored" by a duplicate drive group attached to a second drive controller.

RAID 2

RAID 2 is an architecture that succeeds in reducing disk overhead (the cost of storage space lost to redundancy) by using Hamming codes to detect and correct errors. Check disks are required in addition to the data disks. The data is striped across the disks along with an interleaved Hamming code. Because all of the data disks must seek before a read starts, and because for a write the data disks must seek, read data, all drives (including check disks) must seek again, and then the data is written, seek times are very slow compared to a single drive. However, once the seek is completed, data transfer rates are very high. For an array with eight data drives, the drives will transmit data in parallel. The transfer rate of the array will be 8 times that of a single drive.

RAID 2 is best for reading and writing large data blocks at high data transfer rates. In the microcomputer environment the existing error detection/correction features result in redundant error isolation data for RAID 2 and make RAID 2 impractical for microcomputers. By letting the drives manage error detection, it is possible to implement RAID requiring only one check disk for error correction.

RAID 3

By assuming that each disk drive in the array can detect and report errors, the RAID system only has to maintain redundancy in the data necessary to correct errors. RAID 3 employs a single check disk (parity disk) for each group of drives. Data is striped across each of the data disks. The check disk receives the XOR (exclusive OR) of all the data written to the data drives. Data for a failed drive can be reconstructed by computing the XOR of all the remaining drives. This approach reduces disk overhead from RAIDs 1 and 2. For a five-disk array, four of the drives store data; providing 4 GB of data storage in a 5 GB array. RAID 3 also has the same high transfer rates as RAID 2. However, because every data drive is involved in every read or write, a penalty is paid.

RAID 3 can process only one I/O transaction at a time. In addition, the minimum amount of data that can be written or read from a RAID 3 array is the number of data drives multiplied by the number of bytes per sector, referred to as a transfer unit. A typical five-drive array would have four data disks, one parity disk, and might have a 512-byte sector size on each disk. The transfer unit would be 2048 bytes (4 x 512). When a data read is smaller than the transfer unit, the entire unit is read anyway, increasing the length of a read operation. For a data write smaller than the transfer unit, although only a portion of a sector of each disk needs to be modified, the array must still deal with complete transfer units. A complete unit must be read from the array, the data must be rewritten where necessary, and the modified data must be written back to the data disks and the check disk updated. RAID 3 works well in applications that process large chunks of data.

RAID 4

RAID 4 addresses the problems associated with bit-striping a transfer block of data across the array. As in RAID 3, one drive in the array is reserved as the check disk. This architecture, however, utilizes block or sector striping to the drives, resulting in read transactions involving only one drive and timing comparable to a single drive. In addition, multiple read requests can be handled at the same time. However, since every write accesses the parity disk, only one write at a time is possible. RAID 4 is most useful in an environment where the ratio of reads to writes is very high.

RAID 5

Because RAID levels 2 through 4 each use a dedicated check disk, only one write transaction is possible at any time. RAID 5 overcomes the write bottleneck by distributing the error correcting codes (ECC) across each of the disks in the array. Therefore, each disk in the array contains both data and check-data.

Distributing check-data across the array allows reads and writes to be done in parallel. Data recovery and seek times are comparable to RAID 4.

Disk Array Implementations

Actual disk array implementations are not always as simple or straightforward as described above. Some manufacturers combine features of different RAID levels to create a hybrid, as in RAID 0/1. RAID implementations that

95

are extremely fault-tolerant provide redundancy beyond that of the drives. Additional redundancy is accomplished by providing a system with redundant drive controllers, redundant power supplies, redundant SCSI controllers, and so on. Some manufacturers offer "hot swappability," the ability to replace a failed drive (or other hardware units) without shutting the system down. Other manufacturers offer a spare drive that is automatically put into use rebuilding the failed drive as soon as the system senses a failure.

Still other RAID manufacturers offer only software-based RAID. The RAID architecture is contained in software that the customer implements with his own hardware. Finally, some RAID systems offer more than one level of RAID in the same package, to handle mixed applications more efficiently. A listing of RAID vendors and information about the products they offer appears at the end of this section in 9.5 RAID Vendors Database.

Conclusions

The information contained in this section of the report provides an overview of the vendors of mass storage systems and their products. When determining which system is best suited to an application, the quantity and type of information, and the frequency of access to information to be stored must be considered in addition to the dollars available to do the job. The selection of a mass storage system depends upon the user's requirements. There is no one system which will satisfy every user's needs. As was discussed previously, even within a media class, such as RAID or optical disk, the media choice (such as CD-ROM, WORM, rewritable, etc.) or storage protocol (RAID level) must be selected with things like file size and frequency of access in mind.

For applications with a mix of requirements, systems that offer hierarchical storage management (HSM) present a solution. HSM automatically migrates files from hard drive to optical disk or magnetic tape depending upon how recently the file was last accessed. A record of all migrated files is maintained and all information is available to the system, although not all information is "on-line."

Solid State Memory Technologies

Introduction

For the purposes of this discussion, solid state memories are defined as systems that store electronic data using no mechanical motion, are non-volatile, and are rewritable. Non-volatile means that the data will remain stored for extremely long periods of time even without applied power. Rewritable means that the data stored can be changed and updated as the application requires it.

Using this definition, magnetic or optical disk or tape storage systems are non-volatile and rewritable but are not solid state memory systems because of their mechanical motion. Disk and tape systems do meet the non-volatility requirement, however. Integrated circuit dynamic random access memory (DRAM) meets the criteria of no mechanical

motion; however, it fails the non-volatility test. Read Only Memory (ROM) in the form of integrated circuits does not pass the rewritable criteria even though it is non-volatile and uses no mechanical motion.

Solid state memory technologies offer the advantages of small size, light weight, high speed, and ruggedness, compared to conventional moving media storage technologies, such as disk or tape. These and other features of solid state technologies have the potential to meet the ever-increasing need for rugged, lower power, high density, high speed, non-volatile memory in a wide variety of applications, ranging from sub-notebook computers to space missions.

Today, there are significant changes in the data storage industry that increase the use of solid state storage and make its future success very likely. One of the largest volume applications for this type of storage is in the portable personal computer market. Portable computer applications demand low power, low weight, small size, and ruggedness. This trend is very evident in the industry's development and support for the Personal Computer Memory Card International Association (PCMCIA) standard and rush to incorporate FLASH memory. Commercial products that use solid state memory in place of magnetic tape have already been announced for video and audio recording applications. Many companies now offer solid state integrated circuit systems to replace magnetic disk systems. More commercial products that use solid state memory technology to store data are being introduced each day.

Other more subtle changes in supporting technology for solid state optical systems are coming about because of the optical computing, optical disk, and optical communications fields. These three areas are all supporting improvements in lasers and other optical components that can be used in optical solid state memory systems. In addition, there is a tremendous commercial incentive to remove the computer storage and I/O bottlenecks that improvements in computer hardware have produced. Often solid state memory technologies can be used to remove these bottlenecks.

Solid state storage technologies fall into four broad technology areas:

(1) electrical memories that are based on semiconductor integrated circuit technology and semiconductor physics

(2) magnetic memories that are based on magnetic materials or magnetic field effects

(3) optical memories based on the interaction of light with matter

(4) molecular, chemical, or biological memory based on changes at the atomic, molecular, or cellular level.

Solid State Electrical Memories

The most common semiconductor solid state memories are Electrically Erasable Programmable Read Only Memory (EEPROM), FLASH EEPROM, and Ferroelectric Random Access Memory (FRAM). There are other candidates for this list such as special memory with Static Random Access

Memory (SRAM) connected to EEPROM for storage when the power is removed. An additional technology area is single electron memory based on the idea that the storage elements would use one, or very few electrons each.

Solid State Magnetic Memories

Of the four technology groups, magnetic-based technology has the largest number of successful systems approaches and number of obsolete technologies. The older technologies are magnetic core, plated wire, cross-tie, and magnetic bubble. The two newest and most active technologies in this group are Vertical Bloch Line (VBL) memory and Magnetoresistive Random Access Memory (MRAM). Superconducting Josephson Junction memory has been known for some time but has never really been viable, due to materials problems and the need for low temperatures.

Solid State Optical Memories

Solid state optical technologies include holographic, persistent spectral hole burning, photon echo, and two photon three-dimensional memory. Tamarack Storage Devices is presently attempting to commercialize optical holographic storage. Persistent spectral hole burning, photon echo, and two-photon three-dimensional memory are in the university research stage at present.

Molecular, Chemical, or Biological Memory

Molecular, chemical, and biological technologies offer the promise of storage of one bit of information in the space of an atom, molecule, or cell. In addition, they offer the possibility of overcoming some of the present limitations on integrated circuit lithographic techniques, since they would be assembled chemically or biologically. This assembly concept is sometimes referred to as self assembly. The human brain is one example of proof that chemical and biological memories work.

Obviously, compared to other memory types, chemical and biological memories are not well developed. Concepts and theories for how such systems would work have been developed, however. The most well-known concept in this area is attributed to Dr. Hopfield at the California Institute of Technology. In this method a molecular shift register for electrons is formed using light to energize and move electrons along molecular chains and conventional integrated circuit electronics are used to introduce the electrons for storage and detect them for readout.

Comparison of Technologies

The technology areas that were identified and studied in this work were analyzed in terms of the technical activity over the last five years, the comparative strengths and weaknesses of the technologies, and the time, cost, and risk associated with development or use.

The amount of research in an area of technology can often provide valuable information about the probability of

commercial success of the technology. With this in mind, the publicly available technical literature was examined, revealing an indication of the activity in each of the technologies selected. An on-line library search of several databases was carried out for technology areas of interest. The search results were reported as the number of citations per year for the years 1988 through 1993. Because of lags in indexing and abstracting, the 1993 results cover from about 10.5 to 11 months of 1993. The databases searched included Aerospace Database, COMPENDEX, Energy Science & Technology, INSPEC, and NTIS.

	1988	1989	1990	1991	1992	1993	Totals
DRAM or SRAM	403	459	477	572	477	237	2625
Holographic	63	107	108	110	129	102	619
EEPROM	92	93	70	92	79	68	494
VBL	70	45	40	65	19	9	248
Flash	29	20	33	38	31	23	174
Magnetic Bubble	53	30	29	43	13	1	169
FRAM	16	15	28	33	41	9	142
Josephson Junction	14	30	15	33	16	19	127
Magnetic Core	12	18	13	26	20	3	92
Spectral Hole Burning	8	7	16	18	24	11	84
Biological or Molecular	9	8	6	12	6	7	48
MRAM	5	4	8	11	12	2	42
Two Photon Three Dimensional	0	2	13	7	4	14	40
Single Electron Transistor	1	1	0	5	12	9	28
Hall Effect	1	3	5	6	0	5	20
Magnetic Cross Tie	3	3	2	2	4	4	18
Plated Wire	3	1	1	0	0	0	5

TABLE 1
Technical publication activity from 1988 to 1993 by year.

The total activity in the technical literature over the last five years was plotted as a bar chart on the following page with the x-axis sorted from highest to lowest activity. Technologies on the left of the chart have a higher amount of activity and in general a better chance of becoming commercial in the near term. Technologies on the right of the chart with little activity are either obsolete or very new technologies. The older technologies represent poor investment opportunities, while the newer technologies on the right may be good long-term investments as part of an overall technology strategy.

Another way of looking at the technologies presented is to categorize the technologies by their progress from idea to high volume commercial sales in products. This technology mapping allows the relative cost, time to availability, production volumes, and risk to be assessed when making comparisons. In general, technologies start out in universities

or research laboratories as an idea with some physical basis for belief that the technology will work. As the knowledge in the field increases, functioning prototypes are built to demonstrate that a product can be manufactured. At this point, the technology may find its way into low-volume, high-cost government applications as a commercially available device. Sometimes, after government use and sometimes in place of government use, the technology finds its way into high-volume, low-cost commercial applications. The cost to obtain, the time to availability, and the risk of program failure using the technology decrease as the product moves from research to industrial commercial use.

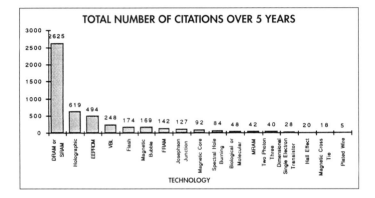

Total technical publication activity for 1988 to 1993.

Conclusions

It is now obvious that the solid state memory technology base and market is growing and will continue to do so into the foreseeable future. Solid state memory is competing in an industry where movable storage media in disk and tape systems dominate. The technological base and research budgets available for disk and tape storage work produce a formidable entry barrier for solid state memory. This barrier can be overcome simply because solid state memory is better suited for certain applications. For example, FLASH memory is now replacing hard disks in some applications and may replace floppy disks in the portable PC market.

These successes are based on selecting the best technology for the target application. Successful technology selection in the future also depends on the correct pairing of the technology with the application.

Archival Stability of Digital Storage Media

This section deals with the longevity of optical disk and magnetic tape media. Physical or chemical changes in a storage medium, over time, will eventually cause it to fail. By accelerating these changes, through an increase in temperature and/or humidity, media failures can be induced in a relatively short period of time. By performing such "accelerated aging tests," failure mechanisms can be determined and media lifetimes can be estimated.

Manufacturers are providing life expectancy (LE) values for some data storage products. However, there are currently no standard methods for the determination of life expectancies. Without proper qualification of the accelerated test procedures and the life expectancy methods used, LE values for different vendors and media types cannot easily be compared. Furthermore, LE ratings may be overly optimistic because the test method does not consider all of the significant stress factors found in a "real world" environment.

Magnetic Tape Stability

Magnetic tape consists of a magnetic particle within a polymer binder that is supported on a backing film. All three of these components-magnetic particle, binder, and backing-are potential sources of failure for a magnetic tape medium. A schematic diagram of a magnetic tape construction is shown in Figure 1.

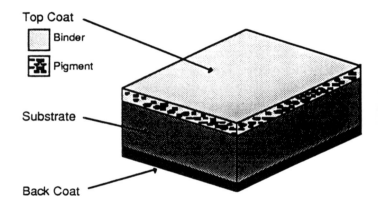

FIGURE 1
Cross-section of magnetic tape: A magnetic pigment is held together with a polymeric binder that is coated on a polymer film substrate. A back coat can also be added to control friction and static charges.

Magnetic Pigment

The magnetic "pigment" (the terminology is a carry-over from paint and coatings technology) is responsible for storing recorded information magnetically. If there is any change in the magnetic properties of the pigment, data can be irretrievably lost. The magnetic remanence (Mr) characterizes the pigment's ability to retain a magnetic field. The strength of the recorded signal output is related to the magnetic remanence of the pigment. Thus, a decrease in the magnetic remanence of the pigment can result in a low output signal and data loss. The coercivity (Hc) characterizes the pigment's ability to resist demagnetization. Demagnetiza-

tion can result from an externally applied field, or from self-demagnetization via thermally induced magnetic reversals. A decrease in pigment coercivity makes a magnetic tape more susceptible to demagnetization and signal loss.

The stabilities of the most common magnetic pigment types are outlined in Table 1. The information and ranking of performance is based on bulk magnetic measurements. The inherent instability of some magnetic particles does not exclude them from successful use in tape products. One of the least stable pigments is chromium dioxide. However, chromium dioxide is used successfully in 3480/3490 tape cartridges. The 3480/3490 data recorder was designed to be a very robust system that takes into account the basic instability of the chromium dioxide pigment. NML tests indicate that 3480 cartridges with Mr losses of 30% show bit error rates which are well below the ANSI limit. A 3480 tape cartridge can lose up to 75% of its recorded signal output and still be read by a 3480 tape drive. Thus, when system formats are considered in addition to bulk magnetic properties, one can arrive at a different view of tape stabilities.

MAGNETIC PIGMENT TYPE	STABILITY INFORMATION
barium ferrite (BaO - 6 Fe2O3)	A stable oxide material.
gamma iron oxide (γ-Fe2O3)	A stable oxide material.
cobalt-modified gamma iron oxide (Co-γ-Fe2O3)	Not as stable as g-Fe2O3. The cobalt is subject to attack by acids in the binder reducing magnetic remanence. Pollutant gases in the environment can reduce the coercivity of the pigment.
metal particulate (Fe)	Pure iron (Fe) is chemically unstable and readily oxidizes. The iron particles are protected with a passivating coating of iron oxide, aluminum oxide, and silicon dioxide. This coating reduces, but does not eliminate the rate of particle oxidation. Over time, oxidation of the particles results in a decrease in magnetic remanence. The rate of pigment degradation can be catalyzed by pollutant gases in the environment.
metal evaporated (Co-Ni) NOTE: Metal evaporated tapes (ME) do not use the conventional pigment-in-binder tape technology. ME tapes consist of a continuous, thin layer of metal alloy which is deposited onto a base film.	The Co-Ni alloy is subject to oxidation. A protective oxide coating can be applied, but this does not completely eliminate the oxidation process. Over time, a decrease in magnetic remanence is observed as the film oxidizes. The rate of Co-Ni film oxidation can be catalyzed by pollutant gases in the environment.
chromium dioxide (CrO2)	CrO2 is a metastable oxide (Cr-IV). Over time, CrO2 converts to the more stable oxide forms — Cr2O3 (Cr-III) and CrO3 (Cr-VI) — both of which are non-magnetic oxides. Thus, magnetic remanence decreases with time.

TABLE 1
Stability of common magnetic pigment types. The pigments are ranked in the order of most to least stable.

Figure 2 shows a chart which is periodically issued by the NML. It gives a general overview of the stability of magnetic pigments used in digital magnetic tape formulations, when bulk magnetic properties, recording system design, and protective properties of the cassette are considered. This chart is based on the magnetic properties of the tape only and does not consider effects of tape binder and backing instabilities. The pigments are assessed on the basis of suitability for an archival medium with an assumed service life of thirty years. From this chart, it can be concluded that all pigment types are suitable for archival (thirty-year) storage (based on magnetic performance), if the tapes are properly stored in moderate environments. Some MP tapes are insufficiently stable at high temperatures and in "dirty" (polluted) environments.

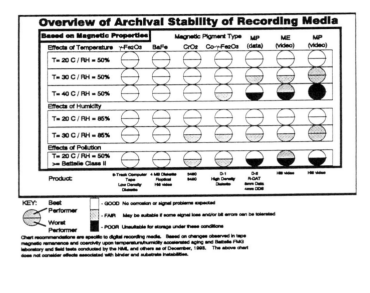

FIGURE 2
Overview of Archival Stability of Recording Media. This chart gives a general overview of the stability of magnetic pigments used in digital magnetic tape formulations.

The "Overview of Archival Stability of Recording Media" chart mentions the Battelle Class II test. This is an accelerated laboratory environment that measures the corrosive effects of low-level pollutant gases on electrical contacts and devices. A Battelle Class II flowing mixed gas (FMG) laboratory test, models air quality conditions that are typical of a US office in an urban environment. These tests have been used to evaluate the stability of metal particle (MP) and metal evaporated (ME) tapes. Initially, these tests involved the direct exposure of tapes to the Battelle Class II FMG environment. Test results indicated severe corrosion of the tapes occurred. More recently, the NML has learned that the cassettes in which the tape samples are encased significantly protect the tape from low-level pollutant gases in the external environment. Cassette protection is considered in the evaluation of the tapes in a polluted environment in Figure 2. Without cassette protec-

tion, most MP-based tapes would be unacceptable for archival storage (thirty years) in an urban or industrial environment.

The Magnetic-Media Industries Association of Japan (MIAJ) has concluded that the shelf life of magnetic tape under normal conditions is controlled by the binder rather than the magnetic particles.

Binder

The binder is responsible for holding the magnetic particles on the tape and facilitating tape transport. If the binder loses integrity, through softening, embrittlement, or loss of lubrication, the tape may become unplayable and data unretrievable.

Polyester polyurethanes are extensively used in tape binder systems. The polyester linkages in these polymers are subject to hydrolysis. Hydrolysis occurs when a polyester group reacts with water to open the polymer linkage, producing an acid and alcohol groups. The produced acid groups further catalyze the hydrolysis reaction. The acid groups can also attack and degrade the magnetic particles.

The scission of polymer chains via hydrolysis reduces the integrity of the binder and results in the production of low molecular weight species that plasticizes (soften) the binder material. When water is more readily present, such as in a more humid environment, the hydrolysis reaction occurs at a much faster rate. Furthermore, a much higher equilibrium level of low molecular weight species and broken chains exists at higher humidity levels. The hydrolysis reaction is reversible; the acid and alcohol groups can recombine to produce a polyester linkage. However, the quality of the produced linkage will not be as good as the original, so that even under constant, low humidity conditions, a degradation in binder properties will occur over time.

Some manufacturers have started to substitute polyether polyurethanes for polyester polyurethane in some tape formulations. Polyether polyurethanes are less subject to hydrolysis, but more subject to oxidation. The long-term behavior of polyether polyurethane-based tape formulations is not well documented in recent literature.

Binder hydrolysis can lead to a "sticky tape" phenomenon, characterized by low tape top coat modulus, high friction, and/or gummy tape surface residues. A "sticky" tape can experience tape shedding, produce head clogs, result in "stick-slip" playback, and in extreme cases, seize and stop in the tape transport. All of this can lead to temporary/ permanent data loss and may cause equipment damage.

Procedures are available involving tape "baking," which can temporarily increase binder integrity allowing "sticky" tapes to be played and data recovered. Ampex reports that treating a "sticky" tape at 50íC for three days will sufficiently firm up the binder coating so that the tape can be played. The effect of the treatment is temporary, and it is recommended that the data on the treated tape be transcribed to new tape within 1-2 weeks. Tape baking should not be considered a universal panacea for the treatment of "sticky" tapes. The tape baking procedure was developed for a specific type of degradation phenomenon on specific tape types-hydrolysis of reel-to-reel audio tapes and computer tapes. For other kinds of degradation on other tape types, tape baking may actually cause more damage.

Substrate

The tape backing, or substrate film, supports the magnetic layer for transportation through the recorder. In general, the tape backing material of choice is an oriented polyethylene terephthalate (PET) film. PET has been shown, both experimentally and in practice, to be chemically stable. PET films are highly resistant to oxidation and hydrolysis. In archival situations, the PET backing will outlast the binder polymer.

The backing is a potential source of tape failure because of dimensional instability of the PET. The dimensions of the backing can change temporarily, as the result of changes in temperature or humidity, or permanently, as the result of polymer creep or relaxation. When a data track is read, it is expected to be at the same location as it was when it was initially "laid down" during recording. If the read head cannot follow the recorded track on playback, "mistracking" occurs. Dimensional changes in the backing can alter the length, position, or orientation of data tracks, resulting in mistracking and temporary or permanent data loss.

Backing films used for magnetic tape are preferentially oriented in the direction of the tape length. This results in anisotropic film properties. Dimensional changes in the length of the tape will not be proportional to changes in tape width. This applies to dimensional changes induced by changes in temperature/humidity and changes resulting from polymer relaxation. In order to increase the storage capacity of tape cassettes, thinner tape backings are being developed using highly tensilized PET base films. These tensilized films have a greater associated degree of anisotropic film properties and more disproportionate dimensional changes on changes in temperature and humidity.

The magnitude of dimensional backing changes can be reduced through the use of a different backing material. The polyaramid and polyethylene naphthalene (PEN) base films used in some tape products are less subject to dimensional changes as a result of environmental variations than conventional PET.

The susceptibility of the recorded data to loss as a result of dimensional changes in the backing is recording format dependent. Helical scan recording formats can be more susceptible to disproportionate dimensional changes in the backing than longitudinal recordings. Tracks are recorded diagonally on a helical scan tape at small scan angles. When the dimensions of the backing change disproportionately, the track angle will change for a helical scan recording. The scan angle for the record/playback head is in a specific range. If the tracks on the tape do not correspond with the scan angle of the head, mistracking and data loss can occur. Some tape systems (DD-2) allow servoing of the read head on playback so that it can actively locate and follow a distorted data track. In a longitudinal tape system, the tracks will always remain parallel to the edge of the tape, so that mistracking is not as great a problem.

Helical and Longitudinal Tape Formats

In the digital data storage realm, there are basically two types of digital information: digital audio/video (for storage of digitized images and sound) and digital data (for storage of text, numbers, and instrument data). The professional digital video formats, D1, D2, and digital BetaCam, use a helical scan format because of the high data rates required for video information. In the helical scan format, the tape is wrapped around a rotating drum recording head that is oriented at a slight angle to the tape. Data tracks are written diagonally on the tape, running from one edge of the tape to the other at a slight angle to the edge of the tape. To maximize the single track length, a large wrap angle around the helical scan head and a shallow scan angle is required. For example, the scan angle for D2 is approximately 6 degrees. Digital data recorders, developed specifically for digital data storage applications, employ a longitudinal recording format. In longitudinal recording, the recorded tracks are parallel to the edge of the tape and run the full length of the tape. Examples of digital longitudinal recording systems are 9-track tape, 3480/3490, DEC's digital linear tape (DLT), and quarter-inch cartridge tape (QIC).

AUDIO/VIDEO RECORDER (Helical Scan)	DIGITAL DATA RECORDER (Helical Scan)
D-1 (professional digital video)	ID-1 instrumentation recorder
D-2 (professional digital video)	Ampex DD-2 recorder
8mm (consumer analog video)	Exabyte 8mm (D8) tape drives
S-VHS (consumer analog video)	Metrum Information Storage Systems
DAT (consumer digital audio)	DDS (4mm) tape drives

TABLE 2
Helical scan digital data recording systems based on audio/video recorder technologies.

Some audio/video recorders, which have been successful in the professional and consumer video areas, have been adapted for use as digital data recorders. Instances of this are given in Table 2. "Video is not data," is a cautionary statement that has been made by the National Media Laboratory. It refers to the difference in system robustness and error correction philosophy used by digital audio/video and digital data recorders. In digital audio/video, a bit error that cannot be corrected by the normal ECC scheme can be concealed (information from the pixels surrounding a lost pixel can be used to conceal the missing pixel, so that a dropout goes unnoticed in the displayed video image). This practice is unacceptable for instrumentation data. More robust ECC schemes are necessary for digital data recording.

Optical Disk Stability

The optical disk schematic shown in Figure 3 illustrates the basic construction of CD-ROM, WORM, and M-O disk media. In general, there is a data layer on a substrate, which is read by a laser. For CD-ROM, the data layer consists of a reflective layer of aluminum with "pits and plateaus" that selectively reflect and scatter the incident laser beam. M-O disks contain a magnetic film that will rotate the polarization of the incident laser beam depending on the local magnetic field recorded on the magnetic "data" layer. In WORM technology, incident laser light is selectively scattered by regions of contrasting optical properties (bumps, pits, or regions of differing physical properties).

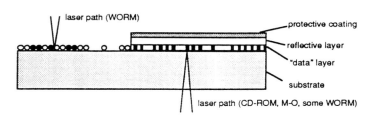

FIGURE 3
Schematic cross section of an optical disk (CD-ROM, M-O, and WORM). Optical disks consist of a data layer (pits, bumps, or regions of differing physical or magnetic properties) supported on a much thicker polycarbonate or glass substrate. A reflective layer is also required for CD-ROM and M-O disks. The data layer/reflective layer is protected with an overcoat.

Optical disks are generally constructed from polymers and metallics. The polymers are subject to deformation and degradation. Metallic films are subject to corrosion, delamination, and cracking. Metallic alloys are subject to de-alloying.

In optical media, there is a data "pit" (CD-ROM), "bump" (WORM), or "magnetic region" (M-O) that is responsible for reflecting/dispersing (CD-ROM, WORM) or rotating the polarization (M-O) of an incident laser beam. Anything that changes the reflectivity, or other optical properties for the data "bits" can result in a misread. The optical clarity of the substrate is important in those systems where the laser must pass through this layer (CD-ROM, M-O, some WORM). Anything that interferes with the transmission of the beam, such as a scratch, or reduced optical clarity of the substrate, can result in a data error.

CD-ROM Stability

CD-ROM technology relies on the difference in reflectivity of "pits" stamped into a polycarbonate substrate and vapor coated with a reflective metallic layer, which is typically aluminum.

A common cause of CD-ROM failure is a change in the reflectivity of the aluminum coating as a result of oxidation, corrosion, or delamination. Deterioration of the protective overcoat (acrylic or nitrocellulose lacquer) can make the aluminum layer more susceptible to oxidation and cor-

rosion. Some manufacturers use a silver reflecting layer that is subject to tarnishing by sulfur compounds in the environment and CD-ROM packaging. CD-ROMs can also fail because of deterioration of the polycarbonate substrate. Polycarbonate is subject to crazing, which locally reduces the optical clarity of the substrate. Oils in fingerprints and organic vapors in the environment can contribute to crazing. Scratches in the substrate as a result of mishandling can also cause disk failures.

M-O Stability

Most of the durability problems encountered with M-O disks are associated with degradation of the magnetic layer, which is a metallic film. The layer is subject to corrosion, which has given M-O a poor stability rating in the past. The rare earth-transition metal (RE-TM) alloys are subject to dealloying, which changes the magnetic properties of the "data" layer. The magnetic layers on M-O disk can be quite brittle. Subjecting M-O disks to temperature and humidity fluctuations can result in cracking of the magnetic layer.

The stability of M-O disks can be improved by the addition of a fourth metal to the RE-TM alloys that slows the oxidation process. Multilayer constructions of transition metals are also more stable, but more expensive to produce.

WORM Stability

There are several different types of technologies utilized for WORM disks, so it is difficult to comment on a specific failure mechanism for WORM. In general, any permanent change in the optical properties of the recording layer can result in a misread and data loss. Technologies involving a phase change in a metallic alloy are limited by the stability of the amorphous phase. Technologies using organic dye/polymer systems are limited by the stability of the dyes.

WORM disks with the longest life expectancies are those using technologies that produce pits on metallic alloys. Of these, WORM disks that produce pits via melting of a bimetallic alloy have a longer life that ablative methods. Ablated materials can redeposit back onto the disks, changing the optical character of previously written bits which may result in a read error.

Areal Densities and Media Longevity

The future promises the introduction of higher areal density mass storage media. All major tape and disk migration paths are partly based on planned increases in areal densities of existing storage media products. Unfortunately, higher areal densities are not conducive to long media lifetimes. Larger areal densities translate to smaller bit sizes. The smaller a bit, the more susceptible it is to loss by a "defect." A "defect" can be a dust particle, a scratch, a corrosive pit, material lost by tape head abrasion, a coating/backing imperfection, or any other bit-obscuring or bit-destroying phenomenon. A defect on a high areal density medium will obscure more data bits that the same size defect on a low areal density medium.

As areal densities increase and greater amounts of information are stored on a single cassette or disk, the number of times that cassette/disk will be accessed over its lifetime will increase. The increased wear and tear on the cassette/disk may inadvertently reduce the life of the data cassette or disk. Ultimately, the life of the storage medium could be limited by a failure of the cassette housing, rather than the stability of the media contained inside. In one instance, the life of a tape cassette was limited by failure of the cassette door, not because of any fault of the tape media.

To ensure the same level of data reliability to which a user is accustomed, migration to a higher areal density storage medium may require increased attention to the cleanliness of the recording/playback environment. Special media cartridge handling procedures may also be required.

Life Expectancies for Magnetic Tape and Optical Disk

Table 3 shows life expectancy (LE) estimates collected from various literature sources. With regard to maximum life, thirty years appears to be the upper limit for tape products, whereas some optical products promise greater than 100-year lifetimes. One of the reasons for the greater durability of the optical disk products is that it is a noncontacting read/write technology. To read/write a tape, the read head must be in physical contact with the tape.

DATA STORAGE PRODUCT	FORMAT / TECHNOLOGY	LIFE EXPECT. (YEARS)
Magnetic Tape	3480/3490	10 - 30
	Digital linear tape (DLT)	10 - 30
	DD-2	10 - 15+
	QIC	5 - 30
	D8 (data 8mm)	2 - 30
CD-ROM	Yellow Book	5 - 100+
M-O	3.5" / 5.25"	5 - 100+
WORM	Pits on bimetallic alloy thin film	100
	Ablative pits on metallic alloy (tellurium)	30 - 40
	Thermal bubble	30
	Phase change metallic alloy	10
	Pits on organic dye/polymer	10

TABLE 3
Life expectancy estimates for various mass storage media types. Sources of information: technical reports, trade literature, and product specification sheets.

Not all manufacturers have the same degree of confidence in their life expectancy claims. One manufacturer who boasts a 30-year life expectancy on a Data Grade 8mm tape only offers a 2-year warranty on this product. On the other hand, it is not unusual to find manufacturers who offer limited lifetime warranties on tape and optical disk products.

LE values for storage media are similar to MPG ratings for automobiles. Your actual "mileage" may vary depending on the number of times the storage disk/tape is accessed during its lifetime, the quality of the conditions in which it is stored, and the care with which it is handled/shipped.

Removable Magnetic Disks

The diskette business has changed drastically over the past two years. Soft-jacket diskette demand declined rapidly in 1992 and 1993, especially in the low-density 300 KB configuration. Hard-jacket diskette (MFD) demand exploded during the last 3 years, especially for the 2 MB "2HD" configuration, which is rapidly becoming the diskette choice in most applications. It is estimated that MFD demand is about 3 billion a year. Prices of MFDs of all kinds have fallen rapidly in 1993, perhaps from the fear that the consumers might seek other alternatives if the prices were not dropped. There are two MFD formats existing today, a 1MB diskette and a 2 MB diskette. It is predicted that the demand for the 1 MB diskette will fall rapidly while that of 2 MB and above will continue to grow. Due to price erosion, many small manufacturers will go out of business.

The Very High Density (VHD) Floppy

Any diskette with an unformatted capacity of 4 MB or more is classified as VHD diskettes.

CAPACITY	FORMAT	DETAILS
4 MB MFD	ED	BaFe diskettes
12.8 MB	TD	Hitachi Maxell/NEC
21 MB MFD	Floptical	Iomega and others
21 MB MP	Magnetic	Sony

All these diskettes require their own proprietary drives. Sony has recently confirmed its intention to manufacture and market its own version of 21 MB floppy drive using metal particle (MP) diskettes. Sony expects to get approval for it from JEIDA and ISO as a new standard.

The Japan Electronic Industry Association (JEIA) has decided to push standardization of a diskette with a formatted capacity of 21.4 MBytes on both sides of a metal particle coated medium. The 3.5-inch floppy will rotate at 600 rpm. An agreement was reached on the specifications of this high density format by a twenty-six-member committee consisting of disk drive and diskette media manufacturers. Included are Hitachi, Maxell, Kao, Mitsubishi Electric, NEC, Sony, and Toshiba. To be sure, Maxell is also supporting Insite Peripheral's high-capacity barium ferrite Floptical.

The Japanese proposal will be submitted to the JIS and then to ISO, probably next year. The new drives will also be compatible with the Japanese 10-MByte diskettes, hardly known in the western part of the world.

Other Removable Magnetic Disks

Iomega Corporation develops, manufactures and sells high-performance removable mass-storage products for desktop and portable computers and for workstations. Iomega's patented Bernoulli technology provides unlimited data storage capability by combining the removability and security of floppy drives with the high capacity and performance of rigid drives. Bernoulli is a line of removable, high-capacity, high-performance, storage drives. They are made with Iomega's patented Bernoulli Technology and provide on-line use, backup, portability, and security for Macintosh and IBM-compatible desktop and portable computers, and for workstations.

Bernoulli media are being used for the distribution of certain software packages that normally require many standard diskettes. For example, Aldus Pagemaker, one of the best of the desktop publishing programs, is now available on Bernoulli cartridges, aiding Bernoulli-equipped users in handling their large storage needs more efficiently and effectively. "Graphics users increasingly find that the use of removable mass storage provides not only the storage they need, but also provides near-line access to their projects."

The Bernoulli MultiDisk 150 PC Powered drive is ideal for many desktop PC users who need more storage for applications such as Windows, graphics, and desktop publishing. PC users will now enjoy removable mass storage at the capacity of MO drives, with hard drive performance, but with the unique benefits of Bernoulli technology. Iomega enhanced Bernoulli MultiDisk 150 with a write cache, an electronic buffer that allows users to save data to a Bernoulli cartridge up to three times faster.

The Bernoulli MultiDisk MacTransportable is ideal for Macintosh users who are heavily involved with multimedia, QuickTime, graphics, and desktop publishing.

With 150 MBytes of storage capacity per cartridge, the MultiDisk 150 offers more storage than any other magnetic removable disk drive and places the Bernoulli drive in the capacity range of optical drives. Moreover, the new drive allows users to choose from four sizes of disk-35 MBytes, 65 MBytes, 105 MBytes, and 150 MBytes, based on their storage requirements. It is also read/write compatible with earlier 90MB disks and read compatible with 44MB disks.

Enhanced Bernoulli MultiDisk 150 models are available now. Their suggested retail prices are: MacInsider MultiDisk 150, a complete internal drive for Macintosh Quadra 900 and 950 computers: $1,099; PC Powered 150, a complete drive and adapter for ISA/EISA desktop PC's: $1,122; Insider MultiDisk 150, an internal drive for PC and PS/2 computers: $1,099; Transportable MultiDisk 150, an external subsystem for PC, PS/2, and Macintosh computers, UNIX workstations, and networks: $1,225; Dual MultiDisk 150, an external subsystem with two 150-MByte drives for PC, PS/2, and Macintosh computers, UNIX workstations, and networks: $2,499. Suggested

retail prices for single Bernoulli MultiDisk cartridges are $225 for 150 MBytes, $169 for 105 MBytes, $129 for 65 MBytes and $79 for 35 MBytes.

End users will enjoy the new MultiDisk feature-the ability to read and write disks of various capacities: 35MB, 65MB, 105MB, and 150MB. The drive is downwards compatible with existing Bernoulli products: it reads and writes Bernoulli 90 disks and reads Bernoulli 44 disks

The PC Powered drive concept eliminates a separate AC power cord by drawing power from the computer like a hard disk drive. Data and power are combined in a single cable from the computer to the drive

End users will be able to purchase the MultiDisk 150 PC Powered drive at a retail price of approximately $799. The retail price for 150 MB Bernoulli media is anticipated to start at $99 per disk. Iomega extended its warranty across its entire line of Bernoulli removable storage drives to two years.

Floptical is a trademark owned by Insite Peripherals Inc., the inventor of a unique computer disk drive that can store 21 megabytes of data on a single 3.5-inch diskette. That's about 15 times more data than most computer diskettes hold today. It is arguably the first quantum leap in floppy drives since International Business Machines Corp. introduced the basic technology twenty-five years ago.

The Floptical, and most versions manufactured by other companies, sells for $300 to $400. Iomega's version, Insider, compatible with the Insite model, fits into the standard 3.5-inch peripheral bay of most computers and is expected to have a list price of $349. For $399, users can get a stand-alone model that plugs into the back of a computer.

Other Data Storage Technologies

Introduction

Many data storage technologies were explored in the course of this work. Some of the technologies were not in the mainstream of the technology area or not a good fit with the rest of the technology examined and were, therefore, left out of the preceding sections of this report. The purpose of this report section is to include interesting technology areas that were not able to be covered in the other sections, with the goal to make the whole report as complete as possible in terms of its breadth. To do this, technologies will be mentioned briefly. For further detailed information about the technologies, the reader is referred to the bibliography at the end of this report section.

Magnetic Disk

One magnetic disk technology of interest is the Sony Pre-Embossed Rigid Magnetic (PERM) media for fixed hard disk drives. The technology improves the data density on fixed magnetic drive media by embossing bumps on the disk substrate before the magnetic media is deposited. This sup-

plies information to serving apparatus that helps to increase track density. Estimates of the limits of this techniques are 15,000 tracks per inch. The present state of the art is at around 3,000 tracks per inch, enabling a 2.5 inch disk to have a capacity of 60 to 80 MBytes.

Optical Disk

Sony recently introduced 2.5 inch M-O drives and media to the marketplace and will most likely be increasing sales of this system over the next few years. The drive and media are based on the audio MiniDisc (MD) technology and are usually referred to as MD Data Drives and Media. This system gives 140 MBytes of storage on a 2.5 inch disk. The disks can be rewritable, read only, or a combination of rewritable and read only. The data transfer speed is 150 KBytes per second with a 30 ms average access time.

In optical disk technology, several new media ideas are available to increase storage density. The most successful technology to do this has been developed by Optex Corporation of Rockville, Maryland. This Electron Trapping Optical Memory (ETOM) utilizes the movement of electrons between energy states to store data. Information is written with blue light and read back with infrared light. This technology currently allows 1 GBytes of storage on a 5.25 inch disk. Currently, Optex is concentrating on the remote digital video on demand market.

Another attempt to improve storage density by changing the media can be seen in technology developed at Oak Ridge National Laboratory. Disks are coated with a material that changes its optical Raman spectrum after exposure to intense laser light. This technology is currently in the laboratory research stage.

Storage density of optical disks can also be increased by reducing the size of the spot written by the laser with shorter wavelength lasers or by making use of the near field optical intensity distribution at the end of an optical fiber. This potential use is one reason research and development has been very active in the area of "blue" laser diodes. There has also been activity in the area of near-field magneto-optical recording where an optical fiber is used to image the spot in the optical "near field," thus overcoming limits in traditional optical recording.

Magnetic Tape

Thompson CSF has been developing a linear magnetic tape storage system that uses conventional technology to write information magnetically on the tape but uses the Kerr effect to read the data on the tape optically. This technology is directed at an HDTV tape recorder. Unlike video recorders of today however, this technique will use linear tracks.

AFM/ STM

There has been significant activity in the area of using Scanning Tunneling Microscopy (STM) techniques to read and write data at the molecular scale. The basic idea is to

use a very small tip of a STM to produce pits or move atoms on the surface of a substrate, then use the same apparatus to detect the rearranged atoms. It has been estimated that this technique can record information at densities of 10,000 times the density of current optical disk technology.

Integrated Circuit

There are several technologies of interest in the integrated circuit area. These include Semiconductor-Oxide-Nitride-Oxide-Semiconductor (SONOS), nonvolatile SRAM (NVRAM), and ferroelectric RAM with optical readout. The SONOS technology has been available for many years but is not the dominant technology in nonvolatile integrated circuit memory today. NVSRAM or Shadow RAM uses EEPROM to back up the SRAM on the chip at the loss of power. NASA has demonstrated a nondestructive means of optically reading ferroelectrically stored information. Finally, one company has proposed the use of hall effect transistors to read information stored in a magnetic film.

CHAPTER 5

Aerial Triangulation Adjustment And Image Registration

Introduction

CHRIS McGLONE

Aerial triangulation was the defining problem during the development of analytical photogrammetry. Tremendous effort was spent on the mathematical basis of block adjustment, not just on the purely mathematical and statistical aspects, but also in optimizing the solution to be feasible on the available computers.

Today, standard block adjustment must be considered a solved problem. Full-featured commercial packages are available on a number of inexpensive computers. The basic mathematical model of the bundle adjustment, has been refined to accuracy levels which would have un-imaginable years ago and which, in many cases, cannot be approached by other methods.

But, as in all technologies, the problem never stays the same. The Global Positioning System (GPS) adds a whole new type of information to the solution which promises to greatly improve the economics, accuracy, and operational flexibility of aerial triangulation. How best to combine this information with the existing photogrammetric structure? How do we model the random and systematic error proper-

ties of the GPS information, and properly combine it with the photogrammetric information with its own types of error? What are the most effective block geometries for its use?

The papers by Ackermann and Collins in this section address these issues. Ackermann discusses optimal block configurations and data reduction procedures for incorporating GPS information into a block adjustment, with an emphasis on robustness against over-reliance on the GPS data. Lucas addresses the study of optimal block configurations using simulated images and covariance propagation techniques.

Another aspect of the current problem is the increasing availability of digital sensors with non-frame geometries. Before they can be used in analytical photogrammetry these sensors must be mathematically modeled. The form of these models is crucial, since this completely determines the future utility of the data. The paper by McGlone describes types of sensor models and outlines criteria for their selection and evaluation.

The Status and Accuracy Performance of GPS Photogrammetry

FRIEDRICH ACKERMANN

Abstract

The basic features of high precision GPS camera positioning for aerial triangulation are recalled. In view of potential signal interruptions and biased ambiguity solutions the method of combined blockadjustment with linear GPS drift parameters has been developed. It relies on some ground control points and additional cross strips. It is fully operational and widely used in practice. Its high accuracy performance and its economy is demonstrated.

The recent developments in kinematic GPS promise to provide directly continuous GPS trajectories on absolute GPS datum, as a result of which the combined aerial triangulation is expected to become completely autonomous and independent of ground control. A number of critical questions are asked concerning the reliability of results in view of the severe operational conditions of air survey flight missions. Extensive empirical investigations are necessary before the seemingly ideal methods can be safely relied upon in practical aerial triangulation.

Introduction

GPS Application in Photogrammetry

GPS positioning is applied in aerial photogrammetry in different ways: (1) Determination of ground control points by terrestrial GPS (2) GPS flight navigation (3) GPS camera positioning for aerial triangulation (4) Positioning of other airborne sensors. In the following the scene is reviewed, mainly from a practical and application point of view, as has been asked. The discussion will concentrate on the kinematic camera positioning for aerial triangulation.

GPS Signals

Let us recall that GPS positioning is based on the signals emitted from the satellites, giving essentially distance information. We distinguish originally the C/A code pseudorange observations and the phase observations on the L1 and L2 carrier waves. The satellite positions (ephemeries) and the derived receiver-antenna positions refer, in principle, to the WGS84 coordinate system, an earth-fixed cartesian system.

The C/A code pseudoranges have direct real-time capability, but they are subject to selective availability (SA) and other systematic error effects (e.g. multipath, ionosphere, troposphere, orbits), by which the original random measuring precision of about 3 m deteriorates to about 30m - 40m. The pseudorange positioning accuracy with SA is guaranteed to be < 100 m with 95% probability. The carrier phase observations in airborne applications are precise to some mm, which qualifies them for all high precision positioning applications. However, they have the ambiguity problem.

The large error effects in the GPS system can be compensated to a great extent by differential GPS methods. They operate usually with double differences between observations of at least one stationary receiver on a known point and - in the photogrammetry case - a moving receiver in the airplane. With differential GPS the accuracy of relative pseudorange positioning (with SA) is in the order of 10 m. Special techniques (i.e. phase smoothed pseudoranges) can push it to about 2 - 3 m. With differential phase observations (L1 only) the precision of relative kinematic positioning of a photogrammetric camera in flight has been experimentally assessed to be in the order of 2 cm - 5 cm, the interpolation effect between GPS positions and actual camera exposures being included (Friess, 1990).

The mentioned numbers summarize very briefly the GPS performance of only 2 or 3 years ago, on which safe and reliable application methods had to be designed. The actual performance figures may have changed since, but they still characterize the basic situation up to today. P code or Y code data were not considered at the time, having not been truly available.

Ground Control Points by GPS

The first application of GPS for photogrammetry concerns the geodetic determination of conventional ground control points by standard GPS ground survey methods. It has become every day practice, with considerable gain in time and economy, especially as intervisibility between points is not any more required. The points are to be provided in the national horizontal and vertical reference system. Logistics being often the limiting economic factor there remains pressure in general - exceptions granted - to further reduce ground control for aerial triangulation by airborne GPS.

GPS Flight Navigation

GPS is widely and regularly used in aerial photogrammetry for flight navigation. It is based on real-time positioning by pseudorange observations. The computed position is displayed to the pilot together with the planned flight line. In addition the camera exposure can be automatically triggered by the computer, at closest distance to the preplanned and stored position. The resulting photo-blocks are extremely regular, with pin-point exposures (at the expense of constant forward overlap). GPS flight navigation

is fully operational. Satisfactory commerical systems (equipment and software) are available.

The required navigation accuracy (1σ) can be specified to be about 5 mm in the photoscale. It means > 50 m for photo scales < 1 : 10000, which is directly obtainable with pseudorange positioning and related flight navigation. Larger photo scales or other airborne sensors warrant higher navigation accuracy. It is obtained by relative pseudorange positioning, with realtime data transfer from the ground station to the airplane by radio communication.

GPS Camera Positioning for Aerial Triangulation

Severe Operational Conditions, the Ambiguity Problem

The determination of camera air stations for aerial triangulation is the major and most challenging application of GPS in photogrammetry. It corresponds to the classical case of auxiliary data (statoscope, APR) for vertical camera positioning, extended to horizontal positioning, although the term auxiliary data is not appropriate any more, in view of GPS taking over a major role. Nevertheless, the basic approach is still the same: GPS data and conventional photogrammetric aerial triangulation observations are merged into a combined block adjustment, the main purpose being reduction of ground control points, possibly up to "aerial triangulation without ground control."

Accuracy considerations specify in general that we are concerned with relative kinematic GPS positioning by differential carrier phase observations. The task may seem simple, almost standard. There are, however, very severe operational conditions and inherent error problems which require thorough considerations about the strategy of approach. The main problem has been, apart from ordinary cycle slips, the high probability of signal interruptions during flight turns and the subsequent reassessment of the ambiguity solutions, in order to maintain a continuous GPS trajectory. Related is the GPS datum problem, whether the GPS coordinates are absolute within the required accuracy with regard to WGS84 and how they are transferred into national geodetic coordinate systems, with the geoid problem showing up. In addition there is the general problem of inherent systematic GPS errors (e.g. atmosphere, orbit), especially if only L1 signals are used, as has been the case in the past. These basic problems are aggravated by severe operational conditions. A photogrammetric flight mission may extend over several hours of time, without any possibility of intermediate control or update of GPS data. For economic and logistic reasons usually only 1 stationary GPS receiver is considered, which may be located at a large distance from the mission area (upto 500 km or more). We must not forget that GPS aerial triangulation is particularly interesting for project missions in foreign countries, not only for systematic national mapping programs, for which safer operational conditions may be provided or asked for. Finally, there are minor problems concerning the spatial off-set between GPS antenna and the camera in the airplane, as well

as the time off-set between GPS observations and camera exposures. They can be considered as solved, not requiring any further attention.

Combined Block Adjustment, GPS Drift Parameters

Facing the described situation a solution had to be found which would be sucessfully and safely applicable under practically all operational conditions, as far as photo-flights for aerial triangulation are concerned. A special approach, characterized by GPS drift parameters, has been suggested by the author some time ago (Ackermann, 1988). It has been realized and programmed. And quite a number of European agencies and institutes have developed similar systems. The method has been successfully applied in practice since.

The basic consideration has been, that a continuous GPS trajectory cannot safely be obtained and is therefore not attempted. Instead, after any loss of lock of the GPS signals, each string of continuous GPS data is treated independently. In practice even each photo strip is treated separately, whether a loss of lock has occurred or not. The reassessment of the phase ambiguities is based simply on pseudorange positions. The resulting ambiuiguity solutions are biased causing systematic errors in the subsequent GPS positions. The resulting systematic positioning errors are linear, in first approximation. No attempt is made at that stage to avoid the drift errors, except for keeping them small enough to maintain linearity, as a function of time. Instead, the error effects are mathematically modelled by linear correction terms which are determined and applied during the combined block adjustment. The operational consequences of that approach are highly favourable. Any pre-mission stationary baseline determination is abandoned. GPS data recording may start only when the mission area is reached. Flying and navigation are not concerned with the GPS data recording and steep banking angles are acceptable. It is a particulary important feature that the method also allows large distances between the stationary receiver and the mission area, up to several hundred km and more. A side effect is that any other linear systematic GPS errors, which may or may not be present, are implicitly compensated.

In evaluating the theoretical status of the method it is essential to recall that the main motivations have been operational aspects for a safe, reliable and still highly accurate method. It is the prime concern that missions must not be lost in practical application.

The Datum Problem

The described method implies that no absolute GPS coordinate reference is maintained nor attempted. The datum for the photogrammetric block has to be provided in a different way, not via GPS. The obvious and standard way is to rely on a few conventional ground control points, normally just 4 XYZ control points (or pairs of points) in the corners of a regular block. That number is sufficient (although it might be increased in case of irregularly shaped blocks), as the control points, contrary to conventional aerial triangulation, are to provide the datum transformation only.

In this way also the geoid problem is practically solved, at least for medium and small scale applications. If a geoid is known, it is superimposed accordingly. To circumvent all datum problems by referring to a few ground control points again constitutes a simple, practical solution which relies on standard techniques in a highly economic way.

Cross Strips

Under the assumptions made, the combined adjustment of conventional photogrammetric aerial triangulation measurements and GPS camera station data, including linear parameters for stripwise correction of systematic GPS errors, can be approached in a straight forward way. The resulting matrix structures require only minor modifications of the standard block adjustment programs. Modified adjustment programs have been developed in a number of places and are also commercially available.

There is, however, the problem of singularities. A block with standard overlap and 4 ground control points is geometrically instable and remains so with GPS camera station data if the additional GPS correction parameters are applied stripwise. The combined block adjustment becomes numerically unstable, i.e. runs into singularities resp. near singularities. To compensate for the deficiencies 2 remedies can be applied: either a chain of vertical control points at either end of a block, or alternatively, 2 cross strips (see cases a and b in Figures 1,2). The cross strip option is the standard recommendation in order to ensure safe, reliable and accurate GPS aerial triangulation with the method in question.

Accuracy

GPS supported blocks have extremely favourable accuracy features. The GPS determination of the perspective photo centres strengthens the geometry of a block rigidly. The blocks are extremely well controlled by GPS, as if each perspective centre would be a control point. The effect is strongest if the GPS coordinates are absolute. With additional free parameters in the block adjustment the geometry is somewhat weaker, but the overall accuracy level is still very high.

The general accuracy features of GPS blocks have been investigated theoretically by simulation and inversion of normal equations. It has been shown in (Ackermann, 1992) that the accuracy distribution within a block is highly homogeneous, and that the accuracy depends little on size and shape of the blocks. The most important result is that the accuracy level of GPS is in general very high. Similar accuracies could be achieved in conventional aerial triangulation only with a large number of ground control points. GPS data suppress effectively any propagation of errors within a block — taking over that previous function of ground control points — to the extent that the resulting accuracy is close to the mere intersection accuracy of image rays as it is determined by the image coordinate measurements alone. This is so as long as the GPS positioning precision is as good as the photogrammetric measuring precision (expressed in object space units).

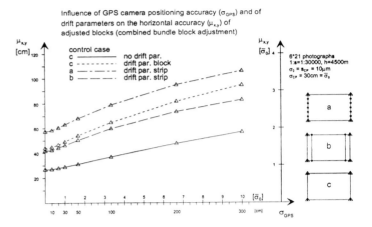

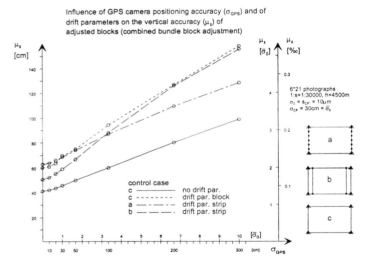

FIGURES 1 AND 2
Influence of the GPS Positioning Accuracy on the Block Accuracy.

The redisplayed Figures 1 and 2 summarize the essential theoretical accuracy relations. They show the accuracy of adjusted GPS blocks as function of the accuracy of the GPS camera positions (σ_{GPS}) for various cases. The results are expressed in units of σ_0, i. e. the photogrammetric measuring accuracy of the image coordinates, transformed as $\sigma_0 \cdot s$ into object space. We recognize that the accuracy results can be taken as constant, as long as $\sigma_{GPS} < \sigma_0 \cdot s$ (lower left ends of the curves), i. e. as long as the GPS accuracy is equal to the photogrammetric measuring accuracy ($\sigma_0 \cdot s$) or better. This can be reached easily, as $\sigma_0 \cdot s$ amounts to 10 cm for photo scale 1 : 10000 resp. 60 cm for photo scale 1 : 60000, if $\sigma_0 = 10$ µm. The further extensions of the curves show that even with poorer GPS accuracy still highly acceptable results can be obtained. The photogrammetric requirements

for GPS accuracy are not really extreme. Accuracies better than 10 cm are only required for large photo scales. An equally important result of Figures 1 and 2 is the finding, that the different scenarios have a dominating influence on the accuracy. Evidently the best results are obtained if the GPS data are precise and absolute (case c, no drift parameters). In that case the r.m.s. accuracy of adjusted blocks is $0.9\,\sigma_0 \cdot s$ in x, y and $1.4\,\sigma_0 \cdot s$ in z which is equivalent to a height parallax accuracy of $< \sigma_0 \cdot s$. These are the potentially best results obtainable with absolute GPS (under standard overlap and measurement assumptions). The case b (2 cross strips, drift parameters per strip) represents the method which has been described here. It has weaker geometry and is basically less accurate. The difference amounts, at the left side of the respective curves, to 50% in x, y and to 20% in z. This is still very high block accuracy, in conventional terms, amounting in x,y to about $1.4\,\sigma_0 \cdot s$ and in z to about $1{,}8\,\sigma_0 \cdot s$ which is equivalent to 1.2 h/10000, a result which can hardly be reached by very dense vertical control in conventional aerial triangulation with $\sigma_0 \cdot s \approx 10\,\mu m$. The above results refer to negligible magnitudes of the GPS position errors, which is realistic for medium and small scale application. If we allow $\sigma_{GPS} \approx \sigma_0 \cdot s$ then the expected block accuracies are about $1.5\,\sigma_0 \cdot s$ horizontally and $2.0\,\sigma_0 \cdot s$ vertically.

The theoretical studies have established the very high accuracy performance of GPS blocks, even in the case of additional drift parameters. The results are also valid for the whole range of photo scales which are used in practice for mapping purposes. The only case where GPS is not truly sufficient is aerial triangulation for high precision point determination, with signalized points and very large photo scales. GPS still may be used, but additional ground control points would be advisable. That case warrants further investigation.

Practical Application, Results, Experience

On the basis of the described method, which refers to analytical aerial triangulation (there exist independent model versions as well), the GPS supported aerial triangulation has been regularly and successfully applied in practice, for about 3 years by now. In (Ackermann, 1994) 23 GPS block projects are described, the combined adjustment of which has been carried out by Inpho Company alone. All adjustments were successful, although the data were obtained from different companies and refer to different GPS receivers. The projects came from various countries and cover a wide range of photo scales (from 1 : 6100 to 1 : 50000). Also the block sizes varied greatly, ranging between 12 photos and 1633 photos per block or strip. Variable numbers of cross strips were used, depending on shape and geometry of a block. From such experience it can be stated that GPS aerial triangulation with that method is fully operational and has proven to be simple in application, robust and reliable. A particularly important result is the empirical confirmation that the stationary receiver can be very far away. In one of the blocks of photo scale 1 : 6000 a stationary GPS receiver was located in the block area, another more than 400 km away. The 2 sets of GPS data were used for 2 separate block adjustments. The r.m.s. coordinate differences of

the 2 adjusted blocks were in the order of 1 cm.

It is remarkable, in addition to the operational functionality, that the empirical accuracy of the adjusted blocks, as far as it could be assessed by check points, showed the expected high accuracy results which agreed very well with the theoretical prediction. The average r.m.s. accuracy results, as derived from 9 blocks with check points, were 1.5 $\sigma_0 \cdot s$ / 2.2 $\sigma_0 \cdot s$ for x, y / z (to be compared with the general theoretical expectation of 1.5 $\sigma_0 \cdot s$ / 2.0 $\sigma_0 \cdot s$), although there were individual deviations. Equally convincing results can be quoted from (Burman and Torlegård, 1994), a Working Group report of OEEPE (European Organisation for Experimental Photogrammetric Research). Altogether 13 controlled GPS blocks from 5 different European countries were collected and analyzed, most of them taken from practical application projects. The photo scales ranged from 1 : 3300 to 1 : 50000, and the block sizes from 12 photos to 264 photos. GPS drift parameters were applied in all cases. 9 blocks were flown with cross strips. The interesting accuracy results, derived from check points, are summarized in Figure 3, as function of the assumed precision of the GPS camera positioning (σ_{GPS}). The overall high accuracy of the adjusted blocks is generally confirmed. The same accuracies could normally be only reached with considerably more ground control points. At a closer look the results even agree very well with the theoretical accuracy expectation as taken from Figures 1 and 2 (case b).

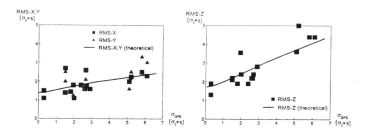

FIGURE 3
Controlled accuracy results of OEEPE blocks

Economy

There are no empirically confirmed data available about the economy of GPS aerial triangulation. It is clear, however, that the essential and only justification of applying GPS for aerial traingulation is economic, by the considerable saving of ground control points, at least as far as the standard case of aerial triangulation is concerned. The author has found, in an internal study based on realistic cost assumptions, that the GPS aerial triangulation is by about 25% more expensive than in the conventional case. That concerns flying, GPS-equipment, -operation and -processing, aerial triangulation measurements and combined block adjustment. These additional expenses are compensated resp. overcompensated by the saving of almost all ground control points which would normally be necessary to obtain

the same accuracy. The total saving amounts to about 40%. It is strongly dependent, however, on the costs for ground control which can vary very much. There are certainly cases where the savings diminish or may not be substantial at all. For standard application it can be concluded, however, that the use of GPS for aerial tringulation is economic and that it can be recommended as a standard procedure.

The New Challenge

Extended Goals

The described method with additional GPS drift parameters satisfies, in the author's opinion, the practical demands for most aerial triangulations, for the time being. The procedure is accurate, reliable, economic and, above all, fully operational without very special requirements on equipment, method and software. But there is certainly more to it. The ideal goal of GPS aerial triangulation is clearly to become completely autonomous and practically independent of any ground control (not considering here the still further reaching concepts of measuring directly all 6 exterior orientation parameters of aerial cameras or other sensors, preferably in realtime and accurate enough to make aerial triangulation obsolete). It would mean continuous GPS trajectories of high accuracy with regard to an absolute GPS datum and transformation to any national reference system. Such goals would simplify the total process and give economic benefits by speed and direct high accuracy results. It would also widen the application of aerial triangulation and be able to meet extended demands.

Extended application of aerial triangulation deserves particular attention. With fixed absolute GPS positions aerial triangulation could be extended to cover hitherto difficult cases, such as photo coverage of forest areas, in polar regions, or with incomplete models in coastal areas, bridging water areas and tying in islands. Another wide and demanding task is the absolute and continuous positioning of other airborne sensors, like laser scanner, radar scanner or multispectral scanner, as well as any push broom linear array camera or sensor system, also in space missions. Those sensor systems depend more on continuous GPS trajectories and preferably absolute GPS positioning than aerial triangulation as there are less possibilities for combined adjustment. The status of those systems cannot be discussed here in more detail, but positioning of airborne sensors has been clearly identified in the introduction as the fourth major field of GPS application in photogrammetry.

Recently, new GPS equipment, refined methods, new GPS software and realtime capabilities have appeared which come closer to the specified ideal performance of GPS aerial triangulation. There are far reaching claims from the vendors and the scientific side, as well as high expections from the users side. The key technical elements are dual frequency receivers, improved noise suppression, fast resp. instantaneous ambiguity solutions on the fly, possibly in realtime, and absolute GPS datum. Preliminary results are certainly most encouraging. On the other hand it is not yet sufficiently

established on which possibly restrictive conditions the new achievements depend and to what extent they are reliable under the operational conditions prevailing in aerial photogrammetry mission. In the following it is attempted to specify the required performance, as far as aerial triangulation is concerned, and to identify areas where extended experimental tests seem necessary. Not questioning the highly encouraging new methods and results which have become known (e.g. Hatch 1990, Schade 1992) the main point of concern is the reliability of the new technology under adverse conditions. Reliability is the major condition for a method to be acceptable and applicable in practice.

Continuous Trajectories, Fast Ambiguity Solutions

There are new methods and software programs claiming ambiguity solutions "on the fly" correct to one cycle. Also, the now complete satellite space segment makes total loss of signals in flight turns unlikely. Thus the conditions for obtaining continuous trajectories are generally favourable. From the point of view of reliability there remain 2 questions which require clarification by theory and experiments: (1) Which stretch of straight flying (30 sec, 10 sec or less?) is required for exact ambiguity solutions? (2) Are the solutions safe over distances up to 500 km or more? An error of 1 or 2 cycles can cause GPS drift errors in the order of 1 m/hour.

Systematic GPS Errors

If continuous GPS trajectories can be safely achieved for photo flight missions the provision of stripwise GPS drift parameters can be dropped. Likewise cross strips will not be necessary any more. It remains to be empirically verified, however, whether there remain some sources of systematic errors, especially if the trajectory extends over hours of flying, at great distances from the reference receiver. Dual frequency receivers will compensate the ionospheric error effects. But the tropospheric error effects are still difficult to model, in particular over large distances. Ambiguity errors of 1 or more cycles may remain which in turn cause drift errors. If some overall systematic errors in long GPS trajectories are still to be expected their magnitudes are to be investigated and whether they behave linearly over the whole mission or not. The possibilities of compensation will depend on it. There is certainly an urgent necessity for extended experimental research in order to assess the conditions and the range within which one can rely on continuous GPS trajectories.

The Datum, Absolute GPS Coordinates.

The discussion on systematic errors is related with the GPS datum problem, to which extent the computed GPS positions can be considered absolute (with respect to WGS 84 and to any national geodetic reference system). It may be expected, optimistically, that we will be concerned only with some overall systematic errors of long GPS trajecto-

ries. They could be modelled, if necessary, by one overall set of GPS drift parameters in the combined adjustment which would be equivalent to a free overall datum transformation. Those datum parameters, that is what they are, might be determined in different ways. The simplest case would be to still rely on a few conventional ground control points. Other solutions to be considered could rely on a closing error at the airport between pre- and post-mission stationary baseline determinations (not advisable for operational reasons) or use nodes of crossing flight lines in the mission area.

To obtain an absolute GPS datum seems realistic if several GPS ground stations are used, possibly outside the mission area. Reliable solutions can be obtained by permanent monitoring GPS stations as they are planned or realized in several countries. They will also be able to provide the immediate transformation into the respective national geodetic reference systems.

All absolute GPS coordinates have the geoid problem with regard to the vertical reference. Large scale photogrammetric applications ask for a decimeter geoid over extensions of 50 km or more. Unless it is known explicitly the geoid must be provided implicitly by additional vertical control points derived by plumb line oriented methods. The photogrammetric requirements for absolute GPS coordinates are high to moderate. Large scale applications ask for accuracy levels of 10 cm or less. The requirements of medium and small scale mapping are in the order 20 cm to 50 cm. The datum solutions should be reliable also in cases where for instance a block is flown on separate days, possibly with different receiver/camera/airplane combinations and monitored from different GPS ground stations.

No Ground Control, Test Field Calibration

If all the previously mentiond problems would be sufficiently and reliably solved then the GPS aerial triangulation would become completely autonomous and could operate without any conventional ground control points, certainly a desirable scenario. In that case, however, the interior camera calibration errors would create a new, most serious problem. Those error effects are normally compensated to a great extent by fitting a block to ground control points, pushing most error effects into the camera orientation parameters. However, if a block is hooked onto the GPS air stations the systematic effects, which are of noticeable magnitude, will be fully imposed on the adjusted block points, being practically not compensated at all. The use of laser altimeter might be a first remedy in that case.

It has been suggested to solve the problem by testfield camera calibration (Merchant, 1993). It may be allowed to express here some cautious reservations against testfield calibrations which the author considers problematic, for several reasons: The method can only be applied in regular conditions as controlled by government agencies. It is not sufficiently operational for arbitrary engineering projects. Also, it is known from experience that testfield calibrations are not truly representative for flight missions on different

days, in different areas and altitudes, with different film magazines and different film rolls. Camera calibration testfields have been suggested and realized in Europe some 15 years ago, to be applied for precise camera calibration beyond the level of laboratory calibration and physical refraction models. But they were not really applied in practice, for operational and cost reasons, and because the same results were reached with self calibration techniques. On the other hand test fields are highly effective for calibrating and checking GPS time delays and off-sets, although there may be simpler methods applied. Thus, the author maintains a sceptical attitude, until proven otherwise. In any case the results of the USGS program are awaited with great interest.

Refined Adjustment

There have have been suggestions to apply more rigorous adjustment methods both in the GPS positioning computations and in the combined block adjustment, for instance by considering the correlation of double differenced phase observations. While it is generally advisable to apply adjustment models and methods as rigorous as possible it makes sense only, from a practical point of view, if the effects are more than marginal. In the case of differenced phase observations it remains questionable whether the mathematical correlation has any substantial effects. First, the original observations are likely to also have physical correlation which would still not be taken into account. Second, the potential effects are in the mm order of magnitude only, at least locally, which is not of particular concern in photogrammetric applications, with the exception perhaps of obtaining more reliable ambiguity solutions. In general, refined error modelling makes sense only if all components involved are treated on the same level of rigorousness. For instance, the correlation between and within photographs might also be considered in the combined adjustment. Not wanting to prevent any refinement it may be concluded, nevertheless, that the attention and refined mathematical modelling ought to be directed as much as possible to the problem of systematic and datum errors of GPS positioning for aerial triangulation purposes. Other potential refinements might yield smaller effects due to the compensating effects of the combined adjustment.

Attitude Determination by GPS Interferometry

It may be briefly mentioned that it would be of great interest to photogrammetry if also the attitude camera orientation parameters could be measured directly in-flight, preferably within the GPS system by multi-antennae arrays. Angular precision in the order of 1/10000 or better would be most valuable for many applications, although it is not sufficient for complete image orientation. Unfortunately, only results in the order of 1/1000 are obtained at present (Schade et al., 1993). The main disturbing factors seem to be multi-path effects. Further efforts should be encouraged in order to obtain the desired results.

Evaluation

The new developments in high accuracy airborne kinematic GPS positioning are certainly highly encouraging and promising. They concern and are of great importance for different fields of application of various airborne or spaceborne sensor systems. In the special case of GPS camera positioning the use of dual frequency receivers and of fast ambiguity solutions will result in continuous GPS trajectories of high absolute accuracy. Through the combined data adjustment aerial triangulation can then become autonomous, i.e. independent of ground control. The expectations with regard to technical and economic benefits are high. Nevertheless, the anticipated performance still needs clarification and confirmation by experimental investigations. It remains to be seen whether the disturbing error effects of interior camera orientation and of the camera/GPS system calibration will be better solved by test field calibration or by some few ground control points. Also, the successfully demonstrated performance of the new receiver and software developments needs clarification as to which extent the high accuracy kinematic GPS positioning can be reliably applied under the severe conditions and over the full range of air survey missions.

References

Ackermann, F., 1988. Combined Adjustment of Airborne Navigation Data and Photogrammetric Blocks. *Int. Archives of Photogrammetry and Remote Sensing*, Vol. 27, B8, Kyoto, 1988, pp. III 11-23.

Ackermann, F., 1992. Operational Rules and Accuracy Models for GPS Aerial Triangulation. *Int. Archives of Photogrammetry and Remote Sensing*, Vol. 29, B3, Washington, 1992, pp. 691-700.

Ackermann, F., 1994. Practical Experience with GPS supported Aerial Triangulation. *The Photogrammetric Record*, in print.

Burman, H. and Torlegård, K., 1994. Empirical results of GPS supported Block Triangulation. OEEPE publication, in print.

Friess, P., 1990. Kinematische Positionsbestimmung für die Aerotriangulation mit dem NAVSTAR Global Positioning System. Dissertation, Deutsche Geodätische Kommission, München 1990, Reihe C, Heft 359.

Hatch, R., 1990. Instantaneous Ambiguity Resolution, *Proceedings of the IAG Symposium 107, Kinematic Systems in Geodesy, Surveying and Remote Sensing*, pp. 299-308, Banff, Canada, 1990.

Merchant, D., 1993. GPS Controlled Aerial Photogrammetry, *Photogrammetric Engineering & Remote Sensing*, Vol. 59, No. 11, November 1993, pp1633-1636.

Schade, H., 1992. Reduction of Systematic Errors in GPS Based Photogrammetry by Fast Ambiguity Resolution Techniques, *International Archives of Photogrammetry and Remote Sensing*, Vol. 29, B1, Washington D.C., 1992, pp. 223-228, 1992.

Schade, H., Cannon, E., and Lachapelle, G., 1993. An Accuracy Analysis of Airborne Kinematic Attitude Determination with the NAVSTAR/Global Positioning System, *Zeitschrift für Satellitengestützte Positionierung, Navigation und Kommunikation* (SPN), Heft 3/93, pp. 90-95, 1993.

Sensor Modeling in Image Registration

CHRIS McGLONE

The widespread availability of digital imagery and the inexpensive computer power to display and process this imagery has given users of cartographic data the ability to generate their own cartographic products, instead of relying upon paper maps generated by professional cartographers and photogrammetrists.

Inexpensive software packages enable the user to perform image registration, DEM generation, feature extraction, terrain rendering, orthophoto generation, and ground cover classification. However, for many users these packages are "black boxes" whose inner workings are little understood or appreciated. Every package has assumptions or approximations in its internal mathematics or structure; the implications of these assumptions are often not detailed in the documentation so that an unsophisticated user can appreciate them. The complications of modeling dynamic digital sensors now in use, such as satellites, make the use of such approximate models even more tempting. A number of different camera models types are available, although it is not clear that most users are equipped to evaluate these models or choose among them.

Another direct consequence of the increased availability of digital imagery has been the rise of computer vision research, which has brought the application of different mathematical techniques and emphases to the analysis of imaging geometry. However, the emphasis has mainly been on image registration [Brown, 1992], the determination of general mapping functions from one image to another, instead of sensor model analysis and application. Cartographic applications of computer vision are of increasing interest [Gee and Newman, 1993], but little rigorous cartographic analysis has been done on the models and algorithms used.

This chapter will outline a taxonomy of sensor models, giving examples and discussing the basic properties of each. Evaluation methods for model parameter solutions and a comparative application example are given. While a chapter of this length cannot hope to provide an exhaustive, in-depth study of the area, it is hoped that it will at least give an appreciation of the issues involved in the selection and use of sensor models.

Types of Sensor Models

This section is an attempt to create a taxonomy of sensor models—to classify them according to their properties as a basis for understanding their proper application and evaluation. The classifications are not mutually exclusive; it is possible in many cases to mathematically transform from one type of model to another, allowing the user to solve for the parameters of one type of model, then use another model for later calculations. The intention is for the classes presented to highlight similarities and differences in the model parameter determination and application for the various models, and to serve as broad indicators of basic properties.

Physical Models

In a "physical" model the parameters describe the location and orientation of the sensor with respect to an object-space coordinate system, the exterior orientation, and its internal dimensions and operational properties, the interior orientation. The position of the sensor is expressed in any of several world coordinate systems while the orientation may be described using any well-defined system of rotation angles [Slama, 1980]. The exterior orientation is typically different for each image, or each portion of an image in the case of dynamic sensors, while the interior orientation is usually taken as constant across a set of images. Quantities making up the interior orientation might include dimensions such as the focal length or detector pixel size, or for dynamic sensors, operational properties such as scan rates and motion compensation rates. The fundamental equations in a physical model are based on physical principles, possibly idealized to simplify the mathematics. For example, the collinearity condition [Moffitt and Mikhail, 1980] expresses the requirement that the light ray from the object point to its image is, ideally, a straight line. Processes such as lens distortion or atmospheric refraction which act to curve the path of the light ray are typically corrected in a separate step, in order not to complicate the form of the collinearity equation.

The most common example of a physical model is the standard frame camera model, with its usual parameterization:

- exterior orientation
 - location: Xc, Yc, Zc in a Cartesian object space coordinate system.
 - orientation: omega, phi, kappa, defined with respect to a Cartesian object space coordinate system, expressed as a 3 by 3 rotation matrix **M**.

- interior orientation
 - focal length (principal distance)
 - principal point coordinates with respect to fiducial point coordinate system.

- systematic error corrections
 - lens distortion
 - atmospheric refraction

115

• imaging equations

$$x = x_o - f \frac{m_{11}(X_p - X_c) + m_{12}(Y_p - Y_c) + m_{13}(Z_p - Z_c)}{m_{31}(X_p - X_c) + m_{32}(Y_p - Y_c) + m_{33}(Z_p - Z_c)}$$

$$y = y_o - f \frac{m_{21}(X_p - X_c) + m_{22}(Y_p - Y_c) + m_{23}(Z_p - Z_c)}{m_{31}(X_p - X_c) + m_{32}(Y_p - Y_c) + m_{33}(Z_p - Z_c)}$$

For a dynamic sensor the physical parameterization becomes much more complicated, since the orientation parameters vary with time and must be expressed as a function of time over the imaging period. In the case of a satellite, orbital and attitude parameters may also be included in the solution [Westin, 1990, Kratky, 1989, Mikhail and Paderes, 1991].

Using a physical model requires defining the level of detail to be modeled—deciding which of the myriad of physical processes operating during image formation are not significant for the required level of accuracy. For example, lens distortion is often neglected for modern mapping cameras since its magnitude is usually not more than a few micrometers, while atmospheric refraction is usually neglected for low-altitude imagery.

One advantage of a physical model is that individual parameters can be determined in different procedures, instead of determining them simultaneously in a resection procedure that may become ill-conditioned as a result of trying to determine too many parameters. The most common example is the calibration of mapping cameras to determine the interior orientation parameters. The focal length and principal point coordinates are extremely difficult to solve for in aerial applications; by calibrating these beforehand, they can be carried as known quantities in the resection solution and contribute to a stronger solution. The exterior orientation parameters may be determined using orbital or GPS information, thereby reducing the control requirements of block triangulation.

An implicit philosophical question arises when using physical models; how well do the parameters actually represent "reality?" In any resection there are un-modeled effects (systematic errors), which are absorbed or hidden by changes in the values of the modeled parameters; for instance, uncorrected radial distortion in vertical imagery is absorbed by a change in altitude. If parameters are precalibrated, then their values may change due to the difference in environments between the calibration chamber and the operational setting. In general, values for the model parameters should be used with caution outside the operational context in which they were determined.

A further refinement to physical models is the addition of calibration parameters to describe effects known or suspected to be present, then solving for these "added" parameters within the resection solution. Several different formulations of added parameter functions have been derived [Ackermann, 1980]. Systematic effects, such as radial distortions, can be represented by explicit representations,

polynomials, or finite elements. Whichever type of error model is used, the block adjustment configuration must be carefully designed with respect to image overlap and ground control placement. The solution must be monitored for excessive correlations among the added parameters.

Although the derivation of a physical model can be complicated and the solution procedures complicated and nonlinear, physical definitions of the parameters make understanding and evaluating the solution much easier. A negative flying height or a standard deviation of a thousand meters on the sensor location give clear indication of problems in the solution, whereas the parameterizations of other types of models may obscure such problems.

Abstract Models

The fundamental basis of photogrammetry is projective geometry; however, models based on such abstract formulations have been little used within the photogrammetric community until recently. Reasons include the emphasis on imagery from calibrated aerial mapping cameras, for which the use of physical models allows the inclusion of calibration data, and the exploitation of the imagery in analog stereoplotters which necessitated the description of the imagery by parameters realizable by mechanical devices.

Several factors have led to the resurgence of interest in abstract models. Most importantly, analytical photogrammetric techniques removed the requirement of having camera models physically realizable in analog plotters. Abstract models became attractive since they didn't require calibration of the sensor interior orientation, which is of special interest for close-range photogrammetric applications. The growing interest of the computer vision community in geometric issues led to increased research on models based on projective geometry, which allow simple representation of objects and their images and facilitate theoretical analysis. For example, recent work in projective invariants (qualities of the images of a scene unchanged by the viewpoint of the image), is based on such models [Mundy and Zisserman, 1992].

The most common form of an abstract model for point perspective imagery is written using homogeneous coordinates:

$$\begin{bmatrix} x' \\ y' \\ z' \end{bmatrix} = \begin{bmatrix} L_1 & L_2 & L_3 & L_4 \\ L_5 & L_6 & L_7 & L_8 \\ L_9 & L_{10} & L_{11} & 1 \end{bmatrix} \begin{bmatrix} X \\ Y \\ Z \\ 1 \end{bmatrix}$$

The physical image coordinates, relative to the principal point, are obtained from the homogeneous coordinates, x', y', z', by

$$x = \frac{x'}{z'}$$

$$y = \frac{y'}{z'}$$

This model is the standard one in computer vision work [Mundy and Zisserman, 1992, Haralick, 1980, Horn, 1986]. The direct linear transform (DLT) [Marzan and Karara, 1975, Abdel-Aziz and Karara, 1971] can also be written in this form.

The solution for the model parameters is an inexpensive linear one if image and object space coordinates are assumed to be perfect. There may be problems with the robustness of the solution, however, since this is equivalent to resecting an uncalibrated camera. If enough well-distributed control points are not available, or if the control points and the perspective center all lie on a quadratic surface, the solution may be too ill-conditioned to reliably solve.

A disadvantage of projective geometric models is that the parameters of the model are not physically interpretable, implying that camera calibration information or external information about camera position or orientation cannot be included in the solution. While physical parameters can be derived [Strat, 1984] and the relationships used as constraints in the solution [Bopp and Krauss, 1978], the resulting non-linear constraint equations negate the advantage of the linear solution.

Generalized Models

An increasingly common type of model is what we will call the generalized model, representing the transformation between object and image space as some general function [Brown, 1992, Wolberg, 1990]. The function can be of several different forms, such as polynomials or Fourier series, or may be based on interpolation procedures.

A widely-used form of generalized model is based on polynomials functions, often referred to as rubber-sheeting. The polynomials from image to object space can be written as:

$$X = \sum_{i=0}^{m} \sum_{j=0}^{n} a_{ij} x^i y^j$$

$$Y = \sum_{i=0}^{m} \sum_{j=0}^{n} b_{ij} x^i y^j$$

or, from object to image space as:

$$x = \sum_{i=0}^{m} \sum_{j=0}^{n} c_{ij} X^i Y^j$$

$$y = \sum_{i=0}^{m} \sum_{j=0}^{n} d_{ij} X^i Y^j$$

Polynomial transforms can also be written between images, if only relative registration is required.

Rubber-sheet models are popular since they require no knowledge of the sensor geometry, thus being equally applicable to different sensor types, and are easy to implement and solve. However, these models are appropriate only

for cases in which perspective and elevation effects are small, such as satellite imagery or vertical mapping photography over flat terrain, and where accuracy requirements are minimal. A polynomial often has insufficient geometric degrees of freedom to accurately describe any complicated perspective or terrain effects. If more terms are added in an attempt to make a higher accuracy model, the solution can become ill-conditioned.

Selection of the proper polynomial degree is difficult. Using too low a degree will not model the image properties well enough, leaving systematic distortions in the solution. Too high a degree produces deceptively small residuals since all of the random error and any blunders in the control point coordinates will be absorbed into the polynomial coefficients. This error will then be interpolated into other points determined from the model. In some cases these models are applied in a piecewise fashion; polynomials of lower degree can then be used, but the problems of determining section boundaries and constraining the solution to ensure continuity at the boundaries must be solved.

Since these models are interpolative, the control points chosen must surround the area of interest and be evenly distributed through it. If the area of interest has varying elevations, the control points must be distributed across elevations. Otherwise, serious extrapolation errors may result which can not be detected unless check points located within the questionable areas are used.

Inclusion of external sensor information is difficult or impossible in such models. Implicit geometric properties of the image, such as vanishing points, are also hard to utilize.

A more sophisticated version of polynomial models are the rational polynomial models, first used by Defense Mapping Agency [Greve, et al, 1992]. The polynomials have the form:

$$
\begin{aligned}
f(u, v, w) = \ & a_0 + a_1 u + a_2 v + a_3 w + a_4 uv + \\
& a_5 uw + a_6 vw + a_7 u^2 + a_8 v^2 + a_9 w^2 + \\
& a_{10} uvw + a_{11} u^3 + a_{12} v^2 u + a_{13} w^2 u + \\
& a_{14} u^2 v + a_{15} v^3 + a_{16} w^2 v + a_{17} u^2 w + \\
& a_{18} v^2 w + a_{19} w^3
\end{aligned}
$$

The image coordinates are then calculated as quotients of the polynomials. The a_0 terms of the denominators are set to 0.

$$x = \frac{f_1(u, v, w)}{f_2(u, v, w)}$$

$$y = \frac{f_3(u, v, w)}{f_4(u, v, w)}$$

In this case, the polynomial terms are determined for each type of sensor modeled and terrain elevation effects are included. The advantage of this model is that the exploitation of different types of images can be done with the

same operational software, with only the polynomial coefficients changing for different types of sensors.

Another type of interpolative method is the NPBS (N-Planes B-Spline) method [Champleboux et al, 1992]. In this case, the direction of the image ray corresponding to each pixel is determined by interpolation using B-splines, based upon data obtained using known calibration planes.

Application of Models

Given an image or set of images to be analyzed, the choice of sensor model type depends primarily upon the accuracy required and the camera and control information available. If the user has no prior experience with the imagery or acquisition geometry, then simulations of the solution should be implemented and evaluated. Whichever model type is chosen, the results must be carefully evaluated to ensure that they meet requirements.

Choice of Model Type

The biggest determinant of model choice must be the performance requirements, specified and tested in a rigorous manner. The quality of the input control and sensor information, as well as the requirements of the application using the model, must be considered.

The availability of camera and control information and the economics and practicalities of obtaining additional information must also be considered. If camera calibration or orientation information is available then a physical model is the logical choice to take full advantage of it. On the other hand, if the camera is uncalibrated but sufficient control information is available, an abstract model may be appropriate. If execution time and computational resources are the most important considerations, as in real time implementations, then generalized polynomial models may be appropriate.

Model Parameter Determination

The solution procedure is, to a large extent, determined by the type of model used. Even using the same model type, however, there can be different types of solutions and implementation choices:

- Simultaneous multiple image or single image solution.

- Control point coordinates treated as perfect or stochastic, with their coordinates carried as weighted unknowns in the solution.

- Systematic error correction—which are neglected, how are the errors modeled?

- Use of prior exterior orientation or calibration information.

- Type of initial approximations required.

If the resection procedure is implemented by the user, then all these choices are under his control. If existing packages are used, however, many of these decisions will have been explicitly or implicitly made. To effectively use an existing package, the user must understand the underlying mathematical model and its implementation, especially any approximations or assumptions which must be met. Nearly all implementations have built-in assumptions on the range of acceptable input data—how good initial approximations must be, maximum image tilt, the variation in elevation across the scene, control point distribution, etc. Ideally, programs would identify conditions violating their operating assumptions and warn the user, but this is seldom done well in practice.

A simulated solution, using possible control and image configurations, can give a useful idea of the results that can be expected from the different solution options, or as a means of verifying the performance of an existing package for a certain imaging configuration. Random noise with the appropriate statistics should be added to the input control information, simulated image measurements, and any sensor orientation information which may be used. After running a simulated solution, the results should be evaluated in the same manner as a real solution for precision and reliability. Information from the evaluation can then be used to modify the solution design or to plan for the acquisition of further control or camera information.

If no choice of sensor or imaging geometry is possible, then attention must be focussed on the control point information, any other information available within the scene, and any external camera information which may be relevant.

Evaluation of the Solution

A rigorous evaluation of any solution must cover three aspects:

- The *accuracy* of the solution—how well the results agree with independent external measurements of the same quantities.

- The *precision* of the calculated parameters—the expected standard deviation, or "spread," of the parameter around the calculated values, along with the correlations between the parameters.

- The *reliability* of the solution procedure—how much the calculated values are affected by large mistakes, or blunders, in the input data.

The accuracy of the solution is assessed using check points, points whose coordinates are known from external sources to higher precision than the expected results of the adjustment. These are typically extra control points, withheld from the solution so that they don't influence its results. Calculation of the mean squared error yields a statistic that is an estimate for the average value of the coordinate covariance matrix, provided that the checkpoint coordinates are considered perfect and that the solution is unbiased [Molenaar, 1978]. If the check point root-mean-square error is not close to the average coordinate standard deviation, then the solution should be examined closely for bad control points or systematic errors in the observations.

If only a limited number of check points are available, the "jackknife" technique can be used [Mosteller and Tukey, 1977]. This consists of repeating the solution by using different subsets of points as control and check points, and then examining the results of each solution. The calculated model parameters should not change significantly when different subsets of points are used as control; if so, a blunder may exist in one of the control points. Each of the control points in the suspect set should then be used as a check point and its consistency with the other points verified.

The precision of the solution is specified by the covariance matrices on the model parameters and the object points. These covariance matrices are the inverse of the normal equation coefficient matrices [Mikhail, 1980] and may be calculated as part of the solution process or as an added step after the adjustment has converged. Covariance matrices may be more easily understood by transforming them into standard deviation-correlation matrices, where the diagonal terms are the square roots (standard deviations) of the diagonal terms (variances) of the covariance matrices. The off-diagonal terms are the correlation coefficients between the parameters; values near 1 or -1 indicate dangerous correlations. In these cases there is not sufficient input data to uniquely determine the model. For instance, if the control points all lie in a plane when solving for an uncalibrated camera, the focal length and the distance to the plane cannot be simultaneously determined since there are an infinite number of consistent combinations of values which will yield the same image. To put it another way, choosing a value of the focal length determines a value for the object distance—a perfect linear relationship exists.

Reliability statistics describe the ability to detect gross errors in the input data [Förstner, 1985, Förstner, 1987, Grun, 1978]. The detection of blunders is based upon the examination of residuals; therefore, we want to quantify the effect of a blunder on the adjustment residuals. The partial derivative of the least squares residuals with respect to the input observations is [Förstner, 1987]:

<div align="center">FIGURE 1
Image residual plot.</div>

$$\Delta v = - R \, \Delta y = - Q_{vv} \, W \, \Delta y$$

The R matrix in equation 8 is called the redundancy matrix, since the trace of the matrix is equal to the redundancy of the adjustment. The diagonal elements of the matrix, r_{ii}, whose values are between 0 and 1 since the matrix is idempotent, indicate the portion of an error in an observation visible in the residual for that observation. The higher the r_{ii} for a particular observation, the more visible an error will be in the residuals and the better the probability of detecting an error in that observation. The off-diagonal terms of the R matrix, the r_{ij}, show the portion of an error in observation j that appears in the residual for observation i. The quantity u_{ii}, which is $1 - r_{ii}$, indicates the portion of the error which will be absorbed into the calculated values of the parameters.

There are, of course, still fundamental limitations in using the residuals to identify bad data [Förstner, 1994]. The reliability of a solution is completely dependent upon the redundancy of the overall solution and also the number of redundant observations determining each individual parameter.

In recent years, work in the area of robust statistics [Huber, 1981, Kubik, et al, 1987] has attempted to make solutions less susceptible to input blunders. These solutions examine the statistics of the calculated residuals to infer which observations may be questionable. A large number of control points are typically required for these methods to be effective.

Visualization of Triangulation and Resection Results

A solution involving more than a few images or points generates an enormous amount of data, too much to be meaningfully understood by simply reading the output. Graphical displays of the information provide an easily understood grasp of the general properties of the solution, and can provide insights into subtle systematic trends which could never be spotted by looking at tables of numbers.

A standard graphical display for the visualization of data quality is the plot of image residuals (Figure 1). The plotted residuals should be randomly oriented and not vary greatly in length. Regular patterns in the residuals, such as predominantly radial orientations, indicate uncorrected systematic errors in the solution. The best way to look for such trends is to overlay the residual plots from a number of images. In a standard block adjustment, the regular arrangement of the images makes such an overlay easy; if oblique images or images of different scales are used, the residuals should be reprojected into a common image or into object space for comparison. A point with a residual longer than its neighbors and whose orientation is opposite to its neighbors probably indicates a bad measurement. Its residuals on other images should be examined—a displacement in the same direction on other images indicates a bad ground coordinate, while displacement in the opposite direction implies a bad image measurement. While raw re-

siduals can be plotted, the most effective plots use the standardized residuals (the residuals divided by their standard deviations). This removes the geometric effects on residual size, leaving the error component.

FIGURE 2
Image coverage and position covariance.

FIGURE 3
Building model with bad corner point covariances.

A similar plot of ground point coordinate corrections can also be useful. The correction information is three dimensional; the traditional display method is to show XY (horizontal) corrections and Z (vertical) corrections separately, since horizontal and vertical control points for aerial blocks were typically separate. However, the use of integrated surveying methods and GPS means that the horizontal and vertical positions are no longer independent, and the coordinate corrections should be visualized in three dimensions.

In situations such as close-range photogrammetric networks, or in aerial blocks involving multiple oblique images,

FIGURE 4
Original left image.

FIGURE 5
Original right image.

the geometry can become extremely complicated. Modern graphics workstations allow the 3D visualization of the image coverage and also the results of the adjustment, depicting the covariance matrices as scaled ellipsoids. In Figure 2, a block of oblique and vertical images is shown, with the position covariances for each image rendered as ellipsoids and the ground coverage of each image outlined. On the workstation display, this view can be rotated and zoomed, to be viewed from different angles. Even a quick examination of this view shows that the covariance for image j3, near the center of the view, is significantly larger than for the images, whereas this might never be noticed on a typical printout of the results.

The ability to generate precision statistics for solution output can be extremely useful for editing. Figure 3 shows a building model, derived as part of a simultaneous bundle adjustment, and the calculated covariance ellipsoids on the corner points (exaggerated for display). The highly elongated ellipsoids at the corner points show that the solution for the building is weak and also point to a likely explanation. In

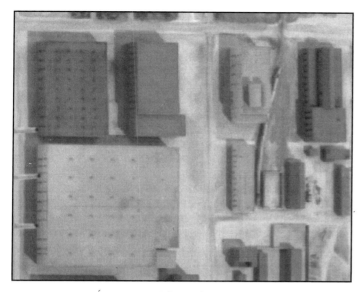

FIGURE 6
Reprojected left image.

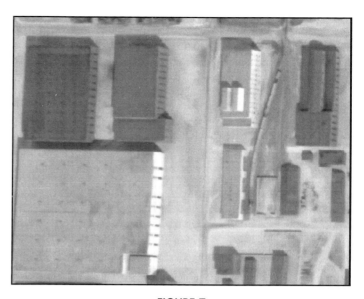

FIGURE 7
Reprojected right image.

FIGURE 8
Stereo results using polynominal model.

FIGURE 9
Stereo results using rigorous reprojection.

this case, the building points were measured on only one image. Each corner of the building model is therefore free to slide along the image ray, constrained only weakly by the input building elevation.

Model Comparisons

Several studies have been done comparing the application of different types of models to the same images.

Cheng and Toutin [Cheng and Toutin, 1995] report on the comparison of polynomial methods of rectification against a method based on modified collinearity equations. A wide range of imagery was studied: 1:40000 scale frame aerial imagery, SPOT panchromatic and HRV images, Landsat TM, and ERS-1 SAR images. They used a test area with about 400 meters of relief and picked control points from USGS 1:24000 topographic maps. Evaluation of check point errors for each type of solution, on each type of image, showed the rigorous method superior in every case.

It is important to note that the evaluation must be based

FIGURE 10
Stereo results using polynominal model.

FIGURE 11
Stereo results using rigorous reprojection.

on check point error, as it was in this test, not control point error. In several cases, the polynomial method's control point RMS error was smaller than the rigorous method, due to the excess degrees of freedom for the polynomial model. However, reliance on the control point statistics would have led to large errors in parts of the image not near the control points, and also would have left the solution vulnerable to errors in control point measurement.

Edgardh [Edgardh, 1992] reports on experiments comparing the standard physical frame camera model, using the collinearity equations (Equation 1) in a bundle adjustment, against the DLT. The collinearity model was tested both with calibrated and uncalibrated interior orientation, while the DLT was tested using linear and non-linear solutions. With 6 control points, the bundle adjustment was better in terms of precision and reliability than the DLT. This is to be expected, due to the larger number of parameters in the DLT and its more general geometry. With 13 control points, the differences diminished. In all cases, the iterative DLT (allowing for corrections to control point coordinates) was superior to the linear version.

In order to evaluate the effects of sensor model type on application results, we investigated the generation of epipolar-aligned images for stereo processing. If an over-lapping pair of digital images is to be viewed in stereo, the parallax direction of the images must be parallel to the eyebase of the observer; in other words, corresponding epipolar lines of the stereo pair must lie along corresponding rows of the digital images. Many automated stereo algorithms also incorporate this requirement, due to processing speed considerations.

Since aerial images are never acquired with this exact geometry, the images must be geometrically processed into alignment. For vertical mapping photography, where tilt and swing are small, the corrections are minimal and can often be done satisfactorily with fairly approximate models such as polynomials. For oblique images, however, the geometric changes are much more pronounced. If adequate sensor modeling is not performed the geometric inaccuracies may adversely affect the results of any algorithms using the images.

Figures 4 and 5 show portions of a pair of oblique stereo images of the RADIUS modelboard [Gee and Newman, 1993]. Each image is tilted about 30 degrees from vertical. These images were processed using our stereo system [McKeown and Perlant, 1992], which fuses the output of two different stereo algorithms, an area-based correlation method and a feature-based matching method. However, the results shown here were done using only the feature-based method [McKeown and Hsieh, 1992].

Previous work investigating the integration of photogrammetric cues for cartographic feature extraction [McKeown and McGlone, 1993], has shown the importance of rigorous modeling of the sensor. Standard procedure in the computer vision community is to create stereo pairs resampled using a polynomial transformation. This procedure previously gave adequate results when used with our stereo system since test imagery was primarily vertical mapping photography. When applied to oblique images, however, epipolar lines were not sufficiently accurate and the geometry of the images was distorted, degrading the results of the stereo algorithm. Accurate epipolar alignment is crucial for feature based methods, especially in built-up areas, since misalignment can result in missed building corners, matches between parts of different buildings, or matches between buildings and shadows.

Figure 8 shows the results using the polynomial-resampled images. Disparity is shown by image intensity, with lighter pixels closer to the viewer and darker pixels farther away.

The image pair was then reprojected into collinear alignment using a rigorous reprojection procedure (Figures 6 and 7) and the stereo processing repeated. Examination of the results using the rigorous reprojection (Figure 9) shows that the building structure is more completely recovered, especially for the large building at the upper left. This is due to the more accurate recovery of the epipolar geometry, allowing better matching of features between the two images. Figures 10 and 11 show a comparison of the results from each method with the original images texture mapped onto the derived disparity data.

References

Abdel-Aziz, Y. I. and Karara, H. M., 1971. Direct linear transform from comparator coordinates into object-space coordinates. In *ASP Symposium on Close-Range Photogrammetry*. American Society for Photogrammetry.

Ackermann, F., 1980. Block adjustment with additional parameters. In *International Archives of Photogrammetry and Remote Sensing*, Volume XXIII, B3, Hamburg.

Bopp, H. and Krauss, H., 1978. An orientation and calibration method for non-topographic applications. *Photogrammetric Engineering and Remote Sensing*, 44(9):1191-1196.

Brown, L. G., 1992. A survey of image registration techniques. *ACM Computing Surveys*, 24(4): 352-376.

Champleboux, G., Lavallee, S., Sautot, R. and Cinquin, P., 1992. Accurate calibration of cameras and range imaging sensors: the NPBS method. In *Proceedings of the 1992 IEEE International Conference on Robotics and Automation*, pages 1552-1557.

Cheng, P. and Toutin, T., 1995. High accuracy data fusion of satellite and airphoto images. In *Proceedings of ASPRS 61st Annual Convention*, pages 453-464.

Edgardh, L. A., 1992. Comparison of precision and reliability of point coordinates using DLT and bundle approach. In *International Archives of Photogrammetry and Remote Sensing*, volume XXIX, B3, pages 35-42.

Förstner, W., 1985. The reliability of block triangulation. *Photogrammetric Engineering and Remote Sensing*, 51(8):1137-1149.

Förstner, W., 1987. Reliability analysis of parameter estimation in linear models with applications to mensuration problems in computer vision. *Computer Vision, Graphics, and Image Processing*, 40:273310.

Förstner, W., 1994. Diagnostics and performance evaluation in computer vision. In *Proceedings, NSF/ARPA Workshop on Performance versus Methodology in Computer Vision*, pages 11-25.

Gee, S. and Newman, A., 1993. RADIUS: Automating image analysis through model supported exploitation. In *Proceedings of the DARPA Image Understanding Workshop*, pages 185-196, Washington, D. C. Morgan Kaufmann Publishers, Inc.

Greve, C. W., Molander, C. W. and Gordon, D.K., 1992. Image processing on open systems. *Photogrammetric Engineering and Remote Sensing*, 58(1):85-89.

Grun, A., 1978. Accuracy, reliability, and statistics in close-range photogrammetry. In *Commission V Inter-Congress Symposium, International Society for Photogrammetry*, Stockholm.

Haralick, R. M., 1980. Using perspective transformations in scene analysis. *Computer Graphics and Image Processing*, 13:191-221.

Horn, B. K. P., 1986. *Robot Vision*. MIT Press, Cambridge, MA.

Huber, P. J., 1981. *Robust Statistics*. John Wiley & Sons, New York.

Kratky, V., 1989. Rigorous photogrammetric processing of SPOT images at CCM Canada. *Photogrammetria, Journal of the International Society for Photogrammetry and Remote Sensing*, 44:53-71.

Kubik, K., Merchant, D. and Schenk, T., 1987. Robust estimation in photogrammetry. *Photogrammetric Engineering and Remote Sensing*, 53(2):167-169.

Marzan, G. T. and Karara, H. M., 1975. A computer program for direct linear transform of the collinearity condition and some applications of it. In *Proceedings of the ASP Symposium on Close Range Photogrammetry*. American Society for Photogrammetry.

McKeown, D. and Hsieh, Y., 1992. Hierarchical waveform matching: A new feature-based stereo technique. In *Proceedings of IEEE Conference on Computer Vision and Pattern Recognition*, pages 513-519, Urbana Champaign, Illinois.

McKeown, D. and McGlone, J. C., 1993. Integration of photogrammetric cues into cartographic feature extraction. In *Proceedings of the SPIE: Integrating Photogrammetric Techniques With Scene Analysis and Machine Vision*, volume 1944, pages 2-15.

McKeown, D. and Perlant, F., 1992. Refinement of disparity estimates through the fusion of monocular image segmentations. In *Proceedings of IEEE Conference on Computer Vision and Pattern Recognition*, pages 486-492, Urbana-Champaign, Illinois.

Mikhail, E.M. and Paderes, F. C., Jr., 1991. *Photogrammetric Modeling and Reduction of SPOT Stereo Images (Phase II)*. Technical Report CE-PH-91-3, Purdue University.

Mikhail, E. M., 1980. *Observations and Least Squares*. Harper and Row, New York.

Moffitt, F. and Mikhail, E. M., 1980. *Photogrammetry*. Harper and Row, New York.

Molenaar, M., 1978. Essay on Empirical Accuracy Studies in Aerial Triangulation. *ITC Journal*, (1).

Mosteller, F. and Tukey, J. W., 1977. *Data Analysis and Regression*. Addison-Wesley.

Mundy, J. and Zisserman, A., editors, 1992. *Geometric Invariance in Computer Vision*. MIT Press, Cambridge.

Slama, C. C., editor, 1980. *Manual of Photogrammetry*. American Society for Photogrammetry, Fourth Edition.

Strat, T. M., 1984. Recovering the camera parameters from a transformation matrix. In *Proceedings of the DARPA Image Understanding Workshop*, pages 264-271.

Westin, T., 1990. Precision rectification of SPOT imagery. *Photogrammetric Engineering and Remote Sensing*, 56(2):247-253.

Wolberg, G., 1990. *Digital Image Warping*. IEEE Computer Society Press, Los Alamitos, CA.

Covariance Propagation in Kinematic GPS Photogrammetry

JAMES R. LUCAS

Abstract

The addition of GPS determined aircraft positions as a new data type in aerotriangulation can significantly increase the efficiency and reduce the cost of photogrammetric projects by eliminating much of the ground control. But few planners of mapping projects have enough experience with this new technology to know what to expect. Covariance propagation is a valuable analytical tool with which to evaluate proposed project designs utilizing airborne GPS against conventional approaches known to produce a desired accuracy. This technique is used to investigate the expected errors in both blocks and single strips of photographs.

Introduction

Most practitioners of conventional photogrammetry have a "feel" for what combination of camera parameters, photo coverage, ground control, etc. it takes to produce a desired photogrammetric product. This expertise or intuition may have been acquired through formal training, many years of practical experience, or both. Now we have a new technology, airborne kinematic GPS, that has the potential for significantly increasing efficiency and reducing costs, but it brings with it a new level of complexity that may require us to change some of our standard practices. The old rules of thumb may no longer be valid when the exposure station positions are no longer computed exclusively from the photogrammetry, but are supplied more accurately by GPS observations. We can certainly accomplish the same results with much less ground control, but do we need any control at all? If so, where should it be placed? Do we need to modify the planned layout of a photogrammetric mission in order to exploit the strengths of GPS? Many such questions can be answered by analyzing kinematic GPS controlled photogrammetry (KGCP) using covariance propagation techniques.

Covariance propagation is a method by which we can investigate the ability of a set of observations to provide precise values for a desired set of parameters. In a least squares adjustment, observation equations with appropriate weights are employed to form a set of normal equations that are then solved for the unknown parameters. The inverse of the least squares coefficient matrix is then the covariance matrix associated with the computed parameter values (see, for example, Hamilton 1964) and provides a statistical estimate of the expected error in these values.

Covariance propagation can be done with either real or simulated data. Simulated data is more economical because we can create any number of data sets on the computer in a few hours as opposed to weeks or months of flight time costing many thousands of dollars to acquire the same configuration of real data. The simulated data can also be kept free from systematic errors so that a fair comparison of data sets can be made in a bias free environment. Simulated data is manufactured by computing error-free observations and then adding to them errors that are chosen at random from a population with a zero mean and specified variance. We must, however, remember that the resulting error estimates are valid for comparisons, but will always be optimistic because real data are always contaminated to some degree by systematic errors. The examples given in this paper are all obtained through covariance propagation using simulated data.

Limitations

Before using covariance propagation to compare KGCP to conventional methods, we must be aware of the cases in which additional constraints are required or in which KGCP doesn't work at all. In theory, the use of airborne GPS data with the appropriate observation equations makes it possible to accomplish aerotriangulation without any ground control whatever (Lucas 1987). This requires a near flawless set of GPS data, however, and some other conditions must be satisfied. As a practical matter, it is prudent to always have some ground control available even if it is only used to check the results.

There is another approach, often called the "Stuttgart method," which places no such stringent requirement on the GPS data, but requires a minimal amount of ground control and extra flight lines (Ackermann and Schade 1993). Since this paper is intended as an elementary treatment of covariance propagation in KGPS, the Stuttgart method will not be considered. Readers interested in a more advanced coverage of the topic should consult the given reference. We will assume in this paper that our objective is to achieve the obtainable accuracy with the least amount of ground control possible.

We can start by realizing that KGCP cannot be applied to the smallest photogrammetric unit, the single photograph. With only a single photo, there is insufficient information to perform an aerotriangulation adjustment without ground control. While we may have a very precise position for the GPS antenna, all that is certain about the camera position is that it lies somewhere on the surface of a sphere whose center is at the antenna position and whose radius is equal to the distance from the antenna to the camera. This situation is shown in figure 1. As a practical matter, we know that the camera is pointing toward the ground and must be located somewhere below the antenna, which must be somewhere on top of the aircraft in order to receive signals from

the satellites, but the exact position of the camera cannot be determined without additional information.

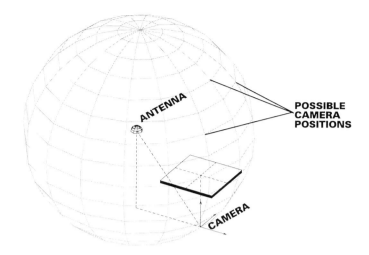

FIGURE 1
Camera position ambiguity associated with a single photo.

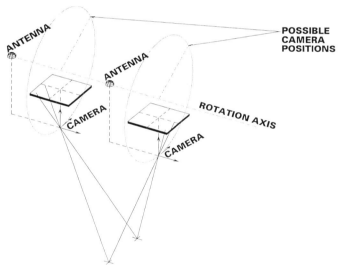

FIGURE 2
Camera position ambuguity associated with a pair of photos or a single strip.

If a second photo is added and if there are a number of ground points that are imaged on both photos, then the combination of the collinearity condition equations associated with these images and the observed antenna positions provides additional constraints that limit the possible camera positions. The collinearity equations state that (after removal of systematic errors) a ground point, the perspective center of the lens, and the image of that ground point must all lie on the same straight line. The constraints provided by these additional conditions establish the relative orien-

tation between the photo pair. But, without any ground control, this whole construction is free to rotate about a line through the two antenna positions, as shown in figure 2. In fact, this deficiency persists for a whole strip of photos because the antenna positions are not likely to deviate far enough from a line.

With these limitations in mind, we can now begin to consider covariance propagation in standard forms of photo acquisition. The most typical form for aerial mapping is the coverage of extended areas with blocks of photography. This format will be considered first. Then we will consider single strips of photography constrained by ground control, a configuration used extensively for mapping of highways and utility lines.

Photo Blocks

In order to map an area, photography is flown as a block consisting of a number of strips with a specified overlap between them, usually 20 percent for mapping and 60 percent for control densification. Within each strip, the overlap between photos is usually 60 percent to provide sufficient stereo coverage. When using conventional methods, ground control is needed about every seven photos around the periphery of the block for planimetric mapping (Slama, 1980). For topographic work, elevation control is needed throughout the block at a spacing of about seven photos. These recommendations are based on simulations that showed that elevation errors grow exponentially with distance from control points while the growth of horizontal errors is almost negligible.

Figure 3 shows a plan view of the error ellipses associated with the ground point positions derived from a simulated photo block consisting of 13 strips of 13 photos each. A photo scale of 1:40,000 was used. Both forward overlap and side overlap were set at 60 percent in order to achieve a near uniform distribution of propagated errors. Complete ground control points, i.e., points whose positions are known in all three coordinates, were placed every seven photos around the periphery of the project. No kinematic GPS data were used, and no additional elevation control was included.

The very large error ellipses in the corners and along the sides are the result of what is know as edge effects. Away from the edges of the block, ground points are imaged on photos from all sides, as many as nine in all. This provides very good geometry and plenty of redundancy. Points along the edges of the block are seen from photos on one side only, thus weakening the strength-of-figure and reducing the redundancy of each point to intersecting rays from no more than three photos. Except for edge effects, the horizontal errors are reasonably uniform and quite small.

A similar simulation using KGCP without any of the ground control produced very similar results. The error ellipses at the control points were slightly larger, but at nearly every other point they were either the same or slightly smaller. In fact, the two error ellipse plots were so similar that it would be impossible to provide a graphic comparison at a scale that would fit this paper.

Elevation errors, on the other hand, were significantly different. As stated above, no additional elevation control was included in this first simulation, which allowed elevation errors to grow quite large in the center of the block.

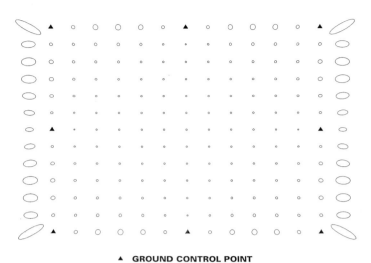

▲ GROUND CONTROL POINT

FIGURE 3
Error ellipses associated with ground points positioned by
conventional aerotriangulation adjustment of a photo block.

Figure 4 is a perspective view of the southeast quadrant of the block of error ellipses shown in Figure 3, this time showing both horizontal error ellipses and vertical error bars. In this figure, only one quadrant of the block is shown. Since the block is symmetrical, this quadrant can be shown at a larger scale and the reader can visualize the missing quadrants. This perspective view illustrates how the elevation errors tend to build with distance from control. This is most easily seen in the row of points at the left where the elevation error bars grow from near zero at the control point toward the center point which is the topmost of those shown. We can also see that edge effects apply to elevation errors as well as horizontal errors, as one would expect.

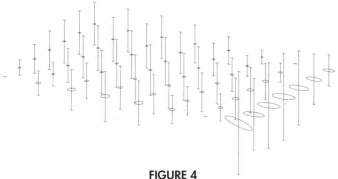

FIGURE 4
Perspective view of error ellipses and error bars of the southeast
quadrant of photo block of Figure 3.

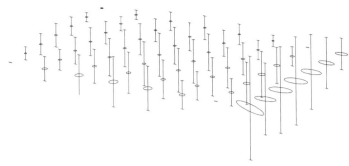

FIGURE 5
Effect of adding a single elevation control point at the
center of the photo block.

One means of reducing the build up of elevation errors is to insert elevation control points at regular intervals of about seven photos throughout the interior of the block. In this case, this would require only one point at the center. This modified version of the block was simulated and the results are shown in Figure 5, again showing only the southeast quadrant. Figure 5, when compared to Figure 4, illustrates the affect that this (elevation only) control point has on the growth of elevation errors.

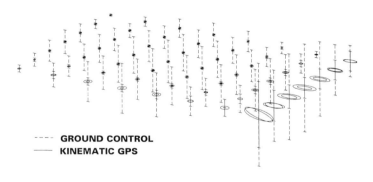

- - - - **GROUND CONTROL**
———— **KINEMATIC GPS**

FIGURE 6
Error ellipses and error bars associated with ground points
positioned from a photo block with and without KGCP.

Kinematic GPS provides a more satisfactory means of reducing the buildup of elevation errors, because every exposure station is a control point so the distance from control is always less than would be practical to achieve with surveyed ground points. This same block was simulated using KGCP without any ground control. The resulting error ellipses and error bars are shown overprinted on those of Figure 5. In this figure, the error bars from Figure 5 are reproduced as dashed lines while the error bars obtained from kinematic GPS are shown as solid. Careful examination of the figure reveals that the only points at which the solid elevation error bars are larger than the dashed ones

are the control points. At all other points, there is some improvement resulting from the additional position observations provided by KGPS.

So far, the results of analyses by covariance propagation have been presented as error ellipses and error bars with no scales attached. This omission is purely intentional. The objective has been to compare the errors expected from KGCP with those from conventional methods. To obtain absolute magnitudes would require far too many assumptions, and the results would only be confusing. But the question always arises as to how accurate the GPS antenna positions must be in order to achieve a desired accuracy in the ground point positions computed from the aerotriangulation. We will, therefore, resort to using numerical values in order to consider this question.

The photo block we have been discussing was simulated with KGCP using standard errors of 0.01 mm for all image coordinate measurements, 2 cm for each horizontal component of all antenna positions and 4 cm for all antenna elevations. The resulting standard errors in the position of the center point were 16.9 cm for each horizontal coordinate and 22.4 cm for elevation. All other points near the center of the block obtained similar results. The block was then simulated again with the standard errors assigned to the antenna position increased an order of magnitude to 20 cm in each horizontal coordinate and 40 cm in elevation. This simulation produced ground point standard errors of 17.4 cm in horizontal coordinates and 25.3 cm in elevation. An increase of 900 percent in the antenna position errors produced only a 3 percent increase in horizontal coordinate errors and a 13 percent increase in elevation errors. Such a result is contrary to intuition and, while it is not an error, it is certainly misleading.

A block of photos fits together as a mathematical model of a nearly rigid structure. Its position, orientation, and scale must be determined by external observations. A minimally constrained adjustment would require two complete control points and one elevation control point that is not collinear with them. To constrain the growth of errors we had to use eight complete control points and one elevation control point to obtain the results shown in figure 5. Using KGCP, this block is constrained by the antenna positions associated with 169 photos, position observations at 160 more points than were deemed necessary. If the errors in these antenna positions are truly random, they will average out as they obviously did in this simulation.

The problem is that there are levels of GPS errors that depend on the method by which the data set was acquired and how it was processed. There are different levels of errors, but not a continuum. Errors that are larger than normal are not likely to be completely random, an assumption on which simulation is based. Therefore, it is reasonable to apply covariance propagation, starting with reasonable errors for the GPS observations and obtain estimates of expected errors in ground points, but it may not be meaningful to try to solve the inverse problem, because the required level of error may not be realizable.

Photo Strips

There are many mapping applications that concentrate on linear features such as highways, railroads, utility lines, shoreline, etc. Such features are conveniently mapped from single strips of photos rather than photo blocks. However, single strips present a different set of problems. Without any parallel overlapping strips, there is less redundancy in that ground points are imaged on no more than three consecutive photos instead of six or nine as in the case of a block. We have a similar situation to the edge effects problem, but it is worse in this case because there are no overlapping strips on either side.

Highway mapping photography is usually acquired at a scale of 1:3000, so that scale was used to simulate a single strip with 60 percent forward overlap. Four ground control points were placed at one end. This is a classic case of violating the principles learned in elementary courses in photogrammetry. It is used here to show how quickly errors build in a single strip. Figure 7 shows the error ellipses associated with ground points positioned along this strip by both a conventional adjustment and by KGCP. In conventional photogrammetry, shown with dashed lines, the errors grow so large that the drawing would soon be completely encompassed by the next column of error ellipses, so the drawing had to be truncated at eight photos. The errors resulting from KGCP are very much smaller, but do show some growth, particularly in the cross-track direction. Such errors are due to the uncertainty in attitude angles.

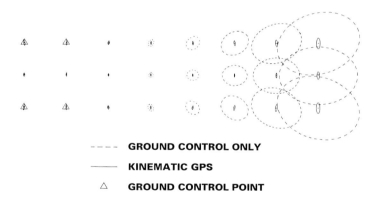

---- GROUND CONTROL ONLY

—— KINEMATIC GPS

△ GROUND CONTROL POINT

FIGURE 7
Error ellipses associated with ground points positioned from a single strip with and without KGPS.

In the conventional case, elevation errors grow even more rapidly than the horizontal ones, as we progress along the strip. They show very little growth when KGCP is employed, however, as seen in Figure 8.

This simulation shows why KGCP is so popular with the Departments of Transportation (DOT) of many states. In order to properly control the single strips used in highway mapping, A DOT must establish ground control points

in nearly every photo. The time and expense of most of this ground surveying can simply be eliminated through the use of KGCP.

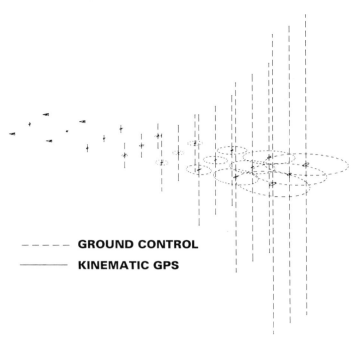

- - - - - **GROUND CONTROL**

———————— **KINEMATIC GPS**

FIGURE 8
Error ellipses and error bars from the same points
shown in Figure 7.

For purposes of comparison, the same ground control points required for conventional photogrammetry of the strip adjustments were used along with KGCP to prevent the strip from rotating about a line through the antenna positions. An alternative method, that would have produced similar or slightly better results, is the addition of a second strip perpendicular to the main one. This secondary strip might be a part of the project or it might be solely for the purpose of anchoring the main strip. A secondary strip used in lieu of ground control should intersect the main strip near one end and could consist of only three photos. And, if the project consists of only a single primary strip, it would be wise to include a cross strip at the other end as well.

In most applications in which single strip photography is employed, the project is flown in a series of single strips such that the first few photos of each new strip overlap the last few photos of the previous one. In highway mapping, for example, a strip is flown along the highway until a curve is encountered. The strip is then terminated and a new one flown along the next straight line segment, allowing sufficient overlap at the point of intersection. The overlapping of these strips, assuming the use of tie points between them, will satisfy the requirement that all antenna positions not be collinear. Hence, strips that intersect at their ends can be adjusted without any ground control, provided that the angle between the strips is large enough. But, how large must the angle be? And, how long can the strips be before we must insert a cross strip?

As shown in Figures 7 and 8, the errors in GPS-controlled photo strips build up much more slowly than in their conventional counterparts. But the errors do build, and covariance propagation is an ideal tool to use in investigating the extent of this error growth. A long strip of GPS-controlled photos with a cross strip at the beginning were simulated for this study. No ground control or external constraints of any kind were included. After 30 photos the along track errors of all ground points remained essentially unchanged. The elevation errors of the nadir points were also unchanged, but elevation errors of the wing points had doubled. The cross-track errors had grown by a factor of 3.75 for nadir points and 4.0 for wing points. This error growth can be attributed almost entirely to uncertainties in roll, the angle of rotation about a line along the flight direction. These results are based on the usual nine images per photo and would probably change dramatically if more images were included. This investigation will be the subject of a future report.

The next simulation study was to determine the minimum angle at which two strips can intersect and still avoid approximating the single strip singularity. Two short strips were simulated such that the end of the first overlapped the beginning of the second and the overlapping photos had at least six ground points in common. In the first case, the two strips were perpendicular, since this is known to provide the maximum constraint. Then additional simulations were completed in which the intersection angle was reduced from 90 degrees to 45, 30, 20, and 10 degrees. There was no significant increase in either the horizontal or vertical errors until the angle was reduced to 10 degrees. Using that angle the propagated horizontal errors increased by 6 percent and vertical errors increased by 7 percent. Hence, 10 degrees is probably the minimum angle at which two strips can intersect and still be expected to provide a satisfactory solution without any external constraints.

Conclusions

Covariance propagation demonstrates that the use of KGCP in a photo block without any ground control produces horizontal errors that are essentially the same as when conventional methods are used and the recommended amount and placement of ground control utilized. Under the same circumstances, KGCP produces smaller elevation errors at every point except for the elevation control points.

Covariance propagation also shows that single strips of conventional photography must have ground control at a much closer spacing than every seventh photo, as recommended for blocks. When KGCP is used with single strips of photos, there must be some means of constraining the rotation of the strip about a line of best fit to the antenna positions. This constraint can take the form of ground control or cross strips with tie points in common with the primary strip. But, when these requirements have been satisfied, the spacing between control points or cross strips can be much greater than with conventional methods.

A series of strips, such that the last photos of each strip overlap with the first photos of the next, is a useful project

pattern for linear features such as highways. It can be made to work with KGCP without any ground control provided that the angles between intersecting strips are greater than 10 degrees and cross strips are used to limit the uncontrolled segments to about 20 photos.

References

Ackermann, F. and Schade, H., 1993. "Applications of GPS for aerial triangulation." *Photogrammetric Engineering and Remote Sensing*, Vol. 59, No. 11, pp. 1625-1632.

Hamilton, W. C., 1964. *Statistics in Physical Science,* The Ronald Press Company, New York, NY, pp. 124-132.

Lucas, J. R., 1987. "Aerotriangulation without ground control." *Photogrammetric Engineering and Remote Sensing*, Vol. 53, No. 3, pp. 311-314.

Slama, C. C. (Ed.), 1980. *Manual of Photogrammetry*, (4th edition), American Society for Photogrammetry and Remote Sensing, Ch. X.

CHAPTER 6

DEM Extraction, Editing, Matching and Quality Control Techniques

Introduction to Digital Elevation Models (DEM)

DAVID F. MAUNE

Abstract

This paper introduces the newcomer to various types of DEM data, including standard DEM produced by the U.S. Geological Survey (USGS). It explains what DEMs are, what they look like, how accurate they are, what they are used for, and how DEM data are acquired from USGS. It compares uniformly spaced DEM data (grid or lattice) with non-uniformly spaced Digital Terrain Data (DTM) and Triangulated Irregular Network (TIN) data. It compares DEM data with another USGS product — Digital Line Graphs (DLGs) which are digital representations of the cartographic point, area and line features (including topographic and bathymetric contours) portrayed on USGS topographic quadrangles.

This introductory paper is followed in sequence by: Professor Ackermann's overview of techniques and strategies for DEM generation; Dick Kaiser's and Scott Miller's co-authored comparison of softcopy vs. hardcopy photogrammetry for DTM collection, editing and quality control; Professor Schenk's paper on automatic generation of DEMs; and Raye Norvelle's paper on the use of iterative orthophoto refinements to generate and correct DEMs. *In total, these papers summarize the current status of DEM extraction, editing, matching and quality control techniques as we approach the 21st century.*

Digital Elevation Models (DEM)

The term "DEM" is sometimes used generically to mean the digital cartographic representation of the earth in any form, rectangular grids or lattices, triangular networks, or irregular spot heights and breaklines, for example. As used

herein, a DEM is the digital cartographic representation of the elevation of the land (z value) at regularly spaced intervals in x and y directions (eastings and northings or longitude and latitude). This definition of DEM also applies to Digital Terrain Elevation Data (DTED) produced by the Defense Mapping Agency (DMA).

USGS DEM Types

USGS produces several standard types of DEM data:

- **7.5-minute DEMs** have 30- by 30-meter point spacing, using UTM coordinates on the NAD 27 or NAD 83 horizontal datum and NGVD 29 vertical datum. They provide the same coverage as standard USGS 7.5-minute quadrangles (1:24,000-scale), covering 7.5 minutes of latitude by 7.5 minutes of longitude. Coverage (now 50% complete) includes the contiguous United States, plus Hawaii and Puerto Rico, but excludes Alaska.

- **30-minute DEMs** have 2- by 2-arc second point spacing — approximately 60- by 60-meter point spacing in x and y — with geographic coordinates (latitude/longitude) on the NAD 27 or NAD 83 horizontal datums and NGVD 29 vertical datum. With half the coverage of a standard USGS 30-minute by 60 minute quadrangle (1:100,000 scale map), it takes two 30-minute DEMs to cover the area of a 1:100,000-scale quad. Coverage (now 30% complete) includes the contiguous United States and Hawaii.

- **1-degree DEMs** have 3- by 3-arc second point spacing — approximately 100- by 100-meter spacing in x and y — with geographic coordinates on the WGS 72 or WGS

84 horizontal datum and NGVD 29 vertical datum. They provide coverage in 1- by 1-degree blocks. They are formatted to USGS specifications from DMA's DTED. Coverage (100% complete) includes the entire United States.

Several other types of DEM are available for Alaska with point spacing that adjusts for the convergence of meridians at Northern latitudes.

This paper primarily addresses the 7.5-minute data which have the best resolution of the standard USGS DEM data and have the most detailed applications.

UTM Structured DEM

A typical 7.5-minute UTM DEM is shown at Figure 1. The data are ordered south to north in profiles ordered west to east. The 7.5-minute DEM profiles are clipped to the straight line intercept between the four geographic corners of the quadrangle, an approximation of the geographic map boundary (neatline). The resulting area of coverage for the DEM is a quadrilateral, the opposite sides of which are not parallel.

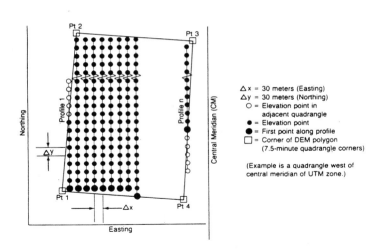

FIGURE 1
Structure of a 7.5-minute Digital Elevation Model, UTM meter grid.

USGS DEM Levels and Their Vertical Accuracy

DEMs are classified into one of three levels of quality. There are varying methods of data collection and degrees of editing available for DEM data. All USGS DEMs are tested and assigned a vertical RMSE (root mean square error).

- **Level 1 DEM** data are created by automated stereo correlation or manual profiling from aerial photographs such as photos from the National Aerial Photography

Program (NAPP). A vertical root mean square error (RMSE) of 7 meters or less is the desired standard. A RMSE of 15 meters is the maximum permitted. A 7.5-minute DEM at this level has an absolute elevation error tolerance of 50 meters (approximately three times the 15-meter RMSE). Level 1 30-minute DEMs may be derived or resampled from level 1 7.5-minute DEMs. Level 1 DEMs meet the minimum accuracy requirements required to support production of orthophotos at a scale of 1:12,000.

- **Level 2 DEM** data are created from digital line graph (DLG) contours or equivalent from any USGS map series up to 1:100,000 scale. Level 2 DEMs are elevation data sets that have been processed or smoothed for consistency and edited to remove identifiable systematic errors. DEM data derived from hypsographic and hydrographic data digitizing, either photogrammetrically or from existing maps, are entered into the level 2 category after review on a DEM editing system. An RMSE of one-half contour interval is the maximum permitted, with no errors greater than one contour interval. The accuracy and data spacing are intended to support computer applications that analyze hypsographic features to a level of detail similar to manual interpolations of information from printed source maps.

- **Level 3 DEM** data are created from DLGs that have been vertically integrated with all categories of hypsography, hydrography, ridge line, breakline, drain files, and all vertical and horizontal control networks. They require a system of logic incorporated into the software interpolation algorithms that clearly differentiates and correctly interpolates between the various types of terrain, data densities, and data distribution. An RMSE of one-third of the contour interval is the maximum permitted, with no errors greater than two-thirds contour interval.

Level 2 and level 3 DEM data derived from contours generally represent slope more accurately than level 1 DEM data.

Virtually all of the 7.5-minute DEMs produced to date are level 1. Only a limited number of 7.5-minute DEMs have been generated by interpolation from digital contours and are classified as level 2. The USGS does not currently produce level-3 DEM data.

Horizontal Accuracy

The horizontal positions of grid posts in USGS DEMs are located at precise mathematically defined positions in UTM meters or arc seconds. These grid posts are fixed in position and can be considered constants for the purpose of determining accuracy. The only measurable or perceivable errors in the DEM exist as vertical errors that may be partially attributable to horizontal errors inherent in the source data or to errors in converting horizontal and vertical components of the source to gridded format.

Acquiring DEM Data From USGS

DEM data are ordered from the USGS Earth Science Information Center (ESIC) by DEM units. One 7.5-minute DEM cell, for example is a single unit. A single unit currently costs $40, but the price per unit decreases with quantity. Ten units, for example, would cost $160, or $16 each on average. One hundred units would cost $790, or $7.90 each on average.

Uses and Limitations

DEMs are used in a wide variety of civil and military applications. They are used to calculate cut-and-fill requirements for earth works engineering, to estimate areas to be inundated by natural flooding or dam construction, to perform intervisibility analyses for site selection of communication towers and antennas, and numerous other automated applications where analysts would otherwise be required to perform detailed manual analyses of contour lines and/or profiles derived therefrom.

For all DEMs, the grid spacing and spatial resolution results in data intervals that span terrain discontinuities, such as ridge tops and drainage features. Some features can be appropriately captured at a given grid spacing while other, smaller features, are subdued or filtered out altogether.

A limitation of DEMs with uniform point spacing is that the same density of elevation points is used for the entire area. Some users prefer data points more closely spaced in complex terrain and sparsely distributed over other areas. Therefore, the need arises for other forms of digital elevation data, as described below.

Digital Terrain Models (DTMs)

In some organizations, DTMs are synonymous with DEMs. As used herein, DTMs are similar to DEMs, but incorporate the elevation of significant topographic features on the land and change points (breaklines) which are irregularly spaced so as to better characterize the shape of the terrain. Breaklines are linear features that describe a change in the smoothness or continuity of the surface. The two most common forms of breaklines are as follows:

- **Soft breaklines** ensure that known Z values along a linear feature are maintained, and they ensure that linear features and polygon edges are maintained in a TIN surface model, as described below, by enforcing the breakline as TIN edges. But they do not define interruptions in surface smoothness.

- **Hard breaklines** define interruptions in surface smoothness. They are used to define streams, shorelines, dams, ridges, building footprints, and other locations with abrupt surface changes.

Z values along a breakline can be constant, or can vary throughout its length. These breakline data normally augment other data that may be uniformly- or randomly-spaced.

The net result is that the distinctive terrain features are clearly defined, and contours generated from DTM more closely approximate the real shape of the terrain.

DTMs can be produced by either analytical or digital (soft-copy) photogrammetry. DTMs are normally more expensive and time consuming to produce because breaklines are ill suited for automation; but the DTM results are technically superior to DEM for many applications.

DTMs are not produced by USGS but are tailored by private photogrammetric contractors to meet unique customer requirements.

Triangulated Irregular Networks (TIN)

A TIN is a set of adjacent, non-overlapping triangles computed from irregularly spaced points with x,y coordinates and z values. The TIN data structure is based on irregularly-spaced point, line, and polygon data interpreted as mass points and breaklines. The TIN model stores the topological relationship between triangles and their adjacent neighbors, i.e., which points define each triangle and which triangles are adjacent to each other. This data structure allows for the efficient generation of surface models for the analysis and display of terrain and other types of surfaces.

A TIN surface can be created from one or more of the following sources:

- point, line and polygon data
- contour maps
- stereoplotter data
- randomly distributed points in ASCII files
- breakline data
- DEM lattices

TINs usually require fewer data points than DEMs or DTMs, while capturing critical points that define terrain discontinuities and are topologically encoded so that adjacency and proximity analyses can be performed. TINs have several other advantages over DEMs and DTMs; but they are probably best known for their superiority in surface modeling, e.g., calculation of slope, aspect, surface area and length; volumetric and cut-fill analysis; generation of contours; interpolation of surface z values; generation of profiles over multiple surfaces; intervisibility analysis; and 3-D visualization and simulation.

Digital Line Graph (DLG) Hypsography

On a computer screen, the hypsography category of Digital Line Graphs (DLGs) looks like the contours on the USGS quads. That's because DLGs are digitized in vector form from USGS quads. Other DLG data includes shorelines with elevations of lakes, for example, and other features that help to define the shape of the terrain and natural/manmade features thereon.

Such digitized contours are commonly used for elevation layer tints and for any application requiring isolines of equal elevation.

DLGs can be ordered from USGS with the same procedures and pricing structure as for USGS DEMs.

Summary

Four principal forms of digital elevation data have been described, but other forms exist or may be tailored for special applications. Elevation data can be converted from one format to another, but some information is lost each time the data are translated.

Various software programs exist which convert DLG hypsography vector files into point files — point arrays as required for DEMs, DTMs and TINs.

The Federal Geographic Data Committee (FGDC) has a "DEM Framework Initiative" with a short range initiative to complete 30-minute DEM coverage by late 1995. It has a long range initiative to have a single DEM which is not scale based, but a multi-resolution data set with variable resolution appropriate for different types of terrain.

Techniques and Strategies for DEM Generation

FRIEDRICH ACKERMANN

Abstract

This paper first reviews the development and the main operational features of conventional DEM generation based on operator measurements on analytical plotters. Some considerations are given to interpolation methods and basic strategies. Then, conventional DEM generation is compared with the recent transition to softcopy image workstations and to the application of digital image matching methods. The new technology implies operation on a completely new level of performance and methods, with new operational strategies — the automation of DEM generation being of central importance. The new operational level is expressed in new accuracy and productivity performance characteristics which have started to impact practical applications. Some problem areas remain on which developments concentrate at present, especially the automatic capture of breaklines and the suppression of obstacles. The outlook suggests general solutions to the problem of vegetation cover and genuine 3D object extraction by combination with laser scanning and multi-sensor systems, the combined processing potential of which is one of the main assets of digital photogrammetry and digital information processing.

General Considerations

The generation of digital elevation models (DEM) has two operational parts: (1) taking the **observations** (measurements), and (2) deriving the DEM from them by **computation** (interpolation). Both parts are usually separated, but highly interrelated nevertheless. In operational terms, we distinguish the data acquisition in the conventional way with the analytical stereoplotter (or even with analog plotters, still) and on the digital (softcopy) image workstation operating with digital image data. That distinction is not as fundamental as it may seem, and is not maintained here. The real methodical dividing line concerns, in the author's opinion, whether the data acquisition is essentially *interactive* by a human operator (on an analytical plotter or on a softcopy workstation), or to a great extent *automatic* by digital image processing. Let us first recall some general considerations about DEMs or DTMs.

Origin of the DTM Concept

The concept of digital terrain models appeared first in 1958, in a publication by Miller and Laflamme of MIT, for the purpose of computerized road design. For about a decade, DTM use concentrated on civil engineering applications until it was realized that the DTM provides *terrain description* in general, applicable for many other purposes. In particular, the application for cartographic mapping came

into view, and the assessment of non-topographic surfaces as well. At first the aims were limited to the computational derivation of contour lines (digital mapping was not yet above the horizon). Then gradually, the concept of the DTM or DEM as a stand-alone base product emerged, along with the tendency to generally move from graphical to computational operations and procedures.

Here, no distinction is made between digital elevation models (DEM) and digital terrain models (DTM). Both terms are used synonymously, as is customary in Europe. In particular, there is no quality distinction between them. A high quality DEM is understood to also contain morphological features, like breaklines, etc.

Concept and Definition

DEMs/DTMs provide a geometrical description of the terrain surface (other surfaces are not considered here any further) by digital means, mainly by point and line elements. It is customary to represent the terrain surface by regularly or irregularly distributed points, completed by morphological features which again are described by points (local maxima or minima) and by line features like soft or hard breaklines. The points and lines, together with the implied local interpolation between them, represent the terrain surface. In most cases the DEM is represented by a *regular grid* pattern, rectangular or square, completed by bilinear interpolation in between. But also triangular irregular networks (TIN) are very popular.

The DEMs generally describe terrain surfaces by *single valued* functions: $z = f(x,y)$. For any given x,y position only one z-value can be derived from the DEM grid. This constitutes a basic difference against genuine 3D modelling of surfaces or bodies in CAD systems.

Data Acquisition

The data input for DEMs can originate from different sources. The main data source is certainly from aerial photogrammetry, either through interactive operator measurements (on the analytical plotter or the softcopy image workstation), or through highly automated measurements by digital image processing methods.

DEM data can also be acquired via tacheometric ground surveys. That case is practically restricted, for economic reasons, to small areas or to particularly difficult terrain. Terrestrial data are usually processed with the same interpolation software as used for photogrammetric data. *Cartographic data* represent another type of DEM input, consisting of digitized contour lines from topographic maps. Cartographic data are important because use is made of *existing* topographic information. But cartographic contour data

normally do not give high quality DEMs, unless additional information, breaklines in particular, is brought in.

Interpolation Methods

The observed points and breaklines, measured manually, serve as input to the computational part of the DEM generation, consisting of interpolation procedures which produce the regular DEM grid. The only exceptions are TIN structures which use the observed points directly as an irregular DEM network. During the 1970s, scientific and technical interests concentrated very much on optimum interpolation methods. The question lost interest since high quality software programs based on different interpolation methods give similar performance. Several classes of interpolation methods can be distinguished. First, there is the large class of more or less sophisticated polynomial and spline interpolation methods, as well as moving average or moving tangential plane methods. A second class of methods operates with finite elements. And finally, there are the statistical interpolation methods, known as collocation methods, which operate on covariance functions or on correlation properties of the terrain.

Tests have shown that the different interpolation methods have similar performance, as long as the data acquisition is appropriate, which means dense and qualified data acquisition. There are, however, considerable differences in the accuracy and quality performance of different interpolation methods, and of different software programs, if the data acquisition is not optimal. It happens often that there are gaps and empty spaces between the observed points, or that the point distribution is generally poor. In such cases, different interpolation methods can give quite different results. The programs must take great care that no improbable, no falsified nor wrong results are produced, like the well-known overshooting of polynomials. In case of poor or bad data input, the interpolation should at least produce plausible results. Thus, sophisticated high level software is necessary to safely ensure good or at least acceptable DEM results. Another separate consideration about DEM interpolation concerns the professional *software quality* as such, relatively independent of the interpolation method. Software must be able to identify and delete outliers on a statistical basis, to apply filtering, to consider breaklines and morphological features rigorously, and to integrate them in the final DEM data structure. Also, it is highly desirable that the program gives at least some statistical accuracy and reliability figures for quality and acceptance assessment of the resulting DEM.

When generating a DEM in the form of a regular grid, the grid spacing must have a certain relationship with the observed data input in order to transfer the inherent information to the DEM. Conventional data acquisition is characterized by sparse densities of points. In those cases, the interpolated DEM grid is generally denser than the observed points. It is a rule of thumb to generate the derived grid spacing about two to three times denser than the original observations. Thus, the DEM grid usually has about five to ten times more grid points than originally observed points.

In that way, the curvature of the terrain can be taken into account and expressed by interpolation within the spacings between observed points.

The above considerations refer to the conventional interactive data acquisition and the respective methods of DEM interpolation. The computational DEM generation is operationally separated from the data acquisition. It can be executed on-line with the data acquisition, although most programs operate off-line. These considerations will be thoroughly altered when the automated DEM generation by digital image processing methods comes into the picture.

A Remark About TIN Structures

DEMs in the form of triangular irregular networks are widespread and highly popular. In the author's personal opinion, however, most alleged advantages would not stand thorough scrutiny, although no comparative investigations have been carried out, so far. The TIN principle goes back to sparse data acquisition where the points are placed individually. This is, however, neither necessary nor effective in photogrammetric data acquisition, especially not in the semi-automated mode of quasi-regular point distribution. By somewhat higher point density, the alleged advantage of representative setting of points is largely overruled. Also, the interpolation in triangles is linear (in practice), filtering of points is normally not applied, and curvature within the triangles is not considered. By comparison, the grid methods are much more flexible and more effective in this respect. Any sophisticated grid interpolation method can certainly give the same or better results, if given the same observed data. It is true that TIN systems can accommodate breaklines very easily, as they are directly represented in the TIN data structure. But other interpolation methods do take breaklines into account with complete rigor too, and make them part of the DEM data structure as well. The TIN storage requirements are higher and the data retrieval is less convenient than with DEM grids. Therefore, TIN DEMs are hardly suggested for nation-wide DEMs with millions of points. And the methods for automatic DEM generation by digital image processing do not consider TIN concepts any more. In the author's opinion, irregular triangular DEM structures are mainly applied because many follow-up programs refer to the TIN structure.

Automated DEM Generation by Softcopy Image Processing Methods

The above considerations about conventional DEM generation are thoroughly altered and shifted when softcopy image workstations are used. Softcopy technology has the potential of greatly automating many previously-manual measuring operations. The *automation aspect* is the main point of development as far as DEM generation by digital image processing is concerned. The technical basis is provided by *image matching* methods of which least squares (area-) matching and feature based matching are of immediate interest and which have been realized in software programs on digital image workstations. The least squares

matching methods have the best accuracy, but they require initial approximations to within a few pixels. They also require locally flat terrain for optimum performance. The feature based matching on the other hand is more robust with regard to approximations and terrain features. It is also faster and capable of high data redundancy.

When talking of automation of DEM generation, it is not only the actual matching procedures by software algorithms which are in question. It is rather the whole system which is to be run without interactive interference, i.e. the *system automation*, except perhaps for some interactive initialization and subsequent editing. Ideally, the whole DEM production would run as a batch process, process steering and selection of points included, up to accuracy and quality self-diagnosis and at least some editing. Such performance is possible due to the power of computer workstations and digital image processing.

There are a number of immediate properties which characterize the automated DEM generation on softcopy image workstations. The problem of initialization and of providing sufficient approximations is solved, often by running through image pyramids. A decisive consideration is the fact that automated systems can measure many more points than can be done manually. The program with which the author is most familiar, and which is based on feature matching, extracts for instance 100 times more DEM points than conventionally, resulting in 500,000 or more points per stereo-pair. That capability, provided it is fast enough, has a number of consequences which alter the strategy and the evaluation of DEM generation thoroughly. The accuracy and the reliability of the DEM is considerably improved. Also, the principle of interpolation of a DEM grid from observed points is practically reversed. Now, there may be 10 - 20 observed points or more in a grid unit. Deriving the grid by finite elements is, in this case, more of an adjustment (overdetermined fit) than an interpolation. The high data redundancy allows recognition of outliers and obstacles and eventually the automatic identification of breaklines. And finally, the data acquisition and the computational derivation of the DEM are combined in one process, in real-time. Thus, the transition to image processing methods not only results in a new technical and operational performance, but also the whole approach and concept of DEM generation is affected.

Philosophy of DEM Data Acquisition

A few more remarks may be added about the fundamentally different approach to DEM generation by automated methods compared to conventional operator-driven data acquisition. In the conventional mode, the human operator did the actual measurements, although there was some support by the analytical plotter (by driving the measuring mark along profiles or to regular or quasi-regular grid positions). The actual measurement being time consuming and costly, it has been the inherent principle to measure as few points as possible to obtain a desired result. To ensure quality, the mass points were complemented by breaklines and other morphological features. Normally, only

between about 2,000 and 10,000 (max 20,000) points used to be measured per stereo-pair of aerial photographs, taking observation times of a few hours up to a day or more. That minimum principle implied that the points were placed as effectively as possible and that breaklines had a great importance. Altogether, the conventional DEM generation constituted a well balanced and highly effective system. In high precision, large scale applications, it is still competitive with automated DEM generation.

When switching to softcopy workstations, the same minimum principle of data acquisition would still hold, if the human operator would do the actual measurements. However, the point measurements being executed by matching algorithms, the data acquisition is considerably faster, even if the points would still be placed manually by the operator. Thus, in the same time, more points can be measured than previously.

The situation is completely reversed, however, if the DEM data capture on softcopy workstations is fully automated. Then the speed of the data acquisition is very much faster, and many more points are easily and economically measured. In that case, the data acquisition becomes highly redundant. This is the key to sophisticated data analysis. In the first instance, the accuracy and reliability is improved, outliers can be eliminated, and breaklines can be identified. In this way, seemingly difficult problems, which would require knowledge-based solutions, become accessible by algorithmic methods.

Nation-Wide DEMs

As previously stated, DEMs today are considered to be a stand-alone base product. They replace the graphical contour representation of the terrain in former topographic maps. Thus it is clearly the task of survey and mapping authorities to provide national DEMs in the same way as topographic contour maps were formerly provided. The national DEMs of the USGS have been described. They are equivalent to medium scale and small scale topographic maps. There remains, however, the question of state-wide or regional high-accuracy DEMs which are equivalent to large scale base maps. Thus, large scale, high precision DEMs are to be envisaged by states or by counties. In Germany, for instance, various states produce DEMs which are equivalent to the national base map of scale 1:5000, with minimum contour intervals of 1 or 2 m, depending on the flatness of the terrain. In practice, this implies base DEMs with a 10 m grid and a vertical accuracy of perhaps 25 to 50 cm — the detailed specifications are still being debated.

Derived Products

The DEM as a stand-alone product has many applications within the field of surveying and mapping as well as outside. The various and diversified applications cannot be part of the DEM generation proper. They are taken into account by special follow-up programs which have recourse to the DEM. Quite a number of such follow-up programs exist. Examples are digital orthophotos and programs which

derive contour lines, digital slope models, or exposition maps. Engineering and GIS applications use volume computations, intersection of different DEMs, as well as intersection of DEMs with other vector or raster data (cadastral maps, soil maps, slope maps etc.). Widely used are programs which provide perspective views of 3D scenes for visualization, often overlaid with image information or other GIS data. Further into special applications go erosion risk maps, or scientific or other applications for which the DEM is part of more-complex modelling, like micro climatic models, hazard models, pollution distribution in relation to wind direction, and surface coverage, to name just a few. The list of direct or indirect DEM applications is very long, which only confirms the great importance of DEMs as a base product. Here, application programs are not considered any further.

Accuracy, Quality, Productivity

Definition of DEM Accuracy

The (vertical) accuracy of a DEM is simply the average vertical error of potentially all points interpolated within the DEM grid. In other words, it is the r.m.s. vertical error of (infinitely) all points. The bias of a DEM is supposed to be small — practically negligible. Hence the average (quadratic mean) vertical standard deviation of the DEM is very close to the r.m.s. accuracy. Any more-refined considerations, like slope accuracy, or variation of vertical accuracy as function of slope, breakline effects, etc., are additional aspects of the more detailed accuracy structure of a DEM. They do not affect the general definition of the overall vertical accuracy.

The *quality* of a DEM is more than just accuracy. Here especially, the appropriate morphological description of the terrain, by breaklines, special peaks, etc., is implied, in addition to the common criteria of completeness, reliability, consistency, and uniformity of the accuracy distribution within the DEM. However, no objective specifications exist for DEM. They are left to general subjective evaluation, which may vary significantly, depending on different conditions and different applications.

Accuracy Specifications

There are no generally accepted specifications about the accuracy of DEMs, in relation to the type of terrain, or in relation to the grid size of the DEM. In conventional contour maps, the contour interval had a specified relation with the contour accuracy. Something similar does not exist with DEMs. There are only vague rules of thumb concerning the relationship with the grid size. A 5 m grid, for instance, is expected to be very accurate, to perhaps 10 to 25 cm r.m.s. error in case of smooth terrain, and perhaps at least 2 times more for rough terrain, excluding rocky areas. Accordingly, the r.m.s. accuracy of level 3 DEMs with 10 m or 50 m grid spacing might be expected to be about 0.5 m, perhaps 2.5 m in the smooth case. It might be useful to establish the general rule that the DEM grid should be such that the vertical accuracy would correspond to perhaps about 1/20th (smooth

terrain) to 1/10th (rougher terrain) of the linear grid size. It is suggested that such relations are investigated, and perhaps specified, in order to avoid mis-evaluation of DEMs.

Objective quality specifications for DEMs are not in use at all. It is especially left to the subjective judgement of the operator, how many and with which threshold breaklines are to be taken into account. It is believed that often too many breaklines are extracted, many of which have almost no effect on the DEM.

Terrain Surface Representation

The main problem of data acquisition for DEMs is the question of how densely the observed points should be placed in order to give desired accuracy results. In other words, it is the question of how well, with which degree of *fidelity*, the interpolated DEM surface represents the terrain surface in general, and between the observed points in particular. The major effect on the DEM accuracy is certainly the distance between observed points in relation to the smoothness or ruggedness of the terrain. A number of other effects are clearly secondary, such as the accuracy of the measured points, the grid spacing, and the interpolation method. It has been mentioned that the grid spacing and the interpolation methods have a certain influence; especially linear interpolation performs poorest, as terrain curvature is to be reflected in the interpolated surface.

The relationship between accuracy, point distance, and type of terrain has been studied theoretically. In such studies the statistical characteristics of the terrain are assumed to be known — expressed in terms of Fourier spectra, Nyquist frequencies, or covariance functions. Then it can theoretically be predicted which point distances give which accuracy, for a given terrain and for a given interpolation method.

Experimental studies have been carried out to some extent, although not very comprehensively. They have confirmed that, within a certain range, the r.m.s. errors of the DEM increase about linearly with the point distance, for a given terrain. This holds separately for different roughness classes of terrain, pointing to the problem of how to assess the roughness of the terrain in practice.

Planning of Conventional DEM Data Acquisition

In the practical execution of manual DEM measurements, the just-mentioned relationship between point density, terrain roughness, and accuracy is to be reversed. Usually certain accuracy requirements are pre-specified. The question then is how to arrange the observations in order to meet the given accuracy specifications for the terrain in question. The unknown part is the terrain characteristics. Unless the terrain is very smooth, its roughness characteristics have to be assessed approximately. A theoretically sound method, which is also operationally simple, is to quickly run a few profiles over the stereo-model or the characteristic parts of it, apply an on-line Fourier analysis within a few minutes by appropriate software, and have the relationship between frequencies (wave lengths of terrain un-

dulations) and amplitudes of the undulations. With a given amplitude threshold (= DEM accuracy), the minimum wavelength λ of the undulations to be captured can be derived, leading to the maximum distance ($\leq \lambda/2$) between points to be observed. That relationship may, in simple cases, also be estimated by the operator by looking at the local undulations of the terrain. It must be understood that the local curvature and slope variation characteristics are essential, not the magnitudes of slope directly. Another method to adapt the data acquisition density to the curvature structure of the terrain is known as *progressive sampling*. It represents a semi-automated on-line procedure for adequate data acquisition.

In practice, such methods for determining the appropriate and necessary data acquisition structure have been hardly applied (except for progressive sampling, to some extent). The conventional data acquisition usually follows predetermined, customary rules, by just assuming a certain point density, based on experience or on generally fixed standards.

Balance Between Breaklines and Mass Point Density

A problem which has not been investigated at all concerns the relationship between the point density and the number of breaklines to be taken into account. There is a certain balance which can be shifted either way. Sparse distribution of surface (mass) points can be compensated by increased numbers of breaklines, even if they are hardly prominent. On the other hand, dense distribution of mass points allows a reduction of breaklines to the genuine sharp breaklines. Especially the dense automatic point extraction by digital image processing methods can benefit of that effect and restrict the breakline extraction to the hard breaklines, of which there are often very few only. However, the opposite approach has also been suggested, to capture first as many line features and breaklines as possible and fill in a moderate number only of surface points. These strategies have not been investigated experimentally, nor does agreement exist amongst developers.

Potential of Automated DEM Generation by Digital Image Processing Methods

As explained above, the automated data acquisition on softcopy image workstations is capable of high data redundancy. The considerations about maximum allowable point distance then lose their importance. Many more points will be measured than would strictly be necessary, in favor of better accuracy, quality control and quality analysis. The prime effect is on the DEM accuracy. Anyway, least squares matching procedures have a high inherent measuring accuracy, amounting to 0.1 pixel size or better. The resulting effect of the high data redundancy is, even with less accurate feature based matching, that the automatically-derived DEMs have a very high accuracy potential. Overall, DEM accuracies of better than 1/10,000th of the flying height (0.1 h/1000) have been empirically confirmed, in not too rugged

terrain. Such accuracy levels were not obtained in conventional DEM generation because of the principle of sparse measurements.

Productivity

It is difficult to give general production estimates for the conventional DEM data acquisition and the DEM interpolation, as there is great variation with regard to demands and circumstances. According to the information available to the author, the **manual data acquisition** with analytical plotters comprises normally between 2,000 and 10,000 (up to 25,000) points per stereo-model, breaklines included. The measuring time is perhaps between 1.5 and 6 to 8 hours (up to 2 days), or about 2 to 3 seconds per point. We may take 5,000 points and 4 hours per model (some editing included) as a representative case.

The interactive data acquisition on softcopy image stations would be similar, if the measurements would be done interactively by the operator. However, as the actual measurements are being automated by image matching algorithms, the DEM data acquisition is faster, even if the points would still be selected manually.

In addition to the data acquisition, **DEM interpolation** should be considered as a separate process. In conventional DEM generation, the interpolation is a separate computer operation. The DEM computation includes a number of *editing* operations. There are always some data mistakes, also breaklines not closed or wrongly numbered, etc. It is the task of the DEM computation to identify, eliminate and rectify all mistakes. Also, the final editing, checking of overlaps and seams, quality control, etc. require serious attention. The objective is to solve the editing and checking operations without having to go back to remeasurements. In all, it usually takes several hours to complete the DEM computations and the editing, unless very small DEMs are handled. Large systems take longer, a day or more, especially if complicated terrain features and many data errors are present and if graphical outputs are required.

On the other hand, the **DEM system automation** by softcopy image processing systems presents a very different scenario. The available software systems and their practical applications have not been compared, so far. It is again difficult, therefore, to give general productivity figures. The author can quote, however, some results from the automated DEM program he is familiar with. It uses point features and operates on feature based matching. Typically, for 15 μm pixel resolution of the aerial image, about 80,000 grid points are derived from perhaps 800,000 or more extracted 3D terrain points. Thus a single finite element-mesh of about 30 by 30 pixels extension contains between 10 and 20 observed points. In case of 30 μm original pixel resolution, the number of observed points and grid points per stereo-pair is reduced by a factor of 4. For the total DEM processing time, automatic feature extraction, feature matching and finite element grid derivation included, the following production figures are quoted, referring to a Silicon Graphics R4000 MIPS RISC processor. Typically, the total processing of one stereo model takes 1.8 hours (15 μm pixel resolu-

tion) or 0.6 hours (30 μm pixel resolution) which amounts to a production rate of 12 grid points per second and 120 to 180 3D terrain points per second — respectively 10 grid points per second and 100 to 150 3D terrain points per second. The figures may be somewhat different in other cases and with other programs. There is no doubt, however, that the automated DEM generation is very fast and that the productivity can be very high. It has been stated, on the other hand, that the automated DEM generation requires some additional interactive editing, the extent of which depends on the actual case. The experience available so far accounts for checking and editing operations of 1.5 hours to 2 hours for a moderately hilly stereo-pair, and about 4 hours per stereo-pair for mountainous scenes. The figures include the manual capturing of breaklines and polygons and the correction or additional measurement of terrain points. Thus, it can be concluded that in most cases the automated DEM generation is economic, even if considerable editing is required. However, if the editing efforts are very high, as is the case in large scale DEMs of built-up and city areas, the conventional DEM generation remains technically and economically competitive for the time being.

Problem Areas

Open Terrain

The photogrammetric DEM generation of open terrain, where the terrain surface is directly visible and not of extreme roughness, is not faced with any serious problems. The operator-driven manual mode of data acquisition works very well in standard conditions and with standard performance, as described. Also, the automated DEM generation by digital image processing methods has few problems, especially if not too many breaklines are involved and unless extreme cases of poor image texture may cause some difficulties. In such standard cases, the automated softcopy methods display their full accuracy and productivity potential. A number of presently available software programs for automated DEM generation are fully operational in practice. They have proven to be most effective and highly economic in those cases, even if some basic questions of image matching are not entirely clarified, as will be shown in T. Schenk's paper below.

Breaklines, Morphological Features

The capture of breaklines and other morphological features still relies on interactive recognition and interference by a human operator. That slows down the operations, but it has the advantage that the knowledge and judgement of the operator solves the interpretation problems which are difficult to be automated by algorithmic methods. There are possibilities, however, for automatic breakline extraction by softcopy image processing tools. The current developments are expected to provide automatic solutions for practical application in the near future. Two cases should be distinguished: breaklines which correspond to visible features in the image and which are accessible by edge extraction, and breaklines which are only geometrically defined. They may be identified via data analysis by intersection of adjacent surface regions.

Terrain Cover by Vegetation and Buildings

Terrain is often covered by vegetation or buildings. This causes the most serious problem of DEM generation from aerial photography, as those parts of the terrain surface are not visible and cannot be measured directly. This is a particularly annoying problem for the automated modes of DEM measurements, especially for large scale high accuracy DEMs. But, conventional data acquisition by a human operator already has the same problem. The human operator can, however, look for gaps in the vegetation cover and apply at least some measurements on the visible ground areas next to buildings. The automated methods should attempt, eventually, to come up with similar strategies.

The present automated methods of DEM generation essentially operate blindly. Therefore, they have great difficulty in recognizing non-visible parts of the terrain surface. However, there are several ways out. In certain cases the canopy level can be measured as DEM. In orthophoto applications with closed dense forest canopies, this is the desired result. In small scale applications, it may be sufficiently accurate to reduce the canopy surface to ground level by subtracting the average tree heights. In the case of local obstacles like trees, groups of trees and bushes, or individual buildings, a different solution exists which is successfully applied in at least one automated DEM generation program. If feature based matching is applied with very high data redundancy, as described, the data analysis can identify such points on trees or houses as outliers and remove them automatically. This is, by the way, a nice and successful example of how genuine *semantic* problems can be solved algorithmically in certain cases, on the basis of data redundancy.

Nevertheless, vegetation coverage and buildings remain a basic problem, both for manual and automatic DEM generation, although interactive interference can ease it to some extent. A principal solution to the problem can only be obtained by switching over to other kinds of data. In particular, the application of airborne laser scanners can solve the problem, as a part of the laser pulses or beams can penetrate the vegetation cover. Such laser systems are operational now and have proven to be highly efficient and accurate, with spot accuracies in the order of 10 cm. Laser scanning can also be applied in open terrain. Laser data, if sufficiently dense, are also capable of depicting houses and buildings in city areas. Thus the combination of laser and image data may give a powerful system for automatic DEM generation, also in the most difficult cases. This demonstrates the great potential of multi-sensor systems, which can be handled and exploited by digital information processing.

Three-Dimensional DTMs

In the above discussion, buildings have been considered as obstacles to be ignored in the DEM generation, or removed, if possible, automatically. There is, however, the reversed aspect, too. In modern geo-information systems, with three-dimensional data bases, spatial objects are to be described. Thus, objects like buildings and other man-made constructions make part of truly 3D digital terrain models (which is now the appropriate term). It means that the automated DTM generation *should* capture those objects. The automatic identification and extraction of buildings by digi-tal image processing has not been generally solved. It requires knowledge-based methods. Nevertheless, there are encouraging developments, at present, which may succeed soon. It is a challenge for the near future to make automatic building extraction by softcopy image processing a practical capability. It is certain that the present efforts for automated DEM generation from digital images are only the beginning of far reaching developments about digital objects and information retrieval — the potential of which cannot be overestimated, due to the power of digital image and system processing.

Comparison of Softcopy VS. Hardcopy Photogrammetry for DTM Collection, Editing and Quality Control

DICK KAISER AND SCOTT B. MILLER

Introduction

In the comparison of softcopy photogrammetry versus analytical photogrammetry for the collection of digital terrain models (DTMs), it will be necessary to discuss a few basic differences between these technologies. It should also be noted, as with any photogrammetric process, the results are dependent on a chain of processes, and the quality cannot be better than the weakest link in that chain. It should also be noted that there is considerable variation in the capabilities and quality of the various scanners and softcopy workstations now available.

Basic Differences Between Softcopy/ Hardcopy Photogrammetry

This section refers to softcopy versus hardcopy rather than softcopy versus analytical. The reasoning is that softcopy photogrammetry is the next step in analytical photogrammetry where even the photography is digital and therefore subject to analytical techniques.

Digital Imagery vs. Film

This leads to the first and most basic difference, i.e., that softcopy requires digital imagery as input while an analytical plotter works directly on the hardcopy film imagery. With softcopy, the metric accuracy and radiometric quality of the digital image depends on the quality of the imaging and digitizing system. For photography, this means the quality and metric accuracy of the camera, the film and film processing, and the scanning system. For digital imaging systems, it means the quality and metric accuracy of the imaging system (digital camera).

For softcopy, the accuracy and image quality (either high or low) of the scanner is shared by all further users of the digital imagery. For hardcopy, the accuracy and image quality depends on the optics, the stage system, the calibration and the environment of each analytical plotter.

An advantage that hardcopy systems have is that they do not require access to a photogrammetric quality scanner. Softcopy systems have the burden (expense) of scanning film that analytical plotters can utilize directly, but softcopy systems can directly use imagery from digital imaging systems.

Digital Triangulation vs. Conventional Triangulation

Not all softcopy users perform the triangulation digitally. But for those that do, digital triangulation provides benefits that pass to the DTM process. Digital triangulation allows for automation in the point measurement process. The greater ease in point measurement means that it is economical to measure more points and therefore have more-robust, accurate, and reliable analytical solutions. Digital imagery also allows for greater accuracy in the point transfer process. With points in areas of good image texture, manual transfer accuracy of 1/3 to 1/5 of a pixel, and assisted transfers of 1/10 of a pixel are typical. With a 15 micron scan, this can yield 3-5 micron manual transfers and 1.5 micron assisted transfers, while 7-10 micron point transfers are common with hardcopy. Production users are reporting a 2 times increase in accuracy for softcopy over hardcopy triangulation and significant increase in productivity.

Model Setups

Since the digital image was frozen when it was scanned (or imaged), no further film distortion occurs. This means that the exact analytic solution obtained in the triangulation can be directly used in the softcopy workstation. For softcopy, the film is frozen at scan time, while with hardcopy, the film continues to be subject to heat, humidity, dust, etc. This means that the softcopy system can fully utilize the increase in accuracy obtained during digital triangulation. The time saving for model setups is also significant, with the softcopy model setup being instant, while loading film and setting up an analytical plotter can take 5-30 minutes. Softcopy systems, in addition to project, camera, photo, model data, must also have the digital imagery on-line. Softcopy image files, even with image compression, are large computer files which must be loaded, backed-up, and managed and are not required when using hardcopy.

Epipolar Stereo Viewing

With aerial photography, the epipolar direction is parallel to the base of the stereo model (base is the line between the two camera exposure stations), and epipolar lines are parallel in the object (ground) space. If the aerial photos are not perfect vertical photos, then the epipolar lines projected to the photo will not be parallel. To achieve Y-parallax free stereo viewing over an entire field of view, it is necessary to resample the imagery to the epipolar condition. Softcopy systems typically resample to epipolar providing easier stereo viewing, but with most hardcopy systems, it is necessary to manually rotate the optics to an approximate epipolar. Tip and tilt will also cause the image scales to vary over model, thus without servo-controlled zoom and rotation, optical systems are rarely at the ideal stereo

viewing conditions. A disadvantage of epipolar resampling is that it can be time-consuming and is generally done as a batch function or in near real-time. Since stereo compilation is generally scheduled after triangulation, and epipolar resampling can be scheduled as a batch job, the negative effect can be minimized with planning.

Stereo Image Separation

The stereo effect requires the left eye to see the left image and the right eye the right image. This is achieved by binocular optics, polarizing systems, time sharing (shuttering) systems, or anaglyph systems. Binocular optics provide perfect stereo separation. Most other systems allow some mixing or ghosting which degrades the stereo effect. It should be noted the stereo roam reduces the impact of ghosting, since the images are converged at the floating mark. There is not a clear distinction here between softcopy and hardcopy, because all of the listed methods of stereo viewing have been used on both softcopy and hardcopy systems. In general, most analytical plotters use binocular optics which provide perfect stereo separation, while most softcopy systems experience some degree of ghosting. Binocular viewing requires the operator to view from a fixed position and therefore is less comfortable than systems using stereo glasses.

Stereo Field of View

Since most softcopy systems have no limits on magnification, the entire model can be viewed at once, providing unlimited field of view. A more relevant measure is the field of view at a given magnification. In this case, not all softcopy systems are equal. The larger the display monitor, the bigger the possible field of view. A 27" high resolution monitor displaying 15 micron resolution imagery will provide a 21 times enlargement from film to screen. Some softcopy systems can provide more than twice the field of view of most analytical plotters. A large field of view provides a good context for digitizing breaklines and DTM points, or allows effective work at higher magnifications. Small low-resolution monitors provide a field of view which is smaller than typical analytical plotters.

Stereo Superimposition

Softcopy systems inherently provide very accurate stereo superimposition. Accurate stereo superimposition of contours or triangles generated from the DTM can provide real-time feedback to the operator as points are collected/edited. This feedback is exceptionally useful in training operators in optimal DTM collection. It is also unparalleled in the quality control and edit of either manually or automatically collected DTM data. Stereo superimposition is inherent in softcopy, but is very expensive on analytical plotters and is not in common use. The distortions involved in the optics and monitor mean that the superimposed vectors are displayed with low accuracy and therefore of limited use for quality control.

Comparison Of Softcopy VS. Hardcopy For DTM Production

Possibility of Automation

The automation of DTM collection with softcopy techniques has reached production acceptance. The benefit-to-cost ratio can be as high as 10:1 for small scale images or for DTMs used only for orthophoto production. The cost effectiveness falls off as the photo scale and accuracy needs increase. This is because, as the need for manual collection of breaklines increase, the possibility for automation decreases. For example, if 50% of the total time is spent manually collecting breaklines, then only 50% of the total is left as a possibility to automate. At large scales it becomes more difficult to automatically withhold points on houses and trees, and interactive edits of automatic points can take longer than manual collection. In complex areas, operators can easily avoid houses and only collect valid points. If the time to edit bad points from the automatic process approaches the time to manually collect points, it becomes more effective to perform manual collection.

Automation is not possible with standard hardcopy analytical plotters. Although some early systems added digital cameras to analytic plotters making a hybrid hardcopy/softcopy system, these systems never reached common acceptance.

Manual Collection

Manual collection on a softcopy system is generally faster than manual collection with an analytical plotter. The softcopy system can roam instantly to the next point to measure, avoiding the wait that occurs while an analytical plotter slews the stages from point to point. Softcopy is also more comfortable to work at for extended periods, since the operator is not required to maintain a single position and can assume a relaxed posture. The feedback provided by stereo superimposition during DTM extraction is a significant softcopy benefit over hardcopy systems.

Assisted Collection

Manual collection on softcopy can be assisted with image matching techniques. The operator then performs quality control as the system places the measuring mark on the surface. Breakline collection can also be assisted with the operator controlling the horizontal position and the system placing the measuring mark on the surface. Assisted collection is not practical with standard hardcopy analytical plotters.

Editing and Quality Control of DTMs

The softcopy stereo superimposition allows real-time stereo displays of contours, triangles, etc. generated from the actual DTM as edits are performed. Stereo superimpo-

sition allows detection and correction of errors in the DTM that would be very difficult to accomplish on hardcopy analytical plotters. Stereo superimposition is available on some analytical plotters, but it is expensive and, due to distortions in the optics, is not as accurate as softcopy. Fast softcopy model resets allow cost-effective QC of DTMs. Because the time spent performing QC can be very short (10-30 minutes), the time spent setting a hardcopy model would be a significant portion of the total. Because of this reset issue, QC on an analytical plotter is often done as a peer review for completeness and spot checks for accuracy while the model is still set up. Subjective review of generated contours is also done. Quality control techniques on typical analytical plotters are inferior to the 100% QC with stereo superimposition possible with typical softcopy systems. It is worthy of note that 100% QC of automatically generated DTMs is required, whereas it has been accepted practice to only spot check manually collected DTMs. It has also been noted that users may tend to over-edit DTMs since stereo superimposition allows 100% QC.

Summary

Softcopy photogrammetry has significant benefits over hardcopy analytical plotters for the extraction, editing, and quality control of DTMs. This is particularly true if the aerotriangulation is also done digitally to gain full accuracy benefits. Softcopy offers the possibility of manual, assisted, and/or automated extraction — all of which provide increased productivity over hardcopy. Hardcopy typically offers only manual collection. High quality accurate stereo superimposition is standard with softcopy while stereo superimposition with hardcopy is expensive and problematic. Stereo superimposition provides tremendous benefits in training of operators in effective DTM collection, real-time stereo displays to aid in edits, and unmatched capabilities in quality control of DTMs. Also, the softcopy seat can offer superior stereo viewing and operator comfort which adds to overall productivity. Softcopy has the drawback of requiring photogrammetric quality scanning and requires the management of large image files which is not required by hardcopy systems; but the rapid reduction in cost and increased compression is reducing this impact.

Automatic Generation of DEM's

ANTON F. SCHENK

Abstract

This paper provides a general framework for assessing programs which generate DEMs automatically. The automatic generation of DEMs is seen as part of the more general problem of surface reconstruction. After defining the problem, some of the fundamental problems to solve it are discussed. This is followed by a brief comparison of the most prominent methods to match images. The remainder of the section is devoted to the densification of automatically matched points and to the quality control problem.

Introduction

The production of DEMs is an important task in photogrammetry. As outlined earlier in this chapter, DEMs are either stand-alone products or they are used for the purpose of generating secondary products such as orthophotos. Digital photogrammetry is an ideal environment to determine DEMs automatically. The purpose of this section is to provide a general framework for assessing the current status and indicating future trends in the automatic generation of DEMs.

Ever since computers became available, researchers have tried to generate DEMs automatically. Despite considerable progress, the problem is still not entirely solved. Consider a large-scale, urban area, for example. No system exists today which would generate a DEM automatically. The problem has been underestimated, like so many other attempts which try to mimic the mental faculty of seeing. What a human operator solves without conscious effort does not mean the task is easy.

Before discussing problems and solutions, a short note on the term *automatic*. With automatic generation of DEMs, one would expect that the computer performs the same task that is usually assigned to an operator. However, this cannot be done without human intervention; today's systems are not autonomous and will not be in the foreseeable future. Therefore, the automatic generation of DEMs is performed in an interactive environment with softcopy workstations.

Background

DEMs are part of a more general problem, usually referred to as *surface reconstruction*. This subject has been extensively studied in the field of computer vision. According to one of the most prominent paradigms in computer vision, surfaces play an important role in guiding subsequent vision tasks, e.g., object recognition and image understanding. Many other perception tasks, such as navigating a robot in a cluttered environment, make extensive use of surface properties. The human visual system is remarkably adept at perceiving shape information and perceptually organizing surfaces into meaningful symbols. Unlike in photogrammetry, the goal here is not to describe a surface as accurately and densely as possible, but as explicitly as possible. Rather than dealing with a cloud of unrelated 3-D points, it is preferred to segment the surface into piecewise continuous patches, which are related to surfaces of objects.

Despite these different goals, the nature of the problem is the same. Reconstructing surfaces, or generating DEMs for that matter, is the reverse process of image formation. Like many other inverse problems, it is ill-posed. Hadamard defined a mathematical problem to be well-posed when its solution exists, is unique, and is robust against noise.

Regularization theories have been proposed to solve ill-posed problems (e.g., Tikhonov and Arsenin, 1977). The basic notion is to restrict the space of acceptable solutions by choosing a function that minimizes an appropriate functional. One method for finding x from $y = Ax$ is to minimize $Ax-y+\lambda Px$ where Px is a stabilizing function and λ is the regularization parameter. In essence, the ill-posed process is regularized by imposing physically plausible constraints, for example, smoothness.

Of course, DEMs have been automatically generated before regularization theory became available. This is accomplished by introducing assumptions and constraints, sometimes in a rather ad hoc fashion. The secret is to strike a fine balance between constraining the problem just enough to obtain a solution and at the same time remain as general as possible. Every DEM program uses some kind of assumptions and constraints which are useful criteria when it comes to comparison of different systems.

An alternative approach to regularization is the combination of different depth cues. The astounding ability of humans to reconstruct surfaces, that is, to perceive a 3-D world (in real-time!), stems from integrating information about the surface that is obtained from independent sources. For example, the gradually changing pattern of texture may be related to a slanted surface. Similarly, smooth changes of the recorded brightness may imply a smoothly varying surface, such as a sphere or cylinder. These are examples of monocular cues. If they support the surface as reconstructed from stereo, a strong perception results. On the other hand, if some of the depth cues contradict each other, the perception becomes unstable.

Some researchers in digital photogrammetry have proposed to integrate stereo and shading by adding the radiometric model to the geometric model in least-squares matching (e.g. Wrobel, 1987; Helava, 1988; Ebner and Heipke, 1988). The predominant method to generate DEMs remains stereo, however. The following discussions are restricted to this traditional approach.

Problem Statement

The automatic generation of DEMs from a stereomodel comprises the following three tasks:

1. Find conjugate points (image matching).

2. Interpolate and densify the surface (surface fitting).

3. Check and edit the DEM (quality control).

Finding conjugate points is known as *image matching*, sometimes also called *image correlation*. The latter expression stems from the popular method used to find conjugate points.

The points obtained by task 1 are not evenly distributed and do not completely represent the surface. Even if all pixels were selected in task 1, there would be holes because matching is not always successful. Thus, the 3-D points must be interpolated — a process called *surface fitting*.

Once initialized, the first two tasks usually do not require any human interaction. In contrast, task 3 is truly interactive.

Finding Conjugate Points (Image Matching)

Image matching, or finding conjugate points automatically, is a fundamental task in digital photogrammetry. First experiments started in the 1950s, most notably by Hobrough. The solution was analog in nature; correlators which were realized in hardware compared (correlated) the gray levels of a stereopair. From the early 1970s to the mid-1980s, research related to image matching focused on digital correlation techniques. Despite considerable effort, no general solution was found. Researchers were puzzled because humans find conjugate points easily.

Overview, Problem Statement

Because of the lack of a unified terminology, the following definitions are introduced in this text:

Conjugate entity is a more general term than conjugate point. Conjugate entities are the images of object space features, including points, lines and areas.

Matching entity is the primitive which is compared with primitives in other images to find conjugate entities. Primitives include gray levels, features, and symbolic descriptions.

Similarity measure is a quantitative measure of how well matching entities correspond to each other. The degree of similarity can either be a maximum or minimum criteria, for example, the cross-correlation coefficient or the least-squares approach.

Matching method performs the similarity measure of matching entities. The methods are usually named after the matching entity, for example, area-based matching, feature-based matching, and symbolic matching.

Matching strategy refers to the concept or overall scheme of the solution of the image matching problem. Strategies include: hierarchical approach, and neural networks approach.

Matching Method	Similarity Measure	Matching Entities
Area-based	Correlation least-squares	Gray levels
Feature-based	Cost function	Edges
Symbolic	Cost function	Symbolic description

TABLE 1
Relationship between Matching Methods, Similarity Measures, and Matching Entities.

Table 1 shows how these terms are related. The first column lists the three best known matching methods.

- *Area-based matching* is associated with matching gray levels, i.e., the gray level distribution of small areas of two images, called *image patches*, is compared, and the similarity is measured by correlation or least-squares techniques. Area-based matching using correlation is often simply called *correlation*. Likewise, area-based matching with a least-squares approach for measuring similarity is referred to as *least-squares matching (LSM)*. Area-based matching is the preferred method in photogrammetry — presumably because of historical reasons.

- *Feature-based matching* is predominantly used in computer vision. Here, edges or other features derived from the original images are compared to determine conjugate features. The similarity, e.g., the shape, sign and strength of edges, is measured by a cost function.

- *Symbolic matching* refers to methods which compare symbolic descriptions of images and measure the similarity by a cost function. The symbolic descriptions may refer to gray levels or to derived features. They can be implemented as graphs, trees, semantic nets — just to mention a few possibilities. In contrast to the other methods, symbolic matching is not strictly based on geometric similarity properties. Instead of using the shape or location as a similarity criterion, it compares topological properties.

There are other approaches to image matching. In the interest of brevity, they are not discussed here.

The problem of image matching can be stated as follows:

1. Select a matching entity (point or feature) in one image.

2. Find its conjugate (corresponding) entity in the other image.

3. Compute the 3-D location of the matched entity in object space.

4. Assess the quality of the match.

Obviously, the second step is most difficult to solve. Although the other steps appear trivial at first sight, there are still interesting issues involved. Take a typical stereopair as an example. In which of the two images should the matching entity be selected? What entity should be selected and how is it determined in the first place? Now, imagine we have successfully matched conjugate edges. How should we compute their location in object space if no conjugate points are available?

Fundamental Problems of Image Matching

In the following, a few fundamental problems of image matching are briefly described. All DEM generation systems must address these problems. How successfully they solve them determines the quality of the product. The solution to the matching problems is therefore a good evaluation parameter.

Search Space, Uniqueness of Matching Entity

According to step 1 of the problem statement, let us pick a pixel P in one image at location i_p, j_p, gray level g_p. If we were to search for the conjugate pixel in the other image in a brute force manner, then the entire overlapping area must be checked for occurrences of gray level g_p. This would lead to $0.6 \cdot N \cdot M$ operations, with $N \cdot M$ the number of pixels (resolution). If every pixel in the reference image is matched, then the computational complexity is $O(n^4)$, with $n = \sqrt{N \cdot M}$ Apart from the untractable computational problem, there is the additional problem of ambiguity. To demonstrate this point, let us assume that every gray level occurs with the same frequency. Thus, we find $0.6 \cdot N \cdot M/256$ matches of which only one is correct. Considering noise, many more potential matches will be found.

This example illustrates two problems:

· **Combinatorial explosion** occurs if the similarity measure between the matching entities is computed over the entire image (model).

· **Ambiguity** occurs if the matching entity is not characteristic (unique) enough.

A solution to the first problem is to restrict the *search space* for finding conjugate entities. The second problem must be conquered by selecting more unique matching entities.

Approximations, Constraints and Assumptions

As pointed out in the beginning, matching, as part of the surface reconstruction process, is an ill-posed problem. For example, no solution (occlusion) or no unique solution (ambiguity) may exist.

A straight-forward way to make image matching well-posed is to restrict the space of possible solutions, for example, by setting bounds. The underlying function of the similarity measure is non-monotonous and rather flat around peaks and troughs. The image matching process must begin rather close to the true solution, otherwise a secondary minimum may be found or too many iterations are required. Consequently, very good approximations are needed to assure convergence. Area-based methods must begin the search process as close as a few pixels from the true conjugate location. Feature-based matching and symbolic matching have a much larger convergence radius (also called *pull-in range*).

Approximations and search space are closely related; the better the approximations, the smaller the search space.

Assumptions about the matching problem are another source of restricting the solution space. A good example is an aerial stereopair with 60% forward overlap. This assumption permits the prediction of conjugate locations fairly well. As long as we work with aerial images, there is nothing wrong with this kind of assumption. It is important to know what kinds of assumptions are built-in for a specific matching program to prevent its use for situations that violate these assumptions.

Geometric Distortions of Matching Entities

The solution to the ambiguity problem is to make the matching entities as unique as possible so that only one solution (match) exists. Instead of comparing the gray level of one pixel, several pixels must be considered in the similarity measure. Thus, the gray levels of an image patch, size $n \times n$ pixels, are compared with those of the patch in the other image. Suppose now that both image patches are centered on the conjugate point. The similarity measure yields a maximum if the gray levels of every pixel compared are identical. This is an ideal situation which will never occur in reality. Noise, changing illumination, and reflection properties between two consecutive images cause differences in the gray levels. Another source that causes two image patches to appear different, even in their true conjugate location, are geometric distortions due to the central projection and relief. In the latter case, the individual pixels are not conjugate, even though a perfectly vertical stereopair is assumed. We conclude that area-based methods are affected by geometrical distortions. Feature-based methods are much less sensitive.

Matching Methods

Area-Based Matching

The entities in area-based matching are gray levels. Here, the idea is to compare the gray level distribution of a small sub-image, called *image patch*, with its counterpart in the other image. The *template* is the image patch which usually remains in a fixed position in one of the images. The *search window* refers to the search space within which

image patches (sometimes called *matching windows*) are compared with the template. The comparison is performed with different similarity measure criteria. The two best known criteria are *cross-correlation* and *least-squares matching*. A number of issues must be addressed, independently of the similarity measure of the method.

- **Location of the Template.** The question of where to select the center of the template may appear trivial. Theoretically, it can be anywhere in the overlapping area of the images. To be precise, the template's center can only be placed within an area which is half the template size smaller than the image. On closer examination, we probably want to be more selective within the accepted boundary. Certain conditions may cause area-based matching to fail, for example, placing the template on areas which are occluded in the other image, selecting an area with low signal-to-noise ratio (SNR) or repetitive pattern, selecting an area with breaklines — the list with bad to disastrous conditions is almost unlimited.

- **Size of the Template.** The size of the template and the matching window is an important parameter. With increasing size, the uniqueness of the gray level function usually increases, but so do the geometric distortion problems. A compromise must be found, e.g., by computing a uniqueness measure for different template sizes. This also serves the purpose of checking the usefulness of the template location.

- **Location and Size of the Search Window.** Since area-based matching depends on very close approximations, the location of the search window is crucial. The size (search space) does not play a significant role because shifts of more than a few pixels are suspicious anyway. A hierarchical strategy is usually employed to ensure good approximations.

- **Acceptance Criteria.** The factors obtained for measuring the similarity of the template and matching window must be analyzed. Acceptance/rejection criteria often change, even within the same image. Threshold values or other criteria should be locally determined (on-the-fly).

- **Quality Control.** The quality control (QC) includes an assessment of the accuracy and reliability of the conjugate locations. Moreover, the consistency of matched points must be analyzed, including the compatibility with expectations or knowledge about the object space.

Correlation

Correlation techniques have a long tradition for finding conjugate points in photogrammetry. In fact, first experiments with analog correlation methods were conducted in the 1950s. The idea is to measure the similarity of the template with the matching window by computing the correlation factor.

The cross-correlation factor is determined for every position r,s of the matching window within the search window. The next problem is to determine the position u,v which yields the maximum correlation factor. If the search window is constrained to the epipolar line, then the correlation factors can be plotted in a graph. The maximum is found by fitting a polynomial through the correlation values (usually a second order parabola).

Least-Squares Matching

First experiments with least-squares matching (LSM) were reported by researchers in Germany (Ackermann, Förstner) in the mid 1980s. The idea is to minimize the gray level differences between the template and the matching window whereby the position and the shape of the matching window are parameters to be determined in the adjustment process. That is, the position and the shape of the matching window are changed until the gray level differences between the deformed window and the (constant) template reach a minimum. While we immediately grasp the idea of moving the matching window until the conjugate position is found, the deforming aspect may be less obvious at first sight. After discussing the various geometric distortions caused by either unknown orientation parameters, tilted surface patch, surface patch with relief, etc., it becomes clear that the shape of the matching window must be changed so that all pixels in the window become conjugate with their counterparts in the template.

Feature-Based Matching

As the name suggests, in feature-based matching (FBM) the conjugate entities are derived properties (features) of the original gray level image. Such properties include *feature points*, *edges*, and *regions*. Edges are by far the most widely used features, although in photogrammetry, feature points, called *interest points*, are more popular; but matching feature points does not actually meet the criteria of FBM.

FBM gained popularity in computer vision in the late 1970s when it was realized that the remarkable stereovision ability of humans is based on finding conjugate edges rather than finding similar gray level distributions in a stereopair.

Edges correspond to brightness differences in the images. Such differences may be abrupt ("sharp" edge) or may occur over an extended area ("smooth" edge). Ideally, an edge operator should be capable of detecting sharp and smooth edges. Also, edges usually occur at all orientations which require a direction independent operator. Detecting brightness differences amounts to determine derivatives or, in case of discrete functions such as digital images, to determine n-order differences. Taking differences amplifies noise, hence edge operators are noise sensitive. Another prerequisite then is to reduce the impact of noise by smoothing the image.

Matching Individual Edge Pixels

After establishing the theory about stereovision, FBM was first implemented by an approach which became known

as the Marr-Poggio-Grimson algorithm. In this method, zero-crossing contours are first matched on a pixel-by-pixel level, followed by disambiguating multiple matches considering regional criteria. It is assumed that the stereopair is normalized, i.e., conjugate entities are found in the same rows of the digital stereopair. The following is a brief discussion of this approach.

Let us begin with the epipolar linepair e'_1, e''_2 where edge pixel p_1 is selected. The first task is to find potential edge pixels in the other image. They are confined to the search interval s, centered on the predicted match to p. Several edge pixels are contained within the search interval, but some can be immediately disregarded as potential matches, namely those with incompatible attributes, the strongest of which is the sign. If the image appears brighter to the left of the selected edge pixel p_1, then the same situation applies for the pixel in the other image. Other attributes such as orientation and strength are used in a later step. All edge pixels within s with the same sign as p_1 are candidates and stored in a list.

The more potential matches are found, the more difficult will it be to determine the correct one. Hence, the cardinal question is how many candidates will we have on an average and — more important — how can this number be influenced and kept to a maximum of 3 to 5.

Selecting the correct conjugate pixel is governed by the principle of continuity along discontinuities. An edge signals a discontinuity in the gray levels across the edge. Edges may correspond to boundaries of real objects, and such boundaries are usually continuous, at least piecewise. As a consequence, the parallax along matched edges changes only gradually, hardly ever abruptly. A possible scenario is to determine all possible parallaxes, for example, between p_1 and all the candidates $c^i_1, i = 1,...,k_1, p_2$ and $c^i_2, i = 1,...,k_2, p_e$ and $c^i_e, i = 1,...,k_e$, where k_i is the number of candidates for the i^{th} pixel.

Matching Entire Edges Simultaneously

When matching entire edges, the following factors must be considered:

- Conjugate edges occur in similar regions. Given a normal aerial stereopair, it is impossible that an edge in the left upper corner is conjugate to an edge in the right lower corner.

- Conjugate edges have similar shape and orientation. A horizontal edge is not conjugate to a vertical edge, and an S-shaped edge is very unlikely to correspond to a question-mark shape.

- Spatial relationships of edges do not change drastically for their conjugate partners. For example, topological properties, e.g. one edge is to the left of another edge, are preserved.

These observations are guiding the strategy to match entire edges. Let r_i be an edge in one image and let $q_j, j = 1,...,n$ be a set of n candidate edges in the other image, se-

lected based on the localization criteria. The problem is to find one edge, a segment of one edge, or segments of several edges which match r_i in terms of similar shape.

Surface Fitting

The points obtained by image matching are not evenly distributed and do not completely represent the surface. Even if all pixels were selected in task 1, there would be holes because matching is not always successful. Thus, the 3-D points must be interpolated. The term surface fitting is more general as it includes interpolation as well as approximation methods.

Lancaster and Salkauskas (1986) define surface fitting as finding a function that agrees with the data points to some extent and behaves reasonably between data points. Surface fitting methods can be classified according to criteria such as goodness of fit, extent of support (local versus global methods) or type of mathematical model (weighted average, polynomials, splines).

In the weighted average method, the elevation at a random position is obtained as the weighted average of all data points with the weight inversely proportional to the distance. To reduce the computational complexity, local average methods do not consider all data points.

Polynomials have long been used for interpolating surfaces. Their notorious oscillation tendency is overcome by spline functions. A spline is a piecewise polynomial function defined on continuous segments. By imposing the existence of derivatives, spline functions become continuous and smooth between segments. A nice property is the predictability of their location; splines lie within the convex hull of data points.

An interesting class of splines are the thin plate splines, derived from nodal basis functions. They are obtained by minimizing the total curvature of a cubic spline. The relationship with thin plates stems from the fact that minimizing the curvature is equal to determining the deflection of a plate due to an external force. This forms the basis for casting the surface fitting problem as an energy minimization problem.

The energy function E to be minimized is constructed from two functionals. The first functional measures the smoothness of the solution S. D is the second functional, and it relates to the closeness of the solution. The energy function is the combination, or $E = S + D$. This concept is taken a step further by including discontinuities.

If the surface is broken along discontinuities, then a lower state of energy is reached. In the extreme case of breaking up the surface into small pieces around every data point, the lowest energy state is reached. This would certainly not correspond to visible surfaces in everyday scenes where we observe a great degree of continuity and smoothness. Therefore, breaking the surface into patches must be penalized. Formally, a third term P is introduced, and we obtain $E = S + D + P$, where P is a cost function.

The energy function E is nonconvex and minimization is nontrivial. Blake and Zissermann (1987) suggest merg-

ing the interpolation function S with the line process P. This solution allows occasional discontinuities in an otherwise continuous environment.

This approach can be used to test hypotheses about breaklines. Breaklines are related to discontinuities in the image function. Since gray level changes are caused by changes in illumination, edges and breaklines are related. By and large, breaklines show up as edges. Thus, matched edges are hypothetical breaklines. This hypothesis is confirmed or rejected by comparing the breaklines that are detected during the surface fitting process.

Checking and Editing

In most DEM generation systems, matching and surface densification are truly automatic tasks, requiring human intervention only in the beginning to initialize the process. Despite all of the checking performed by the two tasks, it is essential that the DEM is now checked by a human operator for accuracy and completeness, a process that may be called *quality control* (QC).

QC is implemented in an interactive environment comprising the two steps of displaying the DEM (visualization) and editing the data if necessary. The task is very crucial for it does not only affect the quality of the DEM but also the economy of an automated approach.

The visualization of the DEM can be grouped into perspective views and true 3-D. The perspective view of a wire-frame model of the DEM allows a quick assessment and the detection of gross errors. However, it completely lacks the capability of assessing the accuracy. An alternative to the wire-frame model is the shading of the DEM based on an artificial light source. This technique, known as *rendering*, is quite effective for detecting errors, but does not offer any accuracy assessment either.

One way to detect subtle mistakes in the DEM and to assess its accuracy is a true 3-D display, superimposed on the images. In this case, the operator perceives the model from the stereopair and can compare it with the 3-D view of the DEM. Softcopy workstations provide an ideal environment for this task. However, careful checking remains a tedious process. Norvelle reports (Norvelle, 1994) that the amount of data produced in 15 minutes of matching a stereopair, using the correlation method, can require up to 5 hours to check and edit.

Norvelle (1994) describes a method to perform the quality control by a computer-assisted technique, called iterative orthophoto refinement. The idea, also described in Schenk, et al. (1991) in a somewhat different context, is to produce two orthophotos with the DEM and the two images of the stereopair. If the DEM is correct, then the two orthophotos should be identical, except for radiometric differences. Geometric displacements incur from a wrong DEM. Such displacements can be discovered automatically by repeating the matching process with the two orthophotos. Moreover, the displacements can be used to correct the DEM.

References

Ackermann, F., 1983. High-precision image correlation. *39th Photogrammetric Week*, Stuttgart, pp. 231-243.

Blake, A. and Zissermann, A., 1987. *Visual Reconstruction.* The MIT Press, Cambridge, MA.

Ebner, H. and Heipke, C., 1988. Integration of digital image matching and object surface reconstruction. *International Archives of Photogrammetry and Remote Sensing*, Congress Kyoto, Vol. 27, part B-11, pp. 534-545.

Förstner, W., 1982. On the geometric precision of digital correlation. *International Archives of Photogrammetry and Remote Sensing*, Helsinki, Vol. 24, Comm III, pp. 176-189.

Helava, U., 1988. Object-space least squares correlation. *Photogrammetric Engineering and Remote Sensing*, Vol. 54, No. 6, pp. 711-714.

Lancaster, P. and Salkauskas, K., 1986. *Curve and Surface Fitting: An Introduction.* Academic Press, London.

Norvelle, R., 1996. Using iterative orthophoto refinements to generate and correct DEMs. *Manual of Photogrammetry Addendum*.

Schenk, A., Toth, C., and Li, J. C., 1991. Hierarchical approach to reconstruct surfaces by using iteratively rectified imagery. Proc. Close range photogrammetry meets machine vision, *SPIE*, Vol. 1395, pp. 464-470.

Tikhonov, A. N. and Arsenin, V. Y., 1977. *Solution of Ill-posed Problems.* Winston.

Wrobel, B., 1987. Facets stereo vision — A new approach to computer stereo vision and to digital photogrammetry. Proc. *Fast Processing of Photogrammetric Data*, Interlaken, pp. 231-258.

Using Iterative Orthophoto Refinements to Generate and Correct Digital Elevation Models (DEM's)

F. RAYE NORVELLE

Abstract

A new technique is described that can be used to correct the digital elevation data obtained using digital correlation methods on terrain stereoimages. The new technique takes advantage of the speed of modern computers and the inherent geometric relationship between elevation data and orthophotographs to provide a speedy, accurate and nearly automatic method for both generating and correcting digital elevation models (DEM's).

Introduction

Digital correlation methods provide a fast and effective means for automatically generating terrain elevation data from digital stereopairs of aerial photographs. Compilation rates of several hundred points per second can be achieved on modern computers. The data produced have to be edited, however, and this can be a very tedious and time-consuming process. For example, the amount of correlation data produced in 15 minutes by the correlation method "match," developed by the U.S. Army Topographic Engineering Center (TEC), can require up to 5 hours to inspect and edit using manual and computer-assisted techniques.

To minimize interactive editing requirements, TEC has developed a new DEM editing/generation technique named the "Iterative Orthophoto Refinements (IOR)" method. It is highly effective and is commensurate in speed with modern correlation methods. The IOR method, which is similar in concept to that reported by Schenk(1989), is based on the premise that, given a DEM and accurate exterior orientation parameters for a stereopair of digital images, it is possible to generate two, supposedly identical, orthophotos of the original stereoimages. If the orientation data are correct, any geometric mismatch between the two orthophotos will be caused by errors in the derived elevations. The mismatches can be measured automatically using a digital correlation method, converted to equivalent elevation errors and used to refine the original DEM. New orthophotos can then be generated from the updated DEM and the process repeated in an iterative manner until no measurable mismatches exist between the orthophotos.

A detailed description of the IOR method is given in the next section. This is followed by sections on test results, a discussion of the results and conclusions.

The IOR Method

The IOR method mainly requires the use of a digital correlation routine, a digital orthophoto generation capability and a technique for converting geometric mismatches between orthophoto pairs to equivalent DEM error. Each of these processes will be discussed in the following sections.

The Digital Correlation Method

The correlation method used in the IOR process is named "match." It is the offspring of a program developed by TEC in the late 1970's named the "Digital Interactive Mapping Program (DIMP)." In the late 1980's, DIMP, which was written in the FORTRAN language for a CDC Cyber computer, was modified to include various new capabilities, rewritten in the C-language for a Silicon Graphics Iris 4D/85 engineering workstation and renamed "match." A full description of "match" is beyond the scope of this paper. The reader is referred instead to Norvelle (1981) which describes DIMP in detail and is sufficiently applicable to "match."

"Match" is an area-based digital correlation method that operates in image space and is referenced to an evenly spaced grid of points on the left image of a stereopair. That is, for equally spaced image points (grid) on the leftmate, "match" attempts to determine, based on the maximization of the normalized cross correlation coefficient, the image coordinates of corresponding points on the rightmate. This routine is used in two ways in the IOR method. First, correlation is performed on a stereopair of images to determine a dense grid of conjugate points. These points are intersected to obtain a DEM. The DEM is then used in conjunction with the exterior orientation data for the stereoimages to generate an orthophoto of each image of the stereopair.

"Match" is used in a second mode to automatically determine the geometric mismatches between the two orthophotos. The procedure is the same as in the first mode but now the conjugate image points determined by "match" should have identical orthophoto image coordinates. The extent to which they are not identical (mismatches) can be transformed into equivalent elevation errors that are then used to correct the current DEM values.

Orthophoto Transformation

Orthophotos are produced using a differential rectification technique. Projection equations are used to rigorously compute corresponding image coordinates (x_p, y_p) for the ground coordinates (X_g, Y_g, Z_g) of a rectangular array of four DEM points. The X_g and Y_g-ground coordinates of the DEM points are then mathematically related to their corresponding image coordinates according to Equations 1.

$$x_p = a X_g + b Y_g + c X_g Y_g + d \quad Eqs\ (1)$$
$$y_p = e X_g + f Y_g + g X_g Y_g + h$$

Once the coefficients are determined, Equations 1 are used to compute image coordinates for ground points (orthophoto pixels) that fall within the boundaries of the four DEM values. For each computed image point (x_p, y_p), a gray level is extracted from the original image using bilinear interpolation and assigned to the orthophoto at coordinates X_g and Y_g. The computations proceed from one rectangular array of DEM values to the next until the full orthophoto is generated.

The ground-sample value (meters) for each pixel of the orthophoto is selected by the user. Its value is normally chosen to have about the same ground resolution as a pixel on the input image. The orthophoto pixel size must also be divisible into the DEM spacing by some integer value. This is required so that the "match" routine will be capable of determining a mismatch between orthophotos at ground coordinates registered with the DEM values.

For example, if an input image pixel is approximately equivalent to 2.12 meters on the ground, and the elevations in the DEM are spaced 25 meters apart, an orthophoto pixel will be chosen that has a 2.5 meter ground resolution. When "match" is used, conjugate points (mismatches) will be determined at a spacing of 25/2.5 = 10 pixels on the left orthophoto and will coincide exactly with a DEM value.

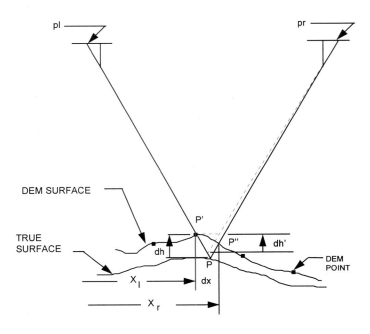

FIGURE 1
Relationship between Orthophoto Mismatches and DEM Errors.

DEM Error Computation

Figure 1 shows the geometric relationship between mismatches in the orthophotos (dx) and the DEM error (dh)

that caused the mismatch. P' is a measured DEM point (shown at the dot positions) and is in error by a value of dh. The orthophoto image of point P' falls at a ground position Xl on the left orthophoto and at Xr on the right. The mismatch between the two is dx. Since the coordinates of the camera stations and the ground positions of P'(Xl) and P" (Xr = Xl+dx) are known, it is possible to compute the position of P by intersection.

The error in elevation between P' and P can be computed and, if the slope of the true ground surface is known, converted to the error dh directly beneath the DEM point P'. The true ground slope is not known, however, but can be approximated from the measured DEM surface. Alternately, the approximate error, dh', can be computed as dh' = dx(H/B), where H/B is the reciprocal of the base-height ratio between camera stations. The error dh (or dh') can then be used to update the DEM value of point P'.

In cases where the DEM errors are erratic (individual "spikes" in the elevation data), the slope of the ground, as approximated by the slope of the DEM surface, may be in serious error. This will cause an exaggerated dh correction. In such cases, the approximate correction, dh', may be more dependable. In either case, since the true ground slope is not known, the IOR process is necessarily an iterative one.

Results

Test Images

Two examples of test results obtained with the IOR method are given in this section. The first test was made with 1280 by 1024-pixel stereoimages obtained by scanning 1:40000 scale photographs of the San Bernardino Mountains in California (Figure 2a) with a 50-micrometer spot size. The terrain is very rugged (elevations range from 1350 to 1950 meters above sea level) with slopes up to 45 degrees and slope changes (ridges and valleys) approaching 70 degrees. Most valleys are lined with densely-populated, tall trees which were imaged with very little variance in gray shades. Ridge lines and slopes have a moderately-dense cover of small trees. The sharp slope changes and low radiometric variance in some image areas cause difficulties for a correlation method and large DEM errors will occur. These images, therefore, present a good test for the IOR method.

In the second test, 2048 by 2048-pixel stereoimages are used. They were obtained by scanning 1:20000 scale photographs of Fort Hunter Liggett, California, (Figure 2b) with a 25-micrometer spot size. The terrain is dotted with tall, isolated trees whose shadows are prevalent on one image but occluded by the trees themselves on the other. The terrain, with elevations from 369 to 480 meters, is otherwise grass covered and provides very little radiometric variance in the images to support digital correlation and DEM generation. Large elevation errors can be expected, especially with regard to tree heights, making these images a difficult test of the IOR method.

(a) (b)

FIGURE 2
(a) San Bernardino Mountains and
(b) Fort Hunter Liggett Test Images.

(a) (b)

FIGURE 3
San Bernardino Mtns. Shaded Relief Images of
(a) The Approximate DEM and
(b) The DEM After 2 Iterations of the IOR Method.

San Bernardino Mountains Test Results

The original stereoimages were initially reduced in scale by 4x to (1) minimize the large x-parallaxes caused by the rugged terrain and (2) reduce the time required to obtain an initial DEM. The reduced images were correlated to provide a DEM with a 40-meter spacing. The spacing was changed to 10 meters by bilinear interpolation. The resulting DEM is shown as a shaded relief image in Figure 3a. The "sun" is in the upper-left corner at an altitude of 50 degrees from the nadir.

The initial DEM, although approximate, was used to generate a pair of orthophotos from the original, full-resolution stereoimages. The geometric mismatches (x-parallax) between the orthophotos were measured automatically with "match," converted to elevations errors and used to refine the initial DEM. The mismatches equated to elevation errors ranging from -100 to +43 meters.

A second set of orthophotos were made and, when viewed in 3D, were found to contain new, but smaller, mismatches. A second iteration of the IOR method was performed and detected elevation errors ranging in value from -11.0 to +13.6 meters. These errors were used to further refine the once-corrected DEM. The refined DEM is shown as a shaded relief image in Figure 3b. The total elapsed time for the above steps was 30 minutes.

For validation purposes, a third set of orthophotos were generated. No significant mismatches were found in the new orthophotos except in one area of dense tree growth. The radiometric variance in this image area was so low that correlation was impossible. Any further DEM corrections would have to be made using manual editing techniques.

Fort Hunter Liggett Test Results

Previous correlation experience with these images showed that it is nearly impossible for "match" to determine the conjugate images of the tall, individual trees be-

cause of the large x-parallax (16 pixels) between tree images and the adverse affects of large tree shadows. Consequently, the original stereoimages were reduced in scale by 4x to (1) reduce the large x-parallaxes, (2) reduce the size of tree shadows and (3) minimize the time required to obtain an initial DEM.

The reduced images were correlated at a 5-pixel spacing on the left image to create a DEM with a 10-meter spacing. This initial DEM is shown as a shaded relief image in Figure 4a. The "sun" is in the upper-left corner at an altitude of 65 degrees from the nadir.

Orthophotos of the reduced images, with each pixel equal to a 2-meter ground-sample distance, were generated and viewed in 3-D to determine the efficacy of the initial DEM. Many significant mismatches were noted among tree images. Therefore, instead of immediately using full-scale orthophotos as in the test above, orthophotos of the reduced images were incorporated in the IOR process to further refine the DEM, including tree heights. Refinements were made for elevation errors that ranged in value from -11.6 to +9.0 meters.

Next, the original steroimages were reduced by 2x and used with the current DEM to create orthophoto pairs with each pixel equal to a 1-meter ground-sample distance.

Four iterations of the IOR method were required to correct the current DEM and produce acceptable orthophoto pairs. The ranges of detected elevation errors with each iteration of the IOR method were -6.9 to +11.1, -17.9 to +11.3, -6.7 to +12.3 and -3.2 to +4.1 meters, respectively. The previously corrected DEM was next used to create orthophotos of the original, full-resolution stereoimages. Each pixel of the orthophotos had a ground-sample distance of 0.5 meters. These orthophotos were correlated at every 20 pixels on the left orthophoto to register precisely with the 10-meter spacing of the DEM. After one iteration of the IOR method, elevation errors from -4.9 to +4.2 meters were detected and used to refine the current DEM. The IOR procedure was repeated a second time at full resolution and provided DEM

(a) (b)

FIGURE 4
Shaded Relief Images of the Fort Hunter Liggett
Test Area. (a) Initial DEM. (b) Final DEM.

corrections for elevation errors ranging from -2.0 to +2.0 meters. The resulting DEM is shown as a shaded relief image in Figure 4b.

Using the final version of the DEM, new orthophoto pairs were created and inspected in 3-D to validate that the DEM was correct. No mismatches were found in the terrain imagery but in some of the grass areas it was not possible to observe mismatches even if they existed. This is because there was not enough variance in the gray shades to provide adequate stereoviewing. Although the orthophotos may appear correct, the DEM may actually be in error.

Mismatches were still evident in the orthophotos where tall trees existed. This indicates that the true height of the trees had not been established by the IOR process. These trees are typically 12 meters in height and produce 16 pixels of x-parallax in the original stereoimages. The mismatches on the orthophoto pairs were generally 4 pixels in size (2 meters on the ground) which equates to an elevation error of about 3 meters.

Discussion of Results

Figures 3 and 4 clearly illustrate that the IOR method is successful in adding high-resolution corrections to a DEM. The Figures do not show the accuracy of the corrections, however, but this is judged by 3-D viewing of the final orthophotos. The 3-D error surface, represented by mismatches in the orthophotos, should be flat. This, with some notable exceptions, was found to be the case in both tests.

San Bernardino Mountains Test

The DEM of the San Bernardino Mountains was fully corrected except in one small area of the stereoimages. The image area is a very sharp, tree-lined valley. When generating the initial DEM, the abrupt change in slope direction, coupled with the low radiometric variance of the trees, caused the correlation process to fail and produce signifi-

cant DEM errors in this region. Further DEM improvements by the IOR method were limited because, in the presence of adverse radiometric characteristics, the "match" routine could not accurately detect mismatches in the orthophotos. In adverse areas such as these, manual editing is required.

The IOR method was completed on the San Bernardino images in 30 minutes. In previous tests with these images, 5 hours were required to manually edit the data obtained by conventional correlation procedures on the full-resolution stereoimages. This is a 10 to 1 improvement in speed using the IOR method. Furthermore, orthophoto pairs made from the manually-edited DEM were not flat when viewed in 3-D, indicating that not all error had been sufficiently corrected.

Fort Hunter Liggett Test

The results of this test are considered to be very good in spite of the fact that the obtained tree heights are not totally accurate (± 3 meters). In previous tests, conventional correlation techniques were used on the full-resolution images and were not successful in detecting tree heights. The IOR method was successful because, by initially reducing the images and x-parallaxes by 4x, it was possible for "match" to correlate on individual trees and, consequently, obtain approximate tree heights. When orthophotos were generated, the positions of the tree tops were sufficiently corrected to allow the IOR process to detect mismatches and further refine the tree heights.

By stepping from 4x to 2x and finally to 1x-reduced images, it was possible to keep the x-parallaxes (mismatches) in the orthophotos small enough that they could be measured by "match" and corrected by the IOR process. If, as in the test above, the intermediate steps performed on the 2x-reduced images had been omitted, the mismatches at 1x would have been too large and the IOR method would have failed on these images.

General

In both test cases, the IOR method is considered more accurate and faster than conventional correlation on original stereoimages followed by manual or interactive editing. It is faster because the orthophotos are more nearly identical and less searching ("pull-in" range) is required to find the conjugate points. It is more accurate because dissimilarities between the original stereoimages, a potential cause of error in a correlation process, are essentially removed from the orthophotos.

Usually, two or three iterations are necessary to correct a DEM. Special cases, such as the Fort Hunter Liggett images, may require more. Generally, if the mismatches are not removed from the orthophotos in 3 iterations, conditions (occlusions, shadows, etc) probably exist which cause DEM errors that can only be corrected by manual methods.

Conclusions

- The IOR Method is a fast and effective technique for generating and editing DEM's.

- The orthophoto transformation process removes image dissimilarities and allows correlation on the orthophotos to be performed more accurately and faster than on the original stereoimages.

- Two to three iterations of the IOR method are typical for accurate DEM correction.

- The IOR method can be 10 times faster than manual editing methods.

Acknowledgements

The stereoimages and associated orientation data of the San Bernardino Mountains, CA, were furnished by the U.S. Geological Survey, Western Mapping Center, Menlo Park, CA.

The stereoimages and associated orientation data of the Fort Hunter Liggett area were furnished by the Test and Experimentation Command, Fort Ord, CA.

References

Norvelle, F. R., October 1981. *Interactive Digital Correlation Techniques for Automatic Compilation of Elevation Data,* ETL-0272, U.S. Army Engineer Topographic Laboratories, Fort Belvoir, Va.

Schenk, A. F., 1989. Determination of DEM Using Iteratively Rectified Images, *Photogrammetry Technical Report No. 3,* Department of Geodetic Science and Surveying, The Ohio State University, Columbus, Ohio.

CHAPTER 7

Digital Orthophotos: Production, Mosaicking, And Hardcopy

Introduction

ALAN M. MIKUNI

Digital orthophotography, a type of geographically-referenced image data, is fast becoming one of the most universally usable "Mapping and Remote Sensing Tools for the 21st Century." Digital orthophotographs, or variously, orthophotos, orthophotoquads, orthos, orthoimagery, or ortho-rectified imagery, are generally defined as computer-compatible aerial photographs that have been geometrically corrected for displacements caused by terrain and relief.

Because the digital images are geometrically corrected, they can be used as map layers in geographic information systems or other computer-based data manipulation, overlaying, management, analysis, or display operations. The papers in this chapter present discussions on a number of technical and practical issues related to the development and application of digital orthophotography.

Avoiding Digital Orthophoto Problems

GARY MANZER

Abstract

Digital orthophotos can be problematic. Troubles can originate with costs, acquiring appropriate imagery, setting project guidelines, image handling and display software, image and archive formats, and magnetic media.

The orthos themselves can suffer poor image quality, or have typical defects such as double image, missing image, smeared image (image stretching), image incompleteness, and inaccuracy. Suggestions as to how to handle these problems are discussed here in detail.

Orthophoto Definition

Orthophotos are image maps. They are rectified photographs of a land mass which contains manmade and natural features. Where these features touch the ground, they are imaged in their true x,y, map position.

Introduction

Problems with digital orthophotography usually relate to the cost, quality, accuracy, and the display/manipulation software/hardware.

The cost of digital ortho projects is closely related to the scale and orientation of the aerial photography and to the mapsheet layout. These two items, photo scale and flight line orientation over the mapsheet most directly affect all downstream costs of the project.

Image quality in the digital ortho are related to all the following components in the production cycle:

- Camera quality

- Magnification from photo to final scale

- Ortho diapositive density range or bits in the scanners pixel

- Quality of the scanner producing the raw scan

- Scan sample rate (expressed in microns or dpi at photo scale)

- Rectification procedures

- Final pixel size (expressed in ground units)

- Electronic auto-dodging (radiometric image smoothing) after rectification

- Selection of control points

- Variance in terrain or building relief (camera focal length)

- DEM data density

Accuracy is related to the magnification, geometric accuracy of the scanner, the Digital Elevation Model (DEM) quality, the control chosen to orient the photo image over the DEM, and the focal length of the camera used to take the images.

Satisfaction in using digital orthos is directly related to the display and handling software and hardware used to manipulate, view and plot the images.

Controlling Overall Project Costs

Orientation of Flight Lines Over Mapsheets

Digital orthos produced to mapsheet boundaries such as townships or sections often require a different scale of photography than that used for contour or planimetric mapping. The reason is that digital orthos are made out of single frames of aerial photography, unlike planimetric mapping, where mapsheets are formatted by an editor after photogrammetric collection is complete.

Therefore, the more photographs it takes to cover the mapsheet, the higher the downstream costs for orthos. These downstream costs include the extra ortho diapositive (diap) production, control for each ortho diap (cross pugging), scanning, rectification, electronic auto-dodging, and mosaicking charges.

Costs decrease when several mapsheets can be produced from within the area of a single frame of photography, as opposed to several frames required to produce a single mapsheet. It is often less expensive and a superior product can be achieved, if a separate level of photography is flown over the mapsheets to optimize ortho production.

Magnification

Although the new digital systems provide unparalleled flexibility, there are still some limitations to keep in mind. In general aerial photography should not be enlarged more than 8 or 9 times. Thus for a final scale ortho at 1"=50' (1:600) we would recommend a photo scale less than 1"=450'. The lower this ratio, the better the image quality will be. Below five times magnification, there really is no noticeable improvement in image quality, but the costs go up rapidly. Thus the optimum for economy and quality lies somewhere between five to nine times magnification.

Magnification ratios more than 10 times up, because of the distance between the silver crystals in most of the aerial film available, will not result in a high quality orthophoto. There is just not so much information in the photography that will allow more than 10 times enlargement.

Image Quality

Tone Matching — Diapositive Scanning or Negative Scanning

Tone matching from photo to photo can be quite complex due to changing light conditions from flight line to flight line, and from frame to frame within a flight line. Moreover within a single frame, exposure variances such as hot spots and dark to light trends are typical. These changing light conditions can seriously affect how a digital orthophoto project looks on screen, especially when adjacent orthos are viewed simultaneously. These typical variances in light conditions in most aerial photography must be dealt with.

Most image display software uses 8 bit imagery (256 possible grey scales). Aerial film negatives however, have a wider dynamic range than can be represented with 256 shades of grey. Some method therefore, must be found to compress the range of possible values in the digital ortho into the grey shade constraints imposed by 8 bit imagery.

Two methods are currently used. With the 1st method an ortho diapositive is produced from the aerial negatives on an electronic auto dodge contact printer to a specific and restricted density range. The density range selected is such that the scanned image can be adequately represented in 256 shades. With the second method the air negatives themselves are scanned with a wider density range (say a 10 bit or 12 bit pixel, 1024 or 4096 grey shades). A software method must then be found to restrict final output to 256 grey scales. Scanners use various methods of doing this. Some software simply truncate the values, and other software runs a logarithmic function on the data, effectively binning the shades to 256 shades. True auto dodging software is still in development for negative film scanners.

Alternately elements of both methods can be used to produce superior 8 bit imagery using a two step process. First ortho diaps are created, and second, electronic auto dodging software is utilized.

This set of ortho diaps is made in addition to the Aero Triangulation (AT) diapositives. These ortho diaps should be produced to a density range between 0.3 +- 0.1 and 1.4 +- 0.2 to ensure they will make a nice looking 256 grey scale scan. The technology for making diaps to specific density ranges has been highly refined by the photographic industry, using electronic auto-dodge contact printers.

At this point the ortho diaps should have the AT points cross-pugged from the AT diaps. Through use of a point transfer device for the cross-pugging and a skilled and experienced technician, a minimum loss of accuracy during control transfer can be achieved. Upon scanning and rectification the ortho can be displayed and quality checked using each image's control points in conjunction with their coordinate ground positions. If out of tolerance points exist, they are investigated at this point, fixed and the ortho regenerated.

Good quality control predecures require that adjacent orthos are then displayed together to check the fit of detail from one image to another, and the tonal balance between images. Tonal imbalance can now be corrected by running electronic auto dodging software on it, in order to make the seams less noticeable. While this procedure can't solve all problems, it goes a long ways to improving the final products and making a virtually seamless data base. The two step tone matching process assures the very best looking 256 grey scale ortho presently possible.

Recommended Scanning Resolution and Finished Pixel Sizes

An important concern is the relationship between the size of the pixel to scan, versus the nominal scale of the photography being scanned, with consideration given to the final scale of the finished ortho required.

A good rule of thumb is to scan at approximately 240 times (in dpi) the magnification ratio (from photo scale to the final ortho scale). Thus for a 5X magnification, a 5 X 240 = 1200 dpi scan or finer would be appropriate; for 7X magnification, a 7 X 240 or 1680 dpi or finer scan. These precise ratios may not always be possible but trying to stay as close as possible to them will help to ensure a high quality product. The parameters for the area of coverage for the ortho and pixel size must now be set and the digital ortho itself generated.

The final pixel size (in ground units) depends on several factors, but most importantly the magnification ratio. However, it is generally better to resample to a coarser pixel than a finer one. That is, don't scan at nominally a one foot pixel, then resample it to one half of a foot. A rule of thumb for creating a quality ortho, is to resample the nominal size of the scanned pixel by a multiplication factor of 1.2 or greater. In the above example the finished ortho should have at least a 1.2 foot pixel. Most orthos accurate to 1"=50' should normally have a 7.5 cm (.246 ft.) pixel; at 1"=100', a 15 cm (.5 ft.) pixel; at 1"=200', a 30 cm (1 ft.) pixel; and at 1"=400', a 60 cm (2 ft.) pixel.

The ortho rectification should be calculated by resampling the original scan using the cubic convolution resampling process. This process is computationally more demanding, but provides a superior product.

Accuracy

The ultimate useability of the digital orthophoto is dependent upon having it created to a known accuracy. In general, relative accuracy in a digital orthophoto is directly related to photo scale; whereas absolute accuracy is directly related to the quality of the ground control, as well as the photo scale.

Using a photogrammetric quality scanner and procedures, relative accuracy can be as good as 50 microns at photo scale. Therefore the relative accuracy using a 1:10000 photo scale could yield a relative accuracy of 50 centimetres.

Controlling the Image to be Scanned

The absolute accuracy of a digital orthophoto is largely dependent upon the quality of the control points used to

attach or orient the scanned image over the DEM, and the accuracy of the DEM used in rectification.

For large scale orthos the control used to attach the photo to the DEM could be surveyed ground targets. More commonly, the control used, is that secondary network of control points established in the course of mapping, called Aero Triangulation (AT) points. The AT points that appear on every frame of triangulated photography have a known accuracy, and are thereby suitable control both for digital mapping and orthophotography.

If the control used to orient the photograph to be rectified over the DEM is chosen from a map, or some other equally inaccurate method, significant errors are introduced, and the accuracy of the ortho accordingly degraded.

The Importance of DEMs to Accuracy

Digital orthophotos can be made from DEM's that range widely in accuracy and content. The DEM is an important component in the digital orthophoto process. The appropriateness of a DEM is related to the scale specification to which the orthophoto is being created, the roughness of the terrain being mapped, the focal length of the aerial camera, and the magnification.

The creation of the DEM can be the most expensive of all the components in the orthophoto process. Highly accurate DEMs compiled for modelling purposes consist of 3-D point files and 3-D breakline files collected by a photogrammetrist or surveyor.

A DEM compiled to the accuracy necessary for modelling purposes, is usually more accurate than that required only for digital orthophoto production. DEMs have many uses in the realm of computer modelling outside the application of digital orthophoto production. These uses are considered in determining the quality and detail to which it will be compiled. For instance, the DEM needed for floodplain or water runoff studies are examples where high accuracy is required.

The density or spacing between the 3-D points collected is dependent upon the roughness of the terrain being mapped, and the accuracy required of the model. Where the terrain changes rapidly the 3-D points are very densely spaced; where the ground is relatively flat a sparser network of points is collected. If the change in terrain elevation is linear such as along a stream bed, mountain ridge, lake, retaining wall, etc., 3-D breaklines are collected in order to ensure the contouring software conforms contour re-entrances in relation to these features.

Designing a DEM appropriate for accurate modelling is somewhat of a black art. The spacing of the 3-D points is dependent on the scale, the terrain, and the accuracy required. 3-D breaklines are collected for all features appropriate to the design specifications of the job.

DEMs required to meet the map accuracy standards for orthophoto production are often most efficiently collected photogrammetrically as a 3-D grid of points.

Costs can be kept to a minimum by designing a DEM with the most efficient spacing possible between the DEM points.

The heighting accuracy required of a DEM for ortho-rectification can be calculated by considering the limits of horizontal shift allowed for a clearly defined object at a certain scale (1/50" at map scale).

An Example of DEM Relationship to Ortho Accuracy

In producing an ortho at 1"=100' (1:1200), a shift in the placement of a clearly defined object should not be in error more than 24" (1/50" x 100') from its true ground position.

If the camera, in the above example, had a focal length of 6 inches, using simple trigonometry, in the extreme corner of a 9" x 9" air photo, an error in the DEM of 22.5" would cause a horizontal error of 24" during rectification. If the orthophoto were to be made only from the area of the photograph that fell within the photogrammetric neat double model (a 6.3" x 7.2" area in the middle of the aerial photograph), an error in the DEM of 30" would cause an error of 1/50" horizontal displacement for a distinct point in the corner of the double model. The closer the area to be rectified is to the centre of the photograph the greater the tolerance of acceptable error in the DEM.

If the aerial camera above had a focal length of 12", acceptable errors in the DEM would double respectively. Therefore longer focal length photography is therefore more tolerant of error in the DEM than is shorter focal length photography.

DEM related positional errors in digital orthophotos can be described more concisely by the general formula $e(o) = e(DEM) \times \tan A$, where $e(o)$ is the positional error in the orthophoto, $e(DEM)$ is the vertical error in the DEM, and A is the viewing angle in degrees outward from the centre of the photograph (determined by the distance ground objects are radially displaced from the photo centre, divided by the focal length of the camera).

Magnification Ratios and DEM Density

As a general rule the DEM will need to be denser with decreasing magnification ratios. The following rules of thumb can be used when selecting spacing for the 3-D point grid in all but the roughest terrain. If the magnification is less than 3 times up, a 4-8 millimetre spacing at final map scale is often appropriate. If the magnification is between 3 and 8 times up, a spacing of 8-16 millimetres at final scale can be used. If the magnification is over 8 times up then a grid spacing between 12 and 24 millimetres at final scale is often appropriate.

The spacing between DEM points does not have to be regular throughout the area of the orthophoto. The spacing may be increased in flat areas, and reduced in areas of rapidly changing terrain.

Beware the Scaleless Digital Orthophoto

Digital orthophotos which seem scaleless in the computer, should be produced accurate to a certain scale. However, due to a lack of metadata (data about data) connected

with digital orthophotos there is a risk that "orthophotos" created with inappropriate DEMs and control will not have known accuracy. Unwitting use of such "orthophotos" could damage the reputation of digital orthophoto technology, not to mention the reputation of the user.

Ortho Defects to Watch for

Digital orthophotos should undergo a quality control check for the following DEM related defects in order to insure that a reliable rectification has occurred:

Image Completeness — If the image area required is not adequately covered by DEM then the image will be inaccurate in that area and the digital orthophoto may not be complete.

Image Stretch (Blurring) — Typical causes of image stretch are anomalies or spike errors in the DEM, or excessive relief especially near the edge of the photo. (e.g. - If a mountain is on the edge of the photo, the side of the mountain facing the camera will be rectified fine, but the side of the mountain facing away from the camera has only a very small amount of photographic information due to the relief displacement of the mountain. The result is that this small amount of information is stretched to fill out the area required by the shift from perspective to orthogonal projection.)

Double Image — Noticeable when comparing adjacent orthos and the same feature is mapped in each orthophoto, when in fact the adjacent orthophotos are designed to map mutually exclusive areas. This error is caused by improper orientation in the control, or inaccurate DEM's that suggest the ground elevations are higher than reality.

Missing Image — Not easily detected, this error is most easily identified by missing sections of linear features. This error is as common as double image and has the same causes except that the DEM in this case is in error by under representing the real ground elevations.

Inaccurate Planimetry — The digital orthophoto's visible ground control coordinates, and triangulation marks, should be compared with these points' true coordinates as a check for the proper placement of the image on the model and the concurrence of the control.

Image Formatting and Display

The type of format the digital ortho is written to, can be a problem if it cannot import readily into the image display and handling software you will be using. There are costs involved in translating these large files both in time and in making the disk space available to do it.

File size can be a problem. The exact size in megabytes of a digital ortho can be calculated by multiplying the length x width of the mapsheet, divide by the pixel size squared, and divide again by the constant 1024 squared (the latter puts the answer in megabytes). Therefore, as the pixel is doubled the file size of a given mapsheet ortho shrinks by a factor of four. A mapsheet ortho 80 Mb in size with a 6 inch image pixel, will take longer to display than the same ortho

with a 1 foot pixel (a 20 Mb file). Similarly the same mapsheet with a 2 foot pixel would be 5 Mb, and with a 4 foot pixel it would be 1.25 Mb. The length of time that it takes software/hardware to display the image represents a cost to the user.

Multiple Pixel Sizes for a Single Orthophoto

Some image formats allow multiple pixel sizes within a single file. Image display on screen can therefore be speeded up by selecting the best suited pixel size for display on screen. For instance if the user requires the entire mapsheet ortho to be displayed within a 1 mega pixel screen window the image handling software can dump a 1 Mb image with a large pixel size (if it exists) to the screen buffer for instant display. As the user zooms the display the software automatically selects the appropriate pixel size to display on the screen.

Other display software require establishing libraries of images according to their pixel sizes for efficient file handling. In this latter case a series of image files are produced, each with its own pixel size. Scripts are then established to map the appropriate library to the display scale, in a user friendly manner.

Rotated or Non-Rotated Images

Some image handling software packages cannot handle rotated images, they require all images to be oriented grid north, or at least with the pixel edges parallel to the mapsheet edges. There can be problems with such software when trying to display strip digital orthos, such as pipeline corridors, or where there is no consistent orientation for all the images.

Care should be taken to choose appropriate image display software/hardware which works seamlessly with in-house vector CAD/GIS programs, so that digital orthos can be quickly displayed at any screen scale.

Magnetic Media and Archive Formats

There are two items to consider when considering how the digital orthos will be delivered. The first is the magnetic media itself and the second is the archive format used to write the orthos onto the tape.

8mm exabyte tape can hold 2.5, 5, or 10 gigabytes of data depending on the hardware, making it an economical choice for large volumes of data. These tape are often written with the UNIX archiving utility "TAR". TAR is universal to UNIX machines and is therefore a standard choice for archiving orthos onto tape.

CD-ROM is another popular media for digital ortho delivery. This media is especially popular in installations that run applications on personal computers, but is equally suitable for larger installations. CD has the advantage that a standard archive (ISO-9660) is used to write all information to CD's. CD-ROM readers are inexpensive and affordable compared to many other devices.

Unfortunately CD's can only hold 650 megabytes of data. Each CD can only hold a few digital orthos in comparison to mass storage tapes. Orthos typically range from 10 to 200 megabytes in size. CD's are expensive to write, so the costs can escalate rapidly as the number of files increase.

CD's are not generally suitable for providing immediate access in day to day ortho use, because their access times are to slow. The best way to rapidly utilize digital orthos is to keep them on the hard disk.

Summary

Digital orthophotos properly designed and produced, can provide the GIS professional an extremely accurate digital basemap of known accuracy on which to build a spatial database.

As in all procurements, costs and problems concerning digital orthophotography present questions to be resolved in design and planning. These questions are best handled by a knowledgable staff who thoroughly grasp the concepts and potential pitfalls of the technology.

DOQQ on Route to Year 2000

BRYAN L. FOLEY

Abstract

Since 1940 mapping has evolved from a major degree of artform combined with a minor degree of science into primarily, scientific procedures with a secondary emphasis placed on cartographic artistry. Gone are the days when looking good alone constitutes quality and accuracy in the minds of men.

The trend may have shifted from cosmetics to conformity. Survey, flying, digital mapping, imaging and all aspects thereof must conform to ever demanding accuracies in specification. Yes, contour lines not only provide the shape of the terrain but now must fit the shape of the terrain. Sophisticated users of digital data and their bi-products are re-evaluating their preferable graphical impressions of products and now placing emphasis on quality and accuracies.

This most welcome trend has and will effect the digital orthophoto quarter quad (DOQQ) sheet generation for the foreseeable future.

Introduction

Based on direct involvement and production for the current versions of DOQQ in the U.S. Geological Survey's (USGS) digital orthophoto contracting program, we will present some fact, some opinions and some speculation as to the generation of this product in the future. The author will use terms common to present day phases of digital image production and extrapolate scenarios for the future.

Point by Point — Today

Standard Survey/Control

Control for DOQQ sheets originates from and is acceptable from a number of sources. Conventional survey-existing or new, provided or secured, G.P.S. ground based or airborne, augmented by natural water features or published approved map coordinates.

Location. Every 7.5 minutes around the perimeter of a project and every 15 minutes through the interior.

Flying. The *standard* photography is fixed wing 6" focal length, 1:40,000 scale, centred on the quarter quad.

Aero-Triangulation

Diapositives emulsion down and photos supplied by USGS. Three point bridging with ties forward and lateral to adjacent models and lines providing a total of 10 to 14 points for any given stereo model.

Analytical adjustments must meet or exceed preset RMSE *standards.*

DEMs

Collected to specifications by photogrammetric means suitable for data entry into the USGS data base meeting a 7 metre accuracy *standard*, **or** provided by USGS from the USGS data bank or off line digitizing from existing quad sheet contour maps accompanied by the inherent problems of that method.

Orthophoto Diapositive

Supplied by USGS, emulsion up, to preset *standards* for DMin/Dmax and density range. Packaged in protective plastic sleeves.

Cross-Pugging

Generated by contractors to preset standards as per, point hole size and measuring accuracy of the point transfer instrument.

Scanning

The *standard* of the scanners used must have resolution scanning capabilities greater than 25 microns to allow for resampling process back to 25 microns during the rectification process. This will avoid degradation of the image and maintain the image content of the original photography as determined by USGS *standards.*

Rectification

Using the bi-linear or cubic convolution algorithms to achieve 50th of an inch *standards.*

Out on a Limb — The Year 2000

In the year 2000, no one knows for sure what that year will mean for the DOQQ program and product except for one thing. USGS at that time will be acquiring a quality product that might resemble today's DOQQ's with one notable exception. **IT WILL COST THEM LESS.** You can rest assured that if it is not as good as, and cheaper than today's product, don't expect any contracts.

So let's analyze how we can achieve that goal and still satisfy our bankers, investors, spouses, pension plans, and medical coverage.

First and most important is the question of standards and as you can see, standards come into play in every aspect of DOQQs. The standards which are considered minimum will probably not change but the accuracies might very well change for the better. Here in lies the key to success for us, the contractors.

Contractors currently with airborne facilities, initially will have an advantage as a prime contractor and that is pure speculation on the part of the presenter. I have talked about this subject briefly at an ASPRS function in Portland in 1993 and estimated that my projections would be reality most likely in ten years.

Survey/Control

Airborne G.P.S. is becoming more and more available, affordable, acceptable and accurate. This increases photo costs but decreases the requirement for conventional or G.P.S. ground based control and consequently saves the USGS dollars. If ground based control is required for verification and truthing. G.P.S. will be the norm. More satellites will be in orbit, calculation times would have decreased with newly developed algorithms and faster computers. Again, this should reflect some cost savings.

Using this method, control density will be much greater compared to the requirements of today.

Flying

More appropriate, we should call this *airborne* imagery. Will it be fixed wing 10" x 10" format, digital, video or satellite? More importantly, what scale. There is a great deal of inefficiencies in time and money when a 1:40,000 scale photo is used. At a minimum, if fixed wing 10" x 10" format is used 1:80,000 scale should be *reconsidered*. I say reconsidered because it has been used in the past. High level capabilities were limited in our industry and couldn't always take advantage of the windows of photo opportunities. With better films, better lenses, and camera technology, one should expect a better end product. With G.P.S. navigation systems centre quad sheet photo should pose no difficulty. So the only problems remaining would be sufficient industry capability and atmospheric conditions. Enlargement factor does not, and would not, present a problem as indicated in the samples on display. Again, costs would drop through the use of high level photo by the decreased need for A.T., photos, diaps, scanning and rectifications. That is fixed wing, but the DOQQ after all is just what the "D" implies "a digital file." The question is "Can a digital image be derived from another source?" The answer is "Yes!" Again we are talking airborne.

For Example: The Space Remote Sensing Centre in conjunction with USDA, ARS in Wesbaco Texas, designed and built a Real Time Digital Airborne Camera System, each with a 3 solid State camera with 8mm lenses each with their own CCD - generating tracks 736 pixels x 484 pixels. Flown at 1666 M AMG (above mean ground) gave the FIELD OF VIEW of 1200 metres or 1.5 metres per pixel.

Landcare Aviation Inc., I believe, is working with Kodak digital photo CD technology in conjunction with the U.S. Air Force, Rome Laboratory, to develop a more commercially viable product.

Video is not as good in resolution as with photography (i.e.: 35mm). Video 512 lines per frame or 20 lines per mm vs. 35mm at 80 lines per mm or 2000 lines per frame.

Multi spectral imaging such as MIES or ADAR system 5500 having .5 to 3 metre pixels may have some potential or application it has yet to be tested for DOQQs.

Then, of course, there is satellite imagery. In keeping with *current standards* of resolution, the standard pixel size available is 10 metre with an upcoming 3 metre resolution launch expected in 1996. And I believe in total 4 licenses have been issued in the US for launches, one, possibly 2 of which are expected to have a one metre resolution.

Aero Triangulation

Aero triangulation with pug points, in strips and blocks with coding in the conventional sense will be replaced with auto A.T. solutions and for reference, the pug positions will be replaced with symbols and new QC procedures developed for the USGS to make checking and verification a relatively simple task. This software already exists but you must be working in the softcopy digital environment to participate.

DEMs

Instead of collecting points using standard photogrammetric means DEM points will be calculated using similar algorithms as will be used for auto A.T. more and more vendors are working on these solutions as we speak and quality claims for speed and performance are being substantiated in a variety of areas. As image analysis and feature recognition are improved and integrated into the auto DEM packages as well as advances in batch processing, auto DEM's will finally be the system of choice. Just to keep one thinking - how about Thermal Topography for auto terrain formulation. We always try to work from the air space to land mass. Lets work in reverse for a moment and go land mass to air space.

Orthophoto Diapositives

Probably not required, in both scenarios, the contractors maybe generating softcopy images downloaded from the aircraft. But if hardcopy diaps are still being produced, only one set of diaps will be generated and used both for auto A.T. and orthos. This again will save money for USGS.

Cross Pugging

There will be additional cost savings as cross pugging will not be required. It will also directly increase quality in accuracies by eliminating errors introduced when transferring emulsion to base transfers which are currently required.

Scanning

This is an area that will probably cancel itself out for cost savings. Again, this may very well be a product which can be generated from and in the aircraft or airborne in some form. But for a moment, lets assume we are still in the digital land based scanning mode. New scanning units

are being developed as we speak. In the near future, one to three years, faster, more economical units will eventually achieve *true* acceptable resolution factors greater than 25 microns, with radiometric and geometric on the fly calibrations and calibrations to manufacturers standards. Hence, there will be a savings generated in cost per scan, however, as everything will be scanned with softcopy photogrammetry combining auto (almost everything) each frame will require scanning. This doubles the number of scans required and consequently there is a trade off in savings.

If height distortion requires elimination, even more scanning will be required such as now evident in some available software requirements.

Rectification

Again, there is, and will continue to be development in algorithms not only to generate rectification and optimize the speed enhancement capabilities of the new computer generations, but also software to actually improve the visual quality of the image itself. Where the potential for greater quality is more apparent, is the optimizing of the frames scanned by rectifying and using only the centre portions of the individual frames. This will decrease the potential for errors most evident near the extremities of any given frame. An example of this might be tree lean or major terrain differences.

After explaining to our graduate in survey engineering what this session was all about, I asked him to give me a pearl to pass on at this meeting. He gave it some intense thought and said to tell the USGS folks that their full 7 1/2' quad images will cost them less than $500, but if they want anything related to a header it will cost them $5,000.

Who Will be Generating the Product

One morning I was in the shower praying for some help (as I often do) not only for this presentation but our company and staff. As sometimes happens an answer came which I will happily share. If you don't like it, I want to be around when you take it up with the author.

The analogy which came to mind was one of balloons. We call them the **"Big Balloona"** like the **"Big Cahoona"** and the **"Little Balloons"**. Right now Triathlon is a little balloona and will never become a big balloona. Of course you ask yourself why, well the answer is that a big balloon has rigid preset parameters and when those boundaries are exceeded it could fall apart without notice. For example, if you add to it or try to take away from it.

The little balloon on the other hand always is adaptable to change. When things get tight in one area there is a migration to another. This balloon can be manipulated in many directions and still functions as a balloon, it can easily work with others and become part of a team effort.

The last statement holds true for the big balloon as well but most of the effort must be the responsibility of the little balloon in order to have the union a success.

The answer to the question is "Super Groups". Here's my idea of the molecular structure of a super group. A paster once told me that statistically one paster can be responsible for and successfully look after 7-11 parishoners. I think that holds true for the USGS. After their intentions were advertised, the USGS started off with 200 responses by companies wishing to be involved with the DOQQ program, they narrowed it down to 40, each of which were interviewed, from these they selected 6 to generate products. Since that time they have added an additional company. I believe that figure could go to 11 and all become efficient in negotiating contracts with Menlo Park. It may become unruly or impractical to excess this number. However, not to close the door on new potential, capacity and capability, the USGS might consider establishing 11 regions throughout the Country with the 11 established companies as the primes of super groups. When a new company qualifies with the USGS they would be added to the super group of that region.

The bottom line is a reflection of my opening statement, in the year 2000 there will be a better product produced faster and more economically. If I were a betting man, which I'm not, but I'm always willing to take on a calculated risk my investment dollars would be oriented towards softcopy airborne technology.

CHAPTER 8

Confluence of Mapping And Resource Management

Issues Involving the Creation of Digital Elevation Models and Terrain Corrected Orthoimagery Using Soft-Copy Photogrammetry[1]

JOHN R. JENSEN

Introduction

Almost 20 years ago, Thrower and Jensen (1976) reviewed how analog (hardcopy) orthophotography were created and identified numerous cartographic applications. They stated that "ortho-photomapping represents a technique by which spatially arrayed data might be both more accurately measured and communicated because of the special attributes of the orthophoto map, namely, the image of an aerial photograph and the metric qualities of a controlled line map." As predicted, the last two decades have seen a steady increase in the creation and utilization of orthoimage products. But recently, their has been a tremendous increase in the use of digital orthoimagery and digital elevation models (hereafter referred to as DEMs) in remote sensing and geographic information (GIS) applications. Remote sensing and GIS practitioners, cartographers, and even the media (e.g. newspapers, magazines, television) are using orthoimages as cartographic backdrops upon which thematic information are overlaid (e.g. property lines, utility lines, drainage networks, contours, troop deployment). This paper provides insight into why the sudden explosion in the use of orthoimagery and photogrammetrically derived DEMs and important issues that should be considered when using them.

Orthoimages are created from stereo pairs of remotely sensed images through the process of differential (bit-by-bit) rectification. The geometry of the unrectified image is changed from that of a conical bundle of rays to parallel rays which are orthogonal to the ground and to the image

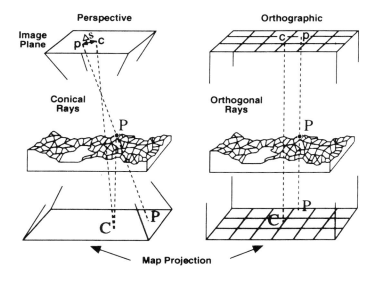

FIGURE 1
The change in image geometry and the removal of terrain-induced displacement (Δs) in an orthographic map projection. Point "P" which lies some elevation above mean sea level on the ground is found at "p" in the traditional perspective projection image plane coordinate system when it should be located at "c". The correction of the shift from "p" to "c" (Δs) is the goal of orthorectification. A separate correction is computed and applied to every pixel in the digitized imagery to produce orthoimagery (modified from Michael, 1992).

plane (Thrower and Jensen, 1976; Michael, 1992; Keating, 1993). Therefore, instead of having a perspective center the viewing perspective is modeled as being an infinite distance from the ground. Figure 1 demonstrates the change in image geometry and the removal of terrain-induced displacement (Δs). The point "P" which lies at a specific elevation above mean sea level on the ground is found at "p" in the image plane coordinate system when it should be located at "c". The correction of the shift from "p" to "c" (Δs) is the goal of orthorectification. Ideally, each small facet of the terrain is independently corrected during the orthorectification process.

The effects of topographic relief displacement and camera (sensor) attitude variations are removed in orthographically rectified imagery. The result is a planimetrically cor-

rect *orthoimage*. This planimetric accuracy allows scientists to use orthoimages like maps for making direct measurements of terrain geographic location, distances, angles, and area. On unrectified imagery such measurements can only be approximate because of image displacement and scale change caused by variations in local relief (i.e. relief displacement).

The expanded use of terrain-corrected orthoimagery and derivative digital elevation models can be explained by comparing and contrasting how the orthoimagery and DEMs were produced traditionally versus how they are created today using digital image processing soft-copy photogrammetry techniques. This involves a discussion of advances in the following technologies:

Stages in the Extraction of Digital Elevation Models and Orthoimagery Using Soft-Copy Photogrammetry

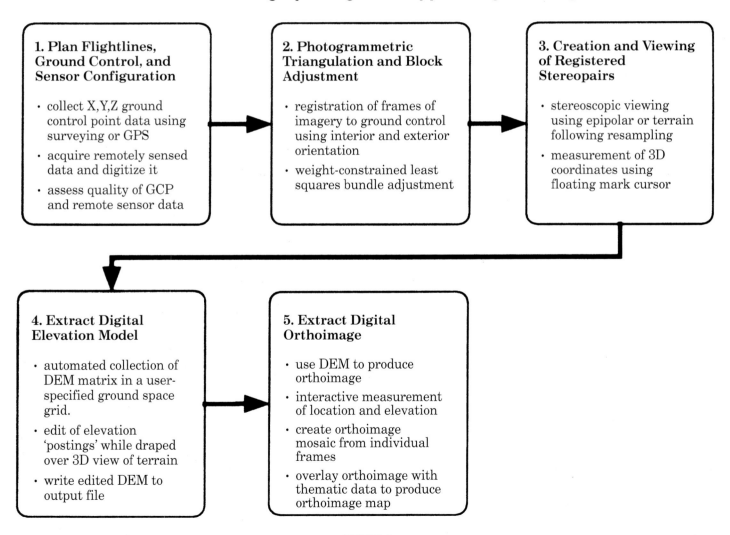

1. Plan Flightlines, Ground Control, and Sensor Configuration

- collect X,Y,Z ground control point data using surveying or GPS
- acquire remotely sensed data and digitize it
- assess quality of GCP and remote sensor data

2. Photogrammetric Triangulation and Block Adjustment

- registration of frames of imagery to ground control using interior and exterior orientation
- weight-constrained least squares bundle adjustment

3. Creation and Viewing of Registered Stereopairs

- stereoscopic viewing using epipolar or terrain following resampling
- measurement of 3D coordinates using floating mark cursor

4. Extract Digital Elevation Model

- automated collection of DEM matrix in a user-specified ground space grid.
- edit of elevation 'postings' while draped over 3D view of terrain
- write edited DEM to output file

5. Extract Digital Orthoimage

- use DEM to produce orthoimage
- interactive measurement of location and elevation
- create orthoimage mosaic from individual frames
- overlay orthoimage with thematic data to produce orthoimage map

FIGURE 2
General stages in the extraction of digital elevation models and creation of orthoimagery using soft-copy photogrammetry.

- ground control point collection,

- collection of metric aerial photography and digital remote sensor data,

- image digitization technology,

- hardware and software associated with the photogrammetric derivation of orthoimages and DEMs,

- the generation of the DEM, and

- the creation of the digital orthoimage.

The final section identifies problems and possible solutions associated with the creation of DEMs and derivative orthoimages.

Global Positioning System

Vertical Aerial Photograph of South Carolina State Capitol

FIGURE 3
A survey grade global positioning system (GPS) located on the grounds of the South Carolina State Capitol. After differential correction the GCP data may approach an x,y,z RMSE of ± 15 cm.

Advances in the Collection of Accurate Horizontal and Vertical Ground Control

Digital elevation models and orthoimagery are produced using the photogrammetric procedures summarized in Figure 2. Their derivation have always required the collection of horizontal (x,y) and vertical (z) ground control points (hereafter, referred to as GCPs). Historically, only registered surveyors with the appropriate equipment were capable of obtaining the required x,y,z GCP data with which to rectify the block of aerial photography and perhaps derive a DEM. Only large government laboratories and photogrammetric engineering firms could afford this type of GCP data collection technology. Fortunately, the situation has changed dramatically. The availability of personal, survey-grade global positioning systems (GPS) make it possible to collect accurate GCP information with x,y,z root-mean-square-error (RMSE) errors of ≤ 15 cm when the data are differentially corrected (Hern, 1989; Keating, 1993). For example, a sur-

vey grade GPS system collecting data on the grounds of the South Carolina State Capitol is shown in Figure 3.

The use of GPS for ground control point collection "... has become everyday practice, with considerable gain in time and economy, especially as intervisibility between points is not any more required" (Ackermann, 1994b). Some members of the surveying community are alarmed that non-surveyors (e.g. geographers, foresters, geologists, agronomists) are collecting such information (Ayers, 1994; Perkins, 1994). Nevertheless, the x,y,z ground control data necessary to orthographically rectify a block of aerial photography to a certain level of precision using soft-copy photogrammetry instruments can now be collected economically by non-surveyors in a day or two for relatively large regions. Thus, a major stumbling block to the creation of 'personal orthoimagery and DEMs' has been removed. This of course assumes that the analyst uses correctly the global positioning system and photogrammetric equipment. In fact, the nonsurveyor analyst should record the 'meta-data' about the GCP points, including methods of data capture, quality, accuracy, and fidelity for future reference using federal 'metadata' standards (Ayers, 1994).

Surveyors will continue to be involved in the GCP data collection process for large engineering projects. But, as Dangermond (1994) points out "... in the future, the surveying community will continue to measure reality, but they will have new instruments, such as GPS and digital photogrammetric tools."

Advances in the Collection of Metric Aerial Photography and Other Remote Sensor Data Used in the Creation of Orthoimage Databases

Metric Aerial Photography

In previous decades, medium scale (1:20,000 to 1:40,000) metric aerial photography were acquired by government agencies (e.g. U.S. Geological Survey, U.S. Coast and Geodetic Survey, Bureau of Land Management) while private photogrammetric engineering firms collected almost all of the large scale (> 1:20,000) photography. The data were expensive to acquire and only a fraction of such data were ever converted into orthophotographic products or DEMs.

Today, much of the large scale aerial photography is still collected by photogrammetric engineering firms. Aerial photography coverage of the United States at 1:40,000 is obtained at ≤ 10 year intervals by the U.S. Geological Survey's National Aerial Photography Program (NAPP). Unfortunately, scientists still have difficulty obtaining *inexpensive* large scale data from photogrammetric engineering firms and it is difficult to obtain *current* NAPP data of a region. Therefore, there is a significant demand for some type of remotely sensed data that can meet many of the orthoimage mapping demands.

FIGURE 4
Simulation of panchromatic satellite digital remote sensor
data derived at 1 m, 2 m, 3 m and 5 m spatial resolution
for downtown San Jose, California.

Digitizer Detector IFOV		Pixel Ground Resolution at Various Scales of Photography (meters)					
Dots per inch	Micrometers	1:40,000	1:20,000	1:9,600	1:4,800	1:2,400	1:1,200
100	254.00	10.16	5.08	2.44	1.22	.61	.30
200	127.00	5.08	2.54	1.22	.61	.30	.15
300	84.67	3.39	1.69	.81	.41	.20	.10
400	63.50	2.54	1.27	.61	.30	.15	.08
500	50.80	2.03	1.02	.49	.24	.12	.06
600	42.34	1.69	.85	.41	.20	.10	.05
700	36.29	1.45	.73	.35	.17	.09	.04
800	31.75	1.27	.64	.30	.15	.08	.04
900	28.23	1.13	.56	.27	.14	.07	.03
1000	25.40	1.02	.51	.24	.12	.06	.03
1200	21.17	.85	.42	.20	.10	.05	.03
1500	16.94	.67	.34	.16	.08	.04	.02
2000	12.70	.51	.25	.12	.06	.03	.02
3000	8.47	.33	.17	.08	.04	.02	.01
4000	6.35	.25	.13	.06	.03	.02	.008

Useful Scanning Conversions:

DPI = dots per inch; μm = micrometers; I = inches; M = meters

From DPI to Micrometers: μm = (2.54 / DPI) 10,000
From Micrometers to DPI: D = (2.54 / μm) 10,000
From Inches to Meters: M = I x .0254
From Meters to Inches: I = M x 39.37

Computation of Pixel Ground Resolution:

PM = pixel size in meters; PF = pixel size in feet; S = photo scale

Using DPI: PM = (S / DPI) / 39.37 PF = (S / DPI) / 12
Using Micrometers: PM = (S x μm) .000001 PF = (S x μm) .00000328

For example, if a 1:6,000 scale aerial photograph is scanned at 500 DPI, the pixel size will be (6,000/500)/39.37 = 0.3048 meters per pixel or (6,000/500)/12 = 1.00 foot per pixel

TABLE 1
Relationship Between Digitizer instantaneous field-of-view (IFOV)
measured in Dots-per-inch or Micrometers and the Pixel Ground
Resolution at Various Scales of Vertical Aerial Photography.

Currently Available High Spatial Resolution Satellite Remote Sensor Data

Some satellite remotely sensed data suitable for photogrammetric applications are now available. For example, it is possible to obtain digital stereo panchromatic remote sensor data from space with a nominal ground spatial resolution of 10 x 10 m from SPOT satellites 1-3. SPOT 5 to be launched in the late 1990s will have 5 x 5 m spatial resolution. When very precise ephemeris information is available concerning the sensor and its position at the exact instant of data collection, SPOT panchromatic data may be used in soft-copy photogrammetric workstations to derive good quality digital elevation models and orthoimages (Dowman and Neto, 1994). Trinder et al (1994) suggest that "accuracies of elevations between 5 and 10 m can be achievable with SPOT data, for images with terrain conditions suitable for matching, but in steep areas, and those covered with dense vegetation, the results deteriorate significantly."

Proposed High Spatial Resolution Satellite Remote Sensor Data

Orthoimagery is often used as a background image upon which thematic information is overlaid in many urban applications. However, the high spatial resolution associated with large scale aerial photography (< 0.3 x 0.3 m when digitized) may not be required in all instances. This is the reason so much 10 x 10 m SPOT panchromatic data are used as local and regional backdrop images, despite the fact that individual houses and small buildings cannot be re-

solved. Imagery with a spatial resolution of 1 to 4 m is required to resolve trailers, houses, small buildings, and narrow roads and drainage networks so important in many urban applications (Jensen et al., 1994; Haack et al., 1997). For this reason, several large corporations have received permission to use previously classified space technology to build high spatial resolution satellite sensor systems to fill this important photogrammetric niche. Simulations of the information content of 1, 2, 3, and 5 m spatial resolution satellite imagery of San Jose, California are shown in Figure 4. EarthWatch intends to launch in 1996 a 3 x 3 m panchromatic sensor and a 15 x 15 m multispectral sensor. In 1998, EarthWatch will launch a 1 meter panchromatic sensor. Orbimage Inc. is scheduled to launch OrbView in 1997 and collect 1 and 2 m panchromatic data as well as 4 meter multispectral data. Space Imaging plans to launch in 1997 a sensor system with 1 x 1 m panchromatic and 4 x 4 m multispectral sensitivity (Christensen, 1994). With proper platform and ground control, several of these sensor systems will produce stereoscopic remote sensor data which can be photogrammetrically processed to yield relatively accurate DEMs and orthoimagery.

While such digital satellite remote sensor data will never replace the demand for quality large scale metric aerial photography, there will be many applications where the orthographically rectified satellite data are sufficient. Thus, another major stumbling block is being overcome as relatively high spatial resolution remote sensor data becomes available for use in the creation of personal DEMs and orthoimages.

Advances in Image Digitization Technology for the Creation of Orthoimage Databases

Only large government and university research laboratories or private photogrammetric firms traditionally had access to high resolution optical-mechanical image scanning systems that could be used to digitize aerial photography. Natural resource scientists wanting to digitize a block of aerial photography to extract a digital elevation model or to produce orthophotographs were at their mercy. Today, linear and area array digitization technology based on charge-coupled-devices (CCD) have revolutionized image digitization. Scientists now have access to desktop systems that will digitize black and white imagery to 12-bits (values from 0 to 4095) and color imagery to 24-bits (>16.7 million colors) at repeatable spatial resolutions approaching ≤ 10 um. Of course, strict image digitization procedures must be adhered to (e.g. the use of the proper filters to extract individual bands of color from a color photograph). Table 1 summarizes the relationship between digitizer instantaneous-field-of-view (IFOV) measured in dots-per-inch or micrometers and the pixel ground resolution at various scales of photography.

The improved image digitization technology has not gone unnoticed in government agencies. For example, the U.S. Geological Survey routinely scans 1:40,000 scale NAPP photography at 15 - 25 um (resulting in approximately 1 x 1 m spatial resolution) to produce digital orthophoto quadrangles (DOQs) for various state agencies (Light, 1993; TeSelle et al., 1994). The Survey produced 8,340 DOQs using digitized NAPP data and photogrammetric techniques through FY 1994 with an additional 10,466 to be completed in 1995-1996.

Improvement in image digitization technology now allows scientists inexpensively to scan images of their choosing (e.g. perhaps just a single stereo model of a flightline) at repeatable, high spatial resolutions for very specific photogrammetric projects. Of course, remote sensing systems that acquire data in a digital format are preferred as the digitization process just described moves the digital data one generation away from the radiometric qualities of the original imagery.

Advances in Soft-Copy Photogrammetric Workstation Hardware and Software for the Creation of Orthoimage Databases

All orthoimagery traditionally were derived using specially modified analog stereo plotting instruments called orthophotoscopes. They were used to create hard-copy orthophotographs based on differential (bit-by-bit) correction of the stereo model in a line-by-line manner (Thrower and Jensen, 1976). In 1958, the analytical stereoplotter was invented by Helava (1958). By 1994, there were approxi-

mately 1,500 analytical stereo plotters in existence out of approximately 5,000 analog instruments. Analytical stereo plotters can be used to extract digital elevation models and orthophotographs from the stereoscopic model. Considerable human interaction is required and the systems are still expensive (usually > $75,000), basically out of the reach of the typical scientist or natural resource agency.

Case (1982) developed the first photogrammetric soft-copy system (Leberl, 1994). Current photogrammetric soft-copy systems allow the analyst to view the stereo model in three dimensions, extract vector contour and planimetric information (e.g. elevation, building outlines, road centerlines, drainage network), extract a digital elevation model, and produce terrain corrected orthophotographs. The typical procedures used to extract DEMs and orthoimagery using a soft-copy photogrammetric system are summarized in Figure 2. The software generally runs on reduced instruction set computers (RISC) with UNIX operating systems although some systems function well on personal computers (Welch, 1994). Stereoscopic vision is obtained using polarized or anaglyphic optical systems. The soft-copy photogrammetry systems usually cost < $50,000 and some function with limited capability for < $5,000. Using proper ground control and orientation (interior and exterior), a scientist can perform true aero-triangulation of the stereo model. Once this is accomplished vector contours may be extracted, a digital elevation model created, and orthoimagery produced. These data may be edited in pseudo 3-D space while viewing the CRT screen. Many systems allow color imagery to be viewed (Helpke, 1995).

Thus, the ability to perform true photogrammetric operations can now be performed on the scientist's desktop using soft-copy photogrammetric systems. The scientist can produce on demand planimetric maps, DEMs, and orthoimages at whatever pixel size (within reason) he or she desires for specific projects rather than being at the mercy of others.

Advances in the Creation of the Digital Elevation Model

A digital elevation model is a regular array of terrain elevations (x,y,z) normally obtained in a grid or hexagonal pattern (Kennie and Petrie, 1990). DEMs have been in use for more than 35 years and are of significant value in urban and natural resource management (Miller and Laflamme, 1958). DEMs may be created using 1) ground survey data, 2) cartographic digitization of contour data, and/or 3) photogrammetric measurements.

Ground Survey

It is possible to conduct field surveying to obtain accurate x,y,z information and then interpolate these data to a grid or triangular irregular network (TIN) model. Unfortunately, each point is usually very expensive to acquire.

171

Cartographic Digitization of Contour Data

Analytical stereoplotters can generate high quality DEMs, but at considerable expense. Therefore, many scientists traditionally rely on DEMs produced using cartographic digitization techniques where 1) government agencies digitize contours from often out-dated contour maps, or 2) the scientist digitizes his or her own topographic maps of the study area (these might be as-built engineering drawings) and use various spatial interpolation algorithms to create a digital elevation model. Important government agency DEMs include (Petrie, 1990):

- the 1:250,000 scale DEM data produced by the U.S. Defense Mapping Agency which is derived from 1 x 1° blocks and represent one-half of a standard 1:250,000 scale, 1 x 2° topographic map sheet; and,

- the 7.5-minute DEM data produced by the U.S. Geological Survey in which the data are derived from the standard 1:24,000 scale, 7.5-minute quadrangle topographic map sheets.

Unfortunately, when using the cartographic contour digitization approach "...the quality of the derived DEM is generally poor, unless great efforts are made to also extract characteristic features and break lines. In that case efforts and costs may be as high as for a new photogrammetric DEM generation" (Ackermann, 1994a). The accuracy of the resulting DEM will be much lower than that achievable with field survey or photogrammetric instrumentation, but it is quite acceptable to a considerable body of users concerned with the modeling of large areas of terrain (Petrie, 1990).

Photogrammetric Methods of Terrain Data Collection

The x,y,z accuracy of the digital elevation model that can be extracted using photogrammetric methods is a function of the scale and resolution of the remote sensor data, the flying height at which the imagery were acquired, the base/height ratio (i.e. geometry) of the stereoscopic imagery, and the accuracy of the stereoplotting equipment used for the measurements (Petrie, 1990).

Assuming quality metric aerial photography is available, stereoplotting instruments may be used to create an exact 3-dimensional stereo model of the terrain. The analyst measures the x,y,z coordinates of individual points in the stereo model very accurately using the "principle of the floating mark" instead of going out to the terrain to obtain the elevation measurement. Traditionally, the terrain models measured in the stereoplotting machine were either optical or mechanical. Analytical stereoplotting machines replace the optical or mechanical models by equivalent purely mathematical or numerical solutions which are executed in real time by a programmed computer. In such systems, the x,y,z coordinates of a point measured by the operator are passed to the computer which computes the corresponding position of the same point on each photograph of the stereo pair in real time. The differential parallax at the point is determined and the elevation of the point is computed and

perhaps stored off line. Digital elevation data may be collected randomly for very specific points of interest, systematically (e.g. grid-based sampling), or a combination of the two. These expensive analytical stereoplotter produce wonderfully accurate DEMs but at significant expense (primarily due to the cost of the instrument).

Using soft-copy photogrammetric systems and suitable ground control and camera calibration information, it is now possible to perform aero-triangulation of the photography (or imagery) and utilize information obtained during the process to generate a lattice (grid) of elevation values within each stereo model of a flightline (Figure 2). The software automatically performs stereo correlation on orthorectified patches of imagery and computes the parallax (and related elevation) associated with each new point in the stereo model. The stereo correlation is performed for all points in a user specified grid. Typical systems can process 75 points/sec on a 60 SPEC computer with a success rate of about 90% (ERDAS and Autometric, 1994).

Elevation values found at each location in the grid can be edited by draping the DEM elevations over the top of the three-dimensional stereo model and manually moving each individual 'elevation posting' until it touches the 3-dimensional ground. In effect, each 'elevation posting' in the DEM becomes a 'floating mark' which can be edited. Scientists can resample and mosaic the final DEM to whatever spatial resolution is considered appropriate (e.g. 5 x 5 m, 20 x 20 m). In this manner the DEM can be brought into geometric congruence with data in a GIS. Thus, earth scientists now have the capability of creating very accurate DEMs on demand for site specific projects using desktop soft-copy photogrammetric workstations. However, there are problems associated with the DEMs which will be discussed.

Advances in the Creation of the Orthophotographs and Orthophotographic Databases

Traditional analog (optical) stereoplotting instruments could be modified to become 'orthophotoscopes' which created an orthophotograph by viewing the stereo model in 3-dimensions, scanning the terrain line-by-line while keeping the floating mark firmly on the ground, all the while exposing a sheet of film exposed from just one of the diapositives of the stereo model. The result was an analog, hard-copy orthophotographic negative which could be printed to produce orthophotographs. It was a time consuming, tiresome task which was prone to problems. Analytical stereoplotters can be made to produce high quality orthophotographs but at considerable expense.

Soft-copy photogrammetric instruments can produce terrain corrected orthoimages on demand at minimal expense. The general procedure is summarized in Figure 2. The user selects any triangulated image in the block of aerial photography (or SPOT data) and its associated DEM to generate a digital orthoimage. During the orthorectification process, the effects of elevation upon the image perspective are

removed to produce a geocoded data set with an even pixel spacing in map space. For each orthoimage pixel of known latitude and longitude, the algorithm first uses the DEM to determine the height of the point. The rational functions for the image are then used to determine the pixel in the triangulated image corresponding to the point in ground space. The intensity of this point (actually resampled based on its neighbors using a bilinear interpolation scheme) is then assigned to the output orthoimage pixel. This process typically runs at a rate > 100,000 pixels/sec until the rectified output orthoimage is completely filled. The result is a terrain corrected orthoimage that can be used as a cartographic map.

Finally, it is important to point out that the geometric accuracy (x,y) of a photogrammetrically terrain corrected orthoimage is superior to the normal remote sensing image

rectification which is often performed. For example, one might suggest that all that is necessary to rectify a 1:6,000 scale aerial photograph of downtown Columbia, S.C. (Figure 5a) is to perform simple first-order polynomial rectification using standard digital image processing techniques as described in Jensen (1996). Unfortunately, this region has considerable local relief being located on the piedmont 'fall-line'. A comparison was made between 1) the geometric accuracy of rectifying the aerial photograph using traditional digital image processing techniques and nine GPS points (Figure 5b), and 2) the x,y geometric accuracy of an orthophotograph derived using a stereo-pair, soft-copy photogrammetric techniques, and the same nine (9) GPS horizontal/vertical ground control points (Figure 5c). Root mean square error (RMSE) statistics for the photogrammetrically derived orthophotograph were \pm 0.005 pixels in x and \pm 0.024 pixels in y (total RMSE of 0.0245) while the traditional 1st order nearest neighbor rectification method yielded RMSE of \pm 12.7 pixels in x and 20.08 pixels in y (total RMSE of 23.81 pixels). This suggests that scientists interested in rectifying remotely sensed data in high local relief urban areas would do well to utilize the improved image rectification capabilities of a photogrammetrically based procedure whenever possible. This includes multiband, multispectral datasets when stereo coverage is available.

Aerial Photography Obtained on March 30, 1993

(a)

(b)
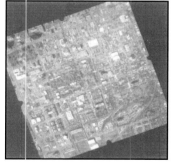

Rectified Using 1st Order Nearest Neighbor Resampling

(c)
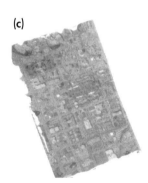

Orthophotograph Created Using Photogrammetric Techniques

FIGURE 5
(a) Vertical panchromatic aerial photography obtained on March 30, 1993 at 1:6,000 scale of downtown Columbia, South Carolina. (b) The photograph was rectified using nine horizontal ground control points and 1st order nearest neighbor resampling. (c) An orthophotograph created using a stereopair, nine horizontal/vertical ground control points, and soft-copy photogrammetric techniques.

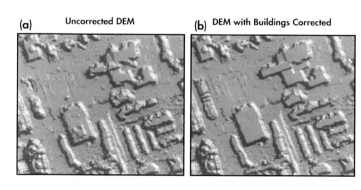

(a) Uncorrected DEM (b) DEM with Buildings Corrected

(c) DEM with Buildings and Trees Removed (d) Slope Map Produced from DEM with Buildings and Trees Removed

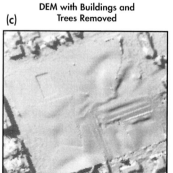
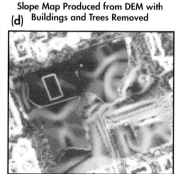

FIGURE 6
(a) The uncorrected, original digital elevation model (DEM) of a portion of the University of South Carolina campus. (b) DEM with building heights corrected. (c) DEM with building and tree heights moved to the nominal terrain elevation. (d) Percent slope map derived from the DEM with buildings and trees moved to the nominal terrain elevation.

Problems and Potential Solutions Associated with Digital Elevation Models Derived Using Soft-Copy Photogrammetry

New users often feel that the DEM derived using soft-copy photogrammetric instruments will be free from error. This is not the case and the user should be aware of several trade-offs.

Tall Structures and Trees Impact the Creation of a Photogrammetrically Derived Digital Elevation Model

The automatic stereo correlation used to create the DEMs works well when the terrain is devoid of trees, buildings, overpasses, bridges, etc. which extend above the nominal terrain. When such objects are present, however, the

Orthoimages Derived from Uncorrected and
Corrected Digital Elevation Models

Perspective
View

(a) Uncorrected

(b) Corrected

FIGURE 7
(a) An orthophotograph of a portion of the U.S.C. campus produced using an uncorrected DEM. (b) An orthophotograph of a portion of the campus produced using a DEM with buildings and trees corrected.

algorithms assume these objects are terrain and compute the differential parallax and resultant height of such surfaces. The heights are then placed in the DEM. For example, Figure 6a depicts a DEM derived for a four block region of the University of South Carolina campus derived from 1:6,000 scale photography. The blocky appearance of the DEM is due to detailed height information for each building and tree in the study area.

The Methods Used to Edit a DEM Impact its Accuracy

Most soft-copy photogrammetric systems allow users to view the grid of DEM elevation "postings" superimposed on a triangulated stereopair in 3D. The analyst can edit individual elevation "postings" by moving them so that they come in contact with the ground using the 'principle of the floating mark' wherein each posting becomes a floating mark. The analyst may 1) correct individual postings, 2) select a polygon of postings and change all of them to the same elevation, or 3) select a polygon of postings along a slope and have them scaled to lie between the highest and lowest points encountered within the polygon. When carefully used, the analyst can correct most problems encountered in the DEM. For example, the DEM in Figure 6b was edited so that the top of each building was at the correct elevation. DEMs that include elevation information about buildings and trees may be of use if the analyst desires to drape one of the triangulated aerial photographs back on top of the DEM and perhaps eventually do a 'fly-by' through the city as will be shown. However, if the analyst wanted a DEM of just the nominal ground terrain in the four block region, this is certainly not present in Figures 6ab.

In order to obtain a DEM of the region which does not have building and tree information in it, the analyst must manually edit the elevation 'postings' in the DEM which correspond with the buildings and trees and effectively drive them to the nominal terrain height in the area. This can be difficult if a building or stand of trees is extremely large. However, if the buildings and trees are not too large it is possible to identify the general trend of the terrain between buildings and large trees such that the 'postings' of buildings and trees can be moved to the nominal terrain elevation. Careful editing of the original DEM in this manner can produce a revised DEM which depicts just the local relief of the area, without buildings and trees as shown in Figure 6c. A percent slope database of the region (important in many environmental studies) cannot accurately be computed from the DEM with buildings and trees in it. It can be produced from the DEM with buildings and trees removed as shown in Figure 6d.

New users of photogrammetrically derived DEMs should remember several important points. First, DEMs of the nominal terrain are most accurate and require the least editing when produced for rural areas which do not have significant 'leaf-on' tree cover or man-made structures (buildings, bridges etc.). Second, urbanized areas with buildings and trees may have to be manually edited to obtain a DEM of just the nominal terrain. This can be a laborious process and is subject to error being introduced by the analyst. Con-

Orthoimages Draped Over Uncorrected and Corrected
Digital Elevation Models

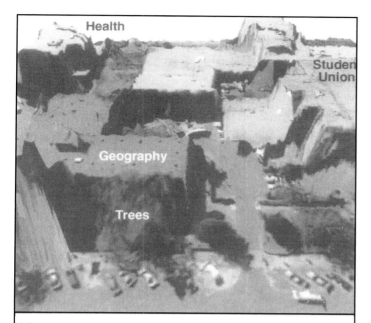

(a) Uncorrected

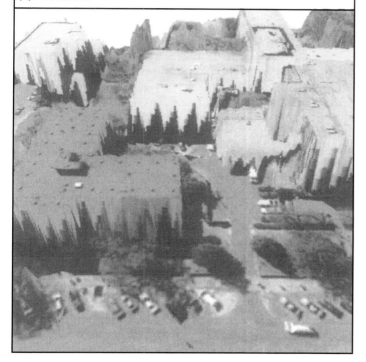

(b) Corrected

FIGURE 8
(a) A perspective 3-D view of a portion of the orthophotograph
of the University of South Carolina campus draped over the
uncorrected DEM in Figure 7. (b) A perspective 3-D display of a
portion of the orthophotograph of the University of South
Carolina campus draped over the corrected DEM in Figure 7.

siderable research is underway to automate this process. Third, the larger the scale of aerial photography and the greater the height of the buildings and structures in the study area, the greater the difficulty of obtaining an accurate DEM of the terrain.

Problems and Potential Solutions Associated with Orthoimagery Derived Using Soft-Copy Photogrammetry

Be Careful Which DEM is Used to Create the Orthoimage

The accuracy of a digital orthoimage is a function of the quality of the imagery, the ground control, the photogrammetric triangulation, and the DEM (Figure 2). The triangulation solution is based on well documented least squares bundle adjustment. However, as pointed out in the previous section, the DEM can have error associated with it. An orthoimage may be produced from the original DEM, a DEM with building rooftops cleaned up, or even a DEM with buildings and trees removed. A DEM produced from the collection of field surveying or even digitized contours may also be used to create the orthoimage. Therefore, the analyst should always have access to the meta-data (history) of how the DEM to be used was created. In this way only the most appropriate DEM data will be used in the creation of the orthoimagery.

Large scale (e.g. 1:6,000) urban orthoimages derived from uncorrected DEMs often exhibit severe distortion of building edges (Joffe, 1994; Nale, 1994). For example, the orthoimage in Figure 7a was derived using an uncorrected DEM while Figure 7b was produced using a DEM with buildings and tree elevations corrected. The roof ridge line at "a" is correct in Figure 7b. The reflecting pond at "b" is now rectangular. All the building outlines of the student union (c), geography department (d), health center (e), and library (f) are geometrically correct.

The importance of the quality of the DEM can be appreciated even more when the orthoimage is draped back onto the DEM used in its creation. For example, consider the two orthophotos in Figure 8ab created and draped over uncorrected and corrected DEMs, respectively. The edges of buildings are 'smeared' due to the effects of adjacent trees in Figure 8a. Conversely, when the rooftop and tree elevations are corrected in the DEM, the resultant orthoimage depicts the same buildings with sharp, distinct edges (Figure 8b). This is the type of orthoimagery that should be used in simulated 'fly-bys' through urban environments.

Traditional Ortho Rectification Does Not Eliminate Radial and Relief Displacement of Tall Structures

Most users have the mistaken impression that the tops of tall buildings or extremely tall trees in an orthoimage are in their proper planimetric location, i.e. that the roofs of tall buildings are over their foundations. This is only the

175

case when the sensor acquires the data from a great altitude and the relief displacement of the buildings or other structures caused by radial distortion is minimal. Unfortunately, when using large scale imagery with significant building and tree relief displacement, only the base of the buildings or trees are in their proper planimetric location

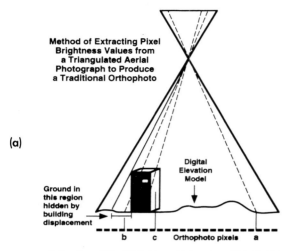

(a)

Method of Extracting Pixel Brightness Values from a Triangulated Aerial Photograph to Produce a Traditional Orthophoto

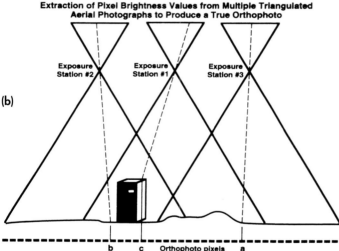

(b)

Extraction of Pixel Brightness Values from Multiple Triangulated Aerial Photographs to Produce a True Orthophoto

FIGURE 9
(a) The brightness value of pixel b in a traditional orthophoto is extracted from a region in the original image which was obscured due to building lean. Pixel c in the orthophoto would be extracted from the side of the building in the original photograph. Pixel a would have the correct gray shade brightness value. Note that all three pixels (a, b, and c) would be extracted from a single photo obtained at a single exposure station. (b) Pixels a, b, and c in a 'true orthophoto' are derived from the triangulated photo in the flightline that is most appropriate. For example, pixel a is derived from the photo obtained at exposure station #3. The brightness value of pixel b is extracted from the photo obtained at exposure station #2 where it is not obscured by building lean. The brightness value of pixel c is extracted from the photo obtained at exposure station #1. (adapted from Southard, 1994; Leica/Helava, Inc.).

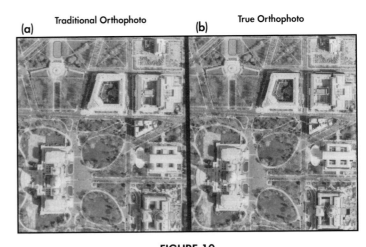

(a) Traditional Orthophoto (b) True Orthophoto

FIGURE 10
The difference between a conventional orthophotograph (a) and a true orthophoto (b) of the Capitol. Building lean has been completely removed and all building rooftops and bridges are in their proper planimetric location. (from Southard, 1994; Leica/Helava, Inc.)

in a orthoimage. A traditional digital orthophoto does not correct for 'building lean' caused by radial distortion. Indeed, the 'building lean' of tall buildings or other structures (bridges, overpasses etc.) may completely obliterate the image of the Earth's surface for several hundred feet. If we attempted to digitize buildings from a traditional digital orthoimage, we would discover that the building locations are misplaced on the Earth's surface relative to the building heights (Nale, 1994).

One solution to fix the tall structure relief displacement problem is to physically move the building, overpass, or bridge using digital image processing techniques to its appropriate location and simply paint in gray the vacated area. This requires that the analyst obtain careful measurements of the exact location of the feature in step 3 of the process when the triangulated photos in a stereopair are viewed stereoscopically (Figure 2). Later on it is possible to 'cut out' the feature and move it to the correct planimetric location (Joffe, 1994). Manual editing of such features is time consuming and involves some subjectivity. The obvious problem remaining is that there is no spectral information content in those areas which have been moved (i.e. in gray area).

Recently, a more analytical and quantitatively accurate method of creating 'true orthophotos' has been developed. In order to understand how it is derived, it is first useful to review how a traditional orthophoto is produced. The brightness value of pixel "a" is obtained by starting at a's ground x,y position, interpolating the elevation from the DEM, tracing up through the math model to the image, interpolating the proper shade of gray from the image, and assigning the resulting gray shade to pixel "a" in the new orthophoto (Figure 9a). The process is acceptable for pixel "a" because there is no obstruction (e.g. building) between the ground x,y,z

location at "*a*" that obscures the view of the ground from the image. The problem that arises is illustrated by pixels "*b*" and "*c*". In the original image, the ground 'behind' the building at "*b*" is not depicted because of the height of the building. Pixel "*b*" will be colored with the gray shade for the roof of the building. Pixel "*c*" should obtain a value for the rooftop but will be assigned a value from the side of the building. The final traditional orthophoto will show the building leaning out away from the center of the photograph as in Figure 10a. The roof will be shown where there should be ground at the back of the building and the side of the building will be shown where the roof should be. The ground behind the building will not be shown at all. These displacements are directly related to the height of the building and the position of the building in the original photo. The taller the building and the closer it is to the side of the original photograph, the worse the displacement will be.

Furthermore, it is obvious when using the traditional orthophoto process that to make a final orthophoto map sheet with a footprint larger than any of the single input orthophotos, it is necessary to mosaic the orthophotos together. While this will solve the footprint problem, it will result in orthophotos with displaced building tops and areas of the ground that are not depicted. It also results in map sheets that show the buildings displaced in one direction on one portion of the sheet and in different directions in other portions of the orthophoto map sheet. These problems are even more acute in the case of bridges and overpasses in large scale orthophotos, such as are used by civil engineers and planners. The industry standard is to distort both the top and the bottom by falsifying the DEM by "ramping" the elevations in the vicinity of the overpass, thereby producing an esthetically acceptable picture at the expense of horizontal accuracy of both the top and the bottom layers of the overpass. The result of all these problems has been some frustration on the part of producers of orthophotos who work hard at trying to minimize the displacement issues which lead to lack of acceptance of the traditional orthophoto by end users in engineering and planning applications.

An elegant solution to the above orthophoto problems was recently developed (Southard, 1994). In Figure 9b we see three triangulated aerial photographs and a DEM covering the entire footprint of the project area. Using traditional 3D stereoscopic feature extraction tools, the outlines of buildings, bridges, and other obstructions are identified. However, the brightness value gray shade for pixel "*a*" is interpolated from the most nadir (directly overhead) camera station (#3 in Figure 9b) that has the best view of the ground at location "*a*". The algorithm then examines the DEM and feature data and determines that the view of the ground for pixel "*b*" is obscured by the building at camera station 1 and automatically selects imagery from camera station 2 to obtain the proper pixel color for pixel "*b*". Likewise the algorithm determines that a building resides over the location of pixel "*c*" in camera station 2 and will choose camera station 1 as the source of gray shades (of the roof) for pixel "*c*". The application of these algorithms results in a 'true orthophoto' in which:

· building rooftops are shown in their correct planimetric x,y location;

· sides of buildings are not shown;

· ground on all sides of all buildings is shown in its proper location;

· tops and bottoms of overpasses are shown in their proper locations;

· there is no need to falsify elevation data to produce esthetically acceptable orthoimages, and

· orthophotos and map sheets can be made that are larger than any of the input images.

For example, a comparison between a traditional orthophotograph and a true orthophoto of the nation's Capitol is shown in Figure 10ab. Building lean has been completely removed and all building rooftops are in their proper planimetric location. A large scale true orthophoto of a portion of downtown Minneapolis, Minnesota is shown in Figure 11b. The creation of true orthoimages should spur the application of orthoimagery in geographic information systems even more.

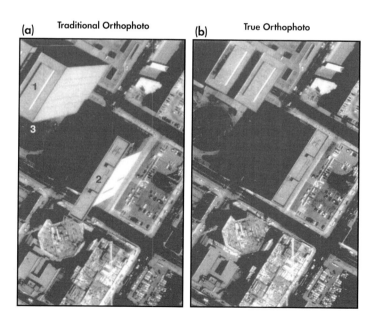

FIGURE 11
Another example of a true orthophoto in (b), and a conventional orthophotograph in (a) for a part of downtown Minneapolis, Minnesota. Note that the rooftop of buildings 1 and 2 are in their correct x,y planimetric location in the true orthophoto. The circular lawn detail at 3 in the true orthophoto was obtained from adjacent photographs using the logic described in Figure 9. (from Walker, 1995; Leica/Helava, Inc.)

177

Summary

As Thrower and Jensen (1976) suggested almost twenty years ago, orthoimage maps are becoming the base map of the future for many geographic information systems. This paper reviewed reasons why DEMs and orthoimagery databases are now so ubiquitous in our society. The advantages and limitations of DEMs and orthoimages derived using soft-copy techniques were identified. Advances in orthoimage creation were then presented. New users of these technologies are encouraged to take these observations into consideration when using DEMs and orthoimagery for earth resource management decision making.

References

[1]Portions of this paper are reprinted with permission from Jensen, J.R., Cowen, D., Kammerer, T. and Huang, X., 1994, "GPS and Softcopy Photogrammetry for Large-Scale Digital Elevation Model Creation and Orthophoto Mapping for Urban Applications," *Proceedings*, Mapping and Remote Sensing Tools for the 21st Century, Washington: American Society for Photogrammetry and Remote Sensing, 169-178; and Jensen, J.R., "Issues Involving the Creation of Digital Elevation Models and Terrain Corrected Orthoimagery Using Soft-Copy Photogrammetry," *Geocarto International - A Multidisciplinary Journal of Remote Sensing & GIS*, 10(1):5-21.

Ackermann, F., 1994a. "Digital Elevation Models - Techniques and Application, Quality Standards, Development," *Proceedings*, Symposium on Mapping and Geographic Information Systems, Athens, GA: International Society for Photogrammetry & Remote Sensing, 30(4): 421-432.

Ackermann, F., 1994b. "On the Status and Accuracy Performance of GPS Photogrammetry," *Proceedings*, Mapping and Remote Sensing Tools for the 21st Century, Washington: American Society for Photogrammetry & Remote Sensing, 80-90.

Ayers, L., 1994. "Redefining The Role of Surveyors and GIS," *The Professional Surveyor*, 15(5):10-12.

Case, J., 1982. "The Digital Stereo Comparator Compiler DSCC," *Proceedings*, International Society for Photogrammetry & Remote Sensing, Commission II, Canadian Institute of Surveying, Box 5378, Station F., Ottawa, 23-29.

Christensen, E. J., 1994. "Commercial Remote Sensing System," paper presented at the Symposium on Mapping and Remote Sensing Tools for the 21st Century, Washington: American Society for Photogrammetry & Remote Sensing, August 27.

Dangermond, J., 1994. "The Information Side of GIS," *The Professional Surveyor*, 15(5):14-16.

Dowman, I. and Neto, F., 1994. "The Accuracy of Along Track Stereoscopic Data for Mapping: Results from Simu-

lations and JERS OPS," *Proceedings*, Symposium on Mapping and Geographic Information Systems, Athens, GA: International Society for Photogrammetry & Remote Sensing, 30(4): 216-221.

ERDAS and Autometric, Inc., 1994. *Imagine OrthoMAX User Manual*, Atlanta: ERDAS, Inc., 80 p.

Haack, B., et al., 1997. "Urban Analysis," *Manual of Photographic Interpretation*, 2nd Ed., Bethesda: American Society for Photogrammetry & Remote Sensing, in press.

Helava, U., 1958. "New Principle for Photogrammetric Plotters," *Photogrammetria* 14(2):89-96.

Helpke, C., 1995. "State-of-the-Art of Digital Photogrammetric Workstations for Topographic Applications," *Photogrammetric Engineering & Remote Sensing*, 61(1):49-56.

Jensen, J. R., 1996. *Introductory Digital Image Processing: A Remote Sensing Perspective*, Englewood Cliffs, N. J.: Prentice-Hall, Inc., 2nd Edition, 318 p.

Jensen, J. R., Cowen, D., Kammerer, T. and Huang, X., 1994. "GPS and Softcopy Photogrammetry for Large-Scale Digital-Elevation-Model Creation and Orthophoto Mapping for Urban Applications," *Proceedings*, Mapping and Remote Sensing Tools for the 21st Century, Washington: American Society for Photogrammetry & Remote Sensing, 169-178.

Jensen, J. R., Cowen, D. J., Halls, J., Narumalani, S., Schmidt, N. J., Davis, B. A., and Burgess, B., 1994. "Improved Urban Infrastructure Mapping and Forecasting for BellSouth Using Remote Sensing and GIS Technology," *Photogrammetric Engineering & Remote Sensing*, 60(3):339-346.

Joffe, B., 1994. "Better and Cheaper: Technical Innovation Builds Palo Alto's High Quality Map Base," *Geo Info Systems*, 4(6):47-51.

Keating, J. B., 1993. *The Geo-Positioning Selection Guide for Resource Management: Technical Note 389*, Cheyenne, WO: Bureau of Land Management, 72.

Leberl, F. W., 1994. "Practical Issues in Softcopy Photogrammetric Systems," *Proceedings*, Mapping and Remote Sensing Tools for the 21 st Century, Washington: American Society for Photogrammetry & Remote Sensing, 223-230.

Light, D. L., 1993. "The National Aerial Photography Program as a Geographic Information System Resource," *Photogrammetric Engineering & Remote Sensing*, 59(1):61-65.

Michael, J. H., 1992. "Digital Orthoimagery: the Map of the Future," *Northpoint*, 29(1):, Survey Discipline of the Ontario Association of Certified Engineering Technicians and Technologists, 10 p.

Miller, C. L. and Laflamme, R. A., 1958. "The Digital Terrain Model - Theory and Application," *Photogrammetric Engineering*, 24:433-442.

Nale, D. K., 1994. "Digital Orthophotography: "What It Is and Isn't," *GIS World*, 7(6):22.

Perkins, S., 1994. "Photogrammetry and Surveying: Working Together as Science and Business," *The Professional Surveyor*, 15(5):20 - 29.

Petrie, G. and Kennie, T. J. M., 1990. *Terrain Modelling in Surveying and Civil Engineering*, London: Whittles Publishing Services, 351 p.

Southard, G. W., 1994. *True Orthophoto Capabilities of SOCET SET*, Englewood, Colorado: Leica/Helava, Inc., 8 p.

TeSalle, G., Plasker, J., Mikuni, A. and Wortman, K., 1994. "A National Digital Orthophoto Program," *Proceedings*, GIS/LIS '94, Bethesda: American Society for Photo-grammetry & Remote Sensing, 741-757.

Thrower, N. J. W. and Jensen, J. R., 1976. "The Orthophoto and Orthophotomap: Characteristics, Development and Application," *The American Cartographer*, 3(1):39-56.

Trinder, J. C., Vuillemin, A., Donnelly, B. E., and Shettigara, V. K., 1994. "A Study of Procedures and Tests on DEM Software for SPOT Images," *Proceedings*, Symposium on Mapping and Geographic Information Systems, Athens, GA: International Society for Photogrammetry & Remote Sensing, 30(4): 449-456.

Walker, A. S., 1994. Correspondence Concerning the SOCET SET (TM), San Diego: Leica AG Photogrammetry and Metrology, Inc., December 20.

Vegetation Mapping and Inventory in the National Parks of the Pacific Northwest

JEFF T. CAMPBELL, KASS GREEN, JUNE C. RUGH,
AND DAVID L. PETERSON

- *How much old-growth forest remains for the northern spotted owl in the Pacific Northwest?*

- *What proportion of land area in each park is occupied by alpine vegetation types?*

- *Which watershed has the largest percentage of Douglas-fir crown cover?*

These are questions that managers in Crater Lake, Mount Rainier, North Cascades, and Olympic National Parks are now able to answer with unprecedented accuracy, consistency, and state-of-the-art documentation. The Pacific Northwest Regional Office worked with Pacific Meridian Resources to develop a comprehensive geographic information system (GIS) database of vegetative, topographic, and landform data layers. Completed in September 1995, this database has increased the knowledge base of ecosystems in the four parks, greatly enhancing resource managers' ability to organize data, analyze relationships between resources in a spatial context, and assess the potential impacts of management decisions.

Until now, the rugged and remote landscapes characteristic of these parks have limited scientists' ability to develop detailed, comprehensive data on vegetation and landforms. Pacific Meridian Resources has tackled this challenge by integrating existing monitoring and research data, extensive field reconnaissance, aerial photography, and satellite imagery into the development of the region's GIS database. Using the various scales and resolutions of each of these data base types, Pacific Meridian has obtained detailed information from more easily accessible areas. The detail was then extrapolated to describe areas in remote locations determined to be similar from the satellite imagery and aerial photography. A GIS database encompassing all regions of the park was the result.

Generally speaking, GIS databases describe the physical, biological, and cultural attributes of resources. GIS's link computerized maps (location data) to computerized databases which describe the attributes of a particular location. This linkage makes it possible to simultaneously access both location and attribute data to simulate the effects of management and policy alternatives. GIS's are powerful tools because a single operator can quickly search, display, analyze, and model spatial information. Moreover, maps and data can be updated more rapidly and accurately than with conventional methods. The core of the Pacific Northwest Region's project is an ecosystem database which focuses on two primary components: 1) characterization of forested and non-forested vegetative types across all park areas, as defined by criteria such as tree species, stem density, stand age, crown cover by species, dominant understory species in forested areas, and species cover in non-forested areas; and 2) characterization of topography and landforms, including development of data layers for slope, aspect, elevation, and landform type.

What makes the Pacific Northwest Region's project unique? After all, many national parks have existing descriptions of physical and biological components, with some already in digital GIS format. First, the innovative use of remote sensing technology has produced a detailed description of multi-resource landscapes, allowing resource managers to address issues in an ecosystem context. This dynamic, spatial database is enabling managers to assess forest stand dynamics and wildlife habitat with accuracy and thoroughness. Second, the database is providing a comprehensive framework on which more extensive and detailed information will be built, and which is consistent from park to park. Most significantly, the project demonstrates a regional approach to ecosystem management by organizing data from the four parks into one contiguous database and by coordinating efforts with adjacent land managers—the Forest Service, state resource management agencies, and private timber companies. The use of satellite image classification facilitated the regional approach to the GIS database development. Satellite imagery not only provided detailed, consistent information about NPS lands of interest, but also presented the same detail and consistency of information for lands adjacent to the parks. This insures compatibility between databases among different agencies, which in turn allows for greater potential in data sharing and collaborative resource management. Moreover, this cooperation reflects an increasing commitment on the part of resource managers to cross political boundaries in order to achieve common goals.

The Technical Approach

The technological hub of the project was a multi-stage sampling process that integrated existing data sources, new field data collection, Landsat Thematic Mapper satellite imagery, aerial photography, digital topographic data and other existing GIS data layers, and the knowledge and experience of Pacific Northwest ecology found within Pacific Meridian's project team and NPS staff.

The database design involved two steps: 1) identifying database standards for both spatial and classification accuracy and 2) developing a preliminary classification system which identifies the types of variation in vegetation and landform of interest to the anticipated users of the database.

Spatial or positional accuracy is defined as the expected deviance in the geographic location of an object in the database from its true ground position. The spatial database standards for this project was largely a function of the scale and/or resolution of various source data ranging from 30 meter Landsat Thematic Mapping imagery and digital elevation data to 1:100,000 and 1:500,000 scale geology map data. All data was coregistered with the satellite imagery to ensure spatial consistency. Classification accuracy was the probability that the class assigned to a particular location on the map was the same class that would be found at that location in the field. While traditional classification standards imply only true or false classifications, Pacific Meridian worked with NPS staff to incorporate "fuzzy sets" into accuracy standards, deriving a set of measures to analyze the nature, frequency, source and relative magnitude of map errors. This has provided NPS with more complete information on map reliability.

In developing the classification system, landform was characterized by slope, aspect, elevation, and landform type, including substrata origin and type (such as bedrock type). Landform identification can be highly variable, ranging from general descriptions of topographic shapes (mountain, plateau) to specific terms indicating depositional form and process (alluvial fan, glacial moraine). This project produced a digital geomorphic landform layer describing substrate origin and type. Landform data can be developed through a variety of methodologies ranging from extensive field reconnaissance to digital data modeling to photo interpretation. The method deemed most efficient and suitable for this project was the interpretation of high altitude aerial photography and topographic base map data. Landform classes were interpreted from 1:80,000 scale National High Altitude Aerial Photography (NHAAP) and delineated directly onto 1:100,000 scale topographic maps. Interpretation was aided by review of both the topographic maps and local geologic maps. Pacific Meridian also utilized digital shaded relief data developed from 1:24,000 digital elevation area draped with satellite imagery. The digital images were interpreted with the assistance of NHAAP photography and previously collected field data. Landform characteristics were then delineated directly on the computer screen. This methodology eliminated the need for many of the hardcopy transfer and digitizing steps required in the strictly photo-interpreted landform mapping methodology. Where feasible, landform classes were verified during field reconnaissance efforts associated with the vegetation database development phase of the project. Based on scale limitations of the source data, the minimum mapping unit for landforms was approximately 40 hectares.

Vegetation was characterized by several variables:

- stem density by tree species
- stand age by species
- tree diameter by tree species
- crown diameter by tree species
- crown cover by tree species
- standing dead trees
- dominant understory species in forested areas
- cover of herbaceous plant species in non-forested areas.

In developing the vegetation characteristics database, satellite imagery was used as a basis for determining the vegetation data themes through the integration of various ancillary data sources. The reason remotely sensed data (such as satellite imagery or aerial photography) can be used to collect vegetation information is because of the high correlation between variation in imagery and actual variation in vegetation. Remotely sensed data is particularly effective for mapping the variation in tree canopy characteristics (such as crown diameter by species, crown closure by species) in forested areas, and the soil type, moisture, and non-tree vegetation variation in non-forested areas. Thus, satellite imagery can be useful in characterizing much of the variation in vegetation across the national parks. Landform classes were digitized directly from the topographic maps to form the final landform type layer. Furthermore, land cover classification data from satellite imagery can provide much more detailed "intensive" information than results from traditional photo-interpreted polygon classifications. For example, while a 5 hectare polygon may summarize a forest's age, canopy cover, structure, and so on, satellite image classification provides information on the variation of forest age, canopy cover, structure, and so on within the 5 hectare polygon area.

Vegetation characteristics which cannot be directly mapped from the imagery can be delineated through the development of relationships among the imagery, fire history, landform characteristics, and/or ground-based vegetation inventory data. For example, tree diameter which cannot be mapped from aerial photos or satellite imagery is highly correlated with tree canopy diameter, which can be estimated from remotely sensed data. In addition, a multistage sampling process was used to determine the relationships of the imagery of forest canopy characteristics to non-forest cover types; canopy characteristics to sub-canopy characteristics; and landform, fire history, and other environmental factors to forest canopy characteristics, forest sub-canopy characteristics, and non-forest cover types. Multistage sampling employs the fact that strong relationships exist between some characteristics which are inexpensive to estimate (such as crown diameter) and other variables costly to estimate (such as tree diameter). The combinations of these relationships was used to develop the database of vegetation characteristics.

In order to effectively integrate field based vegetation inventory information and information developed from spatial remotely sensed data such as forest species, tree crown cover, tree size and forest structure, and non-forest vegetation compositions, a spatial link had to be established. For this project, that spatial link was provided by GPS technol-

ogy. The center point of each vegetation inventory plot that was established throughout the parks to measure vegetation characteristics that can not be directly mapped from remote sensing data (e.g. forest stand age, tree height by species, etc.) was located and recorded using GPS recorders. The differentially corrected GPS points rendered three to five meter spatial locational accuracy for the vegetation inventory plot centers. These points provided the spatial link necessary to integrate the compiled inventory data of stem density by tree species, stand age by species, tree diameter by tree species, crown diameter by tree species, crown cover by tree species, standing dead trees, dominant understory species in forested areas, and cover of herbaceous plant species in non-forested areas with the more generalied spatially mapped information of such as forest species, tree crown cover, tree size and forest structure, and non-forest vegetation compositions mapped from the satellite imagery. This integrated data set provides each park with a complex, powerful landcover database of vegetation characteristics derived from both spatial remotely sensed data and ground-based, vegetation inventory data.

Quantitative assessment of map classification accuracy involves comparing the map to reference data (from photo interpretation or field identification, for example) which is assumed to be correct. Because comparison of every spatial point is impractical, sample comparisons are used to estimate the accuracy of maps. Accuracy assessment requires 1) the design of unbiased and consistent sampling and photo interpretation and field procedures, and 2) rigorous analysis of the sample data. Strict quality control and quality assurance procedures were used in both data collection and subsequent analysis to insure accuracy in the final dataset.

Looking Ahead

The vegetation mapping project completed in the Pacific Northwest Region is an important component of the region's programs in inventory and monitoring, resource management, and science. In fact, it is a very basic component that provides information for a wide range of applications. The database is a high-quality template for monitoring the condition of natural resources. It provides a geographically-based linkage to various disciplines within resource management, such as wildlife, hydrology, and fire. The database is also an important tool for research scientists in identifying specific vegetative and geomorphic resources, and for georeferencing all future scientific activities in the parks.

The vegetation database provides a framework for increased and more specific cooperative with other agencies and institutions. Ecosystems do not stop at park boundaries, and resources such as water and wildlife cross those boundaries freely. The availability of a consistent, compatible database allows national parks to develop interagency partnerships for ecosystem management based on scientific principles. Broader landscape/regional assessments and management strategies is now possible. Furthermore, it is possible for the Pacific Northwest Region to cooperate in other similar vegetation efforts (planned or underway) by the National Park Service, National Biological Survey, and other agencies.

Ecosystems are constantly changing—sometimes gradually, sometimes abruptly. The database is dynamic in order to track spatial and temporal changes in park natural resources. The accurate and detailed GIS database facilitates continual updating over time. It allows park managers and scientists to determine the influence of large-scale disturbances, such as fire, on park landscapes, as well as the potential impacts of long-term phenomena, such as climate change. There are no doubt additional applications which have not yet even been envisioned. The database is more than a mere vegetation map—it will be a powerful managerial and scientific tool for many years to come.

GPS, Photogrammetry and GIS for Resource Mapping Applications

ROY WELCH AND MARGUERITE REMILLARD

Introduction

Accurate maps and digital databases from which large scale thematic maps can be prepared for resource inventory and change assessment tasks are needed by organizations concerned with preservation of the natural environment. Pressures from urban development, loss of wetlands, intensified use of agricultural lands and clear cutting of timber all threaten the long-term sustainability of the nation's resources and contribute to non-point source pollution. Also, the recent popularity of geographic information systems (GIS) as a tool for combining diverse data sets to manage land resources and to model future land uses, threats to the environment and sustainability of resources has been a catalyst for the increased demand for accurate spatial information. However, in order to effectively produce maps, generate statistics and model future developments, the various data sets must be thematically correct and geometrically positioned on a standard reference datum so that there is exact registration of the (map) data layers and an accurate "fit" to the earth's surface. Thus, although it is often overlooked in the enthusiasm to manipulate data, the first and most important requirement is to be able to assemble data layers of adequate detail and accuracy for resource management/inventory tasks.

Consequently, there must be an understanding of positioning, measurement and analysis techniques and how they interrelate in the preparation of maps and databases. Some critical aspects in preparing resource databases are discussed below, followed by a brief overview of projects along the Georgia coast and in the Florida Everglades where integrated Global Positioning System (GPS), photogrammetric and GIS techniques have been employed to establish databases for wetland environments threatened by urban expansion, agriculture and non-point source pollution.

Critical Considerations in Planning and Preparing Resource Databses

In planning for the compilation of resource databases and the eventual preparation of products in digital format, thoughtful consideration must be given to: 1) project and end-product requirements; 2) coordinate systems and GPS; 3) mapping and database assembly techniques; and 4) GIS analysis procedures. In the following discussion, an attempt is made to present new ideas or aspects of GPS, photogrammetric and GIS technologies that are particularly critical to the successful implementation of projects requiring the preparation of maps and databases in digital format.

Project and End-Product Requirements

When undertaking a mapping or database compilation project, it is necessary to give immediate attention to the desired characteristics of the end products. An important requirement is the specification of realistic accuracy criteria for resource map/database products.

Accuracy criteria for resource maps/databases must be considered in terms of: 1) positional accuracy; and 2) thematic accuracy. In the United States, the U.S. Geological Survey (USGS) 1:24,000 scale topographic quadrangles are a standard reference source for many resource mapping/inventory tasks. National map accuracy standards (NMAS) for these products require well-defined horizontal features to be within \pm 0.3 mm of their correct position (as referenced to the map grid) at the 68 percent level of confidence. This root-mean-square error ($RMSE_{xy}$) value is equivalent to \pm 7.2 m on the ground. The new USGS digital orthophoto quad products printed at 1:12,000 scale are reported to have RMSE values of less than \pm 3 m. Thus, when preparing resource maps/databases for which layers are obtained from available USGS products, the accuracy specification threshold should be approximately \pm 3 to \pm 7 m, or \pm 5 m for most purposes. Although thematic data generally are not associated with positional accuracy standards, the above values do provide useful guidelines when considering the accuracy to which points, lines and polygons must be established by GPS, photogrammetric or GIS techniques.

Thematic classification accuracies of 85 percent or better can be obtained for Level III land use/cover classes derived from aerial photographs of 1:40,000 scale and larger. The 1:40,000 scale aerial photographic coverage of the United States acquired under the USGS National Aerial Photography Program (NAPP) is of sufficient quality and resolution to allow maps of 1:5,000 scale and smaller to be produced. For example, at the original photo scale of 1:40,000, logical minimum mapping units of 1 acre and 1 hectare equate to square parcels of approximately 1.6 mm and 2.5 mm, respectively. These dimensions exceed the ground resolution of the photographs by approximately 50 to 75 times. Thus, even photographs at scales as small as 1:40,000 may contain considerably more information than is desired or can be recorded in a digital resource database for any significant land area. A major advantage of aerial photographs is that selectivity of detail to be represented is determined by the analyst rather than by image resolution — as may be the case with satellite imagery

Coordinate Systems and GPS

In most resource inventory/mapping applications, a rectangular coordinate system such as the Universal Transverse Mercator (UTM) grid (or, alternatively, a State Plane coordinate grid), will be specified for establishing the positions of ground control points (GCPs) and terrain features. Global Positioning System surveying technology is most appropriate for establishing ground control and grid coordinates of specific features. It is also excellent for a range of mapping and inventory tasks. However, it is important to understand that GPS derived coordinates are normally referenced to the World Geodetic System of 1984 (WGS 84), whereas UTM coordinates derived from USGS 1:24,000 scale topographic quadrangles will be referenced to the North American Datum of 1927 (NAD 27). The offsets in Easting and Northing coordinates between the WGS 84 and NAD 27 horizontal datums vary with location in the United States, but typically are on the order of 100 to 300 m. Thus, to ensure the registration of GIS data layers derived from different sources, it is necessary to convert all rectangular coordinates to the same horizontal datum — preferably to the North American Datum of 1983 (NAD 83) which, for practical purposes, is identical to WGS 84. These conversions entail applying translations in Easting and Northing to the UTM (or State Plane) coordinates derived from USGS products. Unfortunately, the USGS does not provide the translations for rectangular grid coordinates. Instead, for recently printed 7.5 minute quadrangles, the corner ticks are plotted for the NAD 83 as well as for the NAD 27, and offsets of the graticule (latitude and longitude) positions are specified in metres. It is extremely important to note that the translations to place the graticule locations of the corners of the map sheets on the NAD 83 are not the translations required to convert the UTM grid coordinates (on NAD 27) derived from the USGS quadrangles to UTM coordinates on the NAD 83. In order to efficiently convert rectangular grid coordinates obtained from the USGS maps to NAD 83 — or to take GPS derived coordinates and convert them to NAD 27 values — the use of software such as the U.S. Army Corps of Engineer's CORPSCON program, the Blue Marble Geographics, Inc., Geographic Calculator, or software packages provided by manufacturers of GPS units is required. Failure to correct for offsets between datums will result in a database in which the individual layers are not in register.

Mapping and Database Assembly

The demand for digital image data suitable for GIS and mapping applications has been a catalyst for the development of softcopy photogrammetric techniques where the more traditional analog and analytical plotters are replaced by a computer workstation and software designed to implement the various photogrammetric functions with either satellite images or aerial photographs in digital format. In the latter instance, the aerial photographs must be converted to digital format by scanners that retain the geometric and radiometric fidelity of the original photos. Features are extracted from the digital images by a combination of automated and interactive on-screen digitizing techniques that produce data files in both raster and vector formats.

There are both advantages and difficulties in using a softcopy photogrammetry approach for map and database preparation. For example, a softcopy photogrammetric workstation is designed to perform the measurement functions of an analytical photogrammetric plotter, plus it may allow the operator to:

1. integrate image and map data in raster and vector formats;

2. edit data that have been collected;

3. implement image-processing functions such as contrast enhancement, edge sharpening, change detection and vector on raster overlay;

4. interface with GIS software for overlay analysis and modeling applications;

5. automatically generate digital evaluation models (DEMs) and display data sets in both perspective and plan view; and

6. produce digital orthophotos.

These added features of softcopy photogrammetric workstations make them powerful instruments for the collection, editing and analysis of spatial data. The major drawbacks at this time are cost, data volume, measurement accuracy, stereo display and the availability of well-documented, easy-to-use software (Welch, 1992).

Because softcopy photogrammetry is in an early stage of evolution, it is appropriate to examine some practical relationships between detail requirements, photo scale, pixel size and data volume as related to resource mapping/inventory tasks. There are two major considerations: 1) adequate clarity of detail; and 2) measurement accuracy.

In the first instance, photo scale, photo resolution and scanning resolution are the key factors. Most studies of vegetation, landforms and environmental hazards will involve the use of photographs of approximately 1:5,000 to 1:40,000 scale. Modern camera/film combinations can be expected to produce photos having resolution values of 20 to 50 lprs/mm for low contrast ground objects. These values equate to ground resolutions in the range of 10 cm to approximately 2 m, and require pixel resolutions of about 10 to 25 μm to capture all of the detail when scanning the aerial photographs. However, for most resource mapping/database compilation tasks, there is little (if any) advantage to scanning photographs at pixel sizes below or at the resolution limit of the original photographs. Instead, a pixel size of 25 to 65 μm will provide adequate clarity of detail and measurement accuracy for most resource interpretation/mapping tasks at scales of 1:40,000 and larger. These values equate to 1,000 to 400 dots per inch (dpi) and represent data file volumes of 81 to 13 megabytes (Mbytes) for standard 9 x 9 inch (23 x 23 cm) format aerial photographs. Files of this size can be readily manipulated on small, inexpensive computers with Pentium processors (Spradley,

1996).

Since most resource managers have access to personal computers (PCs) and may wish to undertake measurements, prepare maps or conduct thematic analyses, there is a growing demand for softcopy photogrammetric software packages compatible with fast PCs, and which interface or provide data suitable for use in a standard GIS software package. One softcopy photogrammetry software package that is compatible with PCs, provides a complete range of photogrammetric functions, is of low cost and is currently being used for a range of resource inventory mapping and GIS database construction tasks is the Desktop Mapping System (DMS)™ (Welch, 1987; 1989; 1993).

Geographic Information Systems

Geographic information systems (GIS) are currently an integral component of natural resource monitoring and management operations worldwide. Useful not only for data storage, manipulation and map production, the strength of GIS is spatial data analysis and predictive environmental modeling (Remillard and Welch, 1992; 1993; Cowen, et al., 1995). Some of the GIS functions that are most useful in resource applications include editing capabilities, buffering, reselection for attribute queries and overlay for change analysis (Aronoff, 1989; Berry, 1993).

The integration of GIS with softcopy photogrammetry and GPS has proved particularly useful for resource mapping applications. As a consequence, GIS systems that incorporate vector overlay on geocoded raster images, for example, have increased tremendously (Figure 1).

Due to their geometric fidelity, synoptic coverage and repetitive acquisition, satellite images serve as an excellent reference base for GIS data layers. They are a potential source for ground control and provide up-to-date thematic information, especially when general land use/cover classes are required over relatively large study areas (Jensen, et al., 1995). For greater detail in areas where aerial photographs are available or can be acquired, these photographs can be scanned to create digital photo mosaics and image backdrops for GIS data layers. Some software packages, such as the DMS, use digital stereomodels for 3D terrain viewing and for DEM and orthoimage production. These digital products can be added back into the GIS database for advanced resource analysis (e.g., assessment of hydrologic flows, viewsheds, wildlife habitat and potential nonpoint source pollution).

Coastal Resource Management of the SINERR

The Sapelo Island National Estuarine Research Reserve (SINERR) is a 100 km² coastal wetland area near Brunswick, Georgia under the jurisdiction of the National Oceanic and Atmospheric Administration (NOAA) Estuarine Research Reserve Program (DNR, 1985; NOAA, 1987) (Figure 2). It contains some of the last unaltered saltmarshes along the Atlantic coast. Protection and pres-

FIGURE 1
Planimetric vector data of land use/cover boundaries overlaid on a scanned aerial photograph of Sapelo Island.

ervation of these marshlands requires access to spatial information on vegetation, topography, tidal creek drainage patterns and land use within the marsh and surrounding upland areas. A combination of GPS, remote sensing and GIS techniques have been used to construct a database and maps of the SINERR (Welch, et al., 1991; 1992).

GPS Survey, Aerial Photography and Map Products

A differential GPS survey was conducted to establish a network of 16 GPS control points dispersed throughout the study area. The UTM coordinates of these 16 points were computed and referenced to the NAD 83. Internal accuracy of this network is estimated to be ± 3 cm (RMSE). Elevations (Z) were referenced to a tidal datum marker (elevation 3.05 m relative to mean low water) established by the University of Georgia in the mid 1970s. Each GPS point was marked with a metal stake and a 4- by 8-ft sheet of plywood centered over the stake to ensure that the points would be visible on the aerial photographs.

Panchromatic aerial photographs to be used to photogrammetically compile topographic data of the SINERR were acquired from altitudes of 2,438 m (8,000 ft) and 3,657 m (12,000 ft) by the Georgia Department of Transportation on 27 December 1989 using a Wild RC 10 camera (f = 152 mm). Three flight lines and 34 photographs (1:16,000 scale) were required at the lower altitude to cover Sapelo Island and the marshes of the SINERR. At the higher altitude, two flight lines with 15 photos (1:24,000 scale) provided complete coverage. The time of the flight was arranged

FIGURE 2
Study area locations for projects along the Georgia coast (Sapelo Island) and the Florida Everglades.

Kern DSR-1 analytical plotter. In order to produce a DEM of the terrain, the digital files for topographic contours and spot heights were transferred to the triangulated irregular network (TIN) module of ARC/INFO. Using TIN, a linear interpolation was performed to generate a surface of terrain elevations, which, in turn, was converted to a gridded DEM at 20-m spacing using the ARC/INFO TINLATTICE and LATTICEGRID commands. Approximately 450,000 points were computed to cover the SINERR and surrounding watershed areas.

Final products in digital format included a map database, image mosaic and DEM. Eleven 1:5,000-scale topographic maps in hardcopy format were produced of the study area. In addition, the digital mosaic was draped over the DEM to provide perspective views of the SINERR environment (Figure 4).

Land Use/Cover Maps and GIS Change Analysis

Color infrared (CIR) film transparencies of 1:60,000 scale recorded in 1987 were available for thematic mapping of land use, marshland species distributions and upland vegetation types. Photographic paper print enlargements (at 1:27,000 scale) of the CIR transparencies were taken to the marsh to determine the relationship between "signatures" and the species composition of marsh plant communities, upland vegetation types and land uses. This "ground truth" information aided the interpretation of marshland/

to coincide with the morning low tide so as to facilitate topographic delineation of the marshlands. The low altitude (1:16,000-scale) aerial photographs were subsequently sent to John F. Kenefick Photogrammetric Consultant, Inc., Indialantic, Florida where a photogrammetric block adjustment was performed to establish X, Y and Z terrain coordinates for 83 additional points (Figure 3). The combined GPS and aerotriangulation points then provided an adequate framework for detailed mapping of the SINERR by photogrammetric techniques.

The aerial photographs were scanned at a resolution of 300 dpi and input to a PC on which the DMS software package was operational. These photographs in digital format were then rectified to the aerotriangulation points and mosaicked together to create a unified digital image (6,000 pixels by 12,666 lines) of the entire study area (Plate 1). With this digital mosaic, it was possible to extract and tag planimetric features such as roads, rivers and shorelines using the interactive planimetric mapping options of the DMS. The resulting vector files were accurate to approximately ± 1 to ± 2 m and employed to create ARC/INFO coverages of the study area.

Terrain elevations for the study area ranged from sea level to slightly over 9 m. Contours at an interval of 1 m and spot heights accurate to about ± 0.1 m were produced directly from the 1:16,000-scale film transparencies using a

SAPELO ISLAND
AEROTRIANGULATION
CONTROL POINTS

FIGURE 3
Sapelo Island ground control network established by photogrammetric aerotriangulation techniques.

FIGURE 4
(a) 3D perspective view of the southern portion of Sapelo Island displayed as a wireframe DEM; and (b) air photo mosaic draped over the Sapelo Island DEM.

upland vegetation and land use boundaries which were delineated on clear plastic overlays registered to the CIR paper print enlargements. The vegetation and land use class boundaries were digitized in vector format from the overlays, rectified to the ground control layout from the 1989 aerial photographs to an estimated accuracy of \pm 6 m (\pm 0.22 mm at the photo scale) and input to ARC/INFO to create planimetric coverages that depict marsh/upland vegetation and land use for 1987.

The 1987 land use/land cover data set was subsequently updated by overlaying these vectors on the digital photo mosaic with the aid of the DMS software package and by interactively revising vectors as required. The revised data were then transferred back to ARC/INFO where thematic attribute data also were updated to 1989. In addition to current vegetation and land use data sets, historical aerial photographs recorded in 1953 and 1974 were used to map past conditions in the SINERR marshlands and surrounding upland areas. Ground control was transferred from the 1989 photographs to insure registration of datasets from different dates.

After digital data sets were established for 1953, 1974 and 1989, change analyses were conducted. Changes in the SINERR marshland and surrounding uplands were determined for the time intervals 1953 to 1974, 1974 to 1989, 1953 to 1987 and 1953 to 1989 using ARC/INFO overlay operations (Plate 2). The change information was used by SINERR managers to examine the overall physical changes in Sapelo Island due to coastal erosion and deposition, and relationships between logging practices, population distribution and agricutural clearings.

GIS Database Development for National Parks/Preserves in South Florida

The CRMS is currently working in conjunction with the U.S. Department of Interior's National Park Service (NPS) to construct a GIS database and associated detailed vegetation maps for over 6,000 mi^2 of ecologically unique Everglades wetlands in South Florida, including Everglades National Park, Biscayne National Park, Big Cypress National Preserve and the Florida Panther Refuge (Welch, et al., 1995). These vast South Florida wetland areas, collectively referred to as the "Parks", are threatened by urban expansion, nutrient runoff from agricultural lands, encroachment of exotic plant species, increased recreational use and episodic disturbances such as Hurricane Andrew in 1992 (Duever et al., 1986; Doren et al., 1990; Davis and Ogden, 1994). Extending roughly from Miami on the east to Naples on the west, southward to Florida Bay, the Parks represent the remaining lands of the greater Big Cypress Swamp and Everglades ecosystems that once covered approximately one-third of the Florida peninsula (Light and Dineen, 1994) (Figure 5). Preservation of the natural vegetation within these parks is of national concern and requires detailed information on vegetation distributions, along with planimetric features such as roads, rivers and canals. In order to meet these objectives and construct a GIS database in digital format, it was necessary to: 1) accurately geocode satellite images and develop techniques for using control transferred from the satellite images to rectify several hundred aerial photographs; 2) establish efficient photo-interpretation and feature encoding procedures compatible with a vegetation classification system that takes into account vegetation species, human impacts and hurricane damage; and 3) integrate GPS surveys with attribute recording and digital image processing on a laptop computer to facilitate the real time collection of ground truth information by helicopter surveys.

GPS Surveys and a Satellite Image Mosaic for Controlling Aerial Photographs

In order to meet the initial objectives of providing a geocoded satellite image mosaic and to ensure the registration of vegetation, transportation and hydrographic features in a GIS database, it was first necessary to establish a network of GCPs adequate for rectifying eight SPOT panchrometric images (10-m resolution) of the study area. Past experience has shown that because of their excellent

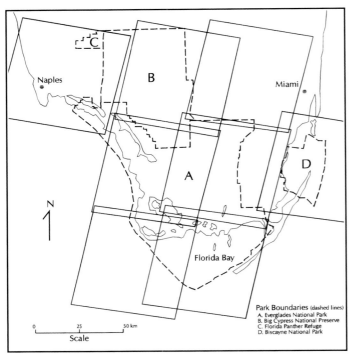

FIGURE 5
The South Florida National Parks and Preserves study area is shown by a dashed line. SPOT images employed to create a geocoded mosaic are indicated by solid lines.

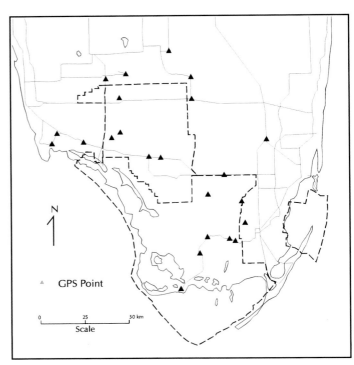

FIGURE 6
Distribution of 23 GCPs established by a GPS survey in 1994 along the roads through the Everglades National Park and Big Cypress National Preserve.

internal geometry, only 4 to 6 GCPs per image are required to geocode a SPOT satellite image to a planimetric accuracy of ± 0.5 to ± 1.0 pixel - or ± 5 to ± 10 m on the ground (Welch, 1985). Such accuracies are compatible with NMAS for 1:24,000 scale maps and were considered acceptable for densifying the horizontal control points needed to rectify the aerial photographs from which the database would be constructed.

The survey to establish GCPs was influenced by the existing road network and by the availability of 1:24,000 scale topographic line maps of recent vintage for the lands adjoining the Parks. Thus, it was decided to use the existing maps for perimeter control and to conduct the GPS survey along the few roads through the middle of the study area to provide the interior control necessary to rectify the satellite images. Control points included the intersections of roads and of roads and canals, both of which are easily located on the SPOT 10-m panchromatic images. In addition, the survey included eight monumented National Geodetic Survey (NGS) and Florida GPS (FLGPS) base points of Order B (1:1,000,000) accuracy (or better) which were used to adjust the network. Based on checks conducted in the post-processing adjustment of the GPS observations, the accuracy to which the UTM coordinates of the 23 points were established as referenced to NAD 83 was about ± 0.05 m ($RMSE_{xy}$) (Figure 6).

The SPOT image mosaic was created from individual SPOT scenes using the DMS software package. Each digi-

tal SPOT image (or tile) was rectified to the UTM coordinate system using 6 to 15 GCPs per image and then placed at its correct location (according to the UTM coordinates of the upper left corner pixel) within a coordinate box for the entire study area. Once the mosaic was assembled, a median filter was employed to minimize banding and reduce artifacts along the margins of overlap between adjacent images. In order to facilitate its use, a UTM grid (NAD 83) with 5,000 m spacing was registered to the mosaic (Figure 7). The planimetric accuracy of the geocoded mosaic was evaluated at 29 withheld control points (check points) and found to be better than ± 1.5 pixels. The mosaic occupies slightly more than 200 Mbytes of disk space.

Interpretation of Aerial Photographs for the Development of a Vegetation Database

Color infrared aerial photographs of 1:40,000 scale acquired as part of the NAPP in 1994 and 1995 were purchased for the entire South Florida study area (Plate 3). In order to expedite the interpretation of these photographs and facilitate the construction of vegetation coverages in digital format, vegetation classes were delineated directly on CIR paper print enlargements (4x) produced from the CIR film transparencies. This approach was determined to be easier and more efficient than scanning the photographs and working in a softcopy environment. Point features common to both the SPOT images and the analog air

photo enlargements were annotated, numbered and their UTM coordinates determined from the geocoded SPOT images to establish a GCP file for each CIR photograph (Plate 4).

The GCPs transferred to the photographs were then digitized, along with the vegetation polygons and other point and line features. By digitizing the GCPs first, a set of photo rectification coefficients were generated that allowed x,y digitizer coordinates for the vegetation polygons to be transformed to UTM map coordinates (Easting, Northing). This procedure permitted a segregation of tasks (interpretation, digitizing, editing) and greatly facilitated the development of the vegetation database. To further improve digitizing efficiency in areas of complex vegetation patterns, clear plastic overlays with annotated vegetation boundaries were scanned at 65 μm resolution and accessed by the VTRAK software package (Laser-Scan, Inc.) for automatic vectorization and input to ARC/INFO. Tests conducted to assess the accuracy to which the features were digitized yielded $RMSE_{xy}$ values of between \pm 5 and \pm 10 m.

Vegetation Classification and Field Verification with GPS Assisted Helicopter Surveys

Since existing vegetation classification schemes did not contain the level of detail required for this vegetation mapping project, a new Everglades Vegetation Classification System was developed in conjunction with personnel from both the NPS and South Florida Water Management District (SFWMD). This classification system includes: 1) vegetation classes at the individual species or species association level that can be identified from the CIR aerial photographs; and 2) a hierarchical organization that allows classes to be readily collapsed for compatibility with existing vegetation classification schemes being used elsewhere in South Florida. In addition to the floristic characterization of the naturally occurring Everglades plant communities, the classification system includes categories of invasive exotic plants, indicators of human influence such as off-road vehicle (ORV) trails and three hurricane damage classes. In this way, the Everglades vegetation database conveys details on current existing vegetation, as well as human impacts and episodic disturbances that influence vegetation species distributions.

Fieldwork to establish correlations between photo signatures and vegetation classes was greatly facilitated by the use of NPS Bell Jet Ranger 206 helicopters that are available for ground truth collection and verification of image interpretations. However, helicopter flight time is expensive ($650.00/hr), and a procedure involving use of the SPOT image mosaic and the latest technology in laptop computers, GPS receivers and image processing/positioning/display software has been developed to expedite data collection and verification. The helicopters are equipped with GPS receivers that enable the pilots to pre-define their flight track, conduct real time navigation guided by the GPS unit and to record the coordinates of landing points or features of interest. In order to maximize the advantage of this posi-

FIGURE 7
A portion of the SPOT image mosaic (10-m spatial resolution) at the eastern boundary of the Everglades National Park with 5,000-m UTM grid (NAD 83) superimposed. Note the agricultural land use adjacent to the Park.

tioning technology, the SPOT image mosaic of 10-m pixel resolution was aggregated to a mosaic of 20-m pixel resolution and divided into four tiles, each about 13 Mbytes in size. These image files were then loaded into a '486' laptop computer (100 Mhz) along with the DMS and Field Notes (Pen Metrics, Inc.) software packages. A Trimble Pathfinder Professional (6 channel) GPS receiver with an external antenna mounted on the forward hull of the helicopter was then connected to the serial port of the laptop computer. This set-up enables a person in the rear seat of the helicopter to hold the computer on his or her lap, display the satellite image mosaic and track in real time the flight path of the helicopter (Plate 5). Most importantly, it provides a means of collecting ground truth information that is linked to coordinates provided by the GPS receiver. Upon reaching an area of interest, the helicopter circles at low altitude and/or lands to allow identification of plants. Species attribute information and additional notes pertaining to fire history or exotic control measures that may have influenced the area are entered into the computer and linked with the GPS coordinates. This procedure also can be used with vehicle or foot surveys.

A handheld digital camera, the Kodak Professional DCS 420 (1500 x 1000 pixels) is also being used to capture digital CIR and true-color images of plant species. Advantages of this system include: 1) resulting images are directly accessible by software packages such as the DMS and Adobe Photoshop for display and enhancement; and 2) positional information (via a Trimble Ensign GPS unit) and voice annotation can be linked with individual images for location recovery and the addition of attributes. In South Florida,

the digital camera was used both on the ground and in the helicopter to document representative plant species and build a digital photo key corresponding to classes of the Everglades Vegetation Classification System.

The data gathered during the ground and helicopter surveys are used to verify vegetation interpretations from the 1994/1995 USGS NAPP air photos. After verification, the digital vegetation boundary files, along with transportation and hydrographic data in digital format, are input to the ARC/INFO software package resident on SUN SPARCstation 10 and IBM RISC System 6000 workstations, edited, attributed and edge matched to create the GIS database. Tiles corresponding to the USGS 1:24,000 scale topographic quadrangle series are then plotted as hardcopy maps (Plate 6).

Conclusion

Today, the development of digital databases for GIS applications requires the integration of GPS, photogrammetric, image processing and GIS technologies. Before beginning a project, however, it is essential to establish end-product requirements. Accuracy criteria are particularly important. In most instances involving the construction of GIS databases for resource mapping applications some information will be derived from standard USGS map products which meet planimetric accuracy standards of between \pm 3 and \pm 7 m. Thus, a nominal figure-of-merit for planimetric accuracy is about \pm 5 m. This "standard" can be easily met using aerial photographs of 1:40,000 scale or larger recorded with modern mapping cameras. Such photographs are of sufficient resolution to achieve thematic classification accuracies of 85 percent or better for most Level III land use/cover classes delineated in polygons of one acre or larger.

In order to achieve "registration" of data layers in a GIS, consideration must also be given to datums and coordinate systems. The UTM grid coordinate system is preferred for most resource mapping applications, and the majority of maps and databases being constructed today with the aid of GPS surveys will be referenced to the NAD 83. Data obtained from USGS map sheets, however, will be referenced to the NAD 27, and translations must be applied to the NAD 27 UTM grid coordinates to convert them to NAD 83 values. These translations must be determined by the user with available software packages.

When extracting features from aerial photographs, some combination of analog, analytical and/or softcopy photogrammetry will be required in most instances. When using a softcopy photogrammetry approach, however, care must be taken to scan the aerial photographs at a resolution that provides adequate clarity of detail and sufficient measurement accuracy, while avoiding excessive data volume. Most resource mapping and GIS database construction tasks can be accomplished with photos of 1:40,000 scale and larger scanned at resolutions of 25 to 65 μm (1000 to 400 dpi). Photographs scanned at these resolutions can be manipu-lated on small computers. With the evolution of GIS software, provision is being made for the use of raster image data as a backdrop for vector compilation and revision. The use of orthophoto products as a reference base for GIS databases also is becoming increasingly popular.

Experience with applications such as resource database development for the Georgia coast and national parks/preserves of South Florida has revealed the advantages of using GPS and softcopy photogrammetry with GIS to facilitate rectification, analysis and verification of data. In the South Florida project, for example, GPS derived control was used to rectify satellite images and to create a satellite image mosaic that, in turn, served as a source of ground control for aerial photographs. Georeferenced to a standard ground coordinate system, the aerial photographs provide source information for the derivation/revision of thematic data layers such as vegetation and land use.

The efficient collection of field data via ground, vehicle and helicopter surveys for attributing database features and/or verifying the interpretation of remotely sensed data also is made possible by GPS. Innovative techniques that integrate GPS, image processing and GIS on laptop computers provide resource managers full mobility in the field and allow the rapid collection of ground truth information. It is expected that routine use of these techniques will lead to improvements in the thematic accuracy of resource databases.

The integrated use of GPS, photogrammetry and GIS for natural resources inventory, mapping and database applications is in an early stage of development. It is hoped that the procedures described here will prove valuable for studies of other remote and/or inaccessible areas to facilitate the generation of detailed databases vital for the preservation of unique environments.

Acknowledgements

Research projects reported herein were sponsored by the U.S. Department of Commerce, National Oceanic and Atmospheric Administration, under Contract Numbers NA89AA-D-CZ024 and NA90AA-H-CZ659; and the U.S. Department of Interior, National Park Service (NPS) through Cooperative Agreement # 5280-4-9006. The assistance of the Marine Institute, The University of Georgia, Sapelo Island, Georgia; the NPS South Florida Natural Resource Center (SFNRC), Homestead, Florida; Florida Department of Environmental Protection, St. Petersburg, Florida; South Florida Water Management District, West Palm Beach, Florida; SPOT Image Corporation, Reston, Virginia; Survey Resources International, Inc., Houston, Texas; Eastman Kodak Company, Rochester, New York; and Mr. William Harris of Global Satellite Surveys, Decatur, Alabama is gratefully appreciated, as are the efforts of the many CRMS personnel who have contributed to these projects.

References

Aronoff, S., 1989. *Geographic Information Systems: A Management Perspective*, WDL Publications, Ottawa, Canada, 294 p.

Berry, J., 1993. *Beyond Mapping: Concepts, Algorithms, and Issues of GIS*, GIS World, Inc., Fort Collins, Colorado, 246 p.

Cowen, D. J., Jensen, J. R., Bresnahan, P. J., Ehler, G. B., Graves, D., Huang, X., Wiesner, C. and Mackey, H. E., Jr., 1995. The design and implementation of an integrated geographic information system for environmental applications, *Photogrammetric Engineering and Remote Sensing*, 61(11): 1393-1404.

Davis, S. M. and Ogden, J. C. (Eds.), 1994. *Everglades: The Ecosystem and its Restoration*, St. Lucie Press, Delray Beach, Florida, 826 p.

Department of Natural Resources, 1985. *Sapelo Island National Estuarine Sanctuary Final Draft Management Plan*, Georgia DNR, Atlanta, Georgia, 226 p.

Doren, R. F., Whiteaker, L. D., Molnar, G. and Sylvia, D., 1990. Restoration of former wetlands within the Hole-in-the-Donut in the Everglades National Park, *Proceedings of the Seventh Annual Conference on Wetlands Restoration and Creation*, Plant City, Florida, pp. 33-50.

Duever, M. J., Carlson, J. E., Meeder, J. F., Duever, L. C., Gunderson, L. H., Riopelle, L. A., Alexander, T. R., Myers, R. L. and Spangler, D. P., 1986. *The Big Cypress National Preserve*, Research Report Number 8, National Audubon Society, New York, New York, 455 p.

Jensen, J. R., Rutchey, K., Koch, M. S. and Narumalani, S., 1995. Inland wetland change detection in the Everglades Water Conservation Area 2A using a time series of normalized remotely sensed data, *Photogrammetric Engineering and Remote Sensing*, 61(2): 199-209.

Light, S. S. and Dineen, J. W., 1994. Water control in the Everglades: A historical perspective, In, Davis, S.M. and J.C. Ogden (Eds.), *Everglades: The Ecosystem and its Restoration*, St. Lucie Press, Delray Beach, Florida, pp. 47-84.

National Oceanic and Atmospheric Administration, 1987. *Final Evaluation Findings for the Sapelo Island National Estuarine Research Reserve Covering the Period from February 1983 through April 1987*, Office of Ocean and Coastal Resources Management, National Ocean Service, National Oceanic and Atmospheric Administration, October 30, Washington, D.C., 20 p.

Remillard, M. and Welch, R., 1992. GIS technologies for aquatic macrophyte studies: I. Database development and changes in the aquatic environment, *Landscape Ecology*, 7(3): 151-162.

Remillard, M. and Welch, R., 1993. GIS technologies for aquatic macrophyte studies: Modeling applications, *Landscape Ecology*, 8(3): 163-175.

Spradley, L. H., 1996. Costs of softcopy orthophoto bases for GIS projects, *ISPRS Journal of Photogrammetry and Remote Sensing*, in press.

Welch, R., 1985. Cartographic potential of SPOT image data, *Photogrammetric Engineering and Remote Sensing*, 51(8): 1085-1091.

Welch, R., 1987. Integration of photogrammetric, remote sensing and database technologies for mapping applications, *Photogrammetric Record*, 12(70): 409-428.

Welch, R., 1989. Desktop mapping with personal computers, *Photogrammetric Engineering and Remote Sensing*, 55(11): 1651-1662.

Welch, R., 1992. Photogrammetry in transition - Analytical to digital, *Geodetical Info Magazine*, 6(7): 39-41.

Welch, R., 1993. Low-cost softcopy photogrammetry, *Geodetical Info Magazine*, 7(12): 55-57.

Welch, R., Remillard, M. and Alberts, J., 1991. Integrated resource databases for coastal management, *GIS WORLD*, 4(3): 86-89

Welch, R., Remillard, M. and Alberts, J., 1992. Integration of GPS, remote sensing and GIS techniques for coastal resource management, *Photogrammetric Engineering and Remote Sensing*, 58(11): 1571-1578.

Welch, R., Remillard, M. and Doren, R., 1995. GIS database development for South Florida's National Parks and Preserves, *Photogrammetric Engineering and Remote Sensing*, 61(11): 1371-1381.

COLOR PLATE 1

A 1989 digital air photo mosaic of Sapelo Island with digitized roads in register. Tidal creeks are shown in blue, hard surface roads in orange, unimproved roads in yellow, logging trails in magenta, and the landing strip in purple.

Land Use/Cover Changes
SINERR - 1953 to 1989

CRMS - UGA

LEGEND

SA	Clearing - Forest
Brackish Marsh	Clearing - Inland Marsh
Inland Marsh	Dunes - SA/Brackish Marsh
Forest (O, P)	Pine - Oak
Timbered Forest	Oak - Pine
Dunes	Forest - Timbered Forest
Clearing	Timbered Forest - Forest
Residential	Residential - Forest
Beach	Residential - Clearing
Water	Beach - Forest
Water - Beach	Beach - Mud Shoals
Water - Dunes	Beach - Dunes
Water - Mud Shoals	Beach - SA/Brackish Marsh
Water - Forest	Dunes - Water/Beach
Water - SA	
SA/Brackish Marsh - Water	
SA/Brackish Marsh - Dunes, P, O	
SA - Brackish Marsh	
Brackish Marsh - SA	
Clearing - SA/Brackish Marsh	

SA - **Smooth Cordgrass**, *Spartina alterniflora*
O - **Oak**, *Quercus* spp.
P - **Pine**, *Pinus* spp.

COLOR PLATE 2

Changes in marshland vegetation and land use/cover for the SINERR and Sapelo Island 1953 to 1989 generated using the ARC/INFO GIS System.

COLOR PLATE 3
Sample 1994 NAPP color infrared (CIR) aerial photograph of mangrove forest located on the west coast of Everglades National Park. Note the contrast between healthy mangrove (red) and damaged mangrove forest (green) caused by Hurricane Andrew.

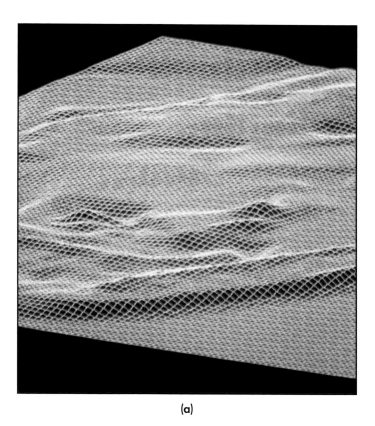

(a)

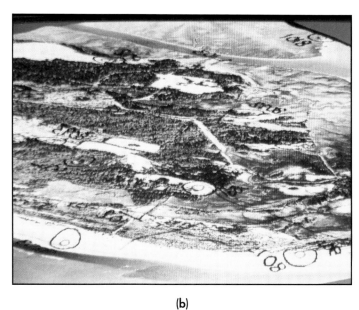

(b)

COLOR PLATE 5
Collection of ground truth is facilitated by the use of helicopters and by employing a laptop computer interfaced to a GPS unit and software for image display/attribute entry. The GPS continually tracks the helicopter. This track is displayed on the SPOT image mosaic and attribute information is recorded in real time. A pre-flight check-out and equipment set-up is illustrated in this photo.

COLOR PLATE 4 (a & b)
Features such as road intersections, tree islands, and small ponds can be located on both the CIR air photos (a) and the SPOT image mosaic (b). The UTM ground coordinates of such features are digitized from the SPOT image and provide planimetric control for the CIR aerial photographs.

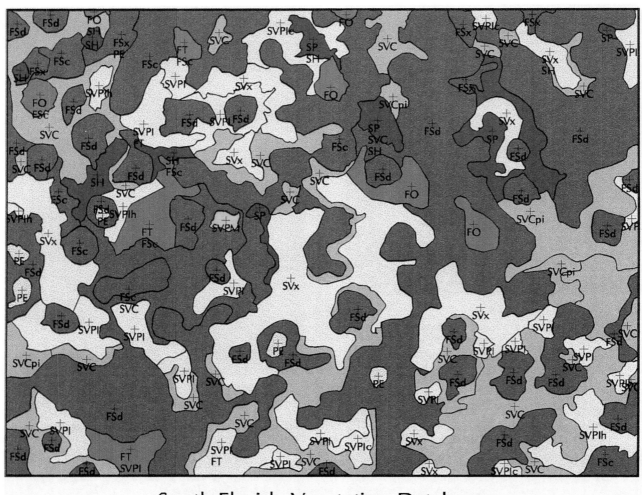

South Florida Vegetation Database

Vegetation Classes

FOREST (F)

■ Mangrove Forest (FM)
 Red (FMr)
 Black (FMa)
 White (FMl)

■ Swamp Forest (FS)
 Mixed Hardwood (FSh)
 Cypress Strands/Heads (FSc)
 Cypress Domes (FSd)
 Cypress Hardwood (FSx)
 Hardwood, Cypress, Pine (FSa)
 Cypress-Pines (FSCpi)
 Bayhead (FSb)

■ Other Forest
 Buttonwood (FB)
 Hammock (FH)
 Subtropical Hardwood (FT)
 Oak-Sabal (FO)
 Fan Palm (FF)
 Cabbage Palm (FC)

SAVANNA (SV)

□ Pine (SVPI)
 Pine / Palms (SVx)
 Pine / Hardwoods (SVPlh)
 Pine / Cypress (SVPlc)

□ Cypress (SVC)
 Dwarf cypress (SVCd)
 Cypress with pine (SVCpi)

□ Palm (SVPM)

□ PRAIRIES AND MARSHES (P)
 Graminoid (PG)
 Black Rush (PGj)
 Sawgrass (PGc)
 Muhly Grass (PGm)
 Mixed Graminoids (PGx)
 Emergent Marsh (PE)

■ SCRUB (S)
 Mangrove (SM)
 Saw Palmetto (SP)
 Hardwood (SH)

□ SHRUBLANDS (SB)
 Willow Head (SBS)
 Thickets (SBT)

■ EXOTICS (E)
 Cajeput (EM)
 Australian Pine (EC)
 Brazilian Pepper (ES)

■ Open Water (W)

□ Cultural Features

Hurricane Damage

□ 1 - Low

▨ 2 - Medium

■ 3 - High

N

0 300 600 m

COLOR PLATE 6
A vegetation map for a portion of Big Cypress National Preserve with complex vegetation patterns of cypress domes, pine savannas and hardwood forests.

CHAPTER 9

Feature Extraction And Object Recognition

Automatic Cartographic Feature Extraction Using Photogrammetric Principles

DAVID M. McKEOWN, JR., CHRIS McGLONE, STEVEN DOUGLAS COCHRAN, YUAN C. HSIEH, MICHEL ROUX, JEFFEREY A. SHUFELT

Introduction

Progress in the application of computer vision and image understanding to the analysis and interpretation of remotely sensed imagery has been slow. One hypothesis is that automated cartographic feature extraction (CFE) is a fundamentally hard problem, made harder by ignoring the additional metric and geometric information available from the use of photogrammetric techniques [McKeown, 1994]. In this chapter we describe how we have attempted to put our computer vision research on a rigorous photogrammetric basis.

Along with the algorithmic requirements, there are also practical reasons for the incorporation of photogrammetry. Research is becoming more applications-oriented; systems must increasingly work within a cartographic framework, using existing feature or terrain data and producing enhanced cartographic products such as visual simulation databases [Lukes, 1995]. Applying photogrammetry as a post-processing step has been a common theme in most of computer vision. That is, perform image-space computations and evaluations and, once the result is known, convert these measurements to a local coordinate system, generally using a single geodetic reference point. Our belief is that this approach will not work; each processing step within an algorithm must take into account the cartographic characteristics of its input and how its processing will affect the cartographic integrity of its output. An additional complication is the increasing availability and utilization of imagery from non-frame sensors, such as linear pushbrooms or line scanners, or from oblique viewpoints. The simple geometric models and assumptions which were adequate for vertical frame photography are will not serve for these modern types of images.

At the Digital Mapping Laboratory we are focusing our work on several aspects of the CFE problem while incorporating photogrammetric knowledge and techniques into existing algorithms, as well as designing new approaches based upon photogrammetric capabilities. The remainder of this chapter describes some of the types of information which can be obtained using photogrammetric techniques, then discusses the differences between photogrammetry in standard practice and the changes necessary for working in an automated environment. Finally, we describe several systems built by members of our research group using specific examples of how and why they utilize photogrammetry in their operation.

Types of Photogrammetric Information

Computer vision algorithms involve general AI problems, including search, hypothesis evaluation, and information fusion, as well as specific problems related to the problem domain, such as geometric reasoning and data representation. There are several types of information available from photogrammetric techniques which directly address these problems.

Position

Positioning is a fundamental photogrammetric capability, which at first might seem to have little effect on object recognition—after all, a house looks like a house, no matter where it is located. In fact, much useful information is location-specific—for instance, building height can be estimated using shadows, assuming that the date, time of day, and location are known. If an algorithm is to make use of existing digital cartographic data, it must be able to relate the data to the imagery of interest. To be cartographically useful, the results of an algorithm must be expressed in a geographic reference frame.

Measurements

The ability to generate linear or angular measurements in object space allows reasoning using meaningful quantities, independent of imaging geometry and viewing distance. For instance, rejecting building hypotheses less than 2 meters high is a much more general rule than rejecting those that are less than 8 pixels high.

Image and World Geometry

In the computer vision community geometry is most often exploited using the methods of projective geometry. These methods typically work in a non-Euclidean space, making the connection to real-world geometric and metric properties problematic. By anchoring the image geometry in the Euclidean world, photogrammetry enhances the power of purely geometric techniques. For example, knowing the orientation of the image allows the explicit calculation of vanishing points for lines of any orientation. For multiple images, we can rigorously calculate the epipolar geometry for use in stereo matching or for finding features across multiple images. We can also use geometric constraints on objects in the scene to add information to the solution.

Stochastic Information

One of the most important types of information to be gained from photogrammetric techniques is the ability to generate stochastic information about observations and calculated parameters. Least squares adjustment techniques allow us not only to estimate object parameters, but to produce an estimate of their precision. The precision information gives us an idea of how valid the estimated value is—values with large standard deviations indicate geometric weakness in the system. Covariance statistics can establish reasonable search ranges, for instance, when doing epipolar search the error bound in the direction perpendicular to the epipolar line can be calculated from the image orientation precision and used to constrain the search area. Covariances are also useful in merging newly acquired data with older data sets, in deciding what the relative weights should be. Reliability statistics are especially useful for automated systems, which can accept wildly bad data without question.

Design of a Photogrammetric Package for Computer Vision Research

Requirements for photogrammetric support of computer vision research are quite different from those for a general production environment. We must deal with a variety of sensor types and image sources, although seldom in the large blocks common in commercial work. In production systems triangulation is the main operation, while in our applications most of the effort is spent in computations after the image orientation is established; calculating object measurements, vanishing points, epipolar geometry, covariances, etc. Production systems emphasize the support of human efforts, chiefly by interface design and bookkeeping support, while leaving the interpretation of the scene to the human. Our main interest is in automatically understanding the scene structure, by bringing to bear prior knowledge of the scene, of image orientation, and of object geometry; therefore, we consider the types of photogrammetric information which best describe the scene and can be utilized by automated algorithms. Instead of using only a few manually-selected, high quality points or features, we must deal with large volumes of data of uneven quality. Approximations must be automatically generated and results automatically evaluated.

Our current photogrammetric capabilities of the are based on an object-oriented photogrammetry package, written in C for compatibility with existing code. The basic structure of the package is similar to that described in [McGlone, 1992]. Points and images are data objects, implemented as structures, while a world object contains ellipsoid parameters and various control variables.

Images may come from sensors with various geometries; models currently implemented include frame, orthoimage, multispectral line scanner, and linear pushbroom sensors. Each image object supports a primary set of methods, which includes the projection routines between object and image spaces, and auxiliary methods which perform input and output, calculate partial derivatives, and other such operations.

A central component of the photogrammetry package is the simultaneous multiple-image bundle adjustment program. The solution can involve images of differing geometries, such as frame and line scanner, and can use object space geometric constraints for additional information [McGlone, 1995]. All input parameters are weighted and full error propagation is performed on all output quantities. The generation of covariance information on derived parameters has proven to be nearly as important as the geometric calculations themselves, since it allows the specification of meaningful search bounds and more meaningful combination of different data sets.

A growing set of application routines computes image properties such as vanishing points, edge azimuths, and epipolar geometry. Applications are written around image methods, allowing them to be utilized for any sensor geometry which supports the required methods.

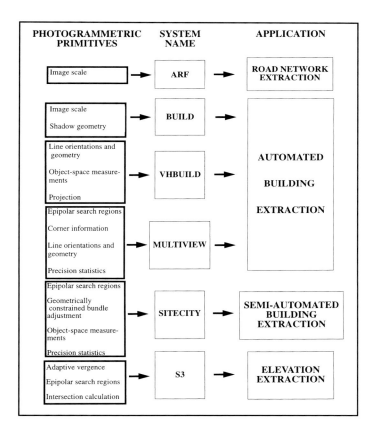

FIGURE 1
Utilization of photogrammetric information in MAPSlab systems.

Utilization of Photogrammetry in CFE

Figure 1 gives an overview of how we have incorporated several types of photogrammetric information into automated and semi-automated CFE systems in our laboratory.

Our earlier systems, such as the ARF road finding system and the BUILD building extraction system, are typical of older feature extraction systems without photogrammetric information. They used only rudimentary geometric information, such as image scale, and were applicable only to single frame nadir views.

By incorporating more photogrammetric knowledge into BUILD we have produced VHBUILD, which uses the image orientation information to predict possible vertical and horizontal lines in the scene. As described in the next section, these line labelings are used to generate, prune, and verify building hypotheses in a much more efficient and meaningful manner than was possible in the original BUILD system. Use of photogrammetric methods has allowed us to extend the system to oblique images, to calculate accurate object-space measurements for use in pruning hypotheses, and to generate 3D building models.

Our newer systems have been designed around our photogrammetric capabilities. The MULTIVIEW system, which performs automated building extraction using multiple ob-

lique images, makes extensive use of multiple image geometry in reprojecting points between images, in defining the epipolar search regions, and in its utilization of precision statistics to determine optimal matches.

SiteCity, a semi-automated building extraction system, also makes extensive use of multiple-image photogrammetry and measurement capabilities. A central part of the system is the geometrically-constrained bundle adjustment, which uses image point measurements on multiple images and assumptions about building geometry to produce precise 3D site models.

Stereo is a traditional computer vision problem, as well as a standard photogrammetric application. We are working on combining the two fields with the S3 system, using object-space matching of multiple oblique or vertical images. Using the image orientations, we can adaptively adjust the disparity search range to allow for the sloping ground plane in oblique images. With multiple images, knowing their precise relative orientation allows us to perform the matching in object space; this allows us to integrate the information from all views and great increase robustness and accuracy.

Very brief technical descriptions of several systems follow. The reader is encouraged to acquire the actual published papers and reports[1] that provide technical detail as well as performance evaluation. This chapter is not an exhaustive survey of the literature; excellent work is being done at a number of other research institutions [ARPA, 1994, IEEE, 1994, SPIE, 1993, SPIE, 1995]. Instead, it is hoped that the specific applications we discuss here will point out aspects of photogrammetry which can be applied to automatic CFE and to computer vision in general.

VHBUILD—Monocular Building Extraction

Building extraction is a fundamental problem in automated cartography [Huertas and Nevatia, 1988, Huertas et al., 1993, Irvin and McKeown, 1989, Liow and Pavlidis, 1990, McKeown, 1990, Mohan and Nevatia, 1988, Nicolin and Gabler, 1987, Shufelt and McKeown, 1993]. Monocular systems implemented to date have all used vertical aerial imagery, assumed simplified imaging geometry in their calculations, and all have used intensity features as the basic cues for feature extraction. Many of these techniques exhibit poor performance when building structures are composed of complex shapes or when viewing geometry, such as in oblique images, causes assumptions on image geometry to be violated. For robust performance, a building extraction system must make use of all available scene and image geometric information.

Our experiments have focused on the inclusion of geometric information into BUILD, a system for the detection of buildings in single vertical images, based on a line-corner analysis method. In brief, BUILD proceeds through four major phases to incrementally generate building hypotheses. The first phase constructs corners from lines, under the assumption that buildings can be modeled by straight line segments linked by (nearly) right-angled corners. The

second phase constructs chains of edges which are linked by corners, to serve as partial structural hypotheses. The third phase uses these line-corner structures to hypothesize boxes, parallelopipeds which may delineate man-made features in the scene. The fourth phase evaluates the boxes in terms of size and line intensity constraints, and the best boxes for each chain are kept, subject to shadow intensity constraints similar to those proposed in [Nicolin and Gabler, 1987] and [Huertas and Nevatia, 1988]. In addition, the results of the third phase of analysis are directly used as sources of building hypotheses for other modules that perform grouping, shadow analysis, and stereo matching.

This modified system, entitled VHBUILD, includes the use of a rigorous photogrammetric camera model, the use of world and image geometry as an additional cue for the building hypothesis construction process, and the substitution of exact metric calculations for distances and angles instead of approximations based upon image scale and near-nadir orientation. This section describes the VHBUILD system, with emphasis on the modifications made to incorporate the additional information made available by the use of rigorous photogrammetric knowledge.

Identification of Vertical and Horizontal Lines

As is well known from projective geometry, parallel lines in a scene meet at a common point, the vanishing point, in an image of the scene. Previous work has used vanishing points to determine image orientation [Barnard, 1983] and to determine the structure of objects within the scene [Brillault-O'Mahony, 1992].

However, most previous work using vanishing point geometry has been done with imagery of objects at close range with large perspective effects and long edges. In aerial imagery perspective effects are lessened and vertical lines are typically only a few pixels long. Therefore, our approach starts with the standard cartographic assumption that the orientation of the aerial image is known beforehand. Instead of using the vanishing point to determine image orientation, we calculate the vanishing point from the image orientation and focus on using the vanishing point geometry to assist in extracting buildings.

In order to find vertical lines in the scene, edges below a minimum length are discarded. Remaining edges are then fit to a line through the vanishing point and eliminated if the rms error of the residuals exceeds 2.0 pixels. As a further test, a line not constrained to pass through the vanishing point is also fit and the direction of that line compared to the direction from the centroid of the edge to the vanishing point. If the directions do not agree within 0.2 radians, the line is eliminated.

In earlier versions of this work we identified horizontal vanishing points using a variant of the Gaussian sphere technique [Barnard, 1983, McGlone and Shufelt, 1994]. Instead, we now directly calculate object-space azimuths for each edge in the image, assuming that the edge is horizontal, and accumulate the azimuths in a histogram. Since man-made structures are typically defined by perpendicular sets of parallel lines, we examine the azimuth histogram for such lines. We add the score of each bin to the scores of the bins representing directions perpendicular to it; the maximum of this sum indicates the directions of the stron-

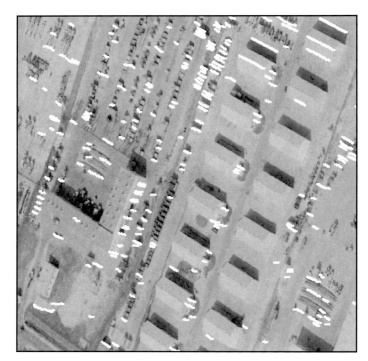

FIGURE 2
Horizontal edges.

FIGURE 3
Vertical edges.

gest mutually perpendicular sets of parallel lines in the scene.

The candidate horizontal and vertical edges for an oblique image of an area within Fort Hood, Texas, are shown in Figures 2 and 3. The raw edge data was obtained from a Nevatia-Babu line finder [Nevatia and Babu, 1980]. Some edges were labeled as both horizontal and vertical due to the viewing angle of the image, which happened to align many of the horizontal edges with the vertical vanishing point.

Corner Detection with Line Attributions

Horizontal and vertical edge segment attributions are useful cues in assembling building hypotheses, under the assumption that man-made features in aerial photography can be modeled by parallelopipeds joined at edges. We illustrate their utility in the context of VHBUILD, a building extraction system originally designed for analysis of nadir and near-nadir images.

VHBUILD begins processing by generating intensity edges, then applying a range search to locate and connect collinear edges whose endpoints are in close proximity to allow for fragmented edges. Another range search is then performed to locate edges which meet at approximately right angles, to determine corner points. VHBUILD then uses these corner points to link sequences of edges into chains of edges which can form parallelopipeds.

Even when a building can be modeled perfectly by a rectangle, the chain of edges representing it may not be a closed structure, due to extraneous or missing corners in the chain. VHBUILD addresses this problem by generating building hypotheses, i.e., boxes, for every subchain of edges in a chain. This is accomplished by taking every subchain of at least two edges and completing them to four-sided boxes. Typically, only about 10% of the boxes generated for a scene correspond to buildings. VHBUILD's verification phase selects building candidates from the boxes generated in the previous phase by examining the boxes for indications of a shadow region along the shadow casting edges.

Under an oblique viewing geometry, VHBUILD's model first breaks down in the corner detection phase, since right-angled corners in the scene will not in general project to right-angled corners in the image. In fact, the actual angle depends not only upon the obliquity of the viewing geometry, but on the position and orientation of the building in the scene.

Using the horizontal and vertical line identification techniques described in the previous section, we can assign attributions to each edge prior to corner generation. We can then make use of simple flat- and peaked-roof building models, shown in Figure 4. Each distinct line segment in the diagram has been assigned a label, indicating whether it is a vertical or horizontal line in object space, or whether it is neither.

It is worth noting that VHBUILD does not explicitly use this simple model in its processing phases; there is noth-ing in principle that prohibits an extension to VHBUILD for constructing more complex shapes by joining these rectangular or pentagonal facets. The model is useful, however, for visualizing the relationships between horizontal, vertical, and unlabeled lines in typical man-made structures.

These properties of building facets suggest the following set of heuristics for corner detection:

- Two intersecting verticals never form a valid corner in object space.
- A horizontal-vertical intersection is allowed to form a corner.
- Two intersecting horizontals are allowed to form a corner, if their intersection in object space forms a right angle.
- An unlabeled line intersecting with a labeled line is allowed as a corner, since it is potentially part of a peaked roof.
- Two intersecting unlabeled lines are allowed to form a corner, as they may be part of a pentagonal facet; it should be noted, however, that the current version of VHBUILD will not generate pentagonal descriptions. We intend to pursue more general shape constructions in future work.

These heuristics must take into account the fact that a given line may be labeled as both horizontal and vertical, if the imaging geometry is such that the direction of the horizontal vanishing point for some set of lines is the same as the vertical vanishing point. They do so by allowing such lines to be regarded as both horizontal and vertical lines during corner formation.

Image Space Building Hypothesis Generation

VHBUILD generates structural hypotheses from the extracted corners, boxes which delineate structure in the scene. In the original implementation the only geometric constraint applied during line-corner linking and box formation was the right-angle constraint on corners. Now, we can apply our simple building model to prune geometrically inconsistent hypotheses.

For each box generated by VHBUILD, we examine the horizontal and vertical line attributions assigned to each line segment of the box. If the four attributions are consistent with the labelings of any building facet in the building model, the box is accepted. For example, a facet with alternating horizontal and vertical lines is consistent with a side facet of a building and would be accepted. If the four attributions do not match any of the allowable building facets, the box is rejected as being geometrically inconsistent.

Figure 6 shows the complete set of boxes generated by VHBUILD prior to the application of geometric labeling constraints; in this case, there are 3459 boxes. Figure 7 shows the set of 746 boxes left after the labeling constraints have been exercised. As the figures show, the labeling constraints

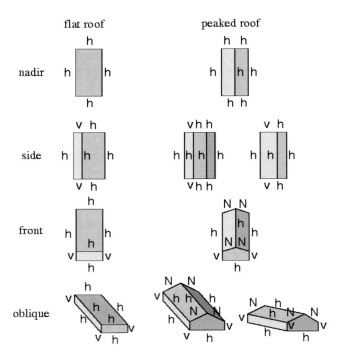

h - horizontal line
v - vertical line
N - unclassified line (neither horizontal nor vertical)

FIGURE 4
Simple building model.

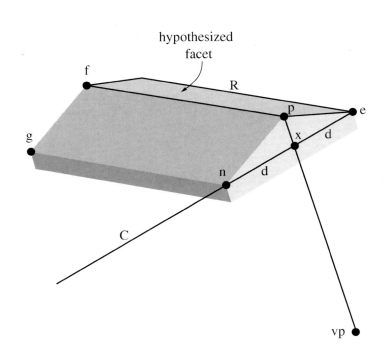

FIGURE 5
Peaked roof projection.

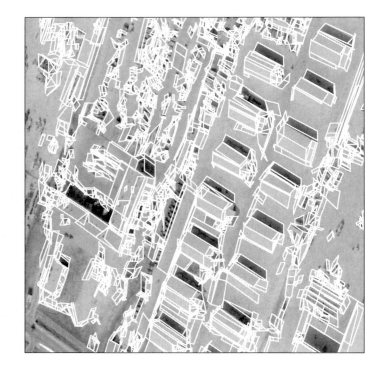

FIGURE 6
VHBUILD hypotheses.

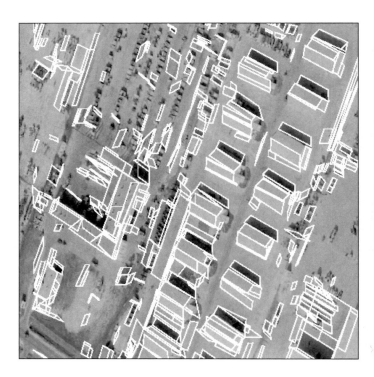

FIGURE 7
Geometrically consistent hypotheses.

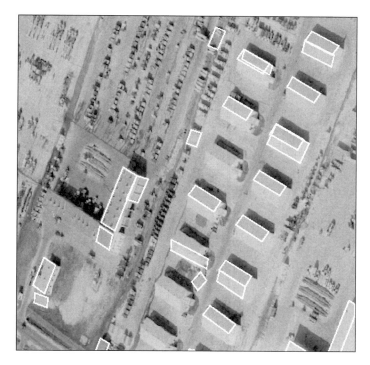

FIGURE 8
Original BUILD results.

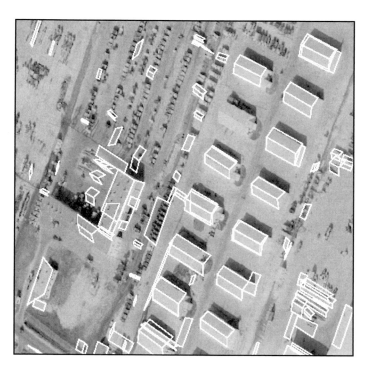

FIGURE 9
New VHBUILD results.

alone provide a strong constraint on the permissible hypothesis geometries.

After the application of the labeling constraints, the boxes are passed through VHBUILD's verification phase, which estimates shadow intensity and sun illumination direction and scores each hypothesis based on its conformance with these parameters.

After verification, we are left with a set of geometrically consistent hypotheses which are presumed to represent facets of three-dimensional structure in the scene. Using the scene geometry in conjunction with our building model, it becomes possible to extrapolate these partial delineations of building structure into more complete building models.

For example, we know that facets with alternating unlabeled and horizontal lines must be peaked roof facets. Starting from a hypothesized facet, as shown in Figure 5, we can use geometric constraints to extrapolate the missing half of the roof. We begin by computing the line perpendicular to the horizontal line R in object space, and projecting this perpendicular into image space (line C). Next, we intersect that line with the line drawn through the roof peak point **p** and the vertical vanishing point **vp**, to obtain a point **x**. In object space, the distance between **x** and **e** is equal to the distance between **x** and **n**; we assume that these distances are equal in image space as well, and complete the new building facet by using the roof peak point **p**, points **n** and **f**, and the application of symmetry to generate **g**.

Figure 8 shows the original BUILD results for the scene; Figure 9 illustrates the final image space result generated by our current extensions to VHBUILD. The major improve-

ment apparent from the figures is due to the peak projection technique, which has improved the modeling of peaked structures by correctly hypothesizing roof facets that were either lost in the shadow evaluation phase of VHBUILD or were never generated due to a lack of edge information.

Object Space Building Hypothesis Generation and Pruning

The delineation of building hypotheses in a single image yields only 2D models; for cartographic purposes, 3D building models are required. To obtain height estimates for the buildings two methods may be applied; shadow mensuration [Irvin and McKeown, 1989] and vertical line height calculation. Image space-based shadow mensuration techniques encounter difficulties in the oblique domain, due to the problems in associating shadow regions with roof regions, as well as general problems in reliably identifying and measuring shadow boundaries. Our current approach is to use the photogrammetric information to search for vertical lines in image space at roof corner points, then calculate the heights of these verticals in object space to obtain building height estimates.

Since we have object space dimensions for the building hypotheses, we can perform a pruning step based on object-space measurements instead of ad-hoc image space measurements, deleting any structure less than two meters in length, width, or height. Figure 10 shows a perspective rendering of the final models. The structures shown here have heights ranging from 2 meters, the pruning threshold, to

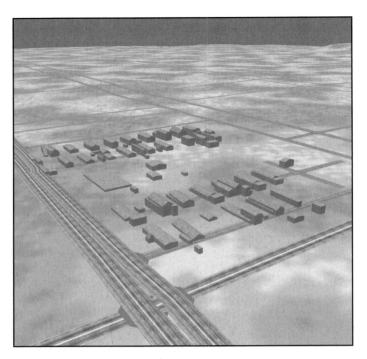

FIGURE 10
Perspective view of 3D building models generated by VHBUILD.

13.8 meters, and are qualitatively comparable to those measured manually.

MULTIVIEW—Building Extraction From Multiple Images

MULTIVIEW, [Roux and McKeown, 1994, Roux, et al., 1995] is a system which directly constructs three dimensional roof surfaces by matching salient building features extracted from different views. We view this work as complementary to the hypotheses produced by VHBUILD, in that it has the potential to relax the building shape constraint to include more general compositions of rectangular solids. Specifically, no assumptions are made concerning the three dimensional structure of the building roof, since both flat roof and peaked roof buildings are handled identically. We begin with sparse features (building corners) extracted from multiple views of the scene. This technique relies heavily on knowledge about the imaging geometry and acquisition parameters to provide rigorous geometric constraints for the matching process.

Figure 11 gives the broad structure of the MULTIVIEW research. We have been working on two different strategies: pairwise matching and multiple views. Pairwise matching uses two views to perform the initial construction of three dimensional corners and line segments, while the utilization of multiple views incorporates information from several views in order to solve hidden surface problems and to provide more accurate positioning of the three dimensional object models.

With pairwise views we use epipolar, height, and orientation constraints to match corners generated by VHBUILD. These image corner matchings provide three-dimensional corners in a local object space coordinate system, that form the nodes of a graph. Links between these nodes are created according to the image intensity gradient between the corners in both images.

In order to form polygonal surfaces we perform a search for cycles of corners and edges in the graph using geometric constraints such as planarity and perpendicularity in the object space. To reduce the complexity of the cycle generation algorithm only the best links, according to the image intensity gradient, are used to generate cycle hypotheses. Weaker links are then used to fill in missing information and to complete the propagation of these hypotheses. This polygonal search allows us to find buildings composed of multiple rectangular solids.

There are many challenges in the robust implementation of this matching approach. These include the combinatorics of feature matching when such techniques are applied to large images containing multiple buildings, issues that arise from the use of highly oblique views, and errors that occurs in the calculation of the actual three dimensional position of the matched features. However, the use of rigorous photogrammetry provides several tools for solving or reducing the impact of many of these problems.

Using the primitives generated by the pairwise matching approach, a complete system integrating information

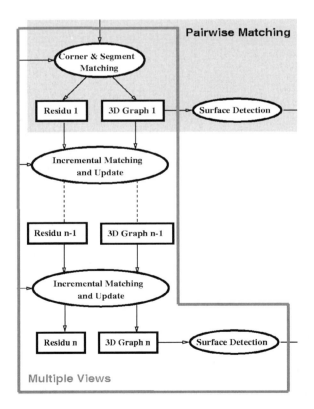

FIGURE 11
Surface extraction from multiple views.

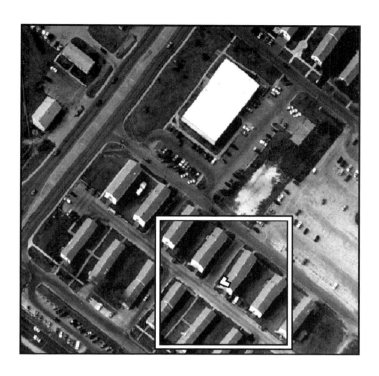

FIGURE 12
Corner in RADT5 to match.

FIGURE 13
All corners in RADT5OB.

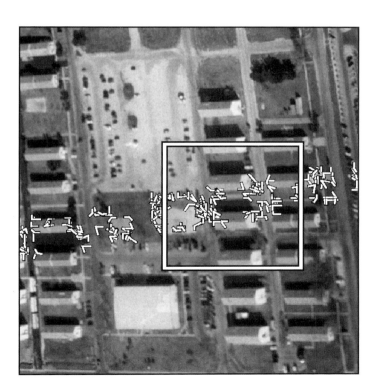

FIGURE 14
Corners in RADT5OB along epipolar band.

FIGURE 15
Corners in RADT5OB pruned by height.

from multiple views has been developed. Each new image viewpoint adds new object surfaces not previously seen and provides additional observations of existing surfaces. These additional observations add information since there are usually significant changes in illumination and viewing geometry. The accumulation of multiple views also reduces potential mismatching due to accidental alignments and increases the three dimensional positioning accuracy of derived object models by simultaneous solution of the collinearity equations. Within the general framework of analysis of multiple views many plausible approaches can be investigated: pairwise structure combination, simultaneous solution of the three dimensional position of the features, etc. The approach developed here is based on the successive incorporation of new image data into an existing partial solution.

Figure 11 depicts the information flow for the complete system. Pairwise matching using data from the first two images provides an initial graph of 3D segments. The relationships between corners and lines in the graph are successively updated with the acquisition of new image data. Surface detection can be performed on the updated graph after each step of the process or it can be deferred until the graph contains information from all of the available imagery. Our results show that better building hypotheses are obtained when we are able to integrate as many images as possible.

Corner Matching Using Photogrammetric Constraints

Our building detection process begins with the matching of corner hypotheses extracted independently from each monocular view by VHBUILD. We attempt to match each corner in the first image with all plausible corners in the second image.

To avoid brute force search, we use the epipolar constraint to establish a band of corners on the second image which could correspond to the corner under consideration on the first image. The width of the search band is determined by the uncertainty of the relative orientation between the two images, a function of the precision of the image resection procedure [McKeown and McGlone, 1993].

To limit search along the epipolar line, only the portion of the line corresponding to "reasonable" elevations (above ground level and less than some maximum building height) is considered. This range can be quite broad so as not to exclude structures but still greatly reduces the number of corners to be considered. This problem is identical to the determination of the disparity search range for stereo matching systems.

Once the corner subset based upon epipolar swath and height have been generated it is possible to further reduce the candidate set using two additional geometric constraints: corner consistency based upon edge labels and consistency in corner direction in object space.

FIGURE 16
Corners in RADT5OB pruned by height and corner type.

FIGURE 17
Corners in RADT5OB pruned by height and orientation.

Edges are labeled as horizontal, vertical, or neither using the vanishing point analysis described previously. The VHBUILD corners have additional information attached that define the types of edges used to form the corner (horizontal-horizontal, horizontal-vertical, etc, in all combinations except vertical-vertical). These corner types are used as part of the matching process to eliminate invalid matches; a horizontal-vertical corner should not match a horizontal-horizontal corner, for instance [McGlone and Shufelt, 1993].

Another geometric constraint is the orientation of the corner in object space. For corners formed from horizontal lines, the object space azimuth of each line can be calculated from each image and directly compared. For other corners, the object space direction of the bisector of the corner is calculated as if it were horizontal and used to compare within a coarse range of angles. This allows corners with obviously dissimilar orientations to be pruned. From these sets of corners, more detailed matching based upon height and local consistency can be performed.

Figure 12 shows a portion of a test area, from a near-nadir image over Ft. Hood, Texas, containing barracks and other low buildings. The test area is approximately 600 by 600 pixels in size. One corner of a building in this image was selected to illustrate the matching of VHBUILD corners using photogrammetric constraints. Figure 13 shows each of the 2060 corners generated by VHBUILD in a corresponding oblique image of the test area. Corners are found primarily clustered around man-made structures such as buildings and vehicles, along roads, and at road intersections. With a single view and no constraint as to where buildings may be in the scene, it is difficult to avoid generating large numbers of corners that do not correspond to any part of a building in the image.

Figure 14 shows those corners within the epipolar constraint, using an uncertainty of about 15 meters on either side of the ideal epipolar line. This constraint reduced to 296 the number of corners that could be considered to match the original test corner. Figure 15 shows those corners along the epipolar swath whose height is from 10 meters below to 30 meters above the local ground plane, determined by intersecting the corner of interest with each potential matching corner and calculating the height. This reduces the number of matchable corners to 19. Figures 16 and 17 are produced by applying corner type and direction constraints to the set of corners in Figure 15. Of these corners only two have the same corner type, horizontal-neither, while three have compatible orientations. In this case the set intersection of these corners yields the correct corner corresponding to the corner in Figure 12.

Surface Extraction From a Single Image Pair

Once corners have been matched between images, we put them into a 3D graph structure, connected by "strong" and "weak" segments. Two corners are connected by a strong segment if they are connected by an intensity edge with nearly the same azimuth on both images. A weak segment has no edge in the original edge data, but shows some gradient in the image.

Finding surfaces now requires finding cycles in this 3D graph. In order to reduce the combinatorics of the standard graph search problem, we use various heuristics. Since we are looking for rectangular buildings, we require right angles at corners. We also eliminate corners at which all the segments connected to the corner are nearly parallel. Cycle search is reduced by finding good starting points for the search such as parallel strong segments of nearly the same length, or two strong segments making a right angle. Starting from these seeds, cycles are found and then tested for coplanarity. Completed cycles are tested for radiometric uniformity, to detect cycles corresponding to more than one surface in object space.

Surface Extraction From Multiple Views

The basic framework we have described previously for detecting roof surfaces in pairs of images can be extended to use multiple views for building extraction. With each new image that is added, new corner, segment, and surface data is merged into the 3D graph structure. This requires that we address two different issues: the verification and position update of corners, lines, and surfaces that have been previously generated, and the generation of completely new features due to the availability of a viewpoint not previously seen.

Points in the 3D graph are matched with the corners extracted from the new image. In principle this could be accomplished either in image space by projecting the 3D points into the new image, or in object space by tracing the line resulting from each 2D corner. The latter approach has been chosen for our system because it allows us to project all of the image data into the common object space coordinate system. This allows us to utilize the complete photogrammetric solution, including covariance information on the point 3D coordinates, to describe the final building structure. Matching is done using the Mahalanobis distance, weighting the distance from the candidate ray to the 3D point by the covariance matrix of the point's coordinates. If a match is obtained, an updated 3D position of the point is determined by a simultaneous intersection procedure using all the image measurements.

In order to be able to generate features not seen in the previous images, a second process has been added. It consists of corner matching and segment generation, as described previously, using the residual (unmatched) data from previous image analysis combined with the new image features that were not used during the graph update. This allows us to generate completely new 3D data not present in the previous 3D graphs.

The data generated during graph update and residual analysis are merged as a collection of 3D segments with their associated confidence. Surface extraction, as described in the previous section, can be performed on the resulting merged graph with strong and weak segments chosen according to their confidence.

FIGURE 18
3D surfaces from 3 views

FIGURE 19
3D surfaces from 4 views

FIGURE 20
3D surfaces from 5 views

FIGURE 21
3D surfaces from 6 views

FIGURE 22
Buildings generated with a DEM

FIGURE 23
Reprojection of buildings
on image K3

Building Generation

Once 3D surfaces have been generated, the next step is to form building hypotheses. As with the VHBUILD system described in the previous section, we consider two types of building hypotheses: peaked roof and flat roof buildings. Peaked roof buildings are generated with oblique surfaces with the additional constraint that if two rectangular surfaces are adjacent and have compatible slope, only one building hypothesis will be generated. Flat roof building are generated with horizontal polygonal surfaces. These buildings can have more than four sides, and therefore can represent arbitrary compositions of rectangular solids.

As mentioned earlier, there are several possible approaches for building height estimation. The MULTIVIEW system currently uses both a DEM and vertical building edges to estimate building heights.

Figures 18 through 21 show the results of 3D surface generation on a portion of the modelboard scene using images J2, J4, J6, J8, J24, and J25. The figures clearly demonstrate the influence of additional views as we integrate from three to six images. In these results a confidence threshold of three (images) has been used for strong segments and a confidence of two for weak segments. Such low values are required by poor contrast in most images between dark buildings and their shadows, such as for the building at the top left of the scene.

This scene exhibits a large number of geometric complexities. The roof surface that first appears in the lower left of Figure 19 is actually occluded by the building adjacent (to the right) in the image. This occlusion occurs in three of the input images. This demonstrates that it is important to be able to integrate information from a collection of complementary viewpoints in order to minimize the chance that object structures will be only partially correct or missed entirely.

Figure 22 shows the full three dimensional buildings generated from the surfaces in Figure 21 using the DEM to compute height estimates as described in the previous section. Figure 23 shows the reprojection of the same buildings into another image, not used to construct the 3D graph, demonstrating the positional accuracy achieved by the simultaneous solution of object space feature positions during the graph update process.

SiteCity—Semi-Automated Building Extraction

While much of the research at the Digital Mapping Laboratory has addressed automated feature extraction methods, semi-automated methods also merit attention. Our philosophy is to first optimize the automated components as much as possible, in terms of robustness and speed, then to integrate them with the minimum human interaction possible to provide top-level guidance and initialization and to approve or edit results. As is often noted, humans and computers have complimentary strengths; humans excel at scanning large areas and in recognition of objects, while computers are best at optimization, detailed delineation, and repetition. However, it is obvious that unless the automated techniques involved function at a high level of reliability there is no productivity gain involved in the combination of human and computer.

SiteCity [Hsieh, 1995] combines an interactive building modeling capability with many of the automated algorithms developed for our work in automated building extraction, built upon a rigorous multi-image photogrammetric foundation. The operational flow is completely flexible and under the operator's control. To illustrate the integration of automated and manual processes, we describe a typical scenario.

The operator typically begins by delineating the outline of a building roof in one image. If the building has a peaked roof, the system can automatically find the peak. The height of the building can be found automatically by searching for the vertical building edges at the roof corners (along a line toward the vertical vanishing point) and the floor lines at the bottom of the building. If these automated processes fail, the operator can adjust the height of the building manually.

The next step is to locate the building in the other images. The system projects the preliminary building model from the first image into the other images, using elevations from a DEM, then searches along epipolar lines to find the precise location of the building. Search bounds around the epipolar lines are determined using the image orientation covariance information, while the search range along the epipolar lines is set using expected elevation bounds and building heights.

Automated verification of the building in the other images is based on a combination of several different criteria; since we have a 3D building model, we can use the full geometry of the building as well as scene knowledge to aid in the verification. Model edges are verified against detected image edges, excluding lines in the model which are hidden in that view. If no edge has been detected at a location predicted by the model, the image gradient is re-examined for evidence of an edge. Shadow verification is also used, based on predicted shadow edges cast by the model and also on shadow regions identified by intensity.

Once the building has been verified in all images, the final geometric model is calculated using a simultaneous bundle adjustment with geometric constraints [McGlone, 1995]. This produces the best estimate for building measurements and geometry, along with precision statistics for the building parameters.

Since the system is interactive, there are many different ways in the task can be accomplished, depending upon prior information (the operator can update or edit an existing site model), scene characteristics, or available imagery. For example, many scenes contain a number of identical or similar buildings. In this case, the operator can delineate a typical building, then command the system to find similar buildings by specifying a point contained in the similar building, a line which crosses a group of similar buildings, or an area which contains a group of similar buildings.

Figure 24 shows a typical SiteCity screen, working with

two oblique images and one vertical image. The extracted buildings are superimposed on the images and also shown in a 3D display.

SiteCity has proven to be an effective and efficient system thus far in the informal evaluations we have conducted during development. We are still conducting rigorous evaluations of the usability of the system, the improvement in operator efficiency due to automation, as well as trying to identify further tasks which could be profitably automated.

S3—Multiple Image Object-Space Stereo Matching

We are extending the idea of working in object-space as opposed to image space in a new, multi-image approach to area-based stereo matching, in a system we call S3 [McKeown, et al, 1994]. The key idea is to conduct the stereo search by selecting an initial vergence and evaluating

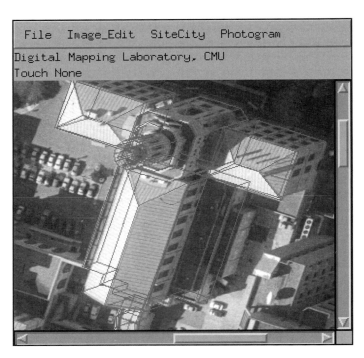

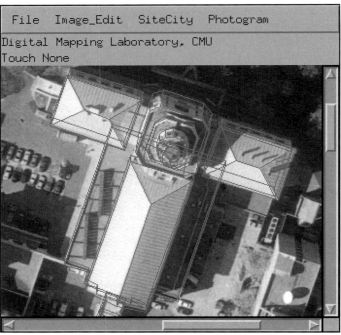

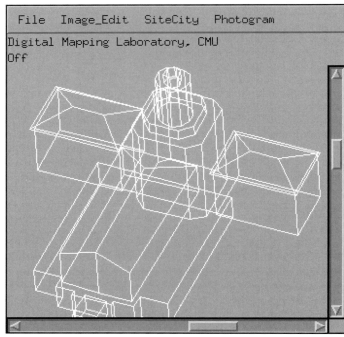

FIGURE 24
Building modeling using SiteCity.

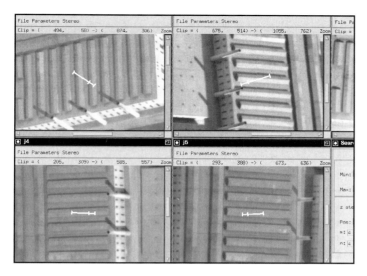

FIGURE 25
Epipolar search range between a set of images of the area of intrest and a hypothetical nadir view.

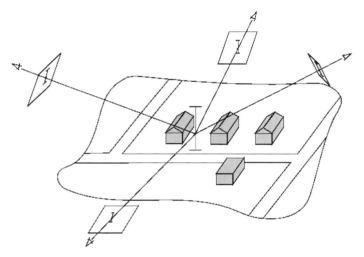

FIGURE 26
World view of the search range.

potentially matching pixels in the set of images by projecting a match window into each of the images and locating the best match (or matches) within the search range. The search range may be varied from the initial vergence position by moving the match window in object space or by adjusting its slope and tilt to match expected or hypothesized local surface conditions. A rigorous photogrammetric framework supports the simultaneous use of multiple images.

Figure 25 shows five RADIUS modelboard images that cover the same area of interest. In our initial implementation of this approach, we select a point in any one image, which, along with a DEM of the region or an estimate of the ground from the resection control points, is used to specify a "ground point" in object-space. The match window is placed tangent to the Earth's surface at this point and is projected into each of the images. This match window is allowed to

move above and below the initial (zero) vergence "ground point" in fixed steps. In the figure, the search range is between -5 and +45 meters with 0.25 meter steps. Figure 26 shows a world view of this type of search arrangement. The match window follows the epipolar line between each image and a line through the "ground point" to zenith.

In Figure 27 we plot the correlation of a single area viewed from the nadir along the indicated search range in image J1 (upper left image in Figure 25). This gives us a close comparison with traditional area-based stereo matching. The differences are that we do not reproject the images into a collinear epipolar alignment, but travel along the epipolar projection and that the match window is aligned with the object-space local-vertical coordinate system rather than with the epipolar projection. Two sources of error are present in the results. First, the aliased area along the search range (the peak of the adjacent vent) appears as a slightly better match for the point and second, elevation of the correct match (the local minimum furthest to the left) is off from the 32.55 meter actual height of the selected point. This latter problem is due to residual distortions in the image. The best human selected match using this single image gives a height of 28.99 meters and is within a pixel of the correct local minimum found by the stereo process. In Figure 28 we plot a generalized multi-image correlation between all of the selected images by stepping along the search range in steps representing 0.25 meter elevations in object-space. For each point we plot the average of all pairs of two-image correlations. In this plot, we now see that the correct match has become the global minimum and the projection into object-space is better localized with a height of 32.75 meters, an error of 0.20 meters or about 1/5 pixel in image J1.

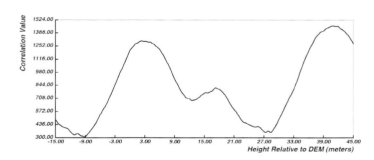

FIGURE 27
Area-based correlation along search range of image J1 with an incorrect global minimum due to aliasing and a 3.56 meter error due primarily to the projection into object-space being based on a single stereo pair.

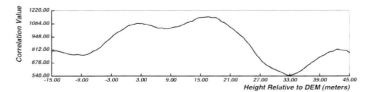

FIGURE 28
Area-based correlation of all five images over the same search range.

Some of the interesting attributes of this approach are that it automatically incorporates image warping [Norvelle, 1992, Quam, 1984] and adaptive vergence [Cochran, 1994a, Cochran, 1994b]. This is because the match window is projected into each of the target images from object space where, if there is sufficient a priori information such as a DEM or prior stereo estimate of the surface, the window will both track the ground surface, and may be fit to the local slope and tilt of that surface.

Pixel versus subpixel matching is now based on the projected size of the match window into each of the target images. Instead of setting a pixel size, we must now consider what to do when a cell of the match window is subpixel, what to do when it spans multiple pixels, and how to smoothly transition between these two extremes. We currently use a cubic interpolation when the cell size is smaller than a pixel, a weighted median average when the cell spans multiple pixels and a linear transition between these methods as the cell size grows between 1 and 2 pixels. In addition, as a side effect of using a photogrammetric approach to projecting the match window into the set of images, we can apply the stereo matching to images of different resolution. This latter effect may be of advantage as we begin using larger sets of images, covering a common area, which were not originally obtained as stereo pairs.

Since we are not comparing a single pixel in one image against a set of possible matches in another image, but rather a series of multi-pixel matches at different elevations, we have the possibility of having multiple matches. This occurs along vertical surfaces, such as building walls. We can use this feature along with hints provided from other algorithms such as monocular analysis, (VHBUILD) or from multi-view feature matching (MULTIVIEW) to orient the match window vertically along the expected wall surface, and to prefer multiple matches while looking for the points where the matches break off.

Finally, as we search for the best cluster(s) of views, we can also look for outliers from this cluster. This is especially interesting when a tight cluster exists among some views and a common set of outlier views are present for neighboring points in object-space. Therefore, this method of stereo matching has the possibility of labeling some spatial points as being occluded from some of the selected image viewpoints. It also will give us some constraints on the possible elevations for a point visible from these images at the corresponding image pixel.

Conclusions

The combination of photogrammetry and computer vision is having a broad impact in both areas, not only in a technical, algorithmic sense, but also in a sociological sense of bringing together two disparate communities, both approaching a common problem in different ways. The synergism of the application-oriented photogrammetric approach and the research emphasis of the computer vision community is leading both groups to new insights. This is fortunate, since the solution of the cartographic feature extraction problem will certainly require both new insights and new algorithms. While results to date have been promising, current feature extraction algorithms are not nearly robust and reliable enough for production applications at this time.

We are, however, confident that at some point in the future automated feature extraction will become an accepted technology. The interesting questions at that point will become how the automated processes are integrated into the production flow and exactly what the output product will be. History has shown that the automation of a technology leads to much more than just the exact replacement of existing tasks—computers are now much more than the adding machines they replaced. In what ways will the analogous transformation take form?

Acknowledgments

The research described in this chapter was supported by the Advanced Research Projects Agency (ARPA/SISTO) and the U.S. Army Topographic Engineering Center under Contracts DACA76-91-C-0014, DACA76-92-C-0036, by ARPA-ASTO under contract DACA76-95-C-0009. Student research and training support was provided by the U.S. Army Research Office ASSERT program under Contract DAAH04-93-G-0092.

Footnotes

[1]The Digital Mapping Laboratory's WWW Home Page may be found at: http://www.cs.cmu.edu/~MAPSLab.

References

Proceedings of the ARPA Image Understanding Workshop. Morgan Kaufmann Publishers.

Barnard, S., 1983. Interpreting perspective images. *Artificial Intelligence*, 21:435-462.

Brillault-O'Mahony, B., 1992. High level 3d structures from a single view. *Image and Vision Computing*, 10(7):508-520.

Cochran, S. D., 1994a. Adaptive vergence for stereo matching. In *International Archives of Photogrammetry and Remote Sensing: Spatial Information from Digital Photogrammetry and Computer Vision*, Volume 30, 3/1, pages 144-151, Munich, Germany. Commission III.

Cochran, S. D., 1994b. Adaptive vergence for the stereo matching of oblique imagery. In *Proceedings of the ARPA Image Understanding Workshop*, pages 1335-1348, Monterey, California. Advanced Research Projects Agency, Morgan Kaufmann Publishers, Inc.

Hsieh, Y. C., 1995. *Design and Evaluation of a Semi-Automated Site Modeling System.* Technical report, CMU-CS 95-195, School of Computer Science, Carnegie Mellon University, Pittsburgh, Pennsylvania 15213.

Huertas, A. and Nevatia, R., 1988. Detecting buildings in aerial images. *Computer Vision, Graphics, and Image Processing*, 41(2):131-152.

Huertas, A., Lin, C. and Nevatia, R., 1993. Detection of buildings from monocular views of aerial scenes using perceptual grouping and shadows. In *Proceedings of the DARPA Image Understanding Workshop*, pages 253-260, Washington, D. C., April 19-21 1993. Morgan Kaufmann Publishers, Inc.

IEEE. *Proceedings of IEEE Conference on Computer Vision and Pattern Recognition*, 1994.

Irvin, R. B. and McKeown, D. M., 1989. Methods for exploiting the relationship between buildings and their shadows in aerial imagery. *IEEE Transactions on Systems, Man & Cybernetics*, 19(6):1564-1575, 1989. Also available as Technical Report CMU-CS-88-200, School of Computer Science, Carnegie Mellon University, Pittsburgh, PA 15213.

Liow, Y. T. and Pavlidis, T., 1990. Use of shadows for extracting buildings in aerial images. *Computer Vision, Graphics, and Image Processing*, 49(2):242-277.

Lukes, G. E., 1995. Cartographic support for advanced distributed simulation. In *Proceedings of the SPIE : Integrating Photogrammetric Techniques with Scene Analysis and Machine Vision II*, Volume 2486, pages 176-185.

McGlone, J. C. and Shufelt, J. A., 1993. Incorporating vanishing point geometry into a building extraction system. In *Proceedings of the SPIE: Integrating Photogrammetric Techniques with Scene Analysis and Machine Vision*, Volume 1944, pages 273-284.

McGlone, J. C. and Shufelt, J. A., 1994. *Projective and Object Space Geometry for Monocular Building Extraction*. Technical Report CMU-CS-94-118, Computer Science Department, Carnegie Mellon University, Pittsburgh, Pennsylvania 15213.

McGlone, J. C., 1992. Design and implementation of an object-oriented photogrammetric toolkit. In *International Archives of Photogrammetry and Remote Sensing*, Volume XXIX, B2, pages 334-338.

McGlone, J. C., 1995. Bundle adjustment with object space constraints for site modeling. In *Proceedings of the SPIE: Integrating Photogrammetric Techniques with Scene Analysis and Machine Vision*, Volume 2486, pages 25-36.

McKeown, D. and McGlone, J. C. 1993. Integration of photogrammetric cues into cartographic feature extraction. In *Proceedings of the SPIE: Integrating Photogrammetric Techniques with Scene Analysis and Machine Vision*, Volume 1944, pages 2-15.

McKeown, D. M., Jr., Cochran, S. D., Gifford, S. J., Harvey, W. A., McGlone, J. C., Polis, M. F., Ford, S. J. and Shufelt, J. A., 1994a. Research in automated analysis of remotely sensed imagery: 1993-1994. In *Proceedings of the ARPA Image Understanding Workshop*, pages 99-132, Monterey, California. Advanced Research Projects Agency, Morgan Kaufmann Publishers, Inc. Also available as Technical Report CMU-CS-94-197, School of Computer Science, Carnegie Mellon University, Pittsburgh, PA 15213.

McKeown, D. M., Jr., 1990. Toward automatic cartographic feature extraction. In L. F. Pau, editor, *Mapping and Spatial Modelling for Navigation*, Volume F 65 of NATO ASI Series , pages 149-180. Springer-Verlag, Berlin Heidelberg.

McKeown, D. M., Jr., 1994. Top ten lessons learned in automated cartography. In *International Archives of Photogrammetry and Remote Sensing: Spatial Information from Digital Photogrammetry and Computer Vision*, Volume 30, 3/1, Munich, Germany, Commission III.

Mohan, R. and Nevatia, R., 1989. Using perceptual organization to extract 3-D structures. *IEEE Transactions on Pattern Analysis and Machine Intelligence*, 11(11):1121-1139.

Nevatia, R. and Babu, K. R., 1980. Linear feature extraction and description. *Computer Graphics and Image Processing*, 13:257-269.

Nicolin, B. and Gabler, R., 1987. A knowledge-based system for the analysis of aerial images. *IEEE Transactions on Geoscience and Remote Sensing*, GE-25(3):317-329.

Norvelle, F. R., 1992. Stereo correlation: Window shaping and DEM corrections. *Photogrammetric Engineering and Remote Sensing*, 58(1):111-115.

Quam, L. H., 1984. Hierarchical warp stereo. In *Proceedings of the DARPA Image Understanding Workshop*, pages 149-155. Defense Advanced Research Projects Agency.

Roux, M. and McKeown, D. M., Jr., 1994. Feature matching for building extraction from multiple views. In *Proceedings of IEEE Conference on Computer Vision and Pattern Recognition*, pages 46-53, Seattle, Washington.

Roux, M., Hsieh, Y. C. and McKeown, D. M., Jr., 1995. Performance analysis of object space matching for building extraction using several images. In *Proceedings of the SPIE: Integrating Photogrammetric Techniques with Scene Analysis and Machine Vision II*, Volume 2486, pages 277-297.

Shufelt, J. A. and McKeown, D. M., 1993. Fusion of monocular cues to detect man-made structures in aerial imagery. *Computer Vision, Graphics, and Image Processing*, 57(3):307-330.

SPIE, 1993. *Proceedings of the SPIE: Integrating Photogrammetric Techniques with Scene Analysis and Machine Vision*, Volume 1944.

SPIE, 1995. *Proceedings of the SPIE: Integrating Photogrammetric Techniques with Scene Analysis and Machine Vision II*, Volume 2486.

CHAPTER 10

Softcopy Photogrammetric Workstations

COORDINATED BY RAAD SALEH
EDITED BY CLIFFORD W. GREVE

Fundamentals of Softcopy Photogrammetric Workstations

EBERHARD GÜLCH

Abstract

The development in digital photogrammetry has been tightly connected to the design and realization of softcopy photogrammetric or digital photogrammetric workstations. The softcopy photogrammetric workstation is a symbol for a new philosophy in photogrammetry which is going to change the way of processing, performing and distributing the photogrammetric products. The fundamentals of such systems are described and their development over the last few decades is followed. The major features of the workstations are the use of digital images and the potential for measurement and interpretation by automated means in photogrammetric applications. With this tool even non-photogrammetrists can perform efficient 3D data capture. It has been realized that user interaction is required for validation and for most of the interpretation tasks today. There are controversial opinions on the necessary amount of automation of the mensuration and the interpretation that is required to make a softcopy photogrammetric workstation a distinct, universal tool and not just a substitute for an analytical plotter. There are many ways to design and implement system components. Some basic hardware and software components and their functionality are described.

Introduction

Softcopy or Digital Photogrammetry has become a very active field of research in the photogrammetric community in the last two decades. Numerous papers have been presented on the hardware and algorithmic aspects. We can find contributions on system concepts, on design aspects of systems, on the implementation and development of systems, on automatic or automated mapping algorithms and on all kinds of photogrammetric applications.

In this study we will concentrate on the fundamentals of softcopy photogrammetric workstations or digital photogrammetric workstations and we will follow the evolution of those fundamentals from the mid 50's until present. The term softcopy photogrammetric workstation is favoured in the US and Canada. We will here not distinguish between softcopy and digital photogrammetric workstations. We regard such a workstation as the core of a digital photogrammetric system, that can be extended with additional peripheral devices for input and output to build a complete system for photogrammetric applications.

The field of softcopy photogrammetric workstations is still young and under ongoing development. There is still considerable confusion and there exist controversial opin-

ions on various aspects of those stations. Our objectives are to extract those principles of a softcopy photogrammetric workstation, that are commonly agreed on, and to identify those that are controversial. To do so we will scan through the last 40 years of literature and we set up two breakpoints: the first fundamental concept of a softcopy photogrammetric workstation and the first realization of a softcopy photogrammetric workstation.

We will pick out papers from the period of ideas, scenarios and concepts starting around 1955 and lasting until 1981, when the first detailed concept of a completely digital stereo workstation was presented. It took about another seven years involving a period of design aspects and design concepts until the first realizations of hybrid or fully digital systems were reached in 1988. The third period until now, was a period where emphasis was put on the human interface, automation and specialization, with efforts to strengthen the interactive side of the workstations, to include automation tools and to develop specialized workstations for different applications.

We will describe essential hardware and software components and their functionality, but we will not discuss technical details or implementations.

The Period of Scenarios and Concepts (1955-1981)

We start our journey through literature with a paper on information theory and electronic photogrammetry (Rosenberg, 1955). He stated "information theory is a guide and aid in studying, evaluating, and developing old and new methods and instruments for photogrammetry, mapping, and surveying, including methods and instruments for the electronic automation of map compilation". The entire mapping process was regarded as a flow of information from the image recording to the map reading. A concept for a system for non-photographic photogrammetry was given with electronically recording or scanning images and storing the information into a modulated radio signal on magnetic tape. The analysis was planned to be done by electronic comparison, adjustment and matching to accomplish all photogrammetric and mapping processes like orientation, rectification, measurement of relief, etc. Rosenberg studied different possibilities of digital recording from aircraft, something which has come up again in the last few years (e.g. Thom and Jurvillier, 1993, Schneider and Hahn, 1994). But he stated "It will be a long time before completely automatic, electronic photogrammetry is actually at hand", thus foreseeing the difficulties we encounter today in developing a system, that could at least partly reach those goals he had described.

In 1958 Helava, who invented the Analytical Plotter (AP), described its advantages compared to analog instruments (Helava, 1958). We can ask of course, what has a softcopy photogrammetric workstation to do with an AP? Many people say "it is an AP using digital images", others say "nothing". So we have here one of the most controversial topics, that we should discuss. To prepare this discussion we need to know a bit more about the fundamentals of an AP. Helava defined the two main parts of an AP as fol-

lows: a viewing-measuring device and the computer (Figure 1). The AP was expected to, and truly did "improve the performance in photogrammetry" with respect to better economy, higher degree of accuracy and increased speed. It allows a high level of accuracy, it offers great versatility and it offers automation, especially for the orientation procedures. The latter seemed to be a major topic throughout the years with dramatic time savings for relative and absolute orientation. What we have to understand is the type of automation involved: it was reached through numerical calculation of the orientation procedures and not by the automation of any measurement involved, the human operator still had to set the floating mark by himself. To even automate that process Helava mentioned the possibility of replacing the human operator by a mechanical device, an electronic correlator (Hobrough,1959) to automate the contouring. With regard to feature extraction Helava named possible solutions for recording planimetric details by employing an electronic scanning and printing technique.

FIGURE 1
Two main parts of an Analytical Plotter (according to Helava, 1958). The human operator performs the measuring and the interpretation.

Sharp et al. (1965) described the Digital Automatic Map Compilation (DAMC) system for contour map and orthophoto production based on scanned images. The system used digital image correlation in a hierarchical way and an interesection operator, speaking in modern terms, for automating the parallax measurements. The human operator was required for stereoscopic identification and precise measurement of control points at a stereocomparator and for the final editing of maps. The critical point of the system was the quality of the scanning, as all further processes depend on it. Today it is the quality and the high scanning costs that attract our attention. Here we find three essential new things compared to an Analytical Plotter: a digital system uses digitized images, some of the measurements are automated and the user is only required for high level interpretation tasks and the final editing of results.

In the same journal Rosenfeld gave his views on the development of automatic imagery interpretation (Rosenfeld, 1965). He wrote "real-world imagery is so complex and so varied that no standard approach exists to the selection of measurements for interpretation purposes". This is what we still have to accept today. Rosenfeld named four concepts (Table 1) that can help to automate the interpretation, but which still require the human interpreter. We are working with our softcopy photogrammetric workstations along all four lines. No real automated solutions for every-

day mapping purposes are available yet.

- Automatically 'screening' imagery for examination by human interpreter
- Automatically performing partial identifications and attracting the human interpreter's attention to them for verification
- Aiding in the decision process by computer-analyzing observations by human interpreters
- Performing quantitative measurements on images which have been identified by a human interpreter

TABLE 1
Concepts for automated imagery interpretation (from Rosenfeld, 1965).

- No high precision optical/mechanical components required
- No regular instrument calibration required
- Digital images are stable
- Images can be loaded without manual operation
- The stereomodel can be changed 'on the fly'
- An optimum image presentation can be chosen for human interpretation
- The stereoplotter can be expanded with digital image correlation
- On-line stereoscopic measurements are possible

TABLE 2
Main features for the use of a digital stereoplotter (from Sarjakoski, 1981).

Panton (1978) described a scenario on future developments where he mentioned intelligent algorithms for Digital Terrain Model (DTM) extraction, for texture analysis, for feature extraction, for planimetric line following and for the creation of symbolic data base structures. We meet the expressions "integrated mapping systems", "digital data bases" and "interactive work stations", which serve as windows into the data base and the processing environment. He wrote "diverse data from many sources can, within the same system, be produced, catalogued, linked up, and retrieved for a wide variety of mapping applications." These are fundamental features of a softcopy photogrammetric workstation, as we can see it today.

In 1981 we find the first detailed concept of a fully digital stereoplotter with a central processing unit, operator interface and peripheral equipment (Sarjakoski, 1981). Those components had essentially the same functionality as analytical stereoplotters, but with some major differences: the two images of a stereomodel were stored in the digital image memories. They are displayed on the operator image display, which is controlled by the central processing unit. Sarjakoski discussed the technical realization and the difficulties. He pointed out, that the design of a digital stereoplotter "could be based on the use of standard image processing displays and the software of existing analytical plotters". He described in detail different principles for stereoscopic viewing and the technical problems in efficient handling of large images for roaming and processing. Sarjakoski mentioned in this paper, the main features for the use of a completely digital stereoplotter (Table 2). In his concept the human interpreter was involved, who required a user friendly design for the viewing and interpretation process, but who could be assisted by digital image correlation. Sarjakoski clearly saw a role of such a stereoplotter for close-range applications with the capability of real-time or nearly real-time photogrammetry.

If we look at the fundamentals for this first period, which is characterized by conceptual ideas by the pioneers in the field, we can arrive at the following summary in Table 3. Softcopy photogrammetric workstations can be described by three major aspects: the data and sensors used, the hardware and user interface and the software and automation tools. The available hardware and software tools of that time were certainly inadequate for realization of all expressed ideas.

Input Data & Sensors	Hardware & User Interface	Software & Automation
Digital images	No high precision optical or mechanical components	Standard orientation and compilation software (like in an AP)
Digital images are stable	No regular instrument calibration required	Reduced labour costs by automation
Data bases for images	Reduced equipment costs by standard image processing displays	Integrated mapping systems with automation of measurement tasks
Access without manual interaction	Human interaction for preparation & editing	Contouring by image correlation (electronically or digitally)
Quality of scanning is a critical point	User friendly design required	Digital Orthophotos can be produced automatically
On-line digital cameras for real-time measurements	Interaction by stereo viewing and XYZ controls	Automated interpretation realizable in stages only

TABLE 3
Fundamentals of Softcopy Photogrammetric Workstations - I

The Period of Design Aspects and First Realizations (1982-1988)

In the following years the conceptual ideas of digital photogrammetric stereoplotters have been developed further until the realization of the first fully digital instrument in 1988 that was commercially available.

In 1982 we can find a design concept for a prototype digital image exploitation system (Case, 1982). Case described that DSCC system as "an analytical stereoplotter which accepts, as input, imagery in digital form on magnetic tape". This all-digital system performed like an analog or analytical stereoplotter concerning point measurement for aerotriangulation, manual monocompilation or stereocompilation of planimetry and elevation data in a roaming mode, but in addition it allowed for graphic monoscopic or stereoscopic superposition for editing and product revision and it performed automated stereo correlation for the automatic collection of elevation data and for pass point transfer. The major driving force was the possibility for greatly improved performance with respect to throughput and response time and for reduced costs in mapping by using digital image processing. Case stated that "functionally the DSCC has to operate in a manner familiar to the operator of conventional analytical stereoplotters". Some of these required features are listen in Table 4. Great emphasis was obviously put on "user friendliness".

- Binocular viewing system with overview display (instead of a hardcopy)
- Handwheels, trackballs, joysticks, footwheels, function keys etc. for control (images, floating mark, etc.) and selection of operation modes
- Handling of very large images (20 k x 20 k)
- Fixed cursor, moving image mode for roaming through the stereo model and for subpixel measurements
- Moving cursor, stationary image mode for the collection of a large number of features within the viewing area
- Image processing procedures
- Image correlation for DTM acquisition
- Monoscopic or stereoscopic data superposition

TABLE 4
Features of the Digital Stereo Comparator/Compiler (Case, 1982)

In the following two years the expression digital photogrammetry emerged and people were dealing with system concepts and models, design aspects and detailed technical solutions.

During the 1984 ISPRS Congress in Rio de Janeiro a detailed concept, based on an adapted digital image processing system, was presented (Albertz and König, 1984). The emphasis was put on the required hardware changes,

the stereo viewing and 3D control capabilities. The authors expressed the need for a human operator, assisted by image correlation for parallax measurement tasks.

Gugan and Dowman (1986) gave four essential features of a digital photogrammetric stereoplotting system: (a) the real-time scanning of a three-dimensional model, (b) the stereo viewing, (c) the capability of handling large images, and (d) the sub-pixel measurement accuracy. Data collection, image correlation and image enhancement were regarded at that stage as additional design features. Their system consisted of an image processing system, that allowed the display of large images on-line and in stereo. Flicker and split screen were regarded as the most promising viewing methods. For the three dimensional model control, with sub-pixel accuracy, three continuous coordinate devices were needed. The problem, at that time unsolved, was supposed to be tackled using real-time correlation.

Grün (1986) introduced several new aspects concerning potential and design of a digital photogrammetric station. The design was for both digital and real-time photogrammetry and for aerial, satellite and close range imagery. This should make it possible to uniquely perform all photogrammetric and cartographic tasks on one platform only. Here we encounter an important aspect compared to analog instruments and partly also to analytical instruments: the task integration on one system, the universality and the flexibility, which directly includes data acquisition. The basic photogrammetric functions were supposed to be used in the digital system as they were used in the analytical systems. Grün saw clear advantages in using normal case images for display and processing. He explicitly included the capability of multi-image processing (matching) into his concept. One of the features of a digital photogrammetric station were products in analog and digital form (hardcopy, softcopy). Here we encounter the word "softcopy" which is used to describe a digital photogrammetric workstation.

Driven by developments in "geo-information technology", a very popular topic at present, a ISPRS Working Group on "Integrated Photogrammetric Systems" was established 1984-1988. In (Makarovic, 1986) a comprehensive presentation of all major aspects of such systems is given. We can find the trend from hardware to software, i.e. from analog to digital and from manual to automatic operations. Further a near-real-time exchange of information and data between data base and all system components is described. Makarovic emphasized both the concept and system model aspect and the design and development aspect. In his scheme we find interactive operations with three types of operator tasks: perception, processing (extraction, verification, editing), and control (tracking, measurement). These are major fundamental features of most digital photogrammetric systems today. Makarovic gave some very interesting comments on the impact on the state-of-the art of information production, on updating and upgrading, on processing and presentation, and on interactive and automatic operations. Those are under intensive discussion today and the impact on the institutional and human environments are going to be very important as well, as they have not yet been clarified.

At the ISPRS Congress in Kyoto, 1988, the first completely digital stereo photogrammetric workstation, the KERN DSP 1 (Cogan et al., 1988a) was presented on site. A variety of other digital stereo workstations were described in detail. All those systems were based on image processing systems and their development was heavily influenced by the availability of digital space imagery (e.g. LANDSAT, SPOT), in order to avoid analog conversion and thus loss of image definition. The KERN DSP 1 integrated the digital image processing techniques into the mapping world. The authors didn't regard this system as a substitute for the analytical stereo plotter, as it required fully digital input, which was not common for the data acquisition for mapping at that time. Viewing could be monocular or stereo, with reduced optics compared to an analytical plotter. Real-time correlation and photometric operations for optimal viewing assisted the human operator. Different processors took care of different operations. The main processor took care of data collection, image orientation, and downloading of images. A second processor was responsible for display, movement controls and digital image processing.

In (Cogan and Polasek, 1988b) the problems of photogrammetric data capturing were stressed. A well defined separation of data capturing and structuring of data was recommended. There were further demands on photogrammetric systems (Table 5), even fully digital systems, which included increased demands from the user's point of view on user friendliness and universality.

- Price-performance optimization by continuity and modular design
- Reliability and serviceability
- User friendly software and efficient operation
- One instrument + integration with geoinformation systems

TABLE 5
Some demands on photogrammetric systems (Cogan and Polasek, 1988b).

In (Euget and Vigneron, 1988) we find the explicit link of a digital photogrammetric workstation to a geographic data base. The human operator is provided with functions for detection and correction of erratic points from the automatic DTM generation, i.e. with editing tools. The production rate was expected to increase with autonomous feature extraction, while the ergonomy and accuracy characteristics of an Analytical Plotter were maintained.

In the stereo system described by (Konecny and Lohmann, 1988) the images are resampled to epipolar line geometry for viewing and measuring, a fundamental principle that is very common today. The integration aspect and the connection to a Geographic Information System (GIS) were emphasized, i.e. the processing of different types of data, like aerial images, geological data or statistical data,

and the presentation to the non-expert, i.e. to a non-photogrammetrists.

In (Stokes, 1988) a fast and accurate digital map revision system is presented based on monoplotting, showing that stereo viewing is not at all necessary for all applications.

Schenk discussed the automation aspect of softcopy photogrammetric workstations, i.e. the concepts and system models for computer solutions of operator tasks (Schenk, 1988, 1986). Criticism against the usual trial and error evolution was expressed and the lack of a real mapping theory was stated. A system consists of computer hardware, software and sensors, but there exist no concensus on how far the computer must carry out subsequent processes and what has to be done interactively. With digital photogrammetry being more than measuring points, the semantic description has to accompany the geometrical description, leading to the final product of map compilation.

Input Data & Sensors	Hardware & User Interface	Software & Automation
Satellite imagery (intrinsically digital)	Human perception (wide field of view on high resolution screen + basic photometric operations for optimal viewing)	'Automation friendly'. (Human interaction = antithesis to efficiency)
Aerial imagery (digitized) Lack of suitable mapping quality cameras	Y-parallax free stereo model in real-time (epipolar images)	Digital image processing for control of image movements
Close range imagery (digitized or digital)	Human processing with editing tools and graphic monoscopic or stereoscopic superposition	Real-time correlation for human assistance of parallax measurements (sub-pixel accuracy)
	Stereo viewing not required for all applications	Most photogrammetric measurement tasks are suited for automation
	Non-photogrammetrists as users for data capturing	Multi-image processing
	Systems consist of off-the-shelf parts	Data management systems required
	General purpose computer as platform	Universality and task integration

TABLE 6
Fundamentals of Softcopy Photogrammetric Workstations - II

A major difference to GIS is the information, it is implicit in photographs and has to be extracted, but it is represented explicitly in a GIS. He strongly believed in analyzing how the human solved problems before developing appropriate methods. Image understanding was neglected then but has

become attractive in research today. Schenk saw clear effects of digital photogrammetry on research, on manufactures and on users.

In Helava's opinion (Helava, 1988) human interaction is an antithesis to efficiency. Human interaction requires expensive hardware, viewing, control and subpixel pointing. The design of a digital photogrammetric system should be "automation friendly", as "the primary merit of digital photogrammetry is its potential for efficient automation". Helava investigated in detail the possibilities of automating the photogrammetric tasks, with the conclusion, that almost everything, from orientation and aerial triangulation, to DTM and orthophoto generation was automated or was on the way to be automated, with one exception: the feature extraction. He strongly suggested tackling the interpretation problem. Helava also stressed the need for data management systems to be able to handle the large amount of data in practical applications. In his conclusions he clearly saw the way to systems consisting of off-the-shelf parts which are not specifically photogrammetric, only the software would remain photogrammetric.

If we summarize that period of strong evolution we can add the following items (Table 6) to our collection of fundamentals. We can keep the division into three major aspects, but now the emphasis is on the development of hardware and software.

The Period of the Human Interface, Automation and Specialization (1988-)

The ISPRS Intercommission Working Group II/III (1988-1992) gave the following definition: "A digital photogrammetric system is defined as hardware and software to derive photogrammetric products from digital imagery using manual and automated techniques". Both types of techniques, manual and automated, are the major subjects for research and development from 1988 and further on and a great variety of softcopy photogrammetric workstations have appeared on the market since then.

Dowman (1989) described a system for mapping from SPOT data, built on the fundamentals described above. A softcopy workstation offers a direct link from photogrammetry to remote sensing. The system is flexible as different sensor models can be introduced and the same platform can be used for image correction, DTM extraction and for creating a line map of cultural and physical features.

Helava emphasized the tremendous revolutionary effect of softcopy photogrammetric workstations on Photogrammetry as well as on Remote Sensing and GIS (Helava, 1991a). He described 25 state-of-the art items of softcopy workstations that have been developed and realized. The need for on-line decompression hardware to increase storage capacity and transfer rates was one important point. Another important item is the generation of perspective views, or highly oblique views of "cityscapes" using photorealistic representations and artificial planting of trees for flights around a city model. Feature extraction tools for feature delineation in three dimensions were mentioned,

that include knowledge based feature attribution. In another paper Helava wrote about the fundamental strength of digital photogrammetry (Helava, 1991b). A digital photogrammetric workstation is not regarded as a new type of analytical plotter, but as a big revolutionary instrument development. It allows the exploitation of the full potential of the accurate and everlasting mathematical relationship between pixels and the ground that digital processes offer, and that are not existent in film based systems. With images and a DTM provided, a fully oriented model can be prepared, ready for analysis by the user. The photogrammetric part can be hidden from the user. Helava expected a strong demand for preprocessed products, that can be produced by high-end photogrammetric stations for the non-expert user.

In (Förstner, 1991) we find a detailed description of the role of concepts and tasks and the importance of the modeling aspect. "The task of photogrammetry is to extract information from images including both geometric and semantic information". Förstner gave some of the algorithmic solutions namely feature extraction, geometric reasoning and performance evaluation. They lead over from the pure measurement to the semantics. The guidance of the human operator, who uses the mouse for coordinate conversion, is still needed. In addition a coding of structural information by pressing buttons is required.

In (Quam and Strat, 1991) the expression "information fusion" is translated to a cartographic modeling environment. The registration of multiple data sources, like stereo images, DTM's, 3D object models is possible. Different camera models, like frame cameras, SPOT, etc. are selectable. Geometric knowledge in the form of lighting models is used to an advantage. Synthetic images and image sequences can be generated, which use phototexture rendering for highly realistic views.

Ackermann described the power of the tools, that have pushed the development of digital photogrammetry forward (Ackermann, 1992). The computer technology and computer methods were the driving forces. He stressed the need to keep the photogrammetric process as accurate, as efficient as reliable and universal as possible. These are principles that have to be fundamental for softcopy workstations. He also saw a strong convergency towards remote sensing through the connection to space imagery.

In (Ebner et al., 1992) a summary of the Intercommission WG II/III is given, covering many of the aspects described above. Portable software was seen as the key factor for the success supported by off-the-shelf components. Also the growing need for end-to-end systems is mentioned, with the emphasis on system integration rather than special solutions and the need of easy-to-use photogrammetric "black boxes".

In (Farrow and Murray, 1992) the higher importance of software modules compared to hardware is expressed. The authors give a comprehensive overview on what types of software should be included in a photogrammetric workstation and described input, data capture/editing and output items. These components are required for a typical na-

tional mapping agency, and they all have their place in a softcopy photogrammetric workstation.

In (Leberl, 1992a) we find explanations for the word softcopy as a contrast to film based but also as an expression for a broader computer application. Data in the computer is denoted as being in "softcopy format" whereas printouts are denoted as being in "hardcopy format". In his paper we encounter another interesting aspect, the GIS-Photogrammetry, i.e. the use of photogrammetric technology for creating, using and updating a GIS. From a technological point of view Leberl described a softcopy photogrammetric workstation as a software package and a procedural manual. Introduction of images in GIS and stereo-viewing as a standard tool in a GIS as well as the connection of data layers, thematic data etc. with images are examples for the "democratization" of photogrammetry. Further ideas along that line were expressed in (Leberl, 1992b). The traditional separation of mapping process into data collection and data presentation was expected to converge into one "mapping tool box". Mapping takes place at a mapping workstation by combined use of stereo and GIS data. He predicted "the shift from traditional long-term mapping programs at high accuracy to short-term database updating and monitoring functions", a trend that we can observe at many places.

Sarjakoski and Lammi (1992) specialized the workstations in the sense, that a high-end digital photogrammetric workstation is used for production and a more simple, but multi-purpose stereo workstation is used for the analysis in a GIS environment. Those workstations, which are a tool for an end-user, have to enable precise 3D measurements. The authors add a new fundamental principle, the just-on-time principle in data collection, which is made possible by softcopy photogrammetric workstations. They highly recommended the use of commercial design and drawing software for object data manipulation. They further recommended the careful use of "user-friendliness", which is not guaranteed by "nice looking windows" only. They suggested the study of user models and metaphors for designing the interfaces, which should consist of a kernel software and a tailoring module.

The democratization of photogrammetry is also expressed by (Dereny, 1993), who proposed "desktop mapping" for users, who don't have to be experts in photogrammetry or cartography. Processes like thematic mapping, resource inventory etc. were called secondary mapping. In this way the softcopy workstations are the tools for spreading the methods.

The softcopy photogrammetric workstation is a suitable platform for the framework for the central tasks of photogrammetry and computer vision given in (Förstner, 1993). It allows the storage and access of object models, for image models, for image understanding models for the analysis and for interpretation. Models for the cognitive aspects of computer programs and human analysts and their interaction have to be developed. In this way the interpretation problem can be tackled and the full potential of a softcopy photogrammetric workstation exploited.

This is the situation regarding the actual development of hardware and algorithms for softcopy photogrammetric workstations and we summarize the fundamentals from this third period in Table 7. Todays digital photogrammetric workstations belong to the second generation, with extended functionality, open architecture and increased performance.

Input Data & Sensors	Hardware & User Interface	Software & Automation
Preprocessed data	Tool driven development	Desktop mapping
Lighting models	Democratization Non-professional operators	Semi-automatic feature extraction the key for efficiency and acceptance
Semantic object models	Uniform interface design principle Tailoring tools	Semantic information as important as geometric information
Photogrammetric and desktop scanning	Just-on-time data collection	Knowledge based feature attribution
Image compression and decompression	Easy-to-use principle	Information fusion with links to GIS and Remote Sensing
	Trend to end-to-end systems	Software package + procedural manual
	Models for human analysts required	Visualisation, animation (Phototexture rendering)
	Commercial design and drawing software	High accuracy and reliability

TABLE 7
Fundamentals of Softcopy Photogrammetric Workstations - III

System Components and Functionality

As a result of the survey through 40 years worth of literature we have established three tables (I-III) containing the fundamentals of softcopy photogrammetric workstations. We have seen how the aspects of data input and sensors, of hardware and user interaction and of software and automation have been weighted differently throughout the period examined. We can clearly see that software has become more important, but mainly for providing a user friendly display of information for the interaction, less for automation. We have the dilemma of user-friendliness as opposed to automation friendliness. It is clear, that the amount of user interaction will be high at the beginning of a systems development, but the overall goal with digital systems, the full automation, should be kept in mind. The efficiency and acceptance of these systems is small as long as the interaction is high or even 100%. In these cases the gain compared to the AP is marginal, if anything at all. Only by putting more emphasis on the development of the automation tools, can the full efficiency inherent in the concept of a softcopy photogrammetric workstation be exploited and the accep-

tance increased. We can identify the following most essential components of a workstation (Figure 2): the computer and data base, the interaction and automation. Together with the peripheral input and output devices they form a digital photogrammetric system.

More details on the system components can be found in (Dowman et al., 1992, Gülch, 1992, Heipke, 1995, Helava, 1988, 1991a, Leberl, 1992b, Sarjakoski and Lammi, 1992, Schenk, 1995, Wiman, 1992). Some examples for representative systems can be found in (Frick, 1995, Miller and Walker, 1995, Nolette et al., 1992, Willkomm and Dörstel, 1995). These examples are not complete by far, but describe some currently available low-cost as well as high-end digital photogrammetric systems in greater detail.

The design of system components, the choice of computer platform, programming language, display, control etc. is not of a fixed type. Systems and components that conform to certain accepted standards are favoured. Those open systems allow, in principle, an upgrade in hardware without dramatic changes of software. Peripherals can be employed as soon as they become available. There exist standards for the operating system, the graphical user interface, the bus and network structure, the interfaces and the data storage.

We will provide here some basic technical descriptions of the major system components and alternative design aspects. We don't focus on details on input and output or on the automation of algorithms, we rather look at hardware and software solutions for the computer, the data base and the interaction as specified in Figure 3.

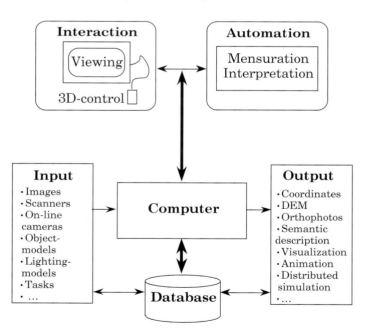

FIGURE 2
The fundamental components of a softcopy photogrammetric workstation and the related input and output devices, tools and products.

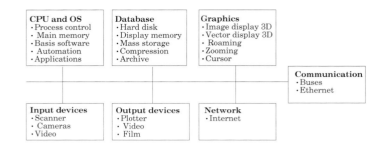

FIGURE 3
Basic hardware components of a softcopy photogrammetric workstation: CPU/OS, Database and Graphics subsystem. These parts are communicating internally and to the input and output devices and external networks.

Computer, Database and Graphics Subsystem

The computer is one of the core elements of a softcopy photogrammetric workstation. All basis software and application software, the user interface, the data transfer and communication are controlled by one or more processing units. Some systems are based on transputers (parallel processors) for speeding up the computations. The determining factor for the performance of the workstation is the speed of the central processing unit (CPU) and the data transfer from the hard disk to the CPU and from the CPU to the user interface (display). An essential component is the graphics subsystem to retrieve image and vector data, to process and store these data in the display memory and to frequently (e.g. 120 Hz) update the monitor. The graphics subsystem may consist of special graphic boards for acceleration of the display functions. Hardware solutions can be applied as well to provide fast computation of the epipolar imagery used in the viewing systems.

There is a general trend to use off-the-shelf general purpose UNIX type workstations as the platform for most high-end softcopy photogrammetric workstations. There do, however, exist PC-DOS based systems as well. A 32 Bit architecture which allows real-time processing and multitasking is standard for the UNIX workstations and is available for PC-systems by using the Windows-NT (New Technology) operating system. As a large amount of data has to be handled and the automation of measurement and automation being computationally very demanding, the typical main memory should be at least 32 MByte (RAM). Depending on the type of application, it should preferably be much more (e.g. 512 MByte). The most commonly used graphics standard for the user interface is X-Windows for UNIX, which is hardware independent and exists with many derivatives on all major computer platforms. For the PC the Microsoft Windows graphical user interface is applied. The most common programming languages for the application software, like automated orientation, orthophoto or DTM generation, are C or C++ and to a limited extent also FORTRAN.

Storage

The hard disk of the magnetic disk type, which is directly connected to the computer accomodates the operative system, the compilers, the basis and application software and possibly also the display memory. Hard disks should have fast access times and should have a size of at least 1 GByte. Hard disks with larger capacity (5-10 GByte) are advisable. CD-Roms (Compact Disk - Read Only Memory), optical disks and juke boxes (stacks of disks) are used for the data storage of images and vector data and provide comparitively fast access. Typical mass storage and back-up media are very often based on magnetic tape, like e.g. Exabyte or DAT (Digital Audio Tape) and can store more than 5 Gbyte of data on one unit, but have long access times. To reduce the storage space several softcopy photogrammetric systems offer on-line compression and decompression of the images to and from the storage media. To receive high compression ratios, so called lossy compression methods are applied. The JPEG (Joint Photographic Expert Group) standard is currently the most applied one. The optimal compression ratio to avoid substantial loss in geometric or interpretation quality for different applications is, however, still unknown.

Image and Vector Database

In the database the images, image parameters, preprocessed images, project parameters, lighting models, object models, semantic information, resulting vector data, DTM, orthophotos etc. are archived. There are high requirements on the data management, i.e. the archiving and retrieval of the data. The correct images must be made available for processing and display in very short time. Sophisticated tools and query languages are needed to keep for example track of images and related orientation and project parameters. The image data base requires large on-line storage capacity. The images are scanned by high resolution photogrammetric scanners or desktop scanners at a smallest pixel size of 7-50 µm with 8-12 Bit grey levels. One standard b/w aerial photograph (23 cm x 23 cm) scanned with a pixel size of 15 µm and 8 Bit grey levels results in about 235 MBytes of data. There is no single common standard for image formats. The TIFF (Tagged Image File Format) standard is, however, quite widely spread. Having only one image format in use for the complete system avoids time consuming image to image conversions. For faster access images are stored in blocks, so called tiles, rather than in the conventional line by line format.

The vector data base should be accessible by standard GIS and other follow-up products and it should allow fast retrieval of vector data for the on-line graphic stereo superimposition.

Network

The computer, the database, peripheral input and output devices are typically connected via very fast buses (e.g. VMEbus, Sbus) or a fast network, like Ethernet with a data transfer rate of e.g. 10-100 Mbits/second. Very often server/client solutions are applied. Via the network several users have access to the data stored on the central server and to common peripheral resources, like printers or plotters.

Interaction

The latest trend in the design of softcopy photogrammetric workstations is to further refine and develop the human interface following the principle of uniform interface design. This is not only due to the lack of automation for mapping or 3D feature extraction, but also due to the fact that the current automated DTM extraction methods still require a substantial amount of preparation to exclude forestry or urban areas, or to perform post editing of areas or single heights. The interaction requires a viewing system and 2D or 3D control devices.

Viewing

The display of the digital images and superimposed vector information requires high resolution monitors (e.g. 1280 x 1024 pixels or more) in 8 Bit colour or in 24 Bit true color with a non-destructive overlay. Images are displayed in mono mode in single or multiple windows or in stereo mode using special techniques (cf. below). The use of an additional control monitor with input menues and process information is very common. Related to the viewing are user callable functions for on-line image processing, like contrast enhancement, edge sharpening or adaption of brightness.

The observable field of view is in the highest possible resolution rather small compared to an Analytical Plotter. For an Analytical Plotter with 8x magnification a field of view (FOV) of about 25 mm is available. Only a 15 x 15 mm window of an image scanned with a pixel size of 15 µm can be displayed on a 1024 x 1024 pixel screen. This means, that even for a smaller resolution than the film based systems, the FOV is smaller in the digital case. An advantage of the softcopy workstation is, however, that zooming can be performed in many steps. Smoothing filters have to be applied to reduce the effects of pixel blocks in large enlargements. The control of the zooming should be flexible and user friendly and is often integrated into the control of the cursor.

For many photogrammetric operations, like the orientation procedures it is necessary to roam through an image or the stereo model in real-time, like on the Analytical Plotter. As a certain image of an aerial triangulation project can be made available in a matter of seconds, it should even be possible to roam over all images of a block. The simultaneous availability of overview images of reduced resolution on the screen for the stereopair or the project area can be very helpful for locating specific areas.

There are two major principles for moving the cursor relative to the image: a fixed image and a moving cursor (Figure 4), or a moving image and a fixed cursor at the center of the viewing area (Figure 5). With the fixed cursor, the familiar situation from the Analytical Plotter is simulated. However, the required real-time roaming puts high demands

on the graphics subsystem to receive a continuous, smooth movement, without delays due to the loading of new image tiles. Eye-strain can occur in case of discontinuous displacements. The demands on the real-time roaming are much reduced if the cursor is moving. It has advantages when a large number of features has to be extracted in the viewing area. A smooth motion can be achieved, but problems occur while moving close or across the boundary. Then new image tiles have to be loaded and the overview might disappear, if discontinuous movements occur.

FIGURE 4
Moving to different parts of an image in Fixed Image Moving Cursor mode. The image is fixed in the viewing area.

FIGURE 5
Moving to different parts of an image in Moving Image Fixed Cursor mode. The floating mark (cursor) is fixed at the center of the viewing area.

Stereo Viewing

For many applications stereo viewing is essential or supports the analysis. In many stations, so called normal (epipolar) images are derived from the stereo images using the orientation parameters to allow a y-parallax free viewing and measuring. Those computations are often performed as batch jobs in a preprocessing stage as they are computationally very demanding.

The stereo viewing requires the separation of the two images of a stereo pair. The separation is based on temporal separation (alternate display of the two images), on radiometric separation (polarization, anaglyph principle) or on spatial separation (split screen and stereoscope) or on combinations of those principles (Heipke, 1995).

The most common techniques today employ a combination of temporal separation and polarization in active or passive mode.

In the case of passive polarization a polarization screen is mounted in front of the monitor (Figure 6). The images are displayed sequentially at a rate of 120 Hz and the polarization screen changes the polarization in synchronization with the image display. The operator uses passive viewing glasses that are vertically and horizontally polarized. In the case of active polarization, the polarization screen is integrated into the viewing glasses (Figure 7). The images are displayed sequentially with a frequency of 120 Hz. The stereo glasses use crystal eyes shutter in LCD (Liquid Crystal Display) technique to polarize the light in synchronization with the image display. The synchronization is enabled by wireless communication. These type of glasses have higher weight due to the LCD shutter and the required battery. The advantage with both methods is, that several users can look in stereo at the same time on the same monitor with free head movement. Both methods allow the display of color images and of color superimposition. The major disadvantage is the reduction in brightness compared to a normal monitor due to the doubled frequency and the absorption of light by the polarization screen or the LCD shutter. Very fast phosphoric for the monitor is essential to avoid afterglow at these high frequencies.

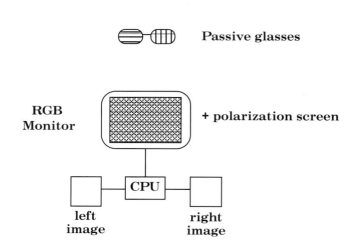

FIGURE 6
Stereo viewing by passive polarization. Alternate display of left and right image at 120 Hz and synchronized polarization by polarization screen in front of the monitor. Viewing by passive polarized glasses.

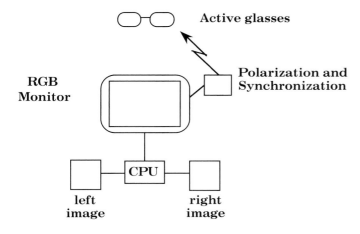

FIGURE 7
Stereo viewing by active polarization. Alternate display of left and right image at 120 Hz and synchronized polarization for viewing by active polarized glasses.

In the case of a spatial separation a mirror stereoscope is mounted in front of the screen and parts of the left and right image of a stereo pair are displayed on the corresponding halves of the screen (Figure 8). This technique of a split screen monitor reduces the observable model area, but provides a familiar environment to operators used to an Analytical Plotter and allows the use of standard monitors (60 Hz) and graphic adapters. A similar solution is based on two screens, one for each image to increase the observable model area. The display of color images and color superimposition is possible, but only one operator can look in stereo at a given time.

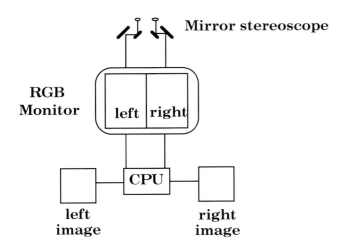

FIGURE 8
Stereo viewing by optical separation. Left and right image are displayed on a split screen. The viewing is performed through a mirror stereoscope.

The anaglyphic viewing presents the two images of a stereo pair in red and green (or blue) colors using anaglyphic glasses to separate the two colors for viewing. With this technique, no color images or color graphic superimposition can be used for stereo.

Superimposition

The graphical display of object data on the image is called superimposition In the case of stereo it is also called stereographic superimposition. In combination with wireframes there can be transparent overlay techniques applied that allow the vision of the image through the graphic overlay. Problems occur on edges which can be solved by proper antialiasing techniques. For 3D superimposition high quality 3D object information is required for high quality overlay.

Control

The subpixel positioning is an essential prerequisite of a softcopy photogrammetric workstation. The cursor (floating mark) can be easily defined in practically any desired shape and size. The cursor should be visible on varying background. Different cursors are used for different displacement modes (slow, fast) or different zoom factors. Even colour patterns can be employed for higher visibility. The cursor can be controlled in many different ways. There are solutions specially for 2D and for 3D control (Table 8). A mouse is most often used for the positioning. Some systems use handwheels and a footwheel to control the apparent movement of the floating mark. Special keyboard keys are used to control the movement in 2D or, for example, the height movement in combination with another device. Advanced 3D cursors allow the control of 3D movement and offer additional programmable function buttons for special tasks. Functions like "zooming in/out" can be called by keys or buttons on the mouse, by using digitizing tablets or by using menues on the display or the control monitor. The sub-pixel accuracy can be reached by real-time resampling of images at intervals less than a pixel for the fixed cursor mode or by sets of convolved cursors in the moving cursor mode.

2D	3D
• Mouse	• 3D mouse
• Trackball	• Trackball
• Keyboard keys	• Keyboard keys
• Handwheels	• 3D cursor with function buttons
	• Handwheels & footwheel/footdisc

TABLE 8
Control devices for the cursor. Combinations occur frequently.

Some Practical Experiences with Softcopy Photogrammetric Workstations

In (Colomina and Colomer, 1995) some initial experience with digital stereoplotting was reported. According to some sixteen weeks of intensive experience, fatigue and eyestrain, the use of a handheld cursor instead of handwheels and the short delays during plotting due to loading new image tiles where no serious problems. After a training period, the productivity was on the same level as with analytical methods. The major advantage that was observed with the digital approach, was the three-dimensional graphical superimposition. Other users can confirm this. The availablity of editing tools is currently highly appreciated. An important factor is the problem free communication between workstation, scanner and other peripheral devices. An increasing emphasis is put on the error free run-time of the computer system, as frequent break downs of servers and networks reduce the efficiency of softcopy photogrammetry dramatically. Quick support for software and hardware updates is of increasing importance. Much emphasis is put on the training of the personnel at mapping authorities and companies, not only with respect to the photogrammetric systems and their components, but for Digital Photogrammetry in general. Support by manufacturers and academia is highly appreciated for that purpose.

Conclusions

There exist many concepts and aspects for a softcopy photogrammetric workstation. The fundamental features are the fully digital environment using digital images and the production of digital output in an interactive and automated fashion.

A softcopy photogrammetric workstation is definitely something other than an Analytical Plotter. The concept goes much further and the major difference is the availabilty of the image information in the computer and the potential for automating the photogrammetric measurement and interpretation tasks in the fully digital system. A general trend is the development of semi-automatic aids under production constraints. An open question is still what the most suitable human interface would look like.

We are on the way to changing the way of processing, performing and distributing the photogrammetric products. There is a definite trend towards producing high quality stereo models and/or orthophoto's and DTM's by experts on high-end softcopy photogrammetric workstations as "map" products. With the universal tool of a softcopy photogrammetric workstation, even a non-photogrammetrist can generate 3D data from those image products in an accurate, reliable way with 3D data consisting not only of pure coordinates, but of meaningful semantic descriptions of objects.

A softcopy photogrammetric workstation can handle many different data sources in mapping and industrial applications. It is a tool for integrating disciplines and applications using the same hardware platform. The application areas can be broadened by users and manufacturers. A digital photogrammetric workstation is not necessarily a part of a GIS or a Remote Sensing system, it can be vice-versa as well. All three disciplines are distinct, but the workstation is a definite tool to link them together.

We still work along Rosenfeld's four concepts (Table 1) for automating the interpretation tasks and have not yet reached automated solutions for everyday mapping processes. The full automation of all processes is the everlasting goal and research is focusing more and more on the conceptual aspects of image understanding to solve the feature extraction problem.

We can close the circle back to 1955 and see that parts of Rosenberg's scenario have become reality. We are using electronic photogrammetry and we are heavily doing research involving information theory. We may soon correlate electronically again. Experiments with digital aerial cameras are on the way, and with high resolution satellite imagery, that bring photogrammetry and remote sensing so closely together, we have reached the level of practical applicability.

We can hope for the driving power of tools again. Up to now it has been the computer technology and the computer methods that have pushed development forward, today it is the concept of a softcopy workstation that will do this. The empty hardware box, the "station", needs the human user and algorithms to do the job, i.e. to "work". Compared to CAD systems, todays softcopy photogrammetric workstations are still of low performance, something which can be significantly changed.

The softcopy photogrammetric workstation is a distinct tool both for mapping and remote sensing for the 21st century. It has to be filled with software for the automation of measurement and interpretation tasks to be as efficient as its concept allows and to be really accepted by users, who are not necessarily photogrammetric experts.

References

Ackermann, F., 1992. Strukturwandel in der Photogrammetrie. *Zeitschrift für Photogrammetrie und Fernerkundung* 1/1992.

Albertz, J. and König, G., 1994. A Digital Stereophotogrammetric System. *15th ISPRS Congress Archives*, Rio de Janeiro, IAP Vol. 25-A2.

Case, J.B., 1982. The Digital Stereo Comparator/Compiler (DSCC). *ISPRS Com. II Symposium*, Ottawa, Canada, IAP, Vol. 24-II.

Cogan, L., Gugan, D., Hunter, D., Lutz, S. and Peny. C., 1988a. KERN DSP 1 - Digital Stereo Photogrammetric System. *16th ISPRS Congress*, Kyoto, *IAP*, Vol. 27-B2.

Cogan, L. and Polasek, A., 1988b. KERN Integrated Systems Hardware and Software Architecture. *16th ISPRS Congress*, Kyoto, *IAP*, Vol. 27-B2.

Colomina, I. and Colomer, J. L., 1995. Digital Photogrammetrische Systeme im Einsatz: *Erfahrungen am Institut Cartogràfic de Catalunya.* ZPF 1/95.

Derenyi, E. E., 1993. Low cost soft copy mapping. *SPIE'93 Conference on "Integrating Photogrammetric Techniques with Scene Analysis and Machine Vision"*, April 14-15, Orlando, Florida, *SPIE* Vol. 1944.

Dowman, I., 1989. Digital Systems for Mapping from SPOT Data. *Conference of Southern African Surveyors* 1989. Paper No. 8.3.

Dowman, I. J., Ebner, H. and Heipke, C., 1992. Overview of European Developments in Digital Photogrammetric Workstations. *Photogrammetric Engineering & Remote Sensing*, Vol. 58, No. 1.

Ebner, H., Dowman, I. and Heipke, C., 1992. Design and Algorithmic Aspects of Digital Photogrammetric Systems. *17th ISPRS Congress Archives*, Washington, D.C., August, *IAP*, Vol. 29-B2.

Euget, G. and Vigneron, C., 1988. MATRA TRASTER T10N Digital Stereoplotter. *16th ISPRS Congress Archives*, Kyoto, *IAP*, Vol. 27-B2.

Farrow, J. E. and Murray, K. J., 1992. Digital Photogrammetry - Options and Opportunities. *17th ISPRS Congress Archives*, Washington, D.C., August, IAP, Vol. 29-B2.

Förstner, W., 1991. Concepts and Algorithms for Digital Photogrammetric Systems. *Zeitschrift für Photogrammetrie und Fernerkundung* 5/1991.

Förstner, W., 1993. A future of photogrammetric research. *NGT GEODESIA* 93-8.

Frick, W. Digitale Stereoauswertung mit der ImageStation. *Zeitschrift für Photogrammetrie und Fernerkundung* 1/95.

Grün, A., 1986. The Digital Photogrammetric Station at the ETH Zurich. *ISPRS Com. II Symposium*, Baltimore, May, IAP Vol. 26-2.

Gülch, E., 1992. Digital Photogrammetric Systems for Industrial and Topographic Applications. *SSAB'92 Conference on Image Analysis*, Uppsala, Sweden, March.

Gugan, D. J. and Dowman, I. J., 1986. Design and Implementation of a Digital Photogrammetric System. *ISPRS Com. II Symposium*, Baltimore, May, IAP Vol. 26-2.

Helava, U. V., 1958. Analytical Plotter in Photogrammetric Production Line. *Photogrammetric Engineering*, Vol. XXIV, No. 5.

Helava, U. V., 1988. On System Concepts for Digital Automation. *16th ISPRS Congress*, Kyoto, IAP, Vol. 27-B2.

Helava, U. V., 1991a. State Of The Art in Digital Photogrammetric Workstations. *The Photogrammetric Journal of Finland*, Vol. 12, No. 2.

Helava, U. V., 1991b. Prospects in Digital Photogrammetry. *The Photogrammetric Journal of Finland*, Vol. 12, No. 2.

Heipke, C., 1995. State-of-the art of Digital Photogrammetric Workstations for Topographic Applications. *Photogrammetric Engineering and Remote Sensing*, Vol. 61, No. 1, January.

Hobrough, G. L., 1959. Automatic Stereo Plotting. *Photogrammetric Engineering*, Vol. XXV.

Konecny, G. and Lohmann, P., 1988. A Digital Image Mapping System. *16th ISPRS Congress*, Kyoto, IAP, Vol. 27-B11.

Leberl, F. W., 1992a. Towards a new Photogrammetry. *Zeitschrift für Photogrammetrie und Fernerkundung* 1/1992.

Leberl, F. W., 1992b. Design Alternatives for Digital Photogrammetric Systems. *17th ISPRS Congress*, Washington, D.C., August, IAP, Vol. 29-B2.

Makarovic, B., 1986. Integrated Photogrammetric Systems. *ISPRS Com. II Symposium*, Baltimore, May, IAP Vol. 26-2.

Miller S. B. and Walker, S., 1995. Die Entwicklung der digitalen photogrammetrischen Systeme von Leica und Helava. *Zeitschrift für Photogrammetrie und Fernerkundung* 1/95.

Nolette, C., Gagnon, P. A. and Agnard, J. P., 1992. The DVP: Design, Operation, and Performance. *Photogrammetric Engineering and Remote Sensing*, Vol. 58, No. 1, January.

Panton, D. J., 1978. A Flexible Approach to Digital Stereo Mapping. *Photogrammetric Engineering & Remote Sensing*, Vol. 44, No. 12.

Quam, L. and Strat, T., 1991. SRI Image Understanding Research in Cartographic Feature Extraction. In Ebner/Fritsch/Heipke (eds) *Digital Photogrammetric Systems*, Wichmann Verlag.

Rosenberg, P., 1955. Information Theory and Electronic Photogrammetry. *Photogrammetric Engineering*, Vol. XXI, No. 4.

Rosenfeld, A., 1965. Automatic Imagery Interpretation. *Photogrammetric Engineering*, Vol. XXXI, No. 2.

Sarjakoski, T., 1981. Concept of a Completely Digital Stereoplotter. *The Photogrammetric Journal of Finland*, No. 2.

Sarjakoski, T. and Lammi, J., 1992. Requirements of a Stereo Workstation for GIS Environment. *17th ISPRS Congress*, Washington, D.C., August, IAP, Vol. 29-B2.

Schenk, A., 1986. Concepts and Models in Photogrammetric Systems. *ISPRS Com. II Symposium*, Baltimore, May, IAP Vol. 26-2.

Schenk, T., 1988. The Effect of Digital Photogrammetry on Existing Photogrammetric Concepts, Procedures and Systems. *16th ISPRS Congress*, Kyoto, IAP, Vol. 27-B9.

Schenk, T., 1995. Digital Photogrammetric Systems. *Proceedings 2nd Course in Digital Photogrammetry*, Bonn, Germany, February 6-10.

Schneider, W. and Hahn, M., 1994. Bildflug mit Real-time-Disk - Experiment geglückt. *GIS* 1/1994.

Sharp, J. V., Christensen, R. L., Gilman, W. L. and Schulman, F. D., 1965. Automatic Map Compilation Using Digital Techniques. *Photogrammetric Engineering*, Vol. XXXI, No. 2.

Stokes, J., 1988. A Photogrammetric Monoplotter for Digital Map Revision Using the Image Processing System GOP-300. *16th ISPRS Congress*, Kyoto, IAP, Vol. 27-B2.

Thom, C., Jurvillier, I., 1993. Experiences with a Digital Aerial Camera at Institut Géographique National (France). *Photogrammetric Week ´93*, Fritsch, D., Hobbie, D., (ed.), Wichmann Verlag.

Willkomm, Ph., Dörstel, Ch., 1995. Digitaler Stereoplotter PHODIS ST Workstation Design und Automatisierung photogrammetrischer Arbeitsgänge. *Zeitschrift für Photogrammetrie und Fernerkundung* 1/95.

Wiman, H., 1992. *Digital Photogrammetry - A Literature Study*. Internal Report, Department of Photogrammetry, Royal Institute of Technology, Stockholm, Sweden.

State-of-the-Art In
Soft Copy Photogrammetry

PETER R. BONIFACE

Abstract

Softcopy arrived unannounced in the early nineties and took most of us by surprise. In these early days of softcopy mapping, opinions have not yet been formed about this dramatic evolution in photogrammetric instrumentation. There are no standardized procedures and the foundations of this field have not yet been laid. This paper attempts to summarize the early experience of some of the users of softcopy photogrammetry in N America, including applications, perceived pros and cons, accuracies and comparisons with the optical mechanical systems.

Introduction

Photogrammetric mapping is in the middle of an evolutionary earthquake — a radical change in mapping technology that was hard to predict in the late eighties. A change that will surely affect the way most of us undertake mapping in the future and will enable mapping technology to spread to other users in allied fields. Now in the nineties, we often hear the message — "My next system will definitely be softcopy!" It is clearly recognized as the wave of the future and the early enthusiasm the writer found amongst users of softcopy systems will probably accelerate the move away from the traditional optical/mechanical hardware in current use.

This paper is based on personal experience with softcopy systems since 1988, numerous discussions with photogrammetrists plus many telephone conversations with a number of users whose names were obtained from the manufacturers of the softcopy systems. Nine manufacturers were contacted and 20 organizations provided the material for this paper.

For a number of reasons it was decided not to divulge the names of manufacturers or users. It was felt that more open an frank discussions could be held with users with this understanding in mind. The list of users is by no means complete, however it is assumed that most of the major users would have been provided by the manufacturers.

Why Softcopy

Why did mapping organizations choose to invest in the softcopy systems? Most users were attracted by the efficiency and price/performance of the softcopy systems in producing digital orthos. Digital ortho production was the most common application and the huge reduction in price offered by softcopy versus the analogue ortho systems was a major factor.

Another major reason was the potential of image matching using correlation to assist the operator in DEM data capture. A number of users found that correlation works extremely well in open terrain with very high data capture rates. As an example one person quoted a landfill area where 450,000 points were generated in 1 hour. The same area and point density would have required no less than 30 hours using manual methods.

The cost of replacing a VAX network was quoted as a reason by one source who said that the softcopy option was less expensive than the traditional hardware. Another reason for not remaining on the VAX was the high cost of maintenance.

There was a general feeling that the softcopy option provided value for money. One could obtain stereo-compilation, aerial triangulation, DEM and correlation, superimposition, and orthophotos at an affordable price.

Comparison with the Analytical Plotter (AP)

It was in this area that users were most divided. At the one extreme one user stated that for stereo-compilation a softcopy system is much better. He quoted the advantage of having a number of applications all in the same environment (compilation, DEM, draping of contours, ortho-generation, etc.) and stated that the softcopy system was less expensive — he had a PC-based system.

At the other extreme a user of both traditional and softcopy systems stated "In my lifetime softcopy will not compete with an analytical plotter." Another said "There is nothing quite as good as a first order analytical stereoplotter although a 15 micron scan comes close."

One user who has been using softcopy for three years stated that with a 15 micron scan he felt that his softcopy system attained the accuracy and reliability of an analytical stereoplotter. He said that an enlargement of 20x was possible on the system monitor yielding a clear, non-pixelated image.

Before looking at this critical question one must define what areas of operation are being considered. First, with regard to **image quality** the vote went in favour of the AP although several users said that the difference, particularly on the higher resolutions (15 microns) was not that great. Nevertheless, there were a few who claimed that softcopy at 15 microns gave a better image. For **stereocompilation** the AP was a clear winner. For large scale mapping many photogrammetrists stated that a softcopy system could not resolve the finer detail that an AP could. Another found serious dot-roll on a softcopy system that could not be removed without frequent correction of the images.

For **DEM generation** there was a positive feeling amongst users that softcopy systems were as accurate or better than APs and that correlation gave the softcopy systems a distinct advantage. **Aerial triangulation** was also mentioned as an area where the softcopy systems performed well and many users stated that they achieved faster and easier production. This is surprising when one considers the impressive production rates that are achieved on APs.

If the only function of a softcopy system was stereoplotting, it appears that their impact would be considerably less than we are experiencing. However, the softcopy system of today is a lot more than just plotting, and covers many areas of map production in a single system.

Image Matching - Correlation — Does It Work?

According to the users, the answer is a resounding YES, but only when the terrain is suitable. Several organizations mentioned projects where there were few man-made features and open terrain and automatic DEM generation was incredibly fast and very accurate — more accurate than an AP according to some. Applications that worked included a land-fill area, a large area in the middle-east using SPOT images and 1/50,000 mapping in Canada using high-flown photos.

The **SPOT project** is interesting and involved no less than 30 pairs. With no ground control horizontal position could be predicted to 100m and elevation to 20m. With sparse GPS these figures reduced to 20m and 5M respectively. A DEM with 30m spacing was required, generating about 4 million points for a totalling overlapping scene. It was stated that virtually no editing was required, except for some scattered cloud areas.

Only one respondent indicated successful automatic heighting in an urban area. He stated that some fine tuning of the software parameters were needed, but a substantial reduction in DEM capture was experienced

Correlation has other uses in softcopy and several users mentioned the selection of tie points for aerial triangulation. Correlation is also used for digitizing fiducials.

One can say that correlation on suitable terrain appears to be extremely efficient and will be one of the main areas of development in the future. It can only improve the performance of softcopy systems. One can foresee the day when for certain applications (e,g, open cut mining earthwork quantities), automatic DEM generation would be standard practice.

Digital Elevation Models

Much of this topic has been covered above under image-matching and clearly the ability to produce DEMs is one of the major considerations in deciding whether or not to travel the softcopy route. Many users agreed that DEM editing was of utmost importance and that more efficient and user-friendly edit routines were required. Opinions were divided on the checking of DEMs. Some users said they panned the model for a visual check to ensure that contours were "on the ground", whereas other said that visual checking of DEM points or contours involved too much data and could not be a manual operation.

A number of users thought that DEMs produced on softcopy systems were as good as or better than those produced on APs. Some users emphasized that it was important to produce quality images (diapositives) if high-quality DEMs were to be automatically produced.

Aerial Triangulation

One of the surprising results of this survey was the extent of the use of softcopy for aerial triangulation and the increased efficiency resulting from the use of correlation for point transfer. One respondent was very enthusiastic about the ease with which an operator can move through the tie point patches. A point which was unsuitable on an adjacent strip could be re-selected and then the original model could easily be recovered for re-transfer.

Another feature of softcopy aerial triangulation was the ability on some systems to scan the tie point patches at say 12 microns as opposed to the standard 25 microns for general viewing. There can be no doubt that aerial triangulation will be enhanced by more and more automation in the coming years.

One of the most impressive developments in one of the softcopy systems was an on-line bundle block adjustment. For small projects the block adjustment can be computed after each model in a matter of seconds. This dispenses with the need for the intermediate stages of strip-formation, absolute orientation, strip adjustment etc. Although the on-line block adjustment does not eliminate the editing of the tie point-numbering, it does, however, greatly simplify the computation of aerial triangulation.

This poses the question of people in other disciplines (civil engineering, forestry, architecture) buying user-friendly softcopy systems for their own particular needs without relying on the experience and expertise of the photogrammetric mapping community. The writer is acquainted with a small company whose aerial triangulation production has been performed by a systems analyst with virtually no background in photogrammetry. The company have their own in-house triangulation and digital ortho software running on a PC. When the operator gets the floating mark near the ground (using anaglyph) — correlation takes over and does the final setting.

Image Compression

Users who have image compression hardware report that compression has become a standard part of their procedure and scans as small as 15 microns become manageable. Without compression, the file sizes would be too large at that high resolution. File reductions of 3-4 are common and one user reported a compression factor of 6x reduction.

Two users who have image compression software on

UNIX wprkstations reported that computer processing time was excessive and that for them it was not a practical proposition. Another user had compression software running on a high-end PC under Windows NT. Images were compressed/decompressed on the fly and 6x reductions were regularly achieved. This user reported that compression was extensively used in a production environment and that it appeared to be highly successful.

Image compression did have the advantage that with the better resolution, softcopy systems could be considered for large scale mapping, whereas at a scanning resolution of 25 microns, the softcopy image was not suitable for fine detail.

There was one user who maintained he could manage 300 mb files without compression. He did however have a high-end UNIX workstation with 288 mb of RAM and two optical storage devices.

Scanners

Organizations involved in softcopy photogrammetry on a production level view the scanner as an important part of the production line second only in importance to the softcopy computer system. Users appeared to be satisfied with the performance of their scanners with the exception of two companies who found unacceptable distortion in drum scanners. These scanners were later returned to the manufacturer. The writer should add however that he was involved with the testing of a drum scanner a few years ago and found that after an affine transformation, a scanned grid maintained it's accuracy to within 1 pixel.

A few users were of the opinion that the bottleneck was in the scanning. One user said that although a diapositive could be scanned in just 20 minutes at 25 microns, by the time TIF tiling was computed, plus the writing to CD, the total time for one photo was about one hour. Some users were reporting very high speeds for their scanners — as little as 5 minutes for a 20 micron scan.

Regarding the precision of scanners there are now several systems on the market that could be called "photogrammetric scanners" — scanners that have tolerances of around 5 microns and scan a 9x9 inch diapositive at 25 microns in anything from 5 to 30 minutes. There is a second class of scanners called "desk-top" which are about one quarter (or less) of the price of the precision scanners and scan at 600 dpi — sometimes 1000 dpi, but do not seem to satisfy the high accuracy requirements of the mapping industry. All of the users contacted used scanners of the "photogrammetric" type.

Hardware — Software

Of the 19 respondents, 15 used UNIX workstations and 4 used PC systems. Memory sizes were unbelievably large in some cases. One user recently took delivery of a UNIX system with 280 mb of RAM and another had no less than 120 gb on a jukebox! Understandably there was a significant price difference between the UNIX systems and the PC systems. The former averaged around the $100,000 mark (hardware plus software) whilst the PC systems were around $50,000. These figures would of course vary significantly depending on software, RAM, disk, peripherals etc. Figures were also distorted by the fact that some users had obtained 50% discounts for Beta versions of the software.

Despite the immense power and speed of the processors used for softcopy photogrammetry, the writer heard some remarks about lack of performance for certain applications. One user seemed to sum up the hardware situation as follows "We need the next generation of hardware to get to where we want to go." Will the user EVER be satisfied with his systems performance? — I doubt it! Perhaps it would be more accurate to say "We will never quite get to where we want to go."

Conclusions

The enthusiasm of softcopy users took the writer by surprise. Although softcopy is a relatively new technology, it is being accepted by mapping organizations as a technology that works — whose time has come. The simplicity of softcopy systems appeals to many users — (few things would be more complicated than an analogue stereoplotter!).

Image-matching using correlation is making a definite impact. Automatic DEM generation is being achieved with great success on satellite images, high-flown aerial photography and over open terrain.

Today, softcopy systems are being used for digital ortho production, aerial triangulation, compilation, DEM generation (automatic and manual) and map revision. It is true that there is a huge investment in traditional mechanical hardware, but as one photogrammetrist put it "I have a large investment in the analytical plotter and would not buy softcopy stereo systems right now. If, however, I was starting a new company based on 1-2 new stereoplotters, I would clearly have to consider the softcopy option very closely."

Acknowledgements

The writer is indebted to the many organizations who willingly provided the information for this paper — and to the manufacturers who provided names and telephone numbers of their clients.

Practical Concerns in Softcopy
Photogrammetry Processing Systems

FRANZ W. LEBERL[1]

Abstract

The transition seems in full swing to abandon measuring methods using film images and replacing them by digital image processing. This development should be a concern to every practitioner of photogrammetry. We will discuss some experiences with the new technologies and provide pointers through the maze of confusing observations and reports about the capabilities and limitations of digital photogrammetry. One of the most puzzling observations is the difficulty in which pixel-based softcopy photogrammetry finds itself, not being accepted in everyday practice, although there is no lack of products and services for digital photogrammetry. The four key elements of photogrammetry include triangulation, DEM generation, orthophoto production and stereo data collection. Only the softcopy production of orthophotos currently finds broad acceptance. But triangulation is the key element which must become available with a clear advantage over traditional analytical plotter solutions in order for the acceptance of softcopy photogrammetry to increase. As long as triangulations are being performed on analytical plotters we will not see softcopy photogrammetry take over. Another concern is the preference of practitioners for an evolutionary transition from the analytical to a softcopy method, rather than the revolutionary "throw away the old, bring in the new" motto under which softcopy photogrammetry is being marketed.

We hope to show in a snapshot of the current situation that the technology works and that hardly an argument will hold up to avoid this new way of photogrammetric mapping, and that its success is also dependent on an appropriate marketing of the new as a transition from analytical photogrammetry.

Introduction

The analytical plotter was invented in 1958 (Helava, 1958). Yet it took until well into the 1980's to see the computer-driven stereo measurements from film images to conquer every modern photogrammetric operation. Thus it took 25 years from demonstrating the analytical plotter until it had matured sufficiently for everyday acceptance. Today, of the perhaps 3500 to 5000 stereo instruments in operation on the globe, at least 1500 are analytical.

Softcopy photogrammetry, which in Europe is denoted as digital photogrammetry, has been demonstrated as part of military programs since the beginning of the 1980's (for example Case, 1982). Some may argue that academic research and planetary programs have preceded this by several years, producing fairly sophisticated stereo matchers (for example Haralick, Shapiro, 1993) and geocoded satel-

lite or scanned film images, beginning with the first digital images from Mariner 4 (1964). However, we will argue that these developments were of components, not systems, and did not, in a systems sense, represent prototypes of photogrammetric work environments. Indeed, first actual photogrammetric softcopy systems were in all likelihood those described by Case (1982) and reviewed by Miller et al. (1990). The 1958-analytical-plotter-milestone can therefore be related to a 1982-softcopy-workstation-milestone. Does this then also mean that we must expect a 25-year period for this technology to become fully accepted, i.e. by about 2007?

No. Developments have accelerated, and innovation towards softcopy photogrammetry is driven not by photogrammetry, but by computer technology. Photogrammetry is merely "riding the coattails" of innovations made somewhere else. The computerized "work-flow", the systems-approach, the simplified hardware and transition to the technology to "mere" software and procedural manuals all will be reasons that acceptance of softcopy digital photogrammetry is just around the corner, not another 10 years away.

It can be shown today that softcopy photogrammetry, if used competently, outperforms analog or analytical technologies. We will discuss some of the issues one needs to consider to actually accomplish a "competent operation".

Softcopy Photogrammetric Tasks

The sequence of operations in a traditional photogrammetric system begins with sensing and the photolab, proceeds through point positioning via aerotriangulation of an entire block of aerial photographs to procedures on individual stereo image pairs, namely stereo-model operations for elevation modeling (DEM), orthophoto-production and stereo data collection, typically for Geographic Information Systems (GIS).

Of these process elements, only the orthophoto production is currently a widely accepted digital process based on scanned photography.

This must and will change. However, it is necessary to provide a clear and persuasive advantage to a photogrammetric user when one proposes to abandon the analytical plotter and embark on the use of image processing work stations. Therefore the triangulation must become superior in throughput and accuracy, the DEM and planimetric feature extraction also must be proven to be better performed in this pixel environment. Quality control, production planning and the entire process management must reflect the advantages of a computer-controlled environment. Once these elements are all in place, there will be no reason to hold on to the analytical plotter.

We argue that aerial triangulation is at least twice as

productive in a digital environment, that DEM-and orthophoto-production are also better done on the computer workstation. It is only the stereoscopic collection of planimetric features where a clear advantage needs yet to be demonstrated taking advantage of color stereo superposition and automated line following.

Digital Cameras

The question is sometimes asked why one needs to bother with film at all: why can one not use digital cameras? For real-time and close range applications, this is actually being put in place (see for example Gruen et al., 1992). But for the photogrammetrist's bread and butter, namely aerial mapping, this is not an innovation that looks imminent. Digital cameras to accomplish the functionality of aerial mapping cameras are not on the horizon. On one hand, such innovation would have to be driven by photogrammetric organizations since there hardly exists a broader application (unlike computers); and secondly, the technological challenge is enormous: in a 1/1000 of a second, an aerial camera is capable of collecting the equivalent of 20 000 x 20 000 pixels, or 1.2 Gigabytes for a color image. Some may argue that the information corresponds to even more pixels.

Sensing technology for digital aerial applications could result from proposed space efforts, for example via recent US-commercial (Eyeglass International, 1994; Gaines, 1995; Space Imaging, 1995) and German programs (Ackermann et al., 1991). In those cases, the cameras employ several long linear detector arrays at three locations in the focal plane of a high performance lens. However, the concept is far from mature and will, if ever proven advantageous over film cameras, totally invalidate the conventional wisdom of photogrammetric school books.

From a practitioner's viewpoint we need not dwell on digital sensing. Instead we will tour the photogrammetric process and comment on the softcopy versions of the process components.

Traditional Versus Softcopy Triangulation

From Analytical to Digital

Traditionally the aerial triangulation is being performed by highly skilled operators on analytical plotters. They are commonly using a three-phased approach: (a) project preparation and planning; (b) coordinate measurements; (c) computation of a solution and blunder removal. These three steps are being implemented sequentially and possibly in separate and different work environments. In a softcopy implementation, the typical suggestion is to use also a multi-phased approach: (a) project preparation and photo scanning; (b) automated coordinate measurements, computation and quality control (Ackermann and Tsingas, 1994).

This suggested approach is a dramatic departure from trusted and well understood triangulation procedures and it exercises enormous stress on most contemporary computer configurations. For the example of a block of 100 photographs, one would be required to create a data set, and move it across the local area network, representing 10 to 270 Gbytes if scanning were done at 1000 to 3000 dpi, with the larger quantity obtained if the source material is in color.

The idea of a fully automated triangulation without an operator of great skill and experience is appealing. It could well become an accepted practice in the future. Yet there exists a more gradual and evolutionary path towards pixel-based triangulation, namely an interactive approach that abandons the traditional separation into the three phases of planning, measuring and computing; instead it rolls them

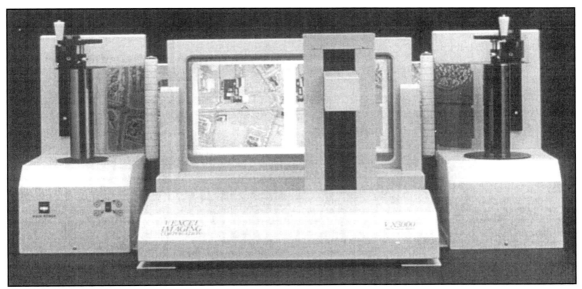

FIGURE 1
A graphics computer workstation is attached to a scanner capable of supporting so-called "region-of-interest" scanning of an uncut roll of film. This is used for interactive triangulations of large blocks of film imagery, using digital image patches using the software product IDAS (courtesy Vexcel Imaging Corp., Boulder, Colorado).

all into one, to be performed on a computer workstation connected to a scanner and supervised by an operator of modest photogrammetric triangulation skills. Figure 1 shows the proposed work environment.

Mass Digitization Versus Region-of-Interest Scanning

Conventional thinking is based on mass digitization of aerial photography for an entire block. Triangulation then starts from these digital files. Agouris, Stefanides and Schenk (1994) or Ackermann and Tsingas (1994) argue that fully automated triangulation is possible and greatly advantageous. A major element of an automated approach is the ability to use clusters of triangulation points instead of single points in each of the Gruber locations. This multiplicity of points is found to increase the overall accuracy and robustness of the triangulation result.

However, a scanner could be used like a measuring device as proposed by Leberl et al. (1988). This produces the option of an interactive triangulation method that is being summarized here. A full description of this triangulation method is being prepared for publication (Leberl et al., in preparation). Its operational implementation has been named IDAS.

The process starts with a roll of photographs that is being scanned at very low resolution to build a layout of the photo block (Figure 2). Based on this overview one will collect preliminary image measurements either by manually pointing to such points, or by automated matching in the selected image patches. This is the basis for performing a preliminary block adjustment. From this one obtains approximate values for the unknowns in the rigorous adjustment. This is applied to coordinates found from rescanned high resolution image patches.

FIGURE 2
Example of a 3-photo block's overview scans at 1500 x 1500 pixels, reduced to even less to fit the display monitor (courtesy Vexcel Imaging Corp., Boulder, Colorado).

Rescanning is then at high resolution, but consists of grabbing only windows of the photographs (Figure 3). The process results therefore in image patches at high resolution, in overview scans of the entire block of photographs, in image measurements, in the traditional block adjustment outcome, and in various graphical support tools that combine points, numbers, digital photographs and error vectors.

FIGURE 3
Example of regions of interest (ROI) at high resolution (10 µm pixels) at relevant locations of triangulation points (courtesy Vexcel Imaging Corp., Boulder, Colorado).

The process could be entirely manual or entirely automated, or any combination of the two. What is important is the fact that scanner and computer form a system and talk to one another. The scanner is a "virtual disk" and "virtual resampling" device. The scanner not only scans, but also operates as a coordinate measuring machine, under manual but more likely under automated control.

Initially it remains unclear at what pixel sizes one needs to scan a metric aerial photograph to prevent any loss of geometric information to occur in the transition from the analog to the digital domains. As a result one is, as a user, free to choose any pixel size between the smallest and the largest (e.g. between 8.5 µm and165 µm). In fact, scans can be of small regions of interest (ROI) with 512 x 512 pixels each. Coordinates of a point are obtained.

Degree of Automation

This triangulation approach can be fully automated so that no operator would be involved, in a manner that is

analogous to the approaches proposed by Agouris, Stefanidis and Schenk (1994) or Ackermann and Tsongas (1994). On the other hand there exists also no need to eliminate the skilled operator. We can see here a scalable approach for automation. Typical functions with machine support include the measurement of fiducial marks and inner orientation of each photograph, image matching to build the preliminary photo layout, computing approximate values for all unknowns and selection of regions of interest ROI for high resolution scanning and high accuracy matching to measure accurate and final image points and for revisiting suspected areas with blunders.

Scalable automation can serve to speed up the process and reduce cost, to reduce the skill needed from the operator, to increase accuracy by increasing redundancy, as shown by Ackermann and Tsingas (1994) or Agouris et al. (1994).

Interactive Quality Assessment and Workflow Management

The actual triangulation is a batch process. At its completion exists a file of adjusted ground coordinates of the triangulation points, and the corresponding image coordinates in each photograph. In addition one has available a number of statistical descriptors of the residual errors and discrepancies in the data. Traditionally this is a highly tabular and numerical presentation.

Softcopy triangulation offers a graphical representation of these results by taking advantage of the digital images stored in the computer. The overview images in the project index map can serve as a backdrop for a graphical presentation of the adjusted ground coordinates and error vectors and the individual patches in the input photographs can show the adjusted and measured image coordinates, and thus visualize the differences between measurement and least squares adjustment result.

Triangulation is now the basis for subsequent procedures such as digital elevation model (DEM) and orthophoto production, and of planimetric stereo data acquistion. These have their own respective needs concerning scanning. Orthophotos may not need to use high resolution pixels. Therefore a separate scanning process, just for orthophotos, may be in order, perhaps at a scale and pixel size that is commensurate with the orthophoto presentation scale and application. A similar comment can be made about DEM generation and planimetric feature extraction. The photogrammetric community has yet a lack of clarity regarding the need for certain pixel sizes for the various components of its processes. Generally, however, it is clear that various component processes have different resolution requirements. Flexibility in this resolution is therefore an advantage.

Initial Experiences with Interactive Softcopy Triangulation

It is the purpose of pixel-photogrammetry to improve the cost-benefit of aerotriangulation over that obtained with an analytical plotter. Table 1 summarizes the results of an analytical and digital procedure.

Method	Analytical	Softcopy
so Image	6.5μm	6.8μm
sx Image	3.3μm	3.5μm
sy Image	3.3μm	3.8μm
sx Ground	7.1cm	4.0cm
sy Ground	6.3cm	4.3cm
sz Ground	2.2cm	1.6cm

TABLE 1
Results of Comparison between P3 Analytical Plotter and Interactive Triangulation of Photos in Figure 2.

It is quickly evident that there exists no accuracy compromise in the pixel-based procedure. The results have errors certainly not greater than those on the analytical plotter. It is to be noted that in this example, the single triangulation points were not replaced by clusters of multiple points. As stated previously and reported by Ackermann and Tsingas (1994) this promises an increase in robustness and accuracy of the triangulation. For the example in Table 1, an entirely manual measurement method was used on the computer workstation.

Regarding throughput and efficiency, the softcopy method clearly wins, even in a first project that probably suffers from a lack of experience and speed when compared with the multi-year use of a DSR in a professional mapping environment.

This initial experience from one photo-block has been confirmed in a series of routine projects and has therefore been the reason to reduce the use of analytical plotter triangulation at the firm which supported the test reported in Table 1.

Pixel Size and Scanning
General Observations

There currently exists only scant and verifiable material for the relationship between pixel size and its effect on photogrammetric results. We may propose the following requirements, based on traditional thinking:

- in *triangulation* we need to ensure that we extract point positions at an accuracy of perhaps ± 1 to ± 2 μm; this is what precision comparators can do;

- *elevation modeling* forces us to an accuracy of ± 7 to ± 15 μm at photo scale when matching two stereo images; this reflects the 1:10,000 to 1:20,000 relative accuracy in elevation measurements using wide-angle photography;

- *orthophotos* need to present about 3 to 8 pixels per millimeter at display scale; the human eye cannot preceive more resolution, therefore a higher resolution will just be wasted;

- stereo *feature extraction* needs to support the full geometric resolution content of the source material to ensure that all relevant data are unambiguously identifiable; very little experience exists about the photo "scale" versus pixel size on the ground to ensure proper interpretability of certain features.

The above numbers merely summarize the rules of thumb of traditional photogrammetry. How do they translate into pixel sizes and pixel positioning accuracies?

Triangulation

There is some evidence that centering on a symmetric target in a pixel array is independent of the target size, but depends on the pixel diameter (for example Trinder, 1989 thereby clarifying Trinder, 1987). Accuracies are quite high, namely on the order of \pm 0.05 pixels. As long as a triangulation effort is based on symmetric targets, the size of the pixels may not be an issue: they may remain fairly large, say in the range of 30 μm, yet they may result in good accuracies of \pm 3 μm. This may change when the triangulation points are no longer symmetric but natural points, and when the triangulation is based on image matching for point transfers within strips and from one strip to the next.

However, there is little evidence in the literature which would clarify this concern. It is therefore unclear what the required pixel size should be to perform a triangulation with natural points and automated point transfer. This lack of clarity is particularly painful when we need to consider a range of contrasts, types of film, of imaged features used in the triangulation.

This issue is of particular relevance when one deals with triangulation at accuracies in the range of \pm 1 to \pm 2 μm. While the use of pugged points would ensure that the "magic" of centering on symmetric objects would take effect even at large pixel sizes, pugging would clearly destroy the automation and throughput advantages of a digital system. Therefore it is necessary that a triangulation rely on natural points. This means that image matches need to be performed with great accuracy. This in turn requires that the differences between two overlapping images be less than the error due to matching, namely in the range of \pm 1.5 μm. This may perhaps be relaxed in the event that larger clusters of points replace the traditionally singular point at each strategic location.

If we assume that matching of natural features in aerial photography has typical errors in the range of 1/s pixels, and if we further stipulate that the individual image needs to be accurate to within 1/1.4 of the matching error, we find that

pixel size < s * 1.5 μm,
pixel position error < \pm 1/(s * 1.4) pixel size.

If the matching error were 1/6 of a pixel diameter, then

pixel size would need to be 9 μm. This, however, represents merely a speculative analysis. Actual accuracies, pixel sizes and scanner accuracies will need to be found from thorough studies with real imagery, since a large factor is the matching accuracy using natural features. Until such studies have produced conclusive evidence for the need for certain pixel sizes and scanner characteristics, it may be advisable to stay with the smallest pixel sizes available.

Orthophoto Scanning

Thus far the photogrammetric literature and experience is mostly focussed on the creation of orthophotos. However, since orthophotos only serve for visual inspection and have inherently large geometric errors due to the unavoidable effects of laid-over vertical objects on top of the bald Earth, orthophotos do not stress the resolution requirements in scanning. Pixel sizes for orthophoto production are largely driven by the fact that the human observer will not see any more detail than that shown at 3 to 8 pixels per millimeter, and by the rule that orthophotos should not be presented at a scale larger than 5 to 10 times the scale of the photographic original.

Stereo Matching for Elevation Extraction

Let us assume that we have used high resolution film with forward motion compensation, and therefore we want an elevation measurement to be very accurate, namely to within 1 part in 20,000 of the camera constant (which amounts to 7 μm). For this we need a matching error of \pm 0.6 * 7 μm = \pm 4.2 μm (note a typical base-to-height ratio of 0.6). What should be the pixel size to obtain such an accuracy of matching? We are unaware of definitive studies to clarify this issue. One may speculate that matching will be accurate to within \pm 0.3 pixels, provided that the object has texture in the overlapping images at the pixel level. In this case the pixel size of 14 μm would appear to be sufficient. Again, the actual relationships are still in need of study.

Feature Extraction

Photo scale is usually determined either by elevation accuracy (often at large scales) or by identifiability of features (often at small scales). Photo scale is usually optimized and as small as permissible to economize on the number of photographs for a project. In the transition to pixels the qualitative content of the photograph is at issue and needs to be fully represented in the digital domain. We may ask the question of the film's geometric resolution. This is typically expressed in terms of line pairs per millimeter, lp/mm, and ranges between 30 lp/mm for regular aerial imagery to 70 lp/mm for high resolution obtained with forward motion compensation (Meier, 1984).

A measure for the pixel array's equivalent resolution is the subject of sampling theory, and is obtained by means of a modulation transfer function, by a so-called Nyquist frequency, or by the Kell-factor. Again, very little research exists which relates the information content of film images to

the pixel size and the pixel's number of bits, i.e. its radiometric resolution. A limited effort was reported by Hempenius and Jia-Bin (1986) which clarified that the radiometric resolution is a determining factor in the geometric information transfer to a pixel array.

A safe assumption is the Kell-factor (Kell, Bedford, 1940) which states that:

$$2.8 * p = 1000/n$$

with p as the pixel diameter in μm and n as the line pairs per millimeter. At 70 lp/mm the pixel size would have to be p = 5.1 μm.

This looks suspicious since we understand very well that the grain size in a photograph is often of the order of 10 μm or more, when considering the weak illumination for aerial photography (in laboratory conditions with bright lights, grain may be in the 1 μm range). If furthermore we realize that grain itself is a binary information carrier, we must assume that the grain can be represented by 1-bit pixels; yet we employ 8-bit pixels.

We have here a largely unresolved issue. While we have various measures of resolution and rules such as MTF or Kell-factors, we obtain counter-intuitive results of pixel sizes that seem to be too small to be meaningful, given the grain size of aerial photography.

Again the actual relationships between film type, number of bits per pixel and pixel size are in need of study, in spite of some work such as that by Almroth (1985).

Performance of a Scanner

Given the uncertainties that exist about the required pixel sizes of a scanning system, it seems that one should tend to the higher resolutions to have the options of addressing all requirements as they may exist in the various phases of photogrammetric work, with slow and fast film, smaller and larger grain, orthophoto or triangulation scanning. Resolutions better than 8μm per pixel may not be exaggerated if a full range of capabilities is needed. This, in turn, would represent a measure of at least 3000 pixels per inch (dpi).

Creating a Digital Elevation Model

Elevation measurements have long been the major target of automation research. Analytical plotters have been equipped with cameras and video signals were matched (Haralick, Shapiro, 1993). Generally, however, DEMs by automated image matching have not yet become an accepted technology. Only at rather small scales and over open terrain has image matching produced acceptable results. A classical example are DEMs produced from stereo SPOT images from satellites. In other cases the manual editing of the match-results requires an effort which may invalidate the assumed advantages of the matching process.

The situation has changed only little over the last few years. Therefore it has remained the preferred method to collect DEM data on an analytical plotter by following contours (the conservative approach) or by measuring point grids and supplementing them by points along terrain break lines. MATCH-T is reported to be a DEM generating software system of as good a performance as can currently be expected. Ackermann and Schneider (1992) suggests that in open terrain, MATCH-T outperforms a manual alternative.

While there is slow progress towards advantageous DEM automation, the analytical plotter can be avoided. Manual measurements are also possible on a softcopy work station. The typical DEM creation will continue to be a process which begins with automation and ends with manual editing of the contour lines or DEM point pattern.

There exists, however, a type of DEM that can routinely be produced by automation: this is the DEM used for orthophoto production only.

Orthophotos

Orthophotos do not challenge the photogrammetric process. Essentially they are a graphical product for visual inspection. Therefore they need not be more accurate than the medium on which they are displayed. Also, orthophotos do simply fit their geometry with respect to a "bald Earth", that is, the vertical objects on top of the bald Earth remain geometrically distorted. Therefore orthophotos remain of limited geometric accuracy.

While the digital version of an orthophoto pixel array would offer the possibility of "fixing" these traditional orthophoto errors, there exist no commercial systems today that actually would correct vertical objects.

Traditionally orthophotos were to be enlarged by a factor not to exceed 10. This has to do with the sensitivity of the human eye with its limit at about 3 to 8 pixels per millimeter at a 25 cm viewing distance. If the source image had 30 lp/mm, then a 10 times enlargement would have a resolution of 3 lp/mm, or 8 pixels per millimeter, taking account of the Kell-factor.

Many photogrammetrists use 30 μm pixels today if they scan a photograph for orthophoto production. At this resolution, the presentation at a 10 times magnification would present the user with 3 pixels per millimeter, which is marginal. Therefore the enlargement should either not be by a factor of 10, or the scan resolution would have to be higher.

All current softcopy systems for sale can produce digital orthophotos on a routine basis. This technology has also been fully accepted since the product — the digital orthophoto — can easily be integrated into a GIS as a backdrop.

To fully satisfy the expectations one should have vis-a-vis digital system, however, the technology has yet to learn how to correct the geometry of vertical objects such as buildings or trees. Just as this capability is missing in the conventional DEM arena, it is also missing in the orthophoto arena.

It is only present in the virtual reality domain in a concept that can be denoted as CyberCity (Gruber et al., 1995).

Stereo Mapping

While numerous vendors and developers offer solutions to extract planimetric features from stereo photography, there is no acceptance by practitioners. Features are all still mapped on analog or analytical plotters. The obvious reason lies in the *perceived* lack of an advantage to collect map features from digital images, and therefore the lack of an economic justification to replace the existing analytical photogrammetric work stations.

This hesitation is further reinforced by various other issues. Most important is the concern about viewing fatigue and quality of the stereo image on a computer monitor. Of course there also exist doubts about the geometric accuracy.

As a practical matter, these concerns have so far not been conclusively dispelled. There exists the paradox that numerous vendors are offering stereo mapping software on very comfortable work stations, but that they cannot publish persuasive reports on productivity, mapping accuracy, throughput increases and operator fatigue.

Yet this lack of data and reports does not imply that there is good reason to abstain from softcopy work stations. There exist significant advantages in interactively tracing features on a stereo monitor, to enjoy the benefits of semi-automation in line following, semi-automation in stereo matching, automated quality control and graphical color stereo superposition.

Both the US Image Understanding Program with its annual conferences (Morgan Kaufman Publishers, 1994) as well as European researchers of automated extraction of man-made structures from aerial and space images (Gruen et al., 1995) report intensive work on the collection of planimetric features. One particular focus is on 3-D city scapes and roads.

Of course today's vendors may be considered somewhat "guilty" of premature product releases: automation in feature tracking is typically not part of the current systems. Yet they all seem to be preparing add-ons to offer such automation. They also are guilty of ignoring the user's need for reliable and persuasive information about throughput advantages in feature collection.

At the current time, the "market" for stereo feature mapping on softcopy environments still needs to "be made".

Current Status of Automation

We already reviewed some elements of automation in photogrammetric softcopy environments. Let us take a closer look at where the developments stand at this time.

In *triangulation*, we already discussed some encouraging developments. A tight integration between the scanning process and the triangulation computations is desired to accomplish nearly complete automation:. Scanning from uncut rolls of negative film is combined with fiducial mark recognition, definition of tie points etc. This is in the process of development and may become the standard process. Automation has been demonstrated.

Elevation modeling has been discussed above, and so has orthophoto production. A high degree of automation has be accomplished in both areas. While there is no question about the acceptance of automated orthophoto production, there exist some serious limitations in the DEM production at large scale, coping with the "bald Earth" and with man-made structures.

The automation of collecting *planimetric features* is the weak link in the softcopy process. Great opportunities exist to dramatically increase throughput by automation. Yet the current user must live with a softcopy analog of the analytical plotter and therefore cannot yet enjoy significant automation. Yet many advantages could be provided with only modest efforts. Vendors are called upon to implement some tools to support the human operator in collecting stereo map data. While throughput advantages are feasible even without much automation support, it will be automation that will persuade the common user that this technology has arrived to replace the analytical plotter.

Image Recording

Today's digital images can be viewed on interactive high resolution computer monitors. However, there remains a need to put these images back onto paper or film, or so-called "hard copy". This can be accomplished without a photo laboratory since such data will be recorded onto paper or film directly and as a positive. Fortunately, there exist many consumers of image recording devices, far beyond the small group of photogrammetrists. Therefore we do see a rapid development of innovative technologies for high resolution film recorders at amazingly low cost.

These are the tools to render the photogrammetric photo lab obsolete. So-called "poster makers" permit one to create large format (48" by infinite) photographic output from digital image files, or smaller 11" x 17" hard copy color photographs, essentially in an instant. Capital equipment may be in the range of US$ 10 000, and material per image may run at US$ 1 to 10 per sheet, depending on speed or quality. Even color copiers are in the process of becoming of reasonable quality to output color photographs from digital files, at a cost of well below US$ 1 per sheet.

Color image recorders are thus soon to be a required tool in every photogrammetry shop.

The Future

Softcopy photogrammetry procedures are operational. All photogrammetric tasks can now be performed in softcopy at a throughput and accuracy either better or at least equal to traditional analytical tools.

Someone starting a photogrammetric operation today would be ill advised to invest into anything else than softcopy photogrammetric environments. Someone already operating with traditional analog or analytical equipment is tempted to wait to better understand the cost/benefit ratios of the new processes as compared to the traditional ways. These advantages are evident in the case of triangulation,

but they are not yet widely being offered as products.

The advantages are also entirely transparent in the production of orthophotos, and a large number of vendors make this the first fully accepted component of softcopy photogrammetry.

In DEM production and in the collection of planimetric map and plan data, the advantages exist also, but they have not been made transparent to the community in a persuasive and conclusive manner. It will be task for the innovators in the field to produce the convincing evidence of the advantages of softcopy photogrammetric DEM and planimetric data collection, and will also be a task to improve these advantages by means of automation.

Conclusions

We have discussed the four phases of photogrammetric operations, namely triangulation, elevation mapping, orthophoto generation and planimetric feature mapping. We have commented on the current state of affairs regarding their implementation and use in a softcopy photogrammetric environment. And we have shed some light on digital cameras and on the scanning of film images into digital pixel arrays, with some considerations of the required pixel sizes. We conclude that scanning must be available at fairly small pixel sizes of perhaps smaller than 10 µm to cover all applications of photogrammetric images.

Many of the procedural and cost issues of softcopy photogrammetry remain unclear. The cost/benefit ratios of a softcopy system versus a traditional system must be studied at many locations so that a persuasive and convincing body of evidence gets created. This will remove the obstacles in the minds of the concerned consumers of photogrammetric technology against making the commitment to embark fully on a digital-only system of operations.

References

Ackermann, F., Bodechtel, J., Lanzi, F., Meissner, D., Seige, H., Winkenbach, H. and Zilger, J., 1991. *MOMS-02 - A Multispectral Stereo Scanner for the Second German Spacelab Mission D2, International Geoscience and Remote Sensing Symposium 1991, IGARSS'91,* Helsinki, Vol. III, pp. 1727-1730.

Ackermann, F. and Schneider, W., 1992. Experience with Automatic DEM Generation, *International Archives of Photogrammetry and Remote Sensing,* Washington D.C., Vol. XXIX., Part B4, Comm. IV, pp. 986-989.

Ackermann, F. and Tsingas, V., 1994. Automated Digital Aerial Triangulation, *Proceedings,* ASPRS Annual Convention, Reno, Nevada, pp. 1-12.

Agouris, P., Stefanidis, A. and Schenk, T., 1994. Multiple Point Multipoint Matching, *Proceedings,* ASPRS Annual Convention, Reno, Nevada, pp.13-22.

Almroth, U., 1985. *Digital Photogrammetry: Pixel Size,*

Image Quality, Noise Considerations, Fotogrammetriska Meddelandan, No. 51, Royal Institute of Technology, Stockholm, pp. 1-15.

Case, J., 1982. The Digital Stereo Comparator/Compiler DSCC, *Proceedings,* ISPRS Comm. II, Canadian Inst. of Surveying, Box 5378, Station F, Ottawa, pp. 23-29.

Eyeglass International, 1994. Company Brochure, Dulles, Virginia 20166.

Gaines, C.D., 1995. *Mapping the Earth with EarthWatch.* Ball Line, Vol. 50, No. 2, published by Ball Corp., 345 S.High St., Muncie, Indiana, pp 8-13.

Gruber, M., Pasko, M., and Leberl, F., 1995. Geometric versus Texture Detail in 3D Models of Real World Buildings. *Automatic Extraction of Man-Made Objects from Aerial and Space Images.* Birkhäuser Verlag, pp. 189-198.

Gruen, A., and Kahmen, H., eds., 1993. Optical 3-D Measurement Techniques II., *Proceedings,* Wichmann-Verlag, Karlsruhe, 624 p.

Gruen, A., Kübler, O., and Agouris, P., eds., 1995. *Automatic Extraction of Man-Made Objects from Aerial and Space Images.* Birkhäuser Verlag, Basel, Switzerland, 321 p.

Haralick, R. and Shapiro, L. 1993. *Computer and Robot Vision,* Addison-Wesley.

Helava, U., 1958. New Principle for Photogrammetric Plotters, *Photogrammetria,* Vol. 14, No. 2, pp. 89-96.

Hempenius, S. and Jia-Bin, X., 1986. On the Equivalent Pixel Size and Meaningful Bit-Number of Air Photography, Optimal Scanning Aperture and Density Increment for Digitizing Air Photographs, *Proceedings,* ISPRS Comm. I, ESA-SP 252, No. V., pp. 451-464.

Kell, R. and Bedford, A., 1940. *A Determination of the Optimum Number of Lines in a Television System,* RCA-Rev. No. 1, pp. 8-30.

Leberl, F., Best, M., Maresch, J., Wang, S., and Gruber, M., (in preparation) *Interactive Digital Triangulation Using Image Patches.* Manuscript, Institute for Computer Graphics, Technical University Graz, Austria, 15p.

Leberl, F., Johns, B. and Curry, S., 1988. Mensuration Frame Grabbing for Softcopy Analysis of Film Imagery. *Proceedings,* International Workshop on Analytical Instrumentation, Phoenix, Arizona. Publ. by American Society for Photogrammetry and Remote Sensing.

Meier, H. K., 1984. Progress by Forward Motion Compensation in Cameras, *Proceedings, 15th Congress of the ISPRS Archives,* Vol. 25, Part AI, pp. 194-203.

Miller, S., Helava, U. and Devenecia, K., 1992. Softcopy Photogrammetric Workstations, *Photogrammetric Engineering and Remote Sensing,* Vol. 58, pp. 77-84.

Morgan Kaufman Publ., 1994. Image Understanding Workshop, Monterey, CA, 13-16 November 1994.

Space Imaging, 1995. Space Imagery, Inc. *Revolutionizes Delivery and Use of Earth Data*, Company Brochure published by Space Imaging, Inc., P.O. Box 29939, Thornton, Colorado, 80229-0939.

Trinder, J., 1987. Measurements to Digitized Hardcopy Images, *Photogrammetric Engineering and Remote Sensing*, Vol. 53, pp. 315-321.

Trinder, J., 1987. Precision of Digital Target Location, *Photogrammetric Engineering and Remote Sensing*, Vol. 55, pp. 883-886.

[1] Also with Vexcel Imaging Corporation, Boulder, Colorado (USA)

Appendix

The DIGITUS digital stereoplotter

Digital Stereoplotter Module:

The DIGITUS digital stereoplotter module includes a full color stereo superimposition viewing system with optional dual screen configuration, fixed floating mark with real-time image panning, fully adjustable zoom, contrast intensity and floating mark size, and two handed, seven button cursor with Z thumb wheel and mode dependent multiple button function. DIGITUS features DAT/EM's DGN/CAPTURE for map compilation and MAP/EDITOR for automatic editing functions.

Aerotriangulation Module:

The DIGITUS digital stereoplotter includes a complete aerotriangulation package with fully analytical & semi-analytical modules, data file input and large block adjustment programs.

Digital Orthophoto Module:

The DIGITUS digital stereoplotter has an optional full orthophoto module with TIN based orthophoto generation, ortho rectification, pixel transformation, controlled mosaicking and automatic tone matching.

Features:
- UNIX Operating System
- X Windows System with Motif Graphical User Interface
- Platform independent design
- Compatible with all current scanning and output devices

Hardware:
- Sun SPARCstation 20 model 61 SX
- 160 MB RAM
- 1 GB internal disk drive
- 9 GB external disk drive
- 3.5" floppy drive
- CD-ROM drive
- 14 GB tape backup system
- 20" Color display monitor
- 19" Tektronix stereo monitor
- 3D stereo display graphics card
- 18" x 24" digitizer and 3D cursor
- MicroStation 32 Sun Version 5.x
- Workstation console with chair

Leica DPW670/770 by Helava with SOCET SET®

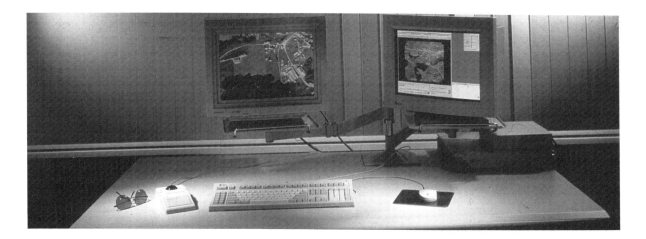

The Leica DPW670/770 by Helava is a range of digital photogrammetric workstation designed for all operations of digital photogrammetry.

The basis of each DPW is a high performance graphics workstation: Sun SPARCstation 5, Sun SPARCstation 20, Sun Ultra or Silicon Graphics Indigo². Workstations are supplied with at least 64 MB RAM and 6 GB of hard disk capacity. Typically, 8 mm tape is preferred for software deliveries and image storage. Both 8 and 24 bit displays are available on 20" colour monitors. The Leica DVP Viewer is available as an option for stereoscopic viewing in split screen mode on the DPW670. Stereoscopic viewing on the DPW770 is achieved on a second 24 bit colour display by means of NuVision passive polarised spectacles or CrystalEyes® active LCD eyewear from StereoGraphics, usually on 19" or 20" monitors. Hand controllers, hand wheels and foot disks are available as options to provide a working environment attractive to experienced photogrammetric personnel.

The software platform consists of the Unix operating system (Solaris on Sun, IRIX on Silicon Graphics) and the graphical user interface follows the standards X Windows and Motif. Networking options include 10-BaseT, 100-BaseT, FDDI and ATM.

The digital photogrammetric software is Helava's comprehensive suite SOCET SET® (Softcopy Exploitation Tools). Its wide selection of modules cover all operations of digital photogrammetry: project management, including coordinate systems and map projections, camera data, ground control data and image handling; workflow management tools; import and export of images, ground control points, GPS data, DTMs and feature data in numerous popular formats; mathematical models for frame, panoramic and close range photography, Landsat, SPOT, JERS-1, direct linear transformation and general polynomials; interior and exterior orientation; automated triangulation; initial values and special bundle adjustment for flexible close range configurations; image pyramids and epipolar rectification; viewing and measurement with moving measuring marks/stationary images or stationary measuring marks/moving images; DTM generation by image matching with versatile interactive editing; orthophotos from single or multiple input images and "true orthos" corrected for building lean; mosaics; feature extraction including semi-automated tools; image maps; perspective scenes, fly-throughs and walk-throughs; tool kit for software developers.

Applications packages for feature collection include Leica PRO600 interface to Bentley Systems MicroStation; KLT ATLAS; Aviosoft X-MAP; and DAT/EM. Communication with GIS databases is by translators or two packages are available on-line: Unisys System 9 and Syseca GeoCity. Links to other software products are developed by the software vendors or by Helava in response to customers' requirements.

The Sun SPARCstation 20 and Ultra versions of the DPW670/770 are available in dual configurations with the DSW200 Digital Scanning Workstation.

I.S.M. International Systemap Corp., CANADA
Digital image Analytical Plotter (DiAP) Software System

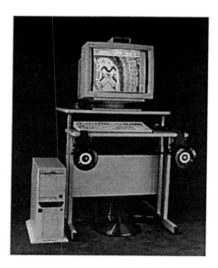

Primary Functions :
- Point marking and transferring;
- Model Orientation and mono/stereo image mensuration;
- Feature compilation with stereo super-imposition;
- Stereo map data editing;
- Raster Image & map vector data file translation, import/export.
- Orthophoto generation (optional)

Main Hardware Components :
- Computer System / Stereo-ready Monitor;
- Stereo viewing devices;
- Input device(s).

Viewing Technology :
- Active LCD Shutter Eyewear

Platform(s) & Operating System(s) :
- Pentium or 486 PC Systems - MS-DOS

Software Functionalities :
- Photogrammetric Project / Model / Control file management;
- Camera files and Model Orientation;
- Coordinate data logging;
- Image Zooming, panning (step/dynamic), rotation;
- Dynamic Epipolar resampling;
- Feature coding & stereo compilation/editing;
- Simple & differential rectification (orthophoto);
- Desktop image/map publication.

DIGITAL VIDEO PLOTTER
version 3.50

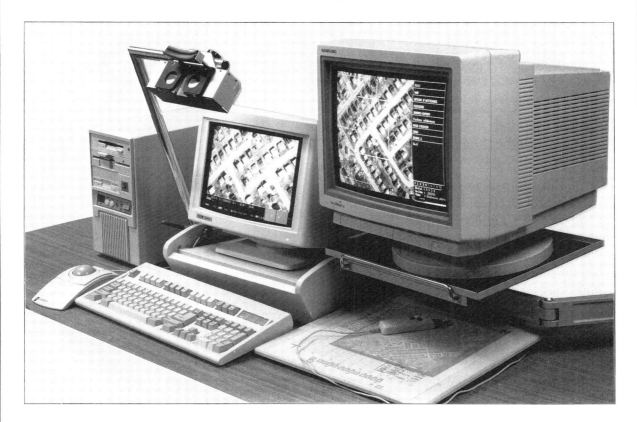

Low cost production oriented video plotter,
runs on PC DOS,
compactness and flexibility,
rigorous mathematical solution,
user-defined accuracy,
complete range of photogrammetric products (scanner calibration, aero-triangulation, stereo map
compilation, 2-D image rectification, TIN creation, ortho-image generation, SPOT image
compilation, monoplotting),
split screen and mirror stereoscope viewing technology,
second monitor in option,
etc........

INTERGRAPH
Mapping Sciences Division

IMAGESTATION INTERMAP DIGITAL

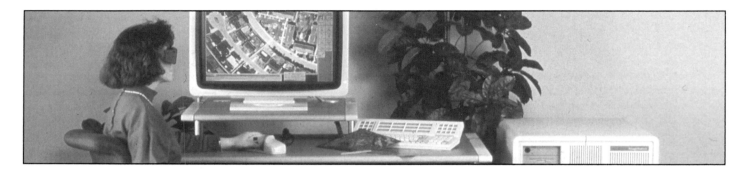

ImageStation is a powerful suite of hardware and software designed for production photogrammetry applications, used worldwide in over 30 countries.

The ImageStation Intermap digital stereoplotter is a specialized UNIX workstation designed specifically as an accurate, high throughput, economic photogrammetric instrument. ImageStation's special features are a 27-inch (69 cm) 2 megapixel resolution monitor; a JPEG image compression/decompression processor; Crystal Eyes TM stereo viewing system; VI-50 image computer, and an ergonomically designed work/digitizer table which includes a 10-button 2-handed cursor; cantilevered monitor table and fully adjustable cyborg chair; and a base memory of 64 megabytes. The 27-inch true color monitor allows for stereo displays with a large field of view using Stereographics Crystal Eyes <TM> liquid crystal shutter glasses and an infrared emitter, and non-destructive stereo vectors.

The JPEG image compression/decompression processor does real time decompression of JPEG images. Image compression facilitates workflows by reducing image storage and transfer times. ImageStation allows the photogrammetrist to use high resolution imagery on large projects.

The VI-50 image computer permits smooth continuous stereo roaming over entire stereo models, regardless of the image file sizes. The

ImageStation software modules cover the complete range of photogrammetry solutions, including project management, aerial triangulation, feature collection, terrain modeling and alignment cross sectioning. ImageStation software solutions utilize automated and semi-automated image correlation techniques for measurements at all stages of the workflow.

The aerial triangulation module incorporates automated measurements for interior, relative and absolute orientations, allows for the simultaneous display of up to 6 photos/images at a time on the 27-inch monitor and has an on-line photo bundle adjustment. It also interfaces with multi-sensor satellite triangulation modules from TRIFID Corporation, St. Louis, as well as several well known industry aerial adjustment programs.

ImageStation's stereo exploitation modules, feature collection, DTM collection and alignment cross sectioning, all take advantage of ImageStation's 27-inch monitor for large and multiple stereo displays, and interactive automated measurement capabilities. There is also a module for completely automatic, batch DTM collection, Match-T offered by INPHO Gmbh, Stuttgart, Germany.

ImageStation also offers complete orthophoto production modules with interactive and batch mosaicking and tone matching.

PRI²SM Softcopy Stereoplotter & Photogrammetric Workstation
DATRON, 1500 Buckeye Drive, Miltipas, CA 95035

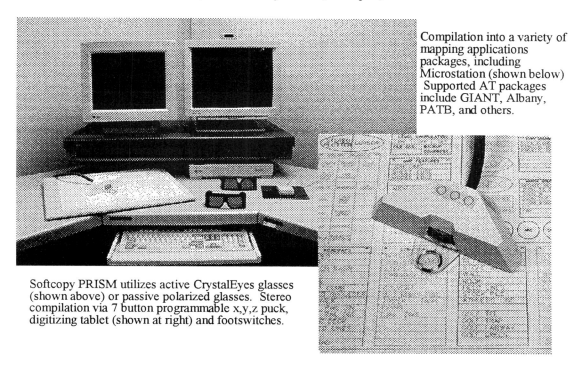

Compilation into a variety of mapping applications packages, including Microstation (shown below) Supported AT packages include GIANT, Albany, PATB, and others.

Softcopy PRISM utilizes active CrystalEyes glasses (shown above) or passive polarized glasses. Stereo compilation via 7 button programmable x,y,z puck, digitizing tablet (shown at right) and footswitches.

The PRI²SM softcopy stereoplotter from Datron/Transco Imaging Systems is supported on UNIX workstations, implemented in X Windows and Motif. Current supported sensors include vertical and oblique aerial photography, airborne scanner data, SPOT and JERS. PRI2SM software easily accommodates new sensor data as they become available, e.g., IRS-1C, CBERS, and others. PRI²SM complies with, and takes advantage of, open system standards to exchange data with a wide variety of third-party applications packages.

Benefits include project management database which guides the operator from the beginning to the completion of mapping projects, and superb image handling and processing. There are no restrictions on image size, both color and monochrome imagery are fully supported, along with map production and revision in stereo and monoscopic modes.

PRI²SM FEATURES

Image Resection
* Relative/Absolute Orientation
* Interior/Exterior Orientation
* Ingest of third-party model parameters
* Automatic fiducial identification
* Aerotriangulation and block adjustment

Automatic DTM generation
* Fast collection at any grid resolution (ground units)
* Interpolation for missed postings or adverse areas
* QA of each posting, indicated by color

DTM Editing in Stereo Mode
* Overlay elevation postings on stereo image
* Edit individual postings
* Stereo profile/contour in area of interest
* Incorporate breaklines and spot elevation
* DTM collection; auto driving to grid location

Orthorectification
* Orthorectify on the fly as the image is roamed
* Output orthoimage in 24 map projections

Softcopy Stereoplotter
* Digital StereoViewing, roam & zoom in real time
* Configurable floating mark (size, color)
* Full color superimposition and compilation
* Two-hand, 7-button puck with Z thumbwheel

Value-added Processing
* Satellite segment processing
* Standard products (DOQ, SpaceMaps, 2A, 2B, 3)
* Map sheet generation
* Topographic contour maps
* Slope, aspect, true 3-D perspectives
* Thematic maps
* Compatible with VISTA remote sensing software
* Interface with GISs; GenaMap, ARC/INFO, more

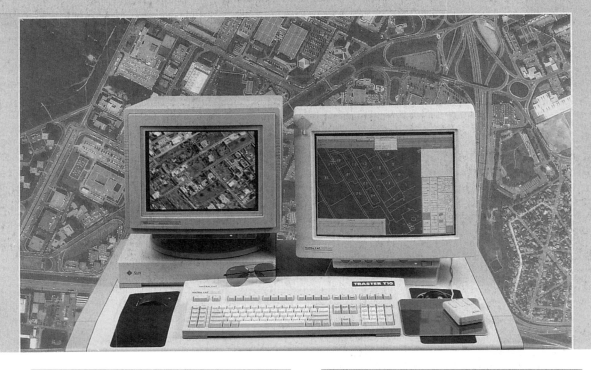

CORE MODULE

- **Stereoscopic viewing**
- Smooth panoramic
- Interpolated zoom
- Subpixel viewing

- **Aerial photogrammetry**
- Generation and management of the auxiliary files
- Definition of the orientations (internal, relative, absolute)
 with the automatic correlation of the image
- Photogrammetric data collection

- **SPOT satellite photogrammetry**
- Generation and management of the auxiliary files
- Model orientation and path modeling with the automatic correlation
 of the image
- Photogrammetric data collection

- **Aerotriangulation module**
- Model observation (with the strip coordinates or with the ground coordinates)
- Independent model adjustment
- Automatic models up-date.

DTM AND ORTHO-IMAGES GENERATION MODULE

- Extraction of the elevation data through an automatic correlation
 (choice of the extraction area)
- Automatic generation of the contour lines
- Stereoscopic superimposition of the contour lines on TRASTER T10 images
- Display, control and correction of the DTM
- Automatic generation of the orthoimage
- Control of the DTM with the orthoimage
- Generation of perspective view

MOSAICKING MODULE FOR ORTHO-IMAGES AND DTM

- Mosaïcking of "n" images
- Control of the geometric quality of the mosaïc.

GRAPHIC DISPLAY MODULE

- Management of the vector data collection under thematic layer principle
- Stereoscopic superimposition of the captured data on TRASTER T10 images.

MATRA CAP SYSTEMES

SoftPlotter™ *Version 1.4*

Providing the functionality and performance demanded by professional mapping organizations

SoftPlotter leads the way in digital photogrammetry providing accurate and efficient data extraction. Designed for the professional organization with high productivity and throughput requirements.

SoftPlotter is available as an upgrade option from OrthoMAX™. OrthoMAX is a generalized package developed for the ERDAS IMAGINE™ product line by Autometric, Incorporated and ERDAS for the GIS community.

Benefits

- **Speed, accuracy and across-the-board functionality**
 - **aerotriangulation, including multi-sensor**
 - **automated terrain model extraction with interactive stereoscopic editing**
 - **orthorectification**
 - **mosaicking**
 - **3D feature data extraction (Kork Digital Mapping System, KDMS and Bentley MicroStation)**

- **Fits current operations/environments providing links through common data formats:**
 - **DXF, DGN, KDMS, TERRAMODEL, ARC/INFO, ERDAS IMAGINE**

- **Silicon Graphics computers provide high processing and throughput power**

- **Custom 3D input device provides relaxed and extended workstation operator time**

- **Graphical visualization and selection of products and imagery as part of Production Management software**

- **ERDAS IMAGINE for image enhancement and hardcopy output composition**

- **Handles common commercial image scanner input**

- **Standard frame, SPOT, close range, and panoramic camera models**